Art and Revolution in Latin America

1910–1990

Art and Revolution in Latin America

1910–1990

David Craven

YALE UNIVERSITY PRESS • NEW HAVEN AND LONDON

This book is dedicated to my brothers, Brian and Paul, and to my sisters, Anita and Laura.

Designed by Elizabeth McWilliams

Typeset in Adobe Minion and Impact by SNP Best-set Typesetter Limited

Printed in China through Worldprint Ltd.

Library of Congress Cataloging-in-Publication Data

Craven, David, 1951–
 Art and revolution in Latin America, 1910–1990 / David Craven.
 p. cm.
 Includes bibliographical references and index.
 ISBN 0-300-08211-8 (alk. paper)
 1. Art, Latin American—20th century. 2. Art—Political aspects—
Latin America. 3. Art and revolutions—Latin America. I. Title.
 N6502 .C735 2002
 709′.8′0904—dc21
 2001006900

A catalogue record for this book is available from The British Library

Frontispiece: Detail of fig. 16.

Contents

Acknowledgments

This book is based on almost twenty years of intermittent work in Latin America, as well as continuous efforts in the United States. Research for it has involved over a dozen trips south of the US border. These include five trips to Nicaragua (one each in 1982, 1986, 1990, and two in 1995); two to Cuba (in 1984 and 1991); and six to Mexico (in 1986, 1992, 1995, 1996, 2000, and 2001). In addition, during the year that I lived in Spain, from 1984 to 1985, I was able to do primary research and to interview Latin American intellectuals visiting the Iberian Peninsular. Although I have incurred far too many debts for all of them to be mentioned, there are some of such significance that they cannot go unnoted. In acknowledging these debts I list them in reverse, since the last set of interviews are the most numerous owing to how my research was done in an especially dynamic phase of the final revolutionary process discussed: the one in Nicaragua from 1979 to 1990.

In Nicaragua, the people to whom I must express special gratitude for invaluable help and insights are the following: Sergio Ramírez, the former Vice President and a leading novelist; Father Ernesto Cardenal, the former Minister of Culture and a renowned poet; Gioconda Belli, the award-winning author; Claribel Alegría, the noted person of letters; Emilia Torres, the former National Director of the Centros Populares de Cultura; Nidia Bustos, National Coordinator of MECATE (Campesino Movement for Art and Theater); Armando Morales, the one-time FSLN Representative to UNESCO in Paris and Central America's greatest contemporary painter; Dr. Carlos Tunnerman, the former Nicaraguan Ambassador to the United States; Raúl Quintanilla, the former Director of the Escuela Nacional de Artes Plásticas and a major art critic as well as an important artist.

In addition, I must thank Donaldo Altamirano, an artist and a former editor of *Ventana,* the weekly cultural supplement of *Barricada*; poets Juan Ramón Falcón, Gerardo Gadea, and Marvín Ríos, who were the editors of *Poesía Libre,* the national publication of the *Talleres de Poesía;* Luis Morales Alonso, former Director of the Sandinista Union of Visual Artists within the ASTC (Association of Sandinista Cultural Workers); Porfirio García, a critic, artist, and professor at the National University of Engineering in Managua; María Gallo, an accomplished painter and one-time coordinator of the program in painting within the CPC (Centros Populares de Cultura); Michelle Najlis,

an acclaimed poet who now holds an administrative post at the Universidad Centroamericana; Santos Medina, an award-winning painter in the ASTC; and, finally, the remarkable group of artists and activists comprising ArteFactoría, the artists' collective that publishes *ArteFacto*—the leading art journal in Central America for the last decade. This group includes some exceptional artists and intellectuals: Raúl Quintanilla, Teresa Codina, Juan Bautista Júarez, Patricia Belli, Celeste González, David Ocón, and Aparicio Arthola, among others.

The people to whom I must express special gratitude in Cuba and Mexico are fewer in number but no less significant in their impact on other parts of this book. In Cuba, this includes both people with whom I have had informative conversations and those with whom I have had long-term intellectual interchange. In the first group would be Roberto Fernández Retamar, the eminent author and Director of Casa de las Américas, one of the most indispensable cultural insititutions in "nuestra América"; poet Nancy Morejón, who is also at Casa de las Américas; and the architectural historian Roberto Segre. In the second group would be Erena Hernández, the accomplished art historian, and Gerardo Mosquera, who is Latin America's most internationally recognized art critic at present. Mosquera is also one of America's most challenging curators, although he once lectured at the University of New Mexico (UNM) in the Fall of 1993 on "The Death of the Curator." It was Mosquera who put me in contact with painter Raúl Martínez, the "inventor of Latin American Pop Art." (Martínez was probably *the* major Cuban artist to gain international fame between the revolutionary victory in 1959 and the emergence in the 1980s and 1990s of such artists as José Bedia and Kcho.)

In Mexico, the special debts of gratitude I owe must be conveyed to the 1995 Fellows at the Instituto de Investigaciones Estéticas of the Universidad Nacional Autónoma de México (UNAM), then directed by the scholar Rita Eder, and including Leticia López Orozco, Alicia Azuela, and Ida Rodríguez-Prampolini. I have also profited from conversations with Augustín Arteaga, the former Director of the Fine Arts Section of the Palacio de Bellas Artes; Adolfo Gilly, the eminent historian of the Mexican Revolution and a professor at UNAM; Raquel Tibol, the former art critic of *Proceso;* Irene Herner de Larrea, the art histo-

rian; Luis-Martín Lozano, a noted Rivera scholar and curator; Ana Elena Mallet, a curator at the Museo de Arte Carrillo Gil in Mexico City; América Sánchez Hernández, Director of the Museo Mural Diego Rivera; and Esther Garza de Navarrete, Director of the Museo Casa Diego Rivera in Guanajuato.

A number of other people should be thanked as well, since they have provided ideas, information, or criticism of value for this book. First and foremost, I must thank John Ryder and Colleen Kattau. John traveled with me on two of the research trips to Nicaragua and Colleen was my traveling partner on one research trip to Nicaragua and one to Cuba. They have both discussed with me many of the things in this study. No doubt they can claim credit for some of the insights that appear here. *Compañero* Stephen Eisenman read and commented quite perceptively on much of the manuscript, as did Juan Martínez. Alejandro Anreus made several valuable observations that made the book more balanced. My dear friend Linda B. Hall not only discussed with me some of the defining ideas in the book, but also set an example with her research that, I hope, will be readily evident.

Many others have been supportive as well as stimulating in various ways. They include Dawn Ades, Rasheed Araeen, Dore Ashton, Holly Barnet, Lavinia Belli, Luis Camnitzer, the late Stanton Catlin, the late Eva Cockcroft, Russell Davidson, Leonard Folgarait, Jonathan Harris, Kathleen Howe, David Kunzle, Mauricio Lara, Francisco Letelier, Lucy Lippard, Sonya Lipsett-Rivera, Alison McClean-Cameron, Félix Masud-Piloto, Patricia Mathews, Gil Merkx, Symrath Patti, James Petras, Raquel Quesada, Margaret Randall, Sergio Rivera, Ken Roberts, Marcos Sánchez-Tranquilino, Eric Selbin, Bill Stanley, May Stevens, Joyce Szabo, Leonardo Vargas, Thomas Walker, Alan Wallach, John P. Weber, and Mary Weismantel.

UNM's distinguished Latin American and Iberian Institute has always been a stimulating place for the interchange of ideas that really matter. Similarly, in the Department of Art and Art History at the UNM, I must thank not only my colleagues on the faculty, but also a number of excellent graduate students. Many of them have done research into the arts in Latin America and some of them have already published scholarly articles in the field. These current and former students at UNM include Jasmine Alinder, Teresa Avila, Kimberly Cleveland, Leah Cluff, Joanna Corrubba, Catherine DiCesare, Teresa Eckmann, Lara Evans, Danny Hobson, Alejandra Jiménez, Christopher Jones, Lindsay Jones, Feliza Medrano, Florencia Bozzano Nelson, Susan Richards, Teresa Rivera, Gina Tarver, Heather Van Horn, Neerja Vasishta, Brian Winkenweder, and Diane Zuliani.

Several institutions off campus, which do invaluable work in their respective fields, have been supportive of my research since the 1980s. They include the Center for Cuban Studies in New York City, under the able direction of Sandra Levinson, and the Center for the Study of Political Graphics in Los Angeles, directed by Carol Wells. The latter institution now contains numerous posters from Cuba and Nicaragua (as well as from elsewhere), that I have donated to their archive.

In addition, there is the Zimmerman Library at the University of New Mexico—with its excellent Center for Southwest Research and deeply impressive Latin American Holdings (such as the Donald C. Turpen Collection). In the area of Mexican culture and history, this library is surely one of the finest institutions in the nation. A major reason for this distinction is the astute leadership of Dr. Russell Davidson, who heads the Latin American section at the Zimmerman. Over the past decade he and Dr. Kathleen Howe, the Curator of Permanent Collections at the University Art Museum, have deftly coordinated their efforts with those of Peter Walch, Director of the University Art Museum, and Stella de Sá Rego, the Archivist of the Center for Southwest Research, to acquire a huge number of Mexican prints, photographs, and books from the first half of the twentieth century for the collections at UNM.

The remarkable result of their joint archival and curatorial efforts is that UNM now has a collection of prints by the Taller de Gráfica Popular (TGP) which, as national rankings go, is second only to that of the Library of Congress in scope and quality. Moreover, the entire Archive of the *Taller de Gráfica Popular* (with its hundreds of unpublished primary documents) is now on microfilm in the Center for Southwest Research at UNM. Most recently, the Latin American Collection in the Zimmerman was augmented considerably by the acquistion of the ten thousand posters (silkscreens and photo-offsets) in the Slick Collection of Graphic Art, with strong holdings in Cuban and Nicaraguan posters. When added to the TGP print holdings (and the unsurpassed collection of photographs from Latin America), this immense new collection now makes the Zimmerman one of the foremost repositories in the entire United States for the graphic arts in Latin America, with special emphasis on Mexico, Central America, and the Caribbean.

Surprisingly, parts of this book were written during 1998 and 1999 while I was a Fellow at the Collegium Budapest in Hungary. Despite its considerable geographic and cultural remove from Latin America, Central Europe proved to be a thought-provoking place in which to consider some of the key issues at stake in this study. After all, the challenging topics of art and the state, along with those of socialism and democracy, were discussed at length by the outstanding group of Fellows from Central Europe at this exceptional institution. In several respects I owe thanks not only to Rector Gabor Klaniczay and Secretary Fred Girod at the Collegium, but also to many of the Fellows during the academic year of 1998–99: Prof. Dr. Franz-Joachim Verspohl, Prof. Dr. Horst Bredekamp, Prof. Dr. Martin Warnke, Prof. Dr. Anna Wessely, Prof. Dr. Wolfram Hogrebe, Dr. Adam Bžoch, Dr. Marina Blagojevic, Dr. Líbora Oates-Indruchova, Dr. Claire Chevrolet, and Ms. Anke Doberauer. All of them gave me much to think about and some of those thoughts have found their way into this book.

Finally, I would like to convey warm thanks to my editors Gillian Malpass and Elizabeth McWilliams at Yale University Press, to my friend Feliza Medrano for helping me to prepare the manuscript, to my parents Dr. and Mrs. Albert Craven, and to my partner Margery Amdur.

David Craven, July 19, 2001

Glossary of Terms and Abbreviations

Mexico

Amauta
Journal (1926–30) founded and edited in Lima, Perú by José Carlos Mariátegui, who published on Diego Rivera.

ARM
Alianza Revolucionaria Mexicanista. An extreme right-wing group comprising the Camisas Dorados (Gold Shirts).

Ayala
Plan de Ayala. The Revolutionary manifesto of the Zapatistas drawn up in November 1911.

Casa del Obrero Mundial
Left-wing union (1912–1917).

CGOCM
Confederación General de Obreros y Campesinos de Mexico (1932–36). Founded by Vincente Lombardo Toledano, it became the CTM in 1936.

CNC
Confederación Nacional Campesina (1936–66). Founded by Lázaro Cárdenas.

CROM
Confederación Regional de Obreros Mexicanos (1918–35). Founded by Luis Morones.

CTM
Confederación de Trabajadores Mexicanos (1936 to present) (*see* CGOCM).

ENAP
Escuela Nacional de Artes Plásticas (in Mexico City). 1929 name for old Academia de San Carlos (1783 to present) which is called Escuela Nacional de Bellas Artes.

ENP
Escuela Nacional Preparatoria (in Mexico City).

INBA
Instituto Nacional de Bellas Artes, a ministry of culture.

LEAR
Liga de Escritores y Artistas Revolucionarios (1934–38). Popular front organization that published *Frente a Frente*.

Maximato
The period 1928–35 when Plutarco Calles dominated the federal government, even though not elected to the preseidency.

PNR
Partido Nacional Revolucionario (1928–36).

PRI
Partido Revolucionario Institutionalizado (1946 to present).

PRM
Partido de la Revolución Mexicano (1936–46).

SEP
Secretariá de Educación Pública (1921 to present).

SOTPE
Sindicato de Obreros Técnicos, Pintores y Escultores (1922–24). Journal: *El Machete*.

TGP
Taller de Gráfica Popular (1937–77).

UNAM
Universidad Nacional Autónoma de México. Includes such institutes as the Instituto de Investigaciones Estéticas (1936 to present).

Cuba

Casa de la Américas
Cultural institute and research center founded in 1959. Publishes a journal of the same name.

CNC
Consejo Nacional de Cultura (1960–76). Replaced by the Ministerio de Cultura.

COR
Comisión de Orientación Revolucionaria (1959 to present). Publicity wing of the PCC.

ICAIC
Instituto Cubano de Arte y Industría Cinematográfico (1959 to present).

OCLAE
Organización Contemporánea de Latinamericanos Estudentiles.

OSPAAAL
Organización en Solidaridad con el Pueblo de Africa, Asia y América Latina.

PCC
Partido Communista da Cuba (1961 to present).

PSC	Partido Socialista de Cuba. The official Soviet-backed party until it was replaced in 1961/62 by the PCC.	CPC	Centros Populares de Culture (1979–90).
		CST	Confederación Sandinista de Trabajadores. Largest urban union.
UNEAC	Unión de Escritores y Artistas Cubanos.	ENAP	Escuela Nacional de Artes Plásticas. Before 1979 the Escuela Nacional de Bellas Artes.

Nicaragua

		FSLN	Frente Sandinista de Liberación Nacional.
AMNLAE	Asociación de Mujeres Nicaragüenses "Luis Amanda Espinoza."	TGE	Taller de Gráfica Experimental (1981–88). Printmakers collective.
ASTC	Asociación Sandinista de Trabajadores Culturales (1979–89). Umbrella sindicate for all the FSLN artists unions.	TSJ	Taller San Jacinto (1979–81). Printmakers collective.
ATC	Asociación de Trabajadores Campesinos. Largest rural union.	UNAD	Unión Nacional de Artes Plásticas (member of ASTC).
CDS	Comités de Defensa Sandinista. Neighbor militias.		

INTRODUCTION

Revolving Definitions of the Word "Revolution"

The word "revolution" has acquired a new meaning that is very different from its traditional associations with conspiracies.

José Carlos Mariátegui, 1927[1]

Three historic revolutions in twentieth-century Latin America stand out because they not only shook the entire world, but also sent out long-term shock waves that stir us still. During the last one hundred years of broken solitude, "los tres grandes" in the roll call of revolution occurred with unrivalled force and unforgettable results in Mexico (1910–40), Cuba (1959–89), and Nicaragua (1979–90). These revolutionary insurrections set the parameters for a shortened version of the twentieth century that nonetheless gains in intensity owing to its more concentrated periodization—from the 1910 Zapatista insurgency with its momentous *Plan de Ayala*, through the epoch-making policies instituted in the 1960s by Cuba's July 26th movement, to the decade-long social experiment in Nicaragua led by the Sandinistas, which concluded only with an electoral defeat in 1990 that was hardly permanent.

Each of these now legendary revolutionary movements exploded on the world stage with an irresistible force that continues to emit powerful ideas and images concerning the future direction of any progressive social process in the Americas. What, if anything, remains viable about these three determinate moments? Answering this question will be of paramount importance to my critical analysis of these revolutions and the nature of their impact on the visual arts worldwide (particularly in the 1930s, 1960s, and 1980s), as well as to social formations, political institutions, and pedagogical practices more generally. Testament to societies in deep transition, the visual arts in each of these revolutions were meant to be fundamental means whereby society itself was to be transformed.

An examination of revolutions now past as well as an assessment of how these revolutions might yet influence our future in a notable way, this book addresses several related issues—particularly in light of the recent events in Chiapas. After all, "revolution" has become a word of such dramatic finality that it almost seems to indicate the unleashing of elemental natural forces, rather than the mobilization of social movements for concerted structural change. Yet the modern etymology of "revolution" in most European languages has much to teach us about the interpretative problems we now confront when discussing the successes and failures of any social process that is said to be revolutionary in scope. A retelling of the revolving history of "revolution" as an explanatory concept will provide us with an updated and newly critical sense of the word. Along the way we should be able to determine how—or even whether—we can continue to deploy the term in the aftermath of 1990, or if we need to demote this word, without nostalgia, to being a chronological designation for a period now past, roughly 1910 to 1990, replete with lessons that are admirable yet outmoded.

Certainly there was a time when "revolution" signified strikingly different things than it did after the popular upheavals in France in 1789 and Russia in 1917—or, for our purposes, Mexico in 1910, Cuba in 1959, or Nicaragua in 1979. This point was outlined by Raymond Williams in a well-known but problematic sketch, just as it had earlier been announced in the above epigraph by José Carlos Mariátegui, who remains perhaps the most vigorous and original thinker to emerge from Latin America during the twentieth century.[2] In addressing the novel aspects of socialism throughout Latin America, as a direct consequence of dramatic social changes along with radical innovations in the arts then occurring in Mexico (as well as in Russia), Mariátegui noted with awe that the word "revolution" was itself undergoing a revolution in meaning. And he was right in saying so.

These noteworthy prospects for a new world order were tied not only to the radical labor laws, national literacy crusade, and crucial land redistribution instituted by the revolutionary government in Mexico, but also to the surprising "Mexican Mural Renaissance" led by the increasingly famed figure of Diego Rivera. Not surprisingly, in his leftist journal *Amauta*

1

1 "Diego Rivera: Biografiá sumaria," taken from *Amauta*, no. 4 (1926).

2 "Diego Rivera: el artista de una clase," taken from *Amauta*, no. 5 (1927).

(1926–30), Mariátegui highlighted the paintings of Rivera in the Ministry of Education as exemplary of these new developments. Just as the fourth issue of *Amauta* called attention to Rivera with a "Biografía sumaria," so issue number five of this same Peruvian publication in 1927 contained a photograph of Rivera with an inscription by the artist himself: "Para Amauta" (figs. 1 and 2). The photograph of Rivera accompanied an article about the artist entitled "Diego Rivera: el artista de una clase," which contained reproductions of murals from the Ministry of Education in Mexico City.[3] This new conjunction of artistic revelation and social revolution was also noted even in the mid-1920s by US novelist John Dos Passos, as well as philosopher John Dewey. While contrasting the momentousness of modern Mexican art with the sad state of the arts in the United States, he wrote, "Going to see the paintings by Diego Rivera in the courts of the Secretaría of public education straightens you out a little bit. ... If it isn't a revolution in Mexico, I'd like to know what it is."[4]

Yet mainstream literature from the West concerning the three major Latin American revolutions of the twentieth century has generally not been up to the challenge of analyzing them. The reason is that conventional scholarship and matching journalis-

tic accounts have been undermined by a stunted Cold War definition of "revolution" that reigned largely unchecked in most mainstream circles right up to 1989. Thus, the drive to social justice and the impetus to self-determination by all local Latin American insurrections with internationalist visions—or even radical reform movements (as in Chile from 1970 to 1973)—were summarily reduced by these mainstream Western accounts to a mere proxy contest circumscribed by global geopolitics. The "real" historical actors were then assumed to be either the capitalist West or the communist East, with no nations outside this narrow, if also worldwide, conflict having the right to determine their own separate destinies. The sadly comic symmetry of this bi-polar Cold War vision of the world has been captured well in a recent comparison of heroic images from the U.S.A. and the USSR during the 1940s (figs. 3a and b).[5]

As E. J. Hobsbawm has recently noted, though, the North/South contradiction has remained alive even after the death of the Soviet Union in 1989 and the victory of the West in the Cold War. The conditions that gave rise to revolutionary insurgency in Latin America throughout the twentieth century are in fact still pervasive, and as unsettling as ever. Indeed, as

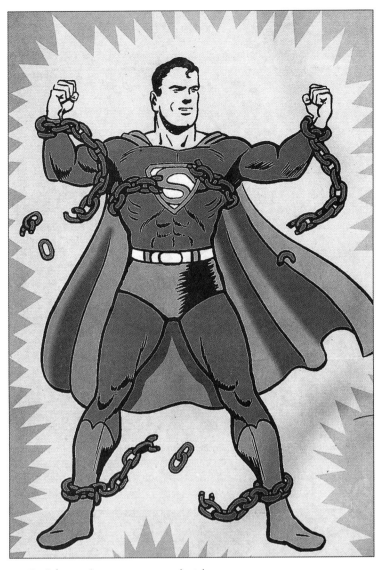

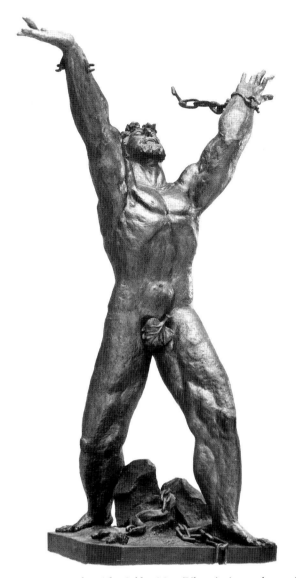

3a Joe Schuster, *Superman*, 1941, comic strip.

3b Sergei T. Konenkov, *The Golden Man (Liberation)*, 1947, bronzed plaster, Russian Museum, St. Petersburg.

is patently clear in a new Inter-American Development Bank report (released in July 2000), an installation of the so-called "marvels of the free market" in post-revolutionary Latin America over the last decade has had devastating consequences on the living standards of the region's majority. Concomitant with the expanding logic of privatization in the last few decades has been a grave deterioration all over Latin America of the public sector, such as, educational institutions, medical facilities, cultural agencies, and justice systems. The one frequent exception to this trend has been Cuba.[6]

Moreover, the average per capita income for private citizens throughout Latin America has also declined dramatically. Whereas in the 1960s this average was 50 percent of that in the Western countries, being higher than that in all other parts of the "developing world," today the per capita private income, on average, in Latin America is less than 30 percent of that in the West. This rate is now lower than that of several other regions in the "developing world," such as, East Asia, the Middle East, and Eastern Europe. Revealingly, polls show that over 60 percent of the people living in Latin America believe that earlier generations lived better and that the current situation in the region is

only becoming more impoverished and disempowered owing to the neo-liberal policies now in place. This potentially explosive situation reminds us that Hobsbawm was correct to note that the Cold War way of dividing up the globe in the second half of the twentieth century was "an arbitrary and to some extent artificial construction, which can only be understood as part of a particular historical context."[7]

Even before the events of 1989 with the collapse of the Eastern Bloc and the historic redefinition of our supposed options within a political economy that privileges the "free market" and corporate capital based in the West, there were many leading Latin American intellectuals representing the majority of people in this region who recognized the non-serviceability of a Cold War framework for making sense of revolutions in Latin America. With its binary view of the world and Manichean conception of history, this mainstream interpretation was in fact used on both sides of the ideological divide, albeit to rather different ends (figs. 4 and 5). The implausibility of this conventional paradigm for understanding revolutions as mere local symptoms of a titanic global struggle restricted to the two superpowers was tartly summarized by Sergio Ramírez. An

4 (right) *Cold War Cartography: The Reagan–Bush Map of the Western Soviet Empire*, Jack Huberman. (Originally published in *The Nation* in 1985.)

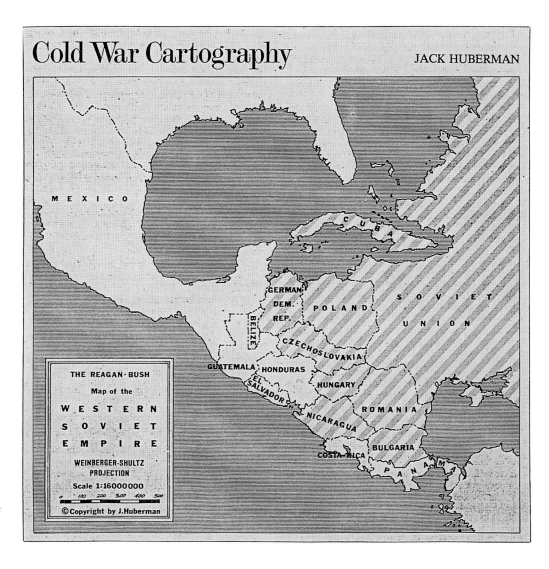

Cold War Cartography

JACK HUBERMAN

MEXICO

CUBA

GERMAN DEM. REP.

BELIZE

POLAND

SOVIET UNION

CZECHOSLOVAKIA

GUATEMALA HONDURAS

EL SALVADOR

HUNGARY

ROMANIA

NICARAGUA

COSTA RICA

BULGARIA

PANAMA

THE REAGAN·BUSH

Map of the

W E S T E R N

S O V I E T

E M P I R E

WEINBERGER-SHULTZ PROJECTION

Scale 1:16000000

0 100 200 300 400 500

© Copyright by J.Huberman

5 *(facing page) El arte de américa latina es la revolución*, c.1970, silkscreen poster, the Allende Years in Chile (1970–73).

acclaimed novelist and former Vice President of Nicaragua (1984–90), Ramírez remarked in *Estás en Nicaragua*, an exemplary collection of essays from 1986:

> The East/West confrontation is a very European philosophical category and a very North American political category, by which I mean that for the Latin American it is not a category at all. . . . Much has been said about . . . the Oriental/Occidental contradiction (more precisely and in terms of usage, the East/West contradiction), but not enough has been said . . . of the us/Latin American contradiction . . . the Sandinista Revolution is not an accident of history, much less one of destiny's ironies. We didn't win it in the lottery; we made it . . . this isn't a War of the Galaxies nor is it a confrontation between superpowers.[8]

The intellectual blinders and blinkered analysis that Ramírez identified had long led commentators from Europe and the United States to a series of "international" underestimations. Gone was any sense of the local distinctiveness of social forma-

tions in Latin America and the relative autonomy of its cultures, especially with respect to the cultural policies instituted by revolutionary movements in the region. This Western paradigm of conventional scholars for suppressing historical difference in "nuestra América" was not only grounded in an untenable notion of "revolution," but was also rooted in an ideological phenomenon of far older provenance, namely, Eurocentrism, or more precisely, Euroamerican-centrism. (The latter term identifies better the neo-imperial ascendancy of us mass culture—during the so-called "American Century"—as a later stage of Eurocentrism following on the heels of Europe's hegemony in the fine arts. In mainstrean accounts, the overall process is known simply as "globalization.")

Eurocentrism arose prior to Cold War power-brokerage and in tense relation to a rapacious Western colonialism, as well as in the context of an emergent internationalization of mercantile capitalism beginning in the fifteenth century.[9] The origin and consolidation of Euroamerican-centrism—and various Latin American critiques of it, particularly in the visual

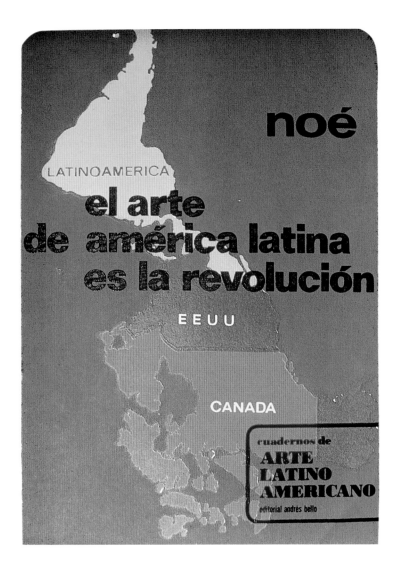

arts—are problems which will necessarily be returned to periodically throughout this study, as specific artworks are examined and assessed in the light of cultural policies. Before going any further though, we need to note another recent development that has been responsible for establishing the dates that bracket my study's eighty-year "century" of revolutionary insurgency. For, ironically, something unexpected has happened on the political left in Latin America. This shift occurred even as there was a disappearance of the old Cold-War ploy of rudely partitioning the world between superpowers located along an East–West fault line.

No sooner had the conventional geopolitical conception of "revolution" as a single-minded Cold War chess game collapsed, than the contrary view of revolutionary change predominant on the left of the political spectrum also appeared to find itself antiquated as well. It was as if the very implausibility of one concept of "revolution" also discredited its converse. In his chilly 1993 postmortem on moribund Cold War antagonisms, Mexican political theorist Jorge Castañeda pointed out that the "left

remains relevant in Latin America," since the end of the Cold War has not solved the social problems that brought the left into being in the first place. Nonetheless, he observed in *Utopia Unarmed: The Latin American Left After the Cold War* that the disappearance of the left's paradigm for revolution seemed to leave it with an uncertain future. He then explained as follows:

> [T]he conditions in Latin America that gave birth to the left in the past are as pervasive as ever, and in fact have become more severe with recent trends. . . . But the idea of revolution has withered and virtually died because its outcome has become reversible . . . the dismal prospect of fighting for partial, ephemeral gains trickles down to everyone . . . the self-destruction of the basic model signified the disappearance of the left's framework for conceiving of an alternative to Latin America's current state of affairs. Even the Cuban Revolution's impressive achievements in education, health, and the eradication of absolute poverty came to be perceived as nonviable: too costly, too statist, too dependent on foreign subsidies to be sustainable or applicable elsewhere [in Latin America].[10]

Yet on January 1, 1994—less than a year after Castañeda's book appeared—another revolution broke out, in his own country of Mexico. But, the indigenous insurgency of "Zapatistas" led by Subcommandante Marcos also redefined the very term "revolution," even as there were prominent emblems of Zapata and Che newly painted in the streets of Chiapas. Accordingly, this revolutionary insurrection was called the "first post-modern revolution" for reasons that obviously "rearm utopia," albeit with rather different weapons than those analyzed by Castañeda or used by Che. This chain of events also posed anew certain questions. After all, if we had nothing more than failed programs, bad art, and flawed ideals from the three greatest revolutionary movements in modern Latin American history, then a new post–Cold War assessment of the ongoing legacy of artworks and cultural policies from this era would not be such a pressing matter. But it is, as the Chiapas insurgency makes all too clear. In fact, the often undervalued or misunderstood record concerning art and culture from the revolutionary movements in Mexico, Cuba, and Nicaragua still contains much of major significance, ongoing vitality, and undeniable pertinence to the future of the Americas and beyond.

It is thus historically imperative that we, at the beginning of a new century, grasp better the lessons of the old one before we take premature leave of it. As such, we need to distinguish carefully that which is still beneficial and compelling in all three cases from those failings of each that neither command admiration nor inspire emulation. Consequently, we should be able to arrive at a renewed sense, a timely reexamination, of the very term "revolution" along lines that will expand our belief in what is possible, and open up the future yet again.

A History of the Word "Revolution"

To be sure, even before the death of the Cold War and the seeming demise of the left's paradigm for revolution in Latin America, there was an animated debate about the correct terminology for what is called the "Mexican Revolution." (No comparable debate has challenged references to the insurrectionary processes in Cuba and Nicaragua as "revolutionary." There the debate has centered on who "stole" the revolution, not on whether or not a revolution actually happened.) Historian Ramón Eduardo Ruíz, for example, insisted that this episode in Mexico be renamed more modestly, "The Great Rebellion."[11] Evidently less certain about this event's ultimate nature, poet Octavio Paz concluded rather that if it was a revolution, it was a unique one because it was not the work of a vanguard party with one overriding agenda. Paz then claimed more broadly that, "The Mexican Revolution was the discovery of Mexico by the Mexicans. I have suggested that it was something like a gigantic revolt; I now add another word: revelation."[12] Thus, for him it was the Mexican Revelation, not the Mexican Revolution. Far and away the most incisive and convincing response to the question of terminology for the Mexican Revolution (as we shall see below), though, was given by author Carlos Fuentes. He wrote not only that the Mexican Revolution deserved its name, but also that the Mexican Revolution was not one but three Revolutions simultaneously.[13]

But what of the modern emergence of the word "revolution," what of its etymology prior to the Mexican Revolution in 1910? How will retracing its change of fortune over the last five centuries help to reframe some of our primary concerns in Latin America over the last one hundred years? How will clarifying the historic meaning of the word "revolution" allow us to advance the debate about its applications, perhaps even resolving the above-noted debate about the acute relevance of the term to the institutionalized insurgencies of these three moments in modern history?

The word "revolution" first appeared in most European languages during the fourteenth century as a derivative of the Latin word *revolvere*, which meant "to revolve." At this point the word referred only to the natural laws of cyclical movements (or circular rotation) in the heavens, not to anything in the way of radical political changes. This original use of the term "revolution" in English, for example, still survives in astronomy and engineering, with the phrase "revolutions per minute" (or revs) being a way of describing the performance of motor engines.[14] (It is necessary to note, however, that modern Spanish, French, and German generally feature two different words in science and politics for the one Latin-based word generally used in English for both phenomena. For example, in German one uses *die Umdrehung* in astronomy for "revolutions" and *die Drehzahl* for "revolutions per minute," while only in politics does one generally use the eighteenth-century *Die Revolution*. Similarly, in Spanish, one uses the words *la rotación* and *la Revolución* for these two different fields of study; whereas, in French one uses *le tour* and *la Révolution*.)

Before the seventeenth and eighteenth centuries, though, there was another grim Latin-based word that in English and other European languages denoted political insurgency: "rebellion." In Latin it meant literally "renewal of war" and had clear antecedents in the Classical world as well as in Biblical texts.[15] Depending upon one's vantage point, "rebellion" and/or "rebels" meant two quite different things, one positive and the other negative. "Rebels" were either those who would not submit to a so-called "natural," even "divine," social order identified with feudal rule—or conversely, those who rightly rose up to overthrow "unnatural" tyrants (thus rotating positions of power from top to bottom). Such popular actions were called for because tyrants suppressed the "ancient rights and liberties of the people" and "the knowne lawes and statues and freedome of the realm"—to quote from the 1689 *Declaration of Rights*.[16] Yet, for the ruling order, then—and its members tended to monopolize the discourse about insurgency— the term "rebellion" was one of condemnation and dread. It meant something much closer in tone to heresy than to emancipation.

Among the earliest representations of "rebellion" in the West is one linked to a detailed description by Cesare Ripa in *Iconologia* (Iconology), the first edition of which appeared in 1593.[17] In the second edition of 1603, Ripa described the "rebel inciting rebellion" quite negatively. (Needless to say, there was no entry in *Iconologia* for "revolution" or "revolutionaries"). Furthermore, Ripa spoke of this phenomenon in a way that also suggested a threat from the East: "The personification of Rebellion is an angry-looking bearded man in classical armor, wearing a rather oriental-looking helmet, who holds up a bundle of arrows in one hand and clenches the fist of the other. . . . The clenched fist, angry look, and belligerent pose are all appropriate to such a personification." (fig. 6).

Only in the late seventeenth and early eighteenth century did the term "revolution" begin to take on a radical import beyond that of mere "rebellion." After having been used in the sixteenth century in relation to the revolving change of fate, that is, as the "wheel of fortune," the term "revolution" gradually assumed a meaning less predetermined and less fateful than it possessed in Ripa's *Iconologia* (fig. 7). With Oliver Cromwell's seizure of state power in England in the 1640s, a debate started to emerge about the adequacy of the term "rebellion" to describe what had occurred. Later, Cromwell's successful insurgency would be renamed the "English Revolution of 1642" by leading scholars like Christopher Hill, even though most mainstream scholars refer to it now as the "English Civil War of 1642." Yet, in the seventeenth century, the forces aligned with Charles II against a continuation of Cromwellian rule inaugurated the so-called "Glorious Revolution" of 1688–89 and they would insist upon calling the anti-feudal uprising led by Cromwell the "Great Rebellion," rather than the "Great Revolution." As Raymond Williams has noted, it is revealing that in the seventeenth century "the lesser event attracted the description Revolution, while the greater event was still Rebellion."[18]

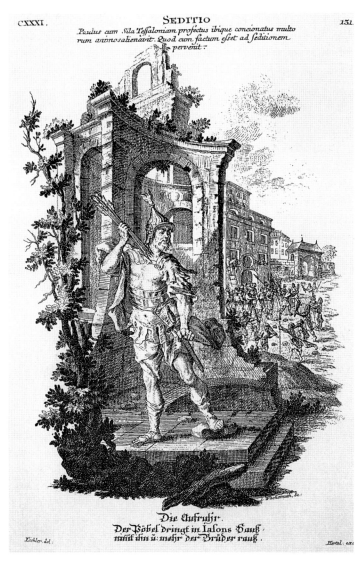

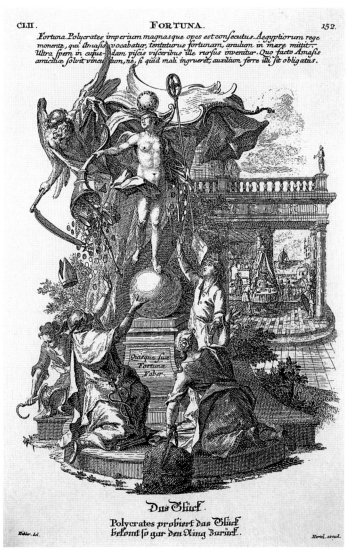

6 Jeremias Wachsmuth, "Rebellion," engraving from *Iconologia* by Cesare Ripa (1593), Hertel edition, Augsburg, c.1760. Reprinted from Cesare Ripa, *Baroque and Rococo Pictorial Imagery*, ed. Edward A. Master, Dover Press, 1971.

7 Jeremias Wachsmuth, "Fortune," engraving from *Iconologia* by Cesare Ripa (1593), Hertel edition, Augsburg, c.1760. Reprinted from Cesare Ripa, *Baroque and Rococo Pictorial Imagery*, ed. Edward A. Master, Dover Press, 1971.

Nonetheless, the monarchy's "natural" claims on the word "revolution" were soon overturned owing to the systematic theoretical ideals of the Enlightenment and the more profound structural changes demanded on the streets by the popular classes. By 1791, Thomas Paine could argue—in words that clearly initiated a novel use of the word "revolution" based on a new reading of recent events in France—that Edmund Burke's classical conservative condemnation betrayed a fundamental incomprehension of what had happened. A participant in both the American and French Revolutions, Paine was well placed to offer a groundbreaking summation of this period:

In the case of Charles I and James II of England, the revolt [in 1642] was against the personal despotism of the men; whereas in France [in 1789] it was against the hereditary despotism of the established government. . . . The revolu-

tions that have taken place in other European countries, have been executed by personal hatred. . . . But, in the instance of France, we see a revolution generated in the rational contemplation of the rights of man, and distinguishing from the beginning between persons and principles. But Mr. Burke appears to have no idea of principles [only one of tradition], when he is contemplating governments.[19]

By this time the monarchists' purportedly "natural" claims on the word "revolution" had come to an abrupt halt with the unprecedented surge of popular forces in Paris under the banner of a programmatic position. Thus, in 1837 Thomas Carlyle could state matter-of-factly in his book *The French Revolution* that "it is not a revolt, it is a revolution."[20] Moreover, as Terry Eagleton has observed, perceptions of what was "natural" in society rotated to such an extent that by the late eighteenth century

defenders of the *ancien régime* reached for their swords when they heard the word "nature."[21]

In the late eighteenth century, then, the word "revolution" had come to mean the legitimate natural subversion or overthrow of tyrannical leaders, whether elected or hereditary, as in the case of the king and members of the nobility. "Rebellion"—like the related term "revolt" from the sixteenth century—remained a more localized and "lawless" term. Furthermore, the word "revolution" suddenly signified a stirring sense of popular mobilization quite at odds with the old stereotypes about the rebellious and rude "rabble" who supposedly "didn't know their proper place." The conceptual shift that allowed "revolution" to be about the natural rights of all people—what we now call "human rights and civil liberties"—rather than the traditional privileges of a well-born few, arose as the result of a fundamental insight concomitant with the social project of the Enlightenment. Any regime that fails to feed, house, and educate its populace is in fact an "unnatural" government that should die of natural causes, because it denies the natural rights of its citizens to physical well-being and intellectual self-realization. In this way, "revolution" came to signify more than just a struggle over positions of power (which remains the meaning of "rebellion" or "revolt"). Rather, "revolution" gained historic momentum and scope with the redefinition of it to denote a fundamental transformation of the institutions of power on behalf of social justice, not just the assumption of power through revolt. The latter process, which is termed a mere "palace coup," does not qualify as a "revolution" owing to its limited transformation of society. In this case leaders in power rotate, but the nature of power does not revolve.

It was the French Revolution of 1789 that introduced into painting, via a reinvigorated Neoclassicism, the theme of the revolutionary individual agent—in human scale—to counter the suprapersonal Leviathan of Hobbes's prerevolutionary state (discussed below). A paradoxical result was the celebration in art of individual martyrdom as a personal contribution to civil rights throughout the revolutionary transformation of an older society that had denied individuality per se, as had Hobbes in his famous tract on behalf the Commonwealth. There are a whole series of groundbreaking artworks in this regard that extend from renowned late eighteenth-century images, such as, Jacques Louis David's depiction of Marat, Anne-Louis Girodet's portrait of Jean Baptiste Belley, and Adélaïde Labille-Guiard's studio self-portrait; right through to the nineteenth-century history painting of Marat's death almost a century later by the Mexican artist Santiago Rebull, who was one of Diego Rivera's main teachers. All of these remarkable paintings of revolutionaries were about the civic duty that required individual loss for collective gain through the institution of laws protecting each citizen's human rights. Thus, the birth of modern individuality in the public sphere was purchased by the personal sacrifice of individuals locked in historic struggle with the old and authoritarian Leviathan that embodied impersonality.

Subsequently, the word "revolution" continued to gain in complexity until it approximated the concept that we know today, which features at least two rather divergent overall directions. The first involves the reclamation of either traditional, time-hallowed rights or the establishment of universal human rights that have never really been instituted by any social order to date. The second involves an idea that emerged only in the nineteenth century to mean giving birth to a new social order per se, and also to a New Person (a twentieth-century idea most often associated with Che Guevara and the 1960s). All of this was to be done through powerfully programmatic actions that alter structurally the majority's traditional fate in relation to all earlier societies, no matter how equitable they might have been. This new order and the New People arising from it would no longer leave society's destiny up to the haphazard contingencies of a so-called "wheel of fortune" or the purported predestination of any presumed "natural order" unmediated by human intervention. Furthermore, sweeping, popular mobilization, not just a few good men, would sustain these new political ideals—ideals contingent on concerted theoretical aims, rather than being just "spontaneous" reactions from below to repression on high.

It was in the late eighteenth century that the word "ideology" was invented to indicate those sets of enlightening ideas and ideals that would chart this new terrain within history, so as to guide society in a fundamentally new direction. This term—meaning simply a "science of ideas"—was a rational system of structuring ideas leading to socially just institutions at odds with the irrational mélange of views inherent to the old order, with its militaristic tradition of "might makes right." The word was coined in 1797 by the French *philosophe* and revolutionary named Antoine Destutt de Tracy, a radical thinker much admired by Thomas Jefferson, who had him elected to the American Philosophical Society.[22]

When they wrote *The German Ideology* in 1846, Marx and Engels not only multiplied the meanings of the word "ideology," but also definitively linked ideology with revolution, so that since the mid-nineteenth century, it has no longer been plausible to speak of a "non-ideological" revolution. An uprising that addresses only local inequities now means no more than a rebellion or a revolt. (Ultimately, Marx would employ at least four different definitions of "ideology." Moreover, as Eagleton noted in a recent book, there are at least sixteen different definitions of the word to be found in contemporary literature on the subject.)[23] Marx and Engels also launched a groundbreaking defense of a dramatically new conception of human nature that is constantly under construction and reconstruction. This new concept would later be the stimulus in the 1960s for Che Guevara's doctrine of the New Person (*El Hombre Nuevo*) that consolidated in quite visionary terms Marx's less dramatic (and far less "voluntarist") view of the social production of the subject. What exactly did Marx contend that was so ground-breaking in linking the programmatic idea of revolution to a concept of human nature in historical formation via social forces?

What Marx did was without precedent in human history. He gave a radical twist to the innovative understanding during the Enlightenment of "humanity making its own history," so that he was led to an utterly new insight about "humanity making itself."[24] As Marx wrote in *Das Kapital* (1867): "Labor is, first of all, a process between people and nature. . . . Through his movement, man acts upon external nature and changes it, and in this way *he slowly changes his own nature*."[25] The social ramifications of Marx's rethinking of the nature of human nature were no less sweeping for art and artistic production. Far from being seen as a mirror of reality or as an open window onto it (as the Renaissance imagined), art was grasped here as a hammer for aiding in the production of reality. This new definition of art as a formative force in social life was eloquently nailed on the head in an essay by Marx from around 1857–59: "An *objet d'art* creates a public that has artistic taste and is able to enjoy beauty—and the same can be said for any other product. Productivity accordingly produces not only an object for the subject, *but also a subject for the object*." (It is worth noting here that this very quotation was an epigraph for a key book by one of the greatest artists to emerge from Revolutionary Cuba, namely, filmmaker Tomás Gutiérrez Alea.)[26]

This Marxian reconceptualization of history, humanity, and artistic practice as interdependent, dynamic, transfiguring forces helped to give the word "revolution" two new dimensions: First, there was a fresh sense of the structuring logic of social transformation beyond even that of the view of the Enlightenment. And, second, there was a novel sense of the self-determining immediacy of ordinary labor that made it an inherently reconfiguring force—especially when tied to an accelerated project of wholesale change called "revolution." A further consequence of both tendencies within the revolutionary process was the new challenge to spawn different, experimental types of cultural practices to accommodate this new concept of art as socially transformative. Such a humanly self-empowering process would thus help to create the creators of society along more open and visionary lines. In this way, the "natural order" of the Revolution of 1789 suddenly acquired a range of natural possibilities and a well of natural potential that made nature itself far more subject to mediation and even alteration, yet without the revolutionary process itself becoming "unnatural"—even as it changed what had been the "natural order" of society in a pre-revolutionary world.

Among the first artworks in history to bring these various multicolored threads of transfiguration together—thus comprising a revolution in historical, human, social, and aesthetic terms all at once—was one that alluded to a revolutionary leader within a dynamic visual field surging in uncontainable directions on numerous levels. This was a precocious painting by Diego Rivera in the teens of the twentieth century. It was also the first great painting of a guerrilla (as we now say in English) or *guerrillero* (as they more correctly continue to say in Spanish) during the Mexican Revolution of 1910. Inspired by photographic images of Zapata, but given its current name only a

decade or so after it was executed in 1915, it is entitled *Paisaje Zapatista: el guerrillero* (Zapatista landscape: the guerrilla) (fig. 8). Interestingly enough, the term "guerrilla" (or "el guerrillero" in Spanish) was not used prior to Zapata's death in 1919. Zapata referred to himself and the Zapatistas as "insurgentes" and "revolutionarios." At the time that the Zapatistas waged their war of liberation from 1910 to 1919, the term "guerrillero" still meant something almost "non-ideological" along the lines of a "bushwhacker" and this was at a point when the Zapatistas had to defend themselves constantly against the charge of being mere "bandidos."[27]

Moreover, the word "guerrilla"—which has become so important in English as a synonym for "revolutionary" since the 1960s—was coined only in the late 1920s by the legendary Nicaraguan revolutionary named Augusto Sandino. The need for it arose in 1926 when Sandino was forced to invent unusual counter-offensive tactics after the invading US military first used air strikes in Central America. These unprecedented bombings from the air made it impossible for him and his troops to occupy an urban space in a conventional manner without there being huge numbers of civilian casualties. Consequently, Sandino "disappeared" into the tropical terrain—with nature itself literally becoming a new ally of the national liberation forces to offset the technological superiority of Western imperialists. As a result, Sandino decided to wage sporadic surprise assaults that were nevertheless still based on a programmatic, ideologically cohesive social project of national self-determination. This revolutionary project of the Nicaraguan guerrillas was as systematic and calculated as their guerrilla tactics were "irregular" and "irrational" to professional US armies.

The usage of the modern term "guerrilla" for the tactics of a revolutionary movement is a remarkably apt testimony not only to the logic of uneven development in the Third World, but also to another development: a redefinition of the word "revolution" to connote a radically new focus on the city versus country conflict. As such, the hyper-exploited countryside of the "developing nations" came to embody a massive national return of the rural repressed that challenged both the capitalist West and the communist East, with their respective conceptions of an urban-based "revolution" spearheaded by an industrial proletariat. (Not surprisingly, the post-1945 period was one that saw the defeat of metropolitan colonial powers in Europe by peasant-based guerrillas in predominantly agrarian societies, especially in Asia and Africa—from China in 1949 to Vietnam in 1974, from Angola in 1974 and Zimbabwe in 1980 to Namibia in the early 1990s.)

In 1927 at the moment when this word entered the lexicon of key revolutionary terms, Sandino explained how his tactical shift in fighting a revolution entailed, "a special system of war that we have taken to calling 'little war' (guerrilla)."[28] It was part of Sandino's legacy to pass on this new concept of anti-imperialist combat to Che Guevara, who, in 1960, published a world-famous book, *La guerra de guerrillas* (The waging of guerrilla warfare). Drawn from pamphlets by former Sandinistas, as well

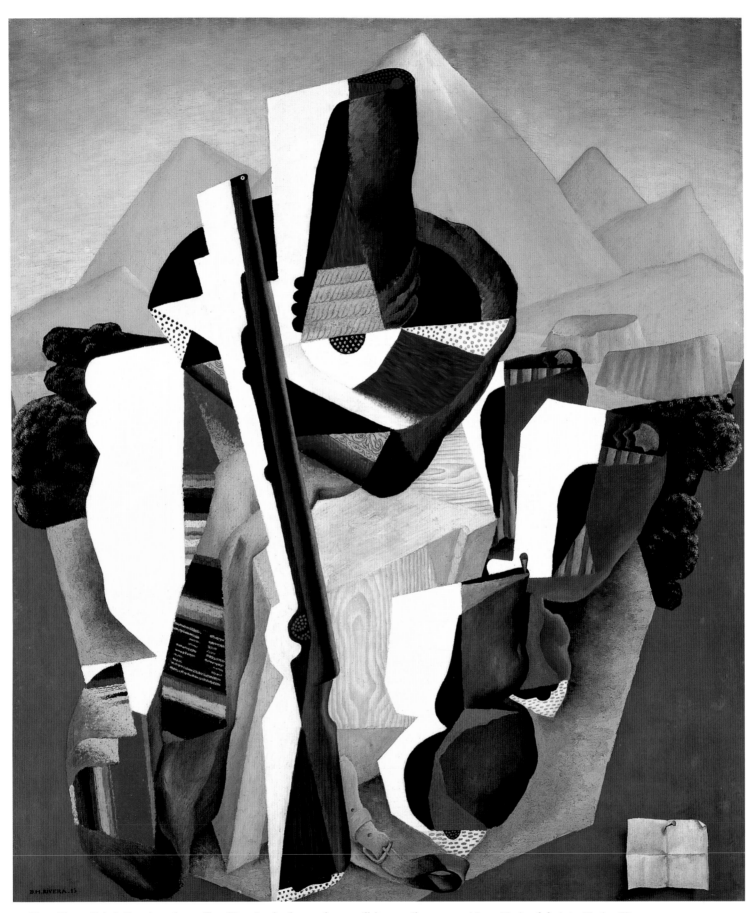

8 Diego Rivera, *Paisaje Zapatista: el guerrillero* (Zapatista landscape: the guerrilla); 1915, oil on canvas, Museo Nacional de Arte, Mexico City.

as from his own direct experiences as *a guerrillero*, this book by Guevara made the term "guerrilla" virtually synonymous with the word "revolutionary" from the 1960s onward. Che did so in a fresh manner that altered the entire debate about the nature of revolution. A subsequent and rather significant publication by Regis Debray in 1967 continued this process of rethinking the term "revolution" in a well-known book that was quite appropriately titled: *Révolution dans la révolution?* (Revolution within the revolution?).[29]

In *the* book from 1960 that introduced the word "guerrilla" in a systematic manner into English, Che Guevara rightly noted the innovativeness of the revolutionary movement that he advocated. It is worth observing that the first English translation published of Guevara's book referred to "guerrilla fighters," not to "guerrillas," so that "guerrilla" entered English in the early 1960s as a modifier for the type of campaign being waged by a revolutionary or "guerrillero." At this point the latter word no longer referred simply to an outlaw who bushwhacked, but to a revolutionary combatant who fought professional soldiers in an ideologically consistent, class-based manner.[30]

It is at once surprising and predictable that just as Cesare Ripa had no entry for "revolution" in his dictionary (1603), so Raymond Williams had no entries in *Keywords* (1976) for "guerrilla," "guerrillero," "guerrilla warfare," or even "Third World" (a word tied to anti-imperialist insurgency by Che Guevara, Frantz Fanon, and C. L. R. James beginning in the early 1960s). These omissions remind us of how much Williams's model for "revolution" unwittingly replicated the hegemonic urban conception of this insurgent process, which was common to both sides of the ideological divide during the Cold War. It is all the more surprising that a book in the mid-1970s by a leading socialist theorist like Williams would be so narrow in focus, so historically dated, and so ethnocentric in character that national liberation struggles in Latin America would seem to play no part in redefining "revolution." Yet, Che Guevara already knew better in 1960, quite aside from what leftists in the West or in the Eastern Bloc might assume about "revolution" and "revolutionaries."

In the first section of *Guerrilla Warfare*, Che noted that "the guerrilla fighter is above all an agrarian revolutionary. . . . The guerrilla combatant is a night combatant."[31] About the "principles of guerrilla warfare," he was convinced that they had "forced a change in the old dogmas" about revolution. In a famous opening passage, he declares,

> We consider that the Cuban Revolution contributed three fundamental lessons to the conduct of revolutionary movements in America. They are: 1) Popular forces can win a war against the [professional] army. 2) It is not necessary to wait until all conditions for making revolution exist [as the Communist Party maintains]; the insurrection can create them. 3) In underdeveloped America the countryside is the basic area for armed fighting. . . . The third proposal is a fundamental strategy. It ought to be noted by those who maintain dogmatically that the struggle of the masses is centered in city

movements, entirely forgetting the immense participation of the country people in the life of all the underdeveloped parts of America . . . we are at the dawning of a new era in the world . . . Asia and Africa joined hands in Bandung [which is when the term "Third World" was first used at an international conference]; Asia and Africa come to join hands with colonial and indigenous America through Cuba, in Havana.[32]

In elaborating on the irregular nature of a revolution based in guerrilla warfare, Che redeems the tactics of ambush and sabotage for revolutionary purposes, thus also gaining redemption for such earlier "bushwackers" as Zapata and Sandino. He also utterly rejected terrorist attacks on civilians:

> Acts of sabotage are very important. It is necessary to distinguish clearly between sabotage, a revolutionary and highly effective method of warfare, and terrorism, a measure that is generally ineffective and indiscriminate in its results, since it makes victims of innocent people.[33]

Far from being a mere "mirror" of reality, then, the magisterial Cubist painting of a Zapatista "guerrilla" by Rivera was composed of a densely relational field of human traces with collage-like space and a convergence of several different cultural traditions ranging from popular art in Mexico to fine art in France. As a type of "agrarian Cubism" that nevertheless had urbanizing inflections, this painting was at once richly detailed and deftly dispersed. Moreover, the brilliant use of Cubism, as a language of decentered fragments camouflaging the figures in it, caused the eye to dart about searchingly, thus eliciting a link between the trail of Cubist clues in paint and the guerrilla's actual elusiveness in nature. Rivera's remarkable choice of the decentering language of Cubism to produce perhaps the first oil painting in history of a guerrilla was hardly fortuitous, however unlikely at first glance. As Rivera himself said,

> [Cubism] was a revolutionary movement, questioning everything that had previously been said and done in art. It held nothing sacred. As the old world would soon blow itself apart, never to be the same again, so Cubism broke down forms as they had been seen for centuries, and was creating out of the fragments new forms, new objects, new patterns, and—ultimately—new worlds.[34]

Significantly, during a key phase of the Mexican Revolution, Rivera produced nothing less than the first painting anywhere of the great Nicaraguan revolutionary Sandino. Executed in 1933, this image appeared in a striking fresco painting (now lost) entitled simply *Imperialism*, which Rivera made for an anti-Stalinist socialist party in New York City that split off from the orthodox Communist Party in the United States. This image contained a depiction of Sandino's bust looking down from the upper right-hand corner of the painting onto the struggle between corporate capital (symbolized by United Fruit as well as Standard Oil) and Latin American guerrillas in a densely packed field of combatants, all of whom exist in fragmentary

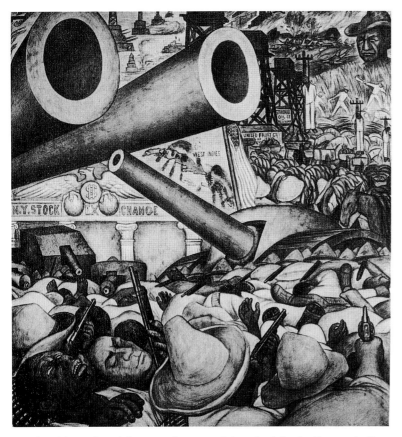

9 Diego Rivera, *Imperialism*, 1933, fresco panel (now lost) for the Communist Party Opposition, New Worker's School, New York City. This photograph was taken from Diego Rivera (with Bertram D. Wolfe), *Portrait of America*, 1935, George Allen & Unwin, London.

10 *Fragment of the Equestrian Statue of Somoza*, 1956, bronze, Museo de la Revolución, Managua. (The Somoza statue was pulled down by a jubilant crowd on July 20, 1979.)

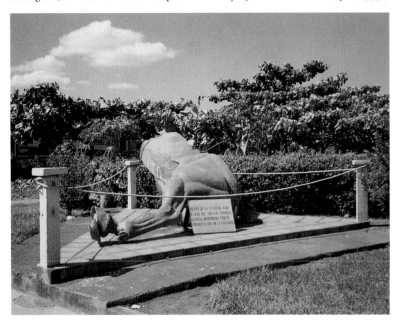

form. Wider access to this artwork in the form of a mechanical reproduction was insured by its inclusion in the book *Portrait of America* by Diego Rivera (with Bertram Wolfe) that was published in 1935 (fig. 9).[35]

The historic significance of Sandino's "guerrillas" was not lost on Diego Rivera, who in the late 1920s was head of the Anti-Imperialist League in Mexico. He (and Bertram Wolfe) summarized quite well why the artist's decision to feature Sandino was predicated on a new development in the history of revolutionary insurgencies. The rationale went as follows:

> Over the panel broods the grim and determined face of the patriot hero ("bandit," Secretary of State Stimson called him) Augusto Sandino. Every age, every struggle, produces its heroes . . . that Sandino was, not merely for Nicaragua, but for the whole of Latin America. Latin America had long been smouldering with hostility at the aggression of the mighty "Colossus of the North". . . . America rode roughshod over country after country, for Yankee power was irresistible. But then a "miracle" occurred, like the "miracle" of David and Goliath. Little Nicaragua . . . that had been overrun by American marines from 1912 to 1925 and had been invaded again in 1926—little Nicaragua with an area of 49,000 square miles and a population under a million—Nicaragua decided to resist!! For more than five years, Augustino Sandino and his heroic bands held out against the American marines in his mountains fastness of El Chipote. Aeroplanes, gas bombs, all the splendor of modern warfare were used against him. . . . It cost the United States Marine Corps more than 130 lives and millions of dollars above its usual budget, but they could not defeat Sandino. The spell was broken . . . In 1932, the marines withdrew, leaving Sandino unbeaten, in possession of the field. . . . When the epoch of imperialism is over, when the Latin American masses have learned to combine against foreign aggression . . . then Sandino will be remembered as the great precursor, *the* first of the battlers for a free American continent . . . not merely as the hero of a Nicaraguan episode, but as the symbol of the struggle against imperialism.[36]

Revealingly, my first encounter with a reproduction of this image of Sandino by Rivera was in Managua during the Summer of 1982, when I visited the Museum of the History of the Nicaraguan Revolution, then located near the Mercado Eduardo Contreras. This exhibit made clear the direct link between artistic advances of the Mexican Revolution and the tactical innovations in revolutionary resistance by Sandino that together would open the way to the more comprehensive ideological values of the Sandinista National Liberation Front within the Nicaraguan Revolution in 1979. In doing so, this "art" exhibit also documented on several levels the direct revolutionary lineage in Latin America that extended from Zapata and Sandino through Diego Rivera, Che Guevara, and Fidel Castro right up to the Sandinista Front for National Liberation (FSLN) in Nicaragua. Next to the Museum of the Revolution in

Managua was a fragment of the large bronze equestrian statue of Somoza as "the steward of the Nicaraguan state," which had been pulled down on July 20, 1979 during celebrations following the triumph of the Sandinista-led Revolution (fig. 10).

But, how did Rivera refer to himself in the late 1920s and early 1930s? Did he follow the lead of his "hero" Sandino and use the term "guerrillero" to label his own politics and artistic practice? The answer is to be found in a remarkable (and until now overlooked) 1927 interview for *Amauta* (the journal of José Carlos Mariátegui), with whom Rivera was interested in forming a united front on the Left with his Peruvian counterparts. In an article entitled "Diego Rivera: el artista de un clase" by Esteban Pavletich, Rivera defined his own position as an artist/activist in terms that immediately show how he had already absorbed Sandino's new definition of "guerrillas" waged by "guerrilleros" only a short time before: "el pintor revolucionario no es ridiculo y excelso creador de obras maestras, sino un combatiente de vanguardia. . . . a veces puede ser *un guerrillero* . . . [Por eso] el artista será revolucionario o no será." (the revolutionary painter is not a ridiculous and honorable creator of masterpieces, but a combatant in the vanguard . . . at times he may be a guerrilla fighter . . . [Therefore] the artist will be revolutionary, or he will not be).[37] Subsequently, in 1929, Rivera would draw a portrait of the fallen revolutionary martyr, José Guadalupe Rodríguez, who had been a socialist union leader in rural Mexico, for the cover of *Amauta* issue no. 24 that was published in Lima in June of 1929 (fig. 11).[38]

Another crucial intermediary link between revolutionary movements in Latin America, and their respective contributions to refining the word "revolution," was one established by Che Guevara with the triumph of the Cuban Revolution. He did so with a momentous rereading of Marx and Marxism. In discussing the process of reconstruction, Che emphasized anew the connection between artistic production within a revolution and the revolutionary production of the New Person. The creation of one, he maintained, presupposed an immediate creative engagement with the other. In saying that a revolution makes Marxists as much as Marxists make a revolution, Che added the corollary position in bold opposition to Soviet-style economism: revolutions do not first construct economic changes in order to change other spheres of society subsequently. Put succinctly, this meant that revolutions produce the New Person (aesthetically, ethically, and ideologically) simultaneously with the production of a new economic base and new workplace relations, all in relation to new political formations.

Che's emphatic oppositon to the Stalinst Doctrine of so-called "socialist realism" (a visual language that Diego Rivera also subjected to withering criticism) was of fundamental significance for the emergence of a new concept of "revolutionary art"—or at least a revolutionary way of making art. His position had a noteworthy impact on the innovative cultural policies in the visual arts within both the Cuban Revolution and the Nicaraguan Revolution. In a sense, one could even say that Che's

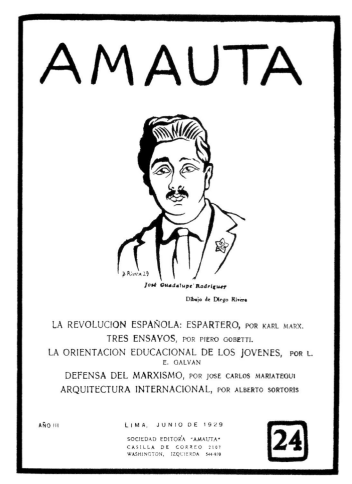

11 Diego Rivera, *Portrait of José Guadalupe Rodríguez*, *Amauta*, no. 24 (June 1929).

conception of revolution was most analogous to the open-ended, if also clearly focused, concept of artistic experimentation that alone could adequately forge an image of the New Person. Che's most notable contribution to defining a modern "revolution" along artistic lines entailed an unprecedented discussion of the relationship between experimental art and the New Person. His fresh argument is worth repeating:

Socialism is young and has made many mistakes. Many times revolutionaries lack the knowledge and intellectual courage needed to meet the task of developing the New Person with methods different from the conventional ones. . . . The men of the [Communist] party . . . sought an art that would be understood by everyone, the kind of "art" that *functionaries* understand. True artistic values were disregarded, and the problem of general culture was reduced to taking some things from the socialist present and some from the dead past (since dead, not dangerous). Thus, Socialist Realism arose upon the foundations of the last century. But the realistic art of the nineteenth century is also a class art, more purely capitalist than this decadent art of the twentieth century which reveals the anguish of alienated people. Why then try to find the only valid prescription for art in the frozen forms of Socialist

13

Realism? . . . Let us not attempt from the pontifical throne of realism-at-any-cost, to condemn all the art forms that have evolved since the first half of the nineteenth century for we would then fall into the Proudhonian mistake of returning to the past, of putting a strait jacket on the artistic expression of the person who is being born and who is in the process of making himself. . . . What is needed is the development of an ideological-cultural mechanism which permits . . . free inquiry . . . What we must create is the person of the twenty-first century. . . . The probabilities that great artists will appear will be greater to the degree that the field of culture and the possibilities of expression are broadened.[39]

Representations of the Modern Body Politic

All of this takes us quite a distance beyond the cautious metro-politan definition of "revolution" provided by Williams in *Keywords*—and indeed most other definitions that have been published since, whether in the West or the East. Before con-cluding the introductory section of the book, a series of para-digmatic artworks (engravings, linocuts, and silkscreens, as well as public sculpture) from the early seventeenth century to the late twentieth century need to be examined (figs. 12–16). These images of the body politic give us an incisive look at the chang-ing ideological constructions of new images for "rebellion" and "revolution" through various visual languages during this over-arching period. Significantly, all of these images embody an experimental effort to imagine the body politic in geographic terms that are visually compelling, rather than in textual ones that are more matter of fact and too literal-minded. A compar-ative analysis of them discloses some key insights into what each of these uneven moments in history were capable of visually embodying and ideologically envisioning.

The first two images from the 1650s served as frontispieces for two of the earliest modern treatises on the centralized secular state underpinning a system of political absolutism (figs. 12 and 13). Both engravings were by Abraham Bosse, one of the more accomplished printmakers of his day. The books that featured these prints were of course Thomas Hobbes's *Leviathan, Or the Matter, Forme and Power of A Commonwealth Ecclesiasticall and Civill* (1651) and his subsequent *Le Corps politique ov les elements de la loy morale et civile* (1652).[40] The pair of images by Bosse representing the body politic in society are striking precisely because of how they almost insist upon fusing two divergent spatial systems for endowing a composition with pictorial order. On the one hand, there is an empirical-based usage of one-point perspective that neatly regulates the relative variations of the figures in accordance with what were understood to be natural laws of perception. On the other hand, though, the dispropor-tionate, even colossal, size of the dominant figure that, in turn, comprises "ordinary" figures in correct scale, is linked to an out-moded medieval schema for determining *extra*-ordinary sig-nificance in accordance with so-called "divine law."

The latter tradition tended to link the relative size of a figure to his or her secular and religious standing, with little attention devoted to representing forms registered by means of empirical observation. By producing this hybrid creature that is at once a regal portrait and an amalgamation of his subordinate "sub-jects," Bosse deftly articulates how Hobbes's "modern" concep-tion of the absolutist state straddled two very different moments in history, which were both neofeudal and postfeudal in character. The singular figure of the Leviathan State embodies Hobbes's nonrebellious—or indeed antirevolutionary—Com-monwealth. About this social system, Hobbes wrote that "it is a real unity of them all, in one and the same person, made by covenant of every man with every man."[41] Paradoxically, the soundness and stability of such a society are based on the indi-vidual choice by all citizens to forgo all markedly individualized choices. As Hobbes said, it is "as if every man should say to every man, *I authorize and give up my right of governing myself, to this man, or to this assembly of men* . . . This done, the multitude so united in one person, is called a Commonwealth, in Latin *civitas*."[42]

Hobbes's modern state was not simply mandated by tradition, but by something new: a rational decision to renounce human reason and its "fractious" consequences. Similarly, Bosse's engravings feature a jarring visual disjuncture between the pre-scientific personification for the Commonwealth as a "trans-cendent" whole and the otherwise consistent use of scientific perspective to represent each of the Commonwealth's parts. There is also an equally stirring contradiction in the engravings between the iconic, as well as hieratic pose, of the Leviathan State and its placement in a sweepingly secular Renaissance-derived landscape that denies the hierarchical scale of any neo-feudal images. Such a nonsystematic treatment goes against the demotic, mathematical grading of all forms in the same empirical terms, however exalted or powerful their civic status in the Commonwealth.

Similarly, the towering waist-up depiction of the Leviathan—which supposedly demonstrates how the whole is far greater than just the brute sum of its parts—shows a supranatural entity looming behind nature and simultaneously obtruding into its midst at certain prominent points. In the 1651 print, the royal scepter both obeys the laws of perspective—by the way it over-laps nature—and denies those same laws—by being rendered in an impossibly large scale that implausibly dominates the land-scape. A comparable set of relationships obtains in the 1652 engraving. In all respects, though, there is a linear clarity and visual intelligibility entirely consistent with the use of this medium's salient attributes and despite the "irrational" neo-feudal size of the Commonwealth in relation to its natural setting. The power of these two images is such that they command our attention visually—even when we feel no alle-giance to the social formations and political choices that they represent so strikingly.

The serene yet awe-inspiring conception of the transcendent state delineated here served as a telling counter to the more

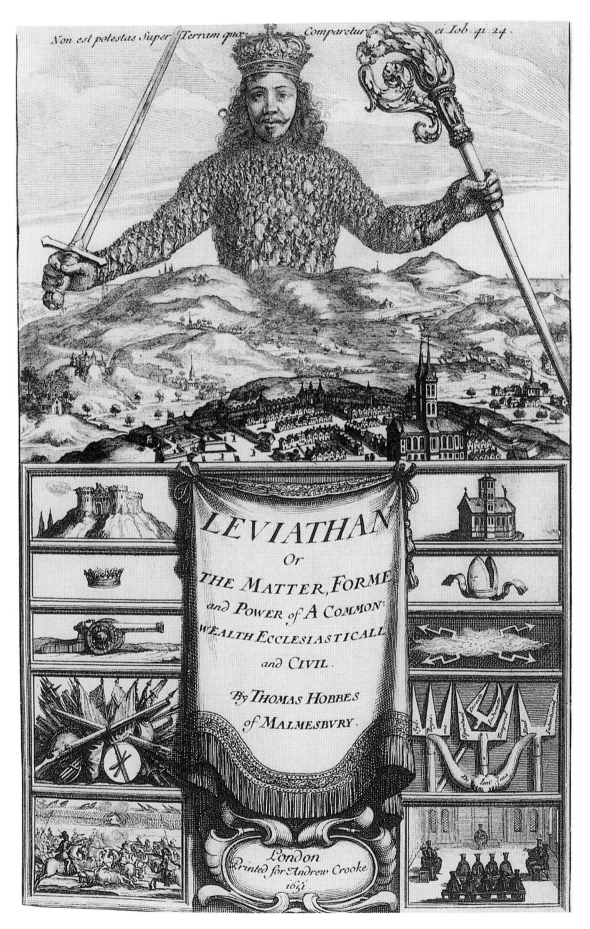

12 Abraham Bosse, *Leviathan*, c.1651, engraving. Courtesy of the British Library.

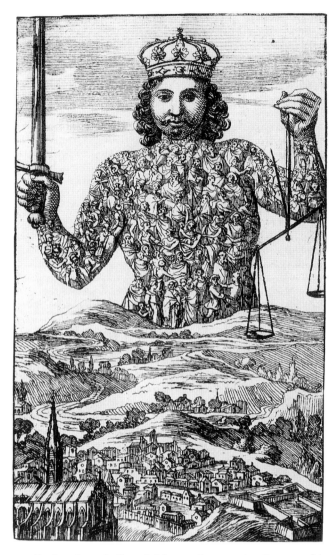

13 Abraham Bosse, *Le Corps Politique*, c.1652, engraving. Courtesy of the British Library.

14 Fernando Castro Pacheco, "Carrillo Puerto: símbolo de la revolución del sureste," linocut, *Estampas de la Revolución Mexicana*, pl. 59, 1947, Julius L. Rolshoven Memorial Fund, University of New Mexico Art Museum.

diminutive yet furious figure of "Rebellion" (fig. 6) noted above, which was earlier found in the pages of Cesare Ripa's *Iconologia*. The personification for "Rebellion" was incorporated smoothly into the urban space with which he was consistently related by one-point perspective, so that the presumed irrationality of the figure's acts were logically contained (or better, constrained) by a scientific setting. The latter made untoward rebellion against society as unwise as it was supposedly "unnatural." Moreover, a singular figure such as that of "Rebellion" was clearly represented as no match for the multitudinous figure of the Leviathan, as it was conceived by Thomas Hobbes and Edmund Burke. This latter embodiment of the traditional body politic would rule largely unchecked until the Revolution of 1789 and the theoretical revolution in understanding the nature of the modern state that would be ushered in by the likes of Thomas Paine and Destutt de Tracy. Neither the prints of the Leviathan nor those of Rebellion, however, would be of much

use in visually articulating the transfigured body politic that would emerge from the late eighteenth century. Thus, the subsequent age of revolution repeatedly gave birth to new and more dynamic social configurations, along with visual personifications for them, as for example in the history paintings of Jacques Louis David after 1785. Those stirring pictorial calls to act were quite at odds with the static social roles endemic to both the Leviathan and the Rebel, as well as the conventional visual representations of them in Europe.

A "revolutionary" response to Abraham Bosse's two prints about the prerevolutionary state was produced by Fernando Castro Pacheco in the aftermath of the Mexican Revolution (fig. 14). Not surprisingly, this Mexican linocut from 1947 by a key member of the Taller de Gráfica Popular was in turn influenced by a famous painting from the Revolution of 1830 in France, *Le 28 juillet: la liberté guidant le peuple, 1830* (Liberty leading the people on July 28, 1830) by Eugène Delacroix, and also by John

Heartfield's 1936 photomontage, *Die Freiheit selbst kämpft in ihren Reihen* (Liberty itself fights in their ranks). Both of these images were known by Castro Pacheco. Less linear and precise in assigning places to figures within the print than was the work of Bosse, the more organic linocut by Castro Pacheco featured surging waves of *campesinos* who loosely terminated in a banner-waving revolutionary martyr—the socialist governor of the Yucatán, Felipe Carrillo Puerto. (He had been an important leader of the Left until he was assassinated by counter-revolutionaries in 1924.) Far from being hieratic in pose or static in stance, the figure of Carrillo Puerto was propelled forward—and even shaped—by his followers, thus actively representing the mobilized body politic that constituted him. As a counterpoint to the Leviathan, who circumscribed the citizenry of the popular classes as if to discipline them and hold them in check, the insurgent image of Carrillo Puerto signified a leader who helped to institute a far-reaching and radical land redistribution program influenced by the Zapatista "guerrilleros" (with whom he made common cause in the late teens). Thus, this latter government program did not originate with the dictates of a "transcendental" state, but rather more organically, and much closer to the earth in parastatal sectors organized by the mobilized rural communities.

Whereas Delacroix's *Liberté guidant la peuple*, with its abstract personification for emancipation, featured troubling class divisions within its revolutionary midst (which made most French governments nervous about showing the painting before the twentieth century), the Mexican linocut showcases an unprecedented degree of interclass unity—as opposed to the general surpaclass "harmony" evinced by the Leviathan.[43] The leader of the Mexican popular classes was no longer seen simply as an allegorical figure symbolizing abstract values, such as, "liberty, equality, fraternity," but instead, he was a more earthy and materialist manifestation of the specific demands propelled forward by the *campesinos* and inscribed on the banner "Tierra y Libertad" ("land and liberty," or perhaps more accurately, "liberty through the appropriation of land").

A popular leader who also followed the figure of Carrillo Puerto—like that of Zapata or Sandino, even more so—visually embodied an explosive type of nonmonolithic and anti-Leviathan civic sector that made any nation-state formation somewhat unstable, if also dynamic and sharply focused on progressive demands. This was the case because such a dynamic polity in ongoing formation is often located on the frontier of social justice, in the act of redefining it with greater historical precision. Such a new concept of state power—or parastatal popular organizations—went much beyond the traditional theory of the state, with its legalistic and ahistorical notions of "justice" along the "tried and true" lines of Thomas Hobbes or Edmund Burke. After all, these two prerevolutionary thinkers saw the popular sacrifice of both liberty and equality as the necessary price of security for all (that is, law and order). Conversely, the popular classes led by Carrillo Puerto realized the contrary: only when you have equitable conditions to guar-antee freedom from want for all can you ever have the sole type of "nontranscendental" stability that most matters to the majority of people.

The linocut by Castro Pacheco was an innovative response to specific historical conditions for a variety of reasons. First, he belonged to a leftist artists' collective, the Taller de Gráfica Popular, which was founded in 1937 at a highpoint of the militant Cárdenas years from 1934 to 1940, when the most sweeping land redistribution program in the history of the Americas was being enacted.[44] As a member of a popular organization committed to precisely the radical program of land reform depicted with such urgency in his linocut, the artist was well aware of the ad hoc back-and-forth, as well as dynamic give-and-take between the individual and the community that his print represents so compellingly.

Second, the artist was aware of such key antecedents as Diego Rivera's *Zapatista Landscape* (1915) and his depiction of Sandino in *Imperialism* (1933), which were both images that revolved around fields of promising fragments at once dispersed and galvanizing, both splintered and unified.

Third, the print by Fernando Castro Pacheco articulates very effectively the new forms of social formations that were indeed a significant accomplishment of the Mexican Revolution from 1920 through 1940. As the historian Alan Knight has noted of this period in Mexican history:

> Mexico's social and political life was dramatically changed by the Revolution, albeit in an often unplanned and unforseen manner. The armed mobilization of 1910–20 gave way to new forms of institutional mobilization. . . . The political nation had expanded to become perhaps the largest in Latin America; a form of mass politics—restless, sometimes radical, often violent. . . . Such a politics defies neat generalization.[45]

Fourth, the TGP print manifests a non-Leninst and anti-Stalinist conception of revolution that had no analogue in Soviet Russia, except for the little-known work of Mikhail Bakhtin. As one commentator has observed, for Bakhtin—and his counterparts in Mexico during the 1920s and 1930s—revolution meant a festival of the oppressed, a return of the rural repressed, not a mere stage show with populist overtures to be directed by an official vanguard party. Thus, when "Socialist Realism had its opening night in 1934, Mikhail Bakhtin, an internally exiled critic, saw the festive energy of the masses reduced to the vicarious pathos of the spectator. . . . [Yet for Bakhtin] popular culture is the privileged bearer of democratic and progressive values."[46]

Fifth and finally, the Castro Pacheco linocut confronts us with the need to use a different conception of the state than is normally found in most other analyses, whether the state happens to be revolutionary or not. An excellent starting point here would be the innovative discussion of this particular institution by Nicos Poulantzas in the late 1970s.[47] In disputing older and more one-dimensional definitions of the state, such as that of orthodox structuralism, he broadened our conception of the

term while nevertheless sharpening our ability to analyze it. Far from being seen as a simple instrument of ruling-class dominion, or as a seemingly neutral arbiter situated above the class struggle, or as a mere superstructural reflection of the structuring logic of society's economic base, the state as understood by Poulantzas combines all three things in addition to featuring yet other attributes as well. Thus, he was able to maintain that it is not to be identified merely with the institutional implementation of power, but can be seen as a site of contestation, as a place of struggle, whereby various classes, class fractions, and competing groups contend with each other for varying shares of power.

In replacing these more limited views of the state with a multidimensional conception of the state's relation to power, Poulantzas reformulated it as a special arena in which there is considerable interaction among competing groups while they negotiate the distribution of power in society. Here, the state is no longer limited to serving as the instrumental expression of any one exclusive set of class-based interests, but rather, it is grasped as a condensation of social conflicts that also pervade other spheres, albeit to varying extents. Such a contested and "contradictory" state is never static nor even conclusively centered, however powerful its position within society. As Poulantzas noted, openings for structural change in society thus emerge from these intraclass shifts and interclass tensions both within the state and outside of it. As should be clear later with the three case studies involving postcolonial revolutionary states in Mexico, Cuba, and Nicaragua, Poulantzas's poststructuralist conceptual framework is a particularly effective model for allowing us to explain the coexistence of competing ideological tendencies within the arts in the very same revolutionary state.

Yet as Josh Brown showed in a 1985 book cover drawing for *Reagan and the World*, a publication by the Monthly Review Press (fig. 15), the Reagan and Bush Administration had a much more single-minded view of the state as a unified guardian and it was bolstered by professional armed forces with unrivalled firepower to enforce it.[48] The "Colossus of the North" (to recall Diego Rivera's reference to the U.S.A.) made a frank appearance here. Furthermore, this view of state power as the gateway to national prosperity (while also being at the expense of the international community) was rendered so that an interimage dialogue with the prints of Bosse and Castro Pacheco seems unavoidable. The forced harmony of Hobbes and Burke, along with the hardly constrained democratic thrust of the TGP linocut, have both been swept aside in this astute drawing of an Administration for which popular self-representation was not an overriding concern. The banner pointed north has been replaced by a broom directed south. Accordingly, the messy terms of citizenship matter less than the cleanly bordered terms of exclusion. The paternalism of classical conservatism has given way to the aggressive indifference of born-again conservatism and triumphalist neoliberalism. In no case, though, is revolutionary social transformation acceptable as a "natural" response within the worldview of Reagan.

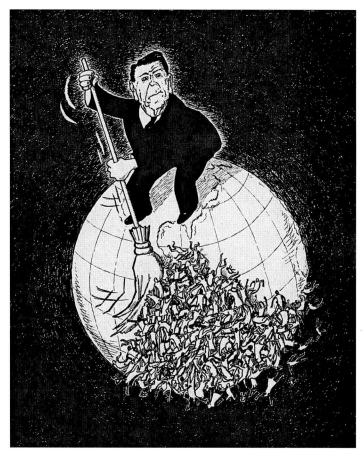

15 Josh Brown, "Reagan and the World," cover for Jeff McMahan, *Reagan and the World: Imperial Policy in the New Cold War*, New York, c.1985.

Given the potency in Cuba of revolutionary responses to this Reaganite view of the world—through the outward expanding Che image by Elena Serrano of the late 1960s, which broadly encompasses, just as the Reagan image readily excludes (fig. 16)—we are left with a number of analytical tasks in order to establish the general terms of this study.[49] The body politic in this representation of Che has become indistiguishable from the landscape or natural terrain of South America, so that we are face-to-face with a silkscreened image that is no longer a collage of figures, but rather a field of shifting fragments. The heterogeneous unity of "Latin America"—itself a troubled but still indispensable term and category—is shown being transfigured by shock waves emanating from the image of Che in Bolivia (where his death during an insurgency made him a revolutionary martyr).[50] Less an actual entity, than a work in progress, Latin America is depicted in the process of assuming a revolutionary new identity, not merely as displaying an old one. All of this is, of course, why art critic Gerardo Mosquera wrote what he did of Cuban artists and the pressing issue of forging a new identify from within the Revolution—one arrived at along lines that recall Che's concept of the New Person conceived by a revolutionary New Society:

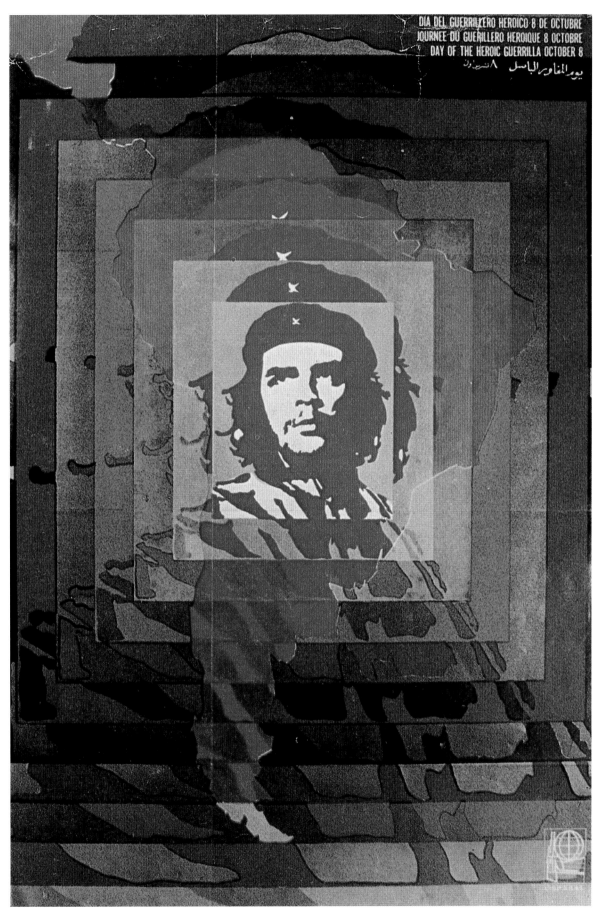

DIA DEL GUERRILLERO HEROICO 8 DE OCTUBRE
JOURNEE DU GUERILLERO HEROIQUE 8 OCTOBRE
DAY OF THE HEROIC GUERRILLA OCTOBER 8

يوم المقاوم الباسل ٨ تشرين

16 Elena Serrano, *Che*, 1967–68, silkscreen for OSPAAAL.

[T]hese artists are in pursuit of a synthesis . . . [based on] the hybridization or coexistence of various traits from different cultures . . . This does not involve escapism, nor any "return to our roots." Instead, there is a reaffirmation of values appropriate for situating ourselves in reality. This represents a Third World effort—if not an entirely conscious one—at constructing a new international order of culture and a more universal perspective wherein the interests of all peoples converge, thus being in opposition to the fabricated cosmopolitanism from the island of Manhattan.[51]

Revolutionary Forms of Democracy

The challenge of constructing one's own identity as part of a national project is inextricably linked with the larger concern of self-representation in the intertwined spheres of politics, economics, and culture. Accordingly, the relationship of revolution to democracy in all its various forms is at issue, both within the state and beyond it—in civil society and the workplace. A barrier to any mainstream analysis of democratic self-representation in a revolutionary process has long been the purported monopoly on definitions of "democracy" possessed by the Western world, especially the United States. Yet, what generally passes for all-encompossing "democracy" in the mainstream West, namely, free parliamentary elections based on universal suffrage and presided over by "neutral" state institutions, has long been attacked in Latin America as a very limited and exploitative form of "democracy" that generally reproduces the inequitable relations upon which the capitalist mode of production so *un*democratically depends. The unwanted net result of this Western style political system is what Sandinista Commandante Carlos Fonseca termed "democratism."[52] Particularly in Latin America and the rest of the Third World, this distorted, largely nonrepresentative form of "democracy" occurs when parliamentary democracy is isolated from other forms of popular democracy. The resulting system is thus put into place, as if democracy and capitalism did not contradict each other structurally in a fundamental way.

In her study of how the Sandinista-led Nicaraguan Revolution of 1979 was able "to retrieve democracy" for revolutionary socialist movements to an unprecedented extent in modern history, Katherine Hoyt shows how all this resulted from a combination of three different forms of democracy: political, or representative, democracy—that is, a republican form of government which is based on periodic elections with universal suffrage; participatory, or mass, democracy—a regime which incorporates citizen participation in popular organizations in civil society; and economic democracy [including autogestion, or workplace democracy]—under which there is an equalization in the ownership of wealth and the people exercise control over the use of the resources of the nation as well as over the type of economic system under which they live.[53]

Recognition of this remarkable achievement by the Sandinistas during the decade of the 1980s will allow us to reassess in a more probing, post–Cold War way both the Mexican Revolution and the Cuban Revolution. The Mexican Revolution featured all three forms of democracy but only to varying degrees and seldom simultaneously, except briefly under Alvaro Obregón in the early 1920s and then again for a while during the Presidency of Lázaro Cárdenas from 1934 to 1940. The Cuban Revolution has shown little interest in Western parliamentary democracy (which is known in Cuba as a "dictatorship of the capitalists"). Nevertheless the Cuban Revolution, especially since 1976, has consistently demonstrated a degree of economic democracy, including autogestion, virtually unrivalled anywhere else in the world. Similarly, the Cuban Revolution has often sanctioned a vigorous type of popular democracy that was crucial to its own avowed aim of "cultural democracy."

Since socialism must be democratic or it will not be, any analysis of democracy's various configurations within the respective revolutionary processes of Mexico, Cuba, and Nicaragua will have to address the authoritarian politics of so-called "democratic centralism" within the Communist Party (CP) in all three instances. Significantly enough, the CP took little or no active role in any of these three revolutionary insurgencies and in the latter two cases the CP actually tried to discourage all revolutionary insurrection as historically "premature." The insurrectionary phase of the Mexican Revolution (1910–17) occurred before the Russian Revolution of 1917 and prior to the founding of the Communist International (Comintern) in 1919, so that there simply was no CP in Mexico to aid in the violent overthrow of the old order.

Moreover, throughout the first decade of its existence in Mexico—from its founding in 1919 to its suppression in 1929 for an attempted putsch—the Partido Comunista Mexicano (PCM) never had any real base in working-class organizations. Even though it was covertly subsidized by the Mexican Government from 1924 to 1929, while being allowed to launch frequent verbal attacks on the same federal government, the PCM always remained tiny (with between 500 and 1,000 members, about half of whom were artists, writers, and intellectuals).[54] Its political ineffectuality and lack of serious support among the working class aside, though, the PCM did enjoy a certain prestige in Mexico and the United States owing to the membership in it of several artists who were then becoming world-famous: Diego Rivera, David Alfaro Siqueiros, Xavier Guerrero, Tina Modotti, and Frida Kahlo. Yet only towards the end of the Mexican Revolution, around 1936–40, did the PCM enjoy more than modest influence among the popular classes and this was a consequence of the heroic teachers on the local level who were often members of the PCM at a point when they were targeted for assassination by counter-revolutionary forces in rural areas.[55] A telling development in recent scholarship, though, has been the release of numerous secret documents about the inner workings of the Mexican CP and its distinctly subordinate relationship with the Comintern coinciding with the ascent to power of Stalin. As Dawn Ades has rightly noted:

Now that the machinations of Stalin's Communist Party are more publicly known, [Diego] Rivera's veerings appear considerably less contradictory. For instance, his expulsion from the Mexican Communist Party in 1929 was plotted and executed by the sinister and murderous figure of Vittorio Vidali and his henchmen, whose mission [on orders from Stalin] to purge the Party of unreliable elements was probably supplemented by more personal motives. . . . Rivera was under no illusions about Vidali's role in the death of Tina Modotti in Mexico, nor in the decimation of POUM [the "Trotskyist" organization in Spain during the Civil War].[56]

With few exceptions in Latin American history (such as, El Salvador and Peru at various points), Cuba was the only nation in which a Soviet-backed communist Party enjoyed anything like an organic link with the working classes. Yet, this relationship occurred in the 1930s—not in the 1950s or 1960s—when Cuba became the first country in the Western Hemisphere to temporarily establish soviets. About as short-lived as the Paris Commune, this insurgency of 1933–34 was defeated by US-backed counter-revolutionaries under the direction of Batista. First, there was the Communist Party's utter failure in El Salvador in 1932, when Farabundo Martí led an unsuccessful uprising against a US-backed professional army that killed 20,000 campesinos, including Farabundo himself. (Today it is still called "La Mantanza," or The Slaughter.) Then, there was the defeat of the CP-led insurrection in Cuba in 1934. Subsequently, the Comintern and its various branches opposed any future revolutionary insurgencies in Latin America. Thus, when the July 26th Movement was created, Fidel Castro, Che Guevara, et al., were forced to break definitively with the Cuban CP. In turn, the CP denounced the ultraleft "voluntarism" of the guerrillas, along with their new strategy of being based primarily in the rural areas. In addition, the Soviet-backed party in Cuba remained a permanent foe of Che's so-called "adventurism."

When the Cuban Revolution triumphed on January 1, 1959, the neo-Stalinist and pro-Soviet Communist Party, which was called the Partido Socialista Popular (PSP), was on the sidelines. It was thus largely discredited for this inactivity and its previous willingness to "work with" the Batista Dictatorship on behalf of "reformist" measures. Under the leadership of an orthodox Marxist named Anibal Escalante, the PSP remained inconsequential in national politics until the Bay of Pigs invasion on April 17, 1961. At this moment of acute crisis, the Cuban Government appealed to the Soviet Union for help (though not for leadership) in the fight against US imperialism. The Soviet leadership then made clear to the Cubans that the price of their support would be a rehabilitation of the PSP and a prominent new role in public life for it under Escalante.

Escalante and his orthodox supporters were then given the powerful new task of constituting a Communist Party along strict Leninst lines from a fusion of the large July 26th Movement and the tiny PSP. Yet, Escalante began a quite sectarian purge from the new party of all the former guerrilleros who were in high posts. These so-called "revisionists" were summarily replaced in every key leadership position by orthodox members of the PSP. Finally, on March 26, 1962, after months of Stalinoid intimidation, this "Dark Period" of sectarianism and enforced orthodoxy came to an end with the public denunciation and banishment to the USSR of Anibal Escalante and eight others. (Escalante returned to Cuba as a private citizen in 1964 only to be convicted of Soviet espionage in 1968 and sentenced to prison during a period of intense polemics between Cuba and the Soviet Union.)[57]

Thus, even when the vanguard party in Cuba was reconstituted as the Partido Comunista de Cuba (PCC) on October 3, 1965, it still consisted overwhelmingly of the "revisionist," unorthodox, and ultraleft members of the July 26th Movement, most of whom continued to be more aligned ideologically with the New Left, than with the orthodox Left. Yet, this membership did not alter the fact that, as a Leninist vanguard party, the PCC was an extremely exclusive group with a disproportionate amount of political power on the national level. The concrete make-up of the party in Cuba does help, however, to account for the absence of an official "revolutionary style" of art and the presence of a broad-ranging socialist pluralism from 1959 to 1989.[58]

The counterforces of the Cuban system were summed up well by William LeoGrande:

> Mass participation affords citizens considerable opportunity to affect local policy, local implementation of national policy, and even the composition of local elites. Above the local level, however, the role of the Communist Party becomes increasingly important, and policy at the national level is undoubtedly the least responsive to popular influence. Even national policy is not wholly impervious to popular demands, however.[59]

Addressing the paradoxical tensions generated by these two sets of unavoidable, and sometimes competing, forces will be a significant concern of this study. Moreover, this analysis will emphasize a key point of Eric Selbin's critique of the uniqueness of the Cuban Revolution, with all its undeniable strengths and matching weaknesses:

> Cuba is intriguing for the position it has come to occupy as the prototype of modern social revolution. Distinguishing characteristics have included the relative lack of internal opposition, the incredible staying power and popularity of Fidel Castro, and, for the first ten years, an almost pathological aversion on the part of the leadership to institutionalization. . . . But can a revolution that has yet to prove its ability to transfer power be considered a success?[60]

Yet there were brilliant accomplishments made by the revolutionary system in Cuba not only in art and culture, but also in education, health care, and public welfare. These achievements were aptly summarized in a 1982 U.S. Congressional

Report, written by a former member of the U.S. State Department:

there is a consensus among scholars of a wide variety of ideological positions that, on the level of life expectancy, education, and health, the Cuban achievement is considerably greater than one would expect from its level of per capita income. A recent study of 113 Third World countries in terms of basic indicators of popular welfare ranked Cuba first, ahead even of Taiwan—which is probably the outstanding example of growth with equity within a capitalist economic framework. Data in the 1981 *World Development Report of the International Bank for Reconstruction and Development* also support the consensus. Cuba excelled according to all main indicators of human needs satisfaction. . . . What has changed remarkably is not so much the gross indicators, as those that reflect the changed conditions of the poor, particularly the rural poor. In 1958, for example, the one rural hospital in the entire country represented about 2% of the hospital facilities in Cuba; by 1982 there were 117 rural hospitals, or about 35% of all hospitals in Cuba.[61]

Concerning economic growth as a whole in Cuba from 1959 to 1989, economist Andrew Zimbalist of the United States has shown that real per capita income in Cuba grew at an annual rate of 2.7 percent. This statistic is impressive when compared with an average of only 1.2 percent in the rest of Latin America during the same period. Even when gauged strictly in quantitative terms along macroeconomic lines, Cuba's overall performance "remains quite creditable, especially compared with the national economies of its Latin neighbors," not to mention the plight of the popular classes in each country.[62]

Yet the events of 1989 have forced consideration once again of a key problem that confronted the Cuban Revolution from the beginning (and now threatens the survival of the revolution with renewed strength). This problem is encapsulated as follows by British scholar Edwin Williams: "The Revolution might have saved Cuba from absorption by the U.S.A., but had it found a way out of the country's historic impasse? . . . between acute dependency on a foreign power for its sugar exports and its intense desire for national sovereignty . . . [and] economic autonomy."[63]

The story of the Nicaraguan Revolution and its pro-Soviet party, the Partido Socialista de Nicaragua (PSN), is equally revealing. The PSN, was even more tangential to the Nicaraguan Revolution, even less central to the history of the nation than were Soviet-backed parties to the Mexican or Cuban Revolutions. Long identified by its reformist, as well as anti-insurgent policy, of "critical" coexistence with the Somoza Dictatorship, the pro-Soviet communists in Nicaragua always opposed the Sandinista National Liberation Front. Moreover, even after the revolutionary victory of the FSLN, the Soviet Union continued to recognize the PSN as the "official" representative of the Nicaraguan people, while accepting "the legitimacy" of the FSLN as a "revolutionary party." (Revealingly, Cuba recognized the FSLN, not the PSN, as the only representative of the Revolution.) In light of its continued criticisms of the "ultraleftism" of the FSLN, it is not really surprising, then, that the pro-Soviet PSN joined the center-right coalition of twenty-two political parties in Nicaragua that comprised UNO and defeated the Sandinistas in the 1990 elections. Ironically, then, in 1990 the PSN was both the "official" Marxist–Leninist Party in Nicaragua, according to the USSR, and also the recipient, as part of UNO, of "anticommunist" U.S. campaign funds from the Reagan Administration.

In concluding with the challenging observation that revolutions led by Marxists have also remade Marxism, we can note that it is the innovative ideological framework of *Sandinismo* in Nicaragua that highlights best the post-1970s expansion of a Marxist framework well beyond the somewhat dated position laid out by Che in Cuba during the 1960s, so as to incorporate many new lessons since 1980 about the dialogical demands of popular democracy. These new revolutionary concerns, which demand critical engagement in this book, drew on the necessity of civil liberties from classical liberalism, on ethical codes from liberation theology, on a rethinking of ethnicity as well as indigenous rights from José Carlos Mariátegui and the American Indian Movement (AIM), on gender parity from the feminist movement in the United States since the 1970s, and on worries about the future of the environment voiced by the international environmental movement led by Greenpeace.

A fine summary of this complex new viewpoint—and a glimpse of how it changed forever what it means to be "revolutionary"—was given by the Minister for Foreign Affairs in the Sandinista government, Father Miguel D'Escoto (who was one of four priests at cabinet level for the FSLN):

Sandinismo is not static. It develops and is enriched by new generations of Sandinistas. As a twentieth-century revolution, we are definitely influenced by Marxist thought. . . . For example, the emphasis on conceptualizing the present as an historical trend to understand it better is one of the contributions of Marxism. . . . From a philosophical perspective, of course, Marx helps us to understand the connection between liberal philosophy, capitalism, and imperialism, and the connection between liberal thought, capitalism, and racism. . . . [Yet] no one has influenced my own life more than Martin Luther King, Jr . . . Another of these four pillars of Sandinista thought is a democratic aspiration. Now, you ask, why should we aspire to democracy if we have never had it? Well, it is natural to humanity . . . I am reminded of a marvelous painting of the baptism of Christ in a gallery in London [The National Gallery]. It was painted by Leonardo da Vinci's teacher, Verrocchio. . . . Verrochio had great love and admiration for Leonardo, his young disciple, and he wanted him to participate in this masterpiece. So, he asked Leonardo to paint the angel. Of course, the disciple was better than the teacher, and what is most interesting in that picture is the angel, although the whole work is very good. . . . Having been

given that orientation, we cannot accept being reduced to the level of simple spectatorship in a game in which only a few play. . . . This democratic aspiration is not to be confused with an aspiration to have just the formality of democracy; we are talking about real participation. We are quite aware that democracy entails social democracy, economic democracy, political democracy, and many rights, such as the right to work.[64]

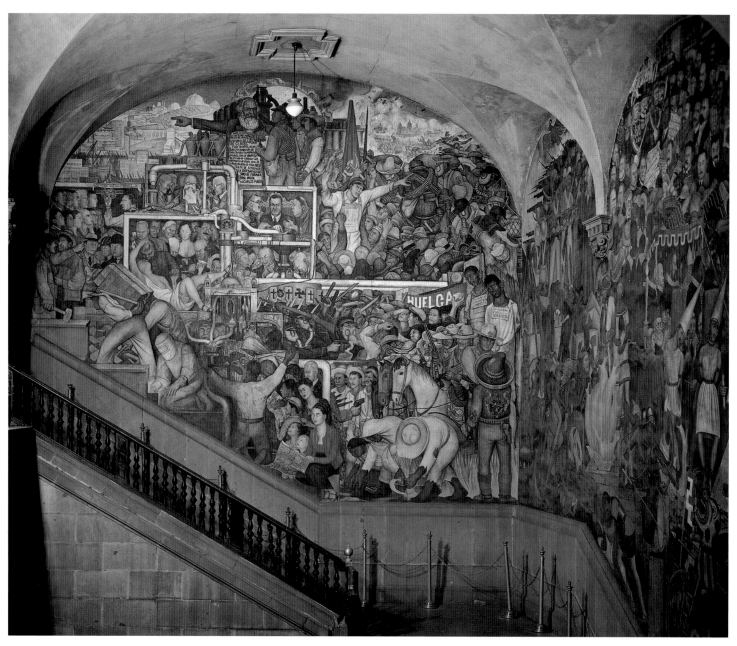

17　Diego Rivera, *Mexico Today and Tomorrow*, 1934–35, south stairway wall, Palacio Nacional, Mexico City.

The Mexican Revolution (1910–1940)

When I returned to my native Mexico almost three years ago [in 1921], after fourteen years in Europe, I found the atmosphere of art fairly stagnant—almost inert. . . . Conditions were therefore not altogether promising. . . . But there was a prodigious quantity of life, of talent and energy going to waste among the young painters. All, or nearly all, of them were revolutionists, members of various radical groups. . . . But they were still thrall to the idea that the artist is an entity distinct from the human world about him, mysteriously set apart from the community. . . . It is to me a more vital sign [in 1924] that artists and craftsmen everywhere are returning to the guild, to the community of labor. (The Indian artists have never departed from it . . . as one of them explained to me!)

Diego Rivera, 1924[1]

Our own aesthetic aim is to socialize artistic expression . . . to create beauty for all, beauty that enlightens and stirrs to struggle.

Union of Technical Workers, Painters, and Sculptors, 1924[2]

Mexico was one of the first countries in the world, and possibly the first in Latin American, to establish a critical framework for linking artistic production to the development of productive forces in society at large.

Francisco Reyes Palma, 1984[3]

The political event with the greatest influence on the modern art of a Latin American nation was the Mexican agrarian revolution.

Marta Traba, 1994[4]

Many years ago, the novelist Carlos Fuentes was traveling through the countryside of Morelos, the home province of revolutionary leader Emiliano Zapata. Fuentes and his companions became lost in this mountainous region with its maze of rice paddies and plots of sugar cane. When the party of travelers came to a *pueblo* (village), Fuentes asked an old *campesino* the village's name. The peasant from Morelos replied, "Well, that depends. We call the pueblo Santa María in times of peace and we call it Zapata in times of war."[5]

This encounter reminded Fuentes of something often forgotten about the legacy of the Mexican Revolution: along with a process of social transformation marked by pronounced uneven development, the Revolution brought with it a heightened sense of how there is more than one conception of time operating at any given moment in most countries. Far from merely facing the social problems and cultural practices of only one epoch in history, most people, especially in the Third World,

have to confront a divergent patchwork of problems and cultures simultaneously. Unavoidable problems that divide versus practices that unify are often carry overs from earlier periods, as well as prior cultures. This is the case even as the unrelenting project of modernization has also imposed its own layer of pressing concerns in relation to all of these issues (fig. 17). This unsettling dynamic was intensified in Mexico after 1910, since as Fuentes has observed, "Only the Revolution made present all of Mexico's pasts—and that is why it deserves a capital R."[6]

The Mexican Revolution is momentous for other reasons as well, since it was the first successful revolution in the world during the twentieth century. Occurring prior to both the Russian and Chinese Revolutions, the Mexican Revolution was based on the ascent to power of a broad popular uprising almost without precedent around the globe. By the end of the first fierce decade of fighting and with the advent of the process of institutional consolidation in 1920, as much as 10 percent of the

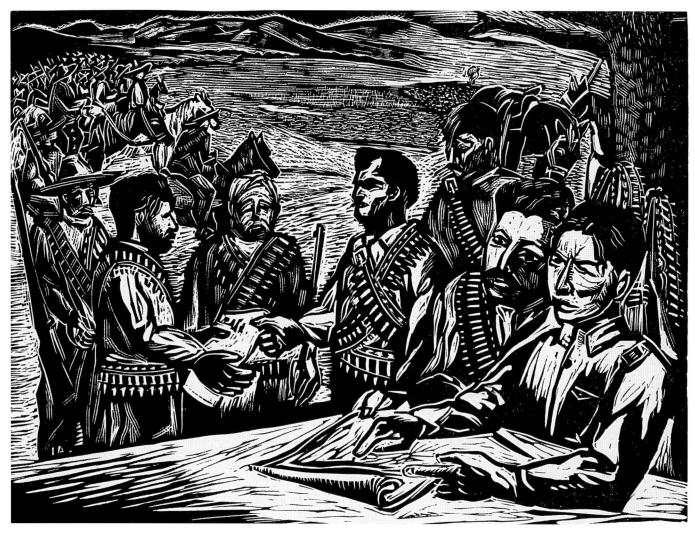

18 Ignacio Aguirre, *Las tropas constitutionalistas hacen el primer reparto de la tierra en Matamoros, 6 de Agosto de 1913* (The constitutionalist troops making the first redistribution of land, in Matamoros on August 6, 1913), linocut, *Estampas de la Revolución Mexicana*, pl. 38, Julius L. Rolshoven Memorial Fund, University of New Mexico Art Museum.

population had perished in the military conflict. The revolutionary outcome was a profound process of social and political transformation, if not also one in the economic sphere. Foremost among the positive achievements of the Mexican Revolution was the creation of the Constitution of 1917, which, as Linda B. Hall has observed, was a "remarkable document, more radical than any other constitution in the world at the time."[7]

Among the most striking parts was article 27, which altered legally the entire definition of private property that had operated in Mexico since its independence from Spain. By stipulating that all land, water, and subsoil rights reverted to the nation as a whole, the Constitution of 1917 expressly called for the subordination of individual property rights to those of society more generally. (This particular article is one of the main reasons that Carranza strongly opposed the 1917 Constitution, while Obregón and representatives of the Zapatistas, as well as the Red Battalions, supported it.) After the constitutional convention, the ownership of land became a broad social issue, not just a matter of individual "freedom." Thus, this new document authorized the Mexican Government to distribute

public wealth more equitably, in accordance with basic human rights that were suddenly seen as taking priority over property rights (figs. 18 and 19).[8]

As applied by the Mexican presidents who emerged from the revolutionary process—from Álvaro Obregón through Lázaro Cárdenas, 1920 to 1940—the "ultraleft" Constitution of 1917 led to the largest and most systematic land redistribution program in the history of the Americas, if not beyond. From the three million acres reallocated by Obregón in the early 1920s through the eight million acres redistributed by Calles in the mid-1920s, to the fifty million acres granted to the popular classes by Cárdenas in the late 1930s, this program resulted in a comprehensive agrarian reform that fundamentally shifted the balance of political power in a country that was soon to become the largest Spanish-speaking nation in the world.[9] (Since 1920 Mexico's population has grown at an extraordinary rate, from only fifteen million to over one hundred million at present. Yet, ironically, even as this huge growth attests, on the one hand, to the advances of the Revolution of 1910, so it has also caused tremendous problems for the social services and public

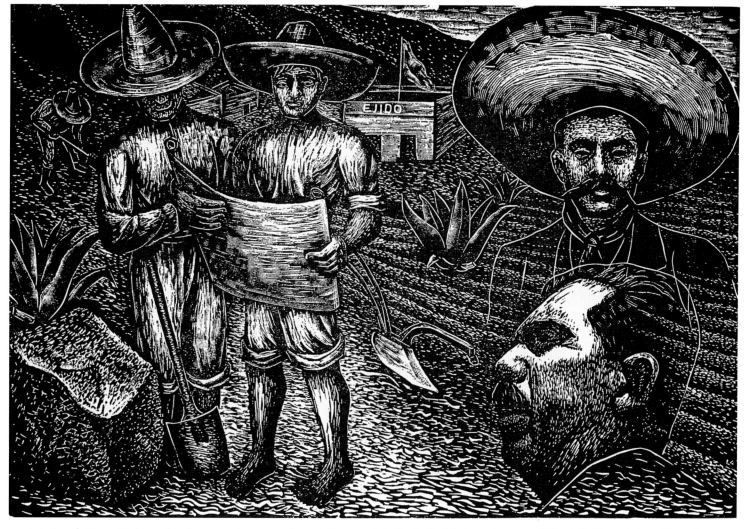

19 Luis Arenal, *Lázaro Cárdenas y la reforma agraria*, 1934–40, linocut, *Estampas de la Revolución Mexicana*, pl. 67, 1947, Julius L. Rolshoven Memorial Fund, University of New Mexico Art Museum.

programs instituted by postrevolutionary governments, on the other. Neither of the latter sets of institutions were ever able to expand rapidly enough to keep pace with this mushrooming growth rate.)[10]

Yet, in 1920 the Mexican economy was in utter shambles and the only part of it capable of generating desperately needed foreign currency was the oil industry—76 percent of which was owned by U.S. corporations. As would be the case later with both the Cuban Revolution of 1959 and the Nicaraguan Revolution of 1979, Mexico's economy was overwhelmingly one-dimensional as a result of two grinding problems: the ongoing legacy of colonialism and the fact of imperialism, that is the aggressive foreign ownership of its natural resources. To be sure, Mexico was far more fortunate to be dependent upon local oil, than either sugar cane, as in the case of Cuba, or coffee, as was true of Nicaragua (neither of which have oil under their subsoil). But, the foreign dominance of the Mexican oil industry—and the monopoly control by the U.S.A. over the technology for extracting and processing oil, which was perhaps even more straightjacketing for the Mexican government—meant

that the revolutionary governments during the first few years of the reconstructive phase of the Mexican Revolution were at a considerable disadvantage. Not surprisingly, the Mexican economy was at first slow to recover, with none of its key sectors experiencing a profound process of structural transformation.[11]

Yet Álvaro Obregón's early, adroit, and deeply progressive handling of this seemingly intractable situation concerning national oil reserves ultimately allowed the Mexican economy to turn a crucial corner on the endless road to economic sovereignty. In turn, this rudimentary economic independence allowed far more radical experimentation to occur during the 1920s and 1930s in the public sphere, both politically and culturally. As such, labor relations and union militancy in the urban domain, as well as in the agrarian sphere, did in fact feature something approaching a revolutionary change. As Alan Knight has shown, the Mexican Revolution resulted in a radical shift in the tone and terms of mass politics. This was particularly true concerning the bold strides toward workplace democracy—even without any immediate revolution in the economic infrastructure or the means of ownership. (The latter would happen only

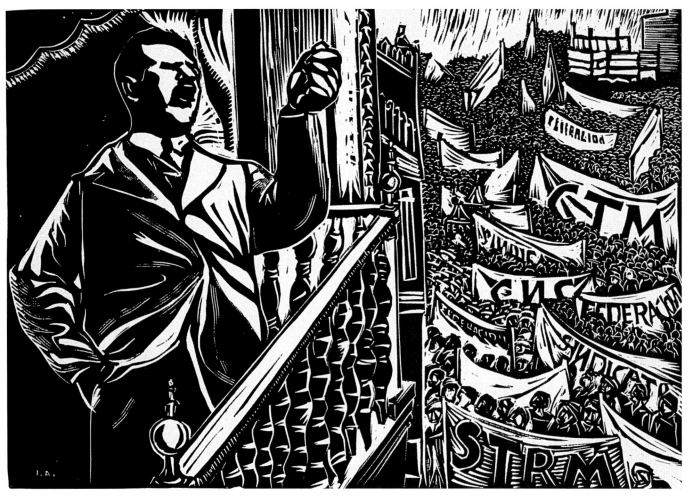

20 Ignacio Aguirre, *El Presidente Cárdenas recibe el apoyo del pueblo mexicano para sus medidas en favor del progreso del país* (Cárdenas recieves support for his measures in favor of the country's social progress), linocut, *Estampas de la Revolución Mexicana*, pl. 72, 1947, Julius L. Rolshoven Memorial Fund, University of New Mexico Art Museum.

during the 1930s with the nationalization of the oil industry by the Cárdenas Administration in 1938. But that act of nationalization in conjunction with the radical agrarian reform was tenable—and it was not easy, owing to the corporate capitalist structure of the world economy—only because of the political and social foundations that had already been constructed quite deftly and patiently by Obregón and even Calles, at least from 1924 to 1928.)[12]

Knight's compelling and "post-revisionist" summation of the situation in Mexico after 1920 through 1940 (figs. 20 and 21) goes as follows:

It is true that Mexico's economy had not been revolutionized by the Revolution.... In contrast, Mexico's social and political life was dramatically changed by the Revolution, albeit in an often unplanned and unforseen manner. The armed mobilization of 1910–20 gave way to new forms of institutional mobilization: peasant leagues, trade unions and a mass of political parties, left and right, great and small. The result was not a decorous politics, such as Francisco

Madero had advocated in 1910; but neither was it a closed, personalist autocratic system of the kind Díaz had maintained to the end.... [A] form of mass politics ... was gestating. Such a politics defies neat generalization.... Although state control over civil society thus increased, the state built by the leaders of Sonora (1920–34) *was not an authoritarian leviathan.* The rumbustious civil society of the 1920s defied such control.... Organized workers and peasants often elected to ally with the state, but they usually did so conditionally and tactically, and there were many examples of popular dissidence.... What is more, by the 1920s, the demands and rhetoric of popular movements ... displayed a new radicalism, a new self-confidence.... it forced employers to reckon with labour as never before.... Equally, the peasantry displayed a different temper compared with pre-revolutionary days [my italics].[13]

While the mass-based politics that emerged from the Revolution of 1910 help to explain many of the social advances after 1920, they alone are an insufficient explanation for all of these

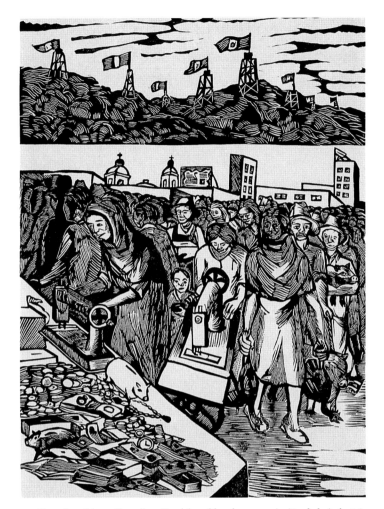

21 Francisco Mora, *Contribucción del pueblo a la expropriación de la industría petrolera, 18 de Marzo 1938* (The Contribution of the people to the nationalization of the oil industry on March 18, 1938), linocut, *Estampas de la Revolución Mexicana*, pl. 74, 1947, Julius L. Rolshoven Memorial Fund, University of New Mexico Art Museum.

changes. As Linda B. Hall has shown, "the interests of the masses in specific reforms and immediate benefits were at least partially met by the revolutionary leadership, principally at the local level."[14] Among the developments that not only permitted unprecedented popular mobilization, but also even elicited it, was the nationwide literacy program predicated on a vastly expanded public school system from 1920 through 1940. This development was hardly unexpected when one considers the earlier political commitments of both Obregón and Calles. Álvaro Obregón was, after all, the brother of several school-teachers in Sonora among the Mayo Indian children. (Obregón himself grew up speaking Mayo, as well as Spanish, and he worked for a time as a mechanic in the Navolato mill.) With these twin experiences linking him to popular laborers and to the Indigenous population, Obregón went into politics in 1911 when he was elected as municipal president in Huatabampo. He quickly instituted the most progressive programs the area had seen both in public education and public works. In fact, he targeted half of the entire municipal budget for reforming

the public school system. Much the same can be noted about Plutarco Elías Calles, a former school teacher in Sonora, and Lázaro Cárdenas, who became well-known for even more radical programs as governor of Michoacán during the late 1920s and early 1930s.

A social revolution in the class room and in the union hall were prominent features of the Mexico encountered by a very distinguished visitor from the United States in 1926. This was the famed philosopher, educational theorist, and guild socialist named John Dewey, whose pedagogical theories remain among the most noteworthy of the first half of the twentieth century. In a series of articles for the *New Republic* (a mainstay of liberal support for the later Work Projects Administration (WPA) programs of Roosevelt), Dewey registered some fairly dramatic observations about Mexican "Bolshevism," as the right wing in the U.S.A. referred to it in those years:

> In one of [Calles's] earlier announcements he summed up his program in two policies: economic liberation, and the development of public education. . . . the government is spending four times as much as was spent in the heyday of the Díaz regime. . . . The most interesting as well as the most important educational development is, however, the rural schools. . . . This is the cherished preoccupation of the present regime; *it signifies a revolution rather than renaissance.* It is not only a revolution for Mexico, but in some respects one of the most important social experiments undertaken anywhere in the world [my italics].[15]

In noting that there were already 2,600 new rural schools since 1920 (where 80 percent of the population was located), Dewey pointed out in addition that 1,000 schools had been set up in the previous year alone. Furthermore, he felt that the "educational revolution" was "also an indispensable means of political integration for the country."[16] Although forced to admit that much of the "actual work is, it goes without saying, crude," he added, nevertheless, that what struck the attentive observer was that it was "the crudeness of vitality, of growth," so that everywhere there is "a marked spirit of experimentation."[17]

John Dewey also made some timely observations about the labor movement in Mexico during the 1920s. In a subsequent article for *New Republic*, he analyzed the radically changing circumstances for the working classes, both rural and urban. To quote him again:

> Fifteen years ago farm labor was in a state of complete serfdom, in fact a slavery as effective as that of Negroes in the U.S. before the Civil War. Industrial labor was unorganized and oppressed. Today Mexico has, on the statute books, the most advanced labor legislation of any contemporary state; and the "syndicates" are the greatest single power in the land. The streets blaze forth the signs of the offices of different unions more prominently than in any place I have ever visited.[18]

Significantly enough, Dewey's own radically democratic pedagogical theory of "learning by doing" in a nonhierarchical

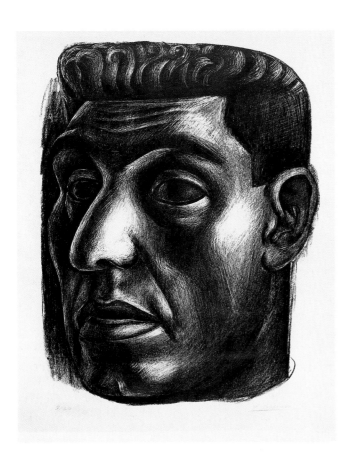

setting was influential on the "educational revolution" in Mexico. This was especially true after the departure of the Neoplatonist thinker José Vasconcelos from the leadership position of the Ministry of Education in 1924. It was the subsequent team of Manuel Puig Casauranc, as the Minister (or Secretary) of Education, and Moisés Sáenz (fig. 22), as Vice Minister (or Sub-Secretary), that redirected the national educational program. They did so along lines that, following Dewey, tied the educational process much more to the practice of mass politics and the actual sphere of production. In fact, in 1926, Sáenz, who was a former student of Dewey, paid a moving public tribute to Dewey and the profound influence on the Mexican Revolution of his most well-known book on education, *Escuela y sociedad* (The school and society).

In citing Dewey as a crucial figure in the struggle against reactionaries and counter-revolutionaries, Sáenz rightly pointed out to his audience at the University of Chicago: "La palabra 'reaccionario' entre nosotros es como 'bolchevique' entre ustedes." (The word "reactionary" means to us what the word "Bolshevick" means to you.)[19] Moreover, in a related public paper, Sáenz followed up his praise of Dewey with an implicit critique of José Vasconcelos and his dreamy Hispanophile ethnocentrism. Sáenz's critique concluded as follows: "La frase de clisé 'incorporar el indio a la civilazación,' debería ser cambiada por la de 'incorporar la civilación al indio.'" (The clichéd phrase

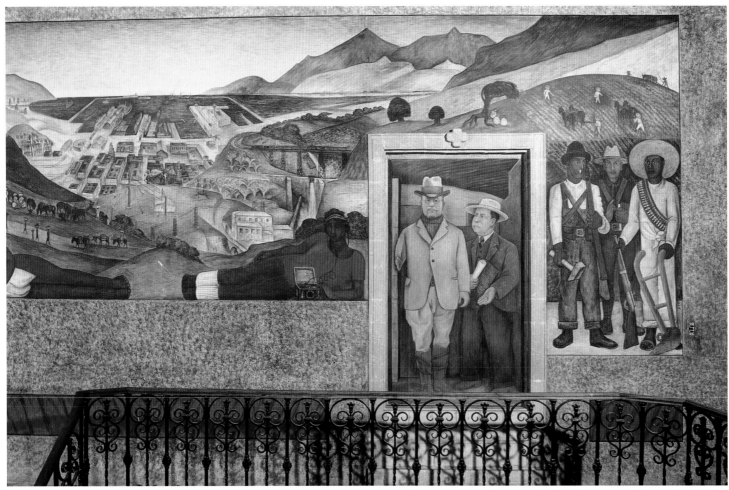

"assimilate the Indian into civilization" should be changed to: "adjust civilization to the Indian.")[20]

These generally overlooked points about the educational revolution in Mexico between 1920 and 1940 call for two major adjustments to the art-historical literature. First, we need to recognize that Obregón, a revolutionary leader—not Vasconcelos, an academic educator—was actually the originary force behind the dramatically new educational program in Mexico. This includes the mural movement, for which Obregón astutely selected Vasconcelos as a key agent of change. In fact, the galvanizing role played by Obregón and his revolutionary allies in this process was often acknowledged by Diego Rivera and other significant artists, even as Vasconcelos sometimes appeared in a critical light.[21]

To appreciate this point, one need only contrast the way that Obregón was strikingly portrayed by Rivera in fresco at Chapingo or by Pablo O'Higgins in linocut (figs. 23 and 24), with the very different representation of Vasconcelos by Rivera in the Patio of Fiestas of the Ministry of Education. Without denying Vasconcelos's importance to the educational program, we must reacknowledge the role of Obregón, who was, after all, further to the left politically than was Vasconcelos and, given his own childhood among the Mayo in rural Sonora, much less guilty of ethnocentrism than was Vasconcelos. The latter thinker in fact championed a concept of "mestizaje" that was fundamentally at odds with the more progressive view on multiculturalism manifested in the murals of Rivera and Siqueiros, if not in the works of other Mexican muralists of the period.[22]

Furthermore, without underrating the wonderfully visionary quality of Vasconcelos's leadership in the Ministry of Education from 1921 to 1924, we must also concede the decrease in Vasconcelos's influence on educational policy from the mid-1920s through the quite radical educational project of the 1930s. This is particularly the case in relation to the more significant, if less dramatic, role played by Moisés Sáenz and other educators after 1924. In the end, while appreciating Vasconcelos's leadership from 1921 to 1924, it is also necessary for us to underscore the telling limitations of Vasconcelos's position. His vague sense of pedagogical theory was based upon an amalgam of the following: a Neoplatonism filtered through Masonic theosophy, a middle-of-the-road socialist pluralism in keeping with the example of Lunacharsky, a predilection for anodyne Art Deco classicism, and an admiration for the partriarchal approach of Spanish colonial missonaries. Aside from the distressingly paternalist directives to educational "misioneros" (as he so ethnocentrically called teachers), there was a retrograde visual aesthetic that Vasconcelos encouraged among Mexican artists, as Leonard Folgarait has perceptively demonstrated in a recent study.[23]

24 *(left)* Pablo O'Higgins, *El General Obregón con los yaquis*, linocut, *Estampas de la Revolución Mexicana*, pl. 48, 1947, Julius L. Rolshoven Memorial Fund, University of New Mexico Art Museum.

22 *(facing page top)* David Alfaro Siqueiros, *Moisés Sáenz*, 1931, lithograph, Inter-American fund, Museum of Modern Art, New York.

23 *(facing page bottom)* Diego Rivera, *Presidente Álvaro Obregón y Ministro Negroponte*, 1940, fresco, Administrative Building, Universidad Nacional Autónoma de Chapingo.

25 Diego Rivera, cover of *El Maestro*, vol. 2, no. 1 (1921), Center for Southwest Research, Zimmerman Library, University of New Mexico.

this program in terms as close to Dewey's knowledge through action, as it was distant from the old-time idealism of Vasconcelos: "Este principio forma parte de nuestra filosofía. Las revoluciones son, después de todo, fenómenos de emoción y de acción, más bien que de ideación." (This principle forms part of our philosophy. Before everything, revolutions are phenomena of emotion and action, rather than of ideation, or theory.)[24]

The consequence of this policy, especially during the most radical days of the Cárdenas Administration, was not merely an authoritarian federally mandated pedagogy. Nor was the educational result simply a grass-roots movement with a solely localized impetus, such as was later envisioned by Ivan Illich or Paul Goodman. What emerged was something arrestingly innovative with characteristics of both, a site of local debate and national negotiation centered on "socialist education," as this program was known nationwide in Mexico. Bolstered by the 1917 Constitution and backed by the Government of Cárdenas along with mobilized labor unions, the educational program of the 1930s in fact succeeded in consolidating much of what had been most progressive in Mexico since the days of Obregón and Calles in the 1920s.

In an exemplary discussion of the culminating phase of the educational revolution in Mexico, Mary Kay Vaughan encapsulated the innovative—and at times unanticipated—aspects of this system as follows:

> the real cultural revolution lay not in the state's project, but in the dialogue between the state and society that took place around this project. Socialist education occurred at a moment when the state was still weak while social groups were highly mobilized in often frenzied defense of their disparate interests. . . . The school became the arena for intense, often violent negotiations over power, culture, knowledge, and rights. . . . If the school functioned to inculcate a state ideology for purposes of rule, it also served communities when they needed to contest state policies. It provided ideological, technical, and organizational tools to do so. . . . Teachers facilitated this dual construction. . . . This outcome of the revolution's cultural politics—a sense of popular, multiethnic inclusion based on the right to protest exclusion and injustice—is [almost] unique in Latin America.[25]

This brief outline of revolutionary Mexico's radical newness—which is so often underestimated at present—illuminates a number of key things about the mural revolution, not just renaissance. First, a significant thing about the sites of the murals should be noted. All of the major, and even many of the minor, murals of the first few years—from 1922 up to around 1928—were located in key educational institutions. This list extends most famously from the amphitheater of the National Preparatory School, where Diego Rivera inaugurated the groundbreaking phase of muralism with *Creación* (1922), through the Ministry of Education (1923–28) and Rivera's brilliant series of frescoes there, to the National Preparatory School, with its masterful 1926 murals by José Clemente Orozco and,

To understand the gap between his aesthetic and that of the most progressive artists in Mexico, one need only examine the covers of *El Maestro* from 1921 and 1922. The first year of this publication by the Ministry of Education features the type of deeply conservative Art Deco classicism that Vasconcelos preferred. The first cover of the second volume of *El Maestro* (fig. 25) was in a radically new vein and it was designed by Diego Rivera, who had recently returned from Paris. The remarkable 1921 cover by Rivera signaled nothing less than a bold effort at forging a novel visual language out of pre-Columbian images and European vanguard forms, the likes of which hardly existed anywhere else in the world. Such a radical new synthesis by Rivera would not have been likely without the audacious new social transformation then beginning in earnest under Obregón.

The strikingly precocious design by Rivera in 1921 would find a parallel only later, in the post-Vasconcelos pedagogical project of Moisés Sáenz, which was referred to as the "sistema ideológica" underpenning the "escuela de acción." Sáenz spoke of

finally, to the interior of the chapel auditorium at the National Autonomous University of Agriculture at Chapingo (1924–26), where Rivera produced the "Sistine Ceiling" of the modern movement. In all of these cases, and others, the Mexican Mural Revolution was centered in the most progressive—and contested—buildings of the social transformation then gathering momentum in the 1920s.

Aside from the stunningly new murals of this audacious period, there were also a number of highly accomplished wall paintings within educational institutions from the 1920s by a whole group of left-wing artists. Their radical intent cannot be disputed, even when their artistic labors did not lead to landmark artworks. Deserving of mention here are all of the other accomplished artists who, in executing notable public fresco paintings, made the Mexican Mural Revolution of the 1920s a national movement, rather than just a two-man band: the early David Alfaro Siqueiros, Ramón Alva de la Canal, Jean Charlot, Amado de la Cueva, Gabriel Fernández Ledesma, Ernesto García Cabral, Emilio García Cahero, Xavier Guerrero, Fernando Leal, Carlos Mérida, Roberto Montenegro, Máximo Pacheco, and Fermín Revueltas.[26]

In the late 1920s and early 1930s, as the conflict centered around schools took on added intensity, a second wave of mural production began. This phase entailed a notable shift, since political debates engulfed most state institutions, thus making their walls literal sites of contestation over political power. At this moment, members of the Mexican mural movement—again led by Diego Rivera and José Clemente Orozco—were increasingly commissioned to do public frescoes in prominent government offices both national and regional, as well as at new state-sponsored civic sites. These mural commissions occurred at a point when there was a semi-insurgent situation in which the direction of the Mexican Revolution literally hung in the balance between an increasingly autocratic Calles regime and an emergent, radically democratic Cárdenas administration confronting it.

Scars of this ongoing social conflict from the final phase of the Mexican Revolution are to be found immediately in all of the commanding murals produced during this convulsive period: from the epic modernist series in the *Palacio National* (1929–35) by Rivera, and the cluster of social protest paintings in the *Mercado Abelardo Rodríguez* (1933–34) by a team of artists allied with the Communist Party (including Pablo O'Higgins and the Greenwood Sisters), through the awe-inspiring paintings by Orozco in the municipal government buildings of Guadalajara (1935–39), to the decade-ending and technically unprecedented stairway mural in the *Sindicato Mexicano de Electricistas* (Mexican Union of Electrical Workers) by David Alfaro Siqueiros.[27]

Another point should also be made concerning the very political framework that would have permitted these multilateral political advances, even as a centralized state was being constructed to contain, or at least stabilize, the decentering class conflict that had been unleashed by the Mexican Revolution. Just as Mexico in 1917 was a former colony that still found itself in a precarious planetary orbit around the U.S. imperium (while, conversely, the Russia of 1917 remained the center of its own geopolitical solar system), so Mexico could not produce a heavily centralized state with regional hegemony (as did the USSR) nor even a vanguard political party with something like monopoly control over the national discourse (as did the Bolsheviks). As such, the Mexican Revolution gave birth after 1920 to an unusual conception of socialism that was semi-Marxist and non-Leninist. The postrevolutionary state was thus seen by its founders in Mexico—Obregón and his very broad multiclass alliance—as the equilizing arbiter between competing classes, but not as the sole representative of any one class. Thus, the Leninist model of one-party rule and one-class ascendancy was no more plausible, or desirable, in Mexico, than was the so-called "dictatorship of the proletariat" in an agrarian country where the laboring classes were mainly composed not of industrial workers, but of rural *campesinos*. (This obtained whether one wished to classify them as rural wage labor, as peasants, or as kulaks—and they were actually all three.)

The singularity of Mexican socialism, which sometimes had more in common with Swedish social democracy in the 1920s than with Soviet Bolshevism in this period, was summed up aptly by President Obregón: "The principal purpose of socialism is to extend a hand to the downtrodden in order to establish a greater equilibrium between capital and labor."[28] Far from presuming to end class struggle, such a revolutionary government with its obvious links to the working classes, simply aimed to level the field of conflict along lines more advantageous to the popular classes, than they had ever been before. Yet, in doing so, the counter-clockwise dynamic of the Mexican Revolution would repeatedly find itself in structural opposition to the clockwise logic of the world economic order. This was especially the case in the Americas where Mexico's powerful, at times even overpowering, neighbor to the North remained a decisive motor for keeping the mainstream movement of corporate capitalism on track.

How, then, would artists in revolutionary Mexico represent a state that until 1940 was without a unified guiding party and/or government that claimed to represent only one class—one which was sustained by a tense multiparty alliance of the popular classes? Similarly, how would visual artists represent a multiethnic process of uneven development, which was fundamentally at odds with the heavily industrializing and socially homogenizing process spearheaded in Russia after the mid-1920s? Moreover, how would vanguard artists "socialize" the arts so as to aid the process of selfrepresentation by the quite varied popular classes to which they were appealing? The latter problem was, after all, a problem that no Leninist political party, with its ultravanguard claims on representation in the public sphere, was interested in addressing during the first stages of a social transformation.

The Institutionalization of the Revolution in the 1920s

One of Obregón's first acts as president was to increase federal spending on education from only around five million dollars annually to fifty-five million. In the period of his presidency from 1920 to 1924, the Mexican government not only built one thousand new rural schools, but also two thousand new public libraries. This meant that the sum granted to education in Mexico stood at 15 percent of the *entire* national budget by 1923, as compared to only 1 percent in 1919. Despite the devastation in 1920 of a nation virtually in ruins, the Obregón government would succeed in elevating the national rate of literacy from around 15 percent to 25 percent. (The latter figure would be doubled again by the end of the Cárdenas Administration in 1940.)[29]

Along these lines, Secretary of Education Vasconcelos established three new departments within the Department of Education. These subdepartments comprised the following: a new national school system (before there were only regional schools and private schools); a new national system of public libraries; and a National Fine Arts Program that included the mural program in the public sphere that would take off in 1922–23 with such a boom. Concomitant with these new agencies were two other programs, namely, the launching of a series of "cultural missions" that went into rural areas to hold literary conferences as well as to arrange art exhibits, and an ambitious publishing program for disseminating "people's editions" of classic texts, from Plato and Homer through Dante and Cervantes (in all, around 105 titles were slated for publication).[30]

Significantly, a major plank in the construction of a national school system was the implementation of an unprecedented nationwide drawing program for all public schools and colleges. It was carried out by the Departamento de Dibujo, which Vasconcelos placed under the direction of Adolfo Best-Maugard, a dandified intellectual who had been prominently portrayed in one of the first paintings by Diego Rivera to engage with Cubist formal components. The reason Best-Maugard was appointed to head this branch of government was because he had invented an "essentially" Mexican "método de dibujo," which was derived from "siete líneas" (seven lines) that were to be found in all pre-Columbian art, along with more recent imagemaking linked both to popular culture and to vanguard art, like that of Wassily Kandinsky. (It is worth noting that Kandinsky was a teacher in the Free Art School, or *Vkhutemas*, that flourished in the USSR during the early 1920s, before leaving this post to teach at the Bauhaus as a *Formmeister* up until 1933.)[31]

These seven basic "lines," or design principles distilled mostly from Aztec and Mayan art, according to Best-Maugard, were the following: straight lines, undulating lines, zig-zag lines, circles, half-circles, spirals, and s-shaped lines. This essentializing and semi-Platonist approach to draftsmanship was seen as a way of encouraging "selfrepresentation" among the Mexican citizenry. With state backing during the tenure of Vasconcelos, Best-Maugard trained 150 art teachers to promote this method

around the country. He also wrote a manual about his approach, entitled *Método de dibujo: Tradición, resurgimiento y evolución del arte Mexicano*, which was published by the Ministry of Education in 1923. The book was then distributed free of charge throughout the nation, where it did exercise an influence later on such artists as Manuel Rodríguez Lozano and Abraham Angel. According to his introductory remarks, Best-Maugard wished to create a "current of unification for Mexican art."[32]

The unification of Mexican culture progressed slowly, though. Best-Maugard's method was already modified in an even more eclectic direction by 1924 and it fell into disuse by 1925, with the departure of Vasconcelos and the arrival of Sáenz. Nonetheless, the fact remains that this artist/impresario/pedagogue did exercise a notable influence on subsequent developments in the visual arts of Mexico. Yet, ironically, Best-Maugard—who encouraged Vasconcelos to entice artists like Rivera back to Mexico in 1921—had an influence that contradicted that of his patron Vasconcelos in a key respect. This was the case because Best-Maugard's method was much less Eurocentric, much less Hispanophile than were the views of Vasconcelos in such instances as his theory of "la raza cósmica." Here, as elsewhere, Vasconcelos commissioned artists to do work that had a rather different cultural or political orientation than he did—with sometimes surprising results.[33]

An educational program that was much more Eurocentric in aim was the well-intentioned but problematic series that began in 1920 (and lasted up to 1935). It consisted of four Barbizan-like *Escuelas de Pintura al Aire Libre* (open art schools) at such semi-rural sites as Chimalistac and three other comparable locations established in 1924. These schools had open admissions and charged no matriculation fees. They were inspired by the nineteenth-century work of José María Velasco and were the brainchild of painter Alfredo Ramos Martínez. In 1913, Ramos Martínez had founded the first one, at Santa Ana Iztapalapa, while he was Director of the Escuela Nacional de Bellas Artes (the old Academia de San Carlos). In teaching a variant of post-impressionism as a way to "desacademizar la Academia" (de-academicize the academy) by directly appreciating the "Mexicanness" of the landscape, Ramos Martínez hoped to foster a "national art." Accordingly, he instructed students to work in direct contact with nature, in sites where the foliage and perspectival relationships will be true to the character of our nation.[34]

These open air schools did allow for some modest experimentation and they produced a remarkable number of accomplished artists from their midst—Rufino Tamayo, Ramón Alva de la Canal, Antonio Ruiz, Julio Castellanos, and Augustín Lazo, among others. Nonetheless, their political naivety and ideological innocence were attacked by David Alfaro Siqueiros and several others of this period. Moreover, as Olivier Debroise has noted, there was an easy and essentializing equation of children's art with that of "pure" Indian art that revealed "the paternalistic attitude and spiritual Eurocentrism (if not outright rascism) of the leaders" in these open air schools.[35] In this particular case,

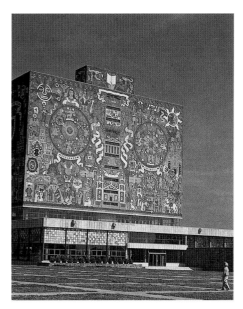

the attitude and ideological stance of Ramos Martínez was much closer to the ethnocentric version of "mestizaje" championed by Vasconcelos and Manuel Gamio, than it was to the "alternative mestizaje" articulated in the murals of Diego Rivera, and perhaps David Alfaro Siqueiros.[36]

The one time that revolutionary pedagogical theory for an art school was the center of intense controversy occurred in 1929 with the appointment of Diego Rivera to head the Escuela Nacional de Bellas Artes (the former Academy of San Carlos), which was quickly renamed the Escuela Nacional de Artes Plásticas, in keeping with the radical redefinition of art introduced by Rivera himself into this institution (fig. 26). As the new Director, Rivera announced a revolutionary program of instruction with few parallels in modern history. (See Appendix A for a translation of the full document.) Among other things, this project meant restructuring the national art school into a national workshop that fused the Fine Arts and the crafts, hence the name "artes plásticas." (In this respect, the proposed program recalled the left-wing, but less radical *Bauhaus* system under Walter Gropius and later Hannes Meyer.)[37]

The students in the National School were to be organized into unions, so that they would be more likely to see themselves as "art workers," rather than as fine artists. In addition, during the first three years of instruction, classes were to be held only at night, so that all students could spend the day working in factories or workshops. Here, Rivera gave the pedagogical theory of "learning by doing" a radical new ideological inflection that dramatically linked artistic practice with industrial production, as Francisco Reyes Palma has rightly noted.[38]

In laying out his vision for the National School of Visual Arts, Rivera spoke of nothing less than overcoming the division of labor between intellectual work and manual work. He thus combined ideas from Marx with those of Dewey. To quote Rivera:

It has been kept in mind that both the work of the apprentice and that of the professional painter, sculptor, or engraver, have the double character of manual work and intellectual work that demand a great quantity of methodical effort and physical strength. From the pupil must be expected great determination, matching enthusiasm, and a love of the art practiced.[39]

This explanation of his educational program is in fact quite consistent with the conception of art as a form of labor that guided his own output. As he noted in 1925:

If [the painter] is a worker [*trabajador*] in the broadest class-based and activist sense, whatever he makes as a good artisan or craftsman [*un buen artesano*], that is, whatever he produces with sincerity, will necessarily be *una expresión revolucionaria*, irregardless of the theme.[40]

Despite the fact that he had been elected to the directorship by the art students in the National School, Rivera soon encountered very stiff opposition to his program. It came from the students of architecture in the National School. At one point street fights even erupted between the left-wing art students and the right-wing architectural students, although the leader of the art students was a radical named Juan O'Gorman (another faculty member in favor of Rivera's plan was the young Rufino Tamayo). As is well known, O'Gorman would later become one of the most important and innovative architects in Mexico for avant-garde, socially engaged architecture. Among his most famous buildings from 1931 to 1932 would be the home/studio complex of Diego Rivera and Frida Kahlo in San Angel. This was one of the first buildings in Mexico inspired by Russian Constructivism and the Bauhaus. Later, in 1952, he would produce a strikingly heterogenous structure exemplifying "post-colonial" architecture *avant-lettre*, when he designed the Library Building at the Universidad Nacional Autónoma de México (National Autonomous University of Mexico) (fig. 27).[41]

Egged on by the deeply conservative architecture faculty within the National School, the architectural students (who were in the wealthy minority), released a communiqué to the newspaper *El Universal Gráfico*, in which they threatened to destroy Rivera's frescoes of the late 1920s and early 1930s in the Palacio Nacional, which are only a few hundred meters from the National School of Visual Arts. Rivera responded by arming himself, as well as his assistants, and then he challenged the "bourgeois" students to make good on their reactionary threats. While working on these murals, Rivera wore pistols and crossed cartridge belts when he mounted the scaffold. Although this might seem overstated in retrospect, Rivera was not engaging in idle theatrics, as the frequent street conflicts in the capital between popular organizations of the Right and the Left during this period make quite clear.[42]

Unfortunately, this public polemic concerning pedagogy at the National School against the political forces of the right coincided with Rivera's very sharp debate with the Partido Comunista Mexicano (Mexican Communist Party), which, in 1928–29, on orders from the Comintern, attempted an utterly ill-advised and quite secretarian "palace coup" against the embattled Mexican Government. The CP did so at *exactly* the point when the centrist governmant of Calles was waging a ferocious fight with the ultraright forces of the Catholic Church, during the so-called "Cristero" Revolt. Because he rightly understood that any successful coup by a tiny CP vanguard would only be quickly defeated by a far more powerful ultraright counter-insurgency, thus paving the way to a rightist regime, Rivera publicly disagreed with the CP, of which he was a member. For this reason and others, he was expelled from the CP, which was then beaten very easily in a military show down that led to the unfortunate death of union leader José Guadalupe González. This occurred when the Calles Government was expecting support from the CP in its fight against the ultraright. (The Calles regime was, of course, furious with the CP for its opportunism during this delicate moment and banned the Communist Party from 1929 to 1934, even though the Mexican Government had been secretly subsidizing it at least since 1924.)[43]

Thus, when the controversy surrounding Rivera and his left-wing program for the National School came to a head in 1929, the situation was literally mined in every direction. Perhaps not surprisingly, the partisans of the CP, like David Alfaro Siqueiros, joined the ultraright to trash-talk Rivera's directorship and "ultraleftism." (Siqueiros simply made false statements in 1934 to excuse his actions. He wrote that Diego Rivera was given the directorship of the old Academy of San Carlos as "un premio" (a reward) for counter-revolutionary activities by the Calles government and that Rivera quickly set up a "programma de mistificación demagógica" (a program of demagogic mysti-fication).[44] (Again, see Appendix A for a quick refutation of this claim.)

Viewed with ambivalence by the Calles Government, utterly reviled by the right, and stridently attacked by the Communist Party, Rivera was unquestionably in an untenable position. He was brought up on twenty-three charges of "incompetency" by a government commission that asked the University Council to investigate in May 1930. Needless to say, his enemies—including the CP—colluded with the Calles Government in having Diego Rivera fired less than a year after he assumed office. The only group to rally around Rivera, aside from the art students led by Juan O'Gorman, were various nonaligned left-wing organizations, such as those associated with the nonorthodox Marxist Vicente Lombardo Toledano. In fact, Toledano was chosen to replace Rivera and he publicly pledged—quite futilely it turns out—to keep Rivera's radical program in place anyway.[45]

Given the short life span of Rivera's pedagogical program, what, if anything, endured from this period of controversy about Rivera's "ultraleft" proposals? First, there was the very radical resolve of Juan O'Gorman to become a left-wing architect who addressed public issues in a way that broke with the style of "neocolonial" architecture that had been predominant under Vasconcelos's direction beginning with the monumental building to house the Ministry of Education in 1923. Second, and more surprisingly, there was the subsequent emergence of María Izquierdo as a notable painter from this period of the National School owing to the personal support of the Director, Diego Rivera. In 1929, Rivera unsettled a group of fellow students when, during a critique, he declared that the then unknown María Izquierdo was the best artist in the school, indeed, perhaps "the only" real artist of merit there. Rivera then backed up his unexpected assessment by securing a show for María Izquierdo at the Galería de Arte Moderno of the Teatro Nacional.

The animated debate that accompanied this critique caused María Izquierdo to write in her memoirs that in Mexico, "It's a crime to be born a woman, [but] it's an even greater crime to be a women and to have talent."[46] In one of the more insightful later summations of the period, Olivier Debroise wrote that her best paintings were a "symbol of the nostalgia for freedom" that propelled this period of the Mexican Revolution (fig. 28).[47] He stated as follows about her later development as a major artist in the history of Mexico during a particularly insurgent period: "As with her nudes and bizarre nocturnal landscapes, and her torn allegories from 1933 to 1937 . . . [these works] are located precisely on the fringes of insightful description and oeiric evocation . . . they reinvented the conventions of genre painting."[48]

In short, Izquierdo's emergence from the National School of Plastic Arts at one of its most contentious moments meant that her artwork was at once a monument to the gains of women within the Mexican Revolution and a sober reminder of just how remote emancipation for women remained. This fact did not stop Izquierdo: she published art criticism, she taught in art schools, she publicly contested the monopoly of male artists in the area of mural painting. This latter position by Izquierdo caused her to end up in a polemic with the ever patriarchal figure of David Alfaro Siqueiros. After bristling at her remarks in print, Siqueiros made his notoriously Stalinist, and hardly

28 María Izquierdo, *Altar de Dolores* (Our Lady of Sorrows), 1943, oil on board, Private Collection.

"revolutionary," claim that *"No hay más ruta que la nuestra"* (there is no other route than ours).[49]

The political spilts created by Rivera's revolutionary program of instruction at the National School of Plastic Arts were deep on the Left and within government circles, as well as between the Left and the Right. Similarly, Siqueiros's contention about muralism in the 1940s was so defensive that we need to ask ourselves a series of questions about the Mexican Mural Revolution, even as we seek to analyze how it developed.

The Ministry of Education Murals (1923–1928) and the New Mass Politics

The outstanding feature of the Mexican Revolution that first garnered international fame and still enjoys the most commanding stature was, of course, the Mexican Mural Movement. Begun under the auspices of the Ministry of Education, this movement in the visual arts far outstripped the accomplishments in this area by all other artists in virtually any other country. While there were indeed notable advances in printmaking, literature, and literacy, as well as in theater and music (though fewer in architecture and sculpture), it was in mural-

ism alone that Mexico attained something approaching pre-eminence worldwide. As scholars have come to appreciate even more of late, the leading public artists of Mexico redefined "modernism" for artworld specialists. In doing so, they also captured the imagination of lay audiences around the world as did few other developments of the day.

No less an authority than Columbia University Professor Meyer Schapiro conceded the international pre-eminence of the major Mexican artists in the 1920s and 1930s—especially that of Diego Rivera, who was a friend of Schapiro during the Rockefeller Center controversy. About Rivera's murals in the Secretaría de Educación and those in the Palacio Nacional (figs. 17, 31, 32, and 36), Schapiro wrote in the *Marxist Quarterly* (1937):

> The murals produce a powerful impression of the density of historical life. . . . No other painter of our time has been so prolific and inexhaustibly curious about life and history. With all its limitations, Rivera's art is the nearest to a modern epic painting . . . yet it was never asked how such an art was possible in a semi-colonial country dominated by foreign imperialism.[50]

Schapiro then concluded that the Mexican mural paintings in general were simply "the most vital and imposing art produced on this continent in the twentieth century."[51]

Recent scholars have noted of the Mexican muralists that they did not repudiate modernism, but rather expropriated or bent the European variant of it to their own ends. These Latin American artists did so in order to create a type of "alternative modernism" more responsive to the radically uneven progression of modern history. As the authors of a noteworthy recent study have pointed out: "In the 1930s, for many radical artists and intellectuals throughout the world, it was Mexico and not Paris that stood for innovation in the arts."[52] The testimony of the leading art critics and historians of the time from within Mexico is quite instructive in this regard. During the 1930s, no commentators in Mexico were more astute or broadranging than Justino Fernández and Luis Cardoza y Aragón (a transplant from Guatemala). Fernández—the Mexican counterpart to Wölfflin, Panofsky, and Hauser all rolled into one—wrote the following in the late 1940s of the Mexican Mural Movement. (Needless to say this account would have featured Siqueiros much more had it been written in the 1960s or 1970s):

> Mexican art in our time, especially mural painting, is intimately connected spiritually and ideologically with the social and political movement that brought about the rejuvenation of life during the second decade of the century: the Mexican Revolution. . . . Nowhere is this conveyed better than in contemporary mural painting. . . . A desire to revive monumental painting had existed since the eigtheenth century. . . . Although under Neoclassicism there was a bright but ephemeral burst of activity [by Juan Cordero and Pelegrín Clavé], it can be said that when Mexican muralism reappeared in 1922, this genre had been dead for a very long

time. . . . The first mural of the century was painted by Rivera in 1922 in the Anfiteatro Bolívar of the National Preparatory School. . . . Yet he executed his first fully developed artworks in the courtyards of the Ministry of Education. . . . José Clemente Orozco [also] bequeathed an inheritance of a high order not only to Mexico, but to the whole world. . . . Entirely different from Rivera, Orozco forms with him a pair of outstanding opposites, such as existed at other times in history. . . . David and Goya, Ingres and Delacroix.[53]

Written by Mexico's major art historian from the first half of the previous century, this account stands up remarkably well. Indeed, Justino Fernández gives us a fine point of departure for analyzing the world historical import of Mexican muralism, as well as its enduring national significance. Immediately following the completion of *Creación* in 1922 for the Escuela Nacional Preparatoria, Rivera was given the most important commission of the period, to paint frescoes on the walls of the newly constructed neocolonial style building designed by architect Frederico Méndez Rivas to house the Secretaría de Educación Pública in downtown Mexico City.[54] This building would be the key national center for spearheading the massive educational program begun by the Obregón Administration and—despite José Vasconcelos's centrist political views—it would be one of the two main government centers for sponsoring leftist social programs over the next two decades.[55]

It was especially appropriate and perhaps predictable that Rivera would go on to produce a staggeringly original series of 117 frescos covering over 1,585 square meters. (This would be a sizeable part of the vast expanse of 6,000 square meters of wall space that he would ultimately paint before his career concluded.) As Stanton Catlin convincingly noted, these awe-inspiring murals by Rivera in the Secretaría de Educación have "come to occupy the same position with relation to the Mexican Mural Renaissance as Masaccio's Brancacci Chapel frescoes to the Florentine quattrocentro."[56] More than any other cycle of frescoes, this particular one was responsible for first capturing the international fame enjoyed by the Mexican muralists after the mid-1920s.

An anodyne iconographic program featuring Mexican women wearing picturesque costumes from the various regions was suggested by Vasconcelos to Rivera and his assistants (who included Xavier Guerrero, Pablo O'Higgins, Alva Guadarrama, and Máximo Pacheco, among others). Nonetheless, the mass politics of the period plus Rivera's active left-wing involvements with such groups as the PCM, the Sindicato de Obreros Técnicos, Pintores y Escultores (SOTEP or, the Artists' Union), the Liga de Comunidades Agrarias y Sindicatos Campesinos del Estado de Tamau Lipas, and the Liga Contra Imperialismo, all conspired to overthrow Vasconcelos's apolitical populism in the Secretaría de Educación. Indeed, as the counter-revolution of 1924 heated up and there was a decided leftward shift in government policies with the election of Plutarco Elías Calles, Vasconcelos himself resigned his post as Secretary of Education.

By 1926 and up to 1928 with the conclusion of the Ministry fresco cycle, Vasconcelos came to dislike the "Bolshevism" that stood out in the later wall paintings by Rivera. Moreover, it was also in this period that Rivera even painted a parody of Vasconcelos's quaint and reactionary "exoticism" in one of the panels of the Court of Fiestas of the Secretaría.[57]

Rivera was hardly engaging in hubristic claims when he wrote of the beginning chapter in epic modernism both at the Secretaría de Educación Pública and elsewhere:

> For the first time in the history of monumental painting, Mexican muralism ended the focus on gods, kings, and heads of state. . . . [F]or the first time in the history of art, I repeat, Mexican mural painting made the masses the hero of monumental art. . . . [O]ur mural painting attempted to represent in a unified and dialectical composition, the historical trajectory of an entire people.[58]

The first set of murals that Rivera executed in 1923 were the eighteen main panels on the ground floor in the Court of Labor (the first of the two courtyards in the Secretaría de Educación), which together were entitled the *Labors of the Mexican People.* Uneven economic development is evident in the coupling of artisanal, industrial, and agricultural labor, along with the broad ethnographic attention given to diverse popular cultural practices that are always inflected by Rivera with class-based values. As Alberto Híjar has incisively shown, the frescoes by Rivera articulate a new form of dissident, alternative *indigenismo*—one rather at odds with the "official" concept of *mestizaje* promoted by José Vasconcelos (as well as Manuel Gamio) and incorporated into their formulation of teachers as *misioneros.* Conversely, through his compelling public murals, Rivera connected his concept of alternative *mestizaje* to the unfinished class-based project of social transformation involving both Native Americans and Euro-americans, as well as mestizos, yet along class lines. In this way Rivera's murals in the Secretaría would often stand as a stark rebuke to the assimilationist and so-called "classless" ideals of national unity championed in the writings of Vasconcelos and Gamio, among others. (Nonetheless, it is important to note that the reception of Rivera's murals encouraged by Vasconcelos and subsequent political conservatives in the Mexican government could sometimes make Rivera's artwork signify ideological values much more in keeping with the "official" government line on such issues as mestizaje and nationalistic unity, with their "Rousseauian paternalism.")[59]

Despite the frequent controversies engulfing these frescoes in 1923–24, which saw loud calls from rightwingers for the destruction of these "slanderous" images and even led to the actual defacing of those in the Ministry stairway, Rivera soon produced a series of markedly innovative panels that have been renowned ever since. Foremost among them are the four panels focused upon here: *El abrazo* (The embrace) (fig. 29) and *La maestra rural* (The rural woman schoolteacher) (fig. 31), which date from 1923, *El día de los muertos* (The day of the dead) (fig. 36),

29　Diego Rivera, *El abrazo* (The embrace) and *Campesinos*, 1923, fresco, Secretariá de Educación Pública, Mexico City.

which was painted in late 1923 or early 1924, and *Distribución de armas* (Distribution of arms) (fig. 32), which was done in 1928. The earliest and one of the most often reproduced images from the Secretaría is of the two panels *El abrazo* and *Campesinos* (fig. 29). Here, Rivera arrived at a new stage of alternative modernism through the deft convergence of several different visual languages, at once Western and non-Western, while being both precolonial and colonial, as well as anticolonial. What emerged was nothing less than a type of "postcolonial" alternative modernism of epic scope. It was created by synthesizing the diffused lighting for crisp figurative elements found in proto-Renaissance muralism (by Giotto and Ambrogio Lorenzetti) with the distinctive two-dimensional texture of fiber arts from the pre-Columbian and postencounter popular cultures of Mexico. Binding these two foreign traditions together almost seamlessly in Rivera's panel were an edgy line taken from Neoclassicism and a faceting of parts derived from Cubist collage. The trans-

cultural result goes beyond mere eclecticism to comprise a synthesis of striking originality.

A painting of warmth and solidarity, *El abrazo* abjures sentimentality through the quiet dignity of restrained emotional resonance. It features a slate-gray sky that is a telling foil for the yellow ground of the image. (The sky is evidently indebted to Ambrogio Lorenzetti's magisterial mural in the City of Siena, which Rivera admired.) In the center of the background is a semi-Cubist cityscape with an unexpected affinity to the elementary geometry of proto-Renaissance space on the one hand, and a link to Cézanne's post-Renaissance space leading to early modernism on the other. An invocation of both precolonial European art and postcolonial modern art are in turn connected simultaneously to Rivera's antipositivist move beyond both one-point perspective and a linear conception of historical development. In all of these senses, this fresco recalls the "Anáhuac Cubism" of Rivera's earlier oil painting, *Zapatista Landscape*.

This calm image was nevertheless engulfed by a firestorm of controversy because of the incorporation in it of some incendiary verse by poet Carlos Gutiérrez Cruz (on a rock depicted in the foreground). These lines urged the popular classes, specifically rural and urban labor, to join in a fraternal embrace against the exploitative logic of industrial capitalism. Such a union, the verse implied, would finally allow the working classes from various regions to control the fruits of their own labor and thus inaugurate a fundamentally new society. Unlike earlier lines from a poem by the socialist author Gutiérrez Cruz in Rivera's panel *Leaving the Mine*, which encouraged violent insurrection against capitalists, these were not chiseled out of the Secretaría fresco. (They survived even though the controversy triggered by the inscription in *El abrazo* featured emphatic calls for the murals suppression by conservative figures both in and out of the government.)[60]

In walking from *El abrazo* to neighboring paintings—such as, *El capataz* (The foreman) and *La maestra rural*—one moves from appeals for working class unity to a focus on the very real impediments to popular mobilization. *La maestra rural* (fig. 31) is among the most stirring and beautiful of all the Secretaría panels. It has a limited, but deeply resonant, color range that includes an expansive flat caramel ground, which casts all the figures into striking relief. An understated color interaction accentuates the design and manifests pictorial values in concert with the visionary ideological concerns of the painting. The ovoid-shaped *campesinos* around the teacher are densely over-determined motifs for all their visual simplicity. They are derived from at least three disparate sources: Giotto's volumetric figures, the nuanced but monolithic formations of Olmec art, and the glyph-like figures found in Aztec manuscripts, such as, the *Codex Mendoza* (fig. 30).[61]

The exquisitely silhoutted bust of the teacher is coupled with an alert mounted union cadre, who is armed with a rifle. The vertically projecting weapon and head of the man are likewise thrown into a splendid figure–ground relief. Spatial cues and the promise of plentitude emerge from the lean background into which are angled several other motifs. Quietly dynamic, calmly militant, and austerely sensuous, all at once, *La maestra rural* is a superb embodiment of the distinctive radicalism of the educational progam in Mexico during the 1920s and 1930s. Diego Rivera's mural about the role of the rural teacher is not only a monument to popular mobilization, but also a masterpiece of multicultural epic modernism.

Thematically, a revolutionary note was sounded at the precise historical moment that the painting was made. The embattled location of these rural teachers in Mexico occured in relation to the intense class struggle that marked the contest over land reform in a period when the haciendas were slowly being broken up and stripped of their vast control over the land. As James Cockcroft has observed:

> In the countryside, the peasants organized themselves into unions and leagues, constantly pressuring the state for agrarian reform and for the arms to defend themsleves against the hacendados' hired gunman. . . . Often the peasants' only allies

30 *Codex Mendoza*, early sixteenth century, facisimile, University of New Mexico Art Museum.

> in demanding implementation of agrarian reform were . . . the schoolteachers, more than two hundred of whom were shot by the large landholders' hired pistoleros.[62]

The gender of the schoolteacher and the defiance of the figures in Rivera's murals led art critic Raquel Tibol (who knew the painter personally) to discuss *La maestra rural* as a signal image for programmatic reconstruction during this crucial phase of the revolutionary process.[63] This painting was one of the first, perhaps the first, in Mexican art history to represent women in a progressive manner on the front lines of conflict. (In fact, we know the model for this image, Luz Jiménez, who was a young indigenous woman aspiring to be a literacy brigadista.)[64] As Tibol observed, Rivera was no doubt influenced in this artwork by a couple of things. First, there was the visit to Mexico in 1921 by Chilean author Gabriela Mistral (who would later become the first Latin American author, male or female, to win the Nobel Prize for Literature). She was impressed with the educational programs underway in Mexico—especially with the active role of women in the process of social transformation. She wrote, for example, that "The Mexican school program corresponds almost entirely to my ideal of education for women *de nuestra raza* [of our ethnicity]."[65] In fact, Rivera actually provided marginal

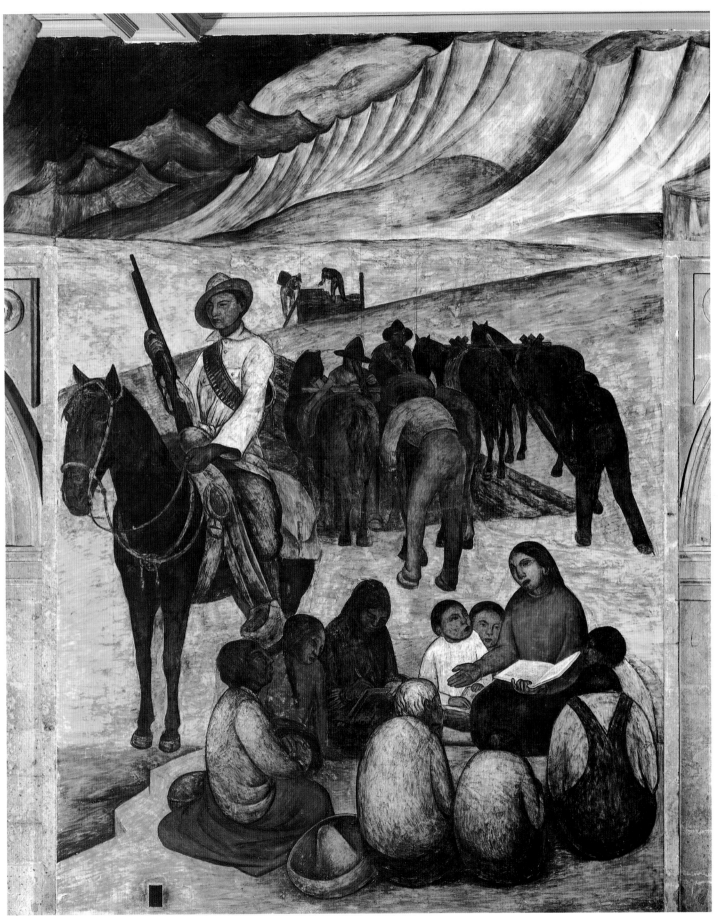

31 Diego Rivera, *La maestra rural*, 1924, fresco, Secretaría de Educación Pública, Mexico City.

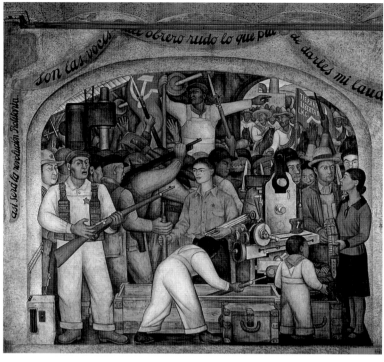

32 Diego Rivera, *Distribución de armas*, 1928, fresco, Secretaría de Educación Pública.

33 *(right)* Anonymous, *Sacred Heart*, ex-voto painting, early twentieth century, oil on metal, University of New Mexico Art Museum.

35 *(facing page)* Frida Kahlo, *Las dos Fridas* (The two Fridas), 1939, oil on canvas, Museo de Arte Moderno, Mexico City.

34 Tina Modotti, *Bandolier, Maize, Guitar*, 1927, gelatin-silver print photograph.

illustrations to accompany the publication in 1921 of Mistral's "El poema de la madre" in the October 1921 issue of *Maestro: Revista de Cultura Nacional*, a publication of the Secretaría de Educación in these years.[66] (The rather conservative theme of female teachers as "mothers" of the national "family"—which was somewhat at odds with the more militant view of Rivera—was a favorite theme of Vasconcelos in the early 1920s, before the depth of right-wing opposition and the danger of counter-revolutionaries to the literacy workers became clear.)[67]

The second reason that Rivera would have used this theme of women revolutionaries in *La maestra rural* was based soundly in insurrectionary events of the period—events that, after all, contradicted both the gender roles and the ideological values of traditional society in Mexico. As early as 1907, for example, there were a number of bold and resourceful women activists who helped to challenge the prerevolutionary order in a commanding way: poet Dolores Jiménez and editor Muro Sara Estela Ramírez, along with Juana Baptista Gutiérrez Mendoza and Elisa Acuña y Rosete, who spearheaded the Grupo de Socialistas Mexicanas. Moreover, by the mid-1920s, there were other emerging female militants of the Partido Comunista Mexicano whom Rivera knew well, namely, Tina Modotti and Frida Kahlo. (Kahlo, ten years younger than Modotti, was only 22 years old at the time of her marriage to Rivera in 1929.) Significantly, when, in 1928, Rivera produced a culminating fresco at the Secretaría de Educación, *Distribución de armas* (The distribution of arms), the mural included portraits of both Modotti and Kahlo (as well as David Alfaro Siqueiros and exiled Cuban leader Julio Antonio Mella) among the revolutionary activists mobilizing for armed struggle against international capitalism (fig. 32). This latter artwork should be seen as a pendant to *La maestra rural*—and even as a heightened recapitulation of it.

Along these lines, Rivera would write an essay in 1926 for *Mexican Folkways* magazine about Italian artist Tina Modotti and her mentor, Edward Weston from the U.S.A. In it Rivera credited them both with being on the cutting edge of artistic practice in the Americas. While noting that they articulated a sensibility that embodied an "extreme modernity [*modernidad*]," he commended their combination of "the plasticity of the north and the living tradition of the land of the south."[68] In concluding his essay Rivera even went so far as to claim that "Tina Modotti . . . has done marvelous things in a sensibility,

which is on a plane that is perhaps even more aerial and intellectual," than that of the better-known Weston.[69]

Modotti's most well-known photographs from the mid-1920s (when almost all of her work was produced) ranged from the ultra-*engagé Workers Reading "El machete"* and the Rivera-influenced *Bandolier, Maize, Guitar* (fig. 34) (which has formal connections with *Zapatista Landscape*) to such remarkable images as *Powerlines*, linked to the avant-garde group called *Estridentismo*, that existed from 1921 to 1928. The way in which she used the clipped, fragmentary compositional "montage" of

competing components reminds us of the Cubo-Futurist lineage out of which she and others worked in this period. At the same time she also shot "documentary" photographs for Anita Brenner, José Clemente Orozco, and Rivera, which appeared in various publications of this decade.

Evidently, Modotti (who was expelled from Mexico in 1930 after the abortive putsch by the Communist Party) was the one who introduced Frida Kahlo to Diego Rivera. The two women had earlier met through their involvement with the Partido Comunista Mexicano. It was only by the early 1930s that Kahlo began to forge in a compelling way the *contracorriente* visual idiom—at once testimonial and extrapersonal in thrust—that would later come to rival the artistic productions of both Rivera and Modotti. In her innovative variant of "postcolonial" modernism, Kahlo used the self-portrait (around fifty-five of her approximately 200 paintings are "self-portraits") to situate herself at the overdetermined crossroads of the politically engaged, the personally probing, and the socially radicalizing.[70]

Kahlo's own body would become a pictorial conceit throughout the 1930s and 1940s for orchestrating a convergence of many of the most distinctive attributes that define Mexican popular culture (the ex-voto, for example) in relation to the fine arts practice of professional artists. One of the most exemplary paintings along these lines was *Las dos Fridas* (1939) (fig. 35), in which Kahlo fuses, through her own hybrid body, the competing cultural traditions, including those of the popular classes, that marked Mexico off so forcefully then and now (fig. 33). This heterogeneous image, like many of her other works, also relies intensely on two key formal devices of Surrealism—condensation and displacement—that in turn were associated by Sigmund Freud with dreamwork. Thus, she was recruited for the Surrealist movement in 1938 by André Breton (whether rightly or wrongly) during his political summit with Trotsky and Rivera.[71] Moreover, the sheer potency of these self-portraits even stopped Picasso in his tracks when he saw a show of her paintings in Paris in the late 1930s that Breton had organized. As Picasso evidently declared, "Neither Derain, nor I, is capable of painting a head like Kahlo."[72]

Revealingly, Kahlo lied about her own birth year (it was 1907, not 1910) less out of vanity, than out of a wish to be born in the same year that the Mexican Revolution began. There can be little doubt that this *soldadera* of the artworld created a corpus of paintings that were intricately linked to the most audacious aims and programmatic promises of the Great Revolution. Psychologically wedded to the social transformation of the 1920s, her work and life always remained a sort of radiant yet troubling afterglow of the highest ideals of the Mexican Revolution. Nor is it by chance that one of her last paintings was an ideologically charged, ex-voto-like image entitled *Marxism Will Heal the Sick*. Similarly, it is not surprising that her last public appearance in Mexico City was at a huge 1954 demonstration against U.S. sponsorship of the overthrow in Guatemala of the democratically elected Arbenz Government, with its radical program for land redistribution that was opposed by the United Fruit Corporation based in the U.S.A.[73]

One of the most noteworthy murals in the entire *Secretaría de Educación* cycle is to be found in the second of the two open courtyards, the Court of Fiestas, which contains over half of the 117 murals that Rivera executed. *El día de los muertos: La oferta* (The day of the dead: The offering) (fig. 36), which was executed in 1923–24, is one of the panels in which the multicultural and transnational "lesson of Cubism" has been most self-consciously demonstrated, as Justino Fernández has pointed out.[74] The scene represents a popular celebration that originated prior to the conquest and yet the panel does so by means of a visual language smoothly situated at the crossroads of several different cultural traditions that extend from pre-Columbian and colonial components through modernist and postcolonial elements. The all-over character of the pictorial space, in tandem with the rhythmical usage of orange ribbons or arcs, endows the whole composition with a formal repetitiveness that connotes ritualistic acts. The result is a brightly enigmatic scene featuring half-illuminated figures and a somber palette, all of which necessitate protracted inspection in order to be culturally unraveled. Popular, yet not populist, this artwork draws on the conventional in order to transform it historically.

The upper register of this fresco contains an unusual, Indo-Christian cross that is similar to the early-sixteenth-century *Cruz atrial* (Atrial cross) at Acolmán (fig. 37). Among the first extant religious symbols in Mexico after Spanish dominion was established, this colonial period cross is as hybrid in formal values, as it is syncretic in theological terms. At one and the same time, this image attests to the persistence of Native American traditions and the imposition of Hispanic institutions. Precisely because this "dialogical" configuration remains a repository of repressed cultural forms, it has become a stimulus for contemporary Latin American artists seeking to reconstruct their regional identities, thus synthesizing new visual forms with fragments from a splintered past. An example of the latter would be a painting by the Chilean-exile artist Mauricio Lara (fig. 38). The artwork telescopes several different historical moments in a manner that is consistent with the type of Liberation Theology that emerged in Latin America during the 1960s. Not surprisingly, the paintings of Diego Rivera have served as key antecedents for this development.[75]

On the second and third floors of the Secretaría de Educación in the Court of the Fiestas, the panels go from being depictions of rituals that communally bind to struggles that collectively unite. These murals comprise two large cycles entitled, respectively, the *Corrido de la revolución proletariado* (The ballad of the proletarian revolution) and the *Corrido de la revolución agraria* (The ballad of the agrarian revolution). One of the best known of these militant panels is the aforementioned *Distribución de armas*, which contains the portraits of Kahlo and Modotti, as well as those of Siqueiros, Antonio Mella, and Vittorio Vidali. The painting was executed after Rivera's return from the Soviet Union in 1928, where he had been the leader of a Mexican labor delegation for several months to mark the tenth anniversary of the Russian Revolution.

36 Diego Rivera, *El día de los muertos: La oferta* (The day of the dead: the offering), 1923–24, fresco, Secretaría de Educación Pública, Mexico City.

37 *Cruz atrial*, Convent of Acolmán, early sixteenth century, sculpture, Spanish colonial period.

38 Mauricio Lara, *Guatemalan Cross*, 1994, acrylic on canvas, Private Collection.

Internationalist in the broadest sense, this panel is as close as Rivera ever comes to so-called "socialist realism" in the USSR. (In fact, Rivera dismissed this form of "revolutionary" art as bad nineteenth-century academicism.) The representation by Rivera of popular mobilization in defense of working-class interests is so densely packed with bodies that it literally becomes a human barricade. His utopian intention here was to harmonize the urban-driven Russian Revolution with the agrarian-based Mexican Revolution. However quixotic it might have been, this depiction of a type of international revolution that had yet to occur was even encouraged by some of the Bolshevik leaders. When, for example, Alexandra Kollantai arrived in Mexico in 1924 as the Soviet Ambassador, she declared that "There are no two countries in today's world as similar to each other as Mexico and the USSR."[76]

Giving visual weight to this rather tenuous claim was a major concern in 1928 of Rivera's culminating part to the entire mural cycle in the Secretaría. (This was the case despite his alarm at the rise of Stalin to leadership during the time of his trip, along with his fundamental opposition to Comintern policy on founding "red" unions to contest other left-wing organizations in Mexico and elsewhere.) When he concluded the ten paintings on the south wall of the "Corrido de la Revolución Proletariado," he introduced as a visual coda the figure of Zapata, a *campesino* leader, and not the portrait of a proletarian leader, such as Lenin. Moreover, several of these panels, with their references to land redistribution based on the premodern model of the *ejido* implicitly manifested a conception of socialism that

was often incompatible with the direction in which Soviet-style socialism (with its collective state farms) was moving so rapidly.[77]

Yet, notwithstanding the political paradoxes pervading his paintings and the intermittent public outcries against them, Rivera's murals survived in several senses. For range, audacity, and innovativeness, they had no parallel in the Western world at this moment. As such, these frescoes became the model for a way of orchestrating "ultraleft" political engagements in art that were matched so closely by notable aesthetic advances as to be indistingishable from them. Similarly, these works embodied an unparalleled effort to fuse intellectual work and manual labor (this in fact was one of the themes of the Court of Labor). All of this sped in the opposite direction from the division of labor within the USSR that was a key motor of Stalinism—and also of Taylorism, the corporate capitalist model for "collective" labor that strongly influenced "socialist" economic development in the Soviet Union from the mid-1920s onward. As Rivera argued in an article from 1925, the painting of frescoes was first and foremost a form of labor, which in turn was uniquely placed to represent all other forms of manual labor, as Rivera would attempt to do thematically in the Secretaría de Educación. Understandably, then, he insisted on equating artistic practice with artisanal labor and referred to his prodigious physical and intellectual efforts as "trabajo como un revolucionario."[78]

• • •

Orozco's Murals in the Escuela Nacional Preparatoria (1926–1927)

Far and away the most impressive murals done in the Escuela Nacional Preparatoria (National Preparatory School) were painted in 1926 by José Clemente Orozco (figs. 39 and 40). This observation obtains, despite fact that the "inaugural" mural of the Mexican Mural Revolution was done there in 1922 by Diego Rivera (as noted above) and also despite the fact that both Orozco and David Alfaro Siqueiros painted murals there from 1922 to 1924—as did several other muralists, including, Ramón Alva de la Canal, Jean Charlot, Ernesto García Cabral, Emilio García Cahero, Fernando Leal, and Fermín Revueltas. Yet all of these murals done before 1926—from Orozco's allegorical *Maternity* and his caricatural *The Rich Banquet While the Workers Quarrel* through Siqueiros's anodyne *Elements* and his unfinished *Burial of a Worker*—were deeply flawed first steps that led more to topical public polemics, than to enduring artistic accomplishments.

The justifiably hardline political stance that accompanied these shrill and "preachy" paintings was done a disservice by these one-dimensional slogans and rarefied personifications. Moreover, the political conflict that exploded around these murals in 1924 was as much a consequence of their naive relation to the national union of students in secondary school, as it was the result of any coherent strategy. After all, at a time when only the most conservative sectors in Mexico had the means to send their children to an elite urban institution such as this, why were the artists surprised at the negative "popular" response they received for doing caricatures of the affluent? Moreover, why did they think that simple denunciations in paint could take the place of grass-roots political organizing that would necessarily have entailed open political dialogue instead of mere public harangues? In fact, Orozco himself destroyed some of his earlier murals when he returned in 1926 to paint in the National Escuela Preparatoria. Nor was the subsequent and quite sober assessment by Siqueiros of these first murals from 1922 to 1924 unfair: "For my part, I painted the elements: fire, earth, water, etc . . . more or less in a colonial style. You can imagine the chaos. . . . We wanted to help the Mexican Revolution, but we were doing a very bad job of it."[79] (In fact, Siqueiros virtually gave up painting to devote himself almost full-time to union organizing from 1924 to 1930, so there is little artwork of note by him throughout this period.)

The older José Clemente Orozco did not place his own career in a state of abeyance as a result of tumultous events in the mid-1920s, when counter-revolutionary forces launched a very serious challenge to the left-wing process of social transformation then occurring under Obregón. (Indeed, it would be interesting to know how many of the students at the Escuela Nacional in 1924 sided with the counter-revolutionary forces of Adolfo de la Huerta.) One thing is certain. When, in 1926, Orozco returned to paint a magisterial series of eighteen large frescoes in the Preparatoria, the right-wing insurgency had been defeated and the new Presidency of Calles had initiated an even more radical period of social change than had happened from 1920 to 1924. The "popular audience" for Orozco's murals in the Escuela Nacional was quite different and the student-based opposition to his 1926 murals was far more muted than before. At least three things can explain this difference in the public reception: the military defeat of the counter-revolution, with more than seven thousand people being killed in the fighting; the ideological successes of the Obregón administration's educational program, which are often underrated; and the utter brilliance of Orozco's second series of paintings in the Escuela Nacional. The latter fact meant that these far more aesthetically complex murals demanded a level of critical thinking unknown to the more agit-prop images of the early 1920s. In sum, it was far more difficult to have an instant response to these densely overdetermined new murals.

Perhaps two paintings in particular stand out from all the outstanding murals Orozco produced when given a second chance in the Escuela Nacional: *La trinchera* (The trench) (fig. 39) and *Cortés y Malinche* (fig. 40). The emotional register of the first work reaches a remarkable pitch almost unattained by any other artist of the twentieth century (excepting, perhaps, for Picasso's *Guernica* and some of John Hearfield's photomontages). Almost all of Orozco's works feature a bold use of illumination, sweeping diagonals, jutting angles, errily blanched highlighting, and a chiliastic mood. These traits are immediately recognizable as Orozco's distinctive contributions to modern art, whatever the accumulated debts to El Greco, Goya, and Austro-German Expressionism along the way. Accordingly, these fresco paintings are the perfect counterweight to Rivera's more visionary, upbeat, and apollonian artworks. In the end, it is precisely the world-historical pessimism and apocalyptic impetus of Orozco's murals that makes them so visually striking, so mentally indelible.

About *La trinchera* and the other seventeen murals in this series, the art critic Justino Fernández wrote a moving tribute to the painter as an existential "hero":

> he [Orozco] is for me the master of greatest stature in the twentieth century. . . . Entirely different from Rivera, Orozco forms with him a pair of outstanding opposites. . . . his historical criticism had as its sole purpose . . . truth without partisanship. He castigated falsehood and human baseness whereever he discovered it with his penetrating gaze. . . . Orozco's work attracts through its exciting forms, and yet invites meditation. He is a painter with a baroque ancestry. . . . He is a master draftsman, and his drawings suggest color in every stroke. No one has carried tragedy beyond the level of Orozco and the variety of expression in his work is unparalled. . . . But it is probably in *El trinchera* that he achieved the most profound emotional impact.[80]

Similarly, Antonio Rodríguez rightly concluded that the potency of Orozco's murals was inextricably linked to the urgency of the Mexican Revolution. He noted as follows:

39　José Clemente Orozco, *La trinchera*, 1926, fresco, Escuela Nacional Preparataria, Mexico City.

He did not glorify revolution. He was sincere in saying that great social phenomena need no glorification. . . . If Orozco did not extol the Revolution, he nevertheless fulfilled himself through it. How could we understand the Orozco of *El trinchera*, *Los soldatos*, and *Adiós* without the Revolution? Diego Rivera idealized it; Orozco showed its . . . tragedy.[81]

In a comparable way, Orozco's dismissive attitude towards almost all forms of *indigenismo* and *mestizaje* was accompanied by a very sober verdict on pre-Columbian history. This attitude distinguished his murals from those of Rivera and accounted for Orozco's more Euro-American, or perhaps *criollo*, visual language. (And yet Orozco's sympathy for the Native American victims of colonialism cannot be questioned.) The way in which he sometimes seems to universalize "history" and essentialize "human nature" means that the supposedly inherent flaws of the one apparently lead to the inevitable failings of the other. The dystopian result can easily be seen as an unbroken—and unbreakable—cycle. Hence, Teresa del Conde's naming of Orozco as the first of the major

catastrofistas (depicters of castrophes). Such was the starting point for Dawn Ades's contention that the evident basis of Orozco's works in "original sin" frequently caused his paintings of the present to be a "grotesque image of the past."[82] If Orozco's bleak view of the prospects for genuine social transformation has a possible counterpart, it would be in the masterful, but also "hopeless" novel by Mariano Azuela from 1915, *Los de abajo* (The underdogs). This text has often been seen as the key work of fiction from the military phase of the Revolution, before 1920. Conversely, if Rivera's more sensual images had a literary complement, it would perhaps be found later in a luminous tour de force by Carlos Fuentes from the 1960s. This book is of course *La muerte de Artemio Cruz*. For all the disillusionment that surfaces in this glittering magical realist novel—and a recent sequel by Fuentes from the vantage point of a soldadera—it is still critically affirmative of the revolutionary process, in a manner that gainsays any final verdict of negativity. Indeed the critical representations of the Mexican Revolution in both of these masterful texts tells us a great deal about the ultimate necessity of it.[83]

40 José Clemente Orozco, *Cortés y Malinche*, 1926, fresco, Escuela Nacional Preparatoria, Mexico City.

Given his skepticism about the concept of *mestizaje* advanced by Vasconcelos in his Hispanophile theory of "raza cósmica" and the alternative Indo-American-accented view of this phenomenon that emerges in the murals of Rivera, Orozco produced a brilliant new treatment of this theme that appears to sit somewhere in between the positions of Vasconcelos and Rivera. This painting is the magisterial *Cortés y Malinche*, which is at once touching, sobering, and open-ended in character (fig. 40). The powerful simplicity of these two equally disrobed figures evinces a tendency neither to lament nor to celebrate their unequal union without qualification. Rather, the coupling of these two physically attractive figures is presented as a generative fact of Mexico emanating from the "encounter" and the Spanish conquest. By now it has acquired all the tender forcefulness of something inevitable and even necessary. Miscegenation was, after all, an embarrassing topic to ruling class Westerners in the age of colonialism. It was treated in the *castas* paintings of the colonial period as a way of assigning hierarchical "ethnic rank," as well as "merit," and was then passed over in silence by "decent" people in segregated societies of the West during much of the twentieth century. Here, though, it is shown in a much more complex and humanist light by Orozco, who was appalled by the racism he had already experienced in the United States. (One of his unflinching images of the 1930s, when he lived for a time in Manhattan, was a lithograph of black men who had been lynched in the South.)[84]

In *Cortés y Malinche* the humanity of each person is not denied and they are both shown in almost heroic scale with Michelangelo-like bodies. The icy blue eyes of the "rubio" Cortés and his more forceful gestures look domineering, but not harsh. Conversely, the downward looking gaze of Malinche ever so sensitively intimates her subordinate position without showing her either as inferior or as unduly compliant. Somehow, Orozco manages to convey the signal inequities of this male/female and European/Indo-American relationship without denying the dignity of the victim. Deftly reinforcing the pensive tone of the work is the monochromatic color scheme of the mural. Thus, every formal component of the work reinforces each of the thematic elements of the painting, so as to unify brilliantly this divided—but not divisive—portrait of an Old World man and a New World woman.

In many senses, though, Orozco's pictorial affirmations of the Great Revolution concluded in Mexico with the murals in the Escuela Nacional Preparatoria in 1927. (Culminating in the U.S.A. between 1927 and 1934 with his remarkable cycles of 1931 to 1934 in the New School for Social Research and at Dartmouth College.) As was true of his prodigious frescoes in Mexico, his murals in "Gringoland" occasioned acclamation and provoked censure. Yet, even today, few artworks have ever provided such a pointed critique of Anglo-American positivism as did his latter series. In fact, Orozco's political career took a fairly predictable route from an anarchism allied with the *Casa del Obrero Mundial* in the teens and early 1920s to fellow traveler status with the *Partido Comunista Mexicano* from 1923 to 1927 (according to FBI files on him) and again in the mid-1930s. His political affiliations then concluded in the late 1930s and 1940s with a fierce form of antifascism that was at times intensely anti-populist as well, even during the progressive period under Cárdenas. This last position is what made Orozco a great humanist with a small "h," while also causing him to be largely humorless and relentlessly skeptical of all other fixed points on the political compass, whether of the right or the left.[85]

The recurrent theme in most of Orozco's works concerning how destructive Western modernization had always been led to four sets of utterly unforgettable images, one in Mexico City in 1934 and three in Guadalajara from 1934 to 1939. These public murals are among the most impressive ever painted any place, but they revolve around a paradox that can hardly be ignored. Impossible without the Mexican Revolution, these irrepressible paintings are also about its demise (figs. 42 and 43). Together these three mural cycles approximated the scale upon which Rivera alone had labored up until then: 430 square meters in the Universidad de Guadalajara, 400 square meters in the Palacio de Gobierno de Guadalajara, and 1,200 square meters in his magnum opus, the Hospicio Cabañas. Closer in spirit to Erasmus's tortured resignation, than to the mission-like resolve of Zapata or Marx (about both of whom he had often been ambivalent), these towering artworks manifested at once a cry against inhumanity and a brief against revolutionary insurgency. Unaccepting of one, they were disbelieving in the other. Yet the terrible equilibrium of a humanist without a cause is precisely what made these commanding murals among the most memorable of the whole epoch.[86]

About Orozco's public murals from 1934 through 1939, which are both a monument to the Revolution and a negative verdict against it, few have been more eloquent than Justino Fernández:

[I]n the Palace of Fine Arts in Mexico City (1934), [is] a tragic and moving work in which the artist again underscores

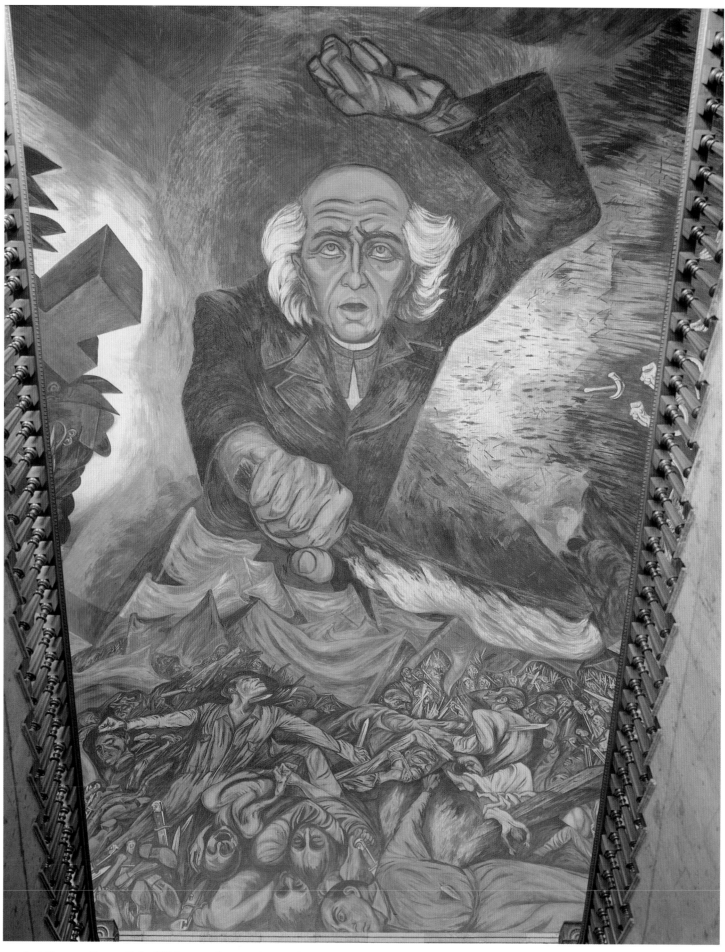

42 José Clemente Orozco, *Padre Hidalgo*, 1937, fresco, stairway, Palacio de Gobierno, Guadalajara.

43 José Clemente Orozco, *Catharsis*, 1934, fresco, Palacio de Bellas Artes, Mexico City.

his criticism of the modern world, and the terrifying fire reappears. . . . Orozco at his highest point—the universal humanist—created his greatest work in Guadalajara . . . [and] Orozco's creations in Guadalajara between 1936 and 1939 are overwhelming. In the university the wall at the end of the Salon de Actos expresses sadness: unhappy people react against their leaders while the purifying fire radiates its menancing tongues. . . . The monumental stairway of the Governor's Palace . . . [contains a] colossal image of Hidalgo in the center, his face in a strong light, [he] raises a fist and with a torch enflames the multitudes. . . . Once more the theme is a criticism of contemporary history, . . . the artist has elevated his expression to the highest aesthetic plane, depicting tragic beauty in all its splendor.[87]

If, in the end, Orozco would paint the Revolution's "Last Judgment," it was Rivera who, in the first instance, painted the Revolution's "Sistine Chapel" (to quote French art critic Louis Gillet). This common contention from the late 1920s until the present first appeared in a major study in 1929, when it was published in André Michel's monumental *Histoire de l'art* (the best selling art-historical text of the entire next decade in Europe):

[T]he Chapel of Chapingo . . . is the Sainte-Chapelle of the Revolution, the Sistine Chapel of the New Age. The artist unfolds there in fiery and riveting images both a catechism and a cosmogony, the double genesis of nature and man. . . . Finally, on the wall which faces the apse, in place of the old paradise, there is a vision of Nature in harmony with society, of an Eden cultivated by a rejuvenated humanity. One sees at first glance the importance of these paintings [fig. 44], in which Diego Rivera has created the *first* revolutionary imagery of our time, along with the *geste* of his people and a

national legend. One will only seek in vain for an equivalent elsewhere, not only in the rest of the Americas, but also in Europe and Russia. By chance Mexico has become the place where the first artworks born from socialist politics and agrarian materialism have definitively emerged.[88]

Chapingo (1926) and the Palacio Nacional (1929–1935)

The revolutionary ideal of agrarian land reform in conjunction with that of free, secular education for all citizens (Article 3 of the 1917 Constitution) did indeed find their most commanding pictorial representation within the newly established public university for agronomy and agriculture situated east of Mexico City. The latter institution of higher learning was founded in 1920 by the Obregón Government as the Universidad Nacional Autónoma de Chapingo (National Autonomous University of Chapingo). It was the direct result of revolutionary land redistribution based upon the expropriation of a huge estate: the Hacienda de San Jacinto that belonged to one Don Manuel González, who had been among the most powerful *hacendados* during the *Porfiriato*. This vast neofeudal estate of a notorious counter-revolutionary was divided up, with some of the land going to the new public university and the rest being returned to local *campesinos* in the form of *ejidos* (called for by the Zapatista platform).

This spectacular action aside, Obregón proceeded in a more measured way on land reform elsewhere (except in Morelos), since he rightly understood that, at least in the short term, the grinding conditions of generalized scarcity confronting Mexico precluded any rapid redistribution of land along mere regional

lines. As such, Obregón knew that the traditional rural population would "produce enough to feed itself but not enough to feed the nonagrarian sector" that was so fundamental to the broader industrial transformation of Mexico.[89] By the end of Obregón's administration in 1924 (when the first group of paintings were done at Chapingo by Rivera), three million acres of land had been granted to 624 villages, with the land being given to communal *eijdos* that benefited around 140,000 individuals. It was, however, only during the Calles presidency, beginning in late 1924 and going through 1928, that radical land reform as a programmatic feature of public policy really took on great momentum. Thus, when Rivera painted his famed 1926 murals inside the chapel at Chapingo, the country as a whole was undergoing a revolutionary change in popular access to arable land. The dramatic setting for Rivera's murals at the national school of agronomy was aptly summarized by Michael C. Myers and William L. Sherman as follows:

[Calles] was not only willing to ride the swelling tide of social revolution but sincerely believed, at least at the outset, that its course was inevitable. . . . Calles inherited a more prosperous Mexico than had Obregón. The postwar economic slump was over and had given way to sustained economic growth. . . . With a solid public treasury, Calles stepped up land distribution, just as the hacendados feared that he would do. Where Obregón had distributed some three million acres, Calles distributed eight million between 1924 and 1928. The vast majority of the land was granted to the communal ejidos rather than outright to individual heads of families. Because the uneducated peasant could alienate his land through cheap sale, he was not subject to the machinations of the local land spectulators. To try to stem a decline in agricultural activity, the administration initiated a series of irrigation projects, established a number of new agricultural schools, and began to extend agricultural credit to the small farmer.[90]

The core buildings comprising the Chapingo hacienda were originally constructed in the late seventeenth century as a convent. Thus, the two buildings housing Diego Rivera's mural cycle from the mid-1920s—especially the beautiful Baroque chapel that was turned into the university auditorium (now a museum)—were originally part of a colonial period *reducción*, or indigenous agricultural community under ecclesiastical direction. The fabled cycle executed in the chapel by Rivera and his assistants (Ramón Alva Guadarrama, Máximo Pacheco, and Pablo O'Higgins) was predicated upon a popular saying of Zapata that Rivera even inscribed textually as part of the fresco cycle: "Enseñar la explotación a la tierra y no la del hombre." (Here one teaches to exploit the land, not other people.) There was, then, a timely fit between the leftist iconographic program chosen by Rivera and the actual phase of militant land reform manifested by the creation of this rural educational institution.

The theme of social justice through land redistribution was in fact the subject of Rivera's four panels from 1924 in the administrative building of Chapingo. Such was the case in the panoramic landscape that framed Rivera's exemplary portrait of President Obregón and the Minister of Agriculture (fig. 23). (It is important to point out that the portrait of Obregón was done posthumously in 1940. There were never any portraits by Rivera or the other muralists that could be accused of furthering a "cult of personality" linked to contemporary political *caudillos*, even when the artists received government patronage.) As has already been noted, the set of murals in this administrative wing of the university was influenced by Ambrogio Lorenzetti's frescoes about good and bad governance, even as this series also featured a nimble recourse to many other visual languages on both sides of the Atlantic.

The most celebrated murals at Chapingo, however, are those that Rivera painted in 1926 in the former Baroque chapel. This unsurpassed series, which seamlessly covers every square inch of the building's interior, is his acknowledged *obra maestra* (masterpiece). Overall, this tight set of strikingly coordinated images balances a vibrant affirmation of sensuality with a sober sense of humanity's struggle to attain emancipation. All problems linked to technique have been surmounted through an almost effortless display of technical virtuosity. In a carefully calibrated move, evolution and revolution are shown to be mutually determining forces in the context of social transformation.

The four main Giottoesque panels on the left wall depict the structural volte-face of a society through popular mobilization. The four primary panels on the right wall represent the process of human evolution and are called "Canción a la tierra." Upon entering the narthex, the spectator is flanked by two paintings of revolutionary martyrs. Each is connected to the sophisticated simplicity of vernacular *retablos*, on the one hand, and to the elevated restraint of neoclassical canvases in the manner of Jacques Louis David, on the other.[91]

In all, Chapingo Chapel contains fourteen main panels and twenty-seven subsidiary paintings that terminate with the largest, most moving ensemble in the entire structure, the apsidal mural: *The Liberated Earth and Natural Forces Controlled by Humanity* (fig. 44). It is around 7 × 6 meters and features a distinctive type of muscular delicacy, which is at once suitably abstract for personifying (earth, fire, water, and electricity) and palpably concrete in its earthy appeal. At issue in the frescoes is the beneficial usage of natural forces for social emancipation nationwide. By means of the frescoes, Rivera showcases a supple alternation of unrestrained dynamism with classically constrained sensuality, all of which was done in relation to the revolutionary redistribution of land to the popular classes during this period.

Perhaps most remarkable of all, though, is the unexpected sophistication with which Rivera has pictorially deployed a Marxist conceptual framework for understanding uneven historical development in uniquely Third World terms. Thus, the general focus on natural forces notwithstanding, there is a counterbalancing message about the mediation of nature by society that precludes any unqualified belief in an undisturbed "natural order." As such, Rivera's iconographic program recalls

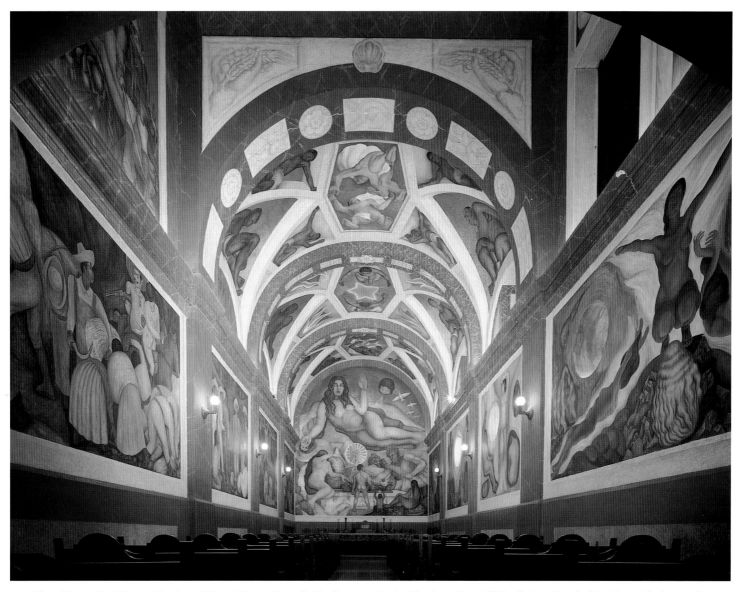

44 Diego Rivera, *The Liberated Earth and Natural Forces Controlled by Humanity* in the Chapingo Chapel ("The Sistine Chapel of the Twentieth Century"), 1926, fresco, Universidad Nacional Autónoma de Chapingo.

what was earlier noted about the radical twist that Marx applied to Vico's concept of "humanity making its own history" to mean, more expansively, humanity making and remaking itself throughout history.

An equally important and less readily recognized attribute of Rivera's Chapingo cycle is an attendant viewpoint embedded in it that represents a minority position within the Marxist tradition per se. This uncommon position was championed in the 1920s and 1930s only by unorthodox Marxists—from Karl Korsch and Rosa Luxemburg through José Carlos Mariátegui and Meyer Schapiro—and it diverged from the conception of history that generally reigned supreme both among Western positivists and Soviet Communists, as well as among Mexican nationalists like Vasconcelos or Gamio. What was unusual about this position? And, how did it allow Diego Rivera to reconcile his alternative view of *mestizaje* with a reading of Marx that

contradicted the Eurocentrism of both Stalinist thought and Anglo-American positivism, as well as the Hispanophilia of Vasconcelos's philosophy? These questions need to be answered if we are to grasp the stunning originality of Rivera's thematic program at Chapingo and its overlooked link to the innovative thought of Mariátegui, while also responding to this dazzling tour de force by a painter's painter at the height of his powers.

The terms of Rivera's earlier representation of uneven historical development were later spelled out in print by Karl Korsch, when he articulated his dissident brand of "critical Marxism." Significantly enough, Korsch's remarkable essay, entitled "Leading Principles of Marxism," appeared in exactly the same issue of *Marxist Quarterly* (October–December 1937) as did Meyer Schapiro's review essay about Rivera's murals entitled "The Patrons of Revolutionary Art."[92] Moreover, Schapiro, who was a friend of Rivera's during the mid-1930s, was also respon-

sible for the publication of Korsch's essay in this short-lived, but rather important "Trotskyist" publication. Whether or not Rivera and Korsch ever met remains unclear, but Schapiro knew and admired them both as kindred spirits on the left. The Rivera-like conception of history subsequently outlined by Korsch was quite revealing. Nothing in Stalin, little in Lenin, and only some of what is in Marx's writings could prepare us for this non-Eurocentric and antipositivist reading of the uneven trajectory of history. It went as follows:

> [Marx] spoke of "Positivism" and "Comtism" as something to which he was "thoroughly opposed as a politician" and of which he had a very poor opinion as a man of science. Marx's attitude is theoretically and historically well-founded. . . . The Marxist critique of the development concept of bourgeois social science starts from a recognition of the illusionary character of that "so-called historical evolution" according to which "the last stage [of history] regards the preceding stages as being only preliminary to itself and therefore can only look at them one-sidedly. . . . This critical consciousness [of Marx] breaks the spell of the metaphysical "law" of evolution. From a valid a priori axiom, it is reduced to a working hypothesis which must be empirically verified in each case. . . . Bourgeois society may contain the relations of earlier societies in a further developed form. It may contain them as well in degenerate, stunted and travestied forms. . . . It likewise contains within itself the germs of future developments in present society, though by no means their complete determination. The false idealistic concept of evolution as applied by bourgeois social theorists is closed on both sides, and in all past and future forms of society rediscovers only itself. The new, critical, and materialistic Marxist principle of development is, on the other hand, open on both sides. Marx does not deal with Asiatic, Antique, or Feudal society, and still less with those primitive societies which preceded all written history, merely as "preliminary stages" of contemporary society.[93]

This discussion by Korsch, with its notable antecedents in the writings of José Carlos Mariátegui and the paintings of Diego Rivera, helps to explain the ideological role of *los científicos* (or positivists), such as Dr. Gabino Barredo (a former student of Comte) in the prerevolutionary period. For the Díaz dictatorship, as for the later Somoza dictatorship in Nicaragua, a presumed modern "law" of economic evolution and of "orderly" social development was the overwhelming concentration of wealth in the hands of those few experts who "understood" the "science" of Western modernization. In turn, these lofty stewards of a "neutral" state realized that the "chaos" of popular involvement in politics would merely constrain the implementation of "scientific" formations on behalf of economic advances. Thoroughly in keeping with the views of *los científicos*, Barredo defended a starkly hierarchical chain of command culminating in the autocratic figure of Díaz as the only viable route to national prosperity. For him, political liberty consisted of a Hobbesian-like resignation to authority, "in submitting

fully to the evolutionary laws that determine these social phenomena."[94]

Social problems were assumed to be the mere consequence of economic inefficiency, since all problems were supposed to be technical, not ideological in nature. Most shortcomings of the Mexican economy were then said to be the result of a shortage of Western capital, Western technology, and Western "science." Just as popular democracy was purportedly a mere anachronistic political framework, so a corollary of positivism in the sphere of culture was the necessary marginalization of all supposedly "prescientific" cultural practices—from the *ejido* in Mexico and its economic counterpart in the Andean regions, the *ayllu* (a revival of which was championed by Mariátegui) to the visual languages from pre-Columbian art that Rivera wished to engage critically on behalf of a hybrid variant of modernism. Revealingly, Rivera contradicted the determinism of positivism (and Stalinism) when he forged a language in the arts that left regressive aspects of the past behind, even as he attempted also to catch up with the progressive facets of earlier cultures as an ironic part of his modernist project. (It is worth noting that when in the 1930s Mikhail Liftshitz, a well-known Soviet apologist for "socialist realism," commented upon Rivera's artwork, he complained of Rivera's use of "very archaic forms.")[95]

Just as evolution in a state of nature often proceeds by means of unexpected mutations, so historical development frequently advances by means of cultural hybrids that move simultaneously both forward and backward in time. In keeping with Rivera's artworks, the response of Mariátegui on this issue was to declare that the socialist's choice was neither one of "returning to one's roots" nor one of totally breaking with all aspects of a "prescientific" past. Rather, the real artistic aim of progressive *indigenistas*, he contended, was not one of cultural restoration or aesthetic resurrection, but, instead, one of critical reinvigoration and reconfiguration in the face of an uneven development that fragmented but did not eradicate the premodern past. Diego Rivera embraced this crucial goal in cultural production, but Vasconcelos did not. To quote Mariátegui: "Vasconcelos, who tends to depreciate native cultures of America, thinks that without a supreme law they were condemned to disappear because of their innate inferiority. . . . [Yet] Inca culture . . . has left us a magnificent popular art."[96] Accordingly, the official version of *mestizaje* advocated by Vasconcelos "is not precisely the mixture of Spanish, Indian, and African that has taken place on the continent. It is a purifying fusion and refusion" that simply treats the past in a quite one-dimensional manner as little more than an outdated preamble to the present.[97]

But, in a certain historical sense, revolution is always about a massive return of the repressed, even as it is also about the powerful infusion of new ideas and the genesis of a future-oriented social vision. It was Rivera's recognition of the latter that led him to produce his own unparalleled form of epic modernism, when in the late 1920s—on the heels of his militant masterworks in the Secretariá de Educación and the Universidad de Chapingo—

he was given a government commission to paint the history of Mexico on the walls of the Palacio Nacional (figs. 17 and 45). (Located on the former Aztec site of Montezuma's Palace, this monumental building from the late seventeenth and early eighteenth centuries, with nineteenth-century renovations, houses the office of the President and the Department of the Treasury.) As Stanton Catlin has observed of this huge series in the main stairway that dates from 1929 to 1935, "it is one of the most compendious visual displays of historical material in near human scale in the history of art."[98] As such, this towering complex invites comparison in scale and comprehensiveness only with such earlier artworks as Trajan's Column, the Bayeaux Tapestry, Michelangelo's Sistine Ceiling, or Tiepolo's Würzburg Ceiling. Antonio Rodríguez has concluded that Rivera's titanic epic of the Mexican people entailed a "feat [that] had never before been attempted in the history of painting, and it raised him to the level of the greatest exponents of his art."[99]

The theme of this vast fresco complex, which covers around 230 square meters, is nothing less than the history of the entire nation from the fall of Teotihuacán, circa 900 AD, down to the ultraleft-wing presidency of Lázaro Cárdenas in 1935, the year the final part was completed. At this culminating moment in the 1930s, during a period of massive popular protests, Rivera painted a commanding portrait not of Cárdenas, but of Karl Marx surmounting the concluding panel. This rare portrayal of Marx, "the Old Moor," as an engaged political activist is probably the greatest painting of him ever to be executed. This is the case despite the fact that images of him in Russia after 1917 and China after 1949 were far more ubiquitous, than in Mexico. But those images were also stodgy and frequently static.

Moreover, the commanding figure of Marx pointing to a future beyond class conflict is shown holding a passage from the 1848 Communist Manifesto that serves as the signal iconographic guide to the entire course of Mexican history, from the precolonial past to the revolutionary present. The portion of this well-known text chosen by Rivera is one with which most people are familiar: "Toda la historia de la sociedad humana hasta el día es una historia de LUCHA DE CLASES." (All of human history down to the present is the history of class struggle.) Our task, therefore, says Marx, in the passage selected by Rivera, is "NO TRATA DE REFORMAR LA SOCIEDAD ACTUAL SINO DE FORMAR UNA NUEVA." (Our task is not to reform existing society, but rather to construct a new one.)[100] This is the epic thesis that Rivera uses to orchestrate a seemingly unwieldy profusion of historial material into something like a coherent narrative, without, however, taking away from the dynamic and open-ended character of such a proactive reading of historical progression.

As Desmond Rochfort has noted, Rivera's frescoes in the Palacio Nacional were the "first of the murals to place the Mexican Revolution within some kind of historical perspective" in relation to the overall trajectory of national life.[101] The visual confrontation with history happens quickly. On the main western wall, which is immediately encountered by spectators as they ascend the stairway, there is an awe-inspiring expanse of

45 Diego Rivera, *Mexico From the Conquest to 1930*, 1929, fresco, stairway, Palacio Nacional.

epic scope (fig. 45). Yet this mural, *Mexico From the Conquest to 1930*, which spans five vaulted bays and extends from 8.59 meters in height to 12.87 meters in width, is epic in much more than scale. As is the case with both primary and secondary epics in world literature (from Homer's *Illiad* to Milton's *Paradise Lost*), Rivera's vast pictorial narrative begins *in medias res*. It likewise features a transcendant muse, as well as a guiding spirit (Quetzalcoalt and Karl Marx), in addition to showcasing almost endless sets of principal protagonists.

Nevertheless, these classic features of a national epic are suddenly counterbalanced by several formal traits that are manifestly modernist in character, so that the proper designation for his art here is "epic modernism." The modernist traits entail both a "postheroic" portrayal of national leaders, so that the real "heroes" are anonymous members of the popular classes, and a decentering compositional logic that is derived from 1920s Soviet cinema, as well as from Parisian Cubism. In turn, these formal attributes feature a usage of *metalepsis*, or chronological reversal, which is traceable to a pre-Columbian narrative form,

the snake-like *boustrophedon* format of the screen-fold manuscripts that was used by the Toltecs and Mixtecs. Furthermore, Rivera's distinctive version of epic modernism shared a number of symptomatic points of intersection with the contemporary "epic theater" of Bertolt Brecht. These Brechtian (and "non-Aristotelian") traits included an open-ended sense of history, a preoccupation with the spectator's "capacity for action," and the presentation of "man as a process," rather than people as "fixed points" on a prescribed journey.[102]

Through his application of a mutilateral aesthetic based on modernist "montage" (instead of classical or realist linearity), coupled with such tactics as the incorporation of pre-Conquest modes for organizing memory, Rivera has placed the spectator in an active role, much as did Brecht in his epic theater. Emerging "in the middle of things" to confront this riot of competing figures and events, the spectators have little choice but to "organize" interpretatively this "indeterminate" narrative, even as there is no Manichean framework for easily identifying the forces of "good and evil." Nor is the pressing visual challenge to choose in relation to the density of historical phenomena relieved when one reaches the top of the first flight of stairs. Whether one looks to the right at *The Aztec World* (which was executed first, in 1929, and remains the earliest historical moment shown) or to the left at *Mexico Today and Tomorrow* (which was painted last, in 1935, and features the moving image of Marx noted above), the pace of history never slows enough to become "transparent." Class and ethnic struggles, both in times of war and in periods of peace, are what the spectator must struggle to decipher—and then act on.

Here as elsewhere, Rivera emerges as a superb colorist for whom each form of color interaction becomes a sort of diacritical accent within the narrative. Seldom in modern art has the counterpointing of cool color and warm hue been employed so subtly or to such telling, political effect. All three walls were done in slightly different visual languages that, in turn, were indebted to the respective periods in art history that correspond to the historic events being depicted. The main wall, for example, particularly in the lower half, is done in a wonderfully hybrid manner that is nevertheless grounded in the Venetian style of Titian or Veronese from the sixteenth century—when the Spanish conquest occurred under Charles I (a patron of Titian). Thus this wall painting features the type of bold forms with diffused and softening lighting, as well as deeply resonant palette, that Titian and his school made famous. A wide array of richly nuanced browns used by Rivera cushion the use of primary hues and render them quite sumptuous in tone, especially as there is no stark chiaroscuro used.

Similar praise can also be made for the subtle appropiateness of visual languages marking the other two walls. The Aztec world is represented by means of flatter, less shaded, more broadly worked passages of color. These passages recall not only the modernist project of 2D–3D tension, at least since Manet, but also the distinctive type of color interaction most characteristic of pre-Columbian manuscripts. This is particularly true in the upper register of this fresco, which contains a glyph of Quetzalcoatl derived from the *Codex Florentina*. The broad passages in the upper register consist of upbeat, uninflected orange, green, and blue, all shown at higher than normal value, along with white, which make the scene look airless. As such, the area around the motionless glyph moves back and forth between the negative pictorial space of Western art and the blank textual space of pre-Columbian manuscripts. Only in the lower zone does one encounter the type of graduated Renaissance shading and matching overlapping that convey a sense of tense entanglement.

The south wall (fig. 17), the third and last of the three, was painted in another pictorial mode. The color interraction is less luminous, more somber than that in the other fresco segments. There is a chilly, even shrill use of high value blue that accents this blue-collar composition about labor militancy in response to an inequitable system. Compositionally, the briskly taut, grid-like compartmentalization of space is Cubist-derived and it is reinforced by a bracingly crisp Neoclassical line. Both traits in conjunction with the egalitarian play of light are heightened by a varied yet somber blue palette that transmits a sense of visual alertness, if not urgency. The metallic preciseness of this urban-situated art work owes a debt to Neue Sachlichkeit from Central Europe (as did the 1927–28 paintings in the Secretaría).[103]

More obviously partisan than the other two panels, this third fresco does not "read" from right to left as does the stairway complex as a whole. Rather, the hardnosed, yet visionary, panorama of class conflicts in the present and their suppercession in the future invites interpretation along a sinuous S-curve, beginning at the base and ascending. The roots of social conflict are to be found in the lower zone. There one encounters the martyrdom of campesinos, the exploitation of urban workers, the debates of radicalized students, and the strength of mobilized union members. Higher up, in the next zone, there are sections partioned by pipelines—the plumbing of capitalism, as it were—that frame the causes of social insurrection: the antidemocratic intervention of foreign capital (represented by the Rockefellers, the Vanderbilts, the Morgans, and the Mellons); the domestic tyrants of the unholy trinity (the military, the Church, and repressive politicians, like Plutarco Elías Calles who is shown here); and corrupt journalists, in addition to their wealthy patrons. In the upper right-hand area there is the representation of workers, who are then shown rising up with arms in the background that refers to downtown Mexico City. (Such uprisings were in fact occurring at the same time that this mural was being painted. This is a key point to which we return later.) The metaphorical and ideological keystone of the wall painting, though, is the striking figure of Marx, who functions as a coda for the whole fresco cycle.

But why Marx in 1934–35, and in one of the foremost sites in the seat of the Mexican government? Was this simply a monumental act of rhetorical bravado by Rivera at a moment when authority in Mexico was being wrested from the dictatorial figure of Calles? Or, was this last mural in the Palacio Nacional

stairway a signal locus of struggle, an unsurpassed site of con-testation, where national power was actually being fought over? The latter interpretation is, for example, how Leon Trotsky saw it when in 1938 he arrived as a political exile in Mexico. To quote the deposed Bolshevik leader: "In the field of painting, the October Revolution has found its greatest interpreter not in the USSR but in faraway Mexico. . . . Do you wish to know what rev-olutionary art is like? Look at the frescoes of Rivera."[104] At that point in his essay for *Partisan Review*, Trotsky elaborated on the active part played by such Rivera murals as those of the Palacio Nacional in the contemporary class struggle:

> Come a little closer and you will see clearly enough, gashes and spots made by vandals: Catholics and other reaction-aries, including of course Stalinists. These cuts and gashes give even greater life to the frescoes. You have before you, not simply a "painting," an object of passive aesthetic contempla-tion, but a living part of the class struggle. And it is at the same time a masterpiece![105]

How this could have been the case, and why it happened as a result of what Alan Knight has called a new type of mass politics, are things that can be answered if we revisit the semi-insurgent situation of 1934–35 in which the Rivera mural was produced. Starting in the early 1930s of Mexico there was a increasingly loud clamor for change by the popular classes, owing to the economic crisis caused by the Depression and to the political constraints precipitated by the rightward drift of the Calles-led *Maximato* (1928–34). A direct outcome of this context was the emergence of Lázaro Cárdenas as a national leader on the left—one who also became President of Mexico and succeeded, finally, in nationalizing Mexican oil and oil pro-duction (fig. 21).

An intriguing way to understand the events surrounding Rivera's noteworthy mural of 1935 in the Palacio Nacional is to recall an incisive study from the 1960s by Pablo González Casanova, *La democracia en México*. In this remarkable book (which has gone through over twenty editions since first appear-ing), González Casanova points out an exceptional feature about the popular democracy in Mexico: between 1920 and 1940, the more democratic the government, and the more accommo-dating it was of popular demands, the more strikes there actu-ally were. Thus, the major years of historic popular gains—from 1921 to 1923 and from 1935 to 1937—were precisely the years that saw the largest number of militant strikes by the greatest number of strikers (table 1). In the defining year of Obregón's policy shifts to the left, 1921, there were 310 strikes by 100,380 workers. This was a larger number of each than at any time during the Díaz dictatorship, when conditions were appalling. Similarly, in the early years of Cárdenas's presidency, especially when he had a powerful public showdown with the more con-servative and often intimidating popular forces linked to Calles, the number of labor strikes skyrocketed. In 1935, there were 642 strikes involving 145,212 strikers and in 1936 there were 674 strikes by 113,885 strikers. (Compare this, for example, with only

Table 1: Frequency of Major Labor Strikes from 1920 to 1946

Presidency	Year	Strikes	Strikers
Obregón	1920	173	88,536
	1921	310	100,380
	1922	197	71,382
	1923	146	61,061
	1924	136	23,988
Calles	1925	51	9,861
	1926	23	2,977
	1927	16	1,005
	1928	7	498
Maximato	1929	14	3,473
	1930	15	3,718
	1931	11	227
	1932	56	3,574
	1933	13	1,084
	1934	202	14,685
Cárdenas	1935	642	145,212
	1936	674	113,885
	1937	576	61,732
	1938	319	13,435
	1939	303	14,486
	1940	357	19,784
Avila Camacho	1941	142	12,685
	1942	98	13,643
	1943	766	81,557
	1944	887	165,744
	1945	220	48,055
	1946	207	10,202

Source: Pablo González Casanova, *La democracia en México* (Mexico City, 1965), p. 233.

seven strikes in all of 1928 under Calles, or a mere thirteen in 1933 during the *Maximato*.) In sum then, the more open and accountable the Mexican government was, the more labor demonstrated in the streets to direct the course of specific federal policies and even the entire political trajectory of the country. At these times, there was a dynamic, if unofficial, form of popular democracy in the public sphere that approached direct democracy in the classic sense.[106]

What made this show of popular forces in the Cárdenas years so necessary and so consequental? Owing to both the severity of the Depression under an inert Maximato and the new reform-minded U.S. administration under President Franklin D. Roosevelt that sent a liberal ambassador to Mexico, Cárdenas felt the moment was right for dramatic social change on behalf of

economic justice. The sweeping changes that he proposed in 1934 during his presidential campaign (which Calles no doubt felt he could co-opt once again) called for several quite radical measures: the intensification of land redistribution, the enforcement of the new minimum wage law of 1933, the unprecedented expansion of "socialist education," and the creation of Mexican national enterprises at the expense of foreign capital (that is, nationalization).

Once in power in December 1934, Cárdenas became emboldened by the popular classes (fig. 20), and he moved with unexpected swiftness to institute these labor-oriented measures. At once inspired by the labor movement and an inspiration for it, Cárdenas allied himself publicly with the Marxist, but non-Stalinist, labor leader Vicente Lombardo Toledano, who was head of the huge Confederación General de Obreros y Campesions de México (CGOCM) that was later renamed the Confederación de Trabajadores Mexicanos (CTM). This umbrella organization comprised over three thousand unions (a few of which were linked to the Communist Party), and had a total membership of at least 600,000. (The high point of Communist Party membership in Mexico was in the late 1930s when it numbered almost thirty thousand. By the late 1940s, though, it had dropped to only three thousand.)[107] When at times Cárdenas seemed hesitant about going through with his radical program, the labor organizations stepped up their pace of strikes and mass mobilizations to demonstate the overwhelming popular mandate for such change. The affluent sectors and entrenched government employees linked to Calles, along with the labor leader Morones, became more and more alarmed. Thus, a public confrontation became all but unavoidable between the "old order" and the new popular forces.

On June 11, 1935, Calles, the ultimate *caudillo*, attempted to retake the reigns of power, as he had several times before in the period from 1928 to 1934. He gave a fiery public speech in which he denounced the labor strikes, red-baited leaders like Lombardo Toledano, and threatened the new government with military action if Cárdenas did not restore "order and stability." The reaction of Cárdenas (who had very quietly moved behind the scenes to neutralize the military) was quick and decisive. He delivered a public speech on June 13 in which he made several bold moves. He encouraged workers to form a "united front," cautioned the military to stay in its barracks, and warned capital that if they tried to decapitalize industry that those businesses which did would be nationalized. A powerful, even awe-inspiring, popular reaction erupted after this public war of words. It led to a huge general strike against Calles and all other reactionary leaders in key institutions.

This situation in 1935—one bordering on open class warfare in the streets—was the one in which Diego Rivera completed his mural in the stairway of the Palacio. His painting was openly anti-Maximato and pro-Marxist when the battle was hardly won. The tense nature of this moment has been aptly described by James Cockcroft:

Throughout the class turbulance of 1935 and 1936, many political figures previously loyal to Calles noted the changes. . . . They grew increasingly awed by the sight of tens of thousands of workers marching in the streets. . . . They understood the shift in political balance when they saw the president arming 100,000 peasants and lesser numbers of workers to form peasant and worker militias in the name of resisting armed reactionaries and an "imperialist threat". . . . Overcome by the deterioration in their own ranks and by the newly fashioned labor-government alliance, Calles and CROM's [Confederación Regional Obrera Mexicana] Morones were put to rout, or more precisely, deported [in April 1936]. . . . Once again it was the actions of the working class, through large-scale strikes and demonstrations, that had precipitated the change.[108]

Many years later, Cárdenas himself would look back on Rivera's interventionary artworks with considerable admiration. In a memorial address shortly after Rivera's death in 1957, the former president spoke of Rivera's "combative brush" and his compassion for humanity, both of which led him to serve the popular classes. To quote Cárdenas:

In his murals, it was as if he were a campesino reclaiming the land, as if he were a leader of May Day demonstrations, yet was at the same time giving scholarly talks in the halls of public buildings, in which he wished to place his talent at the service of social justice and on behalf of the laboring classes, who have been mistreated by an exploitative and sterile minority. . . . [Rivera] interpreted the genesis of humanity sprouting forth from primal energy, and shaping its own biological and social evolution.[109]

This admission by Cárdenas of the considerable autonomy enjoyed by an artist of Rivera's international standing is revealing. It also helps us to understand how Cárdenas could score several significant political points about imperialist aggression from the North when, in 1934, he commissioned Rivera to do a new version of the notorious mural that was originally painted for the Rockefeller Center in New York City. The Rivera mural had been censored, then destroyed by the private business sector in the "land of freedom."[110] (It is important to recall here that the Rockefeller business consortium, which erased the Mexican mural, was also deeply involved with the foreign control of Mexican oil through such corporations as Standard Oil. In 1938, the Cárdenas Administration would nationalize all foreign oil holdings (fig. 21).) The new and very compelling version by Rivera of *Humanity Controller of the Universe* (1934)—which again featured a portrait of Lenin, plus new ones of Marx and Trotsky—was made for the foremost cultural center in Mexico, the Palacio de Bellas Artes. This impressive building houses the governmental counterpart to a Ministry of Culture, namely, the Instituto Nacional de Bellas Artes (INBA) of the Consejo Nacional para la Cultura y las Artes. But what of government patronage in Mexico more generally? Why was such latitude

granted in Mexico (more than in the United States) to painters like Rivera and Orozco, at a time when their public images in paint were definitely embattled like the popular causes they embodied?

The answer here is a paradoxical one. Precisely because the Mexican Government, especially between 1920 and 1940, was engaged in institution building on the national level in relation to the very radical Constitution of 1917, yet within an economic situation that was hardly favorable to this federal construction project, the presidency was constantly in search of prominent allies to legitimate a set of public programs that often scored more regional successes in rural areas, than it did national ones. As such, the liberality of state patronage from Obregón and the early Calles through Cárdenas resulted frequently from their urgent need to orchestrate, however provisionally, a united front of the entire Left that could fight off such powerful counter-revolutionary uprisings as those of Adolfo de la Huerta in 1924, the *Christeros* in 1928 and the *Maximato* in 1935.

Catholicity of viewpoint ideologically was essential in this somewhat unsettled and disunified institutional setting. Para-doxically, the weakness of the "Leviathan"—that is, how much the state functioned as a site of contestation over power—meant that the emergent state was not a mere ruling class instrument of power. (In fact, there was no one ruling class in Mexico during the 1920s and 1930s, however much international capital influ-enced domestic policy decisions.) Hence, a contentious public sphere was all but guaranteed so that there was considerable space for maneuver in the civic arena. As a result, militant left-wing groups such as the very small Communist Party of the 1920s (which was secretly subsidized by the Mexican Govern-ment from 1924 to 1929) or artists' collectives, like SOTPE, the Artists Union (1922–24), and LEAR (1934–38), a Popular Front league of writers and artists, could even criticize (as did Rivera) the very government that provided them with modest pat-ronage. That such a contradictory situation prevailed with respect to patronage (and this situation would not change emphatically until after 1940) tells us a great deal about how much this polycentric state had to seek allies among the more militant and activist sectors that were committed to the promises of the 1917 Constitution, in order to fight off constant challenges from the right.[111]

A more precise way of understanding this unprecedented set of events has been provided by Carlos Fuentes. As he noted in an exemplary essay that gives us a sound conceptual framework for grasping this situation in structural terms: the Mexican Revolution was in fact not one revolution, but three at once. Consequently, the state that was built after 1920 resulted from at least three different revolutionary movements pulling in as many directions. Although there were times when these three moments converged—as in the early 1920s under Obregón, in the mid-1920s under Calles, or in the mid-1930s under Cárdenas—their permanent union was never possible. More-over, all three of them had to contend against a threatening set of countervailing forces emanating either from the marginalized Mexican right or from ascendant Western capital.[112]

The three revolutions, which happened at roughly the same time, were as follows. The First Revolution was the agrarian-based insurrection led by Zapata and, to a less programmatic extent, by Pancho Villa. This revolutionary movement favored a decentralized, communitarian democracy inspired by regional formations, such as, the *ejido*. It was also this revolution that led most resoundingly to a repudiation of the Eurocentric culture linked to Díaz, and it was done in the name of heterogenous popular cultural practices. The radical land redistribution program that was such an original feature of the 1920s and 1930s—and it directly linked Zapata with Cárdenas (fig. 19)—was one of the most enduring attributes of this guerrilla insurgency and its *Plan de Ayala*. Based as it was upon an uncompromising commitment to grass-roots democracy, this revolution was the one most admired by the "ultraleftist" Rivera. He depicted Zapata over forty times in frescoes, oils, and prints, in some of the most memorable portraits of the Mexican Rev-olution, such as his concluding panel at the Palacio Cortés in Cuernavaca in 1929, where the Casasola/Brehme photo of 1915 was used as a model yet again.[113] Not surprisingly, this revolu-tion of the rural popular classes was one that Orozco and Siqueiros viewed with ambivalence, since they both served with the Constitutional Army of Carranza. Images by these two latter artists of Zapata and Villa are less common and at times rather unclear.

The Second Revolution was led by a multiclass alliance of liberal *hacendados* like Madero and Carranza or middle-class intellectuals like Obregón and Calles, as well as Dr. Atl, the painter. This quite diverse revolutionary movement was directly connected to the institutionalization of civil liberties, the "rights of man," and a form of electoral democracy that would allow peaceful transitions of power on the national scene. It began in the tradition of the Liberal, anti-colonial cause led by Benito Juárez and, after the deaths of Madero and Carranza, was trans-formed into a type of semi-Marxist socialism, or social democ-racy, that had a multiclass agenda within the firm constraints of international capitalism. Consolidated and shaped most notably by Obregón, Calles, and Cárdenas, this second revolution attempted to "create a modern national state, capable of setting collective goals while promoting private prosperity."[114] Its aim was a centralizing and economically modernizing revolutionary state with Western political features that would allow Mexico to become a major international player in a postcolonial world order.

The Third Revolution was, to quote Fuentes, an "incipient proletarian revolution" composed of landless urban workers employed in modern factories situated in cities. Its increasing base of power first emerged in the anarchist movement of the Flores Magón Brothers on the eve of the 1910 insurrection. This movement then gained momentum in alliance with Obregón through the formation of the Casa del Obrero Mundial which,

in the teens, expropriated as its headquarters the most impos-
ing palacio in Mexico City, the Casa de los Azulejos. (It is thus
fitting that Orozco, who had been allied with this labor organi-
zation, would later paint a striking wall mural inside the Casa
de los Azulejos during the mid-1920s.) Subsequently, after the
Casa del Obrero Mundial was weakened by a conflict with the
more conservative figure of Carranza, the urban working class
gained its most powerful, if also rather centrist, leadership
through the Confederación Regional de Obreros Mexicanos
(CROM) that was founded by Luis Morones in 1918. The largest
and most powerful urban labor union, CROM began on the
center-left of the political spectrum but gravitated more to the
far center owing to state patronage. Thus, with the advent of
the semi-insurgent labor movement in the 1930s led by the most
prominent Marxist among Mexican labor leaders, Vicente
Lombardo Toledano (a friend of Rivera), CROM and Morones
were swept away by an even larger and more leftist umbrella
group of unions, the CTM.[115]

During the military phase of the Mexican Revolution from
1910 to 1920, the third revolution of urban labor sided with the
second revolution against the first revolution, thus insuring
the defeat of Villa and the deferral of the Zapatista land reform
program. It was the city-based unions that provided Obregón
with the "Red Battalions" that proved decisive at the Battle of
Celaya, the most important military conflict of the entire period.
Thus, the urban workers generally sided with the moderniz-
ing project of revolution number two, in opposition to rural
workers and their communitarian vision within the first revo-
lution of Zapata. Consequently, a defining attribute of the
period from 1910 to 1919 was a stark split among the laboring
classes that kept the popular classes from any long term unified
front. Significantly, the most progressive periods between 1920
and 1940 were those in which there was at least a provisional
unification between urban labor and rural workers, between
obreros and campesinos, such as one saw at certain radical
moments with Obregón, Calles, and Cárdenas. While the first or
agrarian revolution was held in check by 1920, except in
Morelos, it was not beaten definitively, much less destroyed. The
massive land redistribution programs that occurred in the 1920s
and 1930s were eloquent testimony to the powerful afterlife of
this first revolution even after it seemed "beaten" in 1919.

Among the things resulting from the co-existence of three
revolutionary movements throughout the period from 1910 to
1940 was the absence of any one unified historical narrative
about the Revolution. The Maderistas, the Carranzistas, and
the Zapatistas all produced quite different narratives about
the history of the Revolution and they bequeathed them to
posterity for competing reasons. Each group contended that
the Revolution began at a different date and entailed divergent
aims—so much so in fact that each of these three narratives
precluded the other two from being "revolutionary" in any
profound sense. This is certainly not surprising, since a recent
study by Thomas Benjamin has aptly shown that in nineteenth-
century Mexico, "the terms 'revolution' and 'pronouncement'

(pronunciamiento)" were used interchangeably to refer to
"revolts against an incumbent government." Thus, as Benjamin
has further observed, "The concept of revolution in Mexico
before mid-century was impoverished compared to our
twentieth-century usage, its meaning quite narrow and ideolog-
ically neutral."[116]

Perhaps not surprisingly, the Maderistas continued to use the
terms "revolutionary movement" and "insurrectional move-
ment" as complete synonyms. In fact, the latter is now seen
as the first stage of the former, that is, before a revolution
definitively coalesces in a visionary and programmatic
manner.[117] For the Maderistas, then, "la Revolución" involved
only a key set of political and legal changes, not a social trans-
formation. In 1910, for example, Madero would claim in a public
speech that his revolution constituted the third phase of the
Mexican Revolution that began in 1810 with Hidalgo and
extended through the Liberal Reforms of Benito Juárez in 1855
only to be stalled by the Porfiriato and then renewed by the
anti-reelectionist "revolution" that he had led. They all three
had as a common "revolutionary" aim the legal enshrinement
of the "rights of man" that had been affirmed as a cornerstone
of the 1857 Constitution.[118]

A second narrative, that of the Carranzistas, questioned the
Madero reading of Mexican history and generally withheld
using the term "revolution" for any of the national insurgencies
before 1910, however admirable they might have been. This
point was made quite clearly by Carranza himself. His narrative
of the Revolution in the broadest sense thus began with himself
and the Constitutional Army that rose up against the Huerta
dictatorship, which was seen as a mere extension of the Porfiri-
ato that was not adequately challenged by the "reformist" nature
of Madero's program for change. In a 1914 interview,
Carranza argued that he had been the first to lead "a Social
Revolution. Madero's was merely political: the struggle for
Effective Suffrage and No Reelection. The needs of the people,
believe me, go much deeper than that."[119] The followers of
Carranza distinguished the "Revolución Constitutionalista"
from the less sweeping "Revolución de 1910." For them, then, the
renewed military struggle of 1913 was what really inaugurated an
authentic "social revolution," which entailed social, economic,
and national changes, not just the institution of political rights.
In retrospect, however, it is clear that the "Revolución Con-
stitutionalista" was less a consequence of Carranza's cautious
leadership, than of Obregón's more left-wing and social demo-
cratic presidency. After all, the Constitution of 1917 was much
more the work of Obregón in alliance with the popular classes,
than of Carranza and his inner circle. Thus, by his own stan-
dards, Carranza was not really a revolucionary and the Consti-
tutional cause per se deserves that title only because of the
popular successes after 1917 of Obregonismo.[120]

The third, and most compelling, narrative about the Mexican
Revolution to emerge from the 1920s and 1930s was not provided
by the Villistas, who were content with a populist version of the
Madero account. Rather the most implacable narrative was

generated by the Zapatistas. For them, Maderismo was "simply a parody, a falsification" of the Revolution and the movement closest to Carranza—but exempting Obregón after 1920—was even worse. Zapata declared this uncompromising view publicly in 1916: "He [Carranza] pretends to be the genuine representative of the Great Masses of the People, and as we have seen, he not only tramples on each and every revolutionary principle, but harms with equal despotism, the most precious rights and the most respected liberties of man and society."[121] A dramatic incident at the 1914 Aguascalientes Convention linked the "ultra"revolutionary resolve of the Zapatistas not only to class conflict, but also to the ethnic struggle of indigenous people against the ongoing legacy of colonialism in Mexico.

When the leader of the Zapatista delegation, Antonio Díaz Soto y Gama, refused to sign the Mexican national flag along with the others in attendance at the convention, he stated, "we are going to expose the lie of history that is in this flag. That which we are inclined to call our independence was no independence for the native race, but only one for the creoles."[122] (This Zapatista narrative, which found a telling echo in the anarchist narrative of Ricardo Flores Magón from 1916, has been the one to re-emerge so forcefully with the Chiapas insurgency of January 1, 1994, an insurgency that has been called "the first postmodern revolution" in a new collection of writings by Subcommandante Marcos.)[123]

There have, of course, been other narratives to emerge outside Mexico in recent years that include feminist reinterpretations of "la Revolución"—whether Maderista, Carrazanista, or Zapatista. These critiques have treated the Revolution as an ultramacho discourse "that associated virility with social transformation in a way that marginalised women at the very moment when they were supposedly liberated."[124] Such a generalized, uninflected feminist narrative entails a much needed critique of certain aspects of the Revolution, but its overly broad division of citizenship along mere gender lines—and at the expense of those discourses based on class and ethnicity—is deeply problematic as well. Indeed, Bolshevik leader Alexandra Kollontai, the Soviet Ambassador to Mexico in the 1920s, recognized the pitfalls of such an exclusively gender-based narrative very early. In 1920, she wrote, "The world of women is divided, just as is the world of men," continuing "In fighting for the rights of her class [and ethnic group] the working woman is paving the way for the liberation of her sex."[125] (Kollontai then concluded with the less justifiable position that "in a society based on class contradictions, there is no room for a women's movement indiscriminately embracing all women."[126] Such a view as this does not necessarily follow from the observation that class analysis is a key component of social critique.)

But, which of the three revolutions in Mexico was championed in the murals by Rivera and Orozco that we have already discussed ? (And, which of them was used by the printmakers of the Taller de Gráfica Popular in their great 1947 portfolio, *Estampas de la Revolución Mexicana,* discussed below?) Similarly, which of the competing narratives of the Mexican Revolution were invoked in the visual arts by these artists from the 1920s through the 1940s?

In the case of Orozco, the former Carranzista, the answer is ambiguous, but one thing is fairly clear. His work is about a social revolution with messianic overtones that goes much beyond the legal niceties of Madero, even if it never consistently embraces the utopian popular project of the Zapatistas. As is the case of great art with an overwhelmingly emotional appeal, the density of history in force within Orozco's work inspires, engages, and distresses, as defiance mingles with defeat, yet without any dogmatic verdict on the course of history.

Rivera's public murals from 1923 through 1935 are marked by a different type of historical density, but one that is equally far from the pieties of Stalin's "socialist realism." The cause championed by Rivera was, in fact, mostly about a revolutionary transformation that had yet to emerge definitively, though there were certainly powerful glimpses of it to be found at various moments during the presidencies of Obregón, the early Calles, and Cárdenas. What Rivera had already represented in his 1923 murals—and Siqueiros also in a woodcut for the pages of *El machete* in 1924—was to place his faith in an alliance of both the first, agrarian revolution of Zapata and the third, urban revolution of the proletariat. In turn, Rivera was thus opposed in some—but certainly not all respects—to the second revolution that was propelled by institution building and economic modernization. Moreover, in periods of counterrevolution, such as the dangerous 1924 military revolt led by Adolfo de la Huerta, Rivera and the other muralists sided with the emerging state government of Obregón and Calles's second revolution—as did key popular organizations representing both the first and third revolutions.

An excellent and well-known example of this political strategy was the Manifesto of the Sindicato de Obreros Técnicos, Pintores y Escultores, or SOTPE (the Union of Mexican Technical Workers, Painters, and Sculptors), which appeared in *El machete* (June 1924). The manifesto was endorsed by Rivera, Siqueiros, and Orozco, as well as Guerrero, Alva Guadarrama, Cueto y Ramón, Mérida, and Revueltas. Their collective declaration of artistic aims was interrelated with their shared avowal of support for Obregón and Calles against the counterrevolution then raging. This centralizing state government in turn commissioned murals from Rivera that demonstrated the artist's paradoxical and fluid set of commitments, however unavoidable these competing allegiances might have been. The net result of this highly complex political situation was a body of densely overdetermined artworks that did remarkable justice to the varied political options of the period, even as they forged a new visual language to articulate a set of cultural and ideological concerns that went much beyond the topical events of the 1920s. The considerable popularity of Rivera's murals with the more militant members of the popular classes who have been unionized is well documented in several cases both in Mexico and in the United States. When, for example, there was a public drive in 1933 by conservative Republicans in the U.S.A.

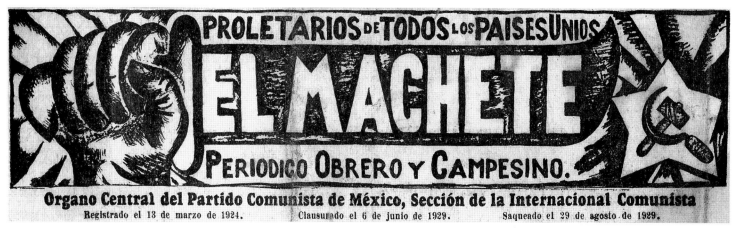

PROLETARIOS DE TODOS LOS PAISES UNIOS

EL MACHETE

PERIODICO OBRERO Y CAMPESINO.

Organo Central del Partido Comunista de México, Sección de la Internacional Comunista

Registrado el 13 de marzo de 1924. Clausurado el 6 de junio de 1929. Saqueado el 29 de agosto de 1929.

46 Xavier Guerrero, *Masthead of "El machete,"* 1924, woodcut, Center for Southwest Research, Zimmerman Library, University of New Mexico.

47 Ramón Alva de la Canal, *Edificio Estridentista*, 1921, woodcut, taken from *El movimiento estridentista* by Germán List Arzubide, Jalapa, 1927.

to censor Rivera's Detroit murals, a united front of twelve thousand industrial workers immediately notified the Mayor of Detroit that they would defend the murals were any further efforts by the right wing made to destroy them. Subsequently, these murals were actually used by labor leaders in the successful drive to unionize the Ford auto plant.[127]

The major artists to emerge from this period did so in a relation to the dynamic and unsettled context of the Obregón and Calles administrations, which sanctioned a series of groups and journals that remain quite important, even though they have been generally overlooked in the scholarly literature. (Nevertheless, the last decade and a half have seen the publication of a few studies—by Francisco Reyes Palma, Olivier Debroise, James Oles, and Karen Cordero Reiman—that entail exemplary scholarly efforts to address this oversight.)[128] There were several journals and newspapers founded by progressive intellectuals in and around the outbreak of insurgencies in 1910. These included the *Revista Moderna*, which lasted until 1911; the "antipositivist" *Savia Moderna* from 1906, with a cover by Rivera, that was founded by writers linked to the *Ateneo de la Juventud* in 1909; and Dr. Alt's art journal from 1913, *L'Action d'Art*, as well as *La Vanguardia* and *El Hijo del Ahuizote*, all of which were linked to Carranza during this period and included caustic images by Orozco.

El machete of the Artists Union, which carried a masthead based on a woodcut by Xavier Guerrero, remained associated with the Artists' Union for only a year, 1924–25 (fig. 46). There were, however, a number of other avant-garde groups and publications to emerge in the 1920s in Mexico and endure much longer. Most notably, these included the first avant-garde journal published in Latin America, namely the part-Futurist, half-Dadaist, avowedly socialist *Revista Actual* of 1921. This eclectic publication marked the public appearance of the *Estridentista* movement (1921–29) led by poet Manuel Maples Arce. Other members of this vanguard coterie were several poets: Germán List Arzubide, Salvador Gallardo, Humberto Rivas, Luis

Ordaz Rocha, and Miguel Aguillón Guzmán. Along with the writer Arqueles Vela, there were several painters who not only belonged to the group but also showed works at the well-known exhibition and performance held at El Café de Nadie (the cafe of no one).

The visual artists who were members of this group included printmaker Leopoldo Méndez, painter Fermín Revueltas, painter Jean Charlot, Xavier González, printmaker/painter Ramón Alva de la Canal—perhaps the most *Estridentista* artist of the group (fig. 47)—and sculptor Germán Cueto y Ramón. (Moreover, Diego Rivera and Tina Modotti were even linked to them at one point.) As has been noted, the graphic art of *Estridentismo* involved a type of "idiosyncratic militancy" that revolved around tropes for modernity (for example, skyscrapers, power plants, radio transmitters). The work of Ramón Alva de la Canal in particular was strikingly innovative, even though it was not widely circulated. Yet the prints of the *Estridentistas* would have an important influence on the work of the Taller de Gráfica Popular. To quote Teresa del Conde, the artworld accomplishments of such groups as the *Estridentistas* were explicable largely as emanations of the political ambience connected to the Revolution.[129]

Among the most memorable things about *Estridentismo* was its Manifesto, "*A Strident Prescription*," by Manuel Maples Arce, which was also posted on walls in urban centers. A hybrid concoction of various vanguard movements, in addition to international socialism—along with the cancellation of each of these intellectual trends at the same time—the rowdy opening of this hectic document read as follows:

> In the name of the contemporary avant-garde, and in genuine horror at the notices and signs plastered on the doors of chemists and dispensaries subsidized by state law at the behest of a cartulary system for the last twenty gushing centuries, I affirm my position at the explosive apex of my unique modernity, as definite as it is eminently revolutionary. The whole off-centre world contemplates its navel with spherical surprise and wringing of hands while I categorically demand (with no further exceptions for "players" diametrically exploded in phonographic fires with strangulated cries) with rebellious and emphatic "stridency" in self-defense against the textual blows of the latest intellectual plebiscites, Death to Hidalgo, Down with San Rafael and San Lázaro, Corner, No bill-posting.[130]

From there, Maples Arce went on to enumerate fifteen points. A few of them were about "honoring telephones whose perfumed conversations are articulated along electric wires," while recognizing that "Man is not a systematically balanced clockwork mechanism." Along with these points were the need to "become more cosmopolitan" so as to end "retrospection," in addition to wishing "Success to the new generation of Mexican poets, painters, and sculptors who have not been corrupted by the easy money of government sinecures."[131]

Other vanguard journals from this period included *Forma* (1926–28)—the first Mexican review dedicated solely to the visual arts—and *Contemporáneos* (1928–31), which was edited by Bernardo Ortiz de Montellano and numbered among its members such artists as Abraham Angel, Julio Castellanos, Augustín Lazo, Manuel Rodríguez Lozano, Antonio Ruiz, and Rufino Tamayo. The latter contingent sought, above all, a dialogue with other cultures, both popular and foreign, and they were keenly interested in national art pedagogy. In fact, one of them, Rodríguez Lozano, even replaced Best-Maugard as Director of the public art education program in 1924. There was also *Mexican Folkways* (1924–29), a cultural journal published by Francis Toor and edited by Diego Rivera (a contributing essayist and designer of the cover). And, finally, there was *!30–30! Organo de los Pintores de México* (1928–30), which was published by a group of "antiacademic" artists who supported such pedagogical projects as the Escuelas de Pintores del Aire Libre. This group took its name from the famous 30–30 carbine rifle, as well as from the fact that there were thirty members in the organization. Among the members were several artists of note: Ramón Alva de la Canal, Gabriel Fernández Ledesma, Fernando Leal, Fermín Revueltas, Rafael Vera de Cordova, and Martí Casanovas. In all they published five manifestoes and their journal appeared in three issues. On January 25, 1929, !30–30! had an exhibition entitled "La Primera Exposición de Grabados en Madera en México" that included over 150 woodcuts. In 1930, the last show by this group was held in De la vida del Café.[132]

As the identification of these media makes clear, several art forms lacked the public patronage and local ingeniuity to make any notable contribution to this restless situation in the arts. Sculpture had only a few names of note—such as, Ignacio Asúnsolo and Oliverio Martínez, as well as Mardonio Magaña, the *campesino* autodidact. Photography also produced only a handful of noteworthy figures—from Agustín Victor Casasola, along with Hugo Brehme, in the teens through Tina Modotti in the twenties to Manuel Alvarez Bravo in the thirties. The latter photographer soon emerged as an outstanding artist, perhaps even as the finest photographer that Mexico has so far produced. Alvarez Bravo, whose famous 1934 image *Obrero en huelga, asesinado* (A striking worker who has been assassinated) appeared in a photomontage on the cover of *Frente a Frente*, was much admired by Rivera and Orozco, as well as by the Surrealists and most other visual artists.[133]

The Taller de Gráfica Popular and *Estampas de la Revolución*

There were other artist collectives of continental import, aside from the muralists, and they included a distinguished group of printmakers, some of whom also worked as muralists in the 1920s and 1930s though few of their wall paintings survive. The all but forgotten group of murals from 1934 in the *Mercado*

48 Pablo O'Higgins, *The Bricklayers, Valley of Mexico*, lithograph from *Mexican People*, 1946, Friends of Art, University of New Mexico Art Museum.

Abelardo L. Rodríguez (which also included part of the seventeenth-century Colegio de San Gregorio) were by eight young artists who were accomplished, if not outstanding practitioners of fresco. Indeed, there was only one major artist in the group, namely, Pablo O'Higgins. His resolutely anti-imperialist ceiling murals in the Colegio, *La lucha de los contra los monopolios* (The worker's struggle against monopoly capitalism), were at once variations on the language he inherited from his mentor Diego Rivera and yet commanding works in their own right. Adept at brooding color interaction, oscillating draftsmanship, and especially at foreshortening for dramatic effect, O'Higgins did find a moving way to follow his own directive about social protest paintings. Such images were, he claimed, to be about "local conditions, actual struggle" that placed "demands up on the wall, with as little allegory as possible."[134] Yet, it was as a printmaker even more than as a painter that Pablo O'Higgins emerged as an outstanding artist after 1930 (fig. 48).

Less impressive technically, but still noteworthy, were the wall paintings by Grace and Marion Greenwood, as well as those of the other muralists: Antonio Pujol, Ramón Alva Guadarrama, Pedro Rendón, Raúl Gambón, Angel Bracho, and Miguel Tzab Trejo. (There was also a striking relief sculpture commissioned

from the young Isamu Noguchi and located on the second floor of the Mercado). All of these artists, who dealt with the quotidian life of the laboring classes, intended to empathize pictorially with the popular classes who frequented this marketplace. Good intentions are seldom enough, however, to justify an artwork. Thus, the lack of resonance that these grim Popular Front images in the Mercado had with the popular classes in Mexico City was soon evident to contemporaries, as it still is to any serious visitor to the site. What Antoino Rodríguez wrote in the 1960s is also the situation now (except for the fine, but less accesible murals by O'Higgins):

> From the election of Cárdenas onward, professional as well as amateur painters formed themselves into teams which went out to the people and painted markets, schools, union halls, factories, and workshops, and thereby gave a new, genuinely popular direction to the mural painting movement. The most interesting attempt of this kind was made in the Abelardo Rodríguez market by a mixed group of painters. . . . Seen as a whole these murals are as heterogeneous as their perpetrators. . . . Most of what was painted in the Abelardo Rodríguez market *died the day after it was completed*. The people who frequent the market nowdays pass the murals without a glance. Even the sellers in the market, who spend their days among them, do not appreciate them. People do not forgive those who paint them uglier than they are, nor do they want to be constantly reminded of their misfortunes. In spite of that, the murals of the Abelardo Rodríguez remain as a testimonial of a period when painters had free access to the people in the markets. . . . It is mainly on that account that the collective experiment in the Abelardo Rodríguez market is of such importance to Mexican mural painting.[135]

As evidenced by the lack of enthusiasm they generated among audiences from the popular classes, these murals were problematic for technical and ideological reasons from the beginning. These problems account for their present reception much more than does any art-historical "conspiracy" in favor of "canonical" paintings by "los tres grandes" (as some "revisionist" scholars have naively suggested). In fact most of these murals in the Mercado are simply dogged by the typical paradoxes of Popular Front populism.

Nevertheless, there was another collective comprised of former members of the Popular Front that managed to make a far more lasting and noteworthy contribution to the visual arts. Nor is it by chance that one of the noteworthy charter members of this collective, the Taller de Gráfica Popular (TGP), was Pablo O'Higgins, who was among the finest of the Popular Front artists. The TGP was founded in 1937 by O'Higgins and two other outstanding graphic artists who belonged to the Mexican Communist Party—Leopoldo Méndez and Luis Arenal. From the late 1930s through the 1960s as many as three hundred artists in the graphic arts followed the lead of this trio in working with the TGP's program, although in general the group averaged around fifteen active members at any one moment. Among the many

excellent visual artists who collaborated with this collective were Ignacio Aguirre (fig. 18), Alberto Beltrán, Angel Bracho, Fernando Castro Pacheco (fig. 14), Elizabeth Catlett, Arturo García Bustos, Francisco Mora (fig. 21), Everardo Ramírez (fig. 55), Mariana Yampolsky (fig. 54), and Alfredo Zalce. By 1960, the TGP artists had already produced thirty-five major portfolios of linocuts, woodcuts, and lithographs, several of which are among the best in the history of prints. The total number of TGP prints (each of varying editions) topped four thousand by the late 1970s, as Helga Prignitz has noted.[136]

In fact, print production in Mexico already had a long and rather distinguished history prior to the Revolution of 1910. Woodcuts and engravings were first made there in the sixteenth century, while lithography arrived in Mexico around 1826. By 1827 there was a lithographic press at the Academia Nacional de San Carlos, which in 1831 appointed a Director of Graphics, Manuel Aráoz. In the nineteenth century a Galería de Grabados was established at San Carlos and it served as a key component of academic instruction. Rivera, Orozco, and Siqueiros, among numerous others, were trained in draftsmanship by means of prints, then plaster casts, before graduating to live models.[137] As early as 1911, Orozco was producing drawings, caricatures of those in power, for such liberal publications as *El Hijo del Ahuizote*. Later, Orozco also worked for such publications as *La Vanguardia*. And, of course, in the late nineteenth and early twentieth century there were the popular engravings by José Guadaloupe Posada for various broadsheets and newspapers owned by Antonio Vanegas Arroyo. Yet Posada was more an inspiration, than an influence, except in the case of Leopoldo Méndez. Subsequent printmakers, after the Mexican Revolution reached its constructive phase in the 1920s, admired his example, but few really followed his lead. Perhaps this was because Posada's populist political sympathies were somewhat inscrutable, though his sense of humanity was obvious. Nevertheless, he came to be revered by later artists like Orozco and Leopoldo Méndez, as well as Rivera, who painted a prominent portrait of Posada in a major 1947 mural.[138]

In the 1920s print production did gain some momentum through the efforts of professional artists in the avant-garde: Orozco, Siqueiros, Ramón Alva de la Canal, Leopoldo Méndez, and Xavier Guerrero (figs. 46–53). All of these artists not only worked in print media for such publications as *El machete* and *Actual*, but also produced posters for display in the streets. Nonetheless, the output of professional prints in Mexico was rather modest before the 1930s. Many of the most widely circulated "prints" were actually cover drawings by Rivera, et al., for journals like *El maestro* and *Mexican Folkways*, with the prints actually being made by professional printers in publishing houses. Contrary to the exaggerated claims of Siqueiros that printmaking rivaled muralism in the 1920s for engagé artists, the opposite situation really obtained.[139]

Even if one enumerates all of the prints produced by each of "los tres grandes" through the early 1940s, that total is small for these three artists. Orozco made around fifty in all, Siqueiros

49 José Clemente Orozco, *la bandera*, 1929, lithograph, University of New Mexico Art Museum.

50 David Alfaro Siqueiros, *Zapata*, 1936, lithograph, Julius L. Rolshoven Memorial Fund, University of New Mexico Art Museum.

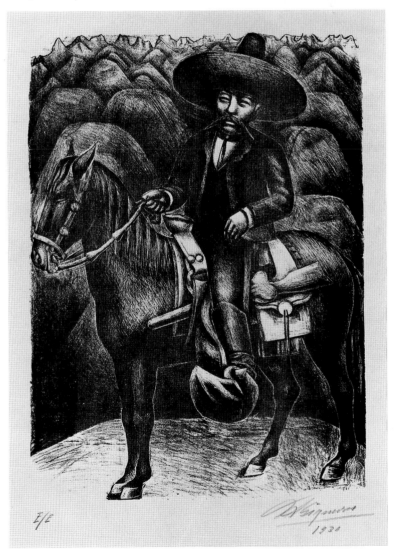

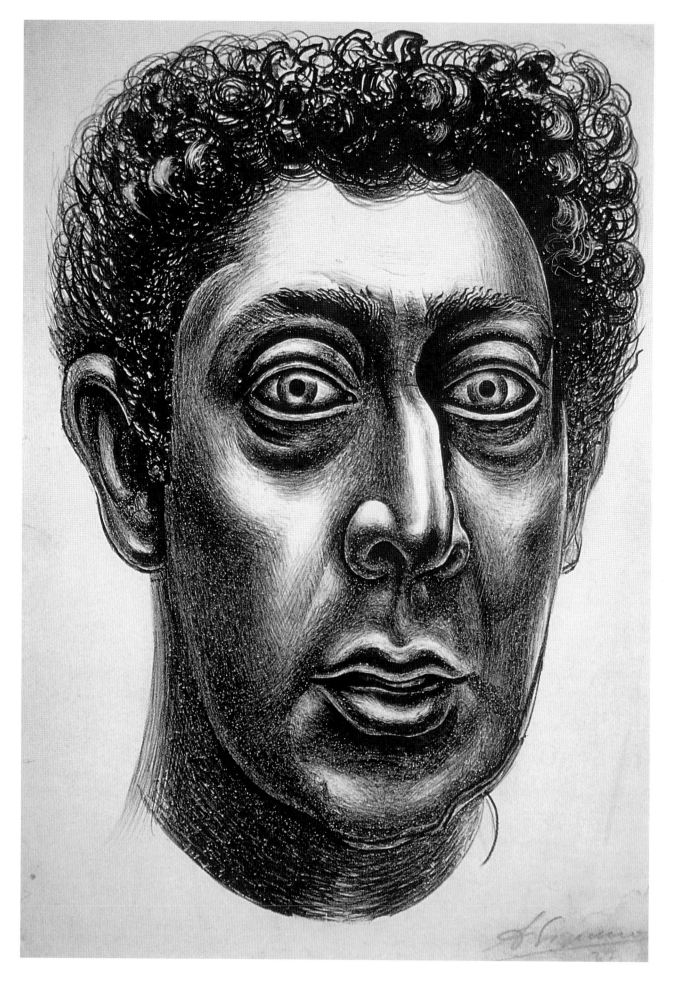

51 David Alfaro Siqueiros, *Autoretrato (Self-Portrait)*, 1936, lithograph, Julius L. Rolshoven Memorial Fund, University of New Mexico Art Museum.

52 Leopoldo Méndez, *Deportación a la Muerte* (Deportation to the concentration camps) linocut from *El libro negro del terror nazi*, 1943, Center for Southwest Research, Zimmerman Library, University of New Mexico.

between thirty and forty, and Rivera only thirteen in total. Moreover, it is also the case that these lithographs, linocuts, and acquatints were often treated as subordinate artforms in relation to oil paintings and murals. In general, prints were used by "los tres grandes" for several reasons: to circulate popular images of previous frescos in a revised format, as with Orozco's etching *La bandera* (fig. 49) or Rivera's *La maestra rural*; to rethink earlier compositional choices in paintings, as with Siqueiros's *Zapata* (fig. 50); and, finally, to address topical ideas in a relatively cheap artform aimed at popular consciousness raising (fig. 46). Among the few exceptions to these usages would be the commanding *Autoretrato* (Self-portrait) by Siqueiros from 1936 (fig. 51).[140]

The real "revolution" in print production took place only in the 1930s and it did not involve "los tres grandes," but rather the coterie of excellent artists linked to the Communist Party. These included the three artists who would found the Taller de Gráfica Popular in 1937, after having been members of the short-lived Popular Front organization, the Liga de Escritores y Artistas Revolucionarios (LEAR). Yet LEAR, which lasted from 1934 to early 1938, produced a publication called *Frente a Frente*, in which photomontages were as important as linocuts or litho-

graphs. Galvanized by the radicalization of public life under Cárdenas, the artists of the TGP became one of the most formidable groups of antifascist artists in world history. Only John Heartfield, who influenced some of the Taller's own images, produced work that was as timely and as compelling as that of the TGP.[141]

The Taller's striking set of eighteen lithographic posters (in runs of 2,000 each) in support of the anti-Nazi Liga Pro-Cultura Alemana (League of Pro-German Culture) came out in 1938, in conjunction with a public lecture series held at the Palacio de Bellas Artes in Mexico City. Similarly, the *Libro negro del terror nazi en Europa* (The black book of Nazi terror in Europe), which appeared in 1943 in an edition of 10,000, was simply unique in the history of antifascist literature, as Debra Caplow has noted in a recent study.[142] It contained the first-known image outside of Europe of the Holocaust, a chilling image of deportation to the concentration camps, and one of the first portraits outside of Italy of the Marxist thinker Antonio Gramsci, a victim of fascist political repression. Both of these superb linocuts were by Leopoldo Méndez, perhaps the finest printmaker in the history of Mexico (figs. 52 and 53). This stirring antifascist tract

53 Leopoldo Méndez, *Retrato de Antonio Gramsci* (Portrait of Gramsci), linocut, from *El libro negro del terror nazi*, 1943, Center for Southwest Research, Zimmerman Library, University of New Mexico.

contained 298 pages of text, 164 photographs, and thirty-two prints by members of the TGP, plus other artworks by Käthe Kollwitz, John Heartfield, and William Gropper. It was carefully managed by the left-wing German emigré publisher Hannes Meyer at El Libro Libre Press, while being underwritten by the President of Mexico, Manuel Avila Camacho.[143]

Less an alternative to muralism during the Cárdenas years than a complement to it, the TGP engaged with popular organizations in yet another way than did fresco painters. (Several of the printmakers in the TGP in fact doubled as muralists, yet printmaking was their forte.) There were several traits about the work of the Taller that caused their prints to stand out in the international arena. First, in the "age of mechanical reproduction," these artists chose to use artisanal, preindustrial techniques rather than the industrial-based photomontage recommended by Walter Benjamin. This was despite the fact that such publications as *Proletariado* (1936–40) of the CTM in Mexico did in fact use photomontages to appeal to urban unions. Second, the TGP members built their artistic practice on a persistent use of "críticas colectivas" (collective critiques) as a *sine qua non* of all art making. Third, the personal accountability of each artist to the group notwithstanding, the members of the TGP practiced a plurality of languages and approaches that certainly qualified as a notable form of "socialist pluralism" with admirable results. The various idioms employed ranged, for example, from a clear debt by Castro Pacheco to the angular compactness of Käthe Kollwitz or Ernst Barlach and the vital, Daumier-like line used

by Pablo O'Higgins to the almost classical hatching technique showcased in the elegant but biting linocuts by Leopoldo Méndez (figs. 18, 24, 48, 52, and 53). Fourth, the Taller relied on sporadic institutional funding from popular organizations, state agencies, and private collectors (particularly in the U.S.A.). This nimble, multifront patronage meant that they enjoyed an austere form of relative autonomy that Hannes Meyer was particularly adept at orchestrating ever since his days at the Bauhaus in Weimar Germany.[144]

There was something deceptively simple, though, about the *Declaración de Principios* (Declaration of principles) in 1937.[145] The language used, conventional Popular Front rhetoric derived uncritically from that of the Soviet Union in the 1930s, made overly easy reference to very problematic terms like "realism" and "reflectionism." In fact, when the TGP had an exhibition of its prints in Moscow during 1940 (101 prints by fifteen of its members), the Soviet commentators were devastatingly dismissive of the "nonrealist" styles used by the TGP. The Mexican artists were even accused of deriving their "schematic approach from Cubism." (This was probably an indirect slap at Diego Rivera, whose "Trotskyist" usage of Cubism was "notorious.") Alfredo Zalce, one of the only TGP members not in the Communist Party, was even accused by the Soviets of creating "pathological" images with utterly "grotesque figures."[146] As a whole, the show was condemned for lacking any "attributes that manifested moral or physical beauty." So much, then, for solidarity by the TGP collective with the Stalinist doctrine of so-called "socialist realism." (In fact, the official Soviet position on "realism" in the arts was guilty of what André Malraux once rightly termed the "neutral style fallacy.") Not surprisingly, subsequent statements by TGP members focused more on pungent images in response to social "reality," than on any "objective" commitment to so-called "socialist realism."[147]

Just as Alan Knight has observed of the highly original, semi-insurgent Cárdenas years that "Agrarian reform was the regime's key policy in 1936–37," so we can explain the recourse by the TGP to traditional linocuts and woodcuts over photomontage along related lines.[148] The Taller preference for more artisanal forms in defiance of the urban-oriented "age of mechanical reproduction" provided evidence for a strong identification with *campesino* cultural forms at a period when *campesinos* were still the preponderance of the work force before 1950. Unquestionably, the TGP's "crude" images and inelegant print media articulated a political embrace of *Cardenista* agrarianism. In addition, their choice of "premodern" artforms like woodcuts and linocuts also embodied a surprisingly pro-Leninist, anti-Stalinist strategy, along lines already laid out to a certain extent within the Mexican Communist Party by David Alfaro Siqueiros. In a provocative 1932 essay entitled "Rectificaciones sobre las artes plásticas en México," Siqueiros addressed the issue of a "mass audience" in an anticolonial way that diverged from Soviet-style Zhdanovism, on the one hand, and Benjaminian-based Western Marxism, on the other.

The noted Mexican muralist defined the relationship of professional artist to popular audience in frankly Leninist terms. In a classic statement of ultravanguard party guidance, Siqueiros both contended that art served the urban proletariat and yet denied that most members of the urban proletariat could understand ideologically or aesthetically the art most identified with their class interests. His non-Western Leninism went as follows:

As for the masses: the bourgeoisie is characteristically *nouveau riche*; the middle class or petty bourgeoisie has been educated by the bourgeoisie; and the proletariat is the final receptacle for the bad taste of the classes that exploit and dominate them. The proletariat owes to the bourgeoisie not only its economic oppression, but also its abominable taste in aesthetics. The radio playing the songs of Augustín Lara, the gramophone and Yankee cinema are the spiritual food of mass culture for the masses: How then can workers have anything other than bad taste? Only the campesinos still have a tradition of good taste, because they are closer to our older cultures and more distant from modern bourgeois culture.[149]

In distinguishing urban mass culture from rural popular culture, Siqueiros was celebrating the Mexican majority's inherited premodern culture as a prologue to the "classless" art of the future. By making this move he cleared the way for a type of Leninist leadership of the popular classes by progressive artists in the Communist Party, since, despite everything, "it is only the educated minority who can evaluate the visual arts."[150] As such, the rural culture of the *campesinos* became a valuable stimulus for the vanguard artists who sought to defend the revolutionary project of dramatic social change. High art and popular culture in Mexico thus stood opposed to Western mass culture and the choice seemed stark:

Artists have only two possibilities: they must decide whom to serve—either the bourgeoisie or the proletariat. I support the latter theoretical position, but I would also like to clarify a few points. . . . I am fighting for this type of classless society because I am ultimately in favor of pure art. I also believe that a painter or sculptor should not subordinate his aesthetic to that of the revolutionary proletariat, because, as we have already seen, the taste of the urban masses has been perverted by the dominant taste of the capitalist class. In his painting or sculpture the revolutionary artist should give expression to the desires of the masses, to their objective qualities and to the revolutionary ideology of the proletariat, while also producing a great art in plastic terms.[151]

This strictly binary, quite nondialogical framework, which was so symptomatic of 1930s Leninism, ended up leaving the spectator two antithetical and equally one-sided choices. Since Siqueiros made no theoretical provision for a dynamic and graduated dialogue between the artist and the audience, only a brittle choice was left. The spectator could either allow the vanguard artist to dictate the right aesthetic path, or accede uncritically to a form of left-wing populism. The latter position concerning the vernacular art of the popular classes naively judged them to be "inherently" nonelitist and "democratic," as well as antomatically progressive. In short, one could either sanction a monologue by the artistic elite or one by the popular classes. The concept of reconstructing a culture through an energetic give-and-take involving both high and low art was not yet on the agenda, as it would be later in Cuba and Nicaragua. The only potential advance beyond this stand off would have been to call for a dialogical interplay between fine art and popular culture, both in relation to mass culture, with none of them being deemed intrinsically superior prior to a multipoint critical interchange in the public sphere.

The avant-garde artists comprising the TGP tacitly rejected the antinomian elitism of Siqueiros's Leninist vanguard artists. Yet, the TGP did so in favor of a vague process of popular self-representation based on the professional use of vernacular popular languages, as well as premodern media, that were assumed to be organic self-expressions of *campesino* culture. These well-intentioned sympathies with agrarian culture did not solve some of the potential contradictions confronting the TGP's aesthetic counterpart to *Cardenismo*. Such contradictions emerge, as soon as one tries to define more precisely the organic appeal of these ambiguous images "for the people," as if the images possessed an aesthetic unity equal to that of their supposedly "monolithic" *campesino* audience. In fact, all of these TGP images presupposed a broadranging, highly nuanced set of shifting aesthetic calculations that belied any ready assumptions about a "collective" art or a "uniform" audience. Every visual idiom used by the TGP members actually had to do "double duty" when making artistic appeals in different regions, to various ethnic groups, as part of a process of uneven development that accounted for a cluster of disparate cultural practices and competing visual languages, even within the same popular classes. To contrast images of rural labor by Mariana Yampolsky with those of Everardo Ramírez or Alfredo Zalce is to encounter differences in the visual dialects that are as important as the ideological values that united these diverse artists (figs. 54 and 55). In short, even where it was obvious which of the three Mexican Revolutions was being invoked by the artwork in question, it was not always clear which of the half dozen revolutionary narratives was being employed in the varied TGP representations.

At least three knotty artistic problems surface, for example, from a critical examination of two tart sentences in Article 3 of the *Declaración de Principios* in 1937:

The TGP believes that, in order to serve the people, art must both reflect [*reflejar*] the social reality of the period and possess a unity of content with form. By acting on this principle, the TGP will try to elevate [*elevar*] the artistic standards of its members, in the belief that art can truly serve the people only if it is of the very highest artistic quality.[152]

But, do these aims really add up to a cohesive set of aesthetic and political concerns that go beyond the typical eclecticism of populism? Is any one aesthetic, one narrative, one revolutionary process identified as a result of this principle?

54 Mariana Yampolsky, *La Juventud de Emiliano Zapata: Lección objectivo* (The youth of Zapata: An objective lesson), linocut, *Estampas de la Revolución Mexicana*, pl. 8, 1947, Julius L. Rolshoven Memorial Fund, University of New Mexico Art Museum.

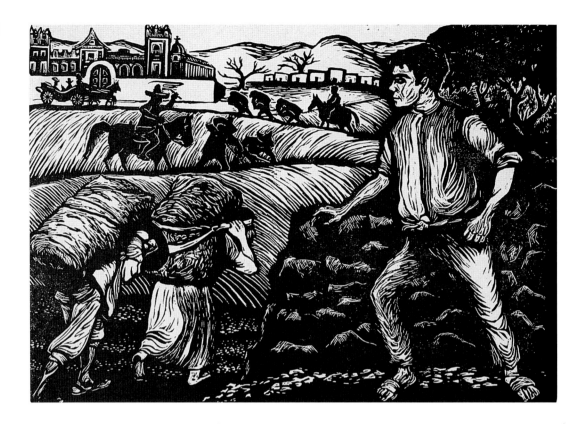

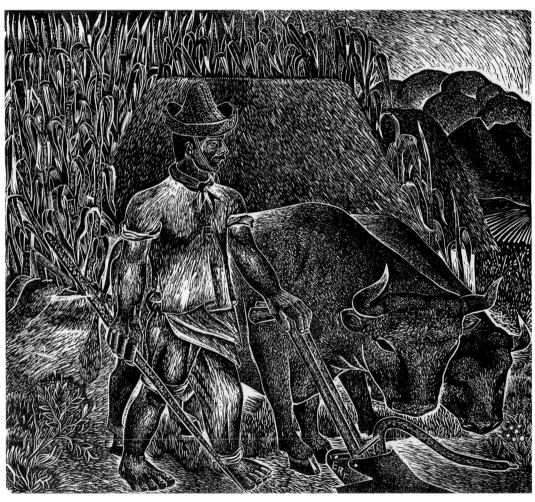

55 Everardo Ramírez, *La tierra* (The land), linocut from *Vida en mi barricada*, 1948, Center for Southwest Research, Zimmerman Library, University of New Mexico.

The challenge to arrive at a cohesive revolutionary narrative and a postpopulist statement about the revolutionary project in Mexico in the 1930s was indeed a profound one. The TGP gave an unduly homogenized and, in fact, rather abstract definition of its audiences, called simply "the people" (*el pueblo*), which is a word that has rural connotations. Plaguing this view, especially in a country as decentered as Mexico, was the implausible viewpoint that members of the various popular organization—at least 3,000 different unions in the CTM alone—somehow had the same assumptions about visual languages and pictorial codes whatever the region and the particular indigenous communities located within them. Yet several of the urban-based popular organizations, such as the Confederación Sindical Unitaria de México (CSUM), were more accustomed to photos than prints, while agrarian unions, such as the Confederación de Campesinos de México (CCM) or the Confederación Nacional Campesino (CNC), were far more inurred to popular broadsheets in a print format. Which visual language, which medium, which narrative was most effective for communicating with both clusters of popular organizations?

Furthermore, the TGP declared rather naively that serious art "must reflect the social reality," as if it were possible simply for artists to reflect passively what they had seen. Yet, the other intentions avowed by the TGP members entailed a good deal more than merely mirroring social reality. Indeed, the TGP was committed to remaking reality, which, as many theorists on the Left recognize, involves the old Brechtian aim to hammer reality with art, so as to help reconfigure it. Such a revolutionary conception of art is after all actively interventionary, not just passively descriptive or reflective of reality.

Finally, the TGP seemed at one point to assume that art was automatically subordinate to structural forces, in keeping with the economic base (a key assumption of Stalinist period economism). Yet, at another point, they asserted their artistic independence, their cultural autonomy, which would ultimately allow them to "make a difference" in terms of how the economic base itself was structured. Along the way, the TGP in fact acknowledged art's status as a language, which is tantamount to recognizing that art can never simply exist in a symmetrical, one-to-one relationship with life. This is contrary to what any reflectionist theory based upon art as a mere "mirror" necessarily assumes. Here the TGP emerged as distinctly nonpopulist when it spoke of "elevating" the popular taste in art through more expansive critical engagement with their artworks.

Implicit in this position was the surprising but necessary vantage point that the "politically correct position"—something members of the Communist Party claimed they always had—was simply not enough to guarantee artistic success owing to art's asymmetrical relationship both with ideological determinations and political declarations. The very complexity of their predicament tells us a great deal, however, about the remarkable achievements of the TGP, especially its most accomplished members—from Leopoldo Méndez, Pablo O'Higgins, and Castro Pacheco to Mariana Yampolsky, Everardo Ramírez, and Elizabeth Catlett. The gap between the rigor of their collective aims and the unpredictablity of the dispersed popular reception in Mexico actually points to a problem with the emerging public institutions wherein all three constituencies would meet. In short, institution-building in Mexico had arrived at an impasse by 1940 and the TGP artists were constrained, though not destroyed, by it. As such, the superb prints of the Taller sometimes existed in contradiction to the various forces motivating their production. Yet, all of this did not stop the TGP from exercising a profound and salutary influence on major print production throughout the post-war Americas, from the Center for Puerto Rican Art that in 1951 produced the notable portfolio called *La Estampa Puertorriqueña* through the Taller Gráfica Experimental in Nicaragua that created many of the major posters from the 1980s during the Sandinista years to the contemporary mixed media prints by Juan Sánchez in New York City.

Critique: the "Socialization of Art"—A Future Challenge

A stalemate soon emerged in Mexico and elsewhere, first in the 1940s with the struggle against fascism and then in the 1950s with the onset of the Cold War. This new predicament was notably at odds with the visionary prospects for social transformation that emerged in the most luminous and hopeful murals of the 1920s and 1930s. In fact, a nostalgic and backward-looking idealism often came to the fore in Mexico as many on the Left found themselves stranded from popular movements. Such was the case with the unjustifiably upbeat murals by Rivera about pre-Columbian cultures that from 1945 to 1951 were painted in the patio of the Palacio Nacional.

Yet, at the same time Mexico—and especially Mexico City—became a commanding world-class intellectual center, a sort of "Paris" of the Americas, in which left-wing dissidents from the intelligentsia of the Americas could not only find tolerance, but also invaluable support. Thus, many major Latin American intellectuals—from Che Guevara, Fidel Castro, Gabriel García Márquez, and Adolfo Gilly through Nestor García Canclini, members of the the Sandinista leadership like Ernesto Cardenal, and cadres of the FDR from El Salvador—found at some point a congenial refuge from the right-wing repression in their own Latin American countries, during the period extending from the 1950s to the 1990s. Aside from granting political asylum to Leon Trotsky (from 1937 till his assassination by Soviet agents in 1940) at a time when no other nation in the world dared to do so, Mexico also provided indispensable space to exiled revolutionaries, such as Fidel Castro and Che Guevara. In fact, it remains an open question as to whether or not the Cuban Revolution of 1959 could even have been launched when it was (in November of 1956), had Mexico not been such a favorable place in which to prepare for a revolution.

The vital intellectual role played by Mexico in sanctioning the Cuban Revolution has been summed up well by Richard Harris in his book on Ernesto "Che" Guevara:

When Ernesto arrived in Mexico City [to escape imprisonment in Guatemala following the 1954 military coup there], he discovered that it was a haven for exiles from all over Latin America. . . . Most of these exiles lived in the same *pensións* and frequented the same bars and cafes. . . . Ernesto managed to make ends meet as a photographer. . . . In one of the many gatherings of his fellow exiles, Ernesto met Raúl Castro, Fidel Castro's brother. The two Castros had arrived in Mexico in mid-1955, following their release from a Cuban prison. . . . Through Raúl, he met Fidel. They immediately took a liking to each other and became close friends. . . . Fidel established a secret training camp for his group at a large ranch in the mountaineous *Chalco district* of Mexico. . . . In November 1956 Che and the others departed for Cuba on an old launch named *Granma*.[153]

Furthermore, the Universidad Nacional Autónoma de México (UNAM)—including such institutes as the Instituto de Investigaciones Estéticas founded in 1935—became the counterpart to Oxbridge in the UK, to the Sorbonne in France or to Harvard and Princeton's Institute for Advanced Study in the United States. Even when, after 1946, the general dynamic of political economy in Mexico involved an increasingly conservative form of manic modernization pursued by the Administration of Miguel Alemán, the country nevertheless remained a site of intellectual and artistic prowess with few rivals in the Americas until the Cuba of the 1960s. (It was probably with the Havana Cultural Congress in January 1968 around the theme of "The Intellectual and Liberation Struggles in the Third World" that Cuba definitively emerged as "the American capital of the 1960s.") To the credit, though, of every post-1945 administration in Mexico, the country stood as a significant counterweight in international affairs to the imperial policies of the United States.

Revolutionary Cuba, for example, has always been accorded a marked degree of respect, and autonomy, by the Mexican Government. Alone among all Latin American nations, Mexico never broke diplomatic relations with the revolutionary government in Cuba nor endorsed an economic embargo of the island. This was a particularly impressive stand at that time, since the United States government applied enormous pressure on all other countries in the hemisphere to ostracize the Cuban Revolution of 1959. Such a courageous and independent national foreign policy represented a potent afterlife of the Mexican Revolution of 1910 and helped to offset the implacable hegemony of the U.S.A.—even when all else had taken a right turn domestically in Mexico itself. Moreover, it is significant that the current probusiness President of Mexico, Vicente Fox, has continued this admirable tradition of independence in international affairs with respect to Cuba, despite the outspoken pro-capitalist sympathies he has always championed otherwise. In fact, Fox even admitted during a 1999 visit to the island nation

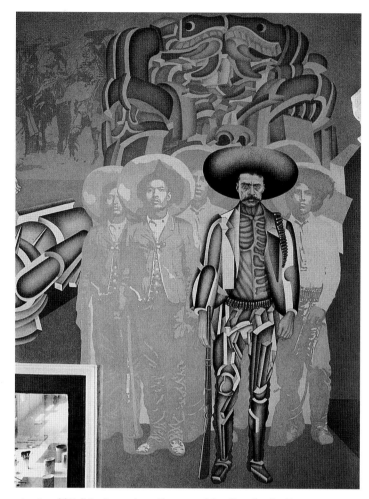

56 Arnold Belkin, *Prometheus: Zapata and Sandino*, detail of Zapata, 1984–85, acrylic, Palacio Nacional, Managua. (Painted in Nicaragua on the seventy-fifth anniversary of the Mexican Revolution.)

that "Cuba was a model in health and social services" for Mexico and all other Latin American nations.[154]

Perhaps not surprisingly, it was the energetic, if doctrinaire, David Alfaro Siqueiros who assumed the main role as a muralist in Mexico after 1940 (although there was some stiff competition at certain points from Rufino Tamayo in the international arena). Indeed from the early 1940s until he died in 1974 (long after the death of Orozco in 1949 and Rivera in 1957), Siqueiros continued to be the "official" painter of revolutionary murals. This undoubted series of successes was based upon such innovative technical ideas as those of using polyangular space, synthetic materials (like Duco), and even air brushes. In fact, it was these technical innovations that would be the source of his influence on certain tendencies within the Nicaraguan Mural Movement of the 1980s.[155] His notable murals included several artworks that are as publicly prominent as they are technically commanding: *Retrato de la Burguesía* (Portrait of the bourgeoisie) of 1940 in a union hall, that of the Sindicato Mexicano de Electricistas; *Nueva democracia* of 1945 in the Palacio de Bellas Artes; *El pueblo a la Universidad, la Universidad al pueblo* (The people in the univer-

sity, the university of the people) of 1956 on the main facade of the Rectory of the Universidad Nacional Autónoma de México; and *La marcha de la humanidad* of 1968 in the Polyforum Cultural Siqueiros, Hotel de México. The convulated politics engulfing Siqueiros's last great project have been disentangled in a now classic study that tells us much about his compromises with the PRI, the institutionalized "revolutionary" political party that emerged as a conservative force for Western modernization only after 1946 in the post-Cárdenas era.[156]

Siqueiros also trained the leading muralists in Mexico of the 1980s and 1990s, such as, Arnold Belkin, whose portrayals of Zapata and Sandino remained highpoints of this insurgent period. In 1984–85, for example, Belkin painted a compelling mural featuring Zapata and Sandino in the Palacio Nacional of Managua, to celebrate the fifth anniversary of the Nicaraguan Revolution and the seventy-fifth anniversary of the Mexican Revolution (fig. 56). Yet, the ascendency after 1940 of Siqueiros, the major "official painter" of the increasingly marginal Communist Party, is somewhat ironic. Just as the Mexican CP declined from thirty thousand members to a mere three thousand in only a decade (1940–50), so the Soviet-backed parties (not unlike the U.S. Government) became frequent barriers to progressive change in Latin America. This record was consistent with the party's history, especially in Mexico.

Although it was the oldest Communist Party in Latin America—having been founded in 1919—the Partido Communista Mexicano was seldom a significant force in the intellectual or political life of the nation, except for a few years during the Presidency of Cárdenas.[157] In the end, both the Cuban and Nicaraguan Revolutions were possible only when the national liberation movements in their respective countries—the July 26th Movement and the Sandinista National Liberation Front—broke with the official, Soviet-backed Communist Parties in these two nations. Ironically, then, the orthodox party of Siqueiros became a serious impediment to revolutionary insurrections throughout the Americas, even as Siqueiros himself, the Party's main man, emerged as the leading "revolutionary muralist" in the world. (So much was this mainstream acceptance in art the case that he actually won the major prize for painting at the xxv Venice Biennale in 1950.)

Few addressed more directly the institutional blockage that stalled the Mexican Revolution of 1910–40, though, than did another more maverick Mexican artist from among "los tres grandes." When, in the 1940s, José Clemente Orozco wrote his memoirs, he brought up the problem of "socializing art." To quote Orozco on the nature of the challenge confronting any revolutionary movement in the arts and beyond after 1940 is to encounter directly what would later be one of the defining cultural aims of both the Cuban and Nicaraguan Revolutions: "Naturally, the socialization of art was a project for the distant future, since it implied a radical change in the entire structure of society. Besides, it was also necessary for artists to provide a definition for the word "socialize," in relation to art, since there were many different interpretations of this term."[158]

57 René Portocarrero, *La Catedral amarilla* (The yellow cathedral), 1961, oil on canvas, Museo Nacional de Bellas Artes, Havana.

TWO

The Cuban Revolution (1959–1989)

Socialism is young and has made many mistakes. Many times revolutionaries lack the knowledge and intellectual courage needed to meet the task of developing the new person with methods different from the conventional ones. . . . The men of the [Communist] party . . . sought an art that would be understood by everyone, the kind of "art" that functionaries understand. Authentic artistic values were disregarded, and the problem of general culture was reduced to taking some things from the socialist present and some from the dead past (since dead, not dangerous). Thus, Socialist Realism arose upon the foundations of the last century. But the realistic art of the nineteenth century is also a class art, more purely capitalist than this decadent art of the twentieth century which reveals the anguish of alienated people. Why then try to find the only valid prescription for art in the frozen forms of Socialist Realism? . . . Let us not attempt from the pontifical throne of realism-at-any-cost, to condemn all the art forms which have evolved since the first half of the nineteenth century for we would then fall into the Proudhonian mistake of returning to the past, of putting a straitjacket on the artistic expression of the person who is being born and who is in the process of making himself. . . . What is needed is the development of an ideological-cultural mechanism that permits . . . free inquiry. . . . What we must create is the person of the twenty-first century. . . . The probabilities that major artists will appear will be greater to the degree that the field of culture and the possibilities of expression are broadened.

Ernesto Che Guevara, 1965[1]

In Cuba, as contrasted with Russia, there is no attempt made to create an art that can be understood by the people, the attempt is to educate the people to the point where they can understand art. I was told that this has been the official policy of the Revolution. . . . The socialist realism of the Russians was merely so much shit. Cuba, they said, found its true socialist realism in Pop Art.

Ernesto Cardenal, 1972[2]

In the early 1960s, a delegation of high-ranking officials from the Soviet Union and Eastern Europe visited Cuba. While touring the Presidential Palace with revolutionary leader Fidel Castro, this group encountered a semiabstract mural by René Portocarrero, who was one of Cuba's leading artists until his death in 1985 (fig. 57). Everyone stopped in front of this artwork and a member of the Soviet delegation asked scornfully: "And this, what does it mean? What does it have to do with the Revolution?" Fidel Castro responded, "Nothing at all. It doesn't mean anything whatsoever. It's just some crazy stuff created by a madman for people who happen to like this kind of craziness and it was commissioned by the madmen who made this Revolution!"[3]

This episode highlights the fresh New Left aesthetic of the 1960s that the Cuban Revolution sanctioned in the face of orthodox opposition from the Soviet Bloc. A notable impact on

the arts followed in the wake of Castro's unorthodox declaration that the enemies of the Revolution were "capitalists and imperialists, not abstract art." Subsequently, to recall an observation of Peruvian art critic Juan Acha, Cuba spawned a whole new period of experimentalism in the arts without precedent in the Americas.[4] Indeed, as late as 1985, even a prominent Cuban-American scholar who opposed the radical path taken by the 1959 Revolution would begrudgingly concede that "Cuba has been at the center of cultural activity in the Hispanic world for the past twenty years."[5]

Equally revealing about the abovenoted "discussion" of art involving Soviet diplomats and the Cuban leadership was how it divulged yet again the tension between their respective social systems. In fact, the pro-Soviet PSC had been an outspoken opponent of the "ultraleftist" insurgency in Cuba throughout most of the 1950s. Furthermore, the uneasy truce in the 1960s

between the July 26th Movement and the urbanized Soviet-backed party did not keep the orthodox Cuban Communists from repeatedly attacking the "revisionist" views and so-called "pathological adventurism" of Che Guevara (who resigned from the Cuban Government in 1965 to resume guerrilla warfare elsewhere, in Africa and Bolivia). Not surprisingly, in an interview with the correspondent I. F. Stone in the early 1960s, Che underscored his own deep dissatisfaction with the Soviet Union by saying, "We are going to be the Tito of the Caribbean." Such discontent with the "right-wing deviationism" of the USSR would only increase on the part of this "pragmatic revolutionary" (as Che called himself when asked about his own lack of "orthodoxy"). Furthermore, this uneasiness grew even as the Cuban Revolution found itself increasingly drawn into the orbit of the Soviet Union by the implacable opposition of the United States Government to socialism in the Americas, regardless of how deeply "heretical" in nature it might be in Cuba or elsewhere.[7]

Yet socialist "heresies" in Cuba that were sometimes constrained in the sphere of political economy by Soviet directives found far less resistance in the arts—and on the grass-roots level of popular organizations throughout society as a whole. (This was true except for two "Dark Periods"—as the Cuban people call them—when there were bouts of stultifying orthodoxy with the temporary cultural ascendancy of Soviet influence during 1961–62 at the time of the Bay of Pigs Invasion and then again from 1970 to 1975). Cuban artists exercised a powerful influence worldwide through their Pop Art-based renovation of "revolutionary public portraits" (fig. 58) and their award-winning neo-Brechtian films that featured a degree of revolutionary self-criticism all but unknown elsewhere in the "socialist world" (fig. 59).[8] As the Cuban art critic Gerardo Mosquera would observe of the Revolution's aesthetic achievement, it was built on the critical acknowledgment of an important aesthetic premise: "Cuban culture is 'mulatto' in many of its forms, it is a product of dynamic hybridization [*mestizaje*], under specific historical and social conditions, of seeds from the West and the non-West."[9] A notably expanded aesthetic, along with an enlarged public sphere for it, resulted in an artistic vocabulary of remarkable scope, both formally and conceptually. Cuban art at its most profound (in the paintings and posters of Raúl Martínez and Manuel Mendive; the films of Tomás Gutiérrez Alea, Humberto Solas, Sara Gómez, and Sergio Giral; the multimedia works of the Volumen Uno Group—José Bedia, Juan Francisco Elso, Flavio Garciandía, Marta María Pérez Bravo, María Magdalena Campos, and Consuelo Castañeda, among several others) has gone beyond mere eclecticism or pastiche to arrive at a hybrid national synthesis of international significance from the 1960s onward (figs. 60–66). The "third generation" of the Volumen Uno movement from the late 1980s included some dynamic and quite irreverent artists working in various media: from Alejandro Aguilera González and Lázaro Saavedra González (fig. 67) to Carlos Rodríguez Cárdenas and Ana Albertino Delgado.

58 Raúl Martínez, *Siempre Che* (Che always), 1970, oil on canvas, Museo Nacional de Bellas Artes, Havana.

Less widely recognized outside of Cuba—but no less important culturally to the overarching process within this Caribbean nation—was the Revolution's commitment to socializing artistic practice through what the Cubans commonly call "cultural democracy." Generally this means that the populace has assumed a more self-conscious and participatory role in the production of culture, than is true elsewhere in the world. As part of its nationwide Movimiento de Aficionados (Movement of amateurs), the Cuban Revolution has not only greatly expanded the audience for the arts, but has also substantially increased the number of those people who are actively engaged either with performing in the arts or producing them. The issue of socializing art will thus be a key area of focus in this section.[10]

In order to discuss the overall cultural dynamic of revolutionary Cuba in relation to the social transformation generated by it, several things must be addressed in addition to the analysis of specific artworks. For example, the concrete cultural agencies and national policies instituted after 1958 must be assessed, as well as the concrete basis for them in "workplace democracy" or autogestion. Such a discussion entails a careful look at the nature of this democratization of culture and also an analysis of the transformed public sphere it presupposed. In determining how the art became more accessible to the Cuban populace as part of a decentralization of political power on the local level, I shall show how this process was also sometimes in structural conflict with the national centralization of power by a Leninist vanguard.[11] Indeed, the centrifugal forces of cultural democracy unleashed locally by the Cuban Revolution were revealingly at odds with the centripetal forces of political vanguardism associated with the Communist Party that directed the

59 Raúl Martínez, *Lucía*, 1968, silkscreen poster for ICAIC to promote the film *Lucía* by Humberto Solas.

60 (right) *Hasta Cierto Punto* (Up to a certain point), 1983, silkscreen poster for ICAIC to promote the film *Hasta Cierto Punto* by Tomás Gutiérrez Alea.

61 (far right) Antonio Pérez (Ñiko), *Images of Three Ballets*, 1974, silkscreen poster for the Cuban National Ballet.

64 Antonio Pérez (Ñiko), *Revolución en cine, cine en la revolución* (The revolution in cinema, the cinema in the revolution), 1982, silkscreen, ICAIC.

65 Juan Francisco Elso, *Por América: José Martí*, 1986, mixed media, Private Collection.

63 *(left)* Julio Eloy, *Que Bueno Canta Usted* (How well you sing), 1975, silkscreen poster for ICAIC to promote the documentary film *Que Bueno Canta Usted* by Sergio Giral.

62 *(far left)* María Magdelena Campos, *Contraceptive*, 1987, mixed media, Private Collection.

66 Manuel Mendive, *Malecón* (Seawall walk), 1975, oil on wood, Museo Nacional de Bellas Artes, Havana.

67 Lázaro Saavedra González, *Caballero, No Ven? El Era de Carne y Hueso* (Hey mister, what's up, he was only of flesh and blood?), from the *Mesa Sueca* (Smorgasbord) series 1989, acrylic, Private Collection.

revolutionary process on a national level. The latter tendencies towards vanguardism were motivated by a desire for national self-determination in the international arena, rather than by a primary wish for grass-roots based self-governance.[12]

Cultural Policy, Public Institutions, and Dialogical Art

In 1983 Armando Hart Dávalos, the Minister of Culture in Cuba, stated: "What we hope to achieve in the future . . . is for art to penetrate all spheres of life."[13] Whether or not this goal will ever be attained is still open to question, but other achievements related to it are no longer in doubt. Prominent among these accomplishments is the immense progress registered towards incorporating diverse cultural activities into the everyday experience of the Cuban public.

During the first decade of the Revolution numerous cultural agencies on the national level without precedent in Latin American history, except for the revolutionary changes in Mexico after 1920, were instituted. Among the earliest cultural acts of the revolutionary government, in March of 1959, was the founding of the Cuban National Film Institute (ICAIC). For over three decades this agency was a haven for the most flexible and open-minded figures within the Cuban government. The establishment of ICAIC followed the consensus at the first National Congress on Education and Culture in Cuba that cinema is "the art *par excellence* in our century."[14] International acclaim was not long in coming to the Cuban national film industry. Within a decade of its founding, Cuba had established itself in commanding fashion. Film critic Pat Aufderheide of the U.S.A. has encapsulated quite effectively the nature of this success:

> Cuban cinema was born without original sin, novelist-screenwriter Manuel Pereira likes to say. . . . But cinema as a national industry began with the revolution, and its tensions and textures are those of life in socialist Cuba. . . . During the 1960s . . . films such as *Memories of Underdevelopment, The Other Francisco*, and *Lucía* became the darlings of international festivals as well as box office hits at home. For a while, it looked like Cubans were developing not only a film industry but a film language . . . ICAIC also confronted pressure from the zealously orthodox. . . . He [the Director of ICAIC] asserted the independence of ICAIC from sectarian "theoretical propaganda and pseudo-cultural phraseology." . . . ICAIC even had to defend (successfully), in 1964, the right of Cuban audiences to watch Frederico Fellini's *La Dolce Vita*.[15]

Several other state institutions of considerable importance and representing various points on the ideological map were also established in 1959 by the revolutionary government: the National Ballet, the National Folkloric Ensemble, the National Chorus, and Casa de las Américas (fig. 68). This latter one, an "International Center for Latin American Art and Literature," has published a notable journal and awarded prestigious literary prizes that have occupied a fundamental role in the intellectual life of the Spanish-speaking world for over three decades. Under the able direction of author Roberto Fernández Retamar (fig. 69), this cultural institute was always an important defender of controversial artists and intellectuals whose constructive critiques of the Cuban Revolution sometimes enraged high-ranking officials in some other government agencies.

In 1971 and in 1983, for example, Casa de las Américas successfully sided with "dissident" artists against those in the Cuban government who wished to censor them. Even during the "dark period" of semi-orthodoxy from 1970 to 1975 this state agency was able to score victories against those who wrote for *Hoy*, a PCC publication and *Verde Olivio*, the official journal of the Cuban Army. Furthermore, Casa de las Américas, along with the Cuban Film Institute and the National Ballet, played a major part during the entire period from the 1960s through the 1980s in fostering a "pan-Latin," or perhaps Pan-American, identity for artists throughout Latin America.[16]

The early 1960s were hardly less noteworthy for the foundation of many other new agencies along these lines. First came the creation of the National Symphony Orchestra, and five provincial concert orchestras, then Cinemateca de Cuba, which today contains the largest collection of Latin American films in the world. Also occurring in 1960 was the establishment of the Consejo National de Cuba (National Council of Culture), which would be replaced in 1976—during the decentralization process—by the Ministry of Culture under the direction of Armando Hart Dávalos. The latter was a more wideranging and flexible agency responsible for coordinating events among the various provincial centers of culture. It was also crucial for defending a "critical" view and pluralistic practices in the arts of *el proceso*, the revolutionary process.

It was by means of its National Literacy Crusade in 1961, however, that Cuba's cultural transformation was advanced most dramatically. Considered by UNESCO and other international educational organizations to be one of the most significant events in the modern history of education, this *Alfabetización* elevated Cuba's rate of literacy from 72 percent to 98 percent in a little over two years. This was the best rate ever attained in Latin America and among the highest in the world (according to the *Quality of Life Index* of the Overseas Development Council and other international agencies). Since this time, Cuba has set the standard for literacy throughout Latin America. Furthermore, between 1961 and 1962, Cuba's number of schools mushroomed from only 2,482 to 22,458.[17]

The pedagogical approach used by the Cuban government in the early 1960s was an eclectic amalgam of John Dewey-inspired "learning-by-doing," Soviet didacticism, New Left dialogism via the early work of Paulo Freire (who in turn was influenced by Cuba's literacy crusade), and a tight student–teacher relationship that resembled an Oxbridge university tutorial. On the one hand, they used photographs to keep the discussion open as Paulo Freire would recommend, yet, on the other hand, the Cuban literacy *brigadistas* "explained" the meaning of the photos

68　Umberto Peña, *Premio Casa de las Américas*, 1975, offset print, Casa de las Américas.

69　Raúl Martínez, *Roberto Fernández Retamar*, 1981, offset print, poster for the Ministry of Culture to promote a book by Retamar, *Para el perfil definitivo del hombre: libro de ensayos* (Towards a definitive profile of man, a collection of essays).

to their students, thus circumscribing the dialogue on which the whole dialogical educative process, outlined later by Freire, was to be based. As has been noted, the more directive role assumed by Cuban teachers (in their prior selection, for example, of a set of active or "generative" words, rather than the slow discovery of such words, as in Brazil or Nicaragua) can be explained at least in part by the embattled posture of the Cuban nation. Nevertheless, the frequent paternalism inherent in this approach would hardly free the popular classes from all pre-revolutionary student–teacher and citizen–leader relationships.[18]

A successful consequence of these advances was an end to what Paulo Freire has labeled the "culture of silence."[19] By this phrase, he meant a condition of cultural disempowerment linked to the economic impoverishment and political disenfranchisement that afflict the majority of people in the Third World, that is, the majority of the world (and now even a growing minority in the West). A revealing monument to the cultural rejuvenation made possible by the literacy campaign were such cases as those of factory–worker poets like José Yañes, Eloy Machado, and Nancy Morejón, the daughter of a dock-

worker. Subsequently one of the leading poets in Cuba, Yañes was an illiterate worker in a sausage factory prior to the literacy crusade in 1961 and Morejón is now perhaps Cuba's leading international poet.[20]

Just as there was a new type of writer, so there was also a new type of reader. Along with the quantitative expansion in readership came a qualitative extension in terms of what was read. The Cuban public became much more sophisticated, as evidenced by the high caliber of the most popular authors there: Gabriel García Márquez, Julio Cortázar, Ernesto Cardenal, and, of course, José Martí, Nicolas Guillén, and Alejo Carpentier. Among the most popular non–Latin American authors in Cuba from 1959 to 1989 were Marcel Proust, Franz Kafka, Jean-Paul Sartre (who in 1961 published an important book about the Cuban Revolution), Alain Robbe-Grillet, Jean Genet, William Faulkner, and especially Ernest Hemingway, who lived in Cuba on and off from 1932 to 1960. Hemingway was also a supporter of the Cuban Revolution, as well as an admirer of Fidel Castro (he remains Castro's favorite author). A well-known image by the outstanding Cuban photographer Osvaldo Salas captured

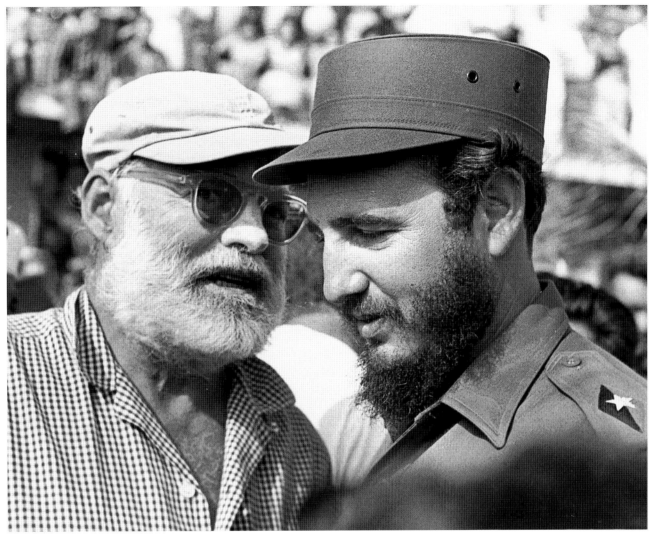

70 Osvaldo Sánchez, Ernest Hemingway and Fidel Castro, June 11, 1961.

a meeting between Hemingway and Fidel Castro on the Caribbean Island (fig. 70).[21]

One of the most moving, as well as insightful, expressions of solidarity with the Cuban Revolution was made by another U.S. author, playwright Tennessee Williams. Published in Williams's *Memoirs* (1975), this informed avowal included a perceptive analysis of the failings of U.S. foreign policy in Latin America:

The first time I went back to Havana after Castro's triumph, I was introduced to him by Ernest Hemingway. . . . He said, "You know that this revolution in Cuba is a good revolution." Well, I knew that it was a good revolution, because I had been to Cuba when Batista was in power. . . . He was a horrifying sadist. The United States, in my opinion, made a drastic error. If only they had appreciated the possibility of a détente. Castro was, after all, a gentleman, and well educated. It would have been quite possible for Cuba to have been drawn amiably into our orbit where Cuba naturally belongs, but our State Department chose instead to oust Mr. Castro. Consequently, we made an enemy of Cuba and Cuba turned toward Russia

for support. This had not happened when I met Hemingway. Anyhow, Hemingway wrote me a letter of introduction to Castro. Kenneth Tynan and I went to the palace. Castro was having a cabinet session at the time. . . . After about a three-hour wait, the door was thrown open and we were ushered in. Castro greeted us warmly. When Kenneth Tynan introduced me, the *Generalissimo* said, "Oh, that cat," meaning *Cat on a Hot Tin Roof*, which surprised me—delighted me, of course. . . . Then he proceeded to introduce us to all of his cabinet ministers. We were given coffee and liqueurs and it was a lovely occasion.[22]

Another famed writer who visited Cuba in 1960 was the French philosopher Jean-Paul Sartre. He was both distressed by the "underdevelopment" confronting the Revolution and heartened by the sober resourcefulness of the guerrillas in the face of it:

The skyscrapers of Vedado [from before 1959] are the witness of her degradation. . . . In Cuba, the craze for skyscrapers had only one meaning—it revealed among the hoarding bour-

geoisie the stubborn refusal to industralize the country. . . . In Cuba, the [revolutionary] leaders were saved by their age. Their youth permits them to approach the revolutionary fact in all its austere harshness. . . . These young people form a cult of energy, so much loved by Stendhal.[23]

In a book about his visit to Cuba during 1970, Nicaraguan poet Ernest Cardenal describes his pleasurable surprise at seeing the rapidity with which entire editions of literary works sold-out in this Caribbean country. He witnessed, for example, a ten thousand edition of his own poetry go out of stock in a week, a fifty thousand edition of writing by Mario Benedetti of Uruguay sell out in a comparable period, and a ninety thousand copy edition of *Cien años de soledad* (One hundred years of solitude) by García Márquez disappear in only a few weeks. In fact, by the early 1980s several million copies of this latter book had been sold in Cuba, a country which had a total population of only around ten million.

Colombian novelist Gabriel García Márquez has in fact sometimes been denied admittance into the United States by the U.S. State Department because of his sympathies for the Cuban Revolution and his friendship with Fidel Castro. Yet, García Márquez has personally experienced the considerable extent of his own work's popularity in the Caribbean nation. On one occasion in the 1970s, he visited Cuba in order to observe changes in some of the most rural and impoverished areas of the country. When García Márquez was introduced to *campesinos* on a farm cooperative, however, they quickly asked if he really were the author of *One Hundred Years of Solitude*, a book they had all read and admired. Instead of discussing the farm cooperative, García Márquez ended up answering questions about literature, especially his own novel.

The mid-1960s saw a continuation of these early developments, with 1962 being the year that several more significant institutions were set up, such as, the National Recording Institute for Music and the National School of the Arts at Cubanacán. British art critic Sir Herbert Read called the latter the most advanced art school in the world when he visited it in the early 1960s. Among the reasons were the architectural innovations that were introduced in the remarkable set of experimental buildings (1961–63) to house the five national schools of fine arts by three notable architects: Ricardo Porro, Vittorio Garatti, and Roberto Gottardi. At Cubanacán, Ricardo Porro designed La Escuela Nacional de Artes Plásticas, along with La Escuela Nacional de Danza Moderna. Vittorio Garatti was responsible for La Escuela Nacional de Ballet and La Escuela Nacional de Música, while Roberto Gottardi drew-up the blue print for La Escuela Nacional de Artes Dramáticas. Nonetheless, these groundbreaking buildings went underappreciated at the time owing to the "Dark Period" of the early 1960s when they were started. Between antimodernist criticisms in the CP and economic hardships induced by U.S. imperialism, these architectural structures were never entirely completed, although they were used nonetheless. They became, in the words of Mosquera,

some of the first "postmodern ruins" in the Caribbean and a testament to the pitfalls of "political correctness" in the Communist Party.[24]

In his recent history of modern art in Cuba, *New Art of Cuba*, the Uruguayan critic and artist Luis Camnitzer has traced the changing nature of this national art school. As Camnitzer notes, Cubanacán later became more conservative pedagogically and one of Cuba's two national middle art schools along with San Alejandro during the mid-1970s.[25] (The highest level art school as of 1976 is the Instituto Superior de Arte.) In 1962 the National Institute for Radio and Television was founded, and the National Commission on Museums and Monuments, whose task was the conservation, restoration, and classification of the country's architecture, was also established. After the early 1970s, a number of more specialized national centers were set up to advance scholarship in various areas. These included the Alejo Carpentier Center for Cultural Promotion, the Juan Marinello Cultural Center, Casa del Caribe (for the advanced study of Caribbean art), the Center for Musical Studies, the Centro Wifredo Lam for the Study of the Visual Arts, and the Centro José Martí.

The immensely important experimental art school, the Instituto Superior de Arte (ISA), came into being as part of the new wave of experimentation and popular mobilization that marked the period after 1975. Moreover this institute for graduate studies in art was established without any programmatic commitment to a "normative style" in art. Rather, its charge was simply to stress critical thinking, detached analysis, and logical consistency in whatever style or aesthetic concepts the art student might decide upon using. This rigorous but open-ended pedagogical approach was in large part responsible for the Volumen Uno artists of the 1980s, almost all of whom were trained at this institution. (See Appendix B for Gerardo Mosquera's assessment of the significance of art schools in Cuba).

In addition, and perhaps more conspicuously, the Cuban government began sponsoring a lengthy list of both international and national art festivals. Among these, the International Festival of Ballet (begun in 1961) was one of the most successful, while the International Film Festival and the crucially important Latin American Biennial in the Visual Arts (which was begun in 1984 and continues on up to the present) were among the most outstanding. They provided a far-reaching forum for the presentation of progressive cultural developments in the Third World. The list of national festivals was a longer one, with celebrations being devoted to the Rumba, Salsa, the Son (a type of peasant music), and numerous other popular art forms.

Even a quick survey of the concrete results generated by these institutional changes is impressive. In 1958, for example, there were only six museums and less than one hundred libraries in the entire country. By the mid-1980s, there were over 250 museums and nearly 2,000 libraries. Although very few people had ever visited a museum before the Revolution, the museum attendance by 1985 averaged over one million a year (or 10 percent of the entire population).[26] In 1958, almost a third of all Cubans were illiterate; by 1975, virtually all were literate and one

of every three was a student in some capacity. Prior to 1959, there were three university centers; by 1979 there were forty. Together these served a college population twelve times larger than the one before the Revolution. Of this number, 46 percent were women, which was one of the highest rates in the world.[27]

In 1959, Cuba published less than one million books a year; by 1980 it published over fifty million books a year, all of which were sold below production costs, with school textbooks being free to all students. (Incidentally, the first book published in an extremely large edition was *Don Quixote*, which is still one of the most widely read books in Cuba.) In 1962, the National Council on Culture sponsored events attended by four million spectators, or almost half the population. During 1975, the Cuban government sponsored events in the arts that were attended by 67 million spectators, almost seven times the national population.[28]

In 1958, there was no national film industry, although Cuba had one of the largest per capita audiences in the world, at one and a half million cinema goers per week from a population of less than seven million at the time. Grade B movies from Hollywood thus constituted over 50 percent of the films shown. By the late 1960s Cuba had a highly esteemed film institute that regularly won numerous awards in international competition and by 1980 this Caribbean island produced an annual average of forty documentaries, ten feature films, five to ten animated films, and fifty-two weeklies. Still, Cuban films made up only 5 percent of the 140 or so shown per year in over 510 theaters, with the vast majority of films coming from other Third World countries and Europe. (According to the terms of the U.S. economic embargo, North American cinema companies are prohibited by U.S. law from sending films there on a regular basis.)[29]

Complementing these other gains was a structural shift that accompanied the transition to "poder local" (local power), a process that languished after the early 1960s, before regaining considerable momentum during the mid-1970s. Foremost in this development was the establishment of a national network of "Casas de Cultura" (Houses of culture). As noted in a 1979 UNESCO publication by Gerardo Mosquera and Jaime Saruski, both of whom then worked at the Ministry of Culture, the objective of the Casas de Cultura was "to bring people into direct contact with art, to disseminate culture, to raise the educational level of the population, and to provide it with opportunities for leisure and recreation."[30]

By the mid-1980s there were around two hundred Casas nationally, including a library, a museum, an amphitheater, an auditorium, conference rooms, music halls, and art studios. It was here that young people studied dance, music, and painting free; that local artists and artisans displayed their work; that touring exhibitions were shown; that musical or theater performances by both visiting professionals and local amateurs took place. As statistics clearly demonstrate, a direct consequence of these Casas de Cultura was a new impetus to the Movimiento de Aficionados and an immense increase in the number of amateur groups involved in music, theater, dance, and the plastic arts. In 1964 there were one thousand such groups. By 1975–76, when the *Casas* were first set up, that number had risen to eighteen thousand groups, with the number of youths participating in the arts through them exceeding 600,000.[31]

Cultural Democracy and Popular Engagement with Art

This lengthy list of accomplishments concerning the socialization of artistic engagement notwithstanding, important questions still remain. What about the nature of this new public? How far did it really shift the public from the passive consumption of art to critical engagement with art? Such questions are all the more pressing because of the situation that prevailed in Western Europe and the U.S. during this same period. As Pierre Bourdieu demonstrated in a 1984 study, cultural consumption in "France and indeed the West as a whole continually generates ideological legitimacy for social differences"—differences that sustained what he termed the "aristocracy of culture."[32] As such, Bourdieu's survey further delineated the direct connection between educational level and class standing, and the nature, as well as degree, of one's interest in the arts.[33]

In France and the Netherlands in the 1960s, for example, less than 1 percent of those with only a primary education visited a museum, while over 15 percent of those with at least a secondary education frequented museums. Even more revealing was the fact that 66 percent of all blue collar workers in these countries associated a museum with a church whose religion remained mysterious, hence off-limits, while most of the managerial sector (54 percent) tended to view the museum as analogous to a library, a lecture hall, or some other site for accessible learning.[34] In other words, there was a further correlation between one's degree of workplace self-management and one's sense of having access to the arts. Thus, Bourdieu's survey showed how only the dominant groups or classes in the West have most often felt entitled to "the right to speak" on all substantive issues, whether political, economic, or cultural.[35]

Cuba was formerly a Western colony that was deeply characterized by the cultural asymmetry associated with subservience to the West. How did this country become culturally transformed, so as to enlarge the number of those who feel they have "the right to speak" about the arts? It is, after all, one thing to eradicate the "culture of silence" and quite another to foster a vigorous and enabling public discourse by the majority. In light of Bourdieu's findings concerning the connection between class power and cultural empowerment, it is clear that any look at the formal devices for opening up public participation in the arts must also include a discussion of how this cultural development is, or is not, grounded in a comparable progression within the sphere of political economy, specifically in workplace self-management.

In short, we can observe the following based upon Bourdieu's conclusions: the socialization of artistic engagement and cultural democracy in Cuba would be advanced only by a corre-

sponding democratization of the workplace. That is, el proceso would be galvanized by a decentralization of political power on the local level in relation to a re-enfranchisement of a largely "silenced majority" in the cultural realm of society. How did all of this take place in Cuba after 1959? Only if the latter two preconditions were met would there be an expanded public sphere for the arts predicated on a principled and rational exchange open to all sectors of society. Yet, how could such a move toward radical popular self-determination not create internal conflicts in Cuba? Art critic Osvaldo Sánchez certainly acknowledged the importance of overcoming governmental paternalism by a vanguard party, when he noted how "political paternalism breeds political infantilism."[36]

The answer to the first part of the above query about the social dynamic of cultural self-representation and workplace democracy is one that can be provided by scholars who attended cultural evens in Cuba from the 1960s through the 1980s. Concrete avenues for expanding public discourse about the arts existed, above all, in the ever-present, generally lively, often lengthy dialogues that accompanied most cultural activities. These were considered essential to the democratization of culture. The public dialogues about cultural events involved informal discussions that were unquestionably attended by people from all sectors of society, particularly factory workers, and were led by recognized writers, filmmakers, musicians, or visual artists.

Such well attended public dialogues accompanied, for example, the various showings of *La Habanera* (1984), a controversial film by Pastor Vega. After one projection of the film, at the Foundation for Cultural Heritage in Havana, there was an especially vigorous debate about the merits of it, with Pastor Vega himself moderating the discussion. Set in the psychiatric ward of a major Cuban hospital, the film explores the gender relationship within this strata of society. Above all, it focuses on the contradictions of the woman who heads her unit, yet is unable to apply the insights from her profession to her own private life.

The open discussion after the film intensely engaged a very heterogeneous audience representing various sectors of Cuban society—from assembly-line workers to members of the intelligentsia. Questions were raised about the plausibility of the ending, about the type of camera work, about the style of the film, and, above all, about the lifestyle of the main protagonists. One young worker stated that everyone in his factory had seen *La Habanera* and that most of them had difficulty relating to the film because of the material benefits, specifically consumer products, enjoyed by those in the medical profession. His point was clear enough. Factory workers and physicians enjoyed much the same access to social wages (to education, housing, health care, and food), but doctors did in fact receive larger salaries, hence, greater access to Western consumer goods.

In reporting on this public film forum, as well as others, a U.S. journalist had the following to say in 1984 in the *International Herald Tribune*:

Film discussions may, to the outsider, seem like college political debates, but the Cubans consider them their form of "cultural democracy". . . . Such debates may or may not have real influence on cultural policy, but they are not merely decorative. They do seem to reflect an awareness of what is happening culturally and a feeling that the opinion of the simple man in the street counts . . . in Cuba, culture is everybody's business.[37]

The basis of controversy surrounding *La Habanera* was the continued existence of a material inequality that contradicted the still more egalitarian society being invoked by partisans of the revolutionary process. This paradox itself had already become the major theme of a profound, and also widely discussed film of 1983. In *Hasta Cierto Punto* (Up to a certain point), Tomás Gutiérrez Alea engaged in a self-critical examination of how a Cuban filmmaker intent on shooting a film about the residual machismo among workers is forced to confront his own otherwise unacknowledged and more subtle sentiments in favor of gender inequality. Not surprisingly, his own machismo, that of an intellectual, manifests itself in a more oblique way owing to his higher educational level and different lifestyle. Here as elsewhere there was no "happy ending," so that the problem of gender inequality was not shown as having been ended by the revolutionary process. Thus, these contradictions had not been eliminated by the revolution but only relocated to a higher historical plane more amenable to resolution, Gutiérrez Alea himself summarized the revolutionary process as follows: "We have to undergo certain contradictions. We discover things that we feel we have to fight against. But this new struggle takes place on another level."[38]

The manifest coexistence of various ideological tendencies within the Cuban national state, as well as within the Communist Party and among local groups, was demonstrated compellingly by the extensive controversy and intense public debate that surrounded Jesús Díaz's film entitled *Lejanía*. Made at the Cuban National Film Institute in 1985, *Lejanía* addresses the highly volatile issue of the difficult relationships within families whose members are divided between those committed to the revolution and those in exile in Miami. Along the way the film depicts a corrupt official in the Communist Party and also openly acknowledges the ongoing shortage of consumer goods in Cuba. Yet Díaz also seems to indicate that this will remain for some time an unavoidable feature of the struggle to overcome the social injustice of underdevelopment in a Third World country plagued at present by the economic legacy of colonialism and also by simple geographic scarcity.[39]

The public reception registered a variety of reactions to this film. A small but powerful sector of the Communist Party sought to prevent the film's release because of the way it admitted venality among some party members, while also casually conceding that consumer goods still unattainable by the average Cuban were readily available to Cuban exiles in the U.S. Largely in response to the negative reaction of these groups, *Lejanía* was not reviewed in the mass media or in *Granma*, the major news-

paper in Cuba that is controlled by the Communist Party. This lack of media attention for an important film by the National Film Institute was virtually without precedent in Cuba, as Dan Georgakas has noted.[40]

Yet, despite this official silence in the national mass media, the film still became something of a sensation with the Cuban public through the abovenoted types of public dialogues on the local level. The director, Jesús Díaz, received numerous invitations to speak at factory assemblies, workplace discussions, university colloquia, and film club meetings. Eventually, *Lejanía* became one of the most well-attended films of the year even though there was no discussion of it in the national media. Perhaps more paradoxically, it won the Cuban Film Critic's Award and then the International Critic's Prize at the 1985 Havana Film Festival. Only with the publication of an interview with Díaz in *Cine Cubano* (a journal of the Ministry of Culture, which since 1976 had been a defender of "critical" artworks) did the ban in Cuba on official governmental discussions of *Lejanía* finally come to an end.[41]

Even among the public sectors that reacted favorably to *Lejanía*, though, there was widespread disagreement about various aspects of the film. While many were pleased to see a film about a very sensitive issue that troubles almost every family on the island, the public discussions provided no clear consensus about the adequacy or inadequacy with which the film addressed the various problems that it raised. Ultimately, *Lejanía* succeeded most at strengthening the position in the mid-1980s of the most open-minded members in the Communist Party and in government institutions. These groups favored the production of artworks that raised controversial issues for open public debate in popular dialogues, instead of art that simply repeated official information about what had already been achieved by the Revolution. (The release of such provocative films as Tomás Gutiérrez Alea's 1994 *Strawberry and Chocolate* is instructive here. This critical, even disquieting cinematic look at the predicament of the homosexual community in contemporary Cuba indicates that there is a continuation on into the 1990s of a trend towards producing state-financed films with constructive criticism).[42]

In the animated public dialogues throughout Cuba about films like *La Habanera, Hasta Cierto Punto*, and *Lejanía*, one encountered the realization that Cuban people from all sectors were neither reluctant to speak out nor afraid to criticize what they had seen. This was especially true of dialogues around films in a country where almost all people consider themselves film critics. As the abovenoted North American correspondent observed, a visitor definitely left these public debates with the sense that "culture is everybody's business" because these dialogues conveyed a feeling that the views of all citizens really matter. Just as people from every sector of the population participated in music, or could be seen at the first Cuban Biennial art exhibition in 1984, which was attended by over 175,000 people, so people from all strata of society attended the film debates about *La Habanera* or *Lejanía*.

71 Antonio Fernández Reboiro, *Memorias del subdesarrollo* (Memories of underdevelopment), 1968, poster for ICAIC film *Memorias del subdesarrollo* by Tomás Gutiérrez Alea.

In fact, the cultural dialogues that emerged in Cuba during the 1960s inspired poetry and became ancillary themes in cinema, thus shaping the formal logic of the artworks in question. A masterful early use of this motif occurs in Tomás Gutiérrez Alea's *Memories of Underdevelopment* (1968), a prize-winning work that is simply one of the finest films of the twentieth century (fig. 71). During a brief part of this densely kaleidoscopic work, there is a public debate about the problem of underdevelopment, its historical origin, and so forth, which prompts a North American (played by Saul Landau) in the audience to remark caustically: can't you do anything more revolutionary than have "an archaic form of discussion?" His dismissive statement in turn strikes a sympathetic response in the mind of the main protagonist, Sergio, a handsome, wealthy, and well-educated man still holding firm to old privileges and inequities in the midst of these strange new social phenomena after 1959.

Sergio Corrieri, who is an ironic embodiment of Hollywood "perfection" in the mold of Cary Grant, leaves the open dialogue acting as if this new public discourse is simply an unpleasant symptom of underdevelopment per se. As such, Gutiérrez Alea looks incisively at the pervasiveness of these new public dialogues, yet through the eyes of one unsympathetic to them. Of necessity, a critical intervention by members of the audience is called for, in order to resolve this debate within the film and in turn decide the fate of these dialogues outside the film. In an interview with scholar Julianne Burton, Gutiérrez Alea noted that the very well-known film had accomplished its goal in Cuba, "in the sense that it disturbed and unsettled its audience; it forced people to think."[43]

About the intended neo-Brechtian quality of this film, Tomás Gutiérrez Alea further explained:

> In my view, the Sergio character is very complex . . . That is to say, he has a set of virtues and advantages which permit the spectators to identify to a certain degree with him as a character. . . . The spectators then have to re-examine themselves and those values, consciously or unconsciously held which have motivated them to identify with Sergio. . . . The film does not humor its audience; it does not permit them to leave the theater self-satisfied. The importance of this phenomenon lies in the fact that it is precondition for any kind of transformation . . . [the film activates] those mechanisms which can be unleashed that aid the audience "to participate in the critique of itself," as Antonio Gramsci put it.[44]

Similarly, a 1979 poem by Nelson Herrera Ysla entitled "Coloquialismo." (Colloquialism) celebrated these everyday dialogues as a seminal force for the art form that he practiced:

> Forgive me, defender of images and symbols.
> I forgive you, too.
>
> Forgive me, hermetic poets for whom I have boundless
> admiration,
> but we have so many things left to say in a way
> that everyone understands as clearly as possible,
> the immense majority about to discover the miracle of
> language.
>
> Forgive me, but I keep thinking that Fidel has taught us
> dialogue
> and that this, dear poets,
> has been a decisive literary influence.
> Thank you.[45]

These dialogical tendencies in the construction of artistic meaning inspired and were themselves subsequently advanced by Brazilian educator Paulo Freire's theory of "dialogical pedagogy" in the late 1960s. (See below, in chapter three, for a sustained discussion of Freire's ideas.) Henceforth, he wrote, advanced culture must be arrived at through a dynamic interchange involving the majority. This contrasts with the hege-monic concept of culture (shared both by conservatives and certain sectors within the avant-garde) as a closed set of exclusive values simply transmitted to the majority.

The most sophisticated film directors in Cuba have engendered this dialogical process of cultural democracy by means of directorial self-criticism and an internal critique of the filmic medium. As such, they have called attention both to the open-ended nature of cinematic statements and to the critically consummative role of the public. In this way, the best Cuban films (several of which have already been noted) initiate a critical dialogue with the public, rather than merely presenting an artistic monologue before an audience. As has been said by Alfredo Guevara, a one-time Director of the National Film Institute: the major aim of Cuban film production was "to demystify cinema for the entire population; to work, in a way, against our own power . . . to dismantle all the mechanisms of cinematic hypnosis," in favor of critical discourse.[46] Termed "cultural decolonization," this process featured an advanced use of medium self-consciousness to call attention to the social limits and ideological dimensions of the medium.

This was particularly important for cinema, since it is often assumed to be conceptually transparent and thus only technically problematic. Various formal strategies were used by Cuban directors, all of which had extraformal consequences for the viewer's participation in a critical dialogue. These devices extended the innovations by Jean-Luc Godard of French cinema, Piero Paolo Pasolini of Italian Neo-Realism, Dziga Vertov and Sergei Einstein of 1920s Russian filmmaking, as well as those by Glauber Rocha of Brazilian Cinema Novo.[47]

Among the formal strategies in Cuban films for triggering interpretive involvement by the audience were several that should be mentioned. These included a Brechtian use of temporal dislocation to undermine linear narrativity and an attentiveness to the actual mechanics of filming (hence, also an artistic production per se as a form of labor). They also entailed a montage shifting between documentary footage and fictional passages, along with a parodistic use of Hollywood genres like Westerns or War films.

Among Cuban films, those of Tomás Gutiérrez Alea, Julio García Espinosa, Sergio Giral, Sara Gómez, and Marisol Trujillo seemed to feature these experimental techniques most often. The commanding cinematic works of Pastor Vega and Humberto Solas incorporated them the least. Aside from creating films to accommodate this new public participation, Cuban cinema was exemplary in another respect—the way it acknowledged the multiethnic character of its public. As U.S. novelist Alice Walker observed in 1977 of Cuban films: "[they] are excellent examples of how a richly multiracial, multicultural society can be reflected unselfconsciously in popular art."[48] (Alice Walker has long been a prominent figure in the international movement to end the U.S. economic embargo on Cuba—an embargo that has been denounced throughout Europe and Latin America, as well as in the General Assembly of the United Nations.)[49]

Cuban literature, including song lyrics, featured formal elements and expansive cultural concerns that were analogous to those in films. While Cuba's greatest modern writers, namely, Nicolas Guillén (1902–1990) and Alejo Carpentier (1904–1980), grew to artistic maturity prior to the Revolution, they did so by means of indigenous Afro-Cuban idioms and European traditions that gained widespread influence only with the popular transformation of culture in 1959. Both authors were lifelong supporters of the Cuban Revolution. It was quite fitting that Nicolas Guillén was the poet laureate of the Revolution, as well as a onetime president of the Union of Cuban Writers and Artists (UNEAC). He was a person of African descent who had long been known for writing poetry of rich hybridity that synthesized various popular art forms with high culture.[50]

The powerful legacy of Guillén's writings from the 1930s forward served as a signal point of departure for the renewal of Cuban poetry and the public for it after 1960. The nature of Guillén's achievement and the reason it would have such profound ethnic resonance within the Revolution, has been summed up well by Mike González and David Treece:

[With Guillén] Blackness became coterminous with nationhood, and the *son* and the voice that sang it became representative of national pride. It was Cuban rather than black culture that Guillén ultimately celebrated, a culture that, like poetry, was the product of a combination of elements, currents, histories. . . . Nonetheless, the voice that spoke the poetry, the persona at its core, was black, rooted in popular culture and speech, and the bearer of a collective experience of oppression. . . . The collective voice was Cuban (and not an ancestral African voice); it had a history and was informed by a social experience and a collective response enshrined in popular culture. Culture was now seen in relation to socioeconomic relations; thus the black idiom expressed a general experience of exploitation and oppression.[51]

If the decades after 1959 did not produce any new writer to match the international standing of Guillén or Carpentier, these years nevertheless produced several writers of undeniable importance: Miguel Barnet, Reynaldo González, and Nancy Morejón stand out in this respect. This period also saw a newly dynamic interchange between recognized writers and the Cuban populace. Both Miguel Barnet (in *Canción de Rachel*) and Reynaldo González (in *La fiesta de los tiburones*) helped to advance a postcolonial hybrid literature approaching the ones earlier achieved in work by Guillén and Carpentier. Barnet and González did so through a collage-like approach that both questioned the role of the author and presented the activity of reading as a socio-political act, in addition to being an aesthetic one.[52]

Meanwhile, the notable and older author Lezama Lima worked in a private vein along more traditional lines after a controversy around his homoerotic novel *Paradíso* in 1966. The highly accomplished and equally caustic author Guillermo Cabrera Infante, however, left the island for European exile during a tense and censorious political debate of the "Dark Period" in 1961, as did Severo Sarduy. (Cabera Infante is easily the most gifted of the Cuban authors to have gone into political exile before 1989 and far exceeds in significance such minor figures as Reynaldo Arenas.) This controversy led to the abrupt cessation of the supposedly "ultraleft" *Lunes de Revolución*, along with the regrettable government censorship of the film *P.M.*, a "decadent" look at night life in Havana. This censorship happened as part of a power struggle on the Cuban revolutionary left in the earliest years of the Revolution. Unquestionably, this episode was a major setback and a serious mistake in literature for both the revolution and for Cuban letters in the early 1960s.

An excellent example of some of the abovenoted dialogical traits for engaging a newly expanded public (in keeping with the "death of the author" thesis of the late 1960s) can be found in the song lyrics of Silvio Rodríguez. One of the major figures in Nueva Trova, or New Troubador folk music, of the 1960s and 1970s (along with Sara González and Pablo Milanés), Silvio Rodríguez used an acute sense of authorial self-criticism plus deft double-entendres on historical events in his popular song, *Playa Girón*. This title was replete with multiple meanings, since it is the Spanish phrase for the place that is mistakenly referred to in English as the "Bay of Pigs" and it was also the name of a fishing vessel upon which Rodríguez once worked. His dialogical lyrics are as follows:

Compañeros poets:
I'd like to ask—it is urgent—
what kind of adjectives should be used to make
the poem of a boat without its getting sentimental,
apart from the vanguard or obvious propaganda
if I should use words
like the Cuban Fishing Flotilla and *Playa Girón*.

Compañeros musicians:
Taking into account those polytonal and audacious songs
I'd like to ask—it is urgent—
what kind of harmony should be used to make
the song of this boat with men no longer children
men and only men on deck
men in black and red and blue
the men who man the *Playa Girón*.

Compañeros historians:
Taking into account how implacable truth must be
I'd like to ask—it is urgent—
what I should say, what limits I must respect
if someone steals food and afterward sacrifices his life what
 must we do
how far must we practice the truths:
How far do we know.
Let them write—then—the story, their story
The men of the *Playa Girón*.[53]

New directions featuring a dialogical aesthetic also arose in Cuban theater in the mid-1960s. These developments engaged portions of the public otherwise unattracted to the classical European drama presented in the major urban centers. Two professional groups, one originating in Santiago and the other in Havana, decided to reclaim much older forms of street theater, called simply "relaciones." These traditional forms were based on indigenous Afro-Cuban music, dance and masks. In 1971, the Santiago group became known as Cabildo Teatral—a title adopted from a colonial word meaning both an assembly of civic leaders and the general grouping of black citizens.[54]

The new relaciones drew on stock characters from the Golden Age of Spanish drama, along with myths from Afro-Cuban traditional music and dance, in addition to social values from the Cuban present. They were first staged in the main plazas of the low-income, largely black neighborhoods of Santiago. When performing in other demographic areas, such as agrarian ones, Cabildo Teatral would stage street theater that drew on folk music and dances like the décima, the guajira, the son, and other forms of *campesino* popular culture.

The second tendency of the New Theater in Cuba was represented by the Grupo Teatro Escambray, which began in 1969 when professionals from Havana (like Sergio Corrieri) took relaciones to some of the most underdeveloped parts of the island. A number of their works dealt with rural folklore, or popular culture, and historical events peculiar to the area. Numbering at least twenty by the mid-1980s, groups such as Cabildo Teatral and Teatro Escambray worked in consultation with local mass organizations like worker councils in factories. Their main objective, as well as major success, was to involve their audiences, which were normally not audiences that attended the theater, in the structure of the production itself.[55]

In some performances, public discussions were used as a starting point for the relaciones. In others the performance was designed to end with the audience turned into a public assembly. Folk music typical of the region was used in the choreography, with performances often terminating in an early Cuban dance form of festivals, namely, the "guateque" (dance line), which was composed of spectators and performers weaving around the city streets.

The success of postrevolutionary street theater both in appealing to and involving the working class was underscored in a 1980 interview with a Cuban performer by author Margaret Randall. The person interviewed was an actress of the Participating Theater Group, which performs near the loading docks of Havana's maritime port. She noted,

> no one here ever used to go to the theater. Now, hundreds of workers have been turned on to serious theater as a worthwhile activity. Going to a play has become something they like to do in the evening. First, the dock workers came out of curiosity to see their fellow workers acting. Now you'll find them at any performance in the city.[56]

Autogestion and the Socialization of Art

To return to Bourdieu's aforementioned studies: what were the political and economic formations in relation to these undeniable gains toward the democratization of culture? Such enhanced access to the arts would hardly have been possible without substantial changes—changes not only on the national level in education, but also on the local level in terms of worker self-management to advance the democratization of the workplace. From the early 1960s up through the 1980s, Cuba's political life was characterized by a peculiar form of leadership, at once unelected and yet characterized by considerable public accessibility. In these years, there was what James Petras called in 1985 "a continuous informal dialogue that is found in few other countries of the world."[57]

Nonetheless there was also a disturbing tendency in the early 1960s and again in the early 1970s (as well as after 1989) towards

72 Alfredo Rostgaard, *La Muerte de un burócrata* (The death of a bureauocrat), 1967, silkscreen poster for ICAIC to promote Tomás Gutiérrez Alea's *The Death of a Bureauocrat*.

an excessive centralization of power along orthodox Leninist lines, with a matching tendency to state bureaucratization. This latter development became an issue of national controversy when Tomás Gutiérrez Alea, in his immensely popular film *The Death of a Bureaucrat* (1967) (fig. 72), deftly satirized the debilitating consequences of this mushrooming national bureaucracy. The controversial topic of a growing monopoly of decision-making by the managerial sector became an even more hotly debated issue in 1970. In a series of national polemics, even Jorge Risquet, the Minister of Labor, and President Castro publicly attacked the minimal amount of workplace democracy, the weakness of unions, and the virtual absence of worker self-management, or autogestion.[58]

After this period of national discussion in the late 1960s and early 1970s, the Cuban people generally embarked on a process of pronounced decentralization, one of marked debureaucratization up until 1989. The structural dynamic, which was spelled

73 Servando Cabrera Moreno, *Retrato de Teresa* (Portrait of Theresa), 1979, silkscreen poster for ICAIC to promote the film *Retrato de Teresa* by Pastor Vega.

out in the new Cuban Constitution of 1976, led to a considerable shift in the distribution of political power, from the national level to poder local ("local power" based on the popularly elected assemblies of the municipalities).[59] The result was an institutionalization of grass-roots democracy without a matching process in relation to parliamentary democracy on the national level.

This process presupposed popular mobilization and gave rise to a degree of autogestion, or workplace democracy, that was hardly matched anywhere in the world. The election of worker representatives to the Management Council, along with quarterly meetings between the Council and factory delegates, insured the ongoing managerial involvement of ordinary workers, who also acquired a new authority to dismiss bad management. By 1976, 80 percent of all workers felt they were able to make decisions of key importance to their production assemblies.[60] In 1980, the national economic plan was discussed in 91 percent of all Cuban factories, with workers' suggestions being used to amend the plan in 59 percent of all enterprises. Cuba's advanced level of worker self-management was even more impressive when one remembers that, as Benavides Rodríguez pointed out, a majority of its labor force was still in the sphere of production (54 percent), with the service sector being 20 percent, the professionals and technicians being 18 percent, and the administrative sector (including party cadres) being only 8 percent.[61]

Significantly for the present analysis, the reconstituted trade union committees, labor councils, and other mass organizations were involved with making decisions not only regarding production levels and working conditions, but also about cultural activities both in the factory and in the community at large. In fact, there were few factories without dance troupes, music groups, or some other cultural brigade. One such factory-based dance troupe appears, for example, in Pastor Vega's very fine feminist film, *Portrait of Theresa* (1979) (fig. 73), which was a big hit at the end of the decade.[62]

The uniqueness of the Cuban Revolution after 1959 was a consequence of Cuba's uniquely underdeveloped situation before the 1950s. No one has explained more deftly, than James Petras, the unusual circumstances that allowed the Cuban Revolution to chart "unknown" terrain throughout the Americas. He did so in terms of workplace democracy, cultural democracy, and popular democracy:

Cuba was the last country to overthrow Spanish colonialism—and the first to encounter U.S. imperial aspirations. In the 1930s, Cuba became the first country in the Western Hemisphere in which workers temporarily established soviets. It was the first country under the Good Neighbor Policy to have its government overthrown by the U.S. policymakers without the direct use of U.S. military force.... Cuba thus came into the modern period with two political experiences which profoundly shaped its political development: an aborted national revolution and an aborted social

revolution. . . . The Cuban Revolution of 1959 telescoped both phases of Cuban history: the national revolution merged and, under the conditions of twentieth-century capitalism, produced a socialist revolution. Failing to complete the struggle against nineteenth-century colonialism, Cuba was the first Latin American country to succeed in overthrowing twentieth-century imperialism, lacking a bourgeois revolution led by an entrepenurial puritan elite. Cuba experienced a social revolution which prepared the way for realizing the goals of a highly productive developing society guided by a collectivist ethic. . . . For both reasons, the Cuban Revolution from the beginning took shape as a mass social revolution; it was not . . . a "middle class revolution" that would later be "betrayed."[63]

As such, the Cuban revolution became the overdetermined historical juncture at which these postponed developments were first able to re-emerge, converge, and be realized independently. The means whereby these revolutionary advances were possible rested most heavily with a mobilized working class, both in the urban and agrarian sectors. During the crucial 1959 deadlock within the revolutionary government, for example (between President Urrutia—who was speaking for moderate fractions in the middle class—and the guerrilla-led popular classes—75 percent of whom were rural wage laborers, not just landed peasantry), it was precisely the mass base composed of the popular classes that resolved the dispute in favor of the latter, and hastened the radicalization of *el proceso*.[64]

At this crucial point in 1959 what determined most deeply the trajectory of the Cuban Revolution was less a recourse to arms by the guerrillas, than the massive general strike of June–July 1959 that was led by the Cuban Confederation of Labor (CTC). This key struggle, which was decided in favor of the working classes (since no professional army was there to break the strike), disallows any retroactive claim that Fidel Castro "hijacked" the Cuban Revolution through ultravanguardist maneuvers.[65]

Any such simplistic reading of history not only ignores the militant resolve of the popular classes in Cuba at that moment, but also overlooks the extent to which nationhood and revolution have become so profoundly identified since 1959. As Louis A Pérez, Jr., has pointed out:

Much of the capacity of the government of Fidel Castro to survive even under the most difficult circumstances [from 1959 to 1989] was related to the larger issues of Cuban nationality, specifically to the degree to which nation and revolution were fused to form a larger metaphysical construction.[66]

Far from being mere vanguard accomplishments, then, cultural democracy and the project of socializing art within the Cuban Revolution of 1959 were in fact manifestations of the Cuban populace intervening in history and assuming an active role in national affairs. Revealingly, the degree to which this majority participation greatly expanded the cultural resources of Cuba helps us to understand how a dance critic for the *New*

York Times wrote with disbelief in 1979 of the exceptional quality of the Cuban National Ballet under the direction of Alicia Alonso. Its international distinction and acclaim were, he conceded, out of all proportion to the country's small size and limited resources.[67]

Popular Culture versus Populism

In concluding our discussion about the democratization of culture and the transformation of local governance, some general observations are in line about the nature of art fostered by these new circumstances. As is now clear, concomitant with an altered view of art's relation to society there was a fundamental redefinition of art itself. To a greater degree than in most other countries, Cuba was able to advance a fundamental insight earlier made by Caribbean writer Frantz Fanon of Martinique in his famous book, *Les damnés de la terre* (The wretched of the Earth) (1961).[68]

As Fanon noted—and as critics in Cuba like Roberto Fernández Retamar, Roberto Segre, Gerardo Mosquera, and Osvaldo Sánchez, among others, have shown—there are crucial differences between a progressive, internationalist popular culture that draws on indigenous art, and a regressive cultural populism that is based primarily on Western mass culture. Far from being the mere revival of static forms from the past, such revolutionary popular culture entails the collective effort of a people in the ongoing process of self-definition. As a radical process of self-definition, it simultaneously draws on the past and yet progresses beyond it, both by means of new ideas from the present and a new vision of the future.[69]

Populist images of Western mass culture (Coca-Cola billboards, Walt Disney Comics, Las Vegas architecture, TV soap operas and the like) are largely engineered from above by multinational corporations in order to sell products, inculcate hierarchical values, and even promote Western ethnocentrism. Conversely, even when the genuine popular culture of a Third World country recycles Western mass cultural forms, the result is necessarily generated from below by the most exploited sectors and in marked opposition to the abovementioned values of corporate capital. Such a process of cultural self-realization is necessarily one based on a popular appreciation of ethnicity that—mediated as it is by international solidarity with others—involves a comparable commitment to a national struggle for equality that precludes ethnocentrism, which is always an ideology of privilege even when it is linked with nationalism.[70]

Significantly, one of the most salient characteristics of Cuban art, and a trait for which Cuban posters and paintings were well known (as we shall see below), was an internationalist orientation that complemented the immense amount of aid (medical, educational, engineering, and military) that Cuba generously provided to over thirty countries in the Third World for several decades (fig. 74). As Nelson Mandela has often noted, revolu-

tionary Cuba was one of the key countries worldwide that aided the African National Congress in its long march to power in the face of Western imperialism. Furthermore, Mandela has also spoken of Cuba's social and cultural programs as inspirational models for the African Congress's own national program in South Africa after the defeat of apartheid.[71]

The designs of the Cuban poster artists, along with the paintings of Wifredo Lam, René Portocarrero, Raúl Martínez, and Manuel Mendive (to name the four most famous Cuban artists at work in Cuba after 1959 and before the emergence of Volumen Uno) are significant because of the way they embody a synthesis of popular Afro-Cuban culture with international concerns. As such, this art embodied Fanon's correlation of the difference between popular culture and populism with that of the distinction between national self-determination and nationalism. Indeed, in light of the modern history of Western Colonialism, as well as enforced underdevelopment of many countries by the contemporary West, authors like Samir Amin and Benedict Anderson have made a key distinction between official nationalism and popular national self-determination (or popular nationalism versus official nationalism). As Amin observed, the aspiration to national self-determination in the Third World is as important for ending dependency and underdevelopment, as the threat of official nationalism in the West is essential for maintaining that same dependency and state of underdevelopment.[72] (It was of course the Mexican Revolution that first defined the stark difference between official nationalism and popular nationalism through the competing narratives that emerged after 1910—and through the mural movement after 1922.)

A corollary of the impetus towards national sovereignty when self-determination is pursued in a consistent and systematic way by one country is that the peoples of all other countries will have an equal right to national self-determination as well. This is an idea patently at odds with the dictates of an official nationalism in the West that permitted routine references in the 1980s by Presidents Reagan and Bush to neighboring countries as "our backyard" or "our sphere of influence." The latter tendency of Western nationalism, especially in a more advanced form known as fascism, implicitly appeals to a restoration of the "aristocratic" and racially hierarchical order purportedly "ordained" by nature and "naturally" centered in the West.

Yet a danger facing any country struggling for cultural self-determination is that of simply rejecting Western European culture *in toto*, in favor of an uncritical revival of so-called "purely" indigenous art forms. Among those who warned against an uncritical displacement of the gains of Western high culture by a simple reversion to "purely" subaltern popular traditions or "pure" indigenismo were Antonio Gramsci of Italy, and José Carlos Mariátegui of Peru, both of whom had a major influence on Cuban thought after 1959.[73]

Gramsci noted, for example, that any subaltern culture will attest to the never entirely dominated aesthetic impulses of a subjugated people, as was the case with the musical culture pro-

74 Faustino (Pérez Organero), *Jornada de solidaridad con Zimbabwe* (Day of solidarity with Zimbabwe), 1970, silkscreen poster for OSPAAAL.

duced by Afro-Cuban slaves within colonial society. In addition, he observed that such a subaltern culture would also be branded by the intellectual insularity of those denied systematic access to other bodies of knowledge and cultural traditions. Furthermore, as is the case with Santería, which draws on ancient African religions and now enjoys considerable popularity in Cuba, such popular traditions can easily be characterized by hierarchical relations that are at odds with social equality and gender parity.

Such a Gramscian critique of Santería along gender lines in fact appears in Sara Gómez's excellent 1974 film about Cuba entitled *De Cierta Manera* (In a certain way). In some instances, then, progressive "indigenous" forms can also be marked by an

excessive recourse to irrationalism or outmoded mysticism that would be at odds with the requisite rational discourse for majority rule. Such a culture of resistance could be both enabling and yet marred by a closed set of repeated cultural rituals at odds with any historical process of social transformation based on rigorous self-criticism in the cultural sphere.

Gramsci's reservations about an uncritical use of subaltern or indigenous culture have often, if not always, been shared by the populace in Cuba. Consequently, the process of critically elevating popular Cuban traditions as a cultural vocabulary for a new art was, ironically, one accompanied by the increased accessibility of European high culture (such as ballet, symphonic music, and Western visual art), as raw material for expanding the public's artistic experience. It was precisely such dialogical developments as these that Nicaraguan poet Ernesto Cardenal had in mind when he wrote about his 1970 stay in this country:

> In Cuba, as contrasted with Russia, there has been no attempt to create a simple art that can be immediately understood by the people; rather there has been an education of the people to the point where they understand the complexity of art. I was told that this has been the official policy of the Cuban Revolution.[74]

From Cuban Pop Art through Volumen Uno (1959–1989)

In a notable series of essays during the 1980s, the Cuban art critic Gerardo Mosquera illustrated the distinctive attributes of contemporary Cuban art that had come to the fore again with the January 14, 1981 *Volumen Uno* exhibition in Havana, after a period of stagnancy in the visual arts during the 1970s. Among other things, Mosquera discussed the cultural and artistic pluralism for which Cuba had earlier been known in the 1960s, although never more so than in the decade of the 1980s with the emergence of the "new generation."[75] Similarly, Mosquera analyzed the renewed emphasis by Cuban artists on an ethnic and cultural synthesis (*mestizaje*) that has constituted a self-conscious conjuncture of Afro-American, Indo-American, and Euro-American traditions. This entailed a "revival" of the 1960s aesthetic associated with Pop Art in the work of Raúl Martínez, Alfredo Rostgaard, Elena Serrano, and others.

Mosquera noted in 1988 that the formal developments of the Cuban visual arts again involved a spectrum "so variegated as to make an identification of general traits hardly possible, save for their diversity."[76] Nonetheless, he enumerated several tendencies that gave some conceptual unity to contemporary Cuban art. The multiple coordinates of the art of the 1980s included the following: a renewed concern with the formal values of art as opposed to a mere focus on extra-aesthetic compositions; a re-engagement critically with avant-garde art from the West; a usage of elements from vernacular culture, along with local homemade kitsch (*picuo*); a preoccupation with international identity through a reclamation of African and Latin cultural values (or what it means to be from Latin America and from the Third World simultaneously); a consideration of the ethical role of art; and, finally, a commitment to the ever greater reintegration of art and life, as a way of reviving the "utopianism" of the revolutionary 1960s.

In sum, Cuban art between 1960 and 1970, and then again during the 1980s, emerged as a distinctive nexus for diverse cultural practices in an expansive range of visual languages that are at once Western and non-Western in origin. To speak of Cuban art, then, is not to speak of the "Cubanness" *(Cubanidad)* of Cuban art. Nor is one speaking of some purportedly "pure" Cuban national character with any historically unified, supposedly "natural" subject behind it. (Here, of course, the issue of a decentered and heterogeneous multinational postcolonial art arises. It was an art at odds with the putative homogeneity of an "international' High Modernism codified by Greenberg and it was a renewal of the "alternative modernism" forged by Mexican artists in the teens and twenties.) As such, Cuban art embodies, in a self-conscious and historically advanced form, what Stuart Hall demonstrated about the condition of progressive "national" cultures and their unavoidable heterogeneity.[77]

These above mentioned concerns of Cuban culture from 1959 to 1989 (except for the Dark Periods of the early 1960s and mid-1970s) will probably come as a considerable surprise to most citizens of the United States and many in Europe. This is the case because we are often told in the West that Cuban society is monotonously uniform and unrelievedly standardized in character, with little appreciation for our much touted "American pluralism."

In order to examine the heterogeneity of Cuban artworks—or what Gerardo Mosquera in the late 1980s called their postcolonial and even "post-modernist penchant" for an inclusive poetics—this section will be divided into two parts: first surveying and analyzing Cuban art from 1959 to 1979, with primary emphasis on the signal changes that occurred in the production of posters and paintings during the first two decades of the revolution, and second, focusing on the art of the "new Generation," which, from the late 1970s through the late 1980s, significantly expanded the resources of Cuban art—in terms of both the media used and the audiences addressed.

The very diversity of these innovative art forms utterly undermines and helps deconstruct the mainstream Western accounts of Cuban society. These conventional narratives from North America cannot adequately explain this broadranging artistic praxis in Cuba, nor can they account for much else in the domain of culture. In short, many people in the West must learn to ask quite different questions about the successes and failures of the Cuban Revolution, than were asked about the shortcomings and strengths of the Soviet Bloc countries up until 1989. A thoughtful look at the accomplishments of Cuba's artists within the Revolution will help to reformulate these questions.

No country in the world contributed more to the images that now define the high points of the 1960s, than did Cuba. Che posters from Cuba are icons of the entire period. In fact, the

decade in Cuban art from around 1964 through the early 1970s has often been called "the golden age of the poster." Such a designation is appropriate in light of the international acclaim garnered by Cuban posters, and owing to the way the Cuban poster has become identified with the New Left in the West as an embodiment of the aspirations and disappointments of the 1960s. Particularly in a billboard format known as the valla, the poster was a more common feature of the public domain in Cuba before the mid-1970s. In 1972 alone, for example, around five million posters were made. Yet, it should be quickly added that the design and production of posters—often of a very high caliber—continued up through 1989, even if in a diminished number. While the quantity of posters did decrease, the quality of those designed did not decline, particularly when one considers the posters produced by artists working for the Cuban Film Institute (ICAIC). Nonetheless, the Cuban poster remains most paradigmatic of the early years of the revolution.[78]

International reception of the Cuban posters was indicative of how these posters embraced a remarkably broad range of visual languages from around the world. Moreover, the plurality of visual languages were in keeping with the support given by Cuba to national liberation movements around the globe. Pop Art, Op Art, Minimalism, and Conceptual Art, as well as the earlier avant-garde tactics of Cubist collage, Constructivist montage, and Surrealist disjuncture, were each important during this period. In turn, the very catholicity of Cuban poster design was interrelated not only with the resolutely internationalist aims for which they were produced, but also with the hybrid, multicultural aesthetic that the revolutionary process was committed to consolidating. This new aesthetic commitment to an experimental, open-ended engagement of diverse cultural traditions was invited by the early opposition of Cuban leaders like Che Guevara and Fidel Castro to the Stalinist doctrine of "Social Realism."

In general, Cuban posters were produced by various artists who worked for a variety of governmental agencies with varying institutional concerns. These agencies included the following: COR, later DOR (Comisión de Orientación Revolucionaria), the publicity arm of the Communist Party whose poster production was directed for several years by Félix Beltrán and featured designs by Eufemia Alvarez, Marcos Pérez, and Roberto Figueredo; ICAIC, whose team of poster artists included Eduardo Múñoz Bachs, Antonio Pérez (Niko), Azcuy, and Reboiro, along with freelancers for the agency including Raúl Martínez and Alfredo Rostgaard; CNC (Consejo Nacional de Cultura), the forerunner from 1960 to 1976 of the present Ministry of Culture, whose group of artists included Frémez, Rolando de Oraa, Aldo Méndez González, and Ricardo Reymena; OSPAAAL (the Organization in Solidarity with the People of Asia, Africa, and Latin America), whose group of artists was led for a number of years by Alfredo Rostgaard and which produced the classic Che images by Rostgaard, Elena Serrano, René Mederos, Faustino, Mario Sandoval, Olivio, and several others; Casa de las Américas (the center for international cultural affairs), whose posters

of 1960 were among the first made in Cuba after the Revolution and whose graphic work was generally done by Umberto Peña (who designed the covers for 120 magazines and over two thousand books); OCLAE (the Latin American Continental Students Organization), whose team included Heri, Acosta, Daisy, René Mederos and Asela; and UNEAC (Unión de Escritores y Artistas Cubanos), the artist and writers union whose graphic work was done by Roger Aquilar Labrada.[79]

Sometimes signed by the artist, as in the case of those for the Film Institute, these posters were generally executed as silkscreens. This was the commercial printing technique that Andy Warhol made famous in his Pop Art of the early 1960s and it deftly combined photographic reproduction with a bold color interaction characteristic of oil painting. The ubiquitous silkscreened Cuban poster encountered the public through a wide variety of avenues. Aside from simply being posted on street walls, these graphic images were mounted in special poster stands (which were periodically changed), reproduced in books as well as in magazines, and presented in monumental scale on billboards. Before 1959 these billboards, or vallas, had been used to advertise consumer goods, as is still the case with most Western billboards at present. Public space as a locus for political debate involving provocative images about the general welfare or international solidarity was as common in Cuba after 1960 as it was uncommon in the United States. Thus, the use of the poster and the billboard in Cuba entailed a rupture with the hegemonic use of this visual language in Western societies.[80]

Contrary to its revolutionary new use in Cuba, the poster was originally an early manifestation of commodity production within industrial capitalism, even though these posters simultaneously represented certain values that contradicted the nature of capitalist development. The Western poster was from the beginning, as Susan Sontag once noted, a visual signifier of the impetus towards commodifying everything, including "public space," on behalf of the implantation of consumerist values that were allied with mass consumption. In general, along with the billboard and the magazine ad, the poster continues to function along these lines in the West and in those parts of the Third World that are dominated by corporate capitalism. To Léger's and Matisse's premature claim that posters had become something like the frescoes of the modern age, we must add that these "frescoes" have had competing usages, along with the commercial one that is hegemonic in the West.[81] Even the earliest posters, such as those by Jules Chéret who invented the poster in 1867, and those by fine artist Henri de Toulouse-Lautrec, almost all involved the use of public imagery to foster personal consumption. Unlike the much earlier public notice or popular print, the Western European poster presupposed both a view of the spectator as a private consumer and the reduction of public space to an arena for personal gain.[82]

Neither of these ideological concerns, which are paradigmatic of most posters in the U.S., were signified by the Cuban poster after 1959. The Cuban poster was not produced to address the

viewer as an isolated consumer for whom free expression simply equated the license to buy whatever one wished. Rather, the Cuban poster was produced to initiate a dialogue with interdependent subjects who consciously acted in relation to others and whose free choices were continually replete with serious implications for humanity in general. Conversely, the private commercial poster of the West encourages ideological naivety among its viewers by the way this poster "naturally" entices the passive spectator into purchasing, while apparently presenting the commodity in a "neutral" way. This purported neutrality involves seeing the commercial poster, as if it were simply promoting a desirable product. Yet the Western poster implicitly advocates an embrace of the prevailing ideological values of the socioeconomic system known as multinational capitalism.

As such, the Cuban poster was not based on the ideological pretense that its images were either "neutral" or "nonideological." Instead, the Cuban poster overtly contested the ideology of mere personal gain by the very way it refused to present ideas and images as if they were outside a system of values mediated by ideology on various levels and intimately linked to an individual choice free of serious implications for others. It would be misguided, however, to discuss the Western commercial poster (particularly at its best when made by Chéret, Toulouse-Lautrec, or Picasso) as a mere reflection of capitalist ideology. After all, from its inception, the Western poster was characterized by a fundamental paradox that caused the visual language of these posters to be decentered, or ideologically unstable. In a word, the posters of Picasso and Toulouse-Lautrec were uneasy combinations of a potentially progressive visual language and resolutely reactionary conceptual aims.

These posters, which have been highly important not only for Pop Art but also for Cuban art after the revolution, featured an innovative public language. This new language was characterized by several traits: a bold new use of color that is even celebratory in effect; a non-Western use of space that undermined the static, ultimately ahistorical, spatial construction of Renaissance perspective; a remarkable new degree of visual intelligibility through a graphic design that was based on sophisticated simplicity, not on simple-minded clarity; and a calligraphic line (reminiscent of visual forms from the Far East and the Middle East) that evoked a sense of volume, even as Western techniques of shading were no longer used. This distinctive type of linearity also elicited a sense of organic, even irreverent vitality through the meandering way it circumscribed form.

Nonetheless, in nineteenth-century Europe and then in twentieth-century North America this new public language was used to advertise a system of values that subordinated the public good to the private monetary interests of a few. Thus, these posters featured a visual language that visually affirmed life in general, yet at the same time they thematically defined desire in a way that negated historical progress for most people. Hence, from the beginning the Western commercial poster was contradictory in ideological terms. It both contained the potential to aid public self-realization—not only aesthetically but also in terms of political economy—and yet it was also pervaded by values that stood in the way of using this new visual language to enrich life for the majority. Rather, this potentially progressive language was often made to serve the exclusionary interests of a few with the resources to buy "freedom" at the expense of everyone else.

Among the first of the deeply impressive posters produced in Cuba was one from 1964 by René Portocarrero. One of the most celebrated painters in Cuban history, Portocarrero designed the poster for *Soy Cuba* (I am Cuba), which resulted from a remarkable joint Cuban-Soviet movie made at the Film Institute in Havana (fig. 75). In a country where filmmaking was not a private business, so that admission to the cinema was virtually free, this poster served as a way of visually presenting the film in another medium, rather than as a way of commercially promoting it. From production through distribution, Cuban cinema was almost entirely subsidized by the government and involved only a nominal admission fee.[83]

The Portocarrero poster is in a style that draws on pre-Columbian components—specifically the use of a densely imbricated space rather than perspectival recession. It also uses a neo-Mayan interplay of cursive figuration with abstract ornamental design that simulates the all-embracing character of nature in the tropics. These pre-Columbian attributes are in turn synthesized with unlikely Western European design elements that include a boldly flat, hard-edged format first used by the German Bauhaus and Russian Constructivists.

These latter traits are the sans serif typography recommended by Josef Albers (which contrasts brilliantly with the calligraphic flourishes of the pre-Columbian image) and a type of color interaction involving primaries and secondaries within a geometric framework that recalls Albers's *Homage to the Square.* This Caribbean variation on something approaching a "pre-Columbian Bauhaus" or "precolonial constructivist" design attests aptly to the type of hybrid formation or *mestizaje* that was deftly forged in the early years of the Revolution.

One of the finest essays about René Portocarrero's artworks was written by Alejo Carpentier in 1963. In writing of this painter as a "baroque" synthesizer, the Cuban novelist made the following points:

> More than a style, the baroque—or baroquism—is a manner for metamorphizing materials and forms, a mode of organizing the disorganized, a means of transfiguration . . . And it is the musicality of forms and their shadows, of objects and entities, that has been captured like never before in the paintings of René Portocarrero.[84]

Aside from the way its design counterposes Native American values with modernist concerns, this poster by Portocarrero for *Soy Cuba* also recalls the interplay between Western and non-Western forms that converge in Abstract Expressionism from the 1940s and 1950s. As Luis Camnitzer has shown in a recent study, the post-1945 style of organic allover images from U.S. Abstract Expressionism exercised considerable influence not

75 René Portocarrero, *Soy Cuba* (I am Cuba), 1964, silkscreen poster for ICAIC to promote the film *Soy Cuba* by Mikhail Kalatozov.

76 Raúl Martínez, *Sin título* (Untitled), 1961, oil on canvas, collection of Dr. Jay D. Hyman.

77 Amelia Peláez, *Still Life*, 1961, oil on canvas, Museo Nacional de Bellas Artes, Havana.

78 Antonio Vidal, *Sin título* (Untitled), 1953, oil on canvas, collection of Dr. Jay D. Hyman.

only on Portocarrero, but also on a significant group of left-wing Abstract Expressionist painters in Cuba during the insurrectionary 1950s.[85] This group, which lasted from 1953 to 1955, was called "Los Once" (The eleven) and it included Raúl Martínez, Guido Llinás and Antonio Vidal, among others. Through its *Anti-Bienal*, in 1954 and the *Anti-Salon* in 1957 that was organized by former members, Los Once was instrumental both in opposing Batista and in helping to guide the artistic transition that was triggered by the Cuban Revolution of 1959 (figs. 76 and 78).[86]

Far from being a signifier of Cold War values in favor of the mainstream United States and such right-wing allies as Batista in Cuba, then, the Cuban version of Abstract Expressionism (which was indebted both to the New York School and to Spanish art) denoted a pictorial negation of the established order. This "negative art" also served to create in Cuba a clean cultural slate for the visual arts after the early 1960s. As such, it played an artistic role in opening up this domain for the progressive, indeed unprecedented developments, that ensued the victory of the Revolution in 1959. In 1963, some of the former members of Los Once held an exhibition in Havana entitled simply *Abstract Expressionism*.

Subsequently, the most famous former member of Los Once was the painter Raúl Martínez who summed up the radical

79 *Vitrales* (stained glass overdoors), late eighteenth century, Old Havana, Cuba.

lineage in Cuba of Abstract Expressionism and Art Informel as follows:

> Abstract artists were strong [as a movement] when the Revolution took place, and they were supporting the Revolution; therefore, there was no negative identification with abstraction.[87]

In a 1984 interview with U.S. art historian Shifra Goldman, Raúl Martínez further elaborated on the situation of the 1950s for modernist painters in Cuba:

> We expressed our attitudes in the titles of our paintings. For example when Fidel appeared [in 1953], we titled our paintings of vegetation *Sierra Maestra* . . . we [in Los Once] supported with our presence all activities against the tyranny. The paintings did not reflect this specifically . . . [But we] also discovered that abstract art was the only weapon with which we could frighten people. When we mounted an exhibition, people were left in a state of shock. . . . Then it seemed to us that our painting served as a means to raise consciousness. . . . Within the context of the backward painting that existed in Cuba at the time, to do abstract painting was a revolution in itself. The social revolution was being made by what we were doing with the work after it was finished.[88]

But, let us return to Portocarrero's particular modernist style that grew out of the context of artistic rejuvenation discussed above. The distinctive hybridity and *mestizaje* of René Portocarrero's "alternative modernism," or perhaps baroque modernism, as in *Soy Cuba*, were representative of the heterogeneous heritage of Cuba. This was the case not only because of his synthesis of pre-Columbian art with some aspects of modernism, but also because of the way Portocarrero's artworks constituted a self-conscious assimilation of other moments in Cuban history as well. This *mélange* included artforms from the baroque colonial period and references to paintings by the first Cuban modernists of the 1920s, along with cultural components from the Mediterranean tradition embodied most famously by Matisse.

The multicolored, mosaic-like imbrication of elements in an allover design that one sees in Portocarrero's paintings entails an interimage dialogue not only with the abovenoted artistic languages, but also with a well-known feature of Spanish colonial architecture that was first used in the fine, almost prismatic, neo-Cubist paintings from the 1920s onward of Amelia Peláez (who remained in Cuba until her death in 1968) (fig. 77). This striking feature of colonial art, which was incorporated into oil painting first by Amelia Peláez and then by Portocarrero, in such works as *Cathedral*, or *Soy Cuba*, is still much in evidence in Old

80 Eduardo Múñoz Bachs, *5th Festival Internacional del Nuevo Cine Latinoamericano* (5th international festival of the new Latin American cinema) 1983, silkscreen, ICAIC.

81 Alfredo Rostgaard, *Canción protesta* (Protest song), 1967, silkscreen poster for Casa de las Americas to promote a music festival devoted to Nueva Canción.

Havana architecture today (there are still 144 buildings from the sixteenth or seventeenth century in old Havana, and 200 that date from the eighteenth century). This colonial feature is the *vitral* (or arcuated stained glass overdoor) (fig. 79).

Vitrales began to appear in *mediopuntos*, or areas filled by windows with 180-degree arches, in buildings from the late eighteenth century in Cuba. The colored glass, which was imported from Europe, was pieced together first with wood and then later with metal. Visually, the multicolored *vitrales* diffused the strong tropical sunlight, while allowing it to enter rooms as a prismatic play of color. Fanning out peacock-like within the segmented archery, these *vitrales* featured an alternation of geometric patterns with Moorish calligraphic swirls and neo-Gothic floral motifs. Thus, as the mudéjar motif here attests, the Arabic con-

tribution to Cuban art (via Spanish culture) was yet another element of Cuban culture that the revolutionaries sought first to reclaim, then to rework as part of the process of national self-definition in culture.

Aside from following the lead of Amelia Peláez in drawing on this Spanish colonial element, Portocarrero's hybrid language in *Soy Cuba* also uses Arabic (or mudéjar) inflections within the parameters of the unlikely pre-Columbian Bauhaus manner noted above. In addition, it displays an affinity with the fluent line of the Mediterranean tradition (from the Alhambra all the way through Matisse). Both Arabic calligraphy and the Mediterranean linearity of Matisse, as employed here by Portocarrero and others, are somewhat at odds with the hierarchical space and Classical clarity of the Renaissance tradition. An interim-

age dialogue with the Mediterranean tradition embodied by Matisse's "decorative" sensuality, in addition to the French artist's lean yet evocative use of line, can also be found in other Cuban artworks, for example Alfredo Rostgaard's lyrical, and quite famous, silkscreen poster *Canción protesta* (Protest song) for Casa de las Américas in 1967 (fig. 81) and Antonio Pérez's graphic 1978 portrait of José Martí for the Ministry of Education. Of his poster *Canción protesta*, Rostgaard has said: "I wanted to show both the beauty and pain of making a revolution. And that, after all, is what protest music is all about—making beautiful music about the world's pain."[89]

Among the most celebrated of all Cuban posters are those about Ernesto Che Guevara (figs. 16, 82 and 83), the Argentinean-born Cuban revolutionary who died an untimely death in 1967. In keeping with his sharp polemic against the Stalinist doctrine of socialist realism, Che's omnipresent image throughout Latin America and the United States is identified with a remarkable range of styles from the 1960s, particularly those of Op Art and Pop Art. Outstanding in this regard are several posters of the late 1960s for OSPAAAL and ICAIC. One of them was designed by Elena Serrano and two others were created by Alfredo Rostgaard. Each artist used the telling repetition of subtly varied shapes along with a brash color interaction featuring primary hues. The consequent visual tension among these elements featured a sense of animation propelled by reverberating forms that signified historical change, as well as the permanent mobility of a guerrilla force.

In some cases, these Cuban posters were related to GRAV (Groupe de Recherche d'Art Visuel), a 1960s movement in Paris that was allied to the New Left and included such major Latin American artists as Julio Le Parc and Luis Tomasello of Argentina, and Jesús Rafael Sóto of Venezuela. In 1961 GRAV issued a manifesto denouncing both "the cult of personality in art" and the process of commodity fetishism in society. Consequently, these artists called for a "new means of public contact": art that challenged the existing order through open-ended artworks and "visual instability."[90] The visual language created by GRAV, however, was shown in a Western gallery context quite antagonistic to it. Furthermore, the unsettling perpetual engagement of the viewer was not balanced by a matching set of thematic codes giving it conceptual grounding (as in the case of the overdetermined Che portrait), and Op Art quickly became appropriated by the mass culture industry in the West, which, ironically, was seeking new ways to package consumer goods.

Nonetheless, the Cuban posters of OSPAAAL succeeded, at least in part, in disappropriating and redeploying the visual language of GRAV, by using Op Art as a progressive visual idiom that was in opposition to its standard usage by Western mass media. This was possible because of the way the Cuban images counterbalanced the visual flux of Op Art with a stable signifier for determinate change in Che, so as to create a potent interplay of indeterminacy and well-directed change, of lively sensory engagement and loaded historical principles. Indeed, the very

82 *(above)* Alfredo Rostgaard, *Che*, 1967, silkscreen, ICAIC.

83 *(left)* Alberto Díaz Gutiérrez (Korda), *Che*, c.1960, photograph, Private Collection.

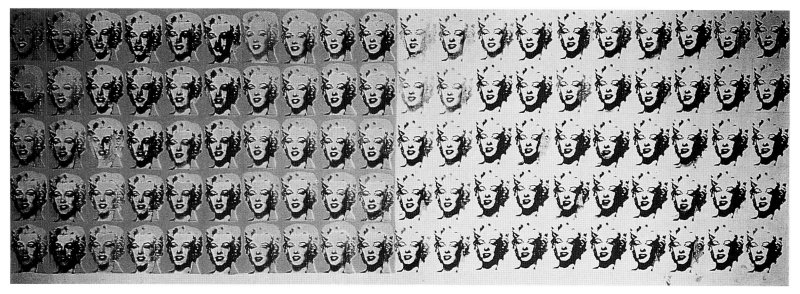

84 Andy Warhol, *Marilyn × 100*, 1967, oil on canvas, Cleveland Museum of Art, Leonard C. Hanna, Jr. Fund, and Anonymous Gift 1997.246.

vitality of the Cuban Che poster reminds us of how much more successful it is as a signifier of active involvement on the part of the spectator, than is true of the "heroic" and quite static portraits of Stalin and Mao, which were as uniform as they were ubiquitous in the 1940s and 1950s.[91]

It is significant (as British scholar David Kunzle has noted) that the Che poster appeared in Cuba only after his death, while the images of Stalin in Russia and Mao in China were used during their lifetimes to foster a "cult of personality" that helped radically centralize power in their respective countries to a degree unknown in Cuba.[92] Indeed, in correspondence such as a letter to W. Blos (November 10, 1877), Karl Marx himself was among the first to attack any personality cult as intrinsically antisocialist.[93]

The heroic portraits of Soviet-based Socialist Realism paradoxically celebrated great individuals in isolation and hierarchical power as "progressive," as if they were legitimate socialist values. These Soviet positions are pounded home in such "social realist" paintings as Alexander Gerasimov's *Lenin on the Tribune* (1929) or his *Stalin and Voroshilov in the Kremlin* (1938). Conversely, the Cuban Che poster featured an abstract and flexible portrait of Che to underscore the larger process of history leading beyond him. In the superb poster by Elena Serrano (fig. 16), the image of Che fractures and disperses as the revolutionary process expands. In this way, the dynamic Cuban poster was not only more compelling aesthetically, but also far less guilty ideologically of any fetishizing individualism. Unlike the Che poster, the heroic representations found in both Western portraits and in Eastern Bloc examples of Socialist Realism are generally static and status-defined.

Comparable points can be made about the groundbreaking images by Raúl Martínez (d. 1996), the painter who in the mid-1960s introduced a highly influential variant of Pop Art into Cuba. This innovation made him one of the most noteworthy artists in Latin America throughout the 1960s and 1970s. Here we see how a visual language that emerged in the West as radically decentered, or unstable, subsequently became in Martínez's

hands more cohesive and centered, without, however, losing its dynamism.

The Pop Art images by Andy Warhol of Marilyn Monroe and Campbell's soup cans were based on a powerfully unsettling ambivalence that, on the one hand, involved a striking visual appeal through bold graphic design, celebratory color, and a sophisticated simplicity of form (fig. 84); and, on the other, often counterbalanced this aesthetically adroit and affirmative tendency internally within the works by a self-negating parody. This latter attribute entailed an exaggeration of color placement to the point of garishness and a mechanical repetition of image to underscore the mechanized nature of life in the West (where, without workplace democracy, mass production presupposes the production of masses). Warhol's images also contained a mock heroic presentation of banal consumer goods, along with cliché-ridden celebrity images, all of which often signified a cynical detachment from that which was also visually appealing.

The Cuban variation of Pop Art developed by Raúl Martínez and others was built on the perceptually sophisticated aspect of Warhol's work—including a measured antiauthoritarian tendency to view the "heroic" in nonhierarchical terms. Yet, Martínez extended the progressive attributes of Pop Art at the expense of the ideological cynicism to which Warhol's work often, but not always, leads in the West. In *La Isla* (The island) (1970) by Raúl Martínez (fig. 85) for example, we see Warhol's grid framework for flattening-out portraits used by the Cuban artist in a new way. Here Martínez does not merely repeat the same portrait. Rather, he presents in quite matter-of-fact terms a group portrait that includes many anonymous people from various sectors of Cuban society, all of whom are shown along with Che, Fidel, and Camilo (as well as Ho Chi Minh and Lenin). Yet none of these leaders stands out in "heroic" isolation or in notably hierarchical placement within Martínez's painting. Martínez has thus "decentralized" Pop Art away from "socialist realism" without dissolving his image into cynicism.

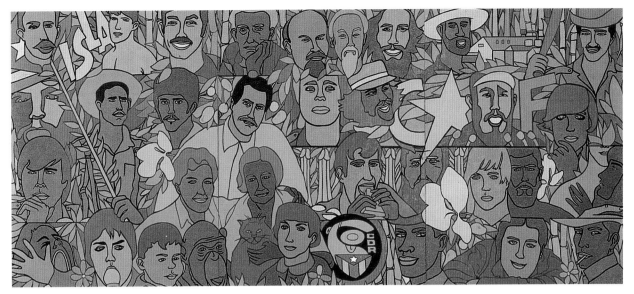

85 Raúl Martínez, *La Isla* (The island), 1970, oil on canvas, Museo Nacional de Bellas Artes, Havana.

Through this nimble play between a geometric grid and considerable variation in imagery, Martínez uses the celebratory color, boldly flat forms, and even a qualified sense of mock-heroism to transform Warhol's potentially cynical ambivalence into a positive openness—one still capable of affirming historical progress, yet not a dogmatic idea of it. All of these innovative traits at the end of the 1960s help us to understand a claim by critic Gerardo Mosquera on the occasion of the 1988 retrospective of Martínez's works. Mosquera called *The Island* a "grand metaphor" for the early years of the revolutionary process. As such, Mosquera wrote of how Martínez had the ability to "express artistically the most important aspects of the Cuban Revolution."[94] He explained:

We can already sense that if any pictorial image continues to be a signifier of the Cuban Revolution, it will come out of the work that he [Raúl Martínez] did in the late sixties. This will be the case because of his way of representing leaders as myths and at the same time as *compañeros* (companions), owing to the collective sense that they portray, to their popular freshness, to a grandeur that is nonetheless free of rhetorical excess, to their being as much a part of the sixties as was the Revolution itself (which, to be precise, defined the sixties to a large degree). . . . On the other hand, Raúl presents us with repeated, omnipresent leader or heroes who constitute a multitude [as with Che or Martí]. And on the other hand, these figures are fused with the masses. . . . But the most significant thing about his work is that these multitudes are formed by completely particularized characters, who are nonetheless united within a system where none stands out over any other. The emphasis is thus not on the disappearance of the individual, as in Mariano's *Masses*, but is rather on the equalizing unity of the most diverse elements. . . . An idealization of this fundamental trait of the Cuban process is the basis of Raúl's work . . . [it] emphasizes what is peculiar to that society, while at the same time projecting in

a visionary way its own more generalized meanings [into the future].[95]

Here as elsewhere, the visual diversity is related to how the Cuban Pop portrait did not pompously glorify the individual leader by highlighting his or her isolation or "uniqueness." Instead the Cuban Pop portrait continually recapitulated, with varying inflections, the general traits whereby one recognized (but was not fixated by) the "uniqueness" of leaders. As such, the highly abstract and nondoctrinaire signification of a Cuban Che poster usually lacks a so-called "realistic" setting, such as one sees in the Soviet portrayals of Stalin. Instead the Che portrait frequently features a formal configuration that induces a sensation of change itself, if not the dynamism of history.

In keeping with Pop and Op, the Cuban Pop portraits of Raúl Martínez lack the solemnity and pomp intrinsic to academic portrayals of "great individuals." The abstractness and approachability, if not conviviality, of Martínez's portraits—whether of Che Guevara, José Martí, or Roberto Fernández Retamar (fig. 69)—make them more self-consciously open-ended in signification, than was "socialist realism." This is because of the paucity of emblems directing the viewer's thoughts and because of the use of a visual language, namely Pop Art, that even in Cuba does not permit an unduly somber reaction to the image.

This particular deployment of Pop Art in revolutionary Cuba helps us to understand retrospectively the progressive potential of Pop Art per se, especially its antiauthoritarian tone and critical detachment during Pop's original phase. As Andreas Huyssen has shown, it was these traits that caused Pop Art to be embraced by the New Left in the 1960s, particularly in Europe. Owing both to the possibilities of the art and to the radical historical context for its reception during the this period, there was a time when, in Europe and the United States, it meant something more radical. To quote Andreas Huyssen, "Pop seemed to have the potential to become genuinely 'popular' art and to

resolve the crisis of bourgeois art."[96] Yet the visionary promise of Pop Art has often remained largely unrealized in the West—with the notable exception of the anti-interventionist works of Claes Oldenburg from the 1960s through the 1980s, such as, his *Artists Call Against US Intervention in Central America* poster from 1985. The progressive dimensions of Pop Art were instead consolidated to a far larger extent within the Cuban Revolution through the work of Martínez, as well as that of Alfredo Rostgaard, Mario Sandoval, Elena Serrano, and René Mederos.

In fact, there is a sense in which Martínez's Pop Art portraits of the late 1960s implied a critique of Warhol's Pop portrayals. Martínez's work depended on a creative tension between "hot" topics—revolutionary change, revolutionary leaders, the end of machismo (as in the striking poster for the feminist film *Lucía* (fig. 59)—and a paradoxically "cool" presentation of them. These images engaged the viewers critically and the spectators were not told visually to line-up behind the "correct position" (as is always true of the bombastic "hot" style of "socialist realism"). Consequently, the "cool" but appealing treatment of "hot" issues was more dynamic as well as ideologically complex, than was true of a Warhol image with its "cool" sensibility and its "cool" topics whether soup cans or film-stars. These latter works by Warhol often forsake intellectual demands for an easy cynicism—a cynicism made all the more convincing because of the visually advanced language of Pop Art whereby it was presented.

While the Pop Art of Martínez offered further challenges (such as how to maintain a principled view of social change without being dogmatic or doctrinaire), the Pop Art of Warhol often encouraged a form of resignation (that is, things are ridiculous but we can do nothing to change them). Thus, the deeply affirmative formal aspects of Pop Art generally led to an adroit and critical resolve in Cuban art, while fostering a maladroit and uncritical resignation in U.S. art. This resignation in the latter case turned aesthetic affirmation into self-satisfaction with the present, by ironically implying that the viewer already was doing "all that could be done." Furthermore, the cynically resigned view frequently signified by the post-1960s reception of North American Pop Art in fact contradicted the brash perceptual experience of Pop Art's design, since this encounter could otherwise signify renewed vitality and disorder, or even the advances of historical change.

As mentioned previously, the range of Cuban posters after 1959 went much beyond the critical assimilation of visual idioms, such as Op and Pop, to many other styles as well. There was a playful Neo-Expressionism reminiscent of Paul Klee's work—as in the well-known posters of Eduardo Múñoz Bachs for the Cuban Film Institute (fig. 86). In them the fanciful figure of Charlie Chaplin (who was expelled from the U.S. in the 1950s as a socialist) appeared with an outsized Klee-like face. There was a refined Minimalism in other posters wherein the formal understatement demonstrated a major lesson of New York School Minimalism less often grasped in the U.S.: the very reticence of this art necessitated a more active discussion by

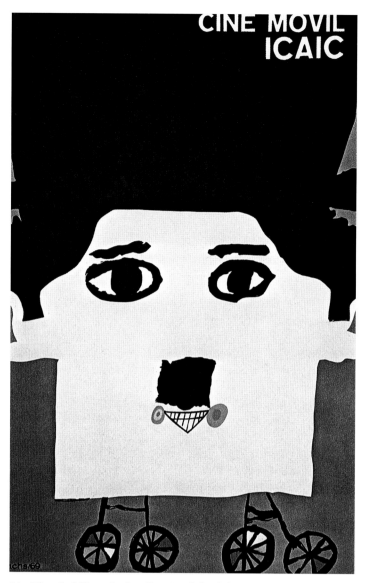

86 Eduardo Múñoz Bachs, *Cine Movil* (Mobile cinema), 1969, silkscreen, ICAIC.

the public. Finally, there was a type of Surrealism, or Magical Realism (a term that Cuban author Alejo Carpentier was among the first to use), which had a direct link with visual traditions that preceded the revolution.[97]

This latter visual language of "magical realism" was used in posters during the 1960s, although it has become far more common after 1981, with the oil paintings, assemblages, and performance pieces of the 1980s generation. One of the finest early examples of this idiom was Alfredo Rostgaard's poster for *The Death of a Bureaucrat* (1967) (fig. 72), the film by Tomás Gutiérrez Alea that deftly satirized the debilitating consequences of a mushrooming bureaucracy in Cuba. Significantly, the film was an immensely popular part of the critical debate within Cuba that ultimately spawned pronounced structural decentralization on behalf of *poder local* and workplace democracy during the mid-1970s, as noted above.[98]

Rostgaard's film poster features two Surrealist tactics that were taken over from the Freudian concept of dreamwork, entailing condensation and displacement. In Rostgaard's image, an unthinking hand has displaced the head and points upward, only to single out a gravestone marker that is associated with the ground, yet located at the top of the composition. As a result, displacement plus abbreviation here leads to and is itself a signifier for misdirection, at a time when Cuban society was engulfed with a debate about the need to change course. Far from representing the "correct political analysis," Rostgaard's poster, like Gutiérrez's probing film, confronted the spectator with a network of conflicting signs that required spectatorial intervention in order to give them "coherence," just as the contemporary debate about bureaucratization required popular involvement.

This self-reflective aesthetic contrasts with the more directive, cautious, and somewhat didactic "hyperrealism" that flourished from around 1973 until 1979. Among the major practitioners in this vein were Flavio Garciandía, Tomás Sánchez, César Leal, Aldo Menéndez, Nelida López, and Rogelio Marín (Gory). Most of the paintings and photographs in this vein were unimaginative and plodding. A few commanding works produced by this stylistic tendency of the 1970s were Flavio Garciandía's *All You Need Is Love* of 1976 (fig. 87) and Tomás Sánchez's hauntingly

Magritte-like landscape *Relaciones* (Relations) of 1986. The former work by Garciandía, which is an oil on canvas based on a photograph by Zaida del Río and the title of the song by the Beatles, depicts a close-up view of a young Cuban woman who is lying sideways on a grassy field. The pleasant expression on her face, in concert with the crisp focus and resonant colors of the work, make this a lyrical painting for all its hard-edged "photographic" precision. At once imposing and informal, the painting is both stylistically alert and thematically relaxed.

Sánchez's painting *Relaciones*, which is in acrylic on canvas, has an eerie quietness to it that re-enforces the dream-like ambience created through the resourceful use of an interplay between negative and positive space, along with deft figure/ground reversals. The interlacement of figurative referents and formal considerations makes this a work that is "naturalistic" and yet distinctly abstract. "Hyperrealism" in Cuba was broadly influenced at various points by the most disparate of preceding "realisms" that extended from the styles of Edward Hopper and Charles Sheeler through that of René Magritte up to the New York School "photorealism" of Philip Pearlstein. In the end, this short-lived Cuban "realism" assumed an unlikely role in the development of the visual arts. It was less important as a movement, than it was significant as a preamble to more energetic and resourceful developments beginning in the 1980s. To quote

87 Flavio Garciandía, *All You Need Is Love*, 1976, oil on canvas, Museo Nacional de Bellas Artes, Havana.

88 Antonia Eirez, *The Annunciation*, 1966, oil on canvas, Museo Nacional de Bellas Artes, Havana.

Luis Camnitzer, this "flexible realism served as a preparatory platform to launch the new art [of Volumen Uno]."[99]

The new and irreverent generation of the 1980s in Cuba drew even more emphatically on the Surrealist tradition of disjunctive figuration and tense assemblages. In addition, this new group used a "postmodernist," or better, postcolonial, engagement with vernacular forms and homemade *picuo* (kitsch). As such, they combined the fine art languages of professional artists with the "amateur" improvisational forms of the Cuban lay audience. This younger generation of artists also re-engaged with the Afro-Cuban cultural traditions that had already been used to great affect by Wifredo Lam, a supporter of the Revolution up to his death in 1982.[100] In addition, these young artists drew locally upon several unlikely sources: the expressionist paintings of Antonia Eirez (who was censored for "decadence"

during the "Dark Period" of the early 1970s) (fig. 88), as well as the longtime abstract work of Umberto Peña and the distinctive variant of Pop Art by Raúl Martínez that fell out of favor somewhat during the "hyperreal" 1970s. Despite her relative "invisibility" in the Cuban artworld of the 1970s, Antonia Eirez was the subject of a 1974 documentary in homage to her work with CDR art groups, *Arte del Pueblo.*

Moreover, the new generation of 1980 was influenced deeply on the international front by such Western idioms as Conceptual Art, Earthworks, Installations, and Neo-Expressionism. A major artist who mediated their engagement with the earthworks and performance art of the United States was Cuban-American artist Ana Mendieta (d. 1985). She actually visited Cuba during the early 1980s and executed some notable artworks on the island. United less by any stylistic continuity,

than by a "shared interest in experimentalism," this insolent and irreverent group of the younger generation produced what the supportive critic Gerardo Mosquera termed "impudent parodies, or even complete disruption."[101]

One of the most important developments in Cuban art history was the now legendary *Volumen Uno* exhibition that opened in Havana on January 14, 1981. It was this show that introduced the generation of 1980 with a remarkably broad spectrum of artworks by eleven different artists: José Bedia, Juan Francisco Elso, José Manuel Fors, Flavio Garciandía, Israel León, Rogelio Marín (Gory), Gustavo Pérez Monzón, Ricardo Rodríguez Brey, Leandro Soto, Tomás Sánchez, and Rubén Torres Llorca (figs. 91, 93, and 94). The exhibition caused a sensation, owing to the controversial, clearly rambunctious tone of the display.[102]

Around eight thousand people visited the exhibition in the first two weeks alone and "orthodox" political leaders lost no time in denouncing the show through such art critics as Angel Tomás in the publication *El Caimán Barbudo*. Nonetheless, the works of the artists in *Volumen Uno* were ably defended by Gerardo Mosquera, who had also written the essay for the catalogue that accompanied the show. In October 1983, Casa de las Américas, ever a defender of socialist pluralism, sponsored a public debate at which these young and "heretical" artists could and did respond directly to their "hardline" critics in the various government agencies.[103]

Two major tendencies connected all these broadranging artists of the new "generations" (the Volumen Uno group is normally said to consist of three distinct "generations" of artists to have emerged in the decade of the 1980s). As a group, they were concerned with addressing the indigenous popular culture of Cuba on the one hand, while establishing what it meant to be "Latin American" on the other. Here we should note the richness of this indigenous culture by recalling that Africans became what Mosquera has termed "imported aborigines," who contributed much to Cuban national culture. As such, both of these diverse tendencies produced art that, while being "Western," was in a certain sense also "Non-Western." That is, these artists assimilated aspects of European art even as they combated a Eurocentric conception of it. Mosquera wrote as follows about the distinctive way in which the new generations worked with the idea of identity:

[All] these artists are in pursuit of a synthesis that is profoundly accessible only to those who address, without contradictions, not only the hybridization or coexistence of various traits from different cultures, but who also deal with the forms of consciousness corresponding to distinct states of historical evolution, that is, to what is called the hybridization of time [*mestizaje del tiempo*]. . . . This does not involve escapism, nor any "return to our roots." Instead, there is a reaffirmation of values appropriate for situating ourselves in contemporary reality. This represents a Third World effort— if not an entirely conscious one—at constructing a new inter-

national order of culture and a more universal perspective wherein the interests of all peoples converge, thus being in opposition to the fabricated cosmopolitanism from the island of Manhattan.[104]

The construction of this new art and culture presupposed much more than the mechanical notion that art merely reflects ideology. These artists did not just embrace the simplistic belief that progressive art involves the "correct" political content, as if the visual language used were of secondary importance. As Mosquera observed, "Art is not mere ideology, nor is it a strict reflection," rather, it is a formative force in its own right. Similarly, Armando Hart Dávalos, the Minister of Culture stated quite arrestingly: "To confuse art with politics is one mistake. To separate art from politics is another mistake."[105]

Both of these positions reaffirmed a dialectical approach to art by disallowing the mechanical reduction of art to the old dichotomy that merely counterposes political or ideological content with aesthetic form. Such a binary view, which implies that art is a passive reproduction or mere reflection of the "correct" position, quite naively overlooks the way a visual language actively shapes, forms, and transforms the ideological values and political position it transmits. All of this is part of a dynamic interchange among these interrelated parts. Here, as elsewhere, the accent was on how art is densely mediated, as any language must be, whether visual or verbal. In turn, attention was given to how art mediates the artist's relation to reality from within it.

Nowhere is the naivety of this traditional bifurcation of form and content more clear than in the misguided "universalism" of those who advocate "socialist realism"—as was true in the Soviet Union from 1930 to 1989. The ethnocentric character of this particular language of art—as Che Guevara and others noted— resided in how it privileged nineteenth-century French art as a "transnational" standard. This innocent belief in "pure" origins undermined all of socialist realism's claims to being a purveyor of egalitarian cultural values and an embodiment of classless ideals. The adoption in Cuba of a Eurocentric style, such as, "socialist realism" would in fact have led only to another form of cultural hierarchy between the Third World and Europe. Fortunately, the Cuban Revolution successfully opposed Soviet aesthetics, with the expert help of Mexican philosopher Adolfo Sánchez Vázquez, the foremost Marxist theorist in Latin America of the 1960s and 1970s. In disallowing any "normative" style by focusing on art as a visual language with polysemic significance, Sánchez Vázquez took a leading role in advancing a New Left conception of art. His influence in Cuba was decisive, as it would be in Nicaragua during the 1980s.[106]

As part of the larger project of self-empowerment through self-definition, the reclamation and reworking of Afro-American, or perhaps Afro-Hispanic cultural practices was of crucial importance to the new generations of artists after 1980. There were a few artists, however, whose paintings preceded the *Volumen Uno* show in focusing on a hybrid identity

89 Manuel Mendive, *Che*, 1967, enamel on wood, Museo Nacional de Bellas Artes, Havana.

with African accents. Foremost among them was the painter Manuel Mendive (fig. 89). In the late 1960s and early 1970s he provided an alternative to the more Western-looking "hyperrealism" of the "Dark Period." Furthermore, he did so by building quietly on the Afro-Cuban aesthetic forged by Wifredo Lam as early as the 1940s.

In addition to being Cuba's most famous visual artist, Lam had also been one of the most important figures to join the Surrealist movement in the late 1930s. (Other prominent artists from the Americas who were associated at various points with the Surrealists were Frida Kahlo and Diego Rivera of Mexico, Roberto Matta of Chile, and poet Aimé Césaire of Martinique). Indeed, while visiting Haiti in 1944–45, French author André Breton declared that the fate of Surrealism depended on the growing historical ascendancy of Third World artists within the movement, in short, on an "ethnographic surrealism." To quote Breton:

> Surrealism is allied with peoples of color, first because it has sided with them against all forms of imperialism and white brigandage . . . and secondly because of the profound affinities between Surrealism and "primitive" thought. . . . It is therefore no accident, but a sign of the times, that the greatest impulses towards new paths for Surrealism have been furnished . . . by my greatest friends of color—Aimé Césaire in poetry and Wifredo Lam in painting.[107]

Lam himself spoke of the Surrealist movement and of the tragic spectacle of the Spanish Civil War as key formative influ-

ences on his own artistic development. Both of these stimuli, in conjunction with his commitment to socialism and the Cuban Revolution, led Lam towards the production of a non-Eurocentric visual language that he hoped would help decolonize the arts of Latin America (through an absorption of Picasso's lead in fusing African art with that of Europe).[108] About his own artistic engagement, Lam said in 1975 that it would never be a variant of the mass cultural version of Afro-Cuban culture, namely, the pseudo-Cuban music for nightclubs that pandered to tourists. To the contrary, he "refused to paint cha-cha-cha" and instead attempted, by drawing, like his friend Picasso, upon African elements, "to paint the drama of my country, but by thoroughly expressing the Negro spirit, the beauty of the plastic art of the blacks."[109]

As Lowery Sims has observed, Lam's distinctively heterogeneous fusion of Cubism and Surrealism with non-Western art led to a type of resistant culture that,

> resulted in a visual vocabulary that correlated with—in an incredibly complementary way—the syncretism of *Santería* and other New World African-based religions. The most persistent character of *Santería* in relation to Lam's art is that various African *orishas* (deities) in *Santería* are masked by the santos (saints) of Roman Catholicism—a subterfuge that evolved to hide the persistence of African observances among black slaves in Cuba.[110]

The most famous works from Lam's entire oeuvre were both painted in Cuba in 1943: *La Silla* (The chair), which is now in the Museo Nacional de Cuba, Palacio de Bellas Artes in Havana, and *La Jungla* (The jungle), which is now in the Museum of Modern Art in New York City. In his iconographic analysis of the deceptively lean-looking chair, Juan Martínez has shown how it is indeed a subtly encoded example of "postcolonial" subterfuge.[111] The fantastic, hybrid plants in *La Silla* are composed of sugar-cane trunks and tobacco leaves that together refer to the implantation of cash-crops in Cuba by European colonialism. Moreover, the vase with leaves located on the chair that is situated in a thicket (*monte* or *manigua*) probably denotes an offering, either to a deity or a nature spirit. For Afro-Cubans, the thicket generally signifies both the jungles of Africa (there are, after all, no jungles in Cuba) and the sacred site or locus of ancestral deities. The chair motif indicated how Yorubas refer to the altars as "the seat of a god." In sum, Lam's *La Silla* represents "an improvised altar with an offering to an orisha."[112]

Much the same could be noted about the signifying code used in *La Jungla*, Lam's acknowledged masterpiece, a 1943 painting in gouache on paper (mounted on canvas) with the commanding proportions of 7′ 10¼″ × 7′ 6½″. In one of the most sustained and convincing iconographic readings of this work to date, Jasmine Alinder has contended that this painting draws heavily on both Santería codes and anticolonial sentiments. The four figures, which are an aggregate of human traits and animal attributes, attest to how a person possessed by an orisha during the Santería ritual is said to be "mounted" like a horse (hence

the equine references).[113] Two significant signs in the painting are the scissors and the leaves. The scissors, which are used in rituals of Santería, probably refer to Ogún, the god of war and technology. Furthermore, this polyvalent and postcolonial sign also signifies something more general in relation to anti-imperialism. Lam implied as much in a 1977 interview with Mosquera when the painter also declared, "I want everyone to know of my solidarity with the Cuban Revolution."[114] The Cuban artist then said that in his painting *La Jungla* the "scissors mean that a break with colonial culture was needed, that we had had enough of cultural domination."[115]

Similarly, the numerous leaves in *La Jungla* remind us of how important herbs are to the practice of Santería and also of what this means about the precolonial origins of homeopathic medicine. Used as protective charms, as cleansing agents, and for spiritual purification, herbs are mixed with sacrificial animal blood to produce the most powerful substance in Cuban Santería, *omi ero*. In all, there were 376 different types of leaves used in the Dahomey rituals that served as the basis for the emergence of Santería. Alinder thus concluded that Lam identified Santería as something like a Surreal mode of self-realization. In this way, ethnographic Santería-based Surrealism became "a dream-like link to his childhood and to Afro-Cuban experience," even as it also provided a building material for reconstituting Cuban identity within the subsequent revolutionary process.[116]

At once a believer and an agnostic in relation to Santería, for which he became a radical interlocutor, Lam also addressed the issue of gender identity. As has been noted, almost all of the figures in Lam's paintings are sexually ambiguous and they involve transgendering that seems to be hermaphroditic in nature.[117] Such creative engagement with and reworking of popular culture did not result here in a form of populism. In fact Lam's works were not immediately accessible to lay audiences in Cuba, as Lam himself admitted, "I knew I was running the risk of not being understood by the man in the street or by others. But an authentic painting has the power to set the imagination to work even if it takes time."[118]

Lam's innovative artwork and political alliances from 1959 until his death in 1982 served as a crucial link in Cuba between the prerevolutionary avant-garde and postrevolutionary artistic practice. His artworks were in turn built upon the foundation laid by the vanguard movement in Cuban art that dated all the way back to 1926–27. This Cuban vanguard included the likes of Victor Manuel and Amelia Peláez, as well as several other artists of note. Perhaps the first famous work produced by this vanguard movement was Victor Manuel's 1929 *Gitana tropical* (Tropical gypsy) (fig. 90). Featuring an assimilation of innovations by Cézanne and Gauguin, this painting by Manuel also suggests (as Juan Martínez has pointed out) "an ethnic mix of European, African, and Asian art that is typical of the Caribbean."[119] It is further marked by a delicate melancholy for which Victor Manuel is widely known. Like Wifredo Lam, who was a life-long leftist, the vanguard artists of Cuba grouped in the 1920s and

90 Victor Manuel García, *Gitana tropical* (Tropical gypsy), 1929, oil on wood, Museo Nacional de Bellas Artes, Havana.

91 Leandro Soto, *Primer Día de Enero* (First of January 1959), 1984, mixed media, Private Collection. This image was made on the 25th anniversary of the revolutionary victory in 1959.

1930s around the avant-garde journal *Revista de Avance* were leftist. It was published by a team of writers named Grupo Minorista that included Alejo Carpentier and Juan Marinello. The artists were also allied to insurgent political forces during this period. Martí Casanovas of this group made the alliance clear enough when he summarized in 1927 the position of these vanguard artists and authors: "We fully condemn and negate the art of the 19th century, the servile instrument of the capitalist bourgeoisie. . . . We are trying to start anew, looking at art as a fountain of emotions, the emotions of everyday life."[120]

The major heir to Lam's lineage (and that of the *engagé* painters from the 1920s) to emerge in the revolutionary period of the late 1960s was Manuel Mendive, a *mulatto* from Havana whose family maintained ties to its Yoruba origins on the West Coast of Africa (figs. 66 and 89). An early variation on this Afro-Cuban tradition was Mendive's strikingly novel depiction in 1968 of Che as a *guerrillero* on horseback. The conventions of the visual language used here, as elsewhere in Mendive's mature oeuvre, owe as much to a fiber arts tradition emanating from Africa as they do to any pictorial tradition coming from Europe. The figure–ground, nature and culture relationships, along with the density of elements and type of clothing in the image, manifest quite palpably the new drive to redefine art in less Eurocentric terms, so as to rethink history in fresh ways.

Yet, as Gerardo Mosquera has observed, the paintings by Mendive derived less from the actual formal attributes of Afro-Cuban art, than did the earlier paintings by Lam.[121] Instead, Mendive's work was based more on the structural logic, or dis-tinctive narrativity, identified with Afro-Cuban tradition. Far from marking Mendive off in separatist fashion, however, this African dimension to his work in fact signified an increasingly heterogeneous path for all Cuban culture—a culture unthinkable without the rich tapestry of African contributions to it. As such, it would be implausible to speak of Negritude or neo-Africanism with respect to Mendive's paintings. This is because, to quote Mosquera, in Mendive's art, "the black person tends to be integrated with few contradictions into a new entity: the Cuban nation."[122]

Elsewhere in Cuban art, the new 1980s waves of artists addressed in hybrid fashion various other aspects of vernacular culture, indigenous artforms, and Western avant-garde art. Flavio Garciandía and Leandro Soto (fig. 91), for example, intentionally drew on the popular production of kitschy visual forms like *picuo*, derived from folk maxims, artisanal traditions, and garish color combinations. In so doing, they raised the provocative issue of an ongoing stratification in image production, linked to the hierarchy of professional artists and nonprofessional artists in Cuba. In a revolutionary society expressly committed to the historical transcendence of all existing social hierarchies, such a social fact raises some challenging questions. Of particular interest here is how later artists (those coming after the first and second waves of the Volumen group) either consolidated or contravened the new developments that began around 1980, in which the utopian project of the 1960s to create a "nation of artists" was examined in a critical light, which at times seemed even "antiutopian" (but not antisocialist).

92 Alejandro Aguilera González, *Che*, from *En el Mar de América* (On the sea of America), 1988, mixed media, Private Collection.

93 (above) Cansuelo Casteñeda, *Lichtenstein and the Greeks*, 1987, mixed media, Museo Nacional de Bellas Artes, Havana.

94 (right) Marta María Pérez Bravo, *Don't Kill Animals or Watch Them Be Killed*, from the *To Conceive* series, 1987, silver gelatin photograph, Private Collection.

In order to narrow the gap between professional art and vernacular traditions, the gifted young artist Alejandro Aguilera González, for example, reinvented the Che portrait (fig. 92) by means of an "unpolished" artisanal language based in traditional woodcarving and later used for Catholic saints. The image of Che Guevara thus became more integrated with the quotidian traditions of the Cuban people outside the professional art scene, albeit in a different sense than previously. In Aguilera González's commanding sculpture this was done specifically through the reference to kitschy popular religious icons from the Caribbean provinces that were generally unrelated to the internationalist visual traditions earlier used for Che by Raúl Martínez or even Manuel Mendive.

Aguilera González, a "third generation" artist, drew in the late 1980s on the extraordinary and even more rough-hewn works by Juan Francisco Elso (fig. 65), who was from the "first generation" of Volumen Uno at the beginning of the 1980s. Here, Francisco Elso's masterful portrait of Martí entitled *Por America* (1986) comes to mind as a signal antecedent. The haunting depiction of Martí by Elso represents a weathered and perhaps "postheroic" figure, yet also an irresistible one who is both quixotic and sobering at once. The jarring unevenness of historical development surfaces here in palpable form on the rude "skin" of the sculpture, as if to give the viewer equal visual doses of inspiration and despair.

As did other "second generation" artists, Consuelo Castañeda attempted in her work a critical assimilation, then destabilization, of Pop Art. This tendency is exemplified in her vernacular rendition *Lichtenstein and the Greeks* (fig. 93). Like Marta María Pérez Bravo in her conceptually oriented, but visually charged photographs (fig. 94), María Magdalena Campos addressed feminist issues, yet she did so in densely formal and thematically oblique assemblages.[123] Similarly, Campos, Humberto Castro, Moisés Finale, and José Franco all used components of Neo-Expressionism in conjunction with various Afro-Cuban visual forms that have become internationally identified with the award-winning works of José Bedia and Ricardo Rodríguez Brey, two of the more well-known artists from the "first generation" (figs. 95 and 96). In a plurality of styles as well as media, all of these Cuban artists have addressed a number of issues that range from gender relations and ecological concerns to the crucial role of concrete popular rituals for creating a social bond on behalf of a more egalitarian society.[124]

Among the younger painters to have emerged as prominent figures in the third wave of the 1980s are two artists of particular note: Lázaro Saavedra González and Carlos Rodríguez Cárdenas(figs. 67 and 97). Each has humorously dissected and reconstituted various aspects of European as well as Cuban culture from the Renaissance representations of Saints to the fetishistic celebrity encasing the achievement of old masters like Rembrandt. In addition, these younger Cuban artists have tried to desloganize the images of Karl Marx and Fidel Castro, along with the socialist rhetoric that had for three decades been used and abused in revolutionary Cuba. In an assessment of images

95 José Bedia, *Autoreconocimiento* (Self-recognition), 1985, crayon on paper, Private Collection.

96 Ricardo Rodríguez Brey, *The Structure of Myths*, 1985, mixed media, Private Collection.

97 Carlos Rodríguez Cárdenas, *Las ideas llegan más lejos que la luz* (Ideas go further than the light) 1987, oil on canvas, Private Collection.

by Carlos Rodríguez Cárdenas that also applies to the other two artists, Gerardo Mosquera has noted:

> Carlos concentrates on appropriating the stereotyped slogans that inundate Cuban life, and placing them in new semantic settings by means of a process of ironic deconstruction. . . . Rather than questioning or ridiculing the slogans, Cárdenas makes them problematical and uses them to analyze aspects of socialism. . . . A work such as *Construir el cielo* (To build the sky), where the sky looks like a wall of blue bricks, leads us to reflect on utopia and reality. . . . His grotesque vein is not Rabelaisian but rather reflexive, but without any dulling of its vernacular edge.[125]

As José Franco has noted of this "third generation" (and even younger artists like Kcho), they were the first group of visual artists in Cuba who were "able to do in school the same kind of work that they do at home."[126] The "informality" and "incompleteness" of their often humorous, even cartoon-like works no longer needed to be given formal or conceptual resolution in the polished "art-school" sense. The comic-book nature of much of this work thus went much further along these aesthetic lines than had the "irreverent" Cuban Pop Art of the 1960s. Not surprisingly, though, the work of Raúl Martínez was both a stimulus and a foil for the three "waves" of artists in the 1980s.[172]

One way to summarize some of these developments would be to cite a lively assessment by the Cuban-American critic Coco Fusco. Her observations about Cuban art since 1960 are as follows:

> If postrevolutionary Cuban culture has proved anything, it is that there is no consensus as to the nature of radical aesthetics, cultural identity or art's relationship to social context.

. . . However, artists and bureaucrats alike generally agree that the development of democratically acceptable arts education and the stabilization of cultural institutions in the 1970s gave birth to a new generation of artists. They debunked cultural bureaucrats' attempts to graft social realism imported from Eastern Europe onto Cuban art. . . .[128]

Finally, the overall logic of this movement in the arts up to 1989 was summed up effectively by Gerardo Mosquera. In so doing, he has provided us with a telling summation for our overall critical survey of Cuban art and culture from 1959 through 1989:

> [These new artists] intend to project values, accents, and points of view layered within a global perspective of humanity, which simultaneously provides the capacity for specific action in the contemporary world. One can say that the art of these younger artists, while being "Western," is in a certain sense also "Non-Western."
>
> Instead of feeling like second-rate Europeans, or "Indians" and "Blacks" who do not belong in the West, or like victims of chaos, we are building on the multilateral nature of our culture, thus constructing our own synthesis that allows us to incorporate naturally the most diverse elements. . . . We seek identity as a form of action, not as a type of exhibition. In the "search for national identity," some have advocated an "expression of our roots" that has caused a grave cultural misfocus. . . . This is a serious mistake, since the problem is not to find an identity, but to construct one. This is what *it means to be ourselves.*[129]

Critique: Successes and Shortcomings on the Thirtieth Anniversary

To say that much was achieved in Cuba between 1959 and 1989 is neither to claim that little was left to be done nor to deny that serious problems remained unsolved. Indeed, when Nicaraguan poet Ernesto Cardenal asked a politically engaged Cuban poet about the role of writers in the Revolution, the poet responded: "For us that function must be criticism."[130] Moreover, Cardenal himself observed that in Cuba it was very easy to distinguish actual revolutionaries (who discussed the Revolution with constructive criticism) from pseudorevolutionaries (who were uncritical of it).[131]

Nonetheless, this observation is misleading if not accompanied by the recognition that there were often barriers to publishing such constructive criticism. While constructive criticism could and did appear in films, in artworks, or public dialogues, such criticism in printed form was uncommon. This occurred because of the fact that both daily newspapers were controlled by sectors of the Communist Party, a Leninist vanguard that claimed to represent the population adequately. Yet only if such a vanguard allows further discussion in the press and on TV can that claim to be fully representative of the majority position be democratically corroborated.[132]

The general absence of any independent daily publications run by the labor unions, as well as by other mass organizations not formally linked to the Communist Party, attenuated the further expansion of public discourse and constricted essential avenues for constructive criticism. The situation of the Cuban press was criticized by Julio Cortázar of Argentina and Mario Benedetti of Uruguay, along with other strong partisans of the revolution.[133] The nature of the press also contradicted the general tendency after the 1970s on the local level to decentralize power and to democratize decision-making. As a result, the only two daily newspapers in Cuba were official organs of an organization whose membership constituted a very small minority of the populace. Even Fidel Castro conceded in several interviews from this period that this situation was "unhealthy."[134] Yet by 1989 the requisite measures to change these circumstances were not forthcoming.

Contrary, however, to Western ideology about what constitutes a "free press" (private ownership of it, coupled with minimal governmental, or public involvement), the democratization of the daily mass media in Cuba could hardly have been achieved by any regression to a press that is privately owned, and hence necessarily antidemocratic in structural terms. A public, and appropriately decentralized, culture is inherently incompatible with a press that is exclusively private, and therefore heavily centralized. Indeed, the existence of such an overwhelmingly private press in the United States is a major means whereby the "aristocracy of culture" in the West has been sustained.[135]

The reason for the exclusivity of the mainstream Western press is that it generally functions as a corporation logistically, as well as ideologically, and is in turn largely owned by a consortium of the most powerful multinational corporations. This situation was summarized by newspaperman A. J. Leibling, who said of the situation in the United States: "here, freedom of the press belongs to those who own one." Or, in other words, since a prerequisite of "free speech" in the U.S.A. on any extended basis is the extensive accumulation of capital, "freedom of the press" in the West is not an affair of the majority. Members of the popular classes are clearly unable to buy a press in order to be heard on a national level. Moreover, one is reminded here of Marx's acute observation in the 1840s that "the first guarantee of a free press is that the press not be a business."[136]

Cuba's pressing dilemma with regard to democratizing the press could not have been resolved, then, by recourse to the U.S. model. The U.S. press is too often antidemocratic and generally unaccountable to the majority in both managerial and editorial terms, as if multinational corporations alone should have the right to discuss issues in a "public" arena. Nonetheless, the Cuban Revolution failed to originate a new model for a press that would have been at odds with the two dominant ones—a privately owned press and one that is party controlled. Neither of these prevailing systems are democratic enough.

As the problem in Cuba shows, having public control over the mass media is not synonymous with having public access to it.

When a small minority speaks for, rather than with, the majority, there is an unacceptable passivity intrinsic to the role of the majority, even when they agree with the vanguard view. As such, a necessary, though not sufficient, precondition for democratizing the press is the further decentralization of power. With such a process of decentralization, the ascendant, often orthodox, sectors of the state institutions could not always speak for the public. Instead, there should be the implementation of a type of press, perhaps a combination of one publicly and privately owned, whereby something approaching consensual decisions could be arrived at in the broadest possible debate in a revitalized "public sphere." Discourse along these line would involve something like an equal footing for all sectors of society.

The Cuban revolutionary process of greatly augmenting the public dialogue in an informal manner (as noted above) did not always automatically translate into a greater public access to the press, even when such changes did notably enhance the dynamic towards *poder local* and *autogestion*. In fact, the 1976 Constitution of Cuba, which guarantees "freedom of speech" to all citizens (Article 52), attested to the still somewhat uncertain political relationship between the Communist Party and the populace as a whole—an uncertainty that explained in part the paradoxical predicament of the press with regard to cultural democracy.[137]

Article 4 of the Constitution, for example, gives ultimate political power to the municipal governments, which directly represent the majority, while Article 5 grants final decision-making power to the Communist Party, which, as an internal organization of select members, is only indirectly accountable to the majority of people in Cuba. From 1959 to 1989, the daily mass press tended to function with regard to Article 5, rather than with respect to Article 4, even though these two articles are mistakenly assumed to be mutually determining in the 1976 Constitution of the Republic of Cuba.[138]

As a last note, one thing should be pointed out—primarily because of a misguided notion religiously repeated in the Western press. The uneven and often ambiguous relationship between the Communist Party and the organs of *poder local* did not result in an unremitting stream of dictatorial or "totalitarian" decisions regulated by the press. As was clearly demonstrated above, vigorous debates over the nature of art, as well as the quality of particular artworks, occurred in print in the major journals of arts and letters (if not in the daily press) from 1959 to 1989.

Significantly, in 1985 Casa de las Américas published strong criticisms by Julio Cortázar of the Cuban government's handling of the notorious case of poet Herberto Padilla in 1971.[139] Among the worst mistakes made in the cultural realm within Cuba, this error that occurred in the "dark period" of the early 1970s involved the detention and interrogation of author Herberto Padilla for thirty-eight days. This happened because the black tone of his writings was perceived as "counter-revolutionary" in certain governmental circles (although Padilla was honored by revolutionary intellectuals

in some groups and state agencies). After Cortázar and other Latin American intellectuals (along with such European authors as Jean-Paul Sartre) sharply disagreed with these actions in 1971, the Cuban government backed off sheepishly from this intimidation.[140]

Yet, some other comparably repressive acts were not overturned in this period. Although no explicit dogmas about art were promulgated by the Cuban Government in this period, there were several occurrences that contradicted in a few cases what I have shown to be the overall logic in the arts and culture from 1959 to 1989. These instances of what can be called "Cold War intolerance" were as follows: the "self-censorship" by painter Antonia Eriz who gave up displaying her morbid "neo-expressionist" images when they were seen as too bleak in some important circles (but who nevertheless always remained a partisan of the revolution); the promotion of some mediocre but "politically correct" artists to prominent positions in the art schools (their influence was in fact shortlived as evidenced by the *Volumen Uno* Show in 1981); the end of some progressive, but "controversial" publications such as *Pensamiento Crítico*; and, finally, the brief ascendancy in Cuba during the early 1970s of Soviet aesthetics, particularly as represented by Avner Zis and the later work of Georg Lukács, over the "unorthodox" thought of Mexican Marxist Adolfo Sánchez Vázquez. (In his study, Camnitzer has given us a thoughtful historical overview of this debate in Cuba.)[141]

In the 1960s and then again in the 1980s the philosopher Adolfo Sánchez Vázquez had an enormous impact on the arts and cultural policies in Cuba. As Gerardo Mosquera wrote at the beginning of the 1980s in a fine tribute to Sánchez Vázquez, this innovative thinker disallowed any notion of a "normative art style" within the Marxist tradition. Similarly, Sánchez Vázquez emphasized the polysemic nature of art over any illustrative political serviceability, and he eloquently defended abstract art within the Marxist tradition. The fate of Sánchez Vázquez's writings was thus a fine gauge for the degree of openness or narrow mindedness of a given moment in the cultural life of Cuba. The overall popularity and unmatched influence of Sánchez Vázquez in revolutionary Cuba for three decades is thus quite revealing.[142]

Yet, one fact becomes clear when we weigh the Cuban improprieties of the "dark period" against the Cold War excesses in the United States that led to the expulsion of Charlie Chaplin, Marta Traba, and Angel Rama purely for political reasons (along with the denial of U.S. travel visas to Pablo Picasso, Gabriel García Márquez, Julio Cortázar, Tomás Borge, Gerardo Mosquera, Tomás Gutiérrez Alea, and Graham Greene, to name only a well-known few): it would be wrong to embrace the simple-minded view that there is "free speech' without qualification in the U.S. and none at all in Cuba.

Ironically, the mainstream Western media, particularly that of the United States, will be unable to criticize Cuban culture legitimately until they gravitate away from their uncritical, and reflex-like dismissal of Cuban culture since the Revolution. Here, as elsewhere, a scholarly grasp of the pertinent data remains a *sine qua non* for focusing on the revolution's failings—failings that can only be assessed fairly in the context of concomitant and often impressive successes. The problem is not that the U.S. media and many in Academia criticize Cuba, but rather that they do so for reasons at once misinformed and self-serving. When the constructive criticism of Cuba is finally accomplished on a regular basis in the U.S., a considerable service will have been done not only the Cuban people, but also the North American public. Then, and only then, will the general public be able to grasp more profoundly the strengths and weaknesses of the joint projects of socializing art and democratizing culture as they were advanced in Cuba from 1959 to 1989. The historical moment of the Cuban Revolution, including its undeniable originality and its most symptomatic paradox, was summed out revealingly by two authors who noted the following:

> The Cuban Revolution placed on the agenda again a possibility that Latin America could conduct and control its own history, could re-enter history. . . . The new concept of revolution in Cuba, however, in rejecting the determinism of Stalin's "stages theory," argued with maximum optimism that those conditions could be overcome by will and self-sacrifice. This voluntaristic vision of change and revolution was enshrined in a version of the history of the Cuban Revolution . . . [and] poetry resumed its visionary role.[143]

THREE

The Nicaraguan Revolution (1979–1990)

The triumph of the Revolution is the triumph of Poetry.

Street Graffiti, July 1979[1]

In Nicaragua we assume that everyone is a poet until they prove otherwise.
The Revolution cannot impose formulas . . . it must be without artistic restrictions of any kind.

Commandante Daniel Ortega, President of Nicaragua (1984–90)[2]

We don't want our revolution to become gray, orthodox. . . . We don't see our revolution as a copy of any other. We don't believe that the problems of Nicaragua can be solved by merely copying other models.

Sergio Ramírez, author and Vice-President of Nicaragua (1984–90)[3]

Culture must be a means of superseding the division of labor between intellectual work and manual work. . . . Culture must be democratized, so that our people will not only be consumers of culture, which is of course very important, but also producers of culture.

Father Ernesto Cardenal, poet and Minister of Culture (1979–88)[4]

No other country in the world during the 1980s was more often at the center of international debate than was Nicaragua. To take a stand one way or another on the novel experiments in this revolutionary society was a defining issue all around the world for an entire era. Few nations of Nicaragua's modest size, with a population of only three million, ever captured the popular imagination on a global basis as did this small Central American country in the decade of the 1980s. Why and how this happened in the domain of art and culture will be addressed at length in this section. As such, I hope to explain the enduring legacy of a moment in history that continues to stand as a challenge to all those for whom the vision of a more just world remains a future hope (fig. 98).

The necessity of such a study as this is immediately clear when one realizes a basic fact of the period. Seldom, if ever, before had any earlier revolutionary process instituted almost at once such a remarkable range of bold new cultural programs involving artistic production in all its various manifestations. Within the first week of its ascendancy to power, for example, the revolutionary government established a new Ministry of Culture with an unusually sweeping agenda in the arts. While this new role

for the arts was criticized by some and praised by many more, no one denied that ambitious, even audacious, new cultural programs were an intrinsic part of the Sandinista-led revolution in Nicaragua from the beginning.

From its inception, the process that began on July 19, 1979 in Nicaragua was termed a "revolution of poets." This unusual title, which surfaced in numerous references from Nicaraguan street graffiti to Hollywood movies such as *Under Fire*, was appropriate for several reasons. Among them was the fact that many Sandinista leaders were accomplished authors and artists. Significantly, the 1969 manifesto of the FSLN or Frente (Sandinista National Liberation Front) featured a key section on the anticipated "Revolution in Culture and Education," that began in earnest with the revolutionary victory in 1979.[5]

Even author Pablo Antonio Cuadra, an editor of the conservative newspaper *La Prensa* and himself an outspoken critic of the Sandinistas, conceded at the time that the Nicaraguan Revolution had "increased the cultural possibilities of the people. It has impelled the democratization of culture with brilliant results."[6] In arriving at an understanding of the truth value of Cuadra's surprising concession, we need to explicate the

98 Alejandro Canales and assistants, *Homenaje a la Mujer* (Homage to women brigadistas), 1980, acrylic, Velásquez Park, Managua. A celebration of the 1980 Literacy Crusade, this mural was painted on the side of a primary school by Canales and several assistants: Genaro Lugo, David Espinoza, Freddy Júarez, Romel Beteta, and María Gallo. The mural was commissioned by the Sandinista-led government in 1980 and it was destroyed in 1990 on orders from Arnoldo Alemán, the right-wing Mayor of Managua.

99 *Somersaulting Literacy Crusade Brigadista*, detail of fig 98.

Sandinistas' noteworthy successes in the arts and in cultural policy. Nonetheless, I also engage in a sober reassessment of the Revolution's manifest shortcomings.

Besides the remarkable educational campaign in 1980, which raised national literacy from only around 50 percent to almost 90 percent (an accomplishment which rightly won the Nicaraguan Government a special award from the United Nations), several other cultural developments also registered international attention. Perhaps the best known of these efforts to democratize culture were the nationwide network of Talleres de Poesía (Poetry Workshops), the national system of Centros Populares de Cultura (Popular centers of culture), and the revival of public mural art to such an extent that Nicaragua became the "world capital" of muralism in the 1980s. There were also other developments of note: the rise of a now famous school of *campesino* oil painting and the unparalleled prominence of Nicaraguan writers in Latin American literature. These noteworthy authors extended from poet Ernesto Cardenal and fiction writer Sergio Ramírez to a whole group of acclaimed women authors, including Gioconda Belli, Michele Najlis, Daisy Zamora, and Rosario Murillo (figs. 99, 100, and 101).[7]

Yet perhaps the most notable gain of Nicaragua's cultural transformation was its initiation during the 1980s of a general process of critical inquiry into the nature of art and its relation to society as a whole. The cultural policies of the Sandinista-led government simultaneously elevated art to a more prominent position within society, while also making the arts more publicly accessible, not just more visible. Much of the international attention focused on the Nicaraguan Revolution was

related to how the Sandinistas initiated a novel process whereby the traditional modes of artistic production were dramatically altered.

As such, both Nicaraguan culture in general and its arts in particular came to mean something more intellectually complex, yet, paradoxically, also more publicly intelligible. Grasping this point will help us to understand how the same small country that gave us the word "modernism"—a term coined around 1890 by Nicaraguan poet Rubén Darío—also provided us with a new conjuncture of advanced art and progressive politics in the 1980s that reasserted on a much higher plane the old and often forgotten convergence of avant-garde art with revolutionary politics in earlier twentieth-century art.[8]

As early as 1905 Rubén Darío (figs. 102 and 103) challenged us to understand the anti-imperialist and aesthetic forces that would ultimately culminate in the Sandinista Revolution of 1979. (It is not by chance that the major national prize instituted by the Sandinistas would be La Orden de la Independencia Cultural "Rubén Darío" or The order of cultural independence of Rubén Darío.) Darío alerted us to these subsequent developments as follows in an introduction to his poetry.

If in these cantos there is a politics, it is because they appear universal. And if you find verses dedicated to a president [Teddy Roosevelt], it is because this is a continental shout. Tomorrow, we could all be Yankees (and it is most probable that we will be); anyhow my protest remains written in the wings of the immaculate swans, which are as distinguished as Jupiter himself.[9]

Various perspectives on art permeated Nicaraguan society in the 1980s, but one view in particular was most commonly held. This view maintained that art and culture had been far too narrowly defined and limited in access before the Revolution. As such, there was a pervasive belief that art, like culture, has many more dimensions than is generally recognized in most other societies. One thus encountered in Nicaragua the sense that art and culture are as complex as they are necessary, that art, like life, suffers from simple formulations.

100 *(below left)* Taller de Gráfia Experimental, *Construyendo la Patria nueva, forjamos la mujer nueva*, 1980–81, photo-offset poster, AMNLAE.

101 *(below right)* *La Mujer Nueva* (The new woman), silkscreen poster, 1981–82, Association of Nicaraguan Women "Luisa Amanda Espinoza" (AMNLAE). In this case, as in most others of the 1980s, the poster was produced by a collective of artists based in Managua, who formed first the Taller de San Jacinto led by Leonel Cerrato and then the Taller de Gráfica Experimental led by Oscar Rodríguez.

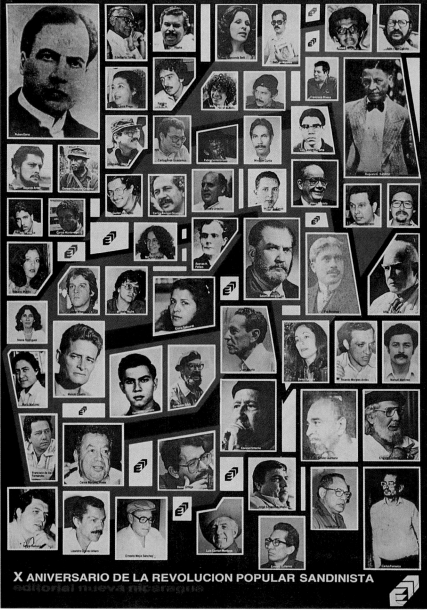

102 *(above left)* *Rubén Darío and his Poem "To Roosevelt,"* 1986, poster for the FSLN, Taller de Gráfica Experimental.

103 *(above right)* *Major Writers in Nicaraguan History,* 1989, poster, Editorial Nueva Nicaragua. Rubén Darío is prominent in the upper register, as is Sandino, while authors like Gioconda Belli, Sergio Ramírez, Daisy Zamora, Michelle Najlis, and Ernesto Cardenal are featured in the mosaic of portrait photos.

104 *(right)* Escuela Nacional de Artes Plásticas, Xavier Kantón Gallery, 1986, Managua. The two cast bronze busts flanking the entry to the gallery are portraits of Carlos Fonseca, a founder of the FSLN, and Voltaire, the eighteenth-century French philosopher.

It was of course this widespread popular conviction that caused the Administration of Commandante Daniel Ortega (a published poet who was President from 1984 to 1990) to be against all government regulation of the arts. In 1979, Ortega said that "the revolution cannot impose formulas" in the arts, because artistic production must remain "without artistic restrictions of any type."[10] Such regulatory roles would have debilitated art and narrowed popular participation in the conception of it in favor of a stultifying bureaucratic control of art from above.

A refusal by the Sandinista-led Government to institute stylistic regulations did not result, however, in an endorsement of aesthetic relativism—a position that trivializes art and culture to the level of inconsequentiality by fetishizing personal caprice and precluding any serious response to shared public values. Instead of dictatorial rules on the one hand or dilatory relativism on the other, the revolutionary process featured a national dialogue, or what has been called a "dialogical process."[11] This dialogical process involved an interchange among people who represented all sectors and classes, from rural wage laborers to urban middle-class professionals.

What emerged from this vigorous national dialogue (and the animated debates concomitant with it) was a clearer sense of the directions in which art should go. This understanding was counterbalanced by a better appreciation of the diverse artistic tendencies and competing cultural traditions that any sophisticated version of this general direction simply had to accommo-

date. Thus, the Nicaraguan revolution fostered a dynamic process of "socialist pluralism." Such a view was at odds with the dogmatism of any "purely" revolutionary style, which, after all, constitutes merely an inverted use of the doctrine of "pure" form. (The former is what English conceptual artist Terry Atkinson once termed the fallacy of "socialism in one artwork.")[12] Nonetheless, the Sandinistas did create a cultural matrix within which artistic practice was unquestionably transformed to a radical extent, yet without the state's instituting any putative "revolutionary style."

The overall logic of this process was eloquently encapsulated by Nicaragua's leading art critic, Raúl Quintanilla (fig. 105). A director of the Escuela Nacional de Artes Plásticas (National School of the Visual Arts) (fig. 104) during the mid-1980s, Quintanilla noted as follows:

> Through the revolution, we earned the right to freedom of expression, and thus set for ourselves the task of re-appropriating part of the heritage that had been taken from us throughout 500 years of colonialism as well as neo-colonialism, and also the task of building upon the new developments constructed by the artists of the West. . . . With this in mind, we looked in a newly liberated way at the Eurocentric nature of much contemporary art . . . We wanted to construct a new visual language that was national and yet also internationalist. In this respect, we had the examples set by Armando Morales, Rubén Darío, and Ernesto Cardenal. They had already been immersed in the process of appropriating con-

105　Raúl Quintanilla, *The Lenin Train*, 1986, collotype, Private Collection.

P/A

jraulquintanilla

J85

GABRIEL GARCIA MARQUEZ

VIVA
SANDINO

editorial nueva nicaragua

106 M. Cerezo Barredo, book cover for Gabriel García Márquez, *Viva Sandino* (published by Editorial Nueva Nicaragua, Managua, 1980). This play is about the famous FSLN raid on Somoza's friend Chema Castillo's Christmas Party, on December 27, 1974. In her novel *La mujer habitada*, Gioconda Belli gives a fictionalized account of this episode.

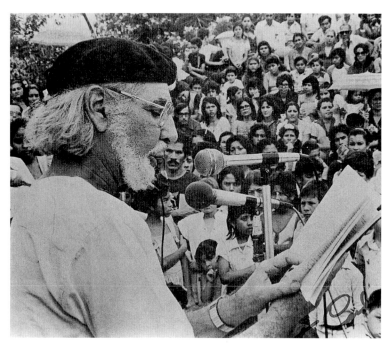

107 Ernesto Cardenal reading poetry, c.1980, taken from a photograph by an un-identified person. This photo was used on the album cover for the Ministry of Culture's *Poemas: Ernesto Cardenal* (Managua, 1980).

temporaneity. Within this process, they had affirmed our national self-identity in a new plurality of ways.

For these reasons, amongst others, we began the process of constructing a visual language together with many dialects through a continuous dialogue that, as I mentioned before, engaged everyone and everything.[13]

Accordingly, this dialogical process in revolutionary Nicaragua led to a protracted rethinking of the concept of aesthetic quality, as Gioconda Belli has noted (see Appendix E). It did so in tandem with the reconstitution of artistic practice as a fundamental mode of human realization for all people. Just as Commandante Tomás Borge, the Minister of Interior during the 1980s, could observe that, "Beyond many deaths, the torture, the poverty, Somoza left us bad taste—*mal gusto*,"[14] so Vice President Sergio Ramírez could add to this view the insight that "Here in Nicaragua, we speak of something we call Somocista kitsch . . . What the Somocistas really wanted was to turn Nicaragua into a kind of Miami—which is not really the best cultural tradition of North America."[15]

A major part of the Sandinista's 1969 Manifesto, concerning its "Historical Program," dealt with the critical reclamation of extant fragments of indigenous and resistant popular culture, as well as of "provincial" high art.[16] From the advent of Spanish colonialism in the sixteenth century through the U.S.-backed Somoza dictatorship (1934–79), these vernacular forms had been systematically devalued. This process of devaluation saw them labeled as "craft" or "low art" or "vulgar taste" because these artforms supposedly did not "measure up" to the standards of the fine arts, or even those of mass culture from the West.

The striking degree of stylistic pluralism that obtained in the Sandinista-led Nicaragua of the 1980s was necessitated by their invocation of a "Revolution in Culture and Education." This declaration was on behalf of a self-determining culture that was both non-Western and Western, both indigenous and international—one that would be freed from "neocolonial penetration."[17] Similarly, the Sandinistas called for the rescue of those "progressive intellectuals and their works that have arisen throughout our history, from the neglect in which they have been maintained."[18]

This key manifesto with its accent on a new class-conscious hybridity, amounted in no way to an uncritical "return" to the indigenous or popular past, such as one encounters in *indigenista* literature. This point must be underscored, since a group of U.S. anthropologists have somehow mistakenly assumed that a type of essentializing *indigenismo* was embraced by some of the Sandinista leaders, particularly Ernesto Cardenal and Jaime Wheelock Román. (To say that these anthropologists were wrong on this point is not, however, to deny the genuine merits of their otherwise valuable fieldwork.[19]) As will become clear below, the Sandinistas never uncritically endorsed conventional *indigenismo*, nor did they unthinkingly recycle any ahistorical "myth of a mestizo Nicaragua."[20] Proponents of a new cultural synthesis, the FSLN drew instead upon various discourses to

arrive at a more sophisticated culture than that of its prerevolutionary antecedents.

As such, the Sandinistas proposed from the very beginning a critical *reconstruction* of the Nicaraguans' unavoidably heterogeneous, or *mestizaje*, cultural lineage, so as to recombine fragments from the past with such new and revolutionary concepts as those that ideologically posited "cultural equality between men and women."[21] The plurality of Nicaraguan identities being constructed would thus involve neither a purist "return to origins" nor any retreat to an idealized past (each of which is a misguided cornerstone of mainstream *indigenismo*). Both the fractured popular past and its fragmented indigenous origins would simply serve as raw material in the remaking of multiple identities by newly mobilized and only recently self-representative popular constituencies allied with the FSLN. In turn, the identities constructed by this process would themselves be subject to popular amendment in the future.

As noted before, the Revolution was a massive "return of the repressed" on a national level. Prior to the Sandinista-led Revolution in 1979, the majority of people were not dissimilar from the inhabitants of Macondo in Gabriel García Márquez's *One Hundred Years of Solitude*. They were unable to empower themselves in the present because they could not situate themselves in relation to the past. Like the denizens of García Márquez's novel, the populace in Nicaragua came to realize that peoples or classes cut off from their own history are less free to act as peoples or mobilized classes, than those who have located themselves in the past and thus have put themselves in a position to advance beyond that very same history.[22] In fact, García Márquez wrote a Nicaraguan "sequel" to his novel with his play about a Sandinista-led insurgency (fig. 106). This text appeared in Nicaragua only after the 1979 overthrow of Somoza opened a new chapter in history that allowed a rethinking of the nation's past, a resituation of the majority's role in history.

From the *Prosas Profanas* (Profane prose) of Rubén Darío in 1896, through Ernesto Cardenal's *Homenaje a los Indios Americanos* (Homage to the American Indians) of 1969 and Sergio Ramírez's *Cuentos* (Stories) of 1986, this concept of resituating oneself in history so as to aid national self-determination along with the reconstruction of identity was in fact a significant theme in all the best and the most revolutionary Nicaraguan literature.[23]

The assessment of revolutionary Nicaragua that follows addresses the following interrelated issues: the protorevolutionary tendencies, both among popular forces and urban intellectuals, that served as a crucial foundation for the cultural programs that emerged after 1979; the overall cultural logic, as well as specific cultural programs, that came into being during the 1980s; particular artworks of importance, from murals to oil paintings and popular images, that were produced in Nicaragua during these years; the new forms of patronage, along with the intense debates surrounding them, that were originated in this period; and, finally, the enduring lessons, both theoretical and concrete, that remain with us today as part of the inextinguish-able legacy of this remarkable moment in history. Accordingly, this section will also entail a look at the internal contradictions of the Nicaraguan Revolution that, along with unrelenting foreign military aggression, slowed down greatly (but did not destroy) the process of popular self-empowerment in this Central American country in 1990.

Protorevolutionary Developments prior to 1979

Far from being conceived in isolation from any related earlier struggles, the Sandinistas' theoretical framework for art after 1979 was partly inspired by actual developments within Nicaragua in the 1960s and 1970s. Some of these took place on the islands of Solentiname in Lake Nicaragua, where a priest and, by then, already celebrated poet named Ernesto Cardenal (fig. 107) (who would be the Minister of Culture from 1979 to 1988) established a religious community in 1966. An early advocate of liberation theology, with its commitment to building *comunidades de bases* that translate readings of the gospels into social critiques and programmatic change, Cardenal originated the idea of such a community in conversations with his mentor Thomas Merton. This famous North American priest was planning to visit Solentiname at the time of his unexpected death in 1968.[24]

In this community of around one thousand impoverished *campesinos*, artisans, and fishermen, Cardenal helped to foster an ambience of radical egalitarianism and communal sharing. These religious ideals were motivated by the type of "elemental communism" attributed to Jesus and his followers by liberation theologists such as José Miranda of Mexico, Gustavo Gutiérrez of Peru, and Leonardo Boff of Brazil. Appropriately enough, such a view was based on New Testament passages like Acts 2: 44–45, which describes Jesus' relationship to his disciples as: "All whose faith had drawn them together held everything in common; they would sell their property and possessions and make a general distribution as the need of each required."[25]

Liberation theology, which is sometimes called "Third World Theology" because of its immense significance in Latin America and Africa, was based on the claim that the central import of the Bible resides in the stories of struggle, liberation, and redemption in which God is said to side with the oppressed. Along these lines, Jesus is interpreted as a Jewish intellectual who was fundamentally opposed both to Roman imperialism and to social inequities. Furthermore, ethical precepts, such as the Golden Rule, are understood as current guides to the historical reconstruction of society, rather than as mere advice on personal conduct that is to be rewarded in an afterlife. Thus, for Cardenal and other liberation theologists, the biblical psalms—in concert with authentic artistic practice—are means for forging "community through the common language of redemption."[26]

As has been noted, liberation theology is compatible with a Marxist analysis of society in several ways: by emphasizing a class analysis in the overcoming of social inequities, by giving economic institutions a central place in this analysis, by relating

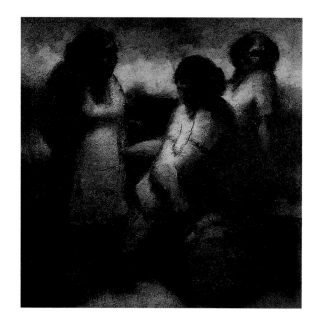

unequal participation in society to inequitable control over the means of production, and by underscoring the importance of collective human agency to the structural transformation of society.[27] In fact, Friedrich Engels even wrote that, "The history of early Christianity has notable points of resemblance with the modern working-class movement. Like the latter, Christianity was originally a religion of oppressed people: it first appeared as a religion of slaves."[28]

About the source of his belief that "capitalism is not compatible with ideals of Christ," Cardenal elaborated in 1976:

> I became politicized by the contemplative life. Meditation is what brought me to political radicalization. I came to the revolution by way of the Gospels. It was not by reading Marx but Christ. It can be said that the gospels made me a Marxist.[29]

Another notable influence on Cardenal was the Cuban Revolution. His first trip to Cuba in 1970, when he was invited to serve as a judge in a poetry contest organized by Casa de las Améri-

108 *(above left)* Roger Pérez de la Rocha, *Pesadilla* (Nightmare), 1978, oil painting, collection of the Ministry of Exterior, Managua.

109 *(left)* Gloria Guevara, *Cristo guerrillero* (Christ as a guerrilla), 1975, oil painting, Solentiname.

110 *(below)* Alejandro Guevara, *Lake Nicaragua*, c.1977, oil painting, Solentiname.

cas, dramatically influenced his change of political perspective. Although he had intended to stay only a short time, he ended up staying three months, so fascinated was he by the social programs that he saw there. The result of his extensive set of interviews with the Cuban people was a book entitled *In Cuba* (1972). He concluded from his study of Cuba that "this revolution was the Gospels put into practice, and what had to happen was for the Christians in Cuba to understand this."[30]

Here as elsewhere, he took his point of departure from Peruvian author José Carlos Mariátegui's emphasis on the incorporation of popular philosophies into Marxian thought.[31] Accordingly, Cardenal reread the Gospels as a prescientific precursor of Marxism that contained the rudiments of the latter's social vision. One of Cardenal's more striking theoretical contributions resulted from how he reinterpreted the biblical theme of a Last Judgement with recourse to the revolutionary concept of the New Person. His viewpoint was that, "The Son of Man will not come again as an individual, as he did the first time . . . He will come as a new society, or rather as a new species, the New Person . . . and this person is the one who is going to judge history."[32] A commitment to these egalitarian ideas resulted in a collective rereading of the New Testament by Cardenal and the rural wage-laborers of his parish. The resulting publication, which is now a classic of liberation theology, was the multivolume book entitled *The Gospels According to Solentiname* (1973–75).[33] Equally momentous was the emergence from this popular dialogue, or dialogical process, of the idea that the making of art, like the interpretation of key texts, should also be made accessible to the popular classes in Nicaragua. In 1968, the accomplished painter Roger Pérez de la Rocha was invited to Solentiname to give lessons in the visual arts to the rural laborers.[34]

Campesino Eduardo Araña, for example, took lessons in oil painting from Pérez de la Rocha (fig. 108) and this example stimulated a general interest in the peasant community for such lessons. Within a few years a very large number of those at Solentiname, including entire families such as the Guevaras, the Arañas, and the Silvas, had become part of a school of what they themselves named "pintura primitivista" (primitivist painting) to underscore the nonprofessional and "spontaneous" nature of this art (figs. 109, 110 and 112).[35] Their hybrid work fused a fine art medium with stylistic references to popular cultural traditions, such as indigenous weaving and images on painted gourds that, at least in part, evidently went back to related practices by the Chorotega Indians. With the arrival in 1976 of Mayra Jiménez, a Costa Rican poet, the idea of teaching the rural workers how to write poetry also arose. In a short time, a large number of them were also composing their own poems (fig. 111).

Jiménez has described the activities of the poetry workshops in Solentiname:

[P]oetry in Solentiname emerges as a collective artistic product. In the first sessions we dedicated ourselves to reading the great poets of Nicaraguan and world literature. . . . We read and commented on texts from the early afternoon until dusk. . . . I never asked anyone to write. The poetry began to emerge very quickly and in a natural manner from the people. . . . The first poems they wrote were discussed between the author and me but always in the presence of the other individual members of the group. Immediately, we began to discuss them with the whole group, with everyone participating. . . . it's a peasant poetry, from the people and for the people and therefore it has resulted in being an eminently social, political, and human production. Above all, [it's] revolutionary and testimonial.[36]

These radicalizing developments and empowering events in Solentiname occurred at the time of the 1968 pronouncements in favour of liberation theology by the Conference of Latin American Bishops at Medellín, Colombia. All of these things together led to an increasing sympathy among the commune's parishioners and by Father Cardenal himself for the Sandinista movement towards revolutionary change. In 1976 Cardenal

111 Rudolfo Arellano, *Pintura primitivista de Solentiname*, 1980, oil, cover of *Poesiá Campesina de Solentiname*, Ministry of Culture (Managua, 1980).

poesía
campesina
de
solentiname

MINISTERIO DE CULTURA. NICARAGUA.

112 Vilma Duarte, *Casa de Campesinos*, 1989, oil on wood, Private Collection.

secretly joined the forces of the FSLN, despite the fact that some members of the Frente considered the community to be a "dangerously utopian" experiment, because, until the mid-1970s, Cardenal was an advocate of nonviolent change in Nicaragua.[37] (It should also be emphasized here that the FSLN was a national front, not a single party, that was composed of various left-wing tendencies. It was not an orthodox Leninist vanguard with a uniform and unyielding line on given issues.)

During the Sandinistas' general uprising of 1977 several members from the island community were involved in an assault on the National Guard's garrison in nearby San Carlos.

In response, Somoza ordered the complete destruction of the parish of Solentiname, including all its artworks and its library. Only the church, which was converted into a barracks for Somoza's troops, was left standing. From 1977 until 1979 with the revolutionary victory by the Sandinistas, Solentiname was terrorized by the Guard, with its "subversive" primitivist paintings in particular being targeted for destruction.

In fact, Cardenal had secretly left Nicaragua shortly before the insurrection in order to go on an international speaking tour to increase solidarity and to raise money for the FSLN. After learning that Somoza had stripped him of special immunity and had

declared him an outlaw, Cardenal then published an open letter from exile, "Lo que fue Solentiname" (What Solentiname was). In it, he both admitted to being a Sandinista from 1976 onward and also declared that a collective meditation by the members of the parish commune on the Scriptures had actually played a crucial role in radicalizing the entire community, not "foreign agitators." Consequently, they had all joined the armed struggle against Somoza, "for one reason alone: out of their love for the kingdom of God. Out of their ardent desire for a just society, a true concrete kingdom of God here on Earth."[38]

Scholars John Beverley and Marc Zimmerman have identified a defining paradox of the period: only after Solentiname was destroyed did it take on international significance as a symbol for the general dynamics of the Sandinista-led insurrection of 1977–79.[39] Solentiname would later come to be, in some respects, both a highly visible model for postrevolutionary cultural policy and the center of considerable controversy within the Sandinista front. This is a subject to which we shall return later when addressing contradictions within the revolutionary government, as well as within civil society more generally.

No one else articulated more eloquently the convergence of liberation theology with a dialogical concept of art than Miguel D'Escoto, another priest in the FSLN who subsequently served as Nicaragua's Secretary of State (or Minister of the Exterior) in the 1980s. He said,

> I am reminded of a marvelous painting of the baptism of Christ. . . . It was painted by Leonardo da Vinci's teacher, Verrocchio. . . . Verrocchio had a great love and admiration for Leonardo, his young disciple, and he wanted him to participate in this masterpiece. . . . Likewise, our Lord also made us co-creators, wanting us to participate and share in the canvas. . . . Having been given this orientation, we cannot accept being reduced to the level of simple spectatorship in a game

in which only a few play. We have a built-in need to participate actively.[40]

Aside from this move toward a radically democratic rethinking of culture in Solentiname, other artistic movements in this period offered new possibilities for altering the standard relationship between art and society. From 1963 to 1972 the avant-garde group Praxis operated in Managua (fig. 113) with the express intention of critically assimilating certain idioms of Western modernism—both from the New York School and from Europe—an example of which is seen in a period painting by Genaro Lugo (fig. 114). This movement would produce an "alternative modernism" while also arriving at a distinctive new regional vocabulary in painting. Although at first the artists in Praxis seemed to emphasize aesthetic issues and formal innovations virtually at the expense of all else, the group soon sought to mediate its preoccupation with artistic advance by means of a commitment to the vanguard politics of the FSLN.[41]

This avowed position of "el doble compromiso" (double commitment) meant fusing a desire for formal experimentation in art with a concerted political examination of society. Such an aim entailed an "exploration of the relations between objective reality and artistic subjectivity" that would be predicated simultaneously on a "knowledge of contemporary art movements" and the search for an expression "identifying our own reality."[42]

For the artists of Praxis, two formal traditions were of paramount importance: the Abstract Expressionist movements from the United States and Europe, especially Spain, where Art Informel and pintura matérica (in the works of artists such as Tàpies, Cuixart, and Millares) were identified with opposition to the fascist government of Franco; and the artistic traditions of pre-Columbian Nicaragua that had survived only in fragmentary archaeological form. This tradition was largely ignored, when not suppressed, in the Somoza era.[43]

113 Cover of *Praxis*, August 1971, Managua.

114 Genaro Lugo, *Cabeza de pájaro* (Head of a bird), 1964, oil painting, collection of the Banco Central de Nicaragua.

115 Leoncio Sáenz, *Mercado pre-colombino* (Pre-Columbian market), 1976, oil on panel, formerly in the Supermarket at the Plaza de España, Managua.

116 Diego Rivera, *The Architect*, 1924, fresco, Ministry of Education, Mexico City.

The latter trait was singled out in 1981 by Argentinean art critic Marta Traba, an admirer of Nicaraguan painting from the 1960s period and a strong supporter of the Sandinistas. Aside from producing such figures as Rubén Darío and Augusto Sandino, while challenging U.S. imperialism through the overthrow of Somoza, Nicaragua was also significant owing to its unexpected originality in the visual arts, according to Traba. In distinguishing the *interioridad* (interiority) of Nicaraguan vanguard art from the *interiorismo* (interiorism) of Mexican art in this period, Traba wrote of how there was a distinctively public quality to the encoded art of Praxis. With its search for a new palette of austere range and geographic associations, this group was also distinguished by a "re-elaboration of the prehistoric past" in its paintings to an extent even unrivalled in Nicaraguan poetry (despite the powerful anticolonial legacy provided there by Darío and Ernesto Cardenal).[44]

This latter concern found early expression in two significant sites: in 1972 in a mural by Alejandro Aróstegui, Orlando Sobalvarro, and Roger Pérez de la Rocha in the *Centro Commercial El Punto* (Managua); and in 1976 with Leoncio Sáenz's two fine murals for a Managuan supermarket at the Plaza de España (fig. 115).[45] In them the artist, himself of Meso-American descent, depicted a precolonial market in a hybrid style that drew at once on Mayan motifs and the neo-Egyptian figuration used by Diego Rivera in some of his allegorical figures from the mid-1920s (fig. 116). In particular, one sees such figures on the second floor of the Court of Labor in the Ministry of Education, Mexico City.

The main artists associated with this group were accomplished painters—Alejandro Aróstegui, Roger Pérez de la Rocha, Leonel Vanegas, Arnold Guillén (figs. 119 and 120), Luis Urbina, Genaro Lugo (fig. 114), Leoncio Sáenz, César Izquierdo, and Orlando Sobalvarro (figs. 117 and 118). With the exception of Aróstegui who emigrated to Costa Rica in the early 1980s, these artists would all play key roles in the conception and guidance of UNAP within the Sandinista Union of Cultural Workers throughout the 1980s. Many of these artists had been students of Rodrigo Peñalba at the National School of Fine Arts in Managua and most of them worked in abstract or semiabstract styles of notable range with matching subtlety. (Poets Michelle Najlis and Francisco de Asis Fernández, as well as sociologist Amaru Barahona, were also members of Praxis).[46]

Even before the Nicaraguan Revolution, several artists in Praxis (in keeping with the greatest European avant-garde movements during the first half of this century) refused to accept any irreconcilable conflict between formal experimentation and wider public access to art. Instead, these painters identified the cleavage between the two as an historical problem inherent to the pronounced economic and social asymmetry of the system under which they lived, dominated as it was by an uneven development linked to Western capital and to the ideology of Eurocentrism. The painter Orlando Sobalvarro, a miner's son, aptly summarized the group's view about the compatibility of advanced art and revolutionary politics: "It is important that the

117 *(top)* Orlando Sobalvarro, *Sandino*, oil painting, 1984, collection of the Ministry of Exterior, Managua.

118 *(bottom)* Orlando Sobalvarro, *Paisaje de verano en Subtiava* (Summer landscape in Subtiava), 1982, oil on wood, collection of the Ministry of Exterior, Managua.

119 Arnold Guillén, *Amanecer* (Dawn) no. 6, 1982, mixed media on wood, collection of the Ministry of the Exterior, Managua. This painting was shown at the 1982 Certamen Nacional in the Casa Fernando Gordillo Gallery of the ASTC.

120 Arnoldo Guillén, *The Volcano*, 1986, oil painting, collection of the Ministry of Exterior. This painting was shown at the 1986 certamen Nacional in the Casa Fernando Gordillo Gallery of the ASTC.

concepts of abstraction be understood by the general public, since the same pictorial qualities apply to painting as to political propaganda."[47] Not surprisingly, some artists associated with the Praxis group, such as labor activists like Santos Medina and Leonel Vanegas, were imprisoned, tortured, and exiled by the Somoza regime.[48]

The most celebrated painter from Nicaragua in the 1950s and 1960s (and indeed right up to the present) was, however, Armando Morales. He is probably the greatest visual artist to come from Central America in this century and was championed by critics who included (earliest and most incisively) Dore Ashton and Marta Traba.[49] From 1982 until 1990, Morales would serve the FSLN as Nicaraguan Ambassador to UNESCO in Paris. As early as the 1950s, he had become an international figure by winning several awards, the most important of which was the major prize for a Latin American artist at the fifth Sao Paulo Biennial in 1959.

Morales did so with some resourceful abstract paintings that were influenced both by Robert Motherwell and Antoni Tàpies. From 1958 through 1961 he developed the original and compelling series entitled *Dead Guerrilla*, which not only included paintings by that name but also such artworks as *Moon Bitten By Dogs* and *Electrocuted Political Prisoner*. Despite the fact that several works in the series were obviously influenced by those of Motherwell in his monumental series of *Spanish Elegies*, the paintings by Morales were nonetheless distinctive and quite accomplished works in their own right. Furthermore, these paintings by Morales assumed a topical import not normally accorded abstract paintings, since they were executed only a few months after the activist poet Rigoberto López Pérez was killed while assassinating the first Somoza in 1956.[50]

Subsequently, in the late 1960s, Morales would feel he had reached a formal impasse with this Abstract Expressionist manner, even though he had achieved acclaim by means of it. Around 1970–71, Morales went in an entirely different artistic direction and experienced substantial success with his own singular variant of "magical realism." While featuring a "metaphysical ambience" further enhanced by the usage of enigmatic spatial elements not unlike those of Giorgio de Chirico, Morales's manner is based on a painterly approach with deft underpainting. It depends upon an unlikely use of color that is marked by a highly nuanced modulation of tones. Giving the works their most unforgettable quality, though, is Morales's unique technique of collaging pieces of painted canvas on top of the whole canvas that he is painting.

A signal work in this "magical realist" vein, which is today in the collection of the Banco Central of Nicaragua, is his *Mujer sentada* (Seated woman) of 1971 (fig. 121). This striking painting helps us to understand why Gabriel García Márquez could claim that "magical realism" is one of the most effective artistic modes in Latin America for engaging with the uneven development of history and the regional underdevelopment related to it. This splendid painting by Morales is based throughout on a deployment of paradoxical and disjunctive relationships that both

121 Armando Morales, *Mujer sentada* (Seated woman), 1971, oil on canvas, collection of the Banco Central de Nicaragua.

encourage diverse readings and foster a surreal or dream-like ambience.[51]

Indicative of this uneven atmosphere is the way that *Seated Woman*, which centers on a fractured classical statue with Middle Eastern headwear as seen in portraits by Ingres, has a pictorial space at once very expansive and quite constrictive. Similarly, the sky is both deeply recessive and boldly flat, so that in one part the head of the statue actually projects a shadow upon the sky. The right side of the painting has a marked presentation of three-dimensional spatial recession. The left side of the painting contains an intriguing tension between an abstract, utterly flat foreground and the serenely distant sky of the background. As such, this painting is marked by a fragmented view of the past coupled with a dream-like, even visionary view of the present image.

A related tendency in literature among urban intellectuals that operated with an organic connection between avant-garde writing and vanguard politics was the Frente Ventana, which was founded in 1960, one year before the foundation of the Sandinista National Liberation Front. Ventana was started by three authors who were also political activists: Octavio Robleto, Fernando Gordillo (who was later killed in the revolution), and Sergio Ramírez (who was Vice-President of Nicaragua in the 1980s, as well as the country's leading novelist). Subsequently, Beltrán Morales and Michelle Najlis also joined this movement. The Ventana group committed itself to organizing literary figures into an "ideological front" against the economic exploitation, political repression and educational deprivation being inflicted on most Nicaraguans.[52]

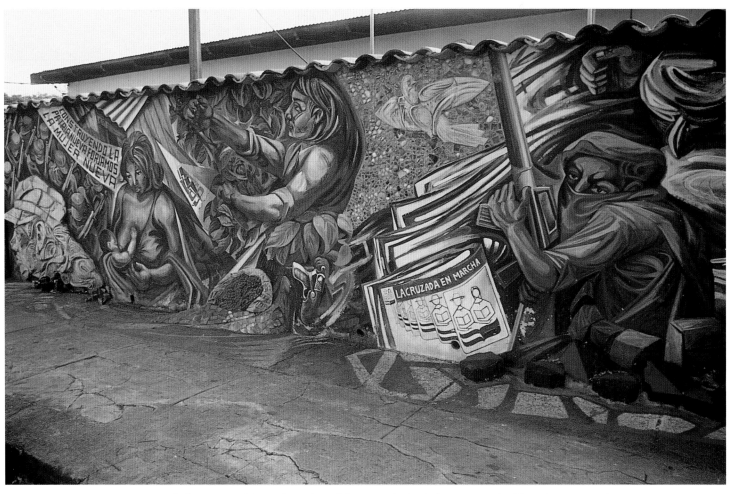

122 Brigada Muralista "Rodrigo Peñalba" (Sergio Michilini and members of the National School of Monumental Public Art), *La mujer y la construcción de Nicaragua Nueva* (Women and the construction of the new Nicaragua), 1983, mixed media, Casa de AMNLAE, Managua (destroyed in 1987).

123 Detail of 122.

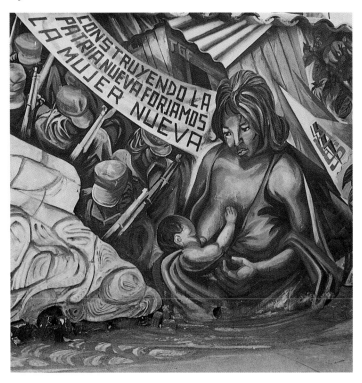

Far from being inspired by the populist desire to simplify literature as part of their political engagement, however, the Ventana group combined its own concern for popular mobilization and self-determination with an admiration for the process of continental self-identification. The latter was boldly exemplified on the international stage by the innovative Latin American literature of Julio Cortázar, Carlos Fuentes, and Gabriel García Márquez, among many others. (It is not by chance that the finest portraits of these writers would later be painted by Armando Morales, a close friend of Ramírez.)

While a young professor at the University of León in 1967, Ramírez organized seminars around "el boom" in Latin American literature. Like Ramírez, many of his students in this Nicaraguan university were Sandinista militants, such as Jaime Wheelock Román (who became Minister of Agriculture during the 1980s). They discussed such books as *Rayuela* (Hopscotch) by Julio Cortázar, *Pedro Páramo* by Juan Rulfo, *La muerte de Artemio Cruz* (The death of Artemio Cruz) by Carlos Fuentes, and *One Hundred Years of Solitude* by Gabriel García Márquez. Thus, the link between the revolution in Latin American literature and the revolutionary politics of Nicaragua became a frequently acknowledged idea.[53]

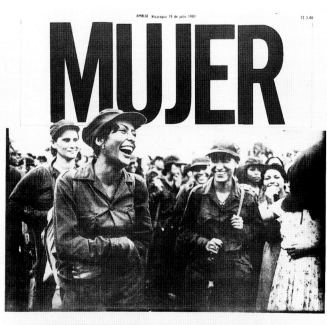

124 *Mujer Revolución* (Women and revolution), 1980, photo-offset poster for AMNLAE, Taller de Gráfica Experimental.

A revealing example involved the Sandinista cadre Luisa Amanda Espinoza, after whom AMNLAE, the Association of Nicaraguan women "Luisa Amanda Espinoza," would be named in the 1980s. When she was killed by Somoza's National Guard, the progovernment newspaper *Novedades* stated that in her possession when she died was a copy of Cortázar's *Rayuela*, an example of "literatura subversíva" (subversive literature). Sergio Ramírez summarized in the following terms the new convergence of art and politics that was advocated by Ventana:

> We were repulsed by the dictatorship and had a militant conception of literature—not "socialist realism" or anything like that. But from the beginning we did reject the position that had reigned up to that time in terms of artistic labor: the famous "art for art's sake". . . . We took a very clear ideological position, and in our rejection of what was nothing but an old dependence on foreign cultural models (however justifiable these models are in their own countries). . . . We entered into a new commitment, a new form of artistic as well as political struggle.[54]

His 1986 book, *Estás en Nicaragua*, was an incisive collection of essays about art and culture that confirmed Ramírez's pre-

eminence in the Americas as a person of letters. In this study he described Argentinean writer Julio Cortázar as the ideal Latin American intellectual because of the latter's fusion of artistic advances with a commitment to progressive politics. (In this context, it should be noted that in 1983 Julio Cortázar, who was an eloquent supporter of the Sandinistas, was awarded Nicaragua's highest national honor, La Orden de la Independencia Cultural "Rubén Darío.")[55]

As Ramírez noted of Cortázar's *Rayuela* (1963), it was the literary work that, more than any other, fascinated the Sandinistas—from Commandante Carlos Fonseca to cadres like Luisa Amanda Espinoza—at a formative stage of their movement in the 1960s. Significantly, this was precisely when their concept of art, with its clear links to the New Left of the 1960s, was first being formulated. Perhaps one of the main reasons that Cortázar's immensely complex "anti-novel" struck such a resonant chord with the Sandinistas was its "open form," or what I would prefer to term its "dialogical character."

Rayuela was highly innovative because, among other reasons, it was not an artistic monologue of closed signification, but rather a book that initiated a dialogue with the reader who had to "complete" the novel again and again. Hence, the reader not only collaborated in constructing its significance, but also aided in "composing" the very structure of the book. As Cortázar stated at the beginning of the novel, "this book consists of many books."[56] Readers were intentionally put in a more active position, as well as a more self-conscious one, than had been true of the passive role prescribed by traditional texts, all of which purported to give the author monopoly control over a book's signification.

The above recalls Roland Barthes's distinction between the "writerly" text, explicitly necessitating the reader's consummative intervention, and the "readerly" text, specifically stipulating the reader's submission to a predetermined meaning.[57] While *Rayuela* would be a profound example of the former dialogical text, "socialist realist" novels, which were rejected by Ventana, would be an obvious category with which to exemplify the latter, monological type. In the best Nicaraguan literature of this period, then, even the call to political engagement was interlaced with competing concerns. This *engagé* literature was, in turn, overdetermined by the desire to initiate an interchange with the audience, rather than by the mere wish to be tendentious.

The fourth artistic tendency to emerge in the insurrectionary period of the 1960s and 1970s and then to have immense currency in the decade of the 1980s was one that involved sexual politics (figs. 122–24). Specifically, this meant the declaration of gender relations, along with sexual emancipation, as defining issues for many, if not all, of the cadres in the FSLN. It was an outstanding group of women poets and combatants in the Sandinista Front that brought this theme to the fore and deftly consolidated it in the years ahead. The main forerunner of this movement within the FSLN was Michele Najlis. Her 1969 collection of poems, *El viento armado* (The wind armed), for example, rapidly became one of the signal texts of the entire period.[58]

giocondabelli
LA MUJER HABITADA

125 Alejandro Canales, book cover for Gioconda Belli, *La mujer habitada* (Managua, 1989), published by Editorial Vanguardia. This award-winning novel is about the political path that leads a young woman named Lavinia to become a guerrillera for the FSLN. See also fig. 106.

126 Genaro Lugo, *No Pasarán*, 1982, silkscreen print. The work is shown as it was exhibited in the Gallery of the Casa Fernando Gordillo of the ASTC, Managua, for the 1982 Certamen Nacional.

Several books of poetry by various other women authors soon followed in rapid succession. Two collections by Gioconda Belli—*Sobre la grama* (On the grass) in 1974 and *Línea de fuego* (Line of fire) in 1978—were perhaps those that resonated most widely. About the first book, Belli said that it "is not a book of political poetry as such, although it is certainly a book that dealt with society's hypocrisy toward women."[59] The second book not only won international acclaim with the awarding in 1978 of the Casa de las Américas Poetry Prize in Cuba, it also grabbed considerable attention in Nicaragua where it was an underground sensation on the eve of the Revolution. The poetry by Belli in *Línea de fuego* drew frequent connections between protracted lovemaking and prolonged guerrilla struggle. The rhythm of one was interwoven with the rhythmic actions of the other. As such, the sexually liberated woman became a trope for the entire revolutionary process in Nicaragua.[60]

In discussing this new and *engagé* quality of her poetic production, Belli wrote as follows about the key issue of personal and/or extrapersonal representation:

> I saw that it was possible to write love poems which were also revolutionary, which could integrate personal and collective experiences. . . . At first I had problems with the so-called "political poems." They always came out of my own individual experiences, and I considered that to be a limitation. But when one lives collective experiences as an individual . . . the truth is that one expresses feelings or ideas which have the force of many experiences born from collective practice and struggle.[61]

Gioconda Belli's book was "only the most sensational of a cluster of *poemarios* by Sandinistas that appeared during and just after the insurrectional period."[62] Along with the collections in the late 1970s and early 1980s by Belli and Najlis, there were also significant books from this period by Rosario Murillo, Daisy Zamora, Vidaluz Meneses, Ana Ilce, and Yolanda Blanco, as well as others. Known as "Sandino's Daughters" because of Margaret Randall's celebrated book about them, this group of Sandinista cadres introduced yet another new inflection to the aforementioned concept of the New Person.[63]

Thematically, their poetry of the 1970s and 1980s manifested the emphatic emergence of the idea of the New Women as a complement to the earlier but also more male-specific concept of the New Man, which was enunciated by Che Guevara in the 1960s. In this sense, the overarching project of the FSLN was tied quite self-consciously to the emancipation of women, as it was to victory in class struggle and the overcoming of Eurocentrism. Yet, all of these women Sandinistas emphasized in their interviews with Margaret Randall that in Nicaragua it was impossible to consider "the process of women's liberation separate from the revolution."[64] (This chapter will later address some of the unresolved problems concerning women's issues within the Nicaraguan Revolution.)

Gioconda Belli's own career as a revolutionary was exemplary. She joined the FSLN in 1970, recruited by Camilo Ortega (a

brother of Daniel). In the Sandinista raid on Somoza ally Chema Castillo's home during a Christmas party on December 27, 1974, she was part of the support team. As a result she was forced into political exile. Her award-winning novel *La mujer habitada* (1988) (fig. 125) in fact gives a fictional account of this revolutionary action that also, nevertheless, draws on the personal life of her sister Lavinia, who is the main protagonist. Among Gioconda's most famous poems in the 1970s was surely "No pasarán" (You will not pass), which was set to music by Carlos Mejía Godoy and soon became the most well-known song of insurgency during the period of the insurrection (fig. 126).[65]

As should now be clear from this brief look at some of these protorevolutionary tendencies in the arts, the Sandinistas forged the rudiments for an innovative cultural program at an early date in their long term struggle. This new program presupposed a commitment to both popular democracy and economic democracy when the Revolution gained power. A major theoretical problem still remained unresolved, however, with the 1979 victory. What conceptual framework would allow the majority of Nicaraguans–rural wage laborers, *campesinos*, artisans, small farmers, and urban workers—to advance beyond the mere passive acquisition of knowledge to an active, participation in the shaping of a new art and a new culture?

Similarly, how could the Sandinista vanguard take a strong, principled position in the national dialogue without seeming to assert its principles too conclusively, thus attenuating vigorous, even counterbalancing, engagement on the part of the popular classes?

Only by approaching a solution to this methodological problem could the FSLN have fostered the concept of art advocated by Ernesto Cardenal, the Minister of Culture, when he wrote:

> We're not seeking a low level of culture for everyone but rather an elevated culture that is accessible to all. . . . We seek an integration of popular culture and high culture, of indigenous culture and international culture. . . . Culture should serve to supersede the division of labor into intellectual work and manual labor . . . culture should be democratized . . . so that our people are not only consumers, which is important, but also the producers of culture.[66]

The basis of this visionary, some would say utopian, ideal of art as a means of overcoming the particular type of division of labor that arose historically with the rise of industrial capitalism is found in a classic text by Karl Marx, *The German Ideology* (1846) where he and Engels wrote:

> The exclusive concentration of artistic talent in particular individuals, and its suppression in the broad mass of people, which is bound up with this, is a consequence of the division of labor. Even if in certain circumstances everyone were an excellent painter, that would hardly exclude the possibility of each one also being an original painter, so that here too the present difference between "human" and "unique" labor amounts to sheer nonsense.[67]

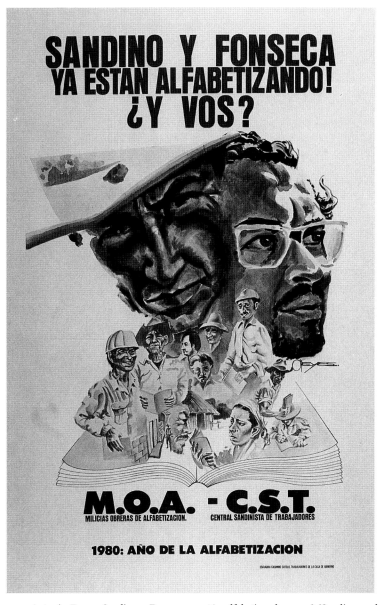

127 Antonio Reyes, *Sandino y Fonseca ya están alfabetizando, y vos?* (Sandino and Fonseca are literate. Are you?), 1980, poster for the CST (Sandinista Central of Workers).

Cultural Policy in Nicaragua during the 1980s

Significantly, an effective means of overcoming these problems in the domain of culture was attained through the radically new pedagogical ideas of Paulo Freire, the Brazilian educator who advised the Sandinistas on how to compose the primer for their spectacularly successful literacy crusade of 1980. As a result of this campaign, over half a million people out of a population of almost three million learned how to read and write (figs. 127–30). In dramatically raising the literacy rate from the prerevolutionary level of 53 percent to 88 percent, one of the highest in Latin America, the Sandinista-led government was given the Krupskaya Award in Education by the United Nations. A compelling reason for the efficacy of the primer, *El amanecer*

135

Cruzada Nacional
de Alfabetización

128 *Literacy Crusade Emblem*, 1980, poster for
the Ministry of Education.

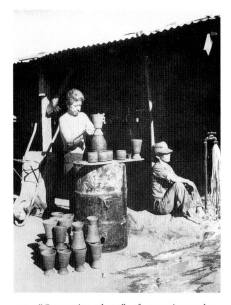

129 "Generative photo" of ceramic produc-
tion, from *El Amanecer del Pueblo*, Ministry of
Education (Managua, 1980).

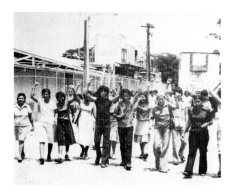

130 "Generative photo" of a popular demon-
stration, from *El Amanecer del Pueblo*, Ministry
of Education (Managua, 1980).

del pueblo (Dawn of the people), was the way it employed
Freire's pedagogical approach, which he named "the dialogical
method."[68]

In the 1960s this method represented a notable advance
beyond that of John Dewey, which had been influential on the
Mexican Revolution's literacy programs. Freire's new concept of
cultural progression—predicated as it was on a vigorous dia-
logue involving all, rather than on a monologue by a few—had
immediate points of theoretical congruence with some of the
main aims of Solentiname, Praxis, Ventana, and the coterie of
feminist poets in the FSLN. A basic presupposition of Freire's
revolutionary pedagogy is that "every human being, no matter
how 'ignorant,' no matter how submerged in the 'culture of
silence,' is capable of looking at the world critically in a dia-
logical encounter with others."[69]

In order to realize every human's ontological vocation to
be a subject with self-determining agency, cultural progression
must be premised on a struggle to overcome the political and
economic exploitation which delimits the lives of the popular
classes. Such an advance—that of aiding people to become
authors of their own advances, rather than being specta-
torial components of someone else's plans—is possible only
through the supersession of the "old paternalistic relationship
of teacher–student."[70] Emancipation, a consequence of self
determination in the deepest sense, can never simply be the
benevolent gift of a revolutionary vanguard. Rather, it must be
the self-achievement of the majority in active interchange with
a catalytic vanguard that proposes but does not dictate a course
of transformation.

The problem of populism with its didactic aims and
pragmatic concerns, however well-intentioned, is one that
has haunted the Latin American Left throughout the twentieth
century. Freire's revolutionary new post-Cuban approach to
education, particularly as it was used by the Sandinistas in
their literacy campaign, was designed to advance beyond the
"populist pitfall" and paternalism that had sometimes plagued
most modern revolutions, even those in Mexico and Cuba.
Freire explained the challenge:

> Critical and liberating dialogue, which presupposes action,
> must be carried on with the oppressed at whatever the stage
> of their struggle for liberation. . . . But to substitute mono-
> logue, slogans, and *communiqués* for dialogue is to attempt to
> liberate the oppressed without their reflective participation in
> the act of liberation and is to treat them as objects which must
> be saved from a burning building; it is to lead them into a
> populist pitfall and transform them into masses which can be
> manipulated. . . . The correct method lies in dialogue.[71]

Cultural progression that empowers the majority can hardly
be based on any conclusive position or official doctrine merely
engineered from the top by a Leninist vanguard. Nor is it based
on any value-free "pragmatism" or non-dialogical "learning
by doing" that is simply imparted from the top down to a
more passive majority—a majority that can issue revolutionary

change only if it actively participates in constructing this development. It was this point that Freire had in mind when he observed that "Education is suffering from narration sickness."[72]

By attempting to base their cultural policy on this new dialogical conception of knowledge, the Sandinistas neither reduced it to a static, predetermined collection of facts nor limited it to a practical, ready-made skill without recourse to systemic self-determination by the majority. Consequently, the literacy process was both a testimony to the current situation and a means of radically transforming the present through popular access to power along more progressive lines. The result would be a firm basis for building popular democracy, even as the impetus to parliamentary democracy and economic democracy should also be accelerated.

All of this demonstrates how Cardenal could describe "cultural democracy" along dialogical lines as an effort to draw upon the "creación espontánea del pueblo" (spontaneous creation of the people), while also helping to "elevar al pueblo" (elevate the people).[73] The orientation of this literacy crusade helps us to understand why one of the first moves of the new Ministry of Culture was to establish a national network of talleres de poesía (poetry workshops). The Ministry's aim was to create a "nation of poets" by socializing the means of artistic production, in tandem with the emergence of popular democracy.

The poet Julio Valle-Castillo, who along with Mayra Jiménez was a director of the workshops, served as editor of the journal produced by them. Entitled *Poesía Libre* (which entailed a wordplay on "free verse" and the "poetry of freedom"), this artisanally made publication was printed on rough brown paper and bound with thin rope (fig. 131). In 1981, Valle-Castillo put forth a manifesto of sorts for this network of poetry workshops:

> [Workshop poetry] is a direct and profound poetry, it is the life of the people in their own language, it is physical geography, it is the history of our Sandinista Revolution written in verse. A poetry full of emotions, of testimonials, it is neoepic . . . it is a poetry written by the peasants of Niquinohomo, of Condega, of San Juan de Oriente, of Jinotega, of Palacaguina; by construction workers; by Monimbó artisans; by militia soldiers, by literacy brigadistas, by members of the Sandinista Workers Union. That is, by the people. . . . It is in the same technique as the poetry of William Carlos Williams, or the poetry of the Polynesian islands, or current Salvadoran guerrilla poetry.[74]

Within a year of the program's inception, there were twenty-five workshops nationally. The first two established were those in the *barrios* (sections) of Monimbó near Masaya and in Subtiava near León. At their high point in the 1980s, there were seventy around the country. North American author Kent Johnson noted how this writing program quickly became "the most interesting and massive grassroots writing program ever conducted anywhere."[75] Two famous enthusiasts of the program were the Uruguayan author Eduardo Galeano and the Venezuelan writer Joaquín Sosa. The latter contended that, "for the first

131 Copies of *Poesía Libre*, the journal of the Talleres de Poesía, Ministry of Culture, that appeared from 1980 to 1988.

time, the means of poetic production have been socialized."[76] In her dedication to an English-translated anthology of poetry from the Nicaraguan workshops, British author Dinah Livingstone rightly declares: "These poems are witness to the time when people struggling all over the world were encouraged, not just by News from Nowhere but from Somewhere in Nicaragua."[77]

Among the most often read and discussed poets were not only Latin American and Asian authors, but also U.S. poets such as Walt Whitman, Ezra Pound, and William Carlos Williams (all of whom Ernesto Cardenal had studied while he was a student at Columbia University in New York City during the late 1940s). The only technical and thematic guidelines disseminated for composing poetry were adopted from Ezra Pound's "A Few Don'ts" (translated into Spanish by Ernesto Cardenal and fellow poet José Coronel Urtecho). The suggestions were that verse need not rhyme, that poetic language be as concrete as possible, and, above all, that such clichés as the "cruel tyrant" not be used.[78]

On March 10, 1980 in *Barricada* (the FSLN newspaper), these "Rules" of what not to do in poetic practice were published by Cardenal. Seven guidelines were introduced with the provocative remark that "Writing good poetry is easy and the few rules for doing it are simple." The "Rules" were as follows:

> 1. Verse need not rhyme. If one line ends with "Sandino," do not try to end another with "destino;" if one ends with "León," there is no need to make another end in "corazón." Rhyme is a good thing in songs and very suitable in slogans. E.g. 'We won in the rising. We shall win alphabetising.' But rhyme is not a good thing in modem poetry. Nor is it a good thing to have a regular rhythm (all the lines with the same number of syllables): verse should be completely free, with the lines long or short, as the poet chooses.

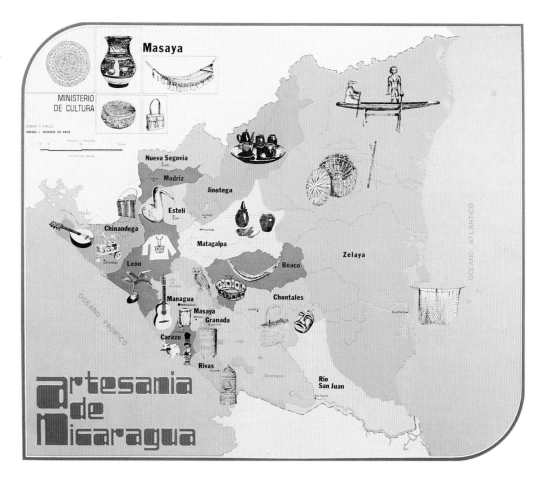

2. We should prefer more concrete terms to vague ones. To say 'tree' is vaguer or more abstract than saying . . . "malinche" [flame tree], which is more concrete. 'Animal' is more abstract than 'iguana', 'rabbit'. And it is more abstract to say 'liquor' than to say 'whiskey', 'champagne' . . . Good poetry is usually made out of very concrete things.

3. Poetry has an added appeal if it includes proper names: the names of rivers, towns, and villages, and people's names . . .

4. Rather than being based on ideas, poetry needs to be based on things that reach us through the senses: which can be felt with the touch, which can be tasted with the palate, which can be heard, which can be seen, which can be smelt. It is good to make a point of saying that corrugated iron is 'rusty' . . . that an iguana is 'rough-skinned', that a macaw is 'red, yellow, and blue' (and try to describe the sound a macaw makes). The most important images are visual ones: most things reach us through our eyes.

5. We should write as we speak. With the natural plainness of the spoken language, not the written language. To put the adjective first, as in "los sombríos senderos" [the shady paths] is not natural in our language, but rather: "los senderos sombríos." By the same token, it is preferable not to use "tú" but "vos" [i.e. the second person singular] in our Nicaraguan poetry, since that is how we speak in daily life. The greater part of the new Nicaraguan poetry is now using *vos* . . . ("Vos" is used in almost all of Latin America, but there are few places where it is used as much as in Nicaragua; the new

Nicaraguan poetry is going to encourage the use of "vos" throughout Latin America.)

6. Avoid what are called commonplaces, clichés, or hackneyed expressions. In other words, whatever has gone on being repeated in the same way for a long time. For example "burning sun," "icy cold," "cruel tyrant". . . . The poet should try to discover new ways of putting things; if what he writes is made up of expressions blunted by use, it is not poetry.

7. Try to condense the language as much as possible. In other words, to abridge. All words that are not absolutely necessary should be left out. If there are two ways of putting something, one should choose the shorter. . . . A poem may be a very long one, but each of its lines should be in very condensed language.

In late 1979 and early 1980 the Ministry of Culture established a national network of Centros Populares de Cultura (Popular centers of culture) (fig. 132), which was yet another profound manifestation of cultural democracy both on the national and local levels. Originally there were twenty-four centers, with at least one in each of the sixteen departments (or states) of Nicaragua. By the mid-1980s this number had risen to twenty-eight, with more than one center being located in a number of concentrated urban areas (Managua had four, León had two, for example). According to its original charter, the CPCs were charged with "the establishment of a library, reading rooms, and free public classes in the areas of music, theatre, dance, literature, and the visual arts."[79] Generally, the CPCs were in large cen-

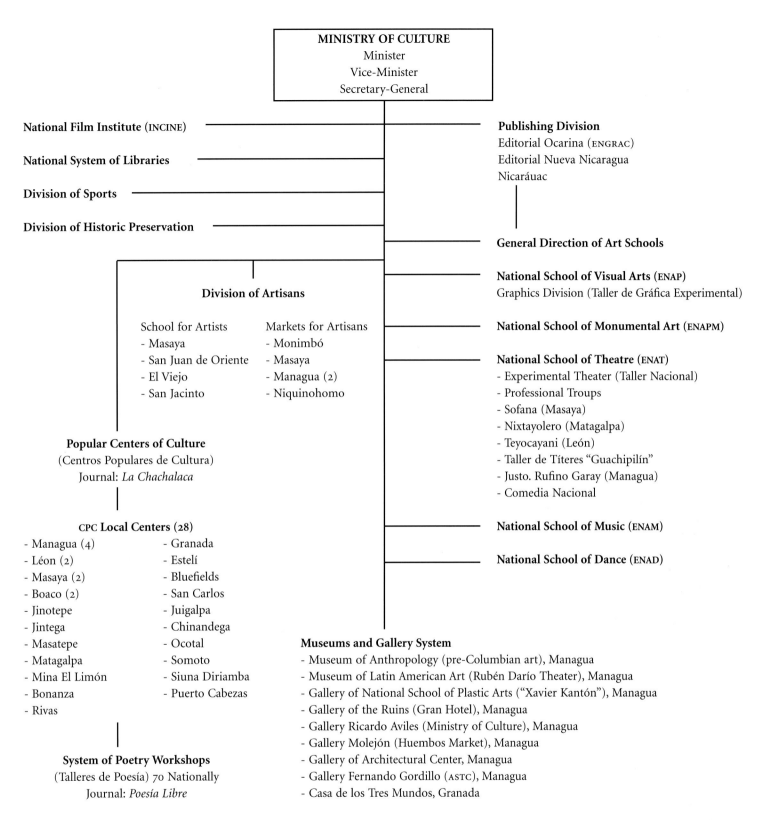

MINISTRY OF CULTURE
Minister
Vice-Minister
Secretary-General

National Film Institute (INCINE)

National System of Libraries

Division of Sports

Division of Historic Preservation

Division of Artisans

School for Artists
- Masaya
- San Juan de Oriente
- El Viejo
- San Jacinto

Markets for Artisans
- Monimbó
- Masaya
- Managua (2)
- Niquinohomo

Popular Centers of Culture
(Centros Populares de Cultura)
Journal: *La Chachalaca*

CPC Local Centers (28)

- Managua (4)
- Léon (2)
- Masaya (2)
- Boaco (2)
- Jinotepe
- Jintega
- Masatepe
- Matagalpa
- Mina El Limón
- Bonanza
- Rivas

- Granada
- Estelí
- Bluefields
- San Carlos
- Juigalpa
- Chinandega
- Ocotal
- Somoto
- Siuna Diriamba
- Puerto Cabezas

System of Poetry Workshops
(Talleres de Poesía) 70 Nationally
Journal: *Poesía Libre*

Publishing Division
Editorial Ocarina (ENGRAC)
Editorial Nueva Nicaragua
Nicaráuac

General Direction of Art Schools

National School of Visual Arts (ENAP)
Graphics Division (Taller de Gráfica Experimental)

National School of Monumental Art (ENAPM)

National School of Theatre (ENAT)
- Experimental Theater (Taller Nacional)
- Professional Troups
- Sofana (Masaya)
- Nixtayolero (Matagalpa)
- Teyocayani (León)
- Taller de Títeres "Guachipilín"
- Justo. Rufino Garay (Managua)
- Comedia Nacional

National School of Music (ENAM)

National School of Dance (ENAD)

Museums and Gallery System
- Museum of Anthropology (pre-Columbian art), Managua
- Museum of Latin American Art (Rubén Darío Theater), Managua
- Gallery of National School of Plastic Arts ("Xavier Kantón"), Managua
- Gallery of the Ruins (Gran Hotel), Managua
- Gallery Ricardo Aviles (Ministry of Culture), Managua
- Gallery Molejón (Huembos Market), Managua
- Gallery of Architectural Center, Managua
- Gallery Fernando Gordillo (ASTC), Managua
- Casa de los Tres Mundos, Granada

133 A Diagram of the Network of Programs under the Ministry of Culture (1979–1988). Material from *Hacia una Política Cultural* (Managua, 1981) and from an interview with Raúl Quintanilla, Director of ENAP, the National School of Visual Arts.

trally located houses confiscated from former Somocistas who fled the country in 1979.

Producing a journal, *La Chachalaca* (fig. 134), to provide a forum for discussion, the centers soon came to play a fundamental role in the national cultural life. By the mid-1980s, there were few people in the country who had not been involved in at least several CPC activities. As of 1983, for example, the centers had organized over 6,733 seminars, 464 public cultural activities, 2,133 recreational events, 397 programs, and 110 music festivals, aside from backing 43 publications (figs. 133 and 135).[80]

134 *(left)* Cover of *La Chachalaca*, 1984, a journal published by the Ministry of Culture about the activities in the Centros Populares de Cultura.

135 *(center)* Cover of *El Artesano* (The artisan), no. 4, a publication of the Ministry of Culture (1984). The cover was designed by Augustín Alonso and shows a drawing of masks for the play entitled *Güegüense* or *Macho Ratón*, which during the Sandinsta years was often staged in public by dance troupes.

136 *(right)* María Gallo, *Amor* (Love), 1982, oil on canvas, collection of the Ministry of the Exterior, Managua. This painting was exhibited at the 1982 Certamen Nacional in the Gallery Casa Fernando Gordillo of the ASTC, Managua.

137 *Dos Cisnes* (Two swans), 1982, Marmolina sculpture, made in the Centro Popular de Cultura, San Juan de Limay (near Estelí), exhibited at Casa de las Artes del Pueblo, Managua.

(Professional musicians played their part in this democratization of culture. There are several *Nueva Canción* (New song) singers of note from Nicaragua, including Carlos Mejía Godoy, the brother and sister team of Guardabarranco, Salvador Bustos, and such groups as Tata Beta or El Guadalupano). One Nicaraguan folk singer praised these cultural programs when he told the *New York Times* in 1980: "Now there is a burst of energy and enthusiasm. There is some good work and some awful work, but the point is that the people are no longer scared of culture."[81]

Far from being a nationally uniform organization, however, the Centros had a regional character that featured instruction in subjects that varied widely from one CPC to the next. The subjects taught depended on the artisanal traditions and popular cultural forms that were peculiar to the area. Their dynamic National Director, Emilia Torres, pointed out to me in an interview that the direction of each distinct CPC, with its grass-roots focus, hinged considerably on both the popular art forms indigenous to the region and also on what new cultural traditions, in addition to artistic media and genres, the local population wished to practice. Relative autonomy on the grass-roots level was thus maintained. Oil painting lessons, for example, were given in Managua's urban CPCs by painters like María Gallo, one of Nicaragua's most gifted painters (fig. 136). The more artisanal tradition of stone-carving in Marmolina was a specialty of the center in Estelí, where Fernando Saravia and Bayardo Gámez were key instructors (fig. 137).[82]

A form called cerámica negra was largely unique to the centers in Matagalpa or in Jinotega. These popular art forms generally drew on the colonial period of the last century, and those traditions did retain some fragmentary linkage with the indigenous artistic practices of the precolonial period, however attenuated the connection had become. This was especially true of cerámica nicoya policroma, the tripod-shaped, multicolored vase influenced at least partially by the Chorotegas of the pre-Columbian period and produced during the 1980s in the centers at San Juan Oriente or San Juan de los Platos (figs. 138, 139, 140).[83]

In regard to work done in the CPCs one cannot speak about any pure "return to indigenous roots." Yet one can write of a frequent reclamation of fragments from the indigenous past, as part of the revolutionary project of constructing a new identity through a dialogical interweaving of the past, present, and future on behalf of national self-determination. As recent anthropological studies have documented, some of these regional centers of culture were far more successful than others.[84] The failings that marked some of these centros, as for example at San Juan de Oriente, are undeniable, but this is not to say that no successes in popular mobilization emerged even in this area. Nor can the shortcomings of Sandinista cultural policies in San Juan de Oriente in the early 1980s be seen as symptomatic of the national network as a whole. As some studies have shown the problems in San Juan de Oriente perhaps resulted from paternalistic policies by the FSLN, but these were generally reversed by the Ministry of Culture in 1985–86 after a popular outcry.[85]

Furthermore, few things attest more to how successful the policy of government-sponsored CPCs really were than what happened to them after government funding was ended in 1990. When the FSLN lost the elections that year, there were forty-four Centros Populares de Cultura nationally. Within months, that number had decreased to merely twelve. Only those that were in municipalities where the Sandinistas won local elections, such as Estelí and León, survived. At this point, the cultural workers formerly in the Ministry of Culture decided to turn the CPCs from the 1980s into an independent union-based network of cultural centers. Thus was born the Association for the Promotion of the Arts (APC), under the direction of Emilia Torres (who had enjoyed a government post in the Sandinista Administration). As a new grass-roots-only network, this union was able to announce in 1996 that there had been a resurgence of national support for the CPCs. Their number rose again to twenty-four nationally and they sponsored around five hundred cultural events, as well as one thousand workshops, that were attended by some two hundred thousand people around the country. Here, as elsewhere, the FSLN legacy translated into an impressive postrevolutionary form of popular democracy with few rivals anywhere else in the world.[86]

In most of the abovementioned cases from the early 1980s, the artforms revived by CPCs were of marginal use, when not virtually extinct, by the end of Somoza's reign. Consequently,

138 (left) Polychrome ceramics produced in San Juan de Oriente, near Masaya, on exhibition in the Casa de las Artes del Pueblo, Managua, 1982.

139 (below) La Casa de las Artes del Pueblo, Managua (near the Plaza de España), 1982. This exhibition space for popular cultural objects was established by the Ministry of Culture in 1979–80 in a late modernist building that was a bank during the Somoza period.

140 Polychrome ceramic pieces from the Centro Popular de Cultura, San Juan de Oriente, mid- to late 1980s, clay, collection of the author.

the Ministry of Culture under Cardenal immediately set to work in 1979 researching, giving workshops in, and disseminating knowledge about such art forms in order to effect their revival. In conjunction with the CPC of Estelí, for example, the sculptor Fernando Saravia helped to trigger a renaissance of stone carving that combined traditional forms with modern art, to arrive at a new synthesis in the visual arts.

As a result of this process of reclamation and re-elaboration, artisans in Nicaragua came to constitute a substantial portion of the national labor force and they crafted a wide range of products including traditional furniture, hammocks, and other items of daily use. (The Nicaraguan Ministry of Labor released studies in the early 1980s showing that "small industries," those with thirty workers or less, accounted for 37 percent of industrial employment, while 54 percent of all industrial establishments employed less than five people. By some accounts this latter group would be classifiable as one consisting largely of "artisans.")[87]

About these cultural policies of the Sandinistas, a key point must be made concerning the different uses of artisanal production by society. On the one hand, there is the revitalization of an artisanal mode of production by the FSLN for use within the larger economy (premised as it is on meeting local needs, as well as on circumventing deficit-generating imports of manufactured goods from more industrialized countries). On the other hand, there was the contrasting and generally populist use of artisanship as a "rustic" form of commodity production (its value only in exchange and contingent on the vagaries of foreign markets, as was the case for local goods before the revolution against Somoza). Aside from the issue of diminishing economic dependency—Nicaragua's continuation of agro-export production was, of course, designed to generate foreign capital for further industrialization—there was a related noneconomic concern. This was a commitment to cultural self-empowerment and cultural self-definition through the reconstitution, as well as redirection, of certain artisanal traditions along with cultural practices that are uniquely associated with the popular classes.

There were many disastrous economic consequences of the Somoza era's relocation of the majority of rural wage laborers into a highly volatile world commodity market. A major problem was that income through low-tech artisanal production suffered substantially from an influx of cheap mass-produced Western goods, such as plastic dinnerware, plastic water containers, nylon hammocks, and synthetic clothing. The structural dynamic of corporate capitalism, as much as ruling-class indifference to indigenous art forms, thus had devastating effects on Nicaraguan popular culture. Accordingly, Antonio Gramsci's view that authentic vernacular culture is necessarily the critic of ruling-class exploitation was invoked by Ernesto Cardenal when he articulated FSLN policies on artisanal production. As Cardenal explains:

The needs of artisans are attended to for cultural, political, and economic reasons. To do so, we have found our own way (not the capitalist way), getting rid of intermediaries and giving them state financing. Culture for us cannot be separated from social development. Also one might say that in Nicaragua it is inconceivable to consider economic development without cultural development.[88]

Here it should be noted that some of the more innovative artistic practices that emerged with the revolutionary process actually tied economic units directly to artistic groups. In theater this was especially true, since there were two theater/farm cooperatives whose aims were to intertwine artistic practice and agricultural production. One was Nixtayolero (meaning "morning star" in Nahault), which was directed by Alan Bolt and occupied 20–30 acres in the coffee growing region of Matagalpa. The other was Teyocoyani (meaning "first among all things"), which was directed by Filiberto Rodríguez and was part of a cooperative in El Sauce near León.[89] In each case, the cooperatives were set up as part of the huge program of land redistribution instituted by the revolution. By 1986, it saw more than 33 percent of the land in Nicaragua given to a majority of the rural population, whereas before 1979 this latter group had been composed of landless wage laborers.[90]

On the role of this innovative and critical—but nondidactic—concept of theater based in agricultural cooperatives, the native Nicaraguan director Alan Bolt said in 1986:

We are not trying to educate. We are not teachers. We are just like bees. We sting in the subconscious memory of the audience so they feel something that will bother them for awhile and they maybe won't know why. It will be there stinging . . . we are subversives. Subversives do not teach. They sting. So, we are not trying to provoke either. We are just putting on stage problems, situations, magic, instinct, with elements of the archetypes and symbols that are part of our collective subconscious memory . . . (the audience) will articulate (these symbols) with their own myths, in their own way, with their own process. Their reaction will be different depending on the experiences of the past, the culture, the education, everything.[91]

With his own radical spirit of independence and a matching tendency to engage in populist rhetoric, Bolt was also frequently, in the mid-1980s, a stinging public critic of the FSLN, as well as of the artists' union in Nicaragua. Despite the fact that the Sandinistas' progressive program of land redistribution had led to the creation of his theater/agricultural cooperative, Bolt nevertheless lambasted the Sandinistas' tendency to create a "vertical structure" of governance. He also criticized the so-called "petit-bourgeois Marxists from the city" in the FSLN and particular economic policies, such as those that mandated price controls on some agricultural goods.[92]

Furthermore, Bolt and Nixtayolero staged the criticisms of the government with complete impunity at the National Theater Festival. They produced plays such as *Luna clara, luna oscura* (Clear moon, dark moon), in which they publicly attacked supposed Sandinista tendencies to bureaucratism and authoritarianism. While Bolt was in turn criticized publicly by some

Sandinistas in newspapers like *El Nuevo Diario*, he was never punished by the government. Indeed, Bolt admitted: "You must understand, the FSLN is not a monolith."[93] When attending a party in 1988, Bolt had the opportunity to converse with President Daniel Ortega. According to Bolt, Ortega first asked how his theater/agricultural cooperative was doing. Upon hearing Bolt's report, Ortega then said: "We've made some mistakes. Keep up the good work. Your theater is important to the nation."[94]

In his study of theater during the Sandinista years, Randy Martin has rightly analyzed the "nature of civil society," in healthy tension with state institutions, so as to underscore the paradoxical relationship at times of parliamentary democracy and popular democracy. Accordingly, he has shown how the popular theater in Nicaragua was an artistic formation capable of prefiguring "broader social developments" beyond the local level—and even the national scene. At issue was nothing less than the ongoing redefinition of socialism along even more democratic lines.[95]

Particular Artworks Exemplary of the 1980s

After 1979, there was a nationwide efflorescence of *pintura primitivista* (primitivist painting), as it was known in Nicaragua by members of the popular classes. No longer limited to Solenti-name, these agrarian working class artists emerged from all parts of Nicaragua (fig. 143). Some of the more accomplished "primitivists," like Timothy Milton Hebbert Watson of Bluefields on the Atlantic Coast, also served as painting instructors in CPCs (fig. 142).[96] Significantly, the new Ministry of Culture under Cardenal promptly commissioned a striking series of public murals in parks and markets by some of the "professional" primitivist painters: Hilda Vogel of Matagalpa, Julie Aguirre of Managua, and Manuel García of Diriamba, for example, produced an epic-like Mural in Velásquez Park in downtown Managua (fig. 141). There was also a notable formal affinity between a 1980 primitivist mural by Manuel García in the Eduardo Contreras Market, Managua, and the artisanal products being sold there. A visual environment accented by "pintura primitivista" even in urban areas manifested in tactile terms the texture of rural life in Nicaragua, where 55 percent of the labor force was still located.[97]

In fact, the Nicaraguan revolution differed from most others because of the country's extremely high level of landless rural wage laborers. They constituted around 40 percent of the entire workforce in 1979 (as opposed to being only 5 percent in pre-revolutionary Russia, 2 percent in Tanzania, or 16 percent in Angola).[98] It was this sector of the working class that gained the most during the revolutionary redistribution of land that made Nicaragua's agrarian reform "one of the most far-reaching in

141 Julie Aguirre, Hilda Vogel, and Manuel García, *Paisaje Primitivista* (Primitivist landscape), 1980, Velásquez Park, Managua. This painting in Managua celebrating rural life was painted by three members of the Artists Union and was commissioned by the Nicaraguan Government in 1980. It was destroyed by Mayor Arnold Alemán in 1990.

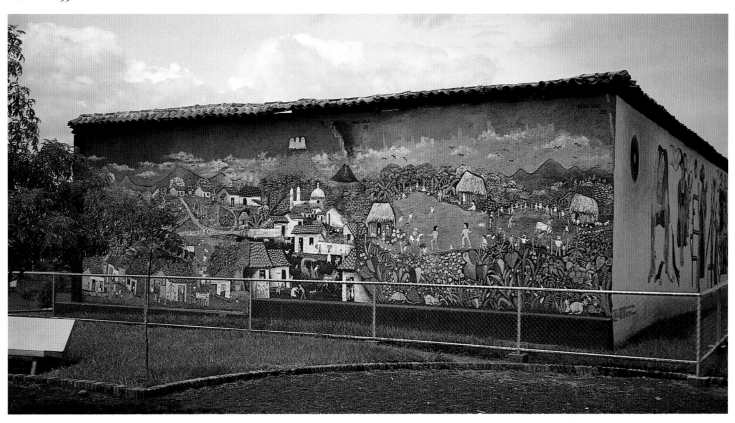

142 *(above)* Timothy Milton Hebbert Watson, *Clear Water, Bluefields*, 1980, oil painting.

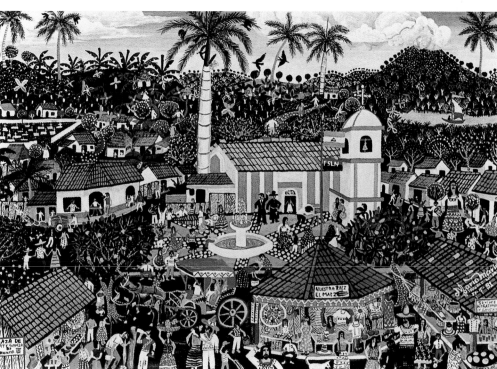

143 *(right)* Mario Marín, *El pueblo de Boaco (y la Plaza Mayor)*, 1981, oil painting, "pintura primitivista" from Boaco, Nicaragua.

144 *(above)* Olivia Silva, *La cosecha de café (con el Ministro de Cultura, Ernesto Cardenal)* (Coffee harvest, with Ernesto Cardenal, Minister of Culture), 1982, oil painting, Solentiname school of "pintura primitivista."

145 *(left)* Jean-Francois Millet, *Man with a Hoe*, 1860–62, oil on canvas, J. Paul Getty Museum, Los Angeles.

Latin American history."[99] Indeed, only the land redistribution program in Mexico under Lázaro Cárdenas in the 1930s can be considered as comprehensive in scope or as influential on national politics, as the program under the FSLN.

As David Kaimowitz has shown, by 1985 over 120,000 families benefited from the agrarian reform: "This represents the majority of all the rural families in the country."[100] These formerly landless laborers formed the backbone of the new cooperatives, as well as of the state farms. It was the heightened productivity of these cooperatives that helped Nicaragua to achieve self-sufficiency for the first time in basic foodstuffs (rice, beans, and corn) by the mid-1980s, while also sustaining part of the nation's agro-export sector and ending malnutrition (which was endemic to rural life before 1979 and which has returned with a vengeance since 1990).

There were well-known primitivist painters with distinctive local styles from various regions of Nicaragua. Mario Marín from Boaco, Carlos Morenco from Masaya, Olga Maradiaga from Subtiava, and, of course, Miriam Guevara, as well as numerous others from Solentiname, all come to mind immediately.[101] Several traits, both thematically and formally, were prevalent in the works of these years by all of the artists working in this vein. Primitivist paintings normally depicted different aspects of daily life (workers in the fields, famous sites in the countryside, quotidian interchange in villages, glimpses of the animal kingdom), while a few interpreted biblical scenes from the perspective of liberation theology.

Most revealing, though, was the way these paintings often embodied the material texture of the popular classes in the rural areas through a distinctive set of formal traits: florid, even brash, tropical colors; artisanal shapes, both rough-hewn and well-improvised; a marked consonance of form between human implements and natural elements; and, above all, a set of decentralizing compositional devices. These latter included a non-hierarchical disposition of figures both in relation to each other and with regard to nature, an equivalent lighting that throws very few components into bold relief and a pictorial structure that is characterized more by densely imbricated and interwoven shapes than by overlapping forms or perspectival spatial recession. In other words, these paintings were not so much realistic representations of *campesino* life as they were textural evocations with visionary overtones of its daily fabric: from everyday production and ordinary leisure to social conditions in relation to the nature that immersed rural labor.

In these paintings, labor was performed in what seems to be a disalienated manner, without undue hardship and in organic relation to other dimensions of human existence. Nature thus existed as an ecosystem to adapt to, rather than as something to be dominated. Overall, this is an art depicting generic human fulfillment characterized by social relations that are notably egalitarian. Unlike much Western art from the Renaissance to nineteenth-century history painting and twentieth-century "socialist realism" (including the nineteenth-century peasant pictures of Jean Francois Millet (fig. 145) and Vincent van Gogh), these Nicaraguan primitivist paintings seldom, if ever, focused on individual heroes or isolated people.[102] The work of Millet, for example, unlike that of Olivia Silva, uses perspective to establish social significance visually by means of a clear pictorial ranking of various elements in the work.

Even when national figures in Nicaragua like Ernesto Cardenal were incorporated into primitivist works, as in Olivia Silva's excellent painting *La cosecha de café* (Coffee harvest) (1982) (fig. 144), there was a pervasively nonhierarchical and decidedly decentered composition rendered without any "heroic" focal point or obvious order of relative social merit. The same demotic pictorial logic was even true of paintings about the life of Jesus. He was shown quite unconventionally as an ordinary *campesino* or *guerrillero* who shared in the grim fate of other workers. He was depicted neither as a transcendental figure outside history nor as a superhuman force within it. To appreciate this point, one need only contrast visually a portrayal of Christ by Gloria Guevara of Solentiname with a well-known 1930s mural depicting Jesus by José Clemente Orozco of Mexico

(figs. 146 and 147). The apocalyptic overtones and transcendent forces of the Mexican mural have given way to a humble resolve and resolute purpose in the Nicaraguan oil painting.

Along with their indifference to "heroic" individualism, these primitivist paintings from Nicaragua, such as those by Olivia Silva and Gloria Guevarra, were also radically equitable in gender-based terms. In them, women were as active as were men whether they were shown as workers, soldiers, or mothers. Just as women were seldom more passive than men, so it was also difficult to know on the basis of gender coding whether a man or a woman had painted the picture. All of these traits in turn registered two facts about Nicaragua: First, the crucial role of women in the revolutionary process itself (30 percent of the Sandinista guerrillas during the insurrection were women, including the legendary Commandante Dora María Tellez, while a majority of the literacy crusade brigadistas in 1980 were women).[103] Second, the marked parity in gender relations that existed in precolonial Nicaragua among the Chorotegas, Chontales, and other indigenous groups. (Most of whom apparently practiced polyandry at some point, a practice that greatly disturbed the more patriarchical Spanish colonists when they entered the region in 1523.)[104] We are also reminded here that the entrenched *machismo* from pre-insurgent Nicaragua, which was opposed ideologically by the Sandinista Revolution, is yet another unfortunate legacy of colonialism, at least in part. It was the deeply egalitarian tenor of most post-Somoza primitivist paintings that the poet Julio Valle-Castillo had in mind when he spoke of the "spontaneous ideology" they communicated as exemplary of organic intellectuals in Gramsci's sense of the term.[105] Similarly, the visionary tone of much of this painting moved Ernesto Cardenal to write of their "nostalgia for the future."[106]

An outstanding painting by Miriam Guevara of Solentiname *El algodonal* (The cotton harvest) (1981) (fig. 148), embodied most of what was so distinctive about Nicaraguan primitivist painting, including a vibrant color range and intertwining of people with nature. This was particularly true if one compared it to the less hopeful and more alienated artworks from else-

147 *(left)* José Clemente Orozco, *The Epic of American Civilization*, panel 21 of *The Modern Migration of the Spirit*, 1932–34, Baker Library, Dartmouth College.

146 *(facing page)* Gloria Guevara, *Cristo alfabetizador* (Christ as martyred literacy crusade brigadista), 1982, oil painting, Solentiname school. One of the most horrific acts of the U.S.-backed *Contras* was to assassinate the rural schoolteachers of Nicaragua as Sandinista-backed "communists." According to an Oxfam Report, by 1984, the Contras had murdered ninety-eight adult education teachers and fifteen primary school teachers, while kidnapping 171 other teachers and destroying fourteen school buildings. The killing of teachers by counter-revolutionaries was also a grave problem for both the Mexican Revolution in the 1920s and 1930s and the Cuban Revolution in the 1960s.

where in the Third World, such as the depiction of cotton farmers by Tshibumba Kanda-Matulu of Zaire during the 1970s.[107] The latter country had also suffered for decades under the Somoza-like dictatorship of Mobutu (which ended only in 1997 when he was overthrown by a former collaborator with Che Guevarra, Laurent Kabil). The African painting of labor in the fields during the colonial period (and, by implication, under Mobutu) was resolutely hierarchical in scale, as well as nonintegrative and nonimbricated spatially. Perspective here accented the distance between nature and people, rather than their interlacement, while also characterizing the inequitable and exploitative nature of colonial labor. All of this is fundamentally at odds with the nimble Nicaraguan painting of dilligent laborers in a cottonfield of great lushness.

Another noteworthy aspect of Miriam Guevara's painting, aside from its decentering formal configuration and effortless integration of people with nature, was one that was especially resonant with iconographic meaning for an ordinary Nicaraguan. This was the almost iconic image of the volcano Momotombo, a site near León often referred to over the years

in Nicaraguan art and literature (fig. 149). Far from being a simple formal device, the mountain in Guevara's work signified at least three different moments in Nicaraguan history. First, there was a reconnection with the religious animism of pre-Columbian native Americans, like the Chorotegas, who revered volcanoes as part of the divine order.[108]

Secondly, the prominent appearance of a mountain here recalled some insights by Nicaraguan author and Sandinista Commandante Omar Cabezas in his book *La montaña es algo más que una inmensa estepa verde* (A mountain is something more than an immense green steep) of 1982. The best-selling book in Nicaraguan history, Cabezas's work dealt with the guerrillas' belief during the insurrection that mountains had a "mythical force" as "our indestructibility, our guarantee of the future."[109] Mexican novelist Carlos Fuentes singled out a related idea in his introduction to Cabezas's book, when he said that Sandino and the Sandinistas were victorious against imperialism because their adversaries could not defeat nature, no matter how formidable the Western-backed technological edge was in military terms.[110]

**Art and Reality
Contemporary Art of Nicaragua**

Museum of Contemporary Hispanic Art (MOCHA)
584 Broadway, New York City
July 10 - August 10, 1986

150 *(above)* Leoncio Sáenz and Raúl Quintanilla, Managua, January 1990.

148 *(facing page)* Miriam Guevara, *El algodonal* (The cotton harvest), 1981, oil painting, Solentiname school.

149 *(left)* Leoncio Sáenz, *La montaña mágica* (The magic mountain), 1984, poster for an exhibition of Nicaraguan art in New York City.

Finally, Momotombo in particular and volcanoes in general had recently acquired a new signification in revolutionary Nicaragua in relation to technological progress. In 1983, Momotombo became the site of a geothermic electric plant, which used volcanic steam to generate over 12 percent of Nicaragua's energy needs. Mountains thus came to signify national self-sufficiency in an entirely new sense, both in *printura primitivista* and in other cultural forms. In this way, a traditional respect for nature was combined with a modern mastery of energy sources that left the ecosystem unharmed (a fact entirely at odds with the ecological devastation endemic to capitalist industrialization under Somoza).[111]

While there are obvious differences between primitivist painting by organic intellectuals of the popular classes like Miriam Guevara, and artworks by vanguard intellectuals with professional expertise, there are also points of convergence even as there are obvious differences. As was observed by the head of the National Union of Visual Artists, Luis Morales Alonso, there were several traits that were common to many of the paintings by Nicaraguan professionals in the fine arts (some of whom were formerly involved with Praxis).[112]

These distinctive formal attributes included heavily impastoed textural values; allusions, sometimes oblique, to landscape elements; and a preference for largely abstract vocabularies of form that, as Morales emphasized, necessitate "spectator participation" in constituting the work's signification. Thus, these paintings were not only dialogical in their Cortázar-like dependency on viewer consummation, but also dialogical in the sense that Mikhail Bakhtin had used the term to denote an interchange or "dialogue," often with critical intent, between various class-divided artistic traditions, particularly those involving high art and popular culture.[113]

A brilliant usage of all these elements can be found in Santos Medina's magisterial painting *The Revolutionary Unity of Indo-Americans* (1982) (fig. 151). Not surprisingly, this painting won a prize at the July 1982 Certamen Nacional de Nicaragua (annual national exposition) put on by the union of visual artists within the ASTC (Association of Sandinista Cultural Workers).[114] Medina's painting then won another prize in 1984 at the First Havana Biennial in Cuba. The Nicaraguan work was done in a manner related to earlier paintings by Diego Rivera of Mexico

151 Santos Medina, *Unidad revolucionaria Indoamericana* (The revolutionary unity of Indo-Americans), 1982, oil painting with mixed media, collection of the Ministry of Culture.

(as well as to subsequent works by Carlos Mérida of Guatemala, Joaquín Torres García of Uruguay, and César Paternosto of Argentina, or even Adolph Gottlieb of the New York School). In a fresh and resourceful way, Medina here synthesized European Cubism with a Meso-American pictorial grid marked by cursive figuration.[115]

Yet, to look at the artwork by Medina more closely is to realize that there is an even stronger formal affinity with pre-Columbian art (of which Medina is a student) than there is with Cubism proper. Contrary to the Cubist works by Georges Braque and Pablo Picasso, or even the related works by Diego Rivera, Carlos Mérida, Joaquín Torres-García, and Adolph Gottlieb, the outstanding painting by Medina features a rather divergent pictorial logic. It is at once more precise and less fluid (fragmented but not faceted), owing to the very tight imbrication of parts in the composition. The work by Medina thus does not have the same fugitive effect as do the works from Western Europe, even as shifting from plane to plane is key to them both. For all the modernity intrinsic to the image, there is a singular density and concomitant tactic of formal intertwinement to the Medina painting that were based on related traits found in Luna Ware from around 1200 AD in precolonial Nicaragua.[116] Perhaps unsurprisingly, salient attributes of pre-Columbian

ceramics were indeed revived in 1980s pottery production in Nicaragua.

Similarly, Medina combined these pre-Columbian conventions for constructing space with a distinctive type of incised line derived from the tradition of polychrome ceramic that was produced on the Nicoya peninsula of the Nicaraguan Pacific coastline around 800 AD. The painting includes figurative elements that are more allusive than referential and that are in turn reminiscent of the glyphs that were used on Nicoya ceramics. In order to consolidate this inter-image dialogue with ancient Indo-American culture, Medina executed his painting in a mixture of oil paint and sand. The resulting texture often resembled more the surface of pre-Columbian ceramics than that of European oil paintings.

In addition, the earthy colors used (burnt orange, burnt sienna, and burnt umber) are those of the Nicaraguan countryside. As such the palette used by Medina in this painting was also linked during this period to the invocations of nature that were so significant in the arts, as for example in the "geographical poetry" by Ernesto Cardenal, such as "Las Tortugas" (The turtles).[117] This multi-signifying link between painting and geography also reminds us of noteworthy works by several other Nicaragua artists, particularly, Leonel Vanegas (fig. 152), Arnoldo

Guillén, and Orlando Sobalvarro, as well as David Ocón (fig. 153). Important works from the period by these artists and others combine astute uses of components identified with a wide range of earlier painters, including Pablo Picasso, Antoni Tàpies, Robert Motherwell, and Mark Rothko, among many others.

In the case of Santos Medina it was the triumph of the Nicaraguan Revolution that allowed him to become a professional artist. As a political prisoner he was freed from jail with the July 1979 victory. A union leader and student activist Medina was imprisoned and tortured three times, for periods of four months to four years, for his political activities. He began work in a textile factory aged fifteen where he "tried to look for solutions, to organize the workers for higher wages, less exploitation. The entire factory was dominated by fear, crime, and prostitution."[118] Between revolutionary activism, jail terms, and factory work, Medina managed to attend the National School of Fine Arts for several months and during his time in jail he made paintings using materials that his mother managed to bring him. After the overthrow of the government, he joined the artists' union and devoted himself full-time to art. A number of his paintings were bought by the revolutionary government, particularly the Ministry of Interior.[119]

Aside from Santos Medina, a number of other Nicaraguan painters from the 1980s both assimilated developments from the Western tradition and critically engaged with this visual language through nuanced recourse to local formal concerns. Until his death in 1988 (while he was still in his thirties), Boanerges Cerrato was one of the most highly regarded Nicaraguan artists of his generation. In an award-winning triptych of paintings in 1986, Cerrato used formal aspects of New York School Abstract Expressionism, yet he also shifted the significance of these pictorial components by subtly connecting all-over space with the impenetrable, hence flattening, natural space of dense tropical terrain. The result was a 2D spatial effect that was associated with the abovenoted "primitivist paintings" by autodidact artists like Olivia Silva or Miriam Guevara.[120]

Triptych by Cerrato, which won first prize at the artist union's Certamen Nacional (National salon) in 1986, drew upon the field-painting format of Jackson Pollock's drip paintings (fig. 154). Yet Cerrato also employed more measured, less densely interlaced brushwork. Thus, the anguished sensibility embodied in Pollock's all-overs through the coiled skeins of animated pigment was displaced in Cerrato's work by fluent, nonfrentic brushstrokes that shifted the historical signification. Instead of the forceful, even harried, bodily movements of which Pollock's paintings were well composed traces, Cerrato's work evoked the fluency of organic motion, the impenetrability of undomesticated flora in Nicaragua. With its dense, polyvalent aesthetic structure, the Cerrato painting also came to signify the revolutionary trope of unbroken nature so current in the guerrilla poetry and testimonials of the period, and so crucial to *pintura primitivista*.[121] Fellow Nicaraguan painter Juan Rivas made this incisive linkage between "revolutionary" terrain and a Pollock field painting even more explicit in a neoabstract expressionist painting from the mid-1980s (fig. 155).

In this way, Cerrato's painting and the one by Rivas triggered a discursive interchange with the art of the New York School in the postwar United States. This was an interchange between an art that came from (yet existed in oppositional relation to)

153 *(left)* David Ocón, *Fruta perforando madera* (Fruit perforating wood), 1983, oil on wood.

152 *(far left)* Leonel Vanegas, *Paisaje* (Landscape), 1986, oil painting, collection of the Ministry of Culture. (This painting was exhibited at the 1986 Certamen Nacional.)

151

154 Boarnerges Cerrato, *Triptych*, 1986, oil painting, collection of the Ministry of Culture.

155 Juan Rivas, *After Pollock*, 1985, oil painting, collection of Raúl Quintanilla, Managua, Nicaragua.

forces of capitalist modernization in the U.S. and a type of non-provincial art that was connected, nonetheless, to a *campesino*-based culture in the periphery of the world economic order that had yet to be industrialized extensively. In turn, this critical usage of the art of the Abstract Expressionists was predicated on an original interpretation of the New York School by Latin America's leading art critic of the 1960s and 1970s, namely, Marta Traba of Argentina. Significantly, Traba, a prominent figure of the New Left, was in Central America in 1981 to write on Nicaraguan art along lines related to her discussion of Abstract Expressionism as a dissident, anti-imperialist force even within mainstream U.S. society.[122]

Traba's brief, but highly influential, analysis of Abstract Expressionism was in her most famous book on art criticism, which appeared in 1973. She began this study by discussing the Frankfurt School's critique of technologism, which is the hegemonic ideology of postwar U.S. society and multinational capitalism. From her vantage point, this critique should serve as the fundamental starting point for assessing any effort at cultural criticism and it did serve, in her view, as the stimulus for the major art of the entire postwar period. In keeping with this reading, Traba wrote of how the "critical resistance" of "the generation of DeKooning, Pollock, Motherwell, Kline, Newman, Rothko," was deeply opposed to "converting art into a component of the technological project that dominates consumer society."[123]

As such, the anti-technologist undercurrent of the Abstract Expressionists was seen as oppositional by Traba, because it maintained "an interior dimension" of self-realization within artistic practice that was largely at odds with the instrumentality, standardization, and repressive impersonality inherent to the logic of a multinational capitalism that was centered in the West. For this reason and others, Abstract Expressionism never came to signify in Nicaragua or Cuba, or at least in their respective art worlds, the consumerist values of the West or the nationalist politics of the "American Way" (much less capitalist values in the Cold War Period).

Consequently, from Morales in the late 1950s through Praxis in the 1960s to the Sandinista artists in the 1980s, Abstract Expressionism came to stand for a set of critical, often paradoxical, and generally multicultural conventions capable of being used as raw material by Latin American artists and deployed on behalf of their own national self-determination in the face of Western domination. In fact, as is clear here, cultural decolonization is not about retaining local "purity" in art but about interrupting and even reversing the flow of cultural forms from the West to the Third World, as was done by Cerrato, Rivas, and other Nicaraguan painters in the 1980s. This important point was conveyed to me in an interview in July 1986 in Managua, as I spoke with several of the leading art critics and artists in the Sandinista Union of Visual Artists. The members of this group were emphatic that New York School art, like all other art of a certain level of accomplishment, was able to be recruited by Nicaraguan artists for their own, often divergent, ends.[124]

These Sandinista-allied artists were then in the process of utilizing progressive features of U.S. art, such as that of the New York School, in order to oppose the imperial designs and ethnocentric values of their powerful neighbor to the North. As Nicaraguan critic Donaldo Altamirano stated, to see all New York School art as mere "cultural imperialism" is a dangerously undialectical view—and also an essentializing way to read the movement.[125] Further reinforcing this position were some highly influential lectures that had been given by Mexican philosopher Adolfo Sánchez Vázquez in Managua during 1980–81. In these public talks at the Escuela Nacional de Artes Plásticas (formerly the Escuela Nacional de Bellas Artes), portions of which were published in *Nicaráuac* (a journal of the Ministry of Culture in Nicaragua), Sánchez Vázquez defended abstract art from within the Marxist tradition, as he had done earlier in Cuba. He did so by discussing painting as a multi-leveled language with dialogical potential, rather than as a form of "realistic" image-making with a didactic function.[126] Moreover, he implicitly distinguished the artistic project of ideo-

logical critique (always an indirect one) from that of politically engaged art (with its desire for the self-evident).

If abstract and semiabstract paintings, with their dialogical appeal, were common in revolutionary Nicaragua, there was hardly any shortage during the 1980s of figurative art in the widest sense. Some artists, like María Gallo, re-employed politically charged components that Western artists had earlier borrowed from traditions in the Third World. Gallo's impressive and heavily impastoed paintings were based on an interimage dialogue both with the indigenous stone-carving tradition found at San Juan de Limay (fig. 137) and also with the European avant-garde art of artists like Paul Gauguin. Gallo's 1986 painting of a woman street vendor (fig. 157) was intended to be (as she explained in an interview in 1986)[127] several things simultaneously. On the one hand, her work was an appreciative engagement with Gauguin's efforts at producing a non-Eurocentric visual language (art critic Porfirio García has written insightfully of Gauguin along these lines).[128] On the other hand, Gallo's painting included a criticism of the sexist way he sometimes depicted women, as in his famous painting from the 1890s of Tahitian women with mango blossoms (fig. 156).

Other artists, such as Raúl Quintanilla, perceptively drew on the enigmatic work of proto-Pop artists like Jasper Johns to produce *engagé* assemblages. They did so in order to demystify the mass cultural products from the West that, ironically enough, had also served as raw material for Pop Art. Concerning Quintanilla's political recruitment of Johns's art, it is interesting to note that Johns in fact helped to monetarily support the exhibition in New York City of contemporary art from Cuba during the 1980s. This was at a time when it was virtually impossible to see art from Cuba in the United States during the censorious years of the Reagan era. Perhaps not surprisingly, Johns's connection to left-wing groups like the Center for Cuban Studies has yet to be discussed in the art-historical literature.[129] Quintanilla's works such as the pointed *Rambo: Final Chapter* (1985) obviously drew on the material framework of Johns's target series from the late 1950s (figs. 158, 159, and 160). Conversely, though, the images in Quintanilla's assemblage added up to a less ambiguous, more anti-interventionary work in thematic terms. He thus combined in a new way artistic insolence with historical urgency, and visual puns with political pungency.

156 Paul Gauguin, *Two Tahitian Women with Mango Blossoms*, 1899, oil on canvas, Metropolitan Museum of Art, New York, Gift of William Church Osborn, 1949.

157 María Gallo, *La Vendedora* (The street vendor), 1986, oil on canvas, collection of the Ministry of the Interior. This painting was shown at the Xavier Kantón Gallery of ENAP in July of 1986.

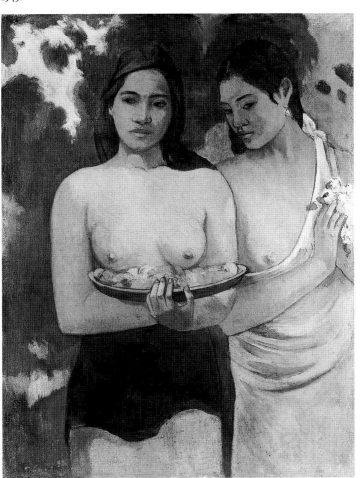

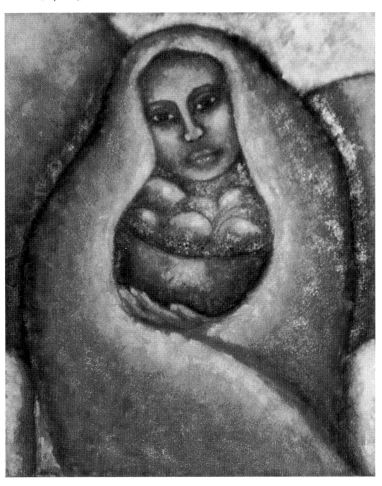

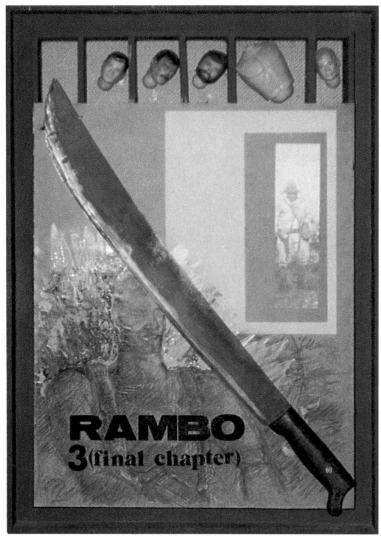

158 Raúl Quintanilla, *Rambo: Final Chapter*, 1985, mixed media, collection of the Artist.

160 Raúl Quintanilla, *Identi-dada*, 1990, mixed media, collection of the Artist.

Perhaps more surprisingly, but on further examination quite logically, the influence of Hieronymus Bosch's work, with its hellish scenes of dismemberment, re-emerged in Nicaragua. One saw this in the period paintings of both Carlos Sánchez Arias and Manuel García, who used this repertoire of figurative elements to comment on the horrifying human consequences of the Reagan-sponsored death squads in Central America, such as the Contras (Counter Revolutionaries) in northern Nicaragua. Even U.S. Congressional Reports showed, for example, that forty-six of the forty-eight Contra military leaders were former members of Somoza's National Guard, whose battle cry was "Abajo al pueblo, viva la Guardia!" (Down with the people, long live the Guard!).[130] Thus, the hellish late-medieval images of Bosch found unwanted currency in Nicaraguan art, owing to the horrors of the Reagan era.

By the mid-1980s, this Reagan-funded counter-revolution had resulted in over forty thousand deaths and billions of dollars in damage to Nicaragua's infrastructure. Needless to say, the mate-rial resources available for cultural development in Nicaragua were greatly diminished in the late 1980s as a result of the war. Following in the footsteps of counter-revolutionaries in Mexico and Cuba, the U.S.-backed Contras executed, for example, as many as 189 Nicaraguan school teachers in an effort to terrorize psychologically the populace of rural areas. The Ministry of Culture in Nicaragua responded by sending cultural brigades to the war zones along the Honduran border. Their job was to perform music, poetry, and theater in order to entertain the Sandinista troops stationed there.[131]

Understandably, one of the most memorable images of the entire decade was Armando Morales's haunting portrait in 1986 of Sandino and other guerrilla leaders, *Adiós a Sandino* (Good bye to Sandino) (fig. 161). As Morales noted in an interview, "my homage to Sandino, maintaining a certain distance, comes from Goya," specifically his *May 3, 1808.*[132] (This famed work by Goya was, after all, about the execution of resistance fighters by impe-rial foreign troops.) Equally significant, though, is how this

SANDINO VIVE...
NICARAGUA VA A SOBREVIVIR

161 Armando Morales, *Adiós a Sandino*, 1985, offset poster for an exhibition entitled *"Sandino Vive . . . Nicaragua va a sobrevivir"* (Sandino lives . . . Nicaragua will survive), Gallery of Casa Fernando Gordillo, Managua. This poster was based on an oil painting by Morales.

1981
año de la defensa
y la producción

162a *(above)* Taller de Gráfica Experimental, *1981 Año de la defensa y la producción* (1981 The year of defense and production), photo-offset poster, commisioned by the FSLN. The motif of Sandino as a spectre or as a shadow frequently appeared in street graffiti, posters, and paintings, as well as in Ernesto Cardenal's sculpture, during the 1980s.

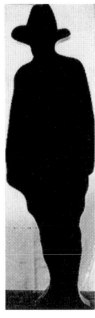

162b *(right)* Ernesto Cardenal, *Sandino*, 1990, steel sculpture in silhouette, Managua.

commanding "magical realist" painting was based on Morales's own childhood recollection of Sandino, whom he saw pass by his father's hardware store in Managua in 1934. This happened shortly before the former guerrilla leader was assassinated on orders from the first Somoza during a truce.

The dream-like *Adiós a Sandino* presents Sandino and his companions in deeply resonant terms, as "an ephemeral apparition and as one already threatened."[133] He is shown both as a shadowy casualty of the past and as the visionary hope of a rejuvenated future. A related and now well-known image of Sandino, which occupies a prominent hill in downtown Managua, is the compelling monumental sculpture of Sandino as a huge black silhouette that was designed by Ernesto Cardenal at the end of the decade and is used as a motif in other works. Seldom in art has a solid shadow loomed more commandingly or challenged more physically (figs. 162 a and b).

In the late 1980s several younger Nicaraguan artists worked in a potent Neo-Expressionist and/or magical realist manner, such as Aparicio Arthola (fig. 163), Cecilia Rojas Martínez (fig. 165), Oscar Rodríguez Méndez, and Patricia Belli (fig. 164). Rojas Martínez and Rodríguez Méndez, like Luis Urbina of the Praxis group, made deft and multicolored use of the motif of the mask, a particularly intense one in Nicaraguan history since the sixteenth century. They did so in a way that both registered a connection with modern masters like Picasso and elicited a link with the crucial role of masks in "resistant cultures" among indigenous peoples during the colonial period. Such, for example, was the case with the performance of *El baile de Güegüence* (The dance of the elders), which probably dates from the late-sixteenth or early-seventeenth century, and all of these paintings intentionally drew upon that contumacious history.[134]

A particularly revelatory interchange is the one that characterizes Luis Urbina's clear link, in his painting *Masks* (1986) (fig. 166), to Oswaldo Guayasamin's oil on canvas from 1951 entitled *Origins*. Compositionally the debt of Urbina to the famous painter from Ecuador could not be more obvious—though at issue here is an avowed tribute to a major South American artist who publicly supported the Sandinista Revolution. Nonetheless, there are notable differences in texture, tone, and brushstroke between the two paintings that remind us of what Traba and others have praised as most distinctive about vanguard painting in Nicaragua in relation to that of other Latin American nations. It is worth mentioning that in 1988 Guayasamin produced an anti-imperialist mural in the national capitol building of Quito, Ecuador that caused an international scandal. Because Guayasamin's mural linked U.S. imperialism (and the CIA) with Nazi Germany's designs on global dominance—particularly in places like Nicaragua—U.S. Secretary of State George Schultz threatened not to attend the inauguration of Ecuador's President. (Although the mural was not destroyed, Schultz relented and did attend.).[135]

If we direct our attention away from oil paintings made for interior spaces to artworks painted on exterior walls, we encounter an equally impressive spectrum of images. As a

163 Aparicio Arthola, *Retrato de un Hombre (Portrait of a Man)*, 1990, oil on canvas, collection of the Artist.

165 Cecilia Rojas Martínez, *Retrato de una Mujer* (Portrait of a Woman), 1985, oil painting, collection of the Ministry of Culture. The painting is shown here in an exhibition space of the Ministry of Culture in Managua, Galería de "Las Ruinas" (Gallery of the Ruins).

164 Patricia Belli, *Vestidos* (Clothes), 1990, oil on canvas, collection of the Artist.

166 Luis Urbina, *Máscaras* (Masks), 1986, oil on canvas, collection of the Ministry of Culture. This painting was shown at the 1986 Certamen Nacional.

167 Front entrance to the Escuela Nacional de Arte Público Monumental (National school of monumental public art, or the National school for mural painting), Managua, 1985.

169 Main view of the Escuela Nacional de Arte Público Monumental, 1985.

168 Sergio Michilini, *Practice Mural* (After Siqueiros), fresco, Escuela Nacional de Arte Público Monumental, Managua. This was the only "true" fresco mural executed in Nicaragua during the 1980s. Almost all the other murals were done in an acrylic paint made for outdoor sites and building exteriors.

number of visitors noted, Nicaragua in the 1980s was "the world capital of mural painting."[136] In an important new study, David Kunzle has catalogued around 270 murals that were created throughout Nicaragua (126 of which were painted in and around Managua) during the Sandinistas' main years of leadership.[137] By any standard, this is a remarkable record. (Although more well-known, and done in the more exacting medium of fresco, the Mexican mural movement of the 1920s and 1930s produced fewer public wall paintings overall.)[138]

Revealingly, the Nicaraguan government, in conjunction with the social-democratic Italian government of this period that actually underwrote much of the funding, established a National School of Monumental Art in Managua in 1982. Its new building, however, did not open until 1986 (figs. 167 and 169). The express aim of the school was to further the revival of mural art,

170 Velásquez Park and Murals from a distance, 1982, Managua.

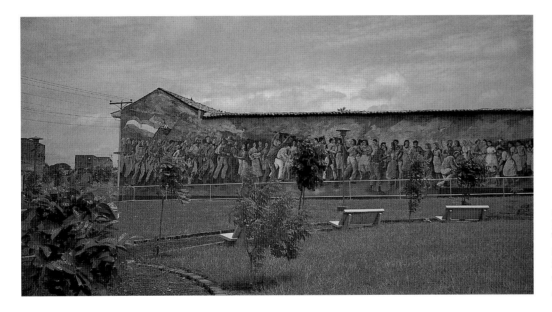

171 Leonel Cerrato, *La Reunión* (The Meeting or Reunion), 1980, acrylic, Velásquez Park, Managua. This mural was commissioned from Leonel Cerrato by the Nicaraguan Government in 1980 and it was destroyed on orders from Mayor Arnoldo Alemán in 1990.

including at some future point classic fresco painting (fig. 168). (Almost all of the murals done in Nicaragua during the 1980s were done in acrylic, rather than fresco, as was true in Mexico.) The director of the school of mural painting was Leonel Cerrato, one of Nicaragua's major muralists (figs. 170 and 171), whose debts to El Greco, German Expressionism, and Orozco are clear, even as his own original contribution to the language is also manifest.[139]

An early result of this new program, involving a collaboration of Italian and Nicaraguan artists, was an imposing cycle of mounted mural paintings (in acrylic, rather than in true fresco). These paintings were for the Church of Santa María de los Angeles in the working-class Barrio Riguero of Managua (fig. 173). Executed between 1982 and 1985 by five Italian artists (led by Sergio Michilini) who worked with twenty-two Nicaraguan painters, the mural cycle was entitled *The History of Nicaragua* (fig. 172). It placed special emphasis on the plight of indigenous people from the precolonial era up through the colonial period and modern times. In fact, the iconography of this fifteen-part series was indebted to liberation theology, and portrayed such figures in church history as Bishop Bartolomé de las Casas (who in the sixteenth century defended Native Americans from exploitation).[140]

Significantly, this iconographic program arose from extensive neighbor discussions among various groups and mass organizations located in the Barrio Riguero. (One of the poorest and most combative barrios of Managua during the insurrection against Somoza.) Among the groups that engaged in a public dialogue with the painters about the subjects, or iconographic program, of the murals were the youth organization, the CDS

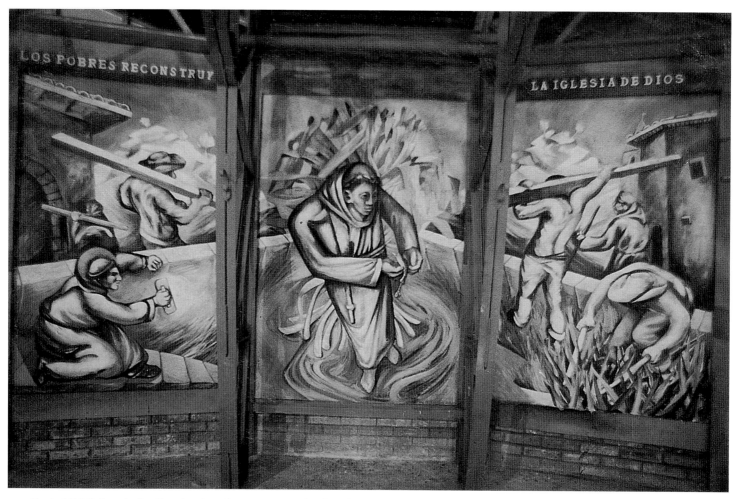

172 Sergio Michilini, et al., *San Francisco: los pobres reconstruyen la iglesia de Díos* (Saint Francis: the poor reconstructing the Church of God), 1984, acrylic and mixed media, Santa María de los Angeles, Barrio Riguero, Managua.

173 Santa María de los Angeles, Managua, 1986.

(Community Defense Committee), the local chapter of the Mothers of Heroes and Martyrs of the Revolution, several other popular labor organizations, and of course the local clergy, led by pastor Uriel Molina, who was one of the leading advocates of liberation theology in Nicaragua. In other words, the program-

matic theme was a direct result of a complex dialogical process whereby the "audience" for the works played a major collaborative role in determining what the artists would execute for them.

In formal terms, the murals at Santa María de los Angeles contain a notable debt to the wall painting designs of the Mexican artist David Alfaro Siqueiros, whose book *Cómo se pinta un mural* (How to paint a mural) was republished in 1985 by the Ministry of Culture in Nicaragua. The boldly illusionistic use of projecting figures in undulating polyangular perspectives, the very broad color range, and the sense of mobilized crowds surging forward that one sees in *San Francis: The Poor Reconstructing the Church* (fig. 172) or in the apsidal painting *The Resurrection*, which was painted on an outwardly curving wall, both recall the defining traits of murals by Siqueiros, as in his wall paintings for the Hospital de la Raza (1952–54) in Mexico City.[141]

This assimilation in Nicaragua of innovations by the Mexican muralist was in turn combined with the use of characteristically Central American cultural traditions. Such was the case with the incorporation pictorially of a variation on the Güegüence mask that was used in the indigenous theater of the colonial

period and which appears in a panel at Santa María de los Angeles. The reference to the Güegüence drama, which has evidently been in existence for several centuries in the "Indian" barrio of Masaya, Monimbó, was especially pertinent to the depictions in this panel of Carlos Fonseca and Augusto Sandino. In fact the Güegüence mask and related masks worn on the feast day of San Jerónimo were actually used by Sandinista combatants during the insurrection against Somoza. Before ending this discussion of the murals executed under the leadership of the Italian artists, one observation is perhaps worth making about artistic preferences. While David Alfaro Siqueiros was the Mexican artist favored by the visiting European painters, especially those from Italy, Diego Rivera was the muralist preferred by several of the most important Nicaraguan mural painters, such as Alejandro Canales, and by exiled Chilean artists working in Nicargua.[142]

The most innovative and among the most compelling mural paintings created during the entire period of the 1980s were two commanding works by Alejandro Canales and his team of assistants (which included María Gallo). The earliest one, his painting from 1980 on the side of a school building in Velásquez Park, Managua, was entitled *Homenaje a la Mujer* (A homage to women) (figs. 98 and 99).[143] Commissioned by the new revolutionary government in Nicaragua, this first mural celebrated the recently completed literacy campaign of that same year and also the fundamental role of women in that nationwide project. Designed and executed by Nicaragua's leading muralist, this painting by Canales deftly synthesized a number of European, Latin American, and pre-Columbian elements into a statement of buoyant affirmation. The major historical precedent for both the affirmative tone of the work and the specific subject matter rendered was to be found in Diego Rivera's unforgettable depiction of a rural schoolteacher in 1923–24 in the Ministry of Education, Mexico City (fig. 31) during the heroic early years of the Obregón Administration.

Characterized by a sensual rotundity and broad forms that not only evoke the sophisticated simplicity of certain figures by Diego Rivera, but also the marmoreal curves of Estelí stone-carving, this mural by Canales also included deft references to non-figurative motifs found in early vanguard sculpture. One such reference was to Julio González's sculpture of the 1930s. All of these elements were tellingly located on a stark, white ground that caused the figures to hover vibrantly. In addition, this mural combined the traditional popular theme of the nurturing mother with a somersaulting literacy crusade *Brigadista* holding a copy of the literacy primer used in the nationwide campaign (fig. 99). This motif signified the new role of women in a revolutionary society and signaled the profound nature of social transformation underway. The aesthetic result was an airy composition with heavy figures that existed largely in one plane and yet the work as a whole nonetheless conveyed a sense of monumental expansiveness. A *tour de force* of affirmative art, this mural lacked the apocalyptic overtones of the Siqueiros–Orozco tradition in muralism and featured instead the particular type of

multicultural language, as well as calm militancy, for which the more apollonian art of Rivera was better known.

Another gigantic mural by Canales was, from 1984–85 until the end of the decade, the most highly visible painting in Managua (figs. 174 and 175). Painted on the side of the Telcor Building (the national center for telecommunications) near Lake Managua, this mural was over seven stories high and it projected a towering presence into the surrounding area. Owing to its broadly epic theme, nuanced design, bold use of color, and conceptual coherence, this masterpiece by Canales was simultaneously the most monumental mural in Nicaragua and a moving monument to Nicaraguan muralism.[144]

From a distance of many city blocks and long before the complex neo-Cubist aggregate of figurative elements was even readable, the Telcor mural captured the viewer's attention. It did so because of the prominent use of primary hues, even as these primaries were modified in accordance with Nicaragua's landscape to become yellow ochre, bluish green, and a red that approximates burnt-orange. The collage or montage format went resourcefully back to the "alternative modernism" of Cubist paintings by Diego Rivera, specifically his early masterpiece, *Zapatista Landscape: The Guerrilla* (fig. 8) of 1915, which, as noted earlier, was the first painting of a *guerrillero* and also one with a link to Sandino.

The Telcor mural by Canales was thus a kaleidoscopic field of considerable dynamism that deftly intertwined signs for history, nature, and technology in a series of shifting narrative references. For all its dense interpenetration of parts, which were easily intelligible from a city block away because of the strong color contrast used throughout, the mural was nonetheless an effective composite of signifiers that were generally accessible to every Nicaraguan. Yet the novel framework adroitly used by Canales for these familiar elements caused a salutary process of defamiliarization on the part of the spectator, owing to the new relationships employed by the artist.

Accordingly, in this composition that repositioned narrative elements in a novel Cubist format, it was the structural syntax more than the use of any individual parts that most distinguished an encounter with the Canales work. At its best, then, the new conjuncture of infrequently linked motifs defamiliarized the viewer, at least momentarily, with what had already been somewhat familiar. Consequently, it tended to stimulate critical thought in the viewer about the historical interconnectedness of these various dimensions within Nicaraguan life.

Especially effective in formal terms was the deployment by Canales of directive, diagonal lines and a loosely centering, but hardly static, composition that propelled visual movement about, as each feature flowed into the next section as part of the ongoing interplay of competing signs. Accenting the center portion of the mural were portraits of three martyred revolutionary leaders in the half-century struggle against the Somoza dictatorship and its U.S. overlords. These three *guerrilleros* were Augusto Sandino (d. 1934), Carlos Fonseca (d. 1976), and Rigoberto López Pérez (d. 1956). Either together or separately,

174 Alejandro Canales, *Comunicación en el Presente y el Pasado*, 1985, acrylic, Telcor, Managua.

175 The Telecommunications Building (Telcor) with the Canales Mural from a distance, 1986, Managua near the lake front.

they functioned as synecdoches for national autonomy and cultural self determination in a tradition extending back to the Che silkscreens of the 1960s.[145]

In the Canales mural from 1984–85, these three figures were deeply embedded in the work, so as to jostle with the surrounding motifs for the viewer's attention. They were not heroically isolated personages standing out from everyone else, as was true of "socialist realist" paintings from the Soviet Bloc. Conversely, unlike the political campaign billboard or television advert in the United States, this mural rendered the historical import of these figures without naively reducing history to a mere parade of "great men" above the popular fray. As had earlier been the case with Cuban depictions of Che in the paintings of Raúl Martínez or the posters of Alfredo Roostgaard and Elena Serrano (figs. 16, 58, and 82), these portraits were without extensive details or anecdotal asides. Thus, Sandino, Fonseca, and López Pérez emerged more as distinctive signifiers for larger forces, than as distinct personalities in their own right.

In the Telcor mural, Sandino confronted the spectator face-on. This position thus signified the commitment to immediate concerns and the resolve to face the present unflinchingly, with both traits being further signified by the inclusion of Sandino's rough-and-ready sombrero. Similarly, Fonseca looked out at an angle into the distance (frequently, Fonseca was shown in an ascensional three-quarter view with his eyes looking skyward). This particular portrayal denoted a visionary vantage point, a theoretical perspective, and perhaps also a command of the unfolding future. The depiction of Fonseca in glasses furthered this reading of his image.

Because both Sandino and Fonseca, along with Rigoberto López Pérez, who peered out from behind the other two, were killed in the national struggle for national liberation, their portraits did not advance any personality cult of a living leader in power. Revealingly, in Nicaragua during the 1980s there were no monumental public portraits of Daniel Ortega, Sergio Ramírez, or any other Sandinista leader, before the elections of 1990. (There was only one major exception in the early 1980s: a portrait of Tomás Borge in a mural at the Plaza 19th of July.) It is important to underscore this point both to intimate something distinctive about the FSLN concept of power and to rebut the contrary reporting during the past decade by U.S. news agencies like *Time Magazine* and even the *New York Times*. (In 1983, for example, the latter publication mistakenly identified a portrait of revolutionary martyrs as a depiction of living leaders in the FSLN government.)[146]

The nimble enjoinment of different elements by Canales occurs as the viewer's gaze goes from the skyward-directed disk to the large, outstretched arms of the anonymous *campesina* woman. Her symmetrical position and broad outreach connected the divergent planes over which her arms were superimposed. Because of the fine use of tertiary colors—coffee brown, beige, burnt-orange—in this passage, and also owing to the absence of three dimensional shapes (which one saw in a modi-

176 Alejandro Canales, *Una mujer campesina* (A peasant woman), 1978, drawing in pen and ink with washes, Private Collection.

fied way in Canales's Velásquez Park mural), the "unknown" *campesina* was hardly an obtrusive presence, but rather a unifying tone. Interestingly enough, her anonymous figure, emerging half-length from behind the head of Fonseca, competed boldly for the spectator's attention with the three revolutionary martyrs portrayed below.

In this case too, the peasant women or rural laborer painted by Canales (fig. 176) found a visual counterpart in the area surrounding the Telcor building, since he had also painted a one-story mural in 1980–81 on a small building nearby (fig. 175). The earlier and more simple mural featured three larger than life-size, but half-length, *campesina* women who were harvesting coffee. From the Avenida Bolívar, which was then the main approach to that part of Managua, both paintings were simultaneously visible

for a lengthy distance. As such, there was an engaging interimage dialogue that emerged between these two Canales murals.

The image of the rural woman laborer in the Telcor mural receded before a quickly shifting set of motifs in the lower right portion of the mural. First, there was a frame with a workman indoors, apparently either artisanal or clerical, that abruptly changed into a large airmail envelope with red and blue trim, flanked on the right by a Nicaraguan flag of undulating blue and white stripes. This flag, the official one of the Nicaraguan Republic, crested a cursive image of the Rubén Darío Theater, located across the street from the Telcor building. Here the theater motif became a basic geometric element, with columns as flat vertical lines that found a visual echo in the telephone pole that anchored the right corner. The telephone pole was

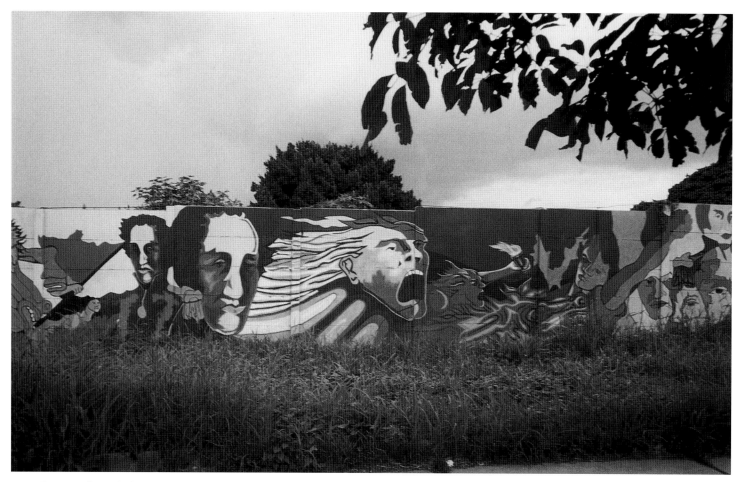

177 Victor Canifrú and Alejandra Acuña Moya, *El Sueño supremo de Bolívar* (The supreme dream of Bolivar), 1983, acrylic, Avenida Bolívar, Managua. This mural was destroyed in 1990 on orders from Mayor Arnoldo Alemán.

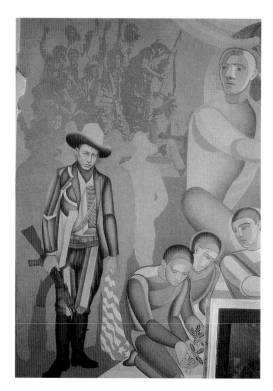

178 Arnoldo Belkin, *Prometheus: Zapata and Sandino*, detail of Sandino, 1985–86, acrylic, Palacio Nacional, Managua. This mural was commissioned by the Mexican Government to honor the 75th Anniversary of the Mexican Revolution and the 5th Anniversary of the Nicaraguan Revolution.

entirely in silhouette, as the Sandinista with an assault rifle seated on it (the motif of which was drawn from a famous photograph) provided yet another vertical accent in this part of the painting.

A key passage for encapsulating the thematic interplay of the whole work, though it was not visually dominant in this somewhat decentered montage, was the superb lower part of this mural. Featuring a green tree, whose trunk formally repeated the bordering diagonal line to the right, this passage showed the roots of the tree turning into the projecting antennae of an orbiting satellite at the base of the tree, all of which was located on a series of layered geometric planes and surrounded by planetary bodies. In addition, the serrated edge of the top, light-blue plane referred to stamps, yet another type of communication but not one that was made possible by satellite systems. Hence, what at first glance seemed like an unlikely composite of salient traits from disconnected phenomena—trees, satellites, stamps, plants, guerrillas, etc.—ultimately constituted a synthesis of interdependent signifiers. They connoted a non-linear historical progression, ever mindful of uneven historical development, which interrelated technology and nature on a variety of heavily mediated levels in the "developing world."

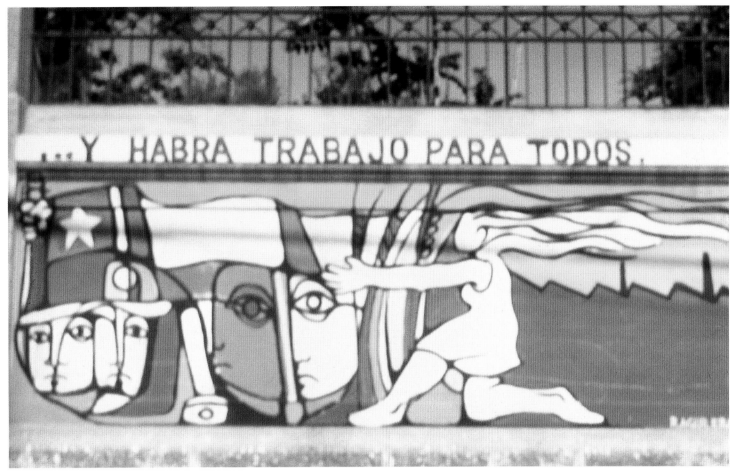

179 Ramona Parra Brigade, *Mural*, 1970, Santiago, Chile. This mural was destroyed in 1973 by General Augusto Pinochet's Military Junta.

The thematic concern with space-age technology in this mural by Canales certainly found a dense network of intertextual images in Nicaraguan poetry of the period. The first and most famous intertext would have been located in a poem by Leonel Rugama. A poet and FSLN cadre who was killed in 1970 in a shoot-out with the National Guard, Rugama was renowned for his poem "The Earth is a Satellite of the Moon."[147] In this lyrical work, Rugama contrasts in both a rhythmic and relentless way the poverty of rural Nicaraguans with the enormous amount spent by the United States on the Apollo moon flight. His poem ended with the memorable, if acrid line: "Blessed are the poor for they shall inherit the moon."[148]

Another poem by Ernesto Cardenal, like the Canales mural, took up the challenge to respond to Rugama in the aftermath of the revolutionary victory for which the young poet had given his life. Entitled "Final Offensive," the poem by Cardenal traced an analogy between the revolutionary struggle and a flight into outer-space. The poem by Cardenal ended as follows:

It was like a voyage to the moon. And with no mistakes.
So very many coordinating their work in the great project.
The moon was the earth. Our piece of the earth.

And we got there.
Now it begins, Rugama, to belong to the poor; this earth (with its moon).[149]

Aside from these abovenoted murals there were several others that merit mentioning again, even in the briefest survey. First among them is the moving 1980 mural *Reunión* in Velásquez Park, Managua, by Leonel Cerrato (figs. 170 and 171), a prominent work noted above (and destroyed in 1990). In addition, there were numerous other murals produced in the 1980s by *internacionalistas* from around the world. These included murals by Arnoldo Belkin of Mexico, Camilo Minero of El Salvador, the Felicia Santizo Brigade from Panama, the Orlando Letelier Brigade of Chilean exiles, a Chicano Brigade from Los Angeles, John Weber of Chicago, and the brigade led by Miriam Bergman and Marilyn Lindstrom from San Francisco.[150]

Perhaps the three most outstanding murals in this group were the indoor painting of Zapata and Sandino from 1985–86 by Arnoldo Belkin in the National Palace (fig. 178), the street mural done in 1980 near the National Stadium by the Orlando Letelier Brigade that celebrated the literacy crusade, and the huge wall painting from 1983 about the history of Latin America that was

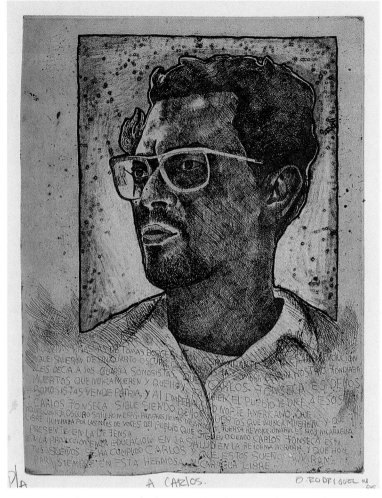

180 Oscar Rodríguez, *A Carlos* (Portrait of Carlos Fonseca), 1986, etching, Private Collection.

181 Taller de Gráfica Experimental, *Por la Paz* (In order to have peace), 1982, silkscreen poster, FSLN.

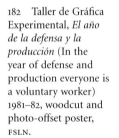

182 Taller de Gráfica Experimental, *El año de la defensa y la producción* (In the year of defense and production everyone is a voluntary worker) 1981–82, woodcut and photo-offset poster, FSLN.

designed and painted by Chilean exile Victor Canifrú. (He was assisted by Alejandra Acuña Moya and several others.) The latter work, which was entitled *El Sueño supremo de Bolívar* (The supreme dream of Bolívar), extended for over one hundred meters along the Avenida Bolívar in downtown Managua (fig. 177). It evinced an impressive set of visual languages, in addition to an immensely complex range of historical references. One visual idiom in particular stood out in this mural and that was a distinctively flat, non-shaded, ungradated manner earlier made famous in Chile by the Ramona Parra Brigade of the Allende years there (the early 1970s) (fig. 179). Here as elsewhere, then, Nicaragua served as an international arena for experimental painting that brought together many of the most accomplished public muralists from the Americas.[151] The result was a development in public space of virtually every leading mural tradition in Latin American history for popular engagement.

The public sphere, which in Nicaragua became a dynamic and open locus for rational debate about the general welfare, was the domain wherein there occurred a dramatic re-enfranchisement of the popular classes. This sphere also became a showcase in the early 1980s for a reintroduction of the *engagé* poster. Commissioned by various mass organizations that did not necessarily have formal ties to the FSLN, these posters were as varied

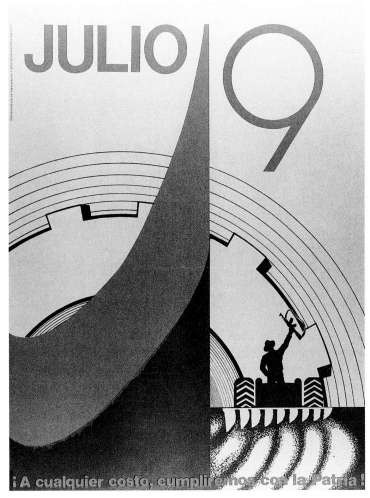

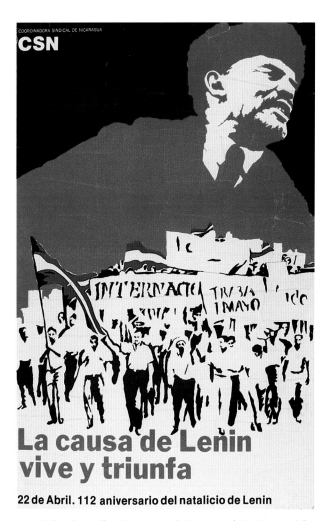

183 Taller de Gráfica Experimental, *Tercero Anniversario de la Revolución–Masaya*, 1982, poster, FSLN. This poster was influenced by Russian Constructivism.

184 Taller de Gráfica Experimental, *La causa de Lenin vive* (The cause of Lenin lives), 1981–82, photo-offset poster for the CSN, a labor union.

in visual dialects as were the murals and as broadranging in message. The dominance of art groups in the production of these posters is a noteworthy historical point. Many of the most sophisticated and nuanced posters made in the twentieth century have been created by artists collectives and/or cooperatives—from ROSTA in Moscow (1919) and the Taller de Gráfica Popular in Mexico (1937–77) through the Quimantú Press in Chile (1970–73) to the trend-setting Cuban artists who worked for OSPAAAL and ICAIC after 1959.[152]

Not surprisingly, this cooperative approach was also the case in Nicaragua during the Sandinista years, at least from 1979 to 1987. In the early 1980s there was the Taller San Jacinto, or TSJ (1979–81). In the mid-1980s there was the Taller de Gráfica Experimental, or TGE (1981–87). Both were sponsored by the Ministerio de Cultura and each was affiliated with the Escuela Nacional de Artes Plásticas (ENAP). Moreover, each cooperative was headed by one of the main figures in the history of Nicaraguan printmaking. The first, the TJS, was led by Leonel Cerrato, a key figure in the rival of woodcuts, and it included the artists Roger Pérez de la Rocha, Genaro Lugo, Franz Orozco, Florencio Arthola, and Leoncio Sáenz. Logistical and technical support was provided to them by the Cuban artist Luis Miguel Valdéz and agencies back in his home country.

When the TSJ was absorbed into ENAP, in part because of the increasing commitment of Leonal Cerrato to muralism, a new and more dynamic cooperative replaced it, namely, the Taller de Gráfica Experimental (1981–87). This latter group, which produced many of the most striking posters of the Nicaraguan Revolution, was also led by a notable printmaker, Oscar Rodríguez, who worked in a more varied manner and in more diverse media (fig. 180). Among the key artists who comprised the TGE were Boanerges Cerrato, Aly Cortéz, Aurelio Flores, Orlando Talavera Rodolfo Tikay, Reyneris Mendoza, Miguel González, and María Gallo. Diverse visual traditions aimed at varying mass organizations, both urban and rural, were employed. Their poster images ranged from the rustic ones of the TGP through the "machine aesthetic" look of Léger and the Russian Constructivists to the brash Pop images of the Cuban contingent (figs. 181–84). An exemplary poster by them from 1982—on the third anniversary of the Revolution—which was plastered all over Nicaragua, contained a crisp collage of precise metallic components that signified technological development in the agrarian sector, among other things (fig. 183).

In drawing on the precedent of Cubist painters like Léger and Delaunay, or on the Constructivist designs of Tatlin and Rodchenko (fig. 184), the team of Nicaraguan artists employed

167

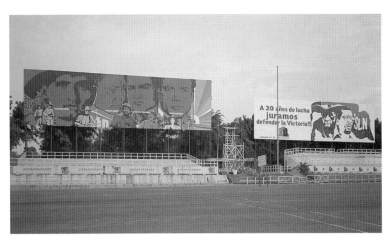

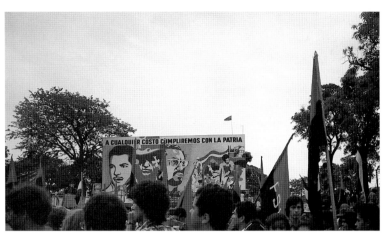

185 Antonio Reyes, *The Founders of the FSLN and Revolutionary Martyrs*, billboard mural, 1980, Plaza of the 19th of July, Managua. The visual language here was influenced by Cuban Pop of the 1960s.

186 Antonio Reyes, *Revolutionary Martyrs: Carlos Fonseca, Rigoberto López Pérez, Augusto Sandino*, 1982, billboard mural, Masaya, Nicaragua.

basic shapes—rims, treads, furrows, wheels, flags—that either resulted from motion or caused it and that were all located on a metallic silver ground. The tight formal cohesion of these parts in turn suggested a new coherence of ideas: agrarian, industrial, ideological. Here again, the overall logic of the photo-offset visual image was designed less to provide the viewer with some idealized depiction of a struggle already resolved, than to present the spectator with an open-ended, even visionary, image to which the viewer's response was intrinsically necessary.

Amplified versions of these posters by Antonio Reyes, which featured broad patches of uninflected, flat color in a manner similar to 1960s silkscreens, were the painted billboards (or rótulos) (figs. 185 and 186). Designed to mobilize the populace as well as to accent the public space where large meetings would occur, these billboard paintings marked the major sites for mass demonstrations in the early years of the decade. In Managua, these billboards were most prominently on display at the Plaza of the Revolution and at the Plaza of the 19th of July. On July 19, 1981, the latter place accommodated a public gathering of over 600,000 people (amounting to one in every five citizens in the country.) In general these acrylic painted, poster-like images on large billboards, featured portraits of the three most famous revolutionary martyrs (Sandino, Fonseca, López Pérez). Such was, for example, the case in Masaya with the billboard done to mark the July 19, 1982 anniversary celebrations of the Revolution.[153]

In a public debate in 1983, in which she defended the so-called "formalism" of much of the public artwork being produced in Nicaragua, Gioconda Belli advanced a dialogical and popular, but also antipopulist view of art in keeping with many of the abovenoted works. Belli contended that, "There are those who think that art, in order to be revolutionary, must be explicit. . . . This is an implicit underestimation of the people."[154] Her target was the simple-minded populist claim of a few FSLN cadres that supposedly self-evident "realistic" art could alone serve as an "art of the people."[155] The latter approach, however reassuring, is really about conveying visually what people already know, thus arresting the social transformation intrinsic to a revolutionary process.

How then would one discuss the character of the new audiences for dialogical art in revolutionary Nicaragua? Above all, much reception theory, which generally presupposes a static class audience or an invariant subset of this group, should be singled out as inadequate. To the contrary, the dynamic process sustaining the dialogical art and culture of the 1980s would require the formulation of a more fluid and dynamic model for delineating the nature of audience responses, than is often used in reception theorists' discussion of either the reader or the spectator. A dialogical framework sees the audience as a heterogeneous group composed of still emergent representatives of popular classes, class fractions, or other social sectors. Such an engaged and activist audience actually remakes what it is by drawing on formerly foreign cultural experiences, even as this diverse group also continues to reaffirm part of its own pre-existing cultural values through some passages of a hybrid art.

In short, all of the artforms of the Nicaraguan Revolution so far discussed were not brought into being to appeal only to already existing audiences. Rather the artforms were aimed at the reconstitution of the audiences in different terms—terms that were necessarily subject to further transformation as part of a process which was being propelled forward by the network of events and agencies mentioned above. Dialogical art and culture, then, were successful in the Nicaraguan context to the degree that they enjoined different, often competing, artistic codes without becoming unintelligible to all the earlier audiences. These partially new artforms appealed in a novel manner to spectators, even as a certain continuity with old spectatorial anticipations was also still important. In this sense, the new and deeply dialogical artworks of revolutionary Nicaragua were about the creation and consolidation of new audiences, while these new audiences in part constructed novel meaning for this art through the redefinition and redeployment of old codes in the public sphere.[156]

New Forms of Patronage and Attendant Debates in the 1980s

One image in particular from July 20, 1979 captured the end of the type of patronage that was symptomatic of the Somoza dictatorship. This was a photograph taken by Peter Kretz of the equestrian statue of Anastasio Somoza being toppled by an angry crowd near the National Stadium in Managua. In fact, the statue has a real pedigree that could have been invented in a short story by Gabriel García Márquez or Sergio Ramírez, although it wasn't. This statue originally represented Mussolini, was made in Italy, and was simply refitted with a new portrait of Somoza when it was bought by the Nicaraguan dictator in the early 1950s.[157] About the nature of patronage during the reign of Somoza and his two sons who succeeded him respectively (both of whom graduated from the U.S. Military Academy at West Point), Ernesto Cardenal wrote a short poem in 1954. Its title alone encapsulated the existing situation with respect to the arts: "Somoza unveils Somoza's Statue of Somoza in the Somoza Stadium (fig. 10)."[158]

In the 1950s there was only modest and intermittent support for mural paintings through commissions from the Catholic Church and the private sector. The few works produced by means of this monetary support included Rodrigo Peñalba's series of murals about St. Sebastian for the parish church of Diriamba, a 1970 mural by César Caracas in the Instituto Maestro Gabriel of Jiloa, and Leoncio Sáenz's aforementioned 1974 mural for the supermarket near the Plaza de España (fig. 115). In general, however, a lack of patronage from the private sector and the church hierarchy, as well as from the Somoza Regime, meant that the situation for professional artists was dire at best. This was the case even at a time when Armando Morales had started to gain international fame.[159]

A turning point occurred with the foundation in 1963 by the Praxis Group of an artist-run cooperative gallery, the Galería Praxis, which lasted until 1972 when it (like most of downtown Managua) was destroyed by an earthquake. This vanguard group of Sandinista cadres and fellow travelers did act as a new stimulus for both collecting and dealing, so that subsequently, in 1974, several private galleries for contemporary art came into existence. (These galleries included Cueva del Arte, Tagüe, La Cascada, and around seven others.)[160]

Unfortunately, this upsurge in new galleries during the mid-1970s happened at precisely the time when things had grown desperately worse for most of the population after the 1972 earthquake. (Much of the international relief money sent to Nicaragua had in fact been siphoned off by the Somoza family and its friends.)[161] Thus, while the general population of Managua was left in an increasingly difficult situation, the post-1972 art market emerged in considerable part as a way of providing elegant decor for the new homes being built or rebuilt in Managua's affluent neighborhoods. Furthermore, the economic position and social status of professional artists did not notably improve, since the new galleries often took a very high percentage on each sale. Nicaraguan author Mario Flores summed up the predicament of the visual artists and their artworks in the mid-1970s: "These galleries isolated the painter and his or her art from the general populace, distorted the content of art, and created a new group, the entrepreneurs, who used their social position to insure that art would exist merely for the wealthy."[162]

With the overthrow of Somoza in July 1979, almost all of these private galleries were closed and most of the commercial dealers moved to Miami, Florida. (After 1986, however, several new private galleries did open in Managua.) It was during this void in the early 1980s that the Union of Visual Artists—a member of the network of cultural unions constituting the ASCT or Association of Sandinista Cultural Workers—worked with the newly founded Ministry of Culture under Ernesto Cardenal to set up a whole series of artist-administered galleries for exhibiting and selling contemporary art. These spaces (which were either indirectly or directly under the auspices of the Ministry of Culture and related government agencies) included the Xavier Kantón Gallery at the National School of Visual Arts in Managua; the Ricardo Morales Aviles Gallery inside the Ministry of Culture, Managua; the Gallery in the Las Ruinas Museum in old Managua; and the Gallery of the Architectural Center in Managua (fig. 189).[163]

There were twenty-eight additional gallery spaces set up by the Ministry of Culture around the country, one in each of the new Popular Centers of Culture. Furthermore, the Ministry of Culture set up five large commercial exhibition spaces for artisanal products: two in Managua, and one each in Monimbó, Masaya, and Niquinohomo. In addition to these state-funded exhibition spaces, there were three significant cooperative galleries run by the Artists' Union. These were: the Gallery Fernando Gordillo on the impressive grounds of the ASTC headquarters in Managua (it was there that the annual national exhibition, or Certámen Nacional, was held each July); El Molejón Gallery in the Huembes Market of Managua; and, established by the Artists' Union somewhat later, the Praxis Gallery. A related but privately backed space at the end of the 1980s was the Pipitos Gallery.[164]

In order to buy paintings, prints, photographs, and sculpture from the Artists' Union, the Sandinista-led government liberally purchased works for the new offices and ministries set up after 1979. The Ministry of the Exterior (under Secretary of State Father Miguel D'Escoto) had a large collection of contemporary art acquired from the union. The person most responsible for advising the Ministry on which works to purchase was the accomplished abstract painter Orlando Sobalvarro, a former member of Praxis. In addition, it was the Ministry of Culture, along with Ministry of Construction and various mass organizations, that were responsible for commissioning many of the murals and public sculpture made in Nicaragua (fig. 187).[165]

But, what of the structure and operation of the Association of Sandinista Cultural Workers? These aspects were explained by poet Rosario Murillo, the General Secretary of this organization (and also the wife of President Daniel Ortega). In an interview in the mid-1980s, she elaborated as follows:

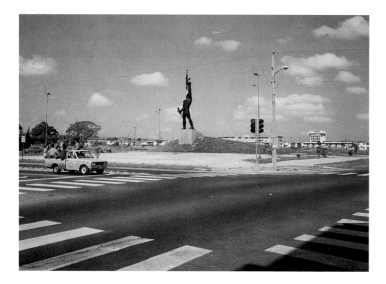

189 *(above)* Museo de Arte Contemporaneo "Julio Cortázar," 1990, Managua. This was the art collection of the FSLN that was donated by Latin American artists in solidarity with the Revolution. The collection has now been given to the government and relocated to the Palacio Nacional, which has been converted into a Museum.

188 Roberto Matta, Poster for the Collection of Latin American Artworks that became the Museo de Arte Contemporaneo "Julio Cortázar," 1980. When the photo was taken in 1982, the collection was temporarily on display in the Teatro Nacional Rubén Darío, a late modernist building designed by Lawrence Durrell-Stone in the 1970s for the Somozas.

187 *(top)* Franz Orozco, *Public Monument to Popular Militia and National Sovereignty*, 1984–85, bronze, Managua, commissioned by the Ministry of Public Construction during the Sandinista Era, located near the lakefront of Managua.

We make up what we call the trade union organization of Nicaraguan artists . . . Above all, our work consists in helping artists disseminate their work, both here and abroad. . . . We actively try to solve the artist's material problems with living and working conditions. . . . We finance ourselves with our resources based on membership fees and international sources. . . . To give you an example, the materials we import for the visual arts are purchased with the 20 percent donated by each artist when he or she sells a painting. The same money helps us to put out publicity and catalogs. Materials are sold at cost. . . . Our goals are at the same time to professionalize the artistic work and to make this art available to the mass of people. We have nine thousand members, of whom one hundred are full-time artists. These are artists who are learning more, teaching others, producing work and building our culture. Nicaragua never before had this climate in which to create art. . . . [Now] we work in all styles: realism, surrealism, primitivism, and abstraction. . . . Our goal is to produce the best art regardless of style . . . [Thus] we are realizing an explosion of work in the visual arts, which did not exist before. . . . When we talk about revolutionary art, we are not talking about pamphlets, the clenched fist, or a raised gun. We are talking about art of quality, which expresses deep insights . . . bad art is bad for the revolution.[166]

As a tribute in 1981 to these developments in the arts as well as to other comparable gains in the realms of education, health care, and human rights, virtually all the major artists of Latin America donated artworks to the FSLN and the Nicaraguan people. This group of donors included, for example, Wifredo Lam of Cuba, Roberto Matta (fig. 188) of Chile, and Oswaldo Guayasamin of Ecuador, along with José Gamarra of Uruguay, Julio Le Parc and Luis Tomasello of Argentina, and Jesús Rafael Soto of Venezuela, to name only a few.[167]

The collection was also intended by these artists as a show of international support for the Nicaraguan Revolution in the face of the growing U.S. military aggression by the Reagan Administration during these years. As author Julio Cortázar of Argentina (and Paris) remarked in 1984: "I was thinking, leaving the museum, how this is the first one in the country, and how already Latin American solidarity has made it one of the richest and most representative on the continent."[168]

This remarkable collection of almost four hundred paintings and prints was originally displayed in the Rubén Darío Theater in Managua and named the Museo del Arte de las Américas. Subsequently, it was moved nearby to a neocolonial style building next to Telcor (and the huge Canales mural). Upon the death of Cortázar, it was renamed in his honor as the Museo "Julio Cortázar" del Arte Moderno de America Latina (fig. 189). Until recently, this museum belonged to a mass organization, the FSLN, thus it was both a "private" and a "public" one simultaneously.[169] (The Sandinista-led government also set up three public museums to house collections of pre-Columbian art. These were located in Managua, Chontales, and Granada.)[170]

The dialogical role of the new museum of modern art in Managua that would later bear his own name was eloquently summed up by Julio Cortázar:

The public strolls through the halls . . . beginning a first silent dialogue . . . [and] the visitors leave the exhibition with something new and distinct in their memories, something that will remain, unconsciously modifying their inner vision, refining their taste and encouraging them to reject every cheap thing that passes for art and beauty, a cheapening which won't disappear overnight. . . . Every new discovery teaches the eye—the aesthetic vision. And the international *always* enhances the experience of the national . . . There can be no revolution without beauty and poetry: two sides of an essential medallion.[171]

All of these developments attested to the vigor of the public sphere and to the profundity of the new cultural synthesis being attempted in Nicaragua against considerable odds. The dialogical nature of this process also helps us to understand, for perhaps the first time in history, an often misunderstood aphorism by Oscar Wilde (which appeared in his essay on behalf of democratic socialism): "art should never become popular; the public should become artistic."[172]

It is precisely such an "artistic public," with its expansive embrace of all classes in the civic domain, that the revolutionary Nicaragua of the Sandinistas often sought to create in its efforts to overcome the problem of populism. Owing to this innovative process of cultural self-determination, the Nicaraguan Revolution became a cause célèbre for Latin American artists, for African-American as well as Latino intellectuals in the U.S., and for all progressive Third World leaders. Many of the latter in fact paid moving tribute to the notable gains in this Central American nation.[173]

In turn, the FSLN itself drew heavily on the insights and ideas of other Third World intellectuals to arrive at its original position. From their use of Frantz Fanon and Amilcar Cabral on popular culture, to their citations of Che Guevara on the unacceptability of Socialist Realism in the arts, and José Carlos Mariátegui on the incorporation of Christian ethics into socialist cultural development, the Nicaraguans consolidated and then substantially extended this crucial body of Third World thought. It was probably this historic role that Ernesto Cardenal had in mind when he stated: "Like the French Revolution, which was not only of French but also of worldwide import, the Nicaraguan Revolution is not only of Nicaraguan, but also of Latin American and worldwide significance."[174]

Contradictions in the 1980s within the Revolution

After having thrived to a remarkable degree, the poetry workshops were attacked in 1981 by professional writers from the ASTC, specifically Rosario Murillo and Guillermo Rothschuh Tablada. These attacks appeared in the pages of *Ventana*, the cul-

tural weekly of *Barricada*, the Sandinistas' official newspaper. Their criticisms voiced "the fear that a single poetic language promoted by an official organization was being imposed on young writers."[175] Around this topic, a public debate was organized by Murillo as head of the ASTC.[176]

This animated discussion, which featured Nicaraguan authors as well as such major Latin American writers as Eduardo Galeano and Juan Gelmán, ended with all sides agreeing on one point: the revolution should allow, indeed promote, various styles and forms of cultural democratization, and Nicaraguan writers should all be exposed to every type of poetic and artistic practice.

In 1982, the debate about the *talleres* resurfaced when some former instructors in the workshops signed and circulated a mimeographed document. In it they criticized what they believed was the "almost mechanical" way in which the model of Solentiname was used nationwide. They also took issue with the supposedly dictatorial methods of poet Mayra Jiménez. This critique recapitulated earlier charges about how the workshops narrowed poetic practice, and closed with a declaration that, "it is healthy for diverse literary currents, within the framework of the revolution, to be cultivated."[177]

Until that point, Cardenal himself had remained out of the debate, but in 1983 he rose to the defense of the workshops and Jiménez by denouncing the most recent accusations as "specious and false."[178] Cardenal stated that the controversy was actually less about opening up artistic practice further, than it was about a class-based drive by professional intellectuals to narrow access to artistic practice on the part of working class amateurs. His pointed response was that through the poetry workshops:

> the working people of Nicaragua have begun to appreciate the heritage of "cultured" poetry in order to better express their own past and present. . . . when the reverse had always been the case: "cultured" poets had appropriated the people's language and poetry to better express their own individuality.[179]

Mayra Jiménez elaborated on this contention with the claim that, "We don't have anything against . . . metaphorical or conceptual [poetry]. It's simply [that the workshop poets are] campesinos and workers. The language they use for their poetry is the language they use in their everyday lives."[180]

Yet, as these remarks indicate, the issue was more than merely a matter of class conflict within the sphere of culture. (This is not to deny that class tensions were one of the issues at hand in this polemic.) Of equal significance was the larger and more complex issue of populism versus popular self-empowerment. The question along these lines went as follows: did the "realistic" and "objective" poetry of the workshops simply repeat in a cliché-ridden manner the ideas, values, and forms of expression that were already in place before the revolution? That is, did this poetry merely reproduce an already existing historical subject? Or, did it discursively transform this subject in keeping with the process of revolutionary structural change? Populism is nor-

mally about the celebration of the popular vernacular merely as it is, which is a fundamentally conservative achievement.

Or, conversely, did the poetry workshops propel popular self-empowerment by making poetic practice more accessible, and less exclusive? Did these workshops provide a means of transforming the popular, without succumbing to an uncritical celebration of it? Did the poetry workshops aid in the emergence of a new historical subject—one that both absorbed the popular or indigenous as it was and then reshaped it artistically into something else? If the workshops did the latter, they were functioning very much in keeping with the aforementioned dialogical pedagogy of the literacy crusade.

Which of these two different roles did the poetry workshops assume? The answer, I think, was a combination of both. On the one hand, they played a regressive populist role and, on the other, they took a remarkably progressive stand that advanced notably the process of popular self-empowerment in a revolutionary sense. Indeed, when one considers the unsettled, and uneven historical circumstances, in response to which the poetry workshops occurred, it seems impossible that some mistakes were not made. Yet, on balance, the programs as a whole were hardly a mistake and the undeniable gains they registered would seem to outweigh their various failings.

The artistic pitfalls and social benefits of Cardenal's poetry workshops were aptly delineated by John Beverley and Marc Zimmerman when they observed that:

> The decision to write "for the people" is to risk the parochial, the trite, the excessively obvious. But Cardenal has been clearly more preoccupied with the peoples' discovery of its own voice and life, than with a need to give intellectual and literary respectability to the revolution. This was a key difference in the debate with Murillo.[181]

Aside from the related issues of working class empowerment, sustaining artistic quality, and the threat of populism, there was also yet one more highly complex issue overdetermining this conflict. The "exteriorismo" or "objective poetry" used and taught by Cardenal and Mayra Jiménez was seen by some of the leading feminist poets, such as Rosario Murillo and Gioconda Belli, as too constraining and even self-repressed. Thus, these women poets in the FSLN wrote lyric poetry that entailed a move away from the "documentary" and epic poetry of Cardenal towards a more personal and testimonial type of poetry with a decidedly intellectual, if not theoretical, bent.[182]

This debate in turn related to others about feminism that took place within the Frente. In her important collection of interviews from 1994 entitled *Sandino's Daughters Revisited*, Margaret Randall helps to illuminate just how much *machismo* was a common form of behavior for most of the FSLN male leaders, whether among the commandantes or in the rank and file of the Frente. Numerous stories of patronizing remarks and routine discrimination against women colleagues by Sandinista males, despite official Sandinista ideology to the contrary, are related by the likes of Michelle Najlis, Daisy Zamora, Gioconda Belli,

and others. Concerning the "woman" question, their testimony adds up to a sobering picture of just how far apart practice and theory often were along gender lines during the 1980s in revolutionary Nicaragua.[183]

Among the more reprehensible things that occurred was the decision of the FSLN leadership during the 1990 electoral campaign to sacrifice its own declared ideals on gender equality simply to win votes in a deeply Catholic country. As Michele Najlis recalled to Margaret Randall:

> I remember Daniel [Ortega] said something about abortion being "one of those exotic ideas imported from Europe and the United States." He said it was something only intellectuals were concerned about, that it didn't have any relevance in the lives of ordinary people. Doctors at the Berta Calderón Hospital told him, "Commandante, two hundred and fifty women a year die of botched abortions in this hospital alone. And that's not counting those who never make it to the hospital." But he kept insisting it was "intellectual claptrap." The same for family planning; he didn't want to hear about it.[184]

In the debate around the poetry workshops, though, there emerged a far more complex situation than one in which revolutionary feminist poets were merely combatting "patriarchal" poetic practice. The position of Murillo and other feminists ended up being not only a counter to the gentle "patriarch" of Nicaraguan letters, Ernesto Cardenal, but also an attack on Mayra Jiménez (and indirectly on Daisy Zamora as well). Jiménez was another woman poet on the Left who was helping large numbers of working-class and *campesino* women to write poetry for the first time. And, here again, we return to the issue of what type of subject was either reproduced or newly constructed by the poetic practice of these amateur women poets in the national network of *Talleres*.[185]

All of these debates continued more or less unresolved before a series of measures were taken during the economic crisis of the late 1980s. Until the end of the decade, the Sandinista leadership had refused to take a stand in this controversy for fear of repeating the mistake made by the Cuban government in the early 1970s. As others have already noted, however, this commendable commitment to artistic pluralism also meant that cultural policy after 1986 was made ad hoc, without any real budgetry priorities or programmatic direction. Things came to a head, however, when, in February 1989, some controversial structural changes definitively altered the abovementioned cultural institutions of Nicaragua.

These changes (particularly when further consolidated after the UNO electoral victory in February 1990) had disturbing consequences for the entire process towards democratizing the production of art that had been a landmark achievement of the Sandinistas from 1979 to 1986. Owing to the immense economic destruction inflicted on Nicaragua by a major U.S.-backed offensive that included the contras and a 1985 trade embargo, funding for all programs in the arts was cut by 50 percent. Yet, more was at stake than a scarcity of funds in a wartime situa-

tion that necessitated *compactación*, or governmental austerity.[186]

Deep reductions were, for example, instituted in these programs in 1988 when for both economic and political reasons the Ministry of Culture was dissolved by the government. In 1989 the decision was made by some powerful sectors of the FSLN-led government to eliminate the ASTC, or umbrella group for all of the artists' unions. Both the public ministry and the private union were replaced by a single new "public" Institute of Culture. This awkward new hybrid institute was thus designed to combine simultaneously the duties of a government agency and those of a mass organization in the civil sector.

In the subsequent and quite animated debate around these changes that surfaced in the pages of *Barricada*, the new institution was defended by some authors, particularly Rosario Murillo. It was vigorously contested by a number of other professional artists and writers, such as Gioconda Belli, Ernesto Cardenal, and Daisy Zamora. As two commentators observed, "Murillo's action implied transferring the activities of what had been an autonomous—albeit admittedly pro-Sandinista—mass organization directly to the state sector."[187]

The group led by Belli, Zamora, and Cardenal consisted of some members of the former Sandinista artists' union and also of high-ranking officials from the former Ministry of Culture. Not surprisingly, this large group opposed the high-handed way in which the decision was made solely at the top levels of the government. They noted emphatically that the changes resulted from a vertical chain of command, with few members of the ASTC other than its General Secretary, poet Rosario Murillo, having been involved in the decision to make these amendments. Revealingly, Murillo had replaced Cardenal as the head of the government section on culture.

Furthermore, one general structural consequence of the reduction in size of the government agency for the arts was an uncertain role for organized professional artists. (This included those in the Union of Plastic Artists, which had 120 members, of whom 60 percent were women.)[188] Hence, the full-time artists suddenly became almost entirely responsible for privately funding themselves and their union, owing to the virtual cessation of state funds. A corollary of this emphasis on funding the production of art through professional sales in the private sector was the undermining of nonprofessional engagement with artistic production. The latter had previously been financed by the Ministry of Culture through such programs as the Popular Centers of Culture and the Poetry Workshops. As such, the whole process of "democratizing artistic production" was suddenly dropped as a nationwide, government-financed program. Amateurs, artisans, and professional artists alike were told to generate all their money through the private sale of their artworks.

At this point, the FSLN leadership further loosened its ties in the sphere of culture with all the mass-based popular organizations that had been among their major affiliates and supporters. Although this trend had first begun in 1986–87 with the crippling economic crisis resulting from U.S.-backed aggression,

there had also been signs of such a potential move as early as 1983. These indicators surfaced in the intense national controversy surrounding the supposed benefits or harmfulness of Ernesto Cardenal's talleres de poesía that had engulfed the Nicaraguan artworld in the early 1980s. As previously pointed out, these debates led to a scaling back of Cardenal's program of poetry workshops for amateur authors from the popular classes, based largely upon objections raised against this program by many (but not all) of the professional artists in the artists' union.

Ironically, these changes of 1988 led to a re-emphasis on the Western idea of producing art as a matter reserved largely for professionally trained specialists (with all that this implies about a renewal of the division of labor regarding the modes of artistic production). Among the perplexing repercussions of this diminished institutional framework for the arts were an increasing concern with the professionalization of the arts, concomitant with a decreased commitment to popular involvement with the making of art; and a far greater dependence on workplace self-management in selling art through the marketplace, as a direct result of the drop in government funding.

As has been observed, these changes in government agencies and art policy in 1988, "meant a partial reinscription within post-revolutionary Nicaragua of the traditional socio-cultural line of division between the intelligentsia and the people that had begun to be effaced in the intense mobilizations of the insurrection and early reconstruction years."[189] This new process of centralization, professionalization, and increased reliance on unmediated marketforces constituted a monumental shift, even if it all resulted from so-called "economic necessity." It was a move quite at odds with the radical new programs on behalf of the democratizing of art and culture that, from 1979 to 1987, had characterized so famously, and at times even brilliantly, much of the first decade of the Nicaraguan Revolution. The far more economically constrained and ideologically moderated artistic process initiated in 1988–89 was less compatible with the construction of popular democracy and economic democracy predicated on mass organizations. It was more in line with the impetus towards a Western-style parliamentary democracy, which was a tendency that characterized much of the process leading up to and beyond the democratic elections in 1990.[190]

Accordingly, the new Institute of Culture created in response to the austerity budget was more about the social democratic plan for public representation in the arts, and less about the democratic socialist program of popular self-representation through the arts. Indeed, as many commentators from various disciplines observed of the reconfiguration of the FSLN as a political party in the period around 1986–87, it increasingly came to be a Western-style social democratic party. (Nonetheless, for all its shortcomings on such issues as feminism, the FSLN remained one of the most socially just and progressive political parties in the entire world.) In the period between 1986 and 1990 the governance of the Sandinista Front also became less of a dramatic and innovative chapter in world history. It had indeed been such a boldly new and historic chapter in the 1980s when it

190 The Destruction of Canales's 1980 mural *Homenaje a la mujer* (Homage to Women) in Velásquez Park. The erasure of the mural was done by city workers on orders from Mayor Arnoldo Alemán, Managua, in November 1990. This combined act of censorship and "official" vandalism occurred despite the fact that this mural, like scores of others, was protected both by national and international law as an invaluable part of the cultural patrimony of Nicaragua.

began to set up an unprecedented type of popular-based democratic socialism with almost unparalleled public access to the process of artistic production balanced by broader civil liberties.

Paradoxically, then, the Sandinistas won the democratic elections of 1984, when they were far more committed to such radical programs as those that have been the subject of this study. The FSLN then lost the democratic elections of 1990, when their policies in the sphere of art and culture as well as in other domains of society had become more conservative, less radically innovative. In a certain sense, one could conclude that the Sandinistas lost power only when, for economic reasons (many of which were simply beyond their control in the Reagan era) the Frente became less of a revolutionary force in their own hemisphere and beyond. Yet, conversely, the visionary example in the arts of the Sandinista years from 1979 to 1987 continues to live on as a challenge not only to the FSLN itself, but also to progressive people everywhere who are still committed to worldwide social justice.

Nor will the gains of the Nicaraguan Revolution in the popular memory be erased by such shameless acts as the wholesale destruction in late 1990 of almost all of the murals from the 1980s that have been discussed here (fig. 190). This act of barbarism against art and culture was committed by Arnold Alemán, the diminutive former Mayor of Managua.[191] (Owing to massive corporate support from abroad and the usual scare tactics, Alemán was barely "elected" President of Nicaragua in October 1996 during a very tight election in which he outpolled the FSLN by only 48 percent to 40 percent. Moreover, the FSLN won the mayoral elections in several key cities, including León and Estelí.)[192]

Alemán's anti-intellectual antics were then followed by some poorly researched and conceptually flawed "assessments" of Nicaraguan art in the 1980s that seemed to justify the postrevolutionary attack on art. These latter right-wing accounts were perhaps predictably written by deeply conservative scholars from Venezuela and the Netherlands, along with those of *La Prensa* in Nicaragua.[193]

In the end, however, neither the actual destruction of art, nor utterly misleading "histories" of the period will eclipse the awe-inspiring achievements of the Nicaraguan Revolution and its luminous legacy for the future. It is hardly necessary to say that, despite the failings noted above, there were some great, even unsurpassed, successes that will always endure. Numerous authors and art critics of the first rank from many different countries all around the world did in fact observe these successes first hand when they were in Nicaragua during the Sandinista years. This large and formidable list of international visitors who were duly impressed with the cultural achievements of the 1980s extended from Dore Ashton, Lucy Lippard, Eva Cockcroft, John Weber, June Jordan, and Raquel Tibol, through Graham Greene, Julio Cortázar, Heinrich Böll, and Günter Grass (Nobel Prize winners in Germany in 1972 and 1999), along with Harold Pinter, Eduardo Galeano, Carlos Fuentes, and William Styron, to include many others. Furthermore, the basis for their observations has been carefully registered and painstakingly documented.

Perhaps no one summed up better the sentiments of the intelligentsia and labor unions around the world, both East and West, as well as North and South, than did Canadian Folk singer Bruce Cockburn in the lyrics for his 1983 song "Nicaragua":

Sandino in his tom mix hat
Gazes from billboards and coins
"Sandino vive en la lucha por la paz"
Sandino of the shining dream
Who stood up to the U.S. Marines
Now Washington panics at U2 shots of "Cuban-style" latrines

In the flash of this moment
You're the best of what we are—
Don't let them stop you now Nicaragua.[194]

In conclusion, Noam Chomsky's remarks of 1995 on the enduring legacy of the Sandinista years, and also the grim yet still hopeful situation in the "postrevolutionary" era of Nicaragua bear repeating at the beginning of the twenty-first century:

The ongoing destruction of the work of Nicaraguan artists is a bitter counterpart to a decade of brutal terror [funded by the Reagan and Bush Administrations] for which one day, in more civilized times, we may feel a fraction of the shame we should. Meanwhile these marvelous and evocative artistic expressions remind us of what could have been, and yet may be.[195]

191 Chico Emery, *Mujer Sandinista y Niño* (Sandinista woman and child), c.1985, acrylic on wall, Metrocenter near Managua. The mural was painted after a defining photograph of the Sandinista years by Orlando Valenzuela. Along with Celeste González and Olga Montiel, Valenzuela was one of the finest photographers of the 1980s. The Valenzuela photo was used for AMNLAE posters and even for postcards.

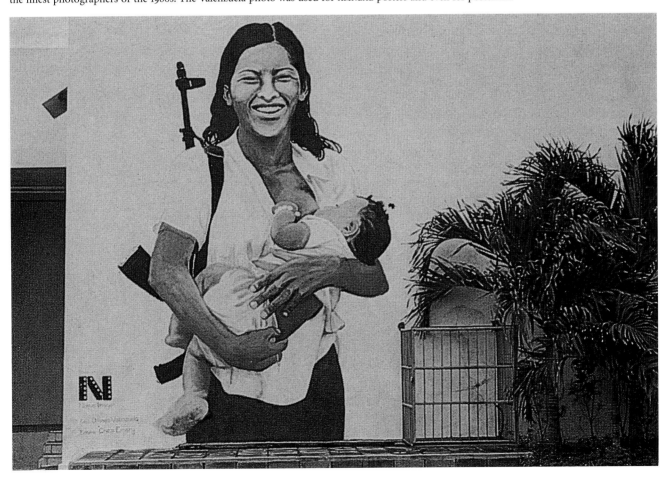

APPENDIX A

Diego Rivera, 1929

New Plan of Study, Escuela Nacional de Artes Plásticas of Mexico

This 1929 document was originally published in Bertram D. Wolfe, Diego Rivera, su vida, su obra, su época (Santiago de Chile, 1944), and then in Raquel Tibol, Arte y política (Mexico City, 1978), pp. 87–94. Translation by Colleen Kattau.

Given that learning to make art cannot be limited to either a minimum or maximum period of study, since the time of instruction depends upon such imponderable factors as those of talent or genius, this plan of study [for the National School of Visual Arts] establishes a minimal program for acquiring the necessary knowledge to practice a profession in the fine arts with social efficacy. It is understood here that a minimum of knowledge is equally necessary for all areas of specialization within the arts, so as to form a requisite foundation for advancing the maximum of development on the part of each student in accordance with his or her talents. Consequently, the five or six years mandated in this program for large-scale painting do not constitute any narrow limitations on the student, since, according to his or her capacity and circumstances, the students can finish the requirement in the time that they deem fit.

Since the National School will constitute a great workshop that will be continually devoted to the establishment of collective work in the arts, as has always been the case during historic high points of artistic achievement, the National School will retain able and committed students through the completion of their studies for the Masters Degree, thus creating a truly national body devoted to collective artistic production.

For those students who have obtained diplomas in any area of the fine arts, the National School will provide workshops and tools for a period of one year after graduation and the National Autonomous University of Mexico is responsible for recommending them both to the National Government and to private institutions for work in their chosen area of concentration.

• • •

Plan of Study for the Central School of Plastic Arts in Mexico

The goal of education in the School of Painting and Sculpture will be to give students the most complete technical expertise possible, so that upon leaving the National School they can carry out the highly significant social role that the artist must perform in today's world. This training will make them true technical workers, who are capable of assuming professions directly connected to the visual arts. At the same time the School will not attempt to influence the individual artist's personality or the student's aesthetic sensibility, but on the contrary will attempt to further the student's development within an atmosphere of complete artistic freedom.

Course study will be divided into two cycles: a preparatory one for three years and a superior one for five years. The preparatory cycle will be open to everyone, and all classes at this level will be held at night, so that factory workers and day laborers can choose to attend them. The superior cycle of classes for a professional degree will be given during the daytime and the requirement for matriculation will be graduation from secondary school.

Special exams will be established for admission into a cycle of classes for the professional training of assistants. Those who will be eligible for this program of study need not be graduates of secondary school. The aim of this latter admissions process will be to open up the National School's technical workshops (in welding, engraving, glass making, etching, and so forth) to all those skilled workers from the popular classes who have not completed secondary school, but who should nevertheless have the right to perfect their artistic practice in the school's areas of speciality. As for these student assistants' proficiency exams, the National School is pledged to put its resources at the disposal of all those who are without sufficient resources to attend the superior cycle of classes on a regular basis.

Qualifying exams for all classes will consist of open proficiency exams. There will be two examination periods per year and all students who consider themselves qualified will be allowed to take these exams. Furthermore, students will be given the right to petition for a special proficiency exam when, for justifiable reasons, they have not been able to take the exam during one of the regularly designated periods. These exams will be set up in a graduated series and a student will not be admitted to an exam on one level unless he or she has taken the previous ones in the established order.

Elementary Cycle and Night Classes

FIRST YEAR

The Elementary Study of Space
This will involve the analysis of simple forms, creative compositional exercises with simple forms and basic themes, and it will be realized through modeling and the construction of maquettes using different materials. Class time: three and a half hours, three times per week.

First Year Technical Drawing Exercises
Class time: one and a half hours, three times per week.

First Course in Theory
(Arithmetic and Elementary Algebra). Class time: one and a half hours, three times per week.

Practice in the Open Workshop within the Area of Specialization
Class time: three and half hours, three times per week.
This workshop will be divided up as follows:
a) Application of drawing and painting to the manual exercises by the student.
b) Drawing and painting used in the service of an aesthetic for the home and for clothing.
c) Creative exercises in the development of artistic faculties, with the students being given absolute freedom to employ the means of artistic expression however they please.

SECOND YEAR

The Study of Live Forms in Space
(Those of vegetables, animals, and human forms). Exercises in working creatively and in working after the live model; developing anatomical concepts. Class time: one and a half hours, three times per week.
In this course, the following will be done:
a) The construction of maquettes from diverse materials.
b) Exercises in modeling.
c) Learning how to engrave in wood and stone.

Second Year Technical Drawing
Class time: one and a half hours, two times per week.

Second Course in Theory
(Elementary Geometry: plane and space) Class time: one and a half hours, two times per week.

Time in the Open Workshop within Area of Specialization
(To the work of the first year will be added the elementary study of styles.) Class time: one and half hours, three times per week.

THIRD YEAR

The Application of Form in Space to Concrete Artistic Problems
Class time: one and a half hours, three times per week.
a) The representation of living form applied to architecture, to engraving, to welding, and to making models for casting.
b) Composing in abstract forms in architecture, addressing problems in furnishings and architectural elements, with the problems being resolved by the Professor of Architecture.
c) Projects calling for the employment of the same materials as in the previous study, with the new addition of carpentry.

One-Point Perspective and the Geometric Elements of Optics
Class time: one and a half hours, two times a week.

Work in the Open Workshop within Area of Specialization
Class time: one and a half hours everyday.
The third year student will work with concrete themes in applying artistic creation to the necessities of life: interior and exterior decoration, objects of utility, paintings and drawings for usage in murals with themes appropriate for the places in which they are to be realized, and drawings for book and magazine illustrations, posters, and advertisements.

Sub-Workshops in Book Arts
Saturday afternoons and Sunday mornings, there will be a series of lectures by professors and the most advanced students. This series will assist in the aesthetic education of each student.

Superior Cycle of Courses

FIRST YEAR

The Advanced Study of Spatial Forms
This will entail creative exercises in elementary architectural composition that is subject to precise programs, which will be resolved by an architect. These projects will be realized by means of maquettes that are either modeled or made from diverse materials. This course will be given by a professor of architecture. Class time: two hours, two times per week.

Algebra, Geometry, and Trigonometry
Class time: five hours per week.

Elements of Descriptive Geometry
Class time: one hour per day.

First Course in Human Mechanics
Class time: two hours, two times per week.

The Study of the Materials of the Visual (Plastic) Arts
This will involve the combination of theory and practice in the workshop for two hours of work, twice weekly.

The First Course in Physics and Chemistry as Applied to Art
(Special Professor). Class time: one hour every day.

The First Course in the Social Theory of Art
Class time: two hours, three times per week.

Students will study the historical development of art by studying its modes of communication to arrive at general aesthetic principles, yet without ever losing sight of the social role of art. By the third course, it will be established that within contemporary society art can play a highly important, even revolutionary role. Taking as its point of departure artworks produced in Mexico in each one of its stages of human development, which can be analyzed and appreciated directly, the entire course will be taught comparatively, thus connecting the students to artistic production around the world.

This course would be given by a professor who has studied art at its source of production, rather than someone who is simply familiar with a large number of artworks.

THIRD YEAR

First Advanced Class in Perspective
Class time: two hours a week at night.

Second Course in the Social Theory of Art
Class time: two hours per week.

Third Course in Mechanical Drawing
Class time: two hours, three times per week.

Work in the Open Workshop within the Areas of Painting, Sculpture, and Engraving
Class time: three hours daily in accordance with one's schedule.

FOURTH YEAR

Architectural Theory
Class time: one hour, three times a week.

A Knowledge of Materials and the Stability of Constructions
Class time: one hour daily.

Analytic Geometry and Infinitesimal Calculus
Class time: one hour three times per week at night.

Second Advanced Course in Perspective
Class time: one hour, two times per week at night.

Work in the Open Workshop in Painting, Sculpture, and Engraving
Class time: three hours daily.

FIFTH YEAR

Third Advanced Course in Perspective
Class time: one hour, two times a week.

Elements of Construction
Class time: one hour three times per week.

Architectural Composition
Class time: two hours per day.

Work in the Open Workshop in Painting, Sculpture, and Engraving
Class time: six hours a day.
The Open Workshop will consist of the following:
a) Live model for students in painting and engraving.
b) Live model for students in sculpture.
c) A warehouse of still-life objects available to all students.
d) A section on direct carving in stone.
e) A section on direct carving in wood.
f) A section on casting.
g) A section on welding.
h) A section on leaded stained glass.
i) A section on wood-engraving.
j) A section on metal-engraving.
k) A section on ceramics.
l) A section on porcelain-painting.
m) A sub-workshop on decorative painting that recognizes it to be all that which is not precisely mural painting in any of its procedures. The sub-workshop will have a distinctly industrial character and will qualify the student to be a decorative painter. This training will involve specialized instruction in making estimates, and so forth, that will be open to all students in the National School and to all workers, even if not enrolled. It will involve instruction in using lithography, textiles, gold and silver works, and print-making.
n) A sub-workshop in photography.

A Third Course in the Social Theory of Art
Class time: one hour, three times a week at night.

A specialization will be established in monumental painting as well as in sculpture and it will consist of studies identical to those noted above through the first four years, plus two additional years (for a total of six years of study in all). In the fifth year the student will work four hours daily in the sub-workshop of decorative painting and four as an apprentice to the Professor of Monumental Painting. In the sixth year, the student will work three hours as an apprentice to the Master Painter and three in the execution of his or her own works in monumental painting, either within the National School or elsewhere.

Second Course in Construction
Class time: one hour daily.

Second Course in Composition
Class time: one hour daily.

On the distribution of time
Classes in theory will be given at night wherever possible, so that the student may utilize most of his or her time during the day for the open workshop in painting, sculpture, and engraving.

It is understood that there is a dual character to the apprenticeship, as well as the professional work, of the painter, sculp-

tor, and engraver. It entails both manual and intellectual labor, and demands a large dose of methodological consideration and physical effort, while requiring great commitment, enthusiasm, and love on the part of students for the art they practice. If a student is without these attributes, it would be better for society that he or she engage in some other type of work than that of being an artist. Consequently, the ideal type of work for students of painting, sculpture, and engraving at the National School is that of a manual laborer who, during the day, works with his hands to earn a living and who, at the end of the workday, studies the theory that is necessary for becoming a more qualified worker.

APPENDIX B

Gerardo Mosquera, 1985

The Social Function of Art in Cuba since the Revolution of 1959

This essay was originally published in El Caimán Barbudo, *Havana, vol. 19, no. 212, July 1985, pp. 11–12 and in another version in* Concha, *Montevideo, vol. 2, no. 545, 31 December 1983, p. 23. Translation by David Craven and Colleen Kattau.*

The purpose of this essay is to outline some ideas that can suggest an analysis of, a constructive discourse about, and, most importantly, an active engagement with the problem intimated by the title. I do not think it necessary to insist any longer on acknowledgment of the extraordinary cultural transformation that has been brought about by the Revolution of 1959. The increase in the educational and cultural levels of the entire population, the establishment of a national system of art education, the foundation of cultural organizations, the social development of art appreciation, the opening up of cultural centers in every municipality, the tacit support of the diffusion of artworks and the social recognition of artists, are just some of the general directions of the impetus toward cultural development and toward increasing the role of the masses in the creation as well as in the enjoyment of art. This endeavor has led to colossal achievements. Today in the mid-1980s, we can affirm that, culturally speaking, Cuba is one of the most highly developed countries in the underdeveloped world.

With respect to this essay, we might ask ourselves: have the Cuban visual arts brought forth *revolutionary* movement in terms of art's social function? When I say "revolutionary," I mean by that transformations in relation to habitual, inherited directions. In a word, I wonder if art has tried revolutionizing its social function, or if art has simply limited itself to amplifying itself in its traditional sense.

Above all, changes in the social function of the visual arts developed within the Revolution have been of a quantitative nature. There are more people making art; more people learning to make it; there are more museums, more galleries, more (perhaps too many) events; but the type of artistic activity within society continues being in its *functional aspect* the same,

in large measure. Of course, I am referring to functionality within the framework of a socialist country where the alienation and mercantilist mechanisms of capitalism have disappeared (although at this time by maintaining market exchange *saque la pezuna*).

In Cuba, as in any other countries, the artist creates a work of personal expression, conditioned by his or her reality. This work is exhibited in a gallery, reproduced in a catalog and sometimes discussed in the newspaper; it is sold or given to someone who hangs it at home (perhaps playing with the "arnoyo" lamp and the "kitsch" wicker chair), in an office, in a museum, or even in a public place, or the artist simply takes it home after the exhibit. The work functions as a system of signs whose primary purpose is to transmit an artistic message (wherein creative, ideological, cognitive, aesthetic, ludic, educational, psychological, and other components all operate) to a spectator who receives and interprets the work from his or her own point of view. It is what we could call the exposition of art as a self-sufficient activity, which began to emerge at the end of the eighteenth century in conjunction with the advent of industrial capitalism.

Art in premodern society did not possess this autonomous and specialized character formerly. Its artistic functioning was ancillary to religious, documentary, representative, ceremonial, and other tasks that we would today call "extra-artistic." Art had not been defined in self-inclusive terms as a particular form of consciousness, which is supposed to be completely independent from religious values or political ideology. Its current autonomy then is at once an historical outcome of economic and social determinations, and a result of the diversification process of consciousness departing from art's primitive syncretism. This character of artistic activity is based on ad hoc circuits of distribution and consumption: systems of museums, galleries, collections, and publications, to name a few agencies. I do not wish to say that the artwork here is incapable of playing a political, ideological, or educational role, but that this role is derived from the realization of these forces. This is because the work of art is

not an image of patrician elegance, an effigy of a sovereign or a ritual of the investiture of power, but rather a sculpture, a painting, or a play.

In revolutionary Cuba, the visual arts are practiced and disseminated on a much higher scale than in the past and under different economic and social conditions favorable to the development of the arts, but the arts are practiced and disseminated within the same functional mode that has been generalized in Western culture. This function deals with something very natural that should not alarm anyone; it is the result of an historic evolution. There is no reason to identify art as a specialized and self-sufficient creation that operates within the active creator–work–contemplative spectator–mechanism, as does the alleged "capitalist art" in the West, although this situation has emerged as part of the great social divisions that have appeared with the development of industrial capitalism. This is the way art is in our time and we should address it along these lines.

In the 1960s, a project on behalf "the socialization of art" was put forth, above all in a Latin America motivated by a revolutionary surge, and one very much connected with attempts at giving more social import to theater and collective creation. Such a process of "socialization" implied generalizing creative activity, breaking with the artist–public structure, and refunctionalizing art. This process was the hypothesis of a revolution in creativity and in every other aspect of life, simultaneous with the political, social, and economic revolution. A new and "truly" socialist concept of art, as opposed to the old notion of "bourgeois" art, was declared. Frequently this idea corresponded— and in fact it still corresponds—to a utopian, ultraradical and ultraleft perspective, that conceives of the revolution as *a novo* change, instead of understanding it as an act of catapaulting into the future, and not as a transformation starting from the present toward what is to come. The revolutionary experience demonstrates that the metamorphosis of life and of consciousness usually is much slower than the process of changing the material base. The desire to transform everything in pursuit of an ideal should not make us lose sight of the reality of praxis. Already in his time, Lenin warned quite well against the laboratory voluntarism of the Proletkult.

All the above does not mean that in a socialist country we do not have the obligation to concern ourselves with transmuting art in a new way, founded upon a new social reality. The propositions aimed at "the socialization of art" call attention to the self-satisfied arrangements within prevailing structures, more and more distant from a revolutionary dynamic. In the visual arts such a process is more difficult, and thus more necessary, owing to the limited communication art has with the masses. The specialization of art as a self-sufficient activity has created a rift between itself and life, thus inserting art into that cultural fissure brought about by the capitalist mode of production. This development established various types of isolation within society ("refined," "popular," "mass"), with all of them involving aesthetic and symbolic systems, so that the visual arts were one of the branches of society where this phenomenon manifested itself in the most pronounced way. For all of us now involved in the arts, then, there is the challenge (even more so under socialism) to increase artistic communication.

But the amplification of art is one thing and the attempt to bring about a new social function for art is another, although the latter itself indicates an increase in communication. The social reformulation of the function of the visual arts requires that they assume once again an extra-artistic role, facilitated by the conditions of democratic socialism. It does not mean a return to precapitalist syncretism, just as socialism is not a regression to primitive communism. Here I am referring to the social functions of the arts that depart from the specialized and independent character acquired by art. At issue is not a retreat, but rather a dialectical advance that cannot leap over the current mode of creation. Instead, this advance must be built on art-making at present.

I am going to mention some isolated experiences that have taken place in Cuba in the field of the plastic arts. We have the painting debates effected by Alberto Jorge Carol and Juan García Milo among the *campesinos* of Escambray,[1] in the context of the work of a theater group by that name concerned with the direct intervention of theater and, in the case of painting, with the solution of concrete social problems in a rural zone. We also have the intervention of diverse artistic manifestations in the attempts to synthesize the arts and popular participation, as celebrated in 1968 during the activities of July 26th in Santa Clara or on the 10th of October in the Demajagua.[2] These were massive, interdisciplinary performances and at the same time activities of a commemorative and political nature. There is the experience of Antonia Eiriz with her popular works of papier mâché, presented through the Committees of the Defense of the Revolution.

In 1981, there was a political demonstration organized by several young painters at the park in front of Carmelo against U.S. interventionism.[3] Through the use of the statue, the fountain, and the grounds, the park itself was imaginatively converted into a letter of condemnation which the passersby signed with paints. During the invasion of Grenada, and at the suggestion of Flavio Garciandía, a workshop in galleries 12 and 23 was formed with the idea of making posters and painting signs to use in popular demonstrations against the aggression. An artistic intervention at the monument to the USS Maine was also proposed. Some of Sandú Darie's proposals share this character, such as the "urban tapestry" project, involving a massive formation in a concentration of the CDR at the Plaza of the Revolution.[4]

Another of Flavio's ideas is "Art in the Factory," where young artists, with the participation of the workers, initiate work with materials in disrepair and employ technological media existing there, thus altering the factory atmosphere by connecting workers to artistic creation while also linking artists to industrial production. This practice, however, continues to be organized as an occasional event rather than going in the direction of an habitual practice of mutual convenience. Consequently,

this idea tends to become bureaucratized by the tentacles of "eventism," instead of being designed as an ongoing project.

These are some of the more interesting experiments with constructing a new function for art. As we can see, these efforts have not often gone beyond the embryonic stage of a possible new perspective on the role of art as a whole. The fact that we insist on this perspective does not mean that we are proclaiming "the death of art" or that we wish to tear down the galleries and museums. Art also has the natural perspective of continuing to be specialized at very sophisticated levels, even more so within socialism, which is a highly complex society. At the same time, many of the most novel discoveries in recent art lean toward a greater social engagement, when artmaking addresses itself to such an end. For example, there is the ecumenical tendency of current visual arts, involving the employment of all types of materials and procedures. Along with this there is art's mediation of nature, a greater pluralism in the arts, and art's increasing incorporation of the popular . . . Socialism itself facilitates this trajectory. But we should not wait until *a que salga o a que la bajen* by decree, until they "orient it from above." The initiative corresponds to that of the artist. It's time that we release some brain cells, lose a few hours of sleep, and concern ourselves with the social function of our plastic arts as well as with the necessity of opening art up to new possibilities.

APPENDIX C

Ernesto Cardenal, 1980

The Nicaraguan Revolution of 1979: A Culture that is Revolutionary, Popular, National, and Anti-Imperialist

This address of February 25, 1980 was given at the First Assembly of Cultural Workers in the Palace of the Heroes of the Revolution, Managua, Nicaragua. The essay was subsequently published by the Ministry of Culture in an anthology entitled Hacia una política cultural *(1980) that consisted of the first public statements by the Sandinista leadership about the role of art and culture within the revolutionary process after July 1979. Father Ernesto Cardenal, a Catholic priest and world-famous poet, was Minister of Culture in Nicaragua from 1979 to 1988. Translation by David Craven.*

One of the most significant cultural acts of the new government in Nicaragua has been the splendid transformation by the Sandinista Front of Somoza's so-called National Congress, so that today we are inaugurating the Asamblea de los Trabajadores de la Cultura (Assembly of Cultural Workers).

If we outline several things about the cultural project, we will conclude, as Comandante Bayardo Arce already has in his address, that this process naturally must be revolutionary, democratic, popular, national, and anti-imperialist.

In the first place it must be revolutionary because our cultural struggle is on behalf of the transformation of society, the transformation of it into another society in which there is no exploitation of the people by a minority of the powerful few. Given what we have already learned from the comunidades de bases (popular Christian bases), we have also learned that everything, including art, must be subordinated to God. Yet authentic Christianity [of the type found in Liberation Theology] teaches that God is actually the love of humanity; therefore, we must say that everything should be subordinated to the love of humanity and that there is no room for any "art for art's sake." Art must be subordinate to the love of humanity, since, before anything else, this love is what the Revolution really is.

In the new Nicaragua, culture will be for developing a revolutionary consciousness and for accompanying our people in the economic transformation that we are commencing, and, like everything else, it will be for the benefit of the great majority.

Culture must be for superseding the division of labor between intellectual work and manual labor.

Culture must be democratic, because it should become accessible to the great majority, and this should mean not only access to our national culture, but also to universal culture. This should occur so that our people are not only consumers of culture, which of course is very important, but also producers of culture.

By this, I do not mean that we are going to simplify the culture that has been given to the people, but rather that we are going to elevate the people through cultural transformation to the level of the finest culture. Here we must remember what Marx has observed, namely, that in matters of art it would be criminal to give the people anything less than the best.

Culture should be popular, as has already been said by *compañeros* Bayardo and Sergio [Ramírez]. We must try never to produce an elitist culture and it is for this reason that the Ministry of Culture is organizing a network of Advocates of Culture to take culture to every corner of the country.

In the Athens of Pericles, people not only paid nothing to go to the theater, which after all was hardly free, but they were actually paid to attend the theater. What does it mean that the people of Athens were not interested in going to the theater during the era of Aeschylus, Sophocles, and Euripedes? It was necessary to pay people so that they would go to see the classical theater! This was because Greek culture, like Greek democracy, was elitist, since the democracy of Greece was only for those who were free, while the overwhelming majority, as much as 80 percent of the population, were slaves and did not have the right to vote. This ancient civilization was an elitist democracy and an elitist culture, but we in Nicaragua will see that the people are going to attend performances of Sophocles, perhaps in Tecolostote, and without being paid to do so. This is not a utopian idea, it will simply be a valorization of the concerns of the people, who are the creators of the highest manifestation to date of Nicaraguan culture, namely, the Sandinista Front's Popular Revolution!

This is how we are going to develop creative forms that will permit our culture to survive, in spite of colonialism or neocolonialism.

This culture, let us note, will necessarily be *nacional*, which means it will define, develop, discover (one could use many more verbs) our national identity and our history. It will take into account the regions of our country, Palacaguina, Telpaneca, Muy-Muy, Matiguas, Kuringuas. It will acknowledge that we have three national cultures, three national languages. And this is also the role that is being assumed and will continue to be played by the Popular Centers of Culture (Centros Populares de Cultura) that have been instituted by the government and also by the Advocates of Culture.

And finally we say that our culture must be *anti-imperialist*. Imperialism has divided the world into the groups that exploit and those who are exploited, and we have a place in this division, so that our role as a liberated people is to struggle against imperialist aggression, together with all the other peoples who have become liberated from imperialism or who are still in a process of gaining liberation from it. And all this must of course be achieved without chauvinism, or undue nationalism. We are conscious of the fact that we are a province of Latin America and that in reclaiming our nation's popular culture, we are also reclaiming the legacy of Latin America, because all else that constitutes popular culture in Latin America is also ours as well.

Our culture, then, must be both national and international, or "universal." Rubén Darío, who was so Nicaraguan in his poetry, was also a universal poet. Another phenomenon of internationalism in Nicaragua was Augusto Sandino, a towering universal figure. Similarly, the Nicaraguan Revolution, which was so Nicaraguan, was also a fundamentally international revolution. Like the French Revolution, which was not only of French but also of worldwide importance, the Nicaraguan Revolution is not only of Nicaraguan but also of global import.

Culture is the product of a dialectical process, as has been noted by our *compañeros* Sergio and Bayardo, so that it not only negates the previous culture, but also transcends this previous culture in such a way as to recuperate elements of it, so as to make possible the ascension of an even higher form of expression, as has occurred with the Sandinista Revolution.

There are other ideas which we must expound upon here, in representing not just the Minister of Culture but also the Ministry. It will be necessary to take into account two things: the first is that in Nicaragua the popular culture has been repressed; the second is that there has been a long imposition by the bourgeoisie of colonial values. As such, we have two missions: to emancipate our culture, to reconstruct our culture. Our culture that, since July 19, 1979, has become the culture of the Revolution is a culture for the consolidation of the Revolution, thus aiding in the creation of the New Person, the New Person who will be a socialist. This culture, then, is aimed at the transformation of existing reality.

Marx said that philosophy has no other role than that of transforming reality. I also believe that theology should be for the transformation of reality; that poetry should be for the transformation of reality; that painting, theater, and all other modes of artistic and intellectual creation should be as well. Again, culture will be for the transformation of reality. When walking around these very streets, in front of the cafeteria named "La India," Leonel Rugama would say that the Revolution was for the transformation of reality. Consequently, we are now beginning to create the new culture of the new Nicaragua.

Yet, art is also a reflection of already existing reality in some respects and our culture, like our art, will in addition be an interpretation of the daily development of the Revolution. We are already seeing these things in, for example, the music of the Mejía Godoy Brothers and in the work of many other valiant revolutionary artists: the art of Nicaragua serves as an interpretation of the Revolution's development, which has become the major cultural achievement of modern Nicaragua.

Our people have resisted cultural genocide, just as in the same manner they have also resisted military genocide. The Revolution has occurred precisely to save this culture and these people. A friend of mine, who was doing military duty on the frontier with Honduras, told me that after the triumph of the Revolution he discovered a contraband load of parrots that were to be exported out of Nicaragua. They were to be sent to the United States where they would learn to speak English. There were 186 parrots and forty-seven had already died in their cages when the smuggling operation was uncovered. . . .

APPENDIX D

Interview with Ernesto Cardenal, 1983

This interview with the Minister of Culture by David Craven and John Ryder took place at the Nicaraguan Mission to the United Nations in New York City on November 30, 1983.[1] There were two other people present: Roberto Vargas of the Nicaragaun Embassy in Washington D.C. and Angel Leiva, an Argentine writer. Translation by Emanuel Cestero with John Ryder and David Craven.

Question: The Nicaraguan Government has made art remarkably accessible to ordinary people. Your innovative cultural policies seem to be based on a concept of art as being essential to the self-realization of every person. Would you discuss the centrality of the arts to the overall revolutionary process in Nicaragua from the very beginning?[2]

Ernesto Cardenal: For us, *la cultura es la Revolución y la Revolución es la cultura* [culture is the Revolution and the Revolution is culture]. There is no separation between our cultural progression and the Revolution, since the transformation that Nicaragua is undergoing is also a cultural transformation. From our point of view, culture is not simply one more aspect of society, as one might consider economics, education, health, or defense. Culture encompasses *everything*: the health projects, the education campaigns, the defense programs, and the campaigns for increasing production. All of the social changes occurring in our country constitute the new culture of Nicaragua. The renaissance that is taking place in all of these areas, the heightend interest in our entire nation, involves our popular culture, our traditions, our national foods and drinks, our publications, our paintings, our poetry, our artisanship, and our Nicaraguan cinema, which we are finally able to realize. All this comprises the cultural transformation engendered by the Revolution.

Question: The Nicaraguan Revolution has been referred to as a "revolution of poets." Even street graffiti in Nicaragua declares that, "El triunfo de la Revolución es el triunfo de la poesía." [The triumph of the Revolution is the triumph of poetry.] Could you discuss the implications of this?

Ernesto Cardenal: Many people believe that the struggle was in fact a "revolution of poets." I remember that a writer first made this remark on the afternoon of July 20th, 1979, when we triumphantly entered Managua. He wrote afterwards that the Nicaraguan Revolution was a revolution made by poets and that the children of Sandino were also the children of Darío. I believe that it is also a revolution of poets in the sense that those guiding the Revolution are actually poets. Many of the Sandinistas write poetry, and in fact very good poetry. Others are genuinely poetic in their public speeches. But, above all, I believe the revolutionaries are poets, because they have created something new. They have been creative in that the Revolution is not simply copying previous ones. That the Revolution coordinated all of the political groups in the country to overthrow Somoza was itself a creative act, given the political position and the social predicament of the Sandinistas. That it was the first revolution with the massive participation of Christians was also a great creative act. And that this new kind of revolution would have won at all was in itself extraordinarily creative.

Question: The whole revolutionary process, then, is a creative act in a way that is analogous to artistic production?

Ernesto Cardenal: Exactly. And during the insurrection it took great creativity for the popular forces to be able to defeat with very few arms, in fact almost none, such a well-equipped professional army as that of Somoza—which was, after all, armed and financed by the United States.

Question: Could you discuss the concept of the *Persona Nueva* [New Person]?

Ernesto Cardenal: Yes. The change that our society is undergoing is profound, both materially and spiritually, and the creation of a new society implies the conception of a New Person. The New Person is a person of solidarity, one who always takes the needs of others into account and who is concerned for others, even more than for himself or herself. This new attitude is a form of comaraderie, and it has given birth to a new word that did not really exist previously in our vocabulary. This is the word "compañero" [companion]. Nor is this term any longer simply a word for us; it is a reality. Our society is now becom-

ing one that is based on *Compañerismo* and this attitude has entailed a fundamental transformation of our country.

Question: Could you elaborate on the network of Centros Populares de Cultura [Popular Centers of Culture]? How were they developed and what do they do?

Ernesto Cardenal: When the revolution triumphed, the people almost spontaneously began to establish Casas de Cultura [Houses of Culture] throughout the country, usually in the finest buildings that had been confiscated in the area from an important ally of Somoza or from a prominent member of *la Guardia* [national guard]. And the Ministry of Culture, in certain localities, created what we call local centers to run these Casas de Cultura and also to attend to all the cultural necessities of the region. In them, they give classes in music, theater, popular dances, and all sorts of other cultural activities. These places are the Ministry of Culture's vehicles for reaching out to the population and they are the channels through which we make cultural activities accessible to the people. This latter aim is the most important aspect of the Ministry's work, although it is true that all of its other work is significant too—the departments of music, theater, literature, crafts, sculpture, cinema, libraries, and sports. But all of these affairs are conducted through the Centros Populares de Cultura, because in this location all of these cultural practices are promoted. The Talleres de Poesía [poetry workshops] are also conducted there, though not only in these locations, but also in other localities, such as, army barracks, police training facilities, air force bases, and at other places in the country where urban workers, rural laborers, soldiers, and the police can learn the proper techniques required to write good modern poetry. In certain areas, though, these same poetry workshops take place in the Centros Populares de Cultura.

Question: How many Centros Populares de Cultura are there?

Ernesto Cardenal: There are twenty-six in the country as a whole. There are four in Managua and one in each of the principal departments. We are not able to have more at present, however, because we do not have the money to finance the sites, the personnel, the materials.

Question: So you are saying that even the police in Nicaragua are becoming poets?[3]

Ernesto Cardenal: This is a question that has already been asked of me several times in European countries. I have had to explain to them that our police are different from those with whom they are familiar, just as our army is different from theirs. Our police are young people, men and women, who were combatants in the Revolution because of their love of humanity and they are now performing the difficult duties of those in the army or the police. These are young men and women who

must be out in the hot tropical sun, stand in the middle of crowded streets in order to direct traffic, or withstand the rain in the middle of the night, as they safeguard the population's welfare, and they do this with a great sense of camaradie and a love of humanity. That is why they are able to write beautiful poetry, poetry that is full of sensitivity and refined sentiments.

Question: How does a Taller de Poesía operate?

Ernesto Cardenal: It is conducted in a populous and readily accessible place, such as in a poor neighborhood or a similar spot in a rural area. When we establish a workshop all those in the vicinity who are already poets are notified and asked if they wish to assist other people who aspire to write poetry, or yet others who have already attempted somewhat unsuccessfully to write poetry, and who wish to have more guidance. The first session usually consists of poetry readings, with various examples taken from the work of writers who are Japanese, Chinese, North American (who are very good), Greek, Latin, Nicaraguan, or Latin American. Sometimes, there is someone who has already written a poem and he or she presents it. And if not already by the first session, then by the next meeting, they discuss and analyze poems line by line, word by word. The members of the Taller begin to give opinions and the instructor of the Taller de Poesía stimulates a discussion by asking such questions as: "What do you think of this line?" Then the participants begin to give some good answers. They respond with remarks like. "This has too many words," or "This can be said more concisely," or "This is a cliché," or "What does the author mean?" or "Why don't you say it this way instead?" In this manner they collectively proceed to analyze a poem and try to improve it. Sometimes the author accepts the criticism and sometimes not. Through this process, the Taller participants learn to express themselves with more precision, innovativeness, profundity, and also with less tired rhetoric. Then, we finally reach a point when these new poets compose poems that merit praise. At this point, they no longer need the workshops to write and they can write on their own.

Question: Could you discuss the origin of *pintura primitivista* [primitivist painting] in Solentiname, which has been so influential on subsequent Nicaraguan painting by nonprofessionals, who are members of the popular classes?

Ernesto Cardenal: The appearance of *pintura primitivista* in Solentiname was caused by an encounter I had with a *campesino* [Eduardo Arana]. One day I came upon a *campesino* who had painted figurines on gourds, and he had drawn some mermaids playing guitars on one of these gourds. Then, I thought to myself that this *campesino* could be a visual artist, so I gave him some colored pencils and paper. I asked him to draw figures on the paper like those he had painted on the gourds. He did so, and these figures were very striking, very "primitivist" [or "naive"]. And then a young Nicaraguan painter who was eighteen years

old came to Solentiname at my invitation. This artist [Roger Pérez de la Roche], who is now one of the best artists in Nicaragua—and who at the time suffered from Somoza's political repression—began to paint and to teach in Solentiname. The deeply impoverished *campesinos*, seeing him paint and noticing that he also sold some of his paintings, were interested in painting their own paintings. In fact, some of them even sold a few of their pictures. Soon there were thirty-nine to forty peasant painters in Solentiname. And, aside from encouraging them to paint, we also established a Taller de Poesía there [under the direction of Mayra Jiménez], so that the *campesinos* could learn to write poetry.

Question: Why have public murals been so popular since the revolution?

Ernesto Cardenal: I think that the painters of the murals have been motivated by the desire to communicate with the people, with the public at large—not, as in the case of the artworks here in the U.S., where paintings are displayed inside buildings, but more in the manner of Mexico, where murals are sometimes located on the exterior of buildings [such is the case with the mural by Diego Rivera at the Teatro de los Insurgentes (1953) in Mexico City or the one by David Alfaro Siqueiros at the Admin-istrative Buildings of UNAM]. This is the case in Mexico where murals are on the outside of university buildings, public offices, and in public sites where art can be encountered directly in the streets.

Question: Are many more murals being planned?

Ernesto Cardenal: Yes, but unfortunately we are limited in how many we can commission, because of a lack of resources—a situation often caused by the diversion of funds from the arts into self-defense because of the Reagan Administration's military aggression against us.

Question: Could you comment on the role of the *Brigadas culturales* (cultural brigades)?

Ernesto Cardenal: At present, the cultural brigades are very important to the embattled regions of Nicaragua, where U.S.-backed *Contras* (counter-revolutionaries) are launching military incursions. Many of our cultural workers have gone to the front as combatants. Others are members of brigades of musicians, poets, dancers, and actors who are sent to the areas in the north where there is fighting, and they go there to entertain the local inhabitants who are resisting the CIA-funded *Contras*.[4]

APPENDIX E

Interview with Gioconda Belli of the FSLN, 1990

This interview by David Craven and Colleen Kattau took place on January 9, 1990, at the home of Gioconda Belli, which is located outside Managua, on a hill overlooking the southern shore of Lake Managua. Also present was Gioconda Belli's sister Lavinia Belli, known to the present author for a few years through CUSLAR, the Committee on U.S.–Latin American Relations, at Cornell University (where Lavinia was a student). The interview occurred in the midst of a much larger and more broadranging conversation. It included such topics as the author's research on Nicaragua and his critical assessment of the arts produced during the Sandinista years. Translation by David Craven.

Question: What about the situation at present in art and culture, particularly in light of the harsh struggle that occurred in 1988 within the FSLN between a group led by Rosario Murillo and a contingent led by you, Ernesto Cardenal, and Daisy Zamora? After all, government changes supported by Rosario and propelled by economic austerity measures caused the elimination of the Ministry of Culture along with virtually all public funding for the artists' union.

Gioconda Belli: Yes, well, Nicaragua and the Frente are definitely in "un período de tránsito" that is marked both by uncertain policy moves, as well as grave financial problems. As you know, I opposed these changes in the governmental structure, even though I am now campaigning for the Frente for the upcoming national elections to be held in little more than a month. Nonetheless, a fundamental rethinking of the revolutionary process was due after ten years of advances and because of a worsening economic situation brought on by U.S. military aggression. The changes made by the national government—and supported by Rosario Murrillo—led to a dictatorial eradication of the entire Ministry of Culture, thus also to a much more vertical chain of command in art and cultural·matters. Still, some sort of change had become unavoidable—and not just for economic or political reasons.

Question: What other factors necessitated changes in cultural policy? Are you referring to the debates about "populismo" (populism) within the ASTC (Association of Sandinista Cultural Workers) that started as early as 1982?

Gioconda Belli: Yes, I am. You must remember that the programs in the Centros Populares de Cultura, including the Talleres de Poesía, were often marred by values that were "populista y paternalista." The art and literature produced in the government tended to manifest these traits. It often led to mediocre art and to weak literature. In this respect, the CPCs were not really serving the most significant aims of the revolutionary process.

Question: But does this signal a lack of support by professional artists like yourself for the democratization of culture and the socialization of artistic production? Or is the problem of populism in the arts one rather at odds with that of popular self-empowerment?

Gioconda Belli: The democratization of culture and art remain key concerns of all revolutionaries, but the means of attaining them have to be re-thought. Nonetheless, I admit that the elimination of these popular programs under the auspices of the Ministry of Culture has left a real void in the public sphere, concerning popular engagement with the arts. . . . But, you see "un compromiso profundo a la democratización de la cultura" should not lead to a mere leveling of art to a low common denominator, to an art and literature so unchallenging that they are just consumed effortlessly. Concomitant with the democratization of art, there should also be "un compromiso a la cualidad en el arte" [a commitment to quality in art]. And here I am associating quality with two things in particular: "una habilidad avanzada" [an advanced skill or great skillfulness] and "una profundización de los recursos culturales" [a deepening or even expansion of cultural resources] in the arts. . . . Of course, I understand that the concept of quality in the arts has been used for elitist ends by reactionaries. Nonetheless, this does not mean that the belief in quality in art is essentially elitist by nature. Nor can we throw out the term "quality" because of its historical misuse. Instead, we must refine and redefine what the concept

of quality means in the arts, especially when the art is being produced on behalf of humanity.

Question: Your point is extremely well-taken about the necessary distinction between "elitist aims" in art and the contrary aim of acquiring "elite skills" in making art. The latter, but not the former, is something that every artist with any professional integrity attempts to do, as do professionals in any other realm of thought, from engineering to medicine. After all, a traditional problem of populism is precisely the cultural confusion of elitist behavior and elite skills, as if the two were both inherently "anti-democratic" in character. No one made this distinction between elitist and elite better than did Walter Benjamin when, in the *Function of the Author* (1934), he wrote that "An artist who does not teach other artists teaches no one."

Giocondo Belli: Exactly, the democratization of culture is compatible with the elevation of aesthetic standards among the people, but only if there are the public programs in place to broaden the dialogue between the professional and the non-professional. This aim—to elevate aesthetic standards even for professionals, while also notably increasing the people's involvement with art—remains "un atributo central del proceso revolucionario Sandinista."

Question: Are there any other artistic concerns within the revolutionary process that strike you as particularly pressing at the moment? Are there any other things about the present direction of artistic practice in Nicaragua that should be reconsidered?

Gioconda Belli: Yes. We need very much to re-emphasize the fundamental importance of individual practice in the arts, at a time when in Nicaragua we have made successes in advancing the collective engagement with art. But a criticism sometimes made of the public programs run by the Ministry of Culture is that they have emphasized collective achievement, as in the Talleres de Poesía, at the expense of any individual achievement. By individual achievement, though, I do not mean the type of exaggerated individualism in the arts that one often sees in the West. There is no reason why individual self-realization in the arts and collective involvement with the arts must exist in an antagonistic relationship.

APPENDIX F

Interview with Nicaraguan Artists in the UNAP, 1990

This interview with Julie Aguirre, Patricia Belli, Rubén Parrales, Raúl Quintanilla, and Juan Rivas by David Craven took place on January 10, 1990 at the Museo Julio Cortázar de Arte Moderno de América Latina. These are excerpts from an interview that lasted for some time, but that also explored the possibility of gaining funds from international sources and concluded with questions about the present author's response as a U.S. art critic to a fine show of contemporary Nicaraguan art that was then on display at the UNAP Gallery Los Pipitos, with the claim that "La selección presentada es representativa de las diferentes direcciones en que camina la plástica joven nicaragüense." The pamphlet for the exhibit concluded with an enigmatic aphorism and unsual signature: "Los perfiles están solo insinuados. Lo sabemos.—Arte Facto." This was an early appearance of the name for the artists' collective that has, since the early 1990s, published the most important art journal in Central America, ArteFacto.[1] Translation by David Craven.

Question: What proportion of members in UNAP are women?

Julie Aguirre: Around 60 percent of the members are women. Most of them, like myself, work in the vein of *printura primitivista*, even when they are not full-time artists. This is the type of painting for which Nicaragua has become most famous since the Revolution.

Question: Is it necessary to be a member of the Frente Sandinista de Liberación Nacional in order to be a member of UNAP?

Juan Rivas: No, this is not a requirement, although almost all artists and intellectuals sympathize with the Frente and support the Revolution. Some members of UNAP belong to the Frente, but many others do not, they are just "sympathizers." Nor is it a requirement to have had a solo show in an established gallery to be an elected member. Every artist is voted in or denied membership based on a majority vote of the union membership. We

also allow people to become *afiliados* [associates] of UNAP. These are people who are only part-time artists or people who are amateur artists.

Question: How many full-time members of UNAP are there as of January 1990?

Juan Rivas: Right now, there are 120 full-time members.

Question: How have the structural changes of 1988, especially the elimination of the Ministry of Culture and the broad public programs associated with it, affected the members of UNAP?

Patricia Belli: It has compounded the struggle to survive as artists for all of us. At a time when the economic crisis—and the U.S. military invention—are hitting us all very hard, it has suddenly become even more difficult to make it. The elimination of almost all public funding for the arts has thrown us back on our own resources in a really harsh way. The decrease in money might mean that we have even more "autonomy" than before from the state, but there is almost no private support for the arts in Nicaragua.[2]

Question: Are there other, secondary problems confronting the artists in Nicaragua now, as a result of this dramatic decrease in governmental support?

Raúl Quintanilla: Yes, there is, for example, a serious problem at ENAP [National School of Plastic Arts]. The lack of public funding has placed the faculty in a precarious position. Owing to this decrease in funds for materials and art supplies at UNAP [all of the faculty members at ENAP are members of UNAP], the faculty members at ENAP have become far more committed to their own survival as practicing artists than to the instruction of their students. Thus, the students at ENAP are being neglected by their teachers and there is a vicious cycle occurring in the National School that, in turn, reflects the desperate state of our artists.

Notes

Unless otherwise noted, all translations from the Spanish sources (as well as those from French and German texts) are by the author. For expert assistance with some of the translations, I should like to thank Colleen Kattau, an Assistant Professor of Spanish at Ithaca College in New York.

Introduction

1 José Carlos Mariátegui, letter of June 11, 1927, published in *La prensa* and *El comercio*, then reprinted in Gernaro Carnero Checa, *La acción escrita: José Carlos Mariátegui, periodista* (Lima, 1964), pp. 198–99. The most famous book by Mariátegui, which influenced subsequent conceptions of revolutionary change in Latin America, is *Siete ensayos de interpretación de la realidad peruana* (Lima, 1928). These essays and related studies are to be found in: José Carlos Mariátegui, *Obras completas*, 20 vols. (Lima, 1959–70), which was edited and published by the Biblioteca Amauta.

2 Raymond Williams, "Revolution," in *Keywords: A Vocabulary of Culture and Society* (1976; Oxford, 1983), pp. 270–74 (page citations are to Oxford edition). On Mariátegui's significance, see: Michael Löwy, *Le Marxisme en Amérique Latine* (Paris, 1980), p. xix. On the importance of Mariátegui's thought for later revolutionary movements in Cuba and Nicaragua, see: Adolfo Sánchez Vázquez, "El marxismo en la América Latina," *Casa de las Américas*, no. 178 (January–February 1990), pp. 3–14. For an analysis of his significance for literary theory, see: Vicky Unruh, "Mariátegui's Aesthetic Thought," *Latin American Research Review*, vol. 24, no. 3 (1989), pp. 45–69 and Vicky Unruh, *Latin American Vanguards* (Berkeley, 1994), pp. 38–39. There are also two other books of genuine merit that must be mentioned: Harry E. Vanden, *Marxism in National Latin America: José Carlos Mariátegui's Thought and Politics* (Boulder, 1986) and Marc Becker, *Mariátegui and Latin American Marxist Theory* (Athens, OH, 1993).

3 See: "Diego Rivera: Biografía sumaria," *Amauta*, no. 4 (December 1926), p. 5 and Esteban Pavelitch, "Diego Rivera: El artista de una clase," *Amauta*, no. 5 (January 1927), pp. 5 ff. We are informed in issue no. 4 that "Estos datos han sido ordenados y redactados por el propio artista."

4 John Dos Passos, "Paint the Revolution!" *New Masses* (March 1927), pp. 2–3. For two overviews of the responses within the U.S. to the Mexican Revolution, see: John A. Britton, *Revolution and Ideology: Images of the Mexican Revolution in the United States* (Lexington, Ky., 1995) and Helen Delpar, *The Enormous Vogue for Things Mexican: Cultural Relations Between the United States and Mexico, 1920–1935* (Tuscaloosa, 1992).

5 Matthew Cullerne Bown, *Socialist Realist Painting* (New Haven and London, 1998), p. xvi.

6 Inter-American Development Bank, *Report on Latin America* (July 2000). Quoted in Jane Bussey, "Latin America's Failure to Lift Its People a Puzzle," *Albuquerque Journal* (July 16, 2000), pp. C1–2.

7 E. J. Hobsbawm, *The Age of Extremes* (New York, 1994), p. 4. One of Hobsbawm's many keenly ironic insights is that, in the end, it was the Red Army that saved the capitalist system from defeat by fascism, even as Western capitalism spawned fascism during a period of systemic crisis. In his fine book on Central Europe, *Court, Cloister and City: The Art and Culture of Central Europe, 1450–1800* (Chicago, 1995), Thomas DaCosta Kaufman notes that the recent term of "Eastern Europe" for this region was a Cold-War construction with little basis in the cultural history of this area between West and East in Europe (p. 16).

8 Sergio Ramírez, *Estás en Nicaragua* (Managua, 1986), pp. 89–91. An English translation by D. J. Flakoll of this book was published by Curbstone Press of Willimantic, Conn. in 1995. In a series of interviews with this author, both in Albuquerque (October 4–6, 1995) and in Managua (October 28, 1995), Ramírez used a post–Cold War framework for analyzing Latin America that accented regional ties as much as international ones. This is the position that he advances rather impressively in his book *Oficios compartidos* (Mexico City, 1994).

9 Samir Amin, *L'eurocentrisme: Critique d'une ideologie* (Paris, 1988). Two related, highly important—and earlier—critiques by Latin American authors who come from Cuba and Uruguay respectively, are: Roberto Fernández Retamar, "Calibán: Cultura en nuestra América," *Casa de las Américas* (Havana), no. 68 (September–October 1971), pp. 3–46 and Eduardo Galeano, *Las venas abiertas de América Latina* (Mexico City, 1971). The powerful role of European languages within the colonial project in Latin America has been discussed in two noteworthy books: Walter D. Mignolo, *The Darker Side of the Renaissance* (Ann Arbor, 1995) and Elizabeth Boone and Walter D. Mignolo, eds., *Writing Without Words* (Durham, N. C., 1994).

10 Jorge G. Castañeda, *Utopia Unarmed: The Latin American Left After the Cold War* (New York, 1993), pp. 240–41. Just as Casteñeda analyzes the failures of the political vanguard in Latin America, so Nicola Miller has attempted to assess the failings of avant-garde intellectuals and the intelligentsia in Latin America, in her study entitled *In the Shadow of the State: Intellectuals and the Quest for National Identity in Twentieth-Century Spanish America* (London, 1999). Miller does make some telling points yet she underestimates the *dialogical interchange* of left-wing intellectuals, which notably influenced government policy in places like revolutionary Nicaragua. This momentous development occurred with the advent of Paulo Freire's theoretical framework for reconfiguring educational institutions in the 1960s.

11 Ramón Eduardo Ruíz, *The Great Rebellion: Mexico, 1905–1924* (New York, 1980). On this, see: Alan Knight, "The Mexican Revolution: Bourgeois? Nationalist? Or Just a 'Great Rebellion'?" *Bulletin of Latin American Research*, vol. 4, no. 2 (1985), pp. 1–37.

12 Octavio Paz, "Re/Visions: Mural Painting," *Essays on Mexican Art*, tran. Helen Lane (New York, 1993), p. 114.

13 Carlos Fuentes, *Nuevo tiempo mexicano* (Mexico City, 1994), ch. 4.

14 *The Oxford Dictionary of English Etymology* (Oxford, 1966): "Revolution."

15 Williams, *Keywords*, p. 270. See also: Rita Mae Brown, *Starting From Scratch: A Different Kind of Writers' Manual* (New York, 1989), pp. 57–66.

16 Göran Therborn, "Reconsidering Revolutions," *New Left Review*, no. 2 (New Series: March–April 2000), p. 148. See also: Fred Halliday, *Revolution and World Politics* (London, 2000) and Noel Parker, *Revolution and History* (Cambridge, 2000). The most recent and comprehensive essay about the issue is Eric Selbin, "Resistance, Rebellion, and Revolution in Latin America and the Caribbean at the Millennium," *Latin American Research Review*, vol. 36, no. 1 (2001), pp. 171–92.

17 Cesare Ripa, *Iconologia* (Rome, 1593), the *Hertel Edition* from 1760 in Augsburg, republished by Dover Press in 1971, p. 131: "Rebellion." The term "iconology" used by Ripa was later employed by Panofsky. Yet, what Ripa called "iconology" was analogous to what Panofsky termed "iconography" and what Panofsky labelled "iconology" was more about the period Zeitgeist. See: Erwin Panofsky, *Studies in Iconology* (Oxford, 1939), introductory essay. See also: Carlo Ginsburg, *Indagini su Piero* (Turin, 1981), preface; and Horst Bredekamp's brilliant discussion of Panofsky's contribution to Art History, "Words, Images, Ellipses," in Irving Lavin (ed.), *Meaning in the Visual Arts: Views from the Outside* (Princeton, 1995), pp. 363–72.

18 Williams, *Keywords*, p. 272. See also: Christopher Hill, *Change and Continuity in Seventeenth-Century England* (London, 1974).

19 Thomas Paine, "The Rights of Man" (1791), in Eric Foner, ed., *Thomas Paine: Collected Writings* (New York, 1995), pp. 444–45. For the first major postcolonial text to consolidate these insights see C. L. R. James, *The Black Jacobins* (London, 1938).

20 Thomas Carlyle, *The French Revolution* (London, 1837), vol. 5, p. vii.

21 Terry Eagleton, *Ideology* (London, 1991), p. 60.

22 Ibid., p. 66.

23 Ibid. See also David Craven, "Marx and Marxism," in Paul Smith, ed., *A Companion to Art Theory* (Oxford, 2002).

24 Raymond Williams, *Marxism and Language* (Oxford, 1977), p. 283.

25 Karl Marx, *Das Kapital*, vol. I (1867), tran. Ben Fowkes (New York, 1977), p. 283 [my italics].

26 Karl Marx, "Introduction to a Critique of Political Economy," in *Collected Works*, vol. 28 (New York, 1975–), p. 30 [my italics]. This passage was used as the epigraph for Tomás

Gutiérrez Alea's *Dialéctica del espectador* (Havana, 1982). The first Marxist author to use this metaphor of the hammer was probably Leon Trotsky in his most well-known book about the arts, *Literature and Revolution* (1924) (Ann Arbor, 1971), p. 137: "Art, it is said, is not a mirror, but a hammer."

27 On this terminology, see the classic study on the issue: John Womack, Jr., *Zapata and the Mexican Revolution* (New York, 1968), p. 76, and in particular the choice of terms used by the Zapatistas in their public manifestoes from 1911 onward (pp. 400 ff).

28 Augusto C. Sandino, *El pensamiento vivo de Sandino*, ed. Sergio Ramírez (San José, Costa Rica, 1976), p. 90. One of the earliest usages in English of the term "guerrilla" appeared in 1929, but it meant little beyond being a rebel, since the word was coupled with a vague use of "revolutionary" as follows: "they aspire of being called revolutionary. They mean by that term exactly that spirit of being with pleasure and talent Mexican, defined already in murals." See: Anita Brenner, *Idols Behind Altars* (New York, 1929), pp. 323–24.

29 Ernesto Che Guevara, "La guerra de guerrillas" (1960), in *Obras: 1957–1967*, vol. 2 (Havana, 1970); Regis Debray, *Révolution dans la révolution?* (Paris, 1967). For an insightful discussion of the theoretical links between Sandino and Che, see: Donald Hodges, *Intellectual Foundations of the Nicaraguan Revolution* (Austin, Tex, 1986), pp. 167–97.

30 Ernesto Che Guevara, *Guerrilla Warfare*, tran. J. P. Morray (New York, 1961). First published in English by Monthly Review Press, this small book soon became an underground "best seller" and was reprinted by Random House in a paperback trade edition in 1969 for mass circulation. Most recently this book was republished by the University of Nebraska Press in 1998. It also included a very fine introductory essay by Marc Becker, in which he made a balanced critique of the shortcomings of Che's thought in relation to the recent insurgency in Chiapas.

31 Che Guevara, *Guerrilla Warfare*, pp. 5, 35.

32 Ibid., pp. 1–2, 122. This strategy of Che's and the originality of the Cuban Revolution more generally are discussed in fresh terms by Fredric Jameson in Patricia Waugh, ed., "Periodising the Sixties," in *Postmodernism: A Reader* (New York, 1992), pp. 145–47: "from the beginning, the Cuban experience affirmed itself as an original one, as a new revolutionary model. . . . [It involved] a whole new element in which the guerrilla band moves in perpetual displacement."

33 Ibid., p. 15.

34 Gladys March, *Diego Rivera: My Art, My Life* (1960, New York, 1991), p. 58. For an examination of Rivera's oeuvre during these years, see: Ramón Favela, *Diego Rivera: The Cubist Years* (The Phoenix Art Museum, March 10–April 29, 1984).

35 Diego Rivera (with Bertram Wolfe), *Portrait of America* (London, 1935), p. 193.

36 Ibid., pp. 196–98.

37 Esteban Pavletich, "Diego Rivera: el artista de una clase," *Amauta*, no. 5 (January 1927), pp. 8–9.

38 Ibid.

39 Ernesto Che Guevara, "El socialismo y el hombre en Cuba" (1965), in *Escritos y discursos*, vol. 8 (Havana, 1977), pp. 264–67 [my italics].

40 Thomas Hobbes, *Leviathan, Or the Matter, Forme and Power Of A Commonwealth Ecclesiasticall and Civill* (London, 1651) and Thomas Hobbes, *Le Corps politique ov les elements de la loy morale et civil* (Paris, 1652). My discussion here is much indebted to a very subtle study of this topic: Horst Bredekamp, *Thomas Hobbes Visuelle Strategien* (Berlin, 1999). Furthermore, I had the good fortune to hear Professor Bredekamp give a public lecture *auf Englisch* on this topic at the Collegium Budapest in Hungary: "Thomas Hobbes' Visual Strategies" (February 16, 1999). It was part of the "Bild und Bildlichkeit Focus Group of Fellows" organized by Professor Franz-JoachimVerspohl of Jena University for the Collegium Budapest. After Bredekamp's lecture, Anna Wessely, Wolfram Hogrebe, and I discussed with Bredekamp several of the key issues that he had raised so resourcefully. Among the many points that Bredekamp presented in a compelling way was the thesis that the conception of the state in Thomas Hobbes's book was deeply influenced by visual images and cultural practices ascendant in the early seventeenth century in England. Far from simply "reflecting" the theory of Hobbes, then, engraved images of his concept of the state actually had a formative influence on government's theoretical reconfiguration. In short, artistic practice also influenced political theory, rather than just the other way around.

It is instructive to contrast Bosse's engraving of the Modern Commonwealth with the premodern image of government by Jeremias Wachsmuth that appears in the Hertel edition of Ripa's *Iconologia*. Based on Ripa's description of governance in relation to "various instruments of torture," the latter image does not attempt to represent "social harmony" as does Bosse. Rather, the Ripa image embodies brute force and *no* identification of sovereign with subjects.

41 Hobbes, *The Leviathan*, in *The English Works of Thomas Hobbes* (London, 1839), vol. 3, pp. 110–18.

42 Ibid. [Hobbes's italics]. See also Horst Bredekamp, "From Walter Benjamin to Carl Schmitt via Thomas Hobbes," *Critical Inquiry*, vol. 25 (winter 1999), pp. 247–66.

43 See: T. J. Clark, *The Absolute Bourgeois* (London, 1973).

44 See: Michael C. Meyer, William L. Sherman, and Susan Deeds, *The Course of Mexican History*, 6th ed. (Oxford, 1999), p. 578.

45 Alan Knight, "The Rise and Fall of Cardenismo," in Leslie Bertell, ed., *Mexico Since Independence* (Cambridge, 1991), p. 241.

46 Ken Hirschkop, "Bakhtin, Discourse, and Democracy," *New Left Review*, no. 160 (November/December 1986), p. 92.

47 Nicos Poulantzas, *State, Power, Socialism*, tran. T. O'Hagan (London, 1978).

48 Jeff McMahan, *Reagan and the World: Imperial Policy in the Cold War* (New York, 1985). As was the case with so many other books of genuine merit in this period, this study was published by Monthly Review. On the crucial role played by the Monthly Review school of political economists in the origin of dependency theory during the 1950s, see: Roger Burbach and Orlando Núñez Soto, *Fire in the Americas: Forging a Revolutionary Agenda* (London, 1987), pp. 35–37.

49 The Che poster by Elena Serrano of Cuba served as the frontispiece for the first book in the English world to feature these posters in a popular format: Dugald Stermer and Susan Sontag, *The Art of Revolution—Castro's Cuba, 1959–70* (New York, 1970). With the translation of "Día del Guerrillero Heroica 8 de Octubre" (Day of the heroic guerrilla), which is in the upper right hand of the poster, we encounter a very early use in English of the word "guerrilla" as a noun that is equated with *guerrillero* in Spanish.

50 David Kunzle, "Uses of the Portrait: The Che Poster," *Art in America*, vol. 63, no. 5 (October 1975), pp. 66–73 and John Berger, "Che Guevara Dead," in Marianne Alexandre, ed., *Viva Che* (London, 1968).

51 Gerardo Mosquera, "Raices en acción," *Revolución y Cultura* (Havana), no. 2 (February 1988), pp. 32–39.

52 Carlos Fonseca Amador, *Desde la cárcel yo acuso a la dictadura* (Managua, 1964), p. 7. See also Matilde Zimmerman, *Carlos Fonseca and the Nicaraguan Revolution* (Durham, N.C., 2001).

53 Katherine Hoyt, *The Many Faces of Sandinista Democracy* (Athens, OH, 1997), p. 1. See also: Gary Ruchwarger, *People in Power: Forging a Grassroots Democracy in Nicaragua* (South Hadley, Mass., 1987); Roger Burbach and Orlando Núñez Soto, *Fire in the Americas* (London, 1987), pp. 41ff; and Pablo González Casanova, *El poder al pueblo* (Mexico City, 1984).

54 Karl M. Schmitt, *Communism in Mexico* (Austin, Tex, 1965), pp. 10–12. For a more general look at the CP's role throughout Latin America, see two well-known studies: Robert Alexander, *Communism in Latin America* (New Brunswick, N.J., 1957) and Boris Goldenberg, *Kommunismus in Latein Amerika* (Stuttgart, 1971).

55 Schmitt, *Communism in Mexico*, p. 19. See also: Mary Kay Vaughan, *Cultural Politics in Revolution: Teachers, Peasants, and Schools in Mexico, 1930–1940* (Tucson, 1997).

56 Dawn Ades, "The Many Revolutions of Rivera," *Times Literary Supplement* (November 6, 1998), p. 17.

57 See the interview with Fidel Castro on this, in Lee Lockwood, *Castro's Cuba, Cuba's Fidel* (New York, 1969), pp. 150–54.

58 For an overview of the size and structure of the PCC, see: Nelson P. Valdés, "The Changing Face of Cuba's Communist Party," *Cuba Update*, vol. 7, no. 1–2 (winter–spring 1986), pp. 1, 4, 16. As Nelson noted, the PCC membership grew from only 50,000, in 1965 to over 500,000 by 1985.

59 William M. LeoGrande, "Mass Political Participation in Socialist Cuba," in *The Cuba Reader*, p. 196. In addition, see: Nelson P. Valdés, "Revolution and Institutionalization in Cuba," *Cuban Studies/Estudios Cubanos*, vol. 6 (January 1976), pp. 1–37; Carrollee Bengalsdorf, *The Problem of Democracy* (New York, 1994); Susan E. Eckstein, *Back from the Future: Cuba under Castro* (Princeton, 1994); and Marifeli Pérez-Stable, *The Cuban Revolution* (Oxford, 1999), chs. 5 and 6. More recently, see: Jorge I. Domínguez, "Cuba in the 1990s: The Transition to Somewhere," in *Democratic Politics in Latin America and the Caribbean* (Baltimore, 1998), pp. 173–203. For a look at how the legal system has also been democratized, see: Debra Evanson, "Law and Revolution in Cuba," *The Cuba Reader*, pp. 199–210.

60 Eric Selbin, *Modern Latin American Revolutions* (Boulder, 1993), p. 43. For an older and more conventional (as well as Althusserian) analysis of political institutions, see: Marta Harnecker, *Cuba: dictadura o democracia?* (Mexico City, 1975). See also two other fine studies: Richard R. Fagen, *The Transformation of Political Culture in Cuba* (Stanford, 1969) and Max Azicri, *Cuba: Politics, Economics, and Society* (London, 1988).

61 U.S. Congressional Report, *Cuba Faces the Economic Realities of the 1980s* (Washington D.C., 1982), p. 5. See also: Alexander Cockburn and James Ridgeway, "Cuba at 25: Was It Worthwhile?" *The Village Voice* (July 26, 1983), p. 16: "World Bank statistics tell us that in 1975, among people 15 and over, Cuba ranked first of all Central and Latin American countries in literacy. . . . Some other simple indices: life expectancy in Cuba increased 9.3 percent, from 64 in 1960 to 70 in 1977. . . . Infant mortality in Cuba decreased from 36 per 1,000 in 1960 to 25 per 1,000 in 1977. . . . An average Cuban's daily caloric intake increased from 2,414 in 1961 to 2,866 in 1980. . . . Compared with almost every country in Central and Latin America, it is a haven of economic stability, personal security, and cultural and intellectual pluralism."

For an extensive compilation of data about these issues, see: Susan Schroeder, *Cuba: A Handbook of Historical Statistics* (Boston, 1982); Ross Danielson, *Cuban Medicine* (New Brunswick, N.J., 1979); Joseph Collins and

Medea Benjamin, "Cuba's Food Distribution System," in Halebsky and Kirk eds., *Cuba*, pp. 62–78; Larry R. Oberg, ed., *Contemporary Cuban Education: An Annotated Bibliography* (Stanford, 1974); Edwin Lieuwen and Nelson P. Valdés, eds., *The Cuban Revolution: A Research Guide, 1959–1969* (Albuquerque, 1991); and Ronald Chilcote, ed., *Cuba, 1953–1978: A Bibliographical Guide to the Literature*, 2 vols. (White Plains, 1986).

62 Andrew Zimbalist, "Does the Economy Work?" NACLA *Report on the Americas*, vol. 24, no. 2 (August 1990), p. 17. See also: Andrew Zimbalist and Claes Brundenius, *The Cuban Economy: Measurement and Analysis of Socialist Performance* (Baltimore, 1989); Nelson P. Valdés, "The Cuban Economy: Economic Organization and Bureaucracy," *Latin American Perspectives*, vol. 6 (winter 1979), pp. 13–37; Carl H. Feuer, "The Performance of the Cuban Sugar Industry, 1981–85," *World Development*, vol. 15, no. 1 (1987), pp. 67–81; and Nora Hamilton, "The Cuban Economy: Dilemmas of Socialist Construction," in Wilbur Chafee and Gary Prevost, eds., *Cuba: A Different America* (Totowa, 1989), pp. 53–63.

For two quite early and well-known, if also contested, assessments by the remarkable Monthly Review School, see: Leo Huberman and Paul Sweezy, *Cuba: Anatomy of a Revolution* (New York, 1960) and Leo Huberman and Paul Sweezy, *Socialism in Cuba* (New York, 1969). For a more centrist critique of Cuba, see: Wassily Leontief, "The Trouble with Cuban Socialism," *New York Review of Books* (January 7, 1971), pp. 19–23 or Carmelo Mesa-Lago, *Are Economic Reforms Propelling Cuba to the Market?* (Coral Gables, 1994).

63 Edwin Williams, *The Penguin History of Latin America* (Harmondsworth, 1996), p. 458. See also: Peter Marshall, *Cuba Libre: Breaking the Chains?* (London, 1987) and Jean Stubbs, *Cuba: The Test of Time* (London, 1989).

64 Father Miguel D'Escoto, "Nicaragua: Unfinished Canvas," in *Nicaragua: Unfinished Revolution*, ed. P. Rosset and J. Vandermeer (New York, 1986), pp. 441–45. When I first traveled to Nicaragua in July of 1982, John Ryder and I were able to visit the home of Father D'Escoto (he was out of the country at that moment). At the time, painter Orlando Sobalvarro had studio space in D'Escoto's residence.

One: The Mexican Revolution

1 Diego Rivera, "The Guild Spirit in Mexican Art" (as related to Katherine Anne Porter), *Survey Graphic*, vol. 5, no. 2 (May 1, 1924): pp. 174–75. This conception of artistic production as one organized along the lines of a "guild" (that of an experienced master working in a highly skilled craft with assistants who were being mentored demonstrating various

levels of accomplishments) contrasted strongly with the other two models of the day: that of either the isolated "genius" like Matisse or Picasso working in relative solitude, or that of the collective of "equals"—such as the Taller de Gráfica Popular from the 1930s—in which differences in skill and experience were not allowed to keep all artists from supposedly contributing "equally" (even though Leopoldo Méndez was the first among equals). The two primary anthologies of Rivera's writings on art and the creative process are: Raquel Tibol, ed., *Diego Rivera: Arte y política* (Mexico City, 1978) and Xavier Moyssén, *Diego Rivera: Textos de arte* (Mexico City, 1986). Finally, for more on the relationship of Diego Rivera and the novelist Katherine Anne Porter, see: Jeraldine Kraver, "Laughing Best: Competing Correlatives in the Art of Katherine Anne Porter and Diego Rivera," *South Atlantic Review*, vol. 63, no. 2 (spring 1998): pp. 48–74. As for the definitive catalogue raisonné of Rivera's own artworks, there is a magisterial two volume *Catálogo General de Obra*, the first of which includes his canvas paintings, as well as drawings, and the second of which includes his murals. This remarkable feat of collective scholarship was produced by the Centro Nacional de Investigación, Documentación e Información de Artes Plásticas (CENIDIAP).

2 David Alfaro Siqueiros, et al., "Manifiesto del Sindicato de Obreros Técnicos, Pintores y Scultores" (1924), in *Palabras de Siqueiros: Selección*, ed. and intro. Raquel Tibol (Mexico City, 1996), p. 24: "nuestra objetivo fundamental radica en *socializar las manifestaciones artísticas*." [my italics]. This manifesto appeared in issue no. 7 of *El Machete* (June 1924).

3 Francisco Reyes Palma, *Historia social de la educación artística en México . . . período de Calles y el Maximato, 1924–1934* (Mexico City, 1984), p. 5: "México fue uno de los primeros países del mundo, y posiblemente el primero en América Latina, en plantear críticamente las relaciones entre el arte y el desarrollo de las fuerzas productivas."

4 Marta Traba, *Art of Latin America, 1900–1980* (Washington, D.C., 1994), p. 2. For a thoughtful review of this book, see: Ilan Stavans, "The Forest and the Tree: Latin American Art," *In These Times*, vol. 19, no. 7 (February 20, 1995): pp. 35–36. See also: Marta Traba, introductory essay for *The Museum of Modern Art of Latin America: Selections from the Permanent Collection of the Organization of American States* (Washington, D.C., 1985).

5 Carlos Fuentes, "Writing in Time," *Democracy*, vol. 2, no. 1 (January 1981): p. 61.

6 Carlos Fuentes, *Nuevo tiempo mexicano* (1994), tran. Marina Gutman Casteñeda (New York, 1994), p. 18.

7 Linda B. Hall, *Álvaro Obregón: Power and Revolution in Mexico, 1911–1920* (College Station, Tex., 1981), p. 181. See also: E. V.

Niemeyer, *Revolution at Quéretaro: The Mexican Constitutional Convention, 1916–1917* (Austin, Tex., 1974).

8 Hall, *Álvaro Obregón*, pp. 180–81.

9 On this and related issues, there is a very fine summary to be found in Michael C. Meyer and William L. Sherman, *The Course of Mexican History* (Oxford, 1995), pt. 9. For two earlier and still important studies, see: Eyler Simpson, *The Ejido: Mexico's Way Out* (Chapel Hill, N.C., 1937) and Linda B. Hall, "Álvaro Obregón and the Politics of Mexican Land Reform," *Hispanic American History Review*, vol. 60 (1980): pp. 213–38.

10 On the "fading miracle," as it has been called, see: Hector Camín Aguilar and Lorenzo Meyer, *In the Shadow of the Revolution, 1910–1989* (Austin, Tex., 1993). There are several other studies that also address these changes. See: James Wilkie, *The Mexican Revolution: Federal Expenditures and Social Change Since 1910* (Berkeley, 1967); Howard Cline, *Mexico: Revolution to Evolution, 1940–1960* (Oxford, 1963); and John W. Sherman, "The Mexican 'Miracle' and Its Collapse," in Michael C. Meyer and William H. Beezley, eds., *The Oxford History of Mexico* (Oxford, 2000), pp. 575–608. An issue that cannot be discussed at length here, but which needs to be acknowledged nevertheless, is the ideological impact of Catholicism on the failure of Mexico to arrive at a national policy on planned parenthood and on birth control (such as one saw in China after 1949).

11 Linda B. Hall, *Oil, Banks, and Politics: The US and Postrevolutionary Mexico, 1917–1924* (Austin, Tex., 1995). See also: José Colomo and Gustavo Ortega, *La industría petrolera en México* (Mexico City, 1927); Friedrich Katz, *The Secret War in Mexico* (Chicago, 1981); Jonathan C. Brown and Alan Knight, eds., *The Mexican Petroleum Industry in the Twentieth Century* (Austin, Tex., 1994); and Jonathan C. Brown, *Oil and Revolution in Mexico* (Berkeley, 1993).

12 Alan Knight, "The Rise and Fall of Cardenismo, c.1930–c.1946," in Leslie Bethell, ed., *Mexico Since Independence* (Cambridge, 1991), pp. 241–321. See also: Alan Knight, *The Mexican Revolution*, 2 vols. (Cambridge, 1986).

13 Knight, "The Rise and Fall of Cardenismo," pp. 241–42.

14 Hall, *Álvaro Obregón*, p. 253.

15 John Dewey, "Mexico's Educational Renaissance" (1926), reprinted in J. A. Boydston, ed., *John Dewey: The Later Works, 1925–1953*, vol. 2 (Carbondale, 1984), pp. 199–200. (It originally appeared in the *New Republic*, vol. 48 (September 22, 1926), pp. 116–18. For an intelligent overview of the entire spectrum of responses in the U.S.A. to the Mexican Revolution, see: John A. Britton, *Revolution and Ideology: Images of the Mexican Revolution in the United States* (Lexington, Ky., 1995). See also, the very insightful publication by James Oles, *South of the Border: Mexico in the American*

Imagination, 1914–1947 (Washington, D.C., 1993) and, more recently, Helen Delpar, "Mexican Culture, 1920–1945," in Michael C. Meyer and William H. Beezley, eds., *The Oxford History of Mexico* (Oxford, 2000), pp. 543–72.

16 Dewey, "Mexico's Educational Renaissance," p. 201.

17 Ibid., p. 202.

18 John Dewey, "From a Mexican Notebook" (1926), reprinted in Boydston, *John Dewey: The Later Works*, vol. 2, p. 206. (The article originally appeared in the *New Republic*, vol. 48 (October 20, 1926): pp. 239–41.) On Dewey's "guild socialism," see: Gary Bullert, *The Politics of John Dewey* (New York, 1996).

19 Moisés Sáenz, "La integración de México por la educación" (1926), reprinted in *Antología de Moisés Sáenz*, ed. Gonzalo Aguirre Beltrán (Mexico City, 1970), p. 17. For an instructive look at the way the relationship of Sáenz and Rafael Ramírez to Dewey had an impact on the educational programs in Mexico during the late 1920s, see: Reyes Palma, *Historia social de la educación artística en México*, pp. 10 ff. As Reyes Palma notes, "Los principales promotores de la 'escuela de la revolución' fueron Moisés Sáenz y Rafael Ramírez. Ambos adoptaron las concepciones pedagógicas del filósofo norteamericano John Dewey, quién promovía la educación por el trabajo, dentro de la llamada 'escuela activa' o 'escuela de acción.'"

20 Moisés Sáenz, "El indio y la escuela" (1927), in *Antología de Moisés Sáenz*, p. 25.

21 Diego Rivera's consistently high opinion of Obregón is a recurring feature of the literature. For a fine sense of Rivera's own position, see the one conveyed by his biographer Bertram Wolfe (who was a member of the Partido Comunista Mexicano in 1924 during the final year of Obregón's administration) in *The Fabulous Life of Diego Rivera* (1969; Chelsea, Mich., 1990), pp. 18, 32: "The government of General Obregón . . . seemed to be the Revolution itself, organized as government. . . . Its first budget allowed as much for schools as for barracks. . . . The new President, corpulent and sanguine, candid, openhearted, brilliant in the field of battle . . . overflowing with wit, unassuming and democratic in his personal ways, was by no means immune to the idealism that was in the air. . . . He surrounded himself with poets, painters, and visionary counselors of all descriptions." See also, Thomas Benjamin, "Rebuilding the Nation," in *The Oxford History of Mexico*, pp. 467–502.

22 On Obregón's impressive relationship with the Mayo and Yaqui, see Hall, *Álvaro Obregón*, pp. 19–20, 35–36, 234–35.

23 Leonard Folgarait, *Mural Painting and Social Revolution in Mexico, 1920–1940* (Cambridge, 1998), pp. 16 ff. For a review of this book, see: David Craven, "Recent Literature on Diego

Rivera and Mexican Muralism," *Latin American Research Review*, vol. 36, no. 3 (fall 2001), pp. 221–37.

24 Moisés Sáenz, "La integración de México por la educación," pp. 17–18.

25 Mary Kay Vaughan, *Cultural Politics in Revolution: Teachers, Peasants, and Schools in Mexico, 1930–1940* (Tucson, 1997), p. 7.

26 See: Orlando S. Súarez, *Inventario del muralismo mexicano* (Mexico City, 1972); *La pintura mural de la Revolución* (Mexico City, 1975); and Philip Stein, *Murales de México* (Mexico City, 1984).

27 For a very fine recent survey by a Canadian muralist and scholar, see: Desmond Rochfort, *Mexican Muralists: Orozco, Rivera, Siqueiros* (San Francisco, 1993). There are many more noteworthy survey-like publications from the 1920s to the present on the Mexican Mural "Renaissance." The most significant ones, in order of publication date, are the following: Anita Brenner, *Idols Behind Altars* (New York, 1929); MacKinley Helm, *Modern Mexican Painters* (New York, 1941); Justino Fernández, *Arte moderno y contemporaneo de México* (Mexico City, 1952), vol. 2; Bernard Myers, *Mexican Painting in Our Time* (Oxford, 1956); Alma Reed, *The Mexican Muralists* (New York, 1960); Luis Cardoza y Aragón, *México: Active Painting* (Mexico City, 1961); Jean Charlot, *The Mexican Mural Renaissance* (New York, 1962); Antonio Rodríguez, *A History of Mexican Painting* (London, 1969); Laurence Hurlburt, *The Mexican Muralists in the United States* (Albuquerque, 1989); Dawn Ades, *Art in Latin America* (London, 1989); and Olivier Debroise, ed., *Modernidad y modernización en el arte mexicano, 1920–1960* (Mexico City, 1991).

28 Álvaro Obregón, *Discursos*, vol. 2 (Mexico City, 1932), p. 274. See also Dr. Atl, "Obregón y el principio de renovación social," in José Rubén Romero, et al., *Obregón, aspectos de su vida* (Mexico City, 1935), pp. 71 ff.

29 For a classic overview, see: Meyer and Sherman, *The Course of Mexican History*, pp. 572–73. See also: Mary Kay Vaughan, *The State, Education, and Social Class in Mexico, 1880–1928* (DeKalb, Ill., 1982).

30 *El Universal* (October 1, 1920). Cited in Folgarait, *Mural Painting and Social Revolution in Mexico*, p. 19. On Lunacharsky's policies, see: Timothy E. O'Connor, *The Politics of Soviet Culture* (Ann Arbor, 1983).

31 Adolfo Best-Maugard, *Método de Dibujo: tradición, resurgimiento y evolución de arte mexicano* (Mexico City, 1923). See also: Teresa del Conde, *Historia mínima del arte mexicano en el Siglo xx* (Mexico City, 1994), pp. 104–5.

32 Juan del Sena, "Best Maugard y su sistema de enseñanza artística," *El Universal Ilustrado* (July 6, 1922), p. 21.

33 On the relationship of Best-Maugard and Vasconcelos, see: Folgarait, *Mural Painting and Social Revolution in Mexico*, pp. 20–21. The

literature on Vasconcelos is extensive. See in particular: Richard Baker Philips, "José Vasconcelos and the Revolution of 1910" (unpublished Ph.D. dissertation, Stanford University, 1953); John Haddax, *Vasconcelos of Mexico* (Austin, Tex., 1967); and José Joaquin Blanco, *Se llamaba Vasconcelos: Una evocación crítica* (Mexico City, 1977).

34 The statements by Alfredo Ramos Martínez about the need to deacademicize art were cited by Teresa del Conde in *Historia mínima del arte mexicano en el Siglo XX*, pp. 99–100.

35 Olivier Debroise, *Figuras en el trópico: Plástica mexicana, 1920–1940* (Mexico City, 1984), p. 33. This stern critique is well taken and it remains an unavoidable challenge to any scholar who wishes to write about the "Escuelas del aire libre" as a progressive or emancipatory phenomenon. Moreover, the fact that these schools collapsed in 1934–35, at exactly the moment when the popular self-representation sanctioned by Cardenismo in politics reached a democratic level seldom rivaled in the Americas, raises some further questions about just how progressive this system of Ramos Martínez really was. Nevertheless, no less a figure than Diego Rivera concluded that the "Escuela de Pintura al Aire Libre no fueron un fracaso sino un éxito importante" in his final assessment. See: *Diego Rivera: arte y política*, p. 295.

36 Alberto Híjar, "Diego Rivera: contribución política," *Diego Rivera Hoy* (Mexico City, 1986), pp. 37–72.

37 See, for example, Walter Gropius, "Programme of the Staatliches Bauhaus in Weimar" (1919) and "Principles of Bauhaus Production in Dessau" (1926), reprinted in Ulrich Conrads, ed., *Programs and Manifestoes on 20th Century Architecture*, tran. Michael Bullock (MIT, 1964), pp. 49–54 and 95–98.

38 Reyes Palma, *Historia social de la educación artística en México*, p. 5.

39 Diego Rivera, "*Exposición de motivos para la formación del plan de estudios de la Escuela Central de Artes Plásticas de México*" (1929), reprinted in *Diego Rivera: Arte y política*, p. 93.

40 Diego Rivera, "Los primeros murales" (1925), in *Diego Rivera: Arte y política*, p. 51. See also: Alicia Azuela, "Rivera and the Concept of Proletarian Art," in *Diego Rivera: A Retrospective* (Detroit Institute of Arts, 1986), pp. 125–30 and Adolfo Sánchez Vázquez, "Claves de la ideología estética de Diego Rivera," *Diego Rivera Hoy*, pp. 205–28.

41 For a new and very perceptive assessment of Juan O'Gorman's contribution to the architecture of the Mexican Revolution, particularly in relation to the conservative neocolonial architectural style supported in the early 1920s by José Vasconcelos, see: Valerie Fraser, *Building the New World: Studies in the Modern Architecture of Latin America, 1930–1960* (London, 2000), pp. 35–58.

42 On the intensity of this conflict, see: David Craven, *Diego Rivera as Epic Modernist* (Boston, 1997), pp. 93–99. For a review of this book, see: Alejandro Anreus, "Diego Rivera como modernista épico," *Arte en Colombia*, no. 78 (April–June 1999), pp. 40–42. This review essay also appeared in *Art Nexus*, no. 32 (May–June 1999), pp. 40–42 and in *ArteFacto* (Summer 1999), the Nicaraguan art journal.

43 Karl. M. Schmitt, *Communism in Mexico* (Austin, Tex., 1965), p. 11. On the Cristero revolt, see: David C. Bailey, *Viva Cristo Rey: the Cristero Rebellion and the Church–State Conflict in Mexico* (Austin, Tex., 1974) and Robert E. Quirk, *The Mexican Revolution and the Catholic Church, 1910–1929* (Bloomington, 1973).

44 David Alfaro Siqueiros, "El camino contra-revolucionario de Rivera" (1934), in *Palabras de Siqueiros*, p. 60. This shrill, sectarian, and often dishonest attack by Siqueiros first appeared in a Stalinist publication based in the U.S.A., *New Masses* (May 1934, pp. 16–18) and then in the Mexican newspaper *El Universal Ilustrado* in September of the same year. For a comprehensive look at this controversy, see: Maricela González Cruz Manjarrez, *La polémica Siqueiros–Rivera: planteamientos estético-políticos 1934–1935* (Mexico City, 1996).

45 For one of the best overall accounts of this affair, see: Bertram Wolfe, *The Fabulous Life of Diego Rivera*, pp. 253–60. For Rufino Tamayo's own account of his "pro-Rivera" position during this controversy, see: Rufino Tamayo, "Mi lenguaje, la pintura," *Revista de la Universidad de México*, vol. 25, no. 4–5 (December 1980–January 1981), p. 2.

46 María Izquierdo, "Memoirs" (1953), unpublished document, Aurora Posadas Izquierdo Archive, Mexico City, n.p. First cited by Olivier Debroise, "El estudio compartido: María Izquierdo y Rufino Tamayo," in *The True Poetry: The Art of María Izquierdo* (Americas Society, New York, 1997), p. 52. Rivera even wrote an essay about Izquierdo for the catalogue of her exhibition in 1929 at the Galería de Arte Moderno del Teatro Nacional. For a reprint of the text by Rivera, see: Miguel Cervantes, ed., *María Izquierdo* (Mexico City, 1966), pp. 51–52.

47 Debroise, "El estudio compartido," p. 60.

48 Ibid.

49 David Alfaro Siqueiros, *No hay más ruta que la nuestra: Importancia nacional e internacional de la pintura mexicana moderna* (Mexico City, 1945).

50 Meyer Schapiro, "The Patrons of Revolutionary Art," *Marxist Quarterly*, vol. 1, no. 3 (October–December 1937), p. 463. Interestingly enough, there is an unpublished document by Schapiro about Rivera from the early 1930s, which is to be found in the personal papers of Meyer Schapiro, New York City, folder 6 (doc. no. 5): Meyer Schapiro, "Rivera

on Russian Art" (four handwritten pages). In it, Schapiro discusses Rivera's claim that theater, not cinema, was the most revolutionary artform in Soviet Russia and Schapiro concludes that the reverse is true.

51 Schapiro, "The Patrons of Revolutionary Art," p. 465.

52 Oriana Baddeley and Valerie Fraser, *Drawing the Line: Art and Cultural Identity in Contemporary Latin America* (London, 1989), pp. 80–81. For a review of the book, see: David Craven, "Book Reviews," *Latin American Art Magazine*, vol. 2, no. 4 (fall 1990), p. 127.

53 Justino Fernández, *Arte mexicano de sus orígenes a nuestros días* (1961), tran. Joshua Taylor (Chicago, 1969), pp. 151, 156, 161.

54 See Antonio Rodríguez, *Diego Rivera: Los murales en la Secretaría de Educación Pública* (Mexico City, 1986), which includes an essay by Luis Cardoza y Aragón, and Antonio Rodríguez, *Guía de los murales de Diego Rivera en la Secretaría de Educación Pública* (Mexico City, 1984).

55 For a fine look at the way that architecture, including that of the Secretaría, in the "post-revolutionary years was constrained and compromised in ways in which the muralists were not," see: Valerie Fraser, *Building the New World: Studies in the Modern Architecture of Latin America 1930–1960* (London, 2000), pp. 21–30.

56 Stanton L. Catlin, "Mural Census," in *Diego Rivera: A Retrospective*, p. 241.

57 The fresco in question is ironically entitled as *Los sabios* (The wisemen, or The sages) and it was painted in 1928 in the Patio of the Fiestas at the Secretaría. A particularly pointed feature of the image is the way that a thinker sitting on a stack of "reactionary" books such as a volume by Auguste Comte (the founder of positivism), is seated next to José Vasconcelos, who is shown from the back. The entire group of thinkers is being viewed with amusement by a number of *guerrilleros* in the background. Vasconcelos in turn conveyed his disapproval of Rivera's frescoes in several texts. See, for example, José Vasconcelos, *Estética* (Mexico City, 1936), p. 575, or José Vasconcelos, "Sobre Diego Rivera," in Elisa García Barragán and Luis Mario Schneider, eds., *Diego Rivera y los escritores mexicanos: Anthología tributaria* (Mexico City, 1986), pp. 227–28.

58 This 1955 statement is quoted by Raquel Tibol in *Diego Rivera: Arte y política*, p. 27.

59 On the essentializing nature of official *indigenismo*, see: David Brading, "Manuel Gamio and Official Indigenismo in Mexico," *Bulletin of Latin American Research*, vol. 7, no. 1 (1988), pp. 75–89. On Rivera's "alternative indigenismo," see: Alberto Híjar, "Diego Rivera: Contribución política," in *Diego Rivera Hoy*, pp. 37–72. See, in addition: Mirko Lauer, "Populist Ideology and Indigenism: A Critique," in Gerrado Mosquera, ed., *Beyond the*

Fantastic (MIT, 1996), pp. 91–113. Among others, Néstor García Canclini and Gerardo Mosquera have also written important critiques of Vasconcelos' conservative form of *mestizaje*.

60 On this controversy, see: Bertram Wolfe, *The Fabulous Life of Diego Rivera*, pp. 174–76.

61 The connection of motifs in Rivera's mural to figures in the *Codex Mendoza* was first brought to my attention by Professor Kathleen Howe (curator of the permanent collection), the Art Museum at the University of New Mexico.

62 James Cockcroft, *Mexico: Class Formation, Capital Accumulation, and the State* (New York, 1983), p. 132.

63 Raquel Tibol, "Diego Rivera: Su visión de la mujer," in *Diego Rivera Hoy*, p. 128.

64 See *Luz Jiménez, símbolo de un pueblo milenario, 1897–1965* (Mexico City, 2000), pp. 46–47 (which is specifically on Rivera's *La maestra rural*). I would like to thank Teresa Eckmann for bringing this source to my attention.

65 "Gabriela Mistral en la escuela que lleva su nombre," *El Maestro: Revista de Cultura Nacional*, vol. 2 (April 1921).

66 Gabriela Mistral, "El poema de la madre," *El Maestro: Revista de Cultura Nacional*, vol. 2 (October 1921).

67 For a very different reading of the mural by Vasconcelos himself, see: Folgarait, *Mural Painting and Social Revolution in Mexico*, pp. 78–79.

68 Diego Rivera, "Edward Weston y Tina Modotti" (1926), in *Diego Rivera: Arte y política*, p. 64. On the work of Tina Modotti, as well as that of Weston, in Mexico, see: Margaret Hooks, *Photographer and Revolutionary* (New York, 1993), Amy Conger, *Edward Weston in Mexico, 1923–1926* (Albuquerque, 1983), and Andrea Noble, *Tina Modotti* (Albuquerque, 2000).

69 Rivera, "Edward Weston y Tina Modotti."

70 The word "contracorriente" comes from the original and quite challenging essays by one of Mexico's greatest art historians and art critics, Jorge Alberto Manrique. In a series of first-rate publications Manrique has challenged scholars to rethink the history of Mexican art. See, for example, Jorge Alberto Manrique, "Las contracorrientes de la pintura mexicana," in *IX Coloquio de historia del arte del Instituto de Investigaciones Estéticas* (Mexico City, 1986), pp. 259–66, plus several other essays and books by Jorge Alberto Manrique, such as: *Historia general del arte mexicano* (Mexico City, 1973); "Identidad o modernidad?" in Damián Bayón, ed., *América Latina en sus artes* (Paris, 1974), pp. 19–33; and "Otras caras del arte mexicano," in *Modernidad y modernización en el arte mexicano* (Mexico City, 1991), pp. 131–43.

71 On Surrealism in Mexico, see the standard work, a classic study in the field: Ida Rodríguez Prampolini, *El Surrealismo y el arte fantástico de México* (Mexico City, 1969). André Breton

not only organized Kahlo's first show in New York City, at the Julien Levy Gallery, he also wrote the catalogue essay. See: André Breton, preface to *Frida Kahlo de Rivera* (New York City, 1938).

72 The statement by Picasso was made to Rivera, who repeated it when he met Raquel Tibol in 1953. See: Raquel Tibol, *Frida Kahlo: Una vida abierta* (1983), tran. Elinor Randall (Albuquerque, 1993), p. 130. The most comprehensive book on Kahlo remains Hayden Herrera's extended study that first made Kahlo famous in the U.S.A., entitled simply *Frida: A Biography of Frida Kahlo* (New York, 1983). For a catalogue raisonné of Kahlo's works, see: Helga Prignitz-Poda, *Frida Kahlo: Das Gesamtwerk* (Frankfurt, 1988). For a solid overview of the Frida Kahlo literature, see: Holly Barnet-Sánchez, "Frida Kahlo: Her Life and Art revisited," *Latin American Research Review*, vol. 32, no. 3 (1997): pp. 243–57.

73 For the best account of the 1945 U.S.-backed military coup in Guatemala, see: Stephen Schlesinger and Stephen Kinzer, *Bitter Fruit: The Untold Story of the American Coup in Guatemala* (New York, 1982).

74 Fernández, *Arte moderno y contemporaneo de México*, vol. 2, p. 22: "El día de los muertos . . . Aquí la lección del cubismo está bien aprovechada."

75 On Liberation Theology, see chapter three of this book.

76 Kollantai is quoted by Octavio Paz in "Re/Visions: Mural Painting," in *Essays on Mexican Art*, tran. Helen Lane (New York, 1993), p. 141.

77 See: Craven, *Diego Rivera as Epic Modernist*, ch. 3.

78 Tibol, *Diego Rivera: Arte y política*, p. 51.

79 David Alfaro Siqueiros, "Lectures to Artists," *New University Thought* (winter 1962), p. 20.

80 Fernández, *Arte mexicano de sus orígenes*, pp. 161–63.

81 Antonio Rodríguez, *A History of Mexican Mural Painting* (London, 1968), pp. 191–92.

82 Del Conde, *Historia mínima*, p. 28 and Ades, *Art of Latin America*, p. 170.

83 Carlos Fuentes, *La muerte de Artemio Cruz* (Mexico City, 1964).

84 Jon H. Hopkins, *Orozco: A Catalogue of His Graphic Work* (Flagstaff, 1967), pp. 68–69.

85 The best overview of Orozco's politics is to be found in an excellent new study: Alejandro Anreus, *Orozco in Gringoland: The Years in New York* (Albuquerque, 2001). An earlier study attempted something similar but was less successful, because the author, Antonio González Mello, tried to show that Orozco was simply a reactionary figure from 1915 onward. The very question of locating a supposedly invariable political position on Orozco's part was a mistaken assumption from which to begin a monograph. In González Mello's short monograph, *Orozco? pintor revolucionario?* (Mexico

City, 1995), Mello provides a definition of the revolutionary that is too rigidly Leninist. He also has a tendency to conflate political intent with ideological critique, which is a fairly standard failing of doctrinaire leftist art history. Nonetheless, González Mello is a scholar of considerable intelligence and undeniable promise. Moreover, his Ph.D. dissertation at UNAM in 1998 on the iconography of works by Orozco, et al., about the machine was much better and more nuanced than the earlier monograph. See: Renato González Mello, "La maquina de pintar: Rivera, Orozco y la invención de un lenguaje" (unpublished Ph.D. dissertation, UNAM, 1998).

86 Anreus, *Orozco in Gringoland*.

87 Fernández, *Arte mexicano de sus orígenes*, pp. 164–65.

88 André Michel, *Histoire de l'art* (Paris, 1929). See also, André Malraux, "Los fresquitas revolucionarios de México," *Todo* (July 7, 1938): pp. 38–39.

89 Meyer and Sherman, *The Course of Mexican History*, pp. 569 ff.

90 Ibid, pp. 582–83.

91 Catlin, "Mural Census," pp. 252–59.

92 Karl Korsch, "The Leading Principles of Marxism," *Marxist Quarterly*, vol. 1, no. 3 (October–December 1937): pp. 356–78. For Schapiro's opinion of Korsch, see: David Craven, "Meyer Schapiro and Lillian Milgram: A Series of Interviews (1992–95)," *Res*, no. 31 (spring 1997), pp. 159–61. See also: David Craven, "Meyer Schapiro, Karl Korsch, and the Emergence of Critical Theory," *Oxford Art Journal*, vol. 17, no. 1 (1994): pp. 42–54.

93 Korsch, "The Leading Principles of Marxism," pp. 356 and 376.

94 Quoted by Leopoldo Zea in, "Positivism," in *Major Trends In Mexican Philosophy* (South Bend, 1966), p. 221.

95 Mikhail Lifshitz, *Karl Marx y la estética* (1933; Havana, 1976), p. 10. He refers to Rivera's use of "formas muy arcáicas" as well as to (on p. 33) Cézanne, Cubism and "semejantes tonterías."

96 José Carlos Mariátegui, *Siete ensayos de la realidad peruana* (Lima, 1928), tran. M. Urquidi, pp. 130–31.

97 Ibid., p. 278.

98 Catlin, "Mural Census," p. 261.

99 Rodríguez, *A History of Mexican Mural Painting*, p. 246. See also: Esther Acevedo, et al., *Guía de murales del centro histórico de la Ciudad de México* (Mexico City, 1984) and Esther Acevedo, "Las decoraciones que pasaron a ser revolucionarias," in *El nacionalismo y el arte de México*, IX Coloquio de Historia del Arte (Mexico City, 1986), pp. 180 ff.

100 For a more extensive analysis of this passage from Marx in relation to the Rivera murals, see: Craven, *Diego Rivera as Epic Modernist*, pp. 110–24.

101 Rochfort, *Mexican Muralists*, pp. 84–85.

102 For more on Brecht and Rivera as epic modernists, see Craven, *Diego Rivera as Epic Modernist*, pp. 119–24.

103 Ibid., pp. 88–89.

104 Leon Trotsky, "Art and Politics" (1938), in Paul Siegel, ed., *Leon Trotsky on Literature and Art* (New York, 1970), p. 110. This article was first published in *Partisan Review* in 1938.

105 Ibid.

106 Pablo González Casanova, *La democracia en México* (1965; Mexico City, 1993), pp. 26–28. See also: Pablo González Casanova, *El estado y los partidos políticos en México* (Mexico City, 1981); Pablo González Casanova, ed., *La clase obrera en la historia de México*, 22 vols. (Mexico City, 1983); and Nora Hamilton, *The Limits of State Autonomy: Post-Revolutionary Mexico* (Princeton, 1982).

107 Schmitt, *Communism in Mexico*, p. 12. See also Barry Carr, *Marxism and Communism in Twentieth-Century Mexico* (Lincoln, Nebraska, 1992).

108 James Cockcroft, *Mexico*, pp. 131–32. See also: Nathaniel and Sylvia Weyl, *The Reconquest of Mexico: The Years of Lázaro Cárdenas* (Oxford, 1939) and William Townsend, *Lázaro Cárdenas: Mexican Democrat* (Ann Arbor, Mich., 1952); plus, Lorenzo Meyer, *Mexico and the United States in the Oil Controversy, 1917–1942* (Austin, Tex., 1977).

109 Lázaro Cárdenas, "Diego Rivera," in *Testimonios sobre Diego Rivera*, p. 11. For two splendid tributes to Cárdenas himself by leading intellectuals of out time, see: Paul Sweezy, "A Great American: Lázaro Cárdenas (1962)," *Monthly Review*, vol. 40, no. 11 (April 1989): pp. 37–44 and Carlos Fuentes, *Nuevo tiempo mexicano*, pp. 156–58. To quote Fuentes: ". . . I have never seen a Mexican more loved, respected, and followed than Lázaro Cárdenas. To understand why, one had merely to hear him talking with the people."

110 For the most comprehensive treatment of the Rockfeller controversy, see: Irene Herner de Larrea, *Diego Rivera's Mural at the Rockefeller Center* (Mexico City, 1990).

111 For more on this, see: Craven, *Diego Rivera as Epic Modernist*, pp. 93–99.

112 Fuentes, *Nuevo tiempo mexicano*, pp. 35–44. This superb essay by Fuentes was originally occasioned by his review in the *New York Times Book Review* (March 13, 1988) of a very fine book by John Mason Hart, *Revolutionary Mexico* (Berkeley, 1987).

113 On Diego Rivera's profusion of Zapata portraits, see: Alberto Híjar, "Los Zapatas de Diego Rivera," in *Los Zapatas de Diego Rivera* (Mexico City and Cuernavaca, 1984), p. 22. As Híjar noted, "La única relación que Zapata tuvo con los pintores fue una entrevista con el Dr. Atl en 1915." As for Zapata himself and the Zapatistas, see two outstanding studies: John Womack, Jr., *Zapata and the Mexican Revolution* (New York, 1969) and Samuel Brunk, *Emiliano Zapata: Revolution and Betrayal in Mexico* (Albuquerque, 1996).

114 Carlos Fuentes, *Nuevo tiempo mexicano*, p. 35.

115 Alan Knight, "The Rise and Fall of Cardenismo," pp. 241–321. See also: Robert P. Millon, *Mexican Marxist: Vicente Lombardo Toledano* (Chapel Hill, N.C., 1966) and Joe Ashby, *Organized Labor and the Mexican Revolution under Cárdenas* (Chapel Hill, N.C., 1967).

116 Thomas Benjamin, *La Revolución: Mexico's Great Revolution as Memory, Myth, and History* (Austin, Tex., 2000), p. 39.

117 Ibid., p. 44.

118 Ibid., p. 39.

119 Venustiano Carranza, "Comentario a cada uno de los artículos del Plan de Guadalupe y a una programa política" (April 10, 1913), reprinted in *Planes de la Nación Mexicana* (Mexico City, 1987), vol. 7, p. 251.

120 See: Hall, *Álvaro Obregón*, chs. 11–14 and Knight, *The Mexican Revolution*, vol. 2, pp. 435 ff.

121 Emiliano Zapata, "Manifiesto a la Nación" (October 20, 1913), reprinted in *Planes de la Nación* (Mexico City, 1987), vol. 7, pp. 275–77. See also, Emiliano Zapata, "Manifiesto de Zapatistas al pueblo mexicano" (August 1914), reprinted in *Planes de la Nación*, vol. 7, pp. 312–14.

122 Antonio Díaz Soto y Gama, "Declaración en 1914," cited in Robert E. Quirk, *The Mexican Revolution, 1914–1915: The Convention of Aguascalientes* (Bloomington, 1960), p. 110.

123 Subcomandante Marcos, *Our Word is Our Weapon: Selected Writings*, ed. Juana Ponce de León (New York, 2001), p. 417. For the interchange between Subcomandante Marcos and Carlos Monsiváis, see: Carlos Monsiváis, *Mexican Postcards*, ed. and intro. John Kraniauskas (London, 1997), p. x. See also: Harvey Neil, *The Chiapas Rebellion* (Durham, N.C., 1998).

124 Jean Franco, *Plotting Women: Gender and Representation in Mexico* (New York City, 1989), p. 102. On the "Rise of Machismo" within the institutionalization of the Revolution, see also: Ilene V. O'Malley, *The Myth of the Revolution* (Westport, Conn., 1986).

125 Alexandra Kollentai, "Towards a History of the Working Women's Movement in Russia" (1920), in *Selected Writings*, tran. Alix Holt (New York, 1977), p. 40.

126 Ibid., p. 51.

127 Edmund Wilson, "Detroit Paradoxes," *New Republic* (July 12, 1933), p. 23. On the use of Rivera's murals to organize unions, see: Terry Smith, *Making the Modern* (Chicago, 1993), p. 235.

128 See, for example, Debroise, *Figuras en el trópico*; Karen Cordero, "The Politicization of Popular Art: A Study of Visual Culture in Mexico, 1921–1940" (unpublished Ph.D. dissertation, Yale University, 1983); and James Oles, *South of the Border* (Washington D.C., 1993).

129 Del Conde, *Historia mínima del arte mexicano*, p. 33.

130 Manuel Maples Arce, "Una prescripción estridentista" (A strident prescription) (1921), reprinted in Ades, *Art in Latin America*, tran. Polyglossia, p. 306. This manifesto originally appeared in *Revista Actual* in Mexico in December 1921. In the late 1990s there was an outstanding exhibition of prints produced by this movement at the Museo Nacional de la Estampa (National Museum of Prints): *El Estridentismo: Un gesto irreversible* (Mexico City, 1998). The catalogue included short essays by Béatriz Vidal de la Alba and Luis Mario Schneider. In all there were 145 items by the Estridentistas on exhibition.

131 Ibid., pp. 306–9.

132 Del Conde, *Historia mínima del arte mexicano*, pp. 114–15.

133 See, for example, Diego Rivera, "Manuel Álvarez Bravo" (1945) in *Diego Rivera: Arte y política*, pp. 297–99. For a short survey of his photos and the literature about them, see: *Manuel Álvarez Bravo,* Aperture Masters of Photography Series, no. 3 (New York, 1987). There have of course been other photographers of distinction, such as Lola Álvarez Bravo and Mariana Yampolsky. For perhaps the best overview to date of this material, see: Olivier Debroise, with Elizabeth Fuentes Rojas, *Fuga mexicana: un recorrido por la fotografía en México* (Mexico City, 1994). A revised English translation of this book by Stella de Sá Rego entitled *Mexican Suite* was published by the University of Texas Press in 2001. Leonard Folgarait has also begun work on a critical history of Mexican photography that promises to be a major study, as is true of his two previous books about modern Mexican art.

134 Pablo O'Higgins, letter to Grace and Marion Greenwood (June 12, 1934), Personal Papers of Robert Plate, East Hampton, Long Island. See: Oles, *South of the Border*, p. 187. On Pablo O'Higgins, see: Elena Poniatowski, *Pablo O'Higgins* (Mexico City, 1984). There is a genuine need for a new monographic study of Pablo O'Higgins's work.

135 Antonio Rodríguez, *A History of Mexican Mural Painting*, p. 242. For an excellent discussion of the public patronage for the murals, see: Esther Acevedo, "Dos muralismos en el mercado," *Plural*, vol. 11, no. 12 (October 1981): pp. 40–50. For a sense of the political debates that provided the setting for the Mercado murals, see: Francisco Reyes Palma, "Radicalismo artístico en el México de los años 30: una respuesta colectiva a la crisis," *Revista de la Escuela Nacional de Artes Plásticas*, vol. 2, no. 7 (December 1988–February 1989): pp. 5–10.

136 Helga Prignitz, *El Taller de Gráfica Popular en México, 1937–1977*, tran. Elizabeth Siefer (Mexico City, 1992), p. 21. This fundamental text and unsurpassed *catalogue raisonné* of TGP prints, by Prignitz, first appeared in Germany: TGP *Ein Grafiker-Kollectiv in Mexico von 1937–1977* (Berlin, 1981).

137 Jean Charlot, "Diego Rivera at the Academy of San Carlos," in *An Artist in Art: Collected Essays of Jean Charlot* (Honolulu, 1972), pp. 201–3. See also: Jean Charlot, *Mexican Art and the Academy of San Carlos, 1785–1915* (Austin, Tex., 1962). Finally, see: Ellen Sharp, "Rivera as Draftsman," in *Diego Rivera: A Retrospective* (1986), pp. 203–34.

138 See, for example, Orozco's praise of Posada: José Clemente Orozco, *Autobiografía* (Mexico City, 1945), p. 13: "el maestro Posada ilustraba todas esas publicaciones con grabados que jamás sido superados, si bién muy imitados hasta la fecha." For a recent monographic overview of Posada's prints, see: Patrick Frank, *Posada's Broadsheets: Mexican Popular Imagery, 1890–1910* (Albuquerque, 1998). For a general essay about Posada's overall import, see: Ilan Stavans, "José Guadalupe, Lampooner," *The Journal of Decorative and Propaganda Arts*, no. 16 (summer 1990): pp. 54–71.

139 See: *Diego Rivera y el arte de ilustrar* (Mexico City: Museo Dolores Olmedo Patiño, 1995). This catalogue, which overlooks Rivera's cover for *Amauta* in 1929, contains two insightful essays about the topic by Jorge Alberto Manrique and Armando Torres Michúa. As for the quite implausible claim by Siqueiros that, in the 1920s in Mexico, prints were more important than murals "to reach the masses," it was made in a pro-Stalinist, Popular Front symposium at the City Hall of New York City in 1936. See: David Alfaro Siqueiros, "The Mexican Experience in Art," in *Artists Against War and Fascism: Papers of the American Artists' Congress* (1936), reprinted by Rutgers University Press in 1986 with a new introduction by Matthew Baigell and Julia Williams, pp. 208–12. In fact, the least sectarian and most intelligent analysis by the Mexican contingent was not made by a stalwart member of the Partido Comunista, like Siqueiros, but by a "fellow traveler," José Clemente Orozco. See the paper Orozco read: "General Report of the Mexican Delegation to the American Artists' Congress" in *Artists Against War and Fascism*, pp. 203–7. This paper, like so many of Orozco's other antifascist political stands, disallows the simplistic designation of Orozco as a mere "reactionary."

140 For a sense of the overall number of prints by Orozco and Rivera, see: Jon H. Hopkins, *Orozco: His Graphic Work* (Flagstaff, 1967), which lists exactly forty-seven; and the *Diego Rivera: Catálogo General de Obra de Caballete* (Mexico City, 1989). As for Siqueiros, there is unfortunately no *catalogue raisonné* of his prints. For a reasonable estimation of Siqueiros's prints, see: *Mexican Prints From the Collection of Reba and Dave Williams* (Brooklyn Museum of Art, 1999), pp. 88–91, which counts ten lithographs by him.) For some informative overviews of Mexican prints in the twentieth century, see: Justin Fernández, *Litográfos y grabadores mexicanos contemporaneos* (Mexico City, 1944); Erasto Cortéz Júarez, *El grabado contemporaneo, 1922–1950* (Mexico City, 1951); and Hugo Covantes, *El grabado mexicano en el siglo xx, 1922–1981* (Mexico City, 1982).

141 As Justino Fernández noted in *Arte mexicano de sus orígenes*, p. 182: Mexican printmaking in the twentieth century took on "renewed energy" and "Without a doubt the most important and successful work has come from the Taller de Gráfica Popular." He then concluded quite justifiably: "Without deprecating the achievements of others, we might say that Leopoldo Méndez stands out in quality." The literature on the TGP certainly breaks down along those lines; the largest number of monographs are indeed about Leopoldo Méndez. Several of the more significant publications are as follows: *Leopoldo Méndez: 1902–1969* (Mexico City, Palacio de Bellas Artes, 1970); *Leopoldo Méndez: Artista de un pueblo en lucha* (Mexico City, 1981); B. Carrillo Azpeitia, *Leopoldo Méndez* (Mexico City, 1984); Francisco Reyes Palma, *Leopoldo Méndez: El oficio de grabar* (Mexico City, 1984); and *Codex Méndez: Prints by Leopoldo Méndez, 1902–1969* (Tempe, Ariz., 1999), with an essay by Jules Heller. Most recently, there has been a noteworthy dissertation written on him, which will appear as a book through the University of Texas Press: Debra Caplow, "Leopoldo Méndez, Revolutionary Art, and the Mexican Print: In Service of the People" (unpublished Ph.D. dissertation, The University of Washington, Seattle, 1999).

142 *El libro negro del terror nazi en Europa* (Mexico City, 1943), published by El Libro Libre. See: Debra Caplow, "Fighting with Prints: The Anti-Fascist Prints of Leopoldo Méndez and the Taller de Gráfica Popular," in David Craven and Kathleen Howe, eds., *A Partisan Press with Revolutionary Intent: The Work and Legacy of the Taller de Gráfica Popular* (Albuquerque, 2002 or 2003, forthcoming through the University of Mexico Press).

143 Hannes Meyer, ed., *Taller de Gráfica Popular, doce años de obra artística colectiva* (Mexico City, 1949). For more on Hannes Meyer's invaluable contribution to the TGP through his management of *La Editorial Estampa Mexicana*, see: Helga Prignitz, *El Taller de Gráfica Popular en México, 1937–1977*, pp. 79–88.

144 See Helga Prignitz's notable new essay on Hannes Meyer and Georg Stibi that will appear in 2002/3 in the forthcoming anthology *A Partisan Press with Revolutionary Intent.*

145 Taller de Gráfica Popular, *Declaración de Principios* (Mexico City, 1937), Archivo del Taller de Gráfica Popular, Mexico City. This manifesto was reprinted in some later publications, such

as, *El Taller de Gráfica Popular en México: 40 años de la lucha gráfica, 1937–1977*, with an essay by Alberto Híjar (Mexico City, 1977).

146 "Crítica Soviética" Archivo del Taller de Gráfica Popular, Mexico City. (This unpublished document consists of five memographed pages. It is kept with another three-page document that lists the TGP prints that were shown in Moscow.)

147 This whole debate about so-called "socialist realism" will be addressed by the editors, Kathleen Howe and myself, for the forthcoming book on the TGP, *A Partisan Press with Revolutionary Intent*.

148 Knight, "The Rise and Fall of Cardenismo," p. 256. In her noteworthy essay about the TGP in 1989 for *Art in Latin America*, Dawn Ades put it this way (pp. 181–82): "*Frente a Frente* included photographs and photo-montages . . . while the Taller de Gráfica Popular concentrated on prints—linocuts and woodcuts, as well as lithographs. There was a sense among the artists that this was part of a particularly Mexican tradition. . . . Printmaking was an appropriately public, popular medium."

149 David Alfaro Siqueiros, "Rectificaciones sobre las artes plásticas en México" (1932), reprinted in *Palabras de Siqueiros*, p. 60.

150 Ibid., p. 59.

151 Ibid., p. 61.

152 Taller de Gráfica Popular, *Declaración de Principios*, n.p. For two perceptive articles about the varied participants in the TGP, as well as the diverse legacies (and hence, competing constituencies) see: Alison Cameron, "*Buenos Vecinos*: African-American Printmaking and the Taller de Gráfica Popular," *Print Quarterly*, vol. 16, no. 4 (1999): pp. 353–67 and Alison Cameron, "In the Shadow of the *Chingada*: Women Artists and Gender Representation in the Taller de Grafica Popular," forthcoming in Craven and Howe, *A Partisan Press with Revolutionary Intent*.

153 Richard Harris, *Death of a Revolutionary* (New York City, 2000), pp. 37–38.

154 Traci Carl (AP News Service), "Scholars Want Mexico To Condemn Cuba's Abuses," *Albuquerque Journal* (April 12, 2001), p. A9. Not long before this book was going to press, the Secretary of State from the U.S.A. actually praised the social programs in Cuba since 1959. See: "Powell Offers Praise to Castro," *Albuquerque Journal* (April 27, 2001), p. A3.

155 In November of 1985, Editorial Nueva Nicaragua, a government press based in Managua, published an edition of 3,000 of David Alfaro Siqueiros's book, *Cómo se pinta un mural*. For an overview of who among the Nicaraguan and Internationalist muralists in Nicaragua was influenced by Siqueiros, see chapter three of this book and also: David Kunzle, *The Murals of Revolutionary Nicaragua, 1979–1992* (Berkeley, 1995), pp. 30, 45–49, 51–59, 70–71.

156 Leonard Folgarait, *So Far From Heaven: David Alfaro Siqueiros' "The March of Humanity" and Mexican Revolutionary Politics* (Cambridge, 1987). See also: *Siqueiros en Lecumberri: una lección de dignidad: 1960–1964* (Mexico City, 1999). For a fine recent assessment of these years in the national life of Mexico, see: John W. Sherman, "The Mexican 'Miracle' and Its Collapse," *The Oxford History of Mexico*, pp. 575–608. See also: Edwin Williams, *The Penguin History of Latin America* (London, 1992), pp. 378–409.

157 Jorge G. Castañeda, *Utopia Unarmed: The Latin American Left after the Cold War* (New York, 1993), pp. 24–25. The traditional date celebrated by the Party itself for the founding of the Partido Communista Mexicano is September 25, 1919. See: Schmitt, *Communism in Mexico*, p. 6. See also: Boris Goldenberg, *Kommunismus in Latein Amerika* (Stuttgart, 1971). For an outstanding overview of the troubling role of the Communist Party and the Comintern in Europe, as well as elsewhere, see: Wolfgang Abendroth, *Sozialgeschichte der europäischen Arbeiterbewegung* (Frankfurt am Main, 1965). Both *New Left Review* in London and *Monthly Review* in New York published English editions of this study, in 1972 and 1973 respectively.

158 Orozco, *Autobiografía*, p. 67: "*la socialización del arte* era promesa a muy largo plazo, puse no podía ser possible mientras no cambiara radicalmente la estructura de la sociedad. Además había que definir con exactitud el significado de la palabra '*socializar*' en relación con el arte, puse ha habido muchas y muy diferentes interpretaciones." (My italics.)

Two: The Cuban Revolution

1 Ernesto Che Guevara, "El socialismo y el hombre en Cuba" (1965), reprinted in *Escritos y Discursos*, vol. 8 (Havana, 1977), pp. 264–67. This famous essay first appeared in *Marcha* (March 12, 1965), a leftist publication based in Montevideo, Uruguay. For a one-volume collection that conveys the Renaissance-like range of Che's thought, see: Alejandro González Acosta, *Che, escritor* (Guadalajara, Mexico, 1989). On the thirtieth anniversary of his death, there were several books of note about him. The three best were the following: Jorge G. Castañeda, *Campañero: The Life and Death of Che Guevara* (New York, 1997); Jon Lee Anderson, *Che: A Revolutionary Life* (New York, 1997); and David Kunzle, *Che Guevara: Icon, Myth, and Message* (Los Angeles, 1997).

For the comments of Fidel Castro on the theme of there being no official "revolutionary" style, see Fidel Castro, "Palabras a los intelectuales" (1961), in Victor Lópe Lemus, ed., *Revolución, letras, arte* (Havana, 1980). In a 1967 interview with North American journalist Lee Lockwood, Fidel Castro was wary of any orthodox Marxist view that demanded the "correct" message in art. His comments were as follows: "We have very few qualified people as yet who could even try to give a Marxist interpretation of problems of art. . . . [Furthermore] without its necessarily having to carry a message [art] can give rise to a beneficial and noble feeling in human beings." This exchange is found in Lee Lockwood, *Castro's Cuba, Cuba's Fidel* (New York, 1969), pp. 110–11. The most sustained overview in English of these debates about art in Cuba since 1959 is to be found throughout the definitive book on the topic, Luis Camnitzer, *New Art of Cuba* (Austin, Tex., 1994).

On the general historiography of the Cuban Revolution, see: Oscar Zanetti Lecuna, "La historiografía de temática social (1959–1984)," *Revista de la Biblioteca Nacional "José Martí,"* vol. 27 (January–April 1985), pp. 5–17; Louis A. Pérez, Jr., *Historiography in the Revolution: A Bibliography of Cuban Scholarship, 1959–1979* (New York, 1979); Edwin Lieuwen and Nelson P. Valdés, eds., *The Cuban Revolution: A Research Guide to the Literature* (Albany, N.Y., 1971); and Ronald Chilcote, ed., *Cuba, 1953–1978: A Bibliographical Guide to the Literature*, 2 vols. (White Plains, N.Y., 1986).

2 Ernesto Cardenal, *En Cuba* (1972), tran. Donald D. Walsh (New York, 1974), p. 189. This book was based on two trips to Cuba in 1970 and 1971. About Fidel Castro's position on art, Cardenal notes: "Fidel has also said that he was opposed to any schools monopolizing art: 'I am in favor of the search for all types of styles, in music, in painting, in poetry, in drama, and in dance." (Slightly revised translation).

3 Ibid., p. 127.

4 Juan Acha, *Las culturas estéticas de América Latina* (Mexico City, 1993), pp. 161–62. See also: Alicia Valenzuela, "Dos libros del crítico de arte Juan Acha," *El Universal* (Mexico City, June 23, 1995), p. 2. Perhaps the most important art historian within Cuba of the Cuban Revolution is Adelaida de Juan. See for example: *Dos ensayos sobre plástica cubana* (Santiago, Cuba, 1972) and *Pintura y diseño gráfico de la Revolución* (Havana, 1989). See also Adelaida de Juan's essays in the UNESCO-funded anthology *América Latina en sus artes*, ed. Damián Bayón (Mexico City, 1974), pp. 34–44.

5 Roberto González Echevarría, "Criticism and Literature in Revolutionary Cuba," in *Cuba: Twenty-five Years of Revolution, 1959–1984*, ed. Sandor Halebsky and John M. Kirk (New York, 1985), p. 155. See the insightful interview of Roberto Fernández Retamar, Director of Casa de las Américas, by González Echevarría, "Roberto Fernández Retamar: An Introduction and an Interview," *Diacritics* (December 1978), pp. 70–88. For an innovative overview of key themes in Latin American literature more generally, see: Roberto González

Echevarría, *Myth and Archive: A Theory of Latin American Narrative* (Durham, N.C., 1998). See also: David William Foster, *Cuban Literature: A Research Guide* (New York, 1984); Lourdes Casal, ed., "The Cuban Novel, 1959–1969," *Abraxas*, vol. 1 (fall 1970), pp. 77–92; and Julio Martínez, ed., *Dictionary of Twentieth Century Cuban Literature* (Westport, Conn., 1990).

6 I. F. Stone, prefatory note (1967), to Che Guevara's *La guerra de guerrillas* (1960), tran. J. P. Morray (New York, 1969), p. ix. The first publication in English of Che's book was by Monthly Review Press in 1961.

7 For one of the many invaluable studies on this topic by one of the main experts on U.S.—Cuban relations, see: Wayne S. Smith, *The Closest of Enemies: A Personal and Diplomatic Account of U.S.—Cuban Relations Since 1957* (New York, 1987). See also the review of this book by Jorge G. Castañeda, "Checking the Colossus of the North," *New York Times Book Review* (March 1, 1987), p. 18. There are several other books of importance on this topic, which include: Philip Foner, *A History of Cuba and Its Relations with the United States*, 2 vols. (New York, 1965); Louis A. Pérez, Jr., *Cuba and the United States: Ties of Singular Intimacy* (Athens, Ga., 1990); Jorge I. Domínguez, *To Make the World Safe for Revolution: Cuba's Foreign Policy* (Cambridge, 1989). The earliest (and still a notable) book along these lines is William Appleman Williams, *The U.S., Cuba, and Castro* (New York, 1961). The latest book of note is: Jane Franklin, *Cuba and the United States: A Chronological History* (New York, 1997).

Finally, see the various essays about this issue in the indispensable anthology titled *The Cuba Reader: The Making of a Revolutionary Society*, ed. P. Brenner, William M. LeoGrande, Donna Rich, and Daniel Siegel (New York, 1989). For a very fine, even definitive, look at how the immigration policy of the U.S.A. has distorted the relationship with Cuba, see: Félix Masud-Piloto, *With Open Arms* (Totowa, N.J., 1988).

8 On the use of the Pop portrait in Cuban art, see: David Kunzle, "Uses of the Che Poster," *Art in America*, vol. 63, no. 5 (October 1975), pp. 66–73. On the remarkable innovativeness of Cuban cinema, see: Michael Chanan, *The Cuban Image: Cinema and Cultural Politics* (Bloomington, 1985); Julianne Burton, *Cinema and Social Change in Latin America: Conversations with Filmmakers* (Austin, Tex., 1986); and Ira Jaffe and Diana Robin, eds., *Redirecting the Gaze: Third World Cinema* (Albany, N.Y., 1999).

9 Gerardo Mosquera, introduction to *New Art From Cuba* (Old Westbury, 1985), p. 1. See also: Gerardo Mosquera, "Raices en acción," *Revolución y Cultura* (Havana), no. 2 (February 1988), p. 33; Gerardo Mosquera, "New Cuban Art: Identity and Popular Culture," *Art Criticism*,

vol. 6, no. 1 (1989), pp. 57–65; and Gerardo Mosquera, "Regionalism and Mainstream," *New Art Examiner*. vol. 17, no. 3 (November 1989), pp. 13–14.

Despite the fact that Gerardo Mosquera is probably the most internationally recognized art critic from Latin America—and it was quite appropriate that he be the editor of the single most noteworthy anthology of art criticism from Latin America to date, *Beyond the Fantastic* (MIT, 1996)—there is still no large collection of his essays available in English. From the late 1980s through the early 1990s, Colleen Kattau and I co-translated (with personal input from Mosquera himself) twenty-five of his best known articles, in the hope of finding a U.S. publisher with the tentative title in 1991–92 of Mosquera's *Post-Colonial Art Criticism: A Selection*. Moreover, publication of the anthology was actively supported by such major art critics from the United States as Dore Ashton and Lucy Lippard. We were unsuccessful, however, in finding a publisher, so the historiographic void in contemporary art criticism remains in place north of the Caribbean basin. At some point, though, a collection of Mosquera's writings (and also those of Marta Traba and Juan Acha) will appear in a mass circulation English translation for the Anglo-American artworld. When that happens, a great service will have been done to advance our understanding of recent art history throughout the Americas.

10 An instructive way to follow the twists and turns of Cuban cultural policy—and the concepts on which it has been based—is to examine symptomatic essays from the 1960s, 1970s, and 1980s. There are five primary sources that seem to chart the trajectory of the visual arts better than almost any other commentaries. They are, in chronological order, the following: Che Guevara's essay from 1965 noted above, "El socialismo y el hombre en Cuba"; Jaime Saruski and Gerardo Mosquera's monograph through UNESCO from 1979, *The Cultural Policy of Cuba* (Paris, 1979); a discussion from 1983 by the Minister of Culture, Armando Hart Dávalos, *Cambiar las reglas del juego* (Havana; 1983); Gerardo Mosquera, "La función social de las artes plásticas dentro la Revolución," *El Caimán Barbudo* (Havana), vol. 19, no. 212 (July 1985), pp. 11–12; and Osvaldo Sánchez, "The Children of Utopia," *Third Text* (summer 1989), pp. 33–40. Among the art critics who emerged at the end of the 1980s, Abdel Hernández San Juan deserves special mention for his defense of the "third generation." For much the best overview of all these developments, see the book by Luis Camnitzer: *New Art of Cuba* (Austin, Tex., 1994). An expatriot from Uruguay living in the U.S.A. at present, Luis Camnitzer is not only an outstanding artist and excellent critic, he is also the foremost non-Cuban expert on Cuban art

since *Volumen Uno*. For an examination of Luis Camnitzer's significance as an *engagé* artist, see: Heather Van Vooren, "Luis Camnitzer: Critical Reality" (unpublished masters thesis, University of New Mexico, 2000).

11 LeoGande, "Mass Political Participation in Socialist Cuba," pp. 196 ff.

12 Ibid.

13 Armando Hart Dávalos, *Cambiar las reglas*, pp. 12–13: "A lo que aspiramos . . . es a que el arte penetre en todos las esferas de la vida. Incluso en la esfera de la industría."

14 *Primer Congreso de Educación y Cultura* (Havana, 1959). pp. 1–5. Cited in Julianne Burton, "Film and Revolution in Cuba," in *Cuba: Twenty-Five Years*, p. 135.

15 Pat Aufderheide, "Cuba Vision: Three Decades of Cuban Film," *The Cuban Reader*, pp. 498–501. See also: Michael Chanan, *The Cuban Image*, pp. 1–10; Douglas Martin, "Cubans Are Out in Force at the 11th Toronto Film Festival," *New York Times* (September 14, 1980), p. 13; and Karen Wald, "Can Cuban Filmmaking Break the Blockade?" *Guardian* (New York, January 28, 1987), p. 20.

16 Judith Weiss, *Casa de las Américas: An Intellectual Review in the Cuban Revolution* (Madrid, 1977). See also: Paul C. Smith, "Theater and Political Criteria in Cuba: Casa de las Américas Awards, 1960–1983," *Cuban Studies/Estudos Cubanos*, vol. 14 (winter 1984), pp. 43–47.

17 Saruski and Mosquera, *Cultural Policy of Cuba*, pp. 25 ff; Marvin Leiner, "Cuba's Schools: Twenty-Five Years Later," in *The Cuba Reader*, pp. 445–56. See also: Samuel Bowles, "Cuban Education and Revolutionary Ideology," *Harvard Educational Review*, vol. 41, no. 4 (November 1971), pp. 472–500.

18 Paulo Freire, *Pedagogy of the Oppressed* (1968), tran. Myrna Bergman-Ramos (New York, 1970). This brilliant book post-dated the Cuban *Alfabetización* and can be seen as a constructive criticism of it.

19 Jonathan Kozol, *Children of the Revolution* (New York, 1978), pp. 18–19 and also: Jonathan Kozol, "A New Look at the Literacy Campaign in Cuba," *Harvard Educational Review*, vol. 48, no. 2 (August 1978), pp. 341–77.

20 Sandra Levinson, "Talking About Cuban Culture," in *The Cuba Reader*, pp. 491–92.

21 Fidel Castro, *De los recuerdos de El Bogotazo y Hemingway: Dos entrevistas* (Havana, 1984). See also: Mireya Navarro, "Cuba Preserves the Hemingway Mystique," *International Herald Tribune* (April 24–25, 1999), p. 22; and Jim Lo Scalzo, "Hemingway's Cuba," *U.S. News and World Report* (May 26, 1997), pp. 62–65.

22 Tennessee Williams, *Memoirs* (New York, 1975), pp. 84–86. For an interesting account of Graham Greene's various visits to revolutionary Cuba, see: Tom Miller, "In Search of Graham Greene's Havana," *Cuba Update* (summer 1991), pp. 38–40.

23 Jean-Paul Sartre, *Sur Cuba* (1961, Westport, Conn., 1974), pp. 8, 14, 98–100. For a comparable account by a major U.S. intellectual on the Left during the same period, see: C. Wright Mills, *Listen Yankee: The Revolution in Cuba* (New York, 1960).

24 Interview of Roberto Segre by this author, Havana, July 31, 1984. Segre's glowing praise for Cubanacán and his subtle analysis of the innovativeness of this architecture contradicted in certain respects the analysis of the Cuban "reception" of Cubanacán that is currently being circulated in the U.S.A. by architectural historians like John Loomis who use the quotation by Mosquera in a cavalier way. See: John Loomis, *Revolution of Forms: Cuba's Forgotten Art Schools* (Princeton, 1999). For the best account by a scholar living in Cuba (actually, Segre is Argentinian), see: Roberto Segre, *Ensayos sobre arquitectura e ideología en Cuba revolucionaria* (Havana, 1970); Roberto Segre, *Arquitectura, historia y revolución* (Guadalajara, 1981); and Roberto Segre, *Arquitectura e urbanismo de la revolución cubana* (Havana, 1989).

25 Camnitzer, *New Art of Cuba*, pp. 159, 167.

26 Saruski and Mosquera, *Cultural Policy of Cuba*, p. 25.

27 Leiner, "Cuba's Schools: Twenty-Five Years Later," p. 31.

28 "Informe Central de Fidel Castro al Congreso del Partido Comunista de Cuba," *El Militante Comunista* (April 1986), pp. 22–26.

29 Burton, "Film and Revolution," p. 136.

30 Saruski and Mosquera, *Cultural Policy of Cuba*, p. 25.

31 Judith Weiss, "The Emergence of Popular Culture," in *Cuba: Twenty-Five Years*, pp. 119–20, 124–25. See also Mirta de Armas, "Casas de Cultura," *Revolución y Cultura*, vol. 61 (1977), pp. 27 ff.

32 Pierre Bourdieu, *Distinction: A Social Critique of the Judgment of Taste*, tran. Richard Nice (Cambridge, Mass., 1984), p. 7.

33 Pierre Bourdieu and Alain Darbel, *L'Armour de l'art* (Paris, 1969), appendix 5, table 4.

34 Ibid., appendix 5, table 8.

35 Bourdieu, *Distinction*, p. 411.

36 Osvaldo Sánchez, "Elogio de Poncio Pilato," *El Caimán Barbudo* (June 1988), pp. 16–17. See also: Osvaldo Sánchez, "La llama de la parodía," *El Caimán Barbudo* (April 1988), pp. 2–4; and Osvaldo Sánchez, *Programa de segundo año, especialidad de pintura* (Havana, 1990).

37 Jeanne Brody, "Cuban Culture Dances to a Popular Beat," *International Herald Tribune* (November 23, 1984), pp. 9–10.

38 Tomás Gutiérrez Alea, *Dialéctica del espectador* (Havana, 1982), appendix. See also: Julio García Espinosa, "Para un cine imperfecto" (1970), tran. J. Burton, in M. Chanan, ed., *Twentieth-Five Years of Latin American Cinema* (London, 1983); and Julio García Espinosa, "Cinco pre-

guntas a ICAIC," *Cine al día*, vol. 12 (March 1971), pp. 22 ff.

39 Dan Georgakas, "Controversial Cuban *Lejanía* Opens," *Guardian* (New York, September 30, 1985), p. 20. For a look at how the U.S. Government has itself censored Cuban films, see: Gary Crowdus, "The Spring 1972 Cuban Fim Festival Bust," *Film Society Review*, vol. 7, nos. 7–9 (March–May 1972), pp. 23–26. For Tomás Gutiérrez Alea's response, see: Burton, *Cinema and Social Change in Latin America*, pp. 115–32.

40 Ibid.

41 Ibid.

42 Dennis West, "Strawberry and Chocolate, Ice Cream and Tolerance: Interviews with Tomás Gutiérrez Alea and Juan Carlos Tabío," *Cineaste*, vol. 21, no. 1–2 (1994), pp. 16–20 and Mario Enrico Santi, "*Fresa y Chocolate*: The Rhetoric of Cuban Revolution," *MLN*, vol. 113 (1998), pp. 407–25.

43 Burton, *Cinema and Social Change in Latin America*, p. 117.

44 Tomás Gutiérrez Alea, *Dialéctica del espectador*.

45 Nelson Herrera Ysla, "Coloquialismo," in *Canto Libre*, vol. 3, no. 7 (1979), p. 5.

46 Alfredo Guevara, *Statement* (c.1965), cited in Majorie Rosen, "The Great Cuban Film Fiasco," *Saturday Review* (June 17, 1972), p. 53.

47 Tomás Gutiérrez Alea, *Dialéctica del espectador*. ch. 6.

48 Alice Walker, "Secrets of the New Cuba," *Ms*, vol. 6, no. 3 (September 1977), p. 99. On Black filmmakers in Cuba, see Julianne Burton and Gary Crowdus, "Cuban Cinema and the Afro-Cuban Heritage: An interview with Sergio Giral," *The Black Scholar*, vol. 10, no. 8–10 (summer 1977). See also: Richard L. Jackson, *The Black Image in Latin American Literature* (Albuquerque, 1976) and Pedro Pérez Sarduy and Jean Stubbs, ed., *Afro-Cuba: An Anthology of Cuban Writers on Race, Politics and Culture* (New York, 1993).

49 Alice Walker was—along with many other famous intellectuals like Noam Chomsky, Paul Sweezy, and Stephen Jay Gould—a sponsor of the International Peace Rally for Cuba to End the Blockade that took place on January 25, 1992 in New York City at the Javits Convention Center. The author of this book was also a cosponsor of this rally and attended the one in Manhattan.

50 Nicolas Guillén, *Obra poética* (Havana, 1972); Angel Augier, *Nicolas Guillén* (Havana, 1972); Keith Ellis, *Cuba's Nicolas Guillén* (Toronto, 1983); and Nancy Morejón, ed., *Recopilación de textos sobre Nicolas Guillén* (Havana, 1974).

51 Mike González and David Treece, *The Gathering of Voices: Twentieth Century Poetry of Latin America* (London, 1992), p. 129.

52 González Echevarría, "Criticism and Literature in Revolutionary Cuba," pp. 154–73.

53 The lyrics were reprinted in Cardenal, *En Cuba*, p. 75. See also: Leonardo Acosta, "La Nueva Trova," *Revolución y Cultura*. vol. 63

(1977), pp. 80–83; Sergio Fernández Barroso, "La música en Cuba durante la etapa revolucionaria," *Revista de la Biblioteca Nacional "José Martí,"* vol. 21 (May–August 1979), pp. 119–31. For a "classic" examination of the older backdrop for recent music more generally, see Alejo Carpentier, *La música en Cuba* (Havana, 1961).

54 Judith Weiss, "The Emergence of Popular Culture," in *Cuba: Twenty-Five Years*, pp. 119–20. See also: Carlos Padrón, "Conjunto Dramático de Oriente," *Revolución y Cultura*, no. 64 (1977), pp. 64–72 and Randy Martin, *Socialist Ensembles: Theater and State in Cuba and Nicaragua* (Minneapolis, 1994).

55 Graziella Pogolotti, *Teatro Escambray* (Havana, 1978); Laurette Sejourne, *Teatro Escambray: Una experiencia* (Havana, 1980); and Randy Martin, *Socialist Ensembles*, pp. 130–32.

56 Quoted from an interview in Margaret Randall, "To Create Themselves: Women in Art," *Women in Cuba* (Brooklyn, 1980), p. 111.

57 James Petras (with Morris Morley), "The Cuban Revolution," in *Cuba: Twenty-Five Years*, p. 431.

58 Andrew Zimbalist, "Cuban Economic Planning," in *Cuba: Twenty-Five Years*, pp. 217–18. See especially: Linda Fuller, *Work and Democracy in Socialist Cuba* (Philadelphia, 1992); Frank T. Fitzgerald, *Managing Socialism* (New York, 1990); and Dawn Keremitis, "Women in the Workplace," in *Cuba: A Different America*, pp. 102–15.

59 JUCEPLAN, *Segunda Plenaria Nacional de la Implantación del SOPE* (Havana, 1976), p. 27.

60 Joaquín Benavides Rodríguez, "La Ley de la distribución con arreglo al trabajo," *Cuba Socialista* (March 1982), pp. 70–73; and Marifeli Pérez-Stable, "Class, Organization, and *Consciencia*: The Cuban Working Class After 1970," in *Cuba: Twenty-Five Years*, pp. 291–306.

61 Benavides Rodríguez, "La Ley de la distribución con arreglo al trabajo."

62 Aufderheide, "Cuba Vision: Three Decades of Cuban Film," p. 503.

63 James Petras, "The Cuban Revolution in Historical Perspective," in *Politics and Social Structure in Latin America* (New York, 1970), pp. 180 ff. This is yet another indispensable book of the period that was published by Monthly Review Press. On the class make-up of the Cuban Revolution of 1959, see: Dennis B. Ward, "The Revolution: Class Relations and Political Conflict in Cuba, 1868–1968," *Science and Society*, vol. 34 (spring 1970), pp. 1–41; Hugh Thomas, "The Fall of the Bourgeoisie: Politics and the Cuban Revolution," in Claudio Veliz, ed., *The Politics of Conformity in Latin America* (New York, 1967), pp. 249–77; and Alfred L. Padula, Jr., "The Fall of the Bourgeoisie: Cuba, 1959–1961" (unpublished Ph.D. dissertation, University of New Mexico, 1974).

For related issues, see: Louis A. Pérez, Jr., *The Cuban Revolutionary War, 1953–1959: A Bibliography* (Metuchen, N.J., 1976); Sheldon B. Liss, *Roots of Revolution: Radical Thought in Cuba* (Lincoln, Nebraska, 1987); Sheldon B. Liss, *Fidel! Castro's Political and Social Thought* (Boulder, 1994); Martin Kenner and James Petras, eds., *Fidel Castro Speaks* (New York, 1969); and Roland E. Bonachia and Nelson P. Valdés, eds., *Revolutionary Struggle, 1947–1958: Selected Works of Fidel Castro* (Cambridge, Mass., 1972).

64 Petras, "The Cuban Revolution in Historical Perspective," pp. 180 ff.

65 Ibid.

66 Pérez, Jr., *Cuba: Between Reform and Revolution*, p. 397.

67 Michael Robertson, "A Cuban Ballet Star Who Cuts Sugar Cane," *New York Times* (July 15, 1979), pp. D 18 ff. See also: Miguel Cabrera, *Orbita del Ballet Nacional de Cuba: 1958–1979* (Havana, 1979); Aurora Bosch, "Desarrollo de la danza en Cuba," *Revista de la Biblioteca Nacional "José Martí,"* vol. 21 (May–August 1979), pp. 89–102; and Araon Segal, "Dance and Diplomacy: The Cuban National Ballet," *The Caribbean Review*, vol. 9 (winter 1980), pp. 30–32.

68 Frantz Fanon, *Les damnés de la terre* (Paris, 1961). Preface by Jean-Paul Sartre. See also: Nigel C. Gibson, ed., *Rethinking Fanon: The Continuing Dialogue* (Amherst, N.Y., 1999), which contains key essays by Homi Bhabha, Edward Said, and Henry Louis Gates, Jr.

69 Fanon, *Les damnés de la terre*.

70 Benedict Anderson, *Imagined Communities* (London, 1983). A revised edition was published in 1991. For a measured critique of Anderson's position, see Nicola Miller, *In the Shadow of the State* (New York, 1999), pp. 38–40. If Anderson tends to emphasize the construction of identity as a consequence of a shared popular culture (of a "popular nationalism"), E. J. Hobsbawm and others tend to accent the construction of identity as a formative political project of a revolutionary or reformist state. See: E. J. Hobsbawm, "Nationalism and Nationality in Latin America," in *Pour une histoire economique et sociale internationale*, ed. B. Etemad, J. Baton, and T. David (Geneva, 1995), pp. 313–23.

71 Carl Rowan, "An Answer to Mandela's Critics," *The Cortland Standard* (June 28, 1990), p. 8. Just as Mandela commended the Cuban Government's consistent opposition to Apartheid, so he also praised the social programs in Cuba as future models for a post-Apartheid system. Similarly, Luiz Inacio da Silva, the leader of the powerful Workers' Party in Brazil (which won 48 percent of the vote nationally in 1989) expressed admiration for the Cuban Revolution. According to a U.S. journalist: "Stressing that Brazil will choose its own path, Mr. da Silva argued that many Americans have a skewed vsion of Cuba. . . . 'But one thing can't be argued—Cuba is the only country on our continent which has no hunger, which has the lowest infant mortality rate, which has the highest standard of education,' said Mr. da Silva." See: James Brooke, "Labor Nominee, a Front-Runner in Brazil," *New York Times* (April 30, 1989), p. A3.

72 Samir Amin, "Crisis, Nationalism, and Socialism," in *Dynamics of Global Crisis*, cowritten by Samir Amin, Giovanni Arrighi, André Gunder Frank, and Immanuel Wallerstein (New York, 1982), pp. 167–232.

73 Antonio Gramsci is cited numerous times by Tomás Gutiérrez Alea in such books as *Dialéctica del espectador*. For his influence and that of José Carlos Mariátegui, see: Donald Hodges, *Intellectual Foundations of the Nicaraguan Revolution* (Austin, Tex., 1986), pp. 179 ff and Michael Löwy, *Le Marxisme en Amérique Latine* (Paris, 1980), pp. xxi–xxiii.

74 Cardenal, *En Cuba*, p. 189.

75 Gerardo Mosquera, "Volumen Uno," *Centro de Arte Internacional* (Havana, 1981). See also: Gerardo Mosquera, "*Volumen I*: Cambio en la plastica cubana," *Arte en Colombia*, no. 40 (May 1989), pp. 48–51. For critical commentaries by other Cuban critics supporting this movement, see the essays by Erena Hernández, Antonio Eligio (Tonel), and Osvaldo Sánchez. For example: Erena Hernández, "El único sitio posible: entrevista con Ricardo Rodríguez Brey," *Revolución y Cultura*, no. 9 (September 1988), pp. 73–74; Tonel, "Arte para llevar puesto," *El Caimán Barbudo*, vol. 22, no. 249 (August 1988), pp. 4–5; Tonel, "Umberto Peña expone: un rayo que no cesa," *Revolución y Cultura*, no. 9 (September 1988), pp. 26–31; Osvaldo Sánchez, "La llama de la parodía," *El Caimán Barbudo*, no. 6 (June 1988), pp. 2–4; and Osvaldo Sánchez, *Programa de segundo año, especialidad de pintura* (Havana, 1990).

76 Mosquera, "New Cuban Art," pp. 57–65.

77 Stuart Hall, "The Local and the Global" and "Old and New Identies, Old and New Ethnicities," in Anthony King, ed., *Culture, Globalization and the World System* (Binghamton, 1991), pp. 19–68. For a more sustained discussion of Hall's position, see: David Craven, "The Visual Arts and the Cuban Revolution," *Third Text*, no. 20 (autumn 1992), pp. 77–102.

78 See: Eva Cockcroft, "The Cuban Poster," in *Cuban Poster Art, 1961–1982* (New York, 1983), pp. 3–7; Dugald Stermer and Susan Sontag, *The Art of Revolution*; or Stephanie Rugoff, "Posters from and for the People," *Cuba Resource Center Newsletter*, vol. 3 (October 1973), pp. 15–18.

79 Cockcroft, "The Cuban Poster."

80 Ibid.

81 Fernand Léger, "Notes sur l'element mécanique" (1923), in *Fonctions de la peinture* (Paris, 1944). For more on this interchange with mass culture, see: Kirk Varnadoe and Adam Gopnik, *High and Low: Modern Art and Popular Culture* (New York, 1991), pp. 286–93.

82 Susan Sontag, "Posters: Advertisement, Art, Political Artifact, Commodity," in *The Art of Revolution*, pp. vii–viii. See also: John Barnicoat, *A Concise History of Posters* (Oxford, 1979), pp. 7–29.

83 See: Arturo Agramonte, *Cronología del cine cubano* (Havana, 1966) and Belkis Espinosa and Jorge Luis Llópez, *Cine Cubano: 30 Años en Revolución, 1959–1989* (Havana, 1989). Portocarrero's poster was made for the film *Soy Cuba* (1964), which was directed by Mikhail Kalatozov of the USSR. The film was deeply influenced by Soviet cinema of the 1920s and by Russian Constructivism. For more on the significance of Russian avant-garde art from the 1920s for Cuban art after 1959, see Gerardo Mosquera, *El diseño se definió en Octubre* (Havana, 1989).

84 Alejo Carpentier, "Color de Cuba: René Portocarrero" (1963), reprinted in *René Portocarrero: Exposición Antológica* (Madrid: Museo Español de Arte Contemporaneo, 1984), pp. 24–25. See also: Roberto Fernández Retamar, "Portocarrero: Color de Cuba," *Cuba, una revista*, vol. 2, no. 16 (August 1963), pp. 54–59; Adelaida de Juan, "La ciudad es una mujer," *Revolución y Cultura*, no. 120 (August 1982), pp. 49–51; and José Lezama Lima, "Homenaje a René Portocarrero," in *La cantidad hechizada* (Havana, 1970), pp. 361–403. For a review of the Portocarrero show in Spain, see: Carlos Santa Cecilia, "El descubrimiento de Cuba," *El País* (Madrid, December 2, 1984), p. 42.

85 Camnitzer, *New Art of Cuba*, pp. 108, 277.

86 Juan A. Martínez, "The Los Once Group and Cuban Art in the 1950s," in *Guido Llinás and Los Once After Cuba* (Miami, 1997), pp. 5–10.

87 Interview with Raúl Martínez by Sandra Levinson, Havana, 1984. On videotape at the Center for Cuban Studies in New York City.

88 Shifra Goldman, "Painters into Postermakers: A Conversation with Two Cuban Artists [Raúl Martínez and Alfredo Rostgaard]" (1984), in *Dimensions of the Americas* (Chicago, 1994), pp. 146–47. See also: Felix Beltrán, *Acerca del diseño* (Havana, 1975); Eva Cockcroft, "Art in Cuba Today: An Interview with Felix Beltrán," *Art in America*, vol. 61, no. 1 (January 1980), pp. 9–11; Eva Cockcroft, "Art and politics: An Interview with Raúl Martínez and Marucha (María Eugenia Haya)," *Art in America*, vol. 71, no. 11 (December 1983), pp. 35–41; and *Cuban Photography, 1959–1982* (New York City 1983).

89 Interview with Alfredo Rostgaard by Sandra Levinson, Havana, 1967, cited in Sandra Levinson, "Talking About Cuban Culture," p. 495.

90 Groupe de Recherche d'Art Visuel, *Propositions sur le mouvement* (Paris, 1961), reprinted in Jack Burham, *Beyond Modern Sculpture* (New York, 1968), pp. 250–51. See also: Guy Brett, "A Radical Leap," in Dawn Ades, *Art in Latin America* (New Haven and London, 1989), pp. 253–84.

91 See: David Kunzle, "Uses of the Che Poster," p. 66. See also: Matthew Cullerne Bown, *Socialist Realist Painting* (New Haven and London, 1998).

92 Kunzle, "Uses of the Che Poster."

93 Karl Marx, letter to W. Blos (November 10, 1877), in Robert Tucker, ed., *The Marx-Engels Reader* (New York, 1972), p. 52. See also, Margaret A. Rose, *Marx's Lost Aesthetic: Karl Marx and the Visual Arts* (Cambridge, 1984).

94 Gerardo Mosquera, "Raúl Martínez," in *Nosotros: Exposición antológica de Raúl Martínez* (Havana, 1992), n.p.

95 Ibid.

96 Andreas Huyssen, "The Cultural Politics of Pop" (1975), in *After the Great Divide* (Bloomington, 1986). See also: Gary Garrels, ed., *The Work of Andy Warhol* (Seattle, 1989).

97 On the development of *realismo mágico*, see: Jean Franco, *An Introduction to Spanish-American Literature* (1969; Cambridge, 1994), p. 318. As she has noted, it was Alejo Carpentier who, in 1943, in the introduction to his novel *El reino de este mundo* spoke of "lo real maravilloso" as a defining trait of art in the Americas. Subsequently, in 1956 Jacques Stephen Alexis wrote an essay titled "Of the magical realism of Haitians," in *Presence Africaine* (Port-au-Prince, 1956). See also: Fredric Jameson, "On Magical Realism in Film," *Critical Inquiry*, no. 12 (winter 1986), pp. 301–25; Roberto González Echevarría, "Carpentier y el realismo mágico," in Donald Yates, ed., *Otros Mundos, otros fuegos* (East Lansing, 1975), pp. 221–31; and Angel Flores, "Magic realism in Spanish American Fiction," in *Hispania*, no. 38 (May 1955), pp. 187–92.

98 See: Enrique Fernández, "Razzing the Bureaucracy: The Cuban Cinema of Tomás Gutiérrez Alea," *Village Voice* (March 25, 1985), pp. 45, 111; Edward González, "The Party Congress and *Poder Popular*," *Cuban Studies/Estudios Cubanos*, vol. 6 (July 1976), pp. 39–65; Joachím Benavides Rodríguez, "La ley de la distribución con arreglo al trabajo," *Cuba Socialista* (March 1982), pp. 70–73; Marifeli Pérez-Stable, "Institutionalization and Workers Response," *Cuban Studies/Estudios Cubanos*, vol. 6 (July 1976), pp. 31–54.

99 Camnitzer, *New Art of Cuba*, p. 12.

100 Antonio Núñez Jiménez, *Wifredo Lam* (Havana, 1982). This study documents the friendship and artistic interchange between Lam and Jackson Pollock: "Lam, con su presencia en Nueva York, influyó en el gran pintor Jackson Pollock. . . . [Pollock] Invitaba frecuentemente a Lam a pasar en su casa el *week end*, durante sus estancias en Nueva York" (p. 183). See also: *Wifredo Lam and His Contemporaries, 1938–1952* (New York, 1992), especially the essay by Lowry Sims on Lam and the New York School. For Lam's importance to the "generation of 1980," see: Gerardo Mosquera, "Modernidad y Africanía: Wifredo Lam en su isla," in *Wifredo Lam* (Madrid, 1992), pp. 21–42.

101 Mosquera, "Raices en acción," p. 32. See also Gerardo Mosquera, "La buena forma de las formas malas," *Unión: Revista de UNEAC*, no. 2 (1984), pp. 35–48.

102 Camnitzer, *New Art of Cuba*, Ch. 1.

103 Ibid., pp. 6–7.

104 Mosquera, "Raices en acción," p. 32. See also: Gerardo Mosquera, "Regionalism and Mainstream," *New Art Examiner* (November 1989), pp. 13–14. The art criticism from the U.S. about the art produced by the "generation of 1980" is instructive. See three essays by Cockcroft and two by Lippard: Eva Cockcroft, "Apolitical Art in Cuba?" *New Art Examiner* (December 1985), pp. 33–34; Eva Cockcroft, "Kitsch in Cuba," *Artforum*, vol. 22, no. 10 (summer 1985), pp. 72–73; Eva Cockcroft, "Cuba Exports Post-Modernism," *New Art Examiner* (April 1988), pp. 33–34; Lucy Lippard, "Running the U.S.–Cuban Blockade," *Village Voice* (February 11–18, 1981) p. 83; and Lucy Lippard, "Made in the U.S.A.: Art from Cuba," *Art in America*, vol. 74, no. 4 (April 1986), pp. 27–35.

105 Gerardo Mosquera, "El conflicto de estar al día," *Revolución y Cultura*, vol. 10 (October 10, 1984), p. 43. The two quotations cited in my text are as follows: Gerardo Mosquera, "El arte no es solo ideología, ni tampoco reflejo estricto"; Armando Hart Dávalos, "Confundir el arte y la política es un error político. Desvincular el arte de la política es otro error político."

106 Adolfo Sánchez Vázquez, *Las ideas estéticas de Marx* (Mexico City, 1965). On the importance of Sánchez Vázquez to Cuban art theory, see: Gerardo Mosquera, "Sánchez Vázquez: Marxismo y abstracción," *Temas*, no. 9 (1986), pp. 23–27. This significance was confirmed by Gerardo Mosquera in an interview with the author in New York City on October 22, 1992. See also: Camnitzer, *New Art of Cuba*, pp. 123, 127, 331–32.

In the early 1980s, Sánchez Vázquez gave a notable series of lectures on abstract art and semiotics in Managua at the *Escuela Nacional de Artes Plásticas*. These lectures had a profound impact on the artists in the Sandinista Artists' Union. Interview with Raúl Quintanilla, Director of the *Escuela Nacional* by the author, Managua, July 21, 1986. For the text of some of these lectures, see: Adolfo Sánchez Vázquez, "La pintura como lenguaje," *Nicarauác*, vol. 5, no. 10 (August 1984), pp. 115–25.

107 André Breton, "Interview with René Belance" (1945), in Franklin Rosemont, ed., *What Is Surrealism?* (New York, 1978), p. 256.

108 Mosquera, "Entrevista con Wifredo Lam," *Explorations en la plástica Cubana* (Havana, 1983), p. 184.

109 Wifredo Lam, "Statement" (1975), in Dore Ashton, ed., *Artists on Art* (New York, 1983), p.

118 Dore Ashton is probably the art critic from the U.S. most revered in Latin America—and with reason. No one else from the U.S. has written as long, as broadly, or as eloquently as she has about vanguard art from Latin America, especially the art of Cuba, Mexico, and Nicaragua. See, for example: Dore Ashton, "Havana, 1986," *Arts Magazine*, vol. 61, no. 6 (February 1987), pp. 38–39.

110 Lowry Sims, "Syncretism and Syntax in the Art of Wifredo," in *Crosscurrents of Modernism: Four Latin American Pioneers* (Washington, D.C., 1992), pp. 215–17. A fine early essay about Lam was written by the great novelist Alejo Carpentier, "Reflexiones acerca de la pintura de Wifredo Lam" (1944), reprinted in *Alcance a la Revista de la Biblioteca Nacional "José Martí,"* no. 3 (1988), p. 99. An outstanding overview of Afro-American cultural practices is to be found in Robert Farris Thompson, *Flash of the Spirit* (New York, 1983). On Afro-Cuban culture, see also: Fernando Ortiz, *La africanía de la música folklórica de Cuba* (Havana, 1950) and Mercedes Cross Sandoval, *La religión afrocubana* (Madrid, 1975).

111 Juan A. Martínez, *Cuban Art and National Identity: The Vanguard Painters, 1927–1950* (Gainsville, 1994), p. 75 ff.

112 Ibid.

113 Jasmine Alinder, "Wifredo Lam's Jungle," in "Picturing Themselves: Nineteenth-Century Photographs of Brazilian Slaves" (unpublished masters thesis, University of New Mexico, 1994), pp. 81–82.

114 Mosquera, "Entrevista con Wifredo Lam," pp. 184 ff.

115 Ibid., p. 183: "Las tijeras quieren decir que era necesaria dar un corte con la cultura colonial."

116 Alinder, "Wifredo Lam's Jungle," p. 82.

117 Ibid.

118 Lam, "Statement," in *Artists on Art*, p. 118.

119 Martínez, *Cuban Art and National Identity*, p. 96.

120 Martí Casanovas, *Declaración del Grupo Minorista* (Havana, May 1927). Translated by Juan A. Martínez and cited in *Cuban Art and National Identity*, p. 11.

121 Gerardo Mosquera, "Manuel Mendive, mestizaje del tiempo," *Resumen Semanal Granma*, vol. 19, no. 15 (April 8, 1984), p. 4. The position of Mosquera here consolidates an earlier viewpoint of Fernando Ortiz, who wrote: "Cuba es ajiaco." "Ajiaco" is a type of multi-ingredient stew that starts with *ají*, a salsa going back to Taíno Indians. See: Fernando Ortiz, "Los factores humanos de la cubanidad" (1940), in *Orbita* (Havana, 1973), p. 154.

122 Mosquera, "Manuel Mendive, Mestizaje de tiempo." See also Nancy Morejón, "Manuel Mendive: El mundo de un primitivo," in *Fundación de la imagen* (Havana, 1988), pp. 150–56.

123 For reproductions of their works and a perceptive look at their significance, see: Coco Fusco, Introductory Essay, *Signs of Transition:*

80s Art From Cuba (New York, 1988). See also: Coco Fusco and Robert Knafo, "Interviews with Cuban Artists," *Social Text*, no. 15 (fall 1986), pp. 41–53.

124 For two more shows of this art, see: *Los híjos de Guillermo Tell: artístas cubanas contemporáneos* (Museo de Artes Visuales Alejandro Otero, 1991), with an essay by Gerardo Mosquera, and *Juan Francisco Elso: Por América* (Mexico City, 1988), with an essay by Luis Camnitzer.

125 Gerardo Mosquera, "Carlos Rodríguez Cárdenas," in *The Nearest Edge of the World: Art and Cuba Now* (Brookline, Mass., 1990), p. 44. For a similar position, see the interview with Kcho (Alexis Leiva): Jen Budney, "Kcho: No Place Like Home," *Flash Art*, vol. 24, no. 188 (May/June 1996), pp. 82–86.

126 For an informative look at the history of art school training, see: Camnitzer, *New Art of Cuba*, Ch. 4.

127 Ibid., Ch. 2.

128 Coco Fusco, "Art and Cuba Now," *The Nation* (June 24, 1991), pp. 858. See also, Coco Fusco, "Drawing New Lines," *The Nation* (October 24, 1988), pp. 397–400.

129 Ibid.

130 Cardenal, *En Cuba*, p. 239.

131 Ibid.

132 See John Spicer Nichols, "The Press in Cuba," in *The Cuba Reader*, pp. 219–228.

133 Cardenal, *En Cuba*, p. 153: "Benedetti said to me that he, Cortázar, and other South Americans told Fidel that Cuban newspapers were very boring and very bad, and Fidel said: 'I agree with you. Why don't you stay here and help us?'" A similar exchange took place a decade earlier with the U.S. journalist Lee Lockwood, when he too asked Fidel about the lack of oppositional views in the newspapers. Castro responded: "Well, what you say is true, there is very little criticism. . . . Furthermore, I admit that our press is deficient in this respect. I don't believe that this lack of criticism is a healthy thing." (Lockwood, *Castro's Cuba, Cuba's Fidel*, p. 114.)

134 Lockwood, *Castro's Cuba, Cuba's Fidel*, p. 114.

135 See, for example: Michael Parenti, *Inventing Reality: the Politics of the Mass Media* (New York, 1986) and Edward Herman, *The Real Terrorist Network* (Boston, 1982).

136 Karl Marx, "Debating the freedom of the Press" (1842), in Lee Baxendall and Stefan Morawski, eds., *Marx and Engels on Literature and Art* (St. Louis, 1973), p. 61: "The first freedom of the press consists in its not being a a business."

137 *Constitución de la República de Cuba (1976*, New York, 1983), pp. 3, 4 (translation by the staff of the *Center for Cuban Studies* in New York City). For an excellent discussion of the entire Cuban legal system, see: Debra Evanson, *Revolution in the Balance: Law and Society in Contemporary Cuba* (Boulder, 1994).

138 *Constitución de la República de Cuba* (1976).

139 The most comprehensive collection of documents concerning the Padilla Affair is probably to be found in Lourdes Casals, *El Caso Padilla: Documentos* (Miami, 1973). For a fine response to his case, see Sandra Levinson, "Talking About Culture in Cuba," *The Cuba Reader*, pp. 494–95: "The years following the Padilla case were difficult for writers. . . . But the fear that the Padilla case would mean cultural 'stalinism' proved groundless."

For a report on the human rights situation more generally, see: Amnesty International, *Political Imprisonment in Cuba* (London, 1986) and Paul Lewis, "UN Tells of Rights Gains in Cuba," *New York Times* (December 18, 1988), p. A2: "The UN team, which visited Cuba from September 16 to 25, found evidence that only 121 long-term political prisoners were still being held in Cuban jails. . . . The six-member team brought back little evidence of torture or inhuman conditions in Cuban prisons. . . . In August 1987, the Reagan Administration estimated that 15,000 political prisoners were being held in Cuba."

140 *Casa de las Américas*, no. 145–46, *Número monográfico sobre Julio Cortázar* (Havana, 1984). See also: Mariano Aguirre, "Tres caminos hacia Cortázar," *El País* (Madrid, June 9, 1985), "Libros" section, p. 2.

141 The case for and against Georg Lukács was made in Cuba by José Antonio Portuando (in favor), and by Gerardo Mosquera (against). See: José Antonio Portuando, "Lukács y el realismo," prologue to, Georg Lukács, *Ensayos sobre el realismo* (Havana, 1978) and Gerardo Mosquera, "Lukács y las artes plásticas, *Unión*, no. 2 (1986), pp. 95–101. For a more "balanced" look, entailing an argument both *for and against* Lukács's position, see Adolfo Sánchez Vázquez, "La estética de Lukács," in *Las ideas estéticas de Marx*. pp. 40 ff.

142 Camnitzer, *New Art of Cuba*, pp. 123, 127, 136, 331–32. See also Gerardo Mosquera, "Sánchez Vázquez: Marxismo y arte abstracto," *Tema* (Havana), no. 9 (1986), pp. 23–37.

143 Mike González and David Treece, *The Gathering of Voices*, pp. 269–70. They rightly conclude of both Cuba and Che that they represented a fundamentally new anti-Stalinist direction on the Left: "The political tradition which gave birth to the Cuban Revolution was deeply hostile to Stalinism and a declared enemy of the Communist parties. . . . What Che Guevara in particular represented was a deep resistence to the residual theories of Stalinism." (pp. 272–73).

Three: The Nicaraguan Revolution

1 Interview with Father Ernesto Cardenal by John Ryder and the author, *The United Nations*, New York City (November 30, 1983).

For a fairly comprehensive survey of the *pintas*, or graffiti images that appeared during and after the Revolution, see *La insurrección de las páredes: Pintas y graffiti de Nicaragua* (Managua, 1984). Published by Editorial Nueva Nicaragua on the fifth anniversary of the Revolution, this book contains some notable texts by Sergio Ramírez, Omar Cabezas, and Dora María Tellez, along with a fine cross section of photographs of the graffiti by such outstanding photographers as Susan Meiselas. See also: Joel C. Sheesley and Wayne G. Bragg, *Sandino in the Streets* (Bloomington, 1991), which contains an introductory essay by Ernesto Cardenal. For the broader significance of graffiti for public muralism, see: Luis Morales Alonso, "Reflexiones sobre el muralismo," *Ventana* (the cultural supplement to *Barricada*) (November 15, 1985), pp. 2–3 and David Craven, *The New Concept of Art and Popular Culture in Nicaragua Since the Revolution in 1979* (Lewiston, N.Y., 1989), pp. 223–35.

2 Daniel Ortega, "La Revolución es creatividad, imaginación," in Daisy Zamora and Julio Valle-Castillo (eds), *Hacia una política cultural de la Revolución Popular Sandinista* (Managua, 1982), p. 88: "La Revolución no impone formulas . . . debe ser sin restricciones de ningún tipo." The anthology in which this speech appeared was the most important collection of policy statements by the FSLN leadership—particularly Daniel Ortega, Sergio Ramírez, and Ernesto Cardenal—concerning art and culture. For another anthology with policy statements that range over a broad area—from economics and proposed political institutions to an early manifesto on art and culture from 1969—see Tomás Borge, Carlos Fonseca, et al., *Sandinistas Speak*, ed. Bruce Marcus (New York, 1982). Two indispensable bibliographic sources on the Nicaraguan Revolution are: *Libros sobre la Revolución* (Managua, 1986), which was published by the Escuela de Sociología de la Universidad Centroamericana and listed over 300 books on the topic, and *Editorial Nueva Nicaragua, Catálogo de publicaciones* (Managua, 1989). See also a special issue on culture of *Envío*, a publication in Managua of the Instituto Histórico Centroamericano: Margaret Randall, "Breves notas sobre la cultura nicaragüense en la Revolución," *Envío*, no. 6 (May 1983).

The first monograph published anywhere on art and cultural policy was from the U.S. It was: David Craven and John Ryder, *Art of the New Nicaragua* (Cortland, N.Y., March 1983). This short monograph was funded by a grant from the New York Council for the Humanities. Angered by grants to progressive projects such as this one, the Reagan Administration launched a right-wing political attack on the New York Council for the Humanities and its director Jay Kaplan. This diatribe involved threats of cutting off federal money to support

the Council. William J. Bennett, the Chairman of the NEH during the Reagan–Bush era, was a particularly strident figure in this effort to censor a public agency with differing political views. See: Irwin Molotsky, "Disputes Continue on Nicaragua," *New York Times* (May 7, 1982), p. 3.

3 Claudia Dreifus, "The Sandinistas: An Interview with Tomás Borge, Ernesto Cardenal, Daniel Ortega, and Sergio Ramírez," *Playboy Magazine*, vol. 30, no. 9 (September 1983), p. 64. See also: Steven White, "An Interview with Sergio Ramírez," in *Culture and Politics in Nicaragua: Testimonies of Poets and Writers* (New York, 1986), pp. 75–84.

4 Ernesto Cardenal, "Cultura revolucionaria, popular, nacional, anti-imperialista" (1980), in *Hacia una política cultural* (Managua, 1982), pp. 178–79: "Y la cultura tiene que ser para superar la división del trabajo, entre trabajo intelectual y trabajo manual. . . . Y la cultura tiene que ser democrática. . . . Y para que nuestro pueblo no solamente sea consumidor de cultura, lo cual ya es muy importante, pero también productor de cultura." For an equally important and often reprinted text, see: Ernesto Cardenal, "La Democratización de la Cultura," *Colección Popular de Literatura Nicaragüense*, no. 2, Ministerio de Cultura (Managua, 1982). This essay was based on a public talk that he gave at UNESCO Headquarters in Paris on April 23, 1982. In attendance was a strong supporter of FSLN cultural policy in the Government of François Mitterand, namely Jack Lang, the Minister of Culture in France. See: Jack Lang, "Anticultura transnacional y el poder de la imaginación," *Nicaráuac*, no. 9 (April 1983), pp. 39–53.

5 The Ministry of Culture was in fact created only one day after the Sandinista leadership came to power in Nicaragua. Surely this must be something like a world record for promptness in establishing a national cultural ministry. The Mexican Government of Obregón established a Ministry of Education (but not just one for culture) within a year of taking office. Similarly, the Cuban Government of Fidel Castro also established a Ministry of Education within the first year, but the Ministry of Culture in Cuba was established only in 1976—that is, seventeen years after the Revolution of 1959 was victorious. Nonetheless, it must be added that the FSLN no doubt acted with such punctuality in setting up a Ministry of Culture, at least in part, because of the considerable gains in cultural affairs already registered in Mexico and Cuba by Revolutionary Governments. For the primary documents concerning the Ministry of Culture in Nicaragua, see "Un Programa de la Revolución: Ministerio de Cultura," in *Hacia una política cultural*, p. 277: "el Ministerio de Cultura fue creado por Decreto Número 6 de la Junta de GRN el 20 de julio de 1979." For a

look at the original manifesto on art and culture of the FSLN, see: "III. Revolución en cultura y educación," in El Programa histórico del FSLN (Managua, 1969), reprinted in *Sandinistas Speak*, tran. Will Reissner, pp. 16–17.

6 Steven White, "An Interview with Pablo Antonio Cuadro," in *Culture and Politics in Nicaragua*, p. 29. Despite his criticism of the FSLN in other interviews, Pablo Antonio Cuadra was always treated with respect. For example, Editorial Nueva Nicaragua published Cuadra's *Obras completas* during the 1980s. Another quite conservative author who sometimes sniped at the Sandinistas was Peruvian novelist Mario Vargas Llosa. Nevertheless, Vargas Llosa also felt compelled to praise the innovativeness and openness of FSLN governance. See his remarks in this regard: "Vargas Llosa cree posible que haya justicia y libertad en Nicaragua," *El País* (Madrid, February 2, 1985), p. 6. In an interview in Managua, Vargos Llosa admitted that "la revolución nicaragüense constituye un fenómeno original" and that "afortunadamente, no ha adoptado el modelo marxista–leninista. . . . La revolución permite todavía. . . . un espacio crítico y cierto pluralismo." See also Francisco Goldman, "Poetry and Power in Nicaragua," *New York Times Magazine* (March 29, 1987), pp. 44–50.

7 There was, for example, an impressive demonstration of this poetic prowess in the summer of 1986 at an event sponsored by the ASTC, the umbrella syndicate for all the artists' unions. This was the "Lectura de la Poetas: Gioconda Belli, Michele Najlis, Daisy Zamora, Gloria Gaburdi, Ana Ilce Gómez, and Cristian Santos," un Recital de Poetas de la ASTC en saludo al 7 m. Aniversario de la Revolución Popular Sandinista, Centro Cultural, Ruinas del Gran Hotel (July 16, 1986). Among the other internationalists in attendance, aside from John Ryder and myself, was Bombay-born author Salman Rushdie. His enthusiastic remarks about this evening are worth repeating: see Salman Rushdie, *The Jaguar's Smile* (1987, New York, 1997): "seven women poets were reciting in the ruins of the Grand Hotel. . . . The ruins were crowded with poetry lovers. I did not think I had ever seen a people, even in India and Pakistan where poets were revered, who valued poetry as much as the Nicaraguans." See also: Mike González and David Treece, *The Gathering of Voices: The Twentieth-Century Poetry of Latin America* (London, 1992) p. 286: "Nicaragua seems proportionally better endowed with poets than almost any other country in Latin America."

8 Nicaraguan poet Rubén Darío (1867–1916) invented the word "modernismo" (or modernism) in Nicaragua during the late 1880s and it was first published in 1888. Evidently, the earliest appearance in print of the word is found in Rubén Darío, "La Literatura en Centro-

America," *Revista de Arte y Cultura* (Santiago, Chile, 1888): "[Ricardo Contreras está usando] el absoluto modernismo en la expresión . . . [de] su estilo compuesto." Subsequently, Rubén Darío published the word "modernismo" a second time in an article entitled "Ricardo Palma," which appeared twice in 1890: in the Peruvian journal *El Perú Ilustrado* (Lima, November 8, 1890) and in the Guatemalan publication *Diario de Centro-América* (Guatemala City, 1890). For a reprint of it, see: Rubén Darío, "Ricardo Palma" in *Obras completas*, vol. 2 (Madrid, 1950): "[el] comprende y admira el espíritu nuevo que hoy ánima a un pequeño pero triunfante y soberbio grupo de escritores y poetas de la América española: el modernismo" (p. 19).

By 1899, the Real Academia Española had incorporated the word "modernismo" into its latest edition of the *Diccionario de la Lengua* (Madrid, 1899). Cited in Max Henrique Ureña, *Breve historia del modernismo* (Mexico City, 1954), pp. 158–59. For an excellent discussion of Rubén Darío and "modernismo," see Jean Franco, *An Introduction to Spanish-American Literature* (1967, Cambridge, 1994), pp. 142–47. See also: Edelberto Torres, *La dramática vida de Rubén Darío* (Barcelona, 1960); David Whisnant, "Rubén Darío as a Focal Cultural Figure in Nicaragua," *Latin American Research Review*, vol. 27, no. 3 (1992), pp. 7–49; and David Craven, "The Latin American Origins of 'Alternative Modernism,'" *Third Text*, no. 36 (autumn 1996), pp. 29–44.

9 Rubén Darío, preface to *Cantos de Vida y Esperanza, Los Cisnes y Otros Poemas* (Madrid, 1905). The passage cited has been reprinted in *Rubén Darío: Poesía*, ed. and intro. Julio Valle-Castillo and Ernesto Mejía Sánchez (Managua, 1994), p. 244: "Si en estos cantos hay una política, es porque aparece universal. Y si encontrais versos a un presidente, es porque son un clamor continental. Mañana podremos ser yanquis (y el lo más probable); de todos maneras, mi protesta queda escrita sobre las alas de los inmaculados cisnes, tan ilustres como Jupiter."

10 Daniel Ortega, "La Revolución es creatividad, imaginación," in *Hacia una política cultural*, p. 88. The FSLN's innovative pluralism in politics, as well as art, during the 1980s was singled out early by certain scholars. See: James Petras, "Authoritarianism, Democracy, and the Transition to Socialism," *Socialist Register, 1985/86*, ed. Ralph Miliband, et al. (London, 1986), pp. 279–83. As Petras noted: "The basic problem in socialist transition" in the twentieth century has been the transition from insurgency against state institutions to one of re-establishing state institutions, while also institutionalizing "democratic pluralism." Despite this prevalent failing in consolidating a "unitary government with pluralist participation," one success story was Nicaragua in the

1980s. It was there in particular, according to Petras, that revolutionaries were able to develop a "realistic conception of socialist pluralism" and a matching "political framework for socialist transition." Subsequent studies corroborated Petras's position.

This analysis was also explained at length by James Petras in a conversation with the author in Cortland, New York on November 20, 1986. For several other related discussions of the distinctiveness of the Nicaraguan Revolution, particularly concerning its novel pluralism, see: Henri Weber, *Nicaragua: la revolution sandiniste* (Paris, 1981); Regis Debray, "Nicaragua: Radical 'Moderation,'" *Contemporary Marxism,* no. 1 (spring 1980), pp. 10–18; Adolfo Gilly, *La Nueva Nicaragua: Antiimperialismo y lucha de clases* (Mexico City, 1980); P. Wheaton, *Nicaragua: A People's Revolution* (Washington, D.C., 1980); and Richard R. Fagen, *The Nicaraguan Revolution* (Washington, D.C, 1981). For some later books that continue this focus on political pluralism, see two exceptionally fine monographs: Gary Ruchwarger, *People in Power: Forging Grassroots Democracy in Nicaragua* (South Hadley, Mass., 1987) and Katherine Hoyt, *The Many Faces of Sandinista Democracy* (Athens, OH, 1997). For a thoughtful post-1990 look at the complex democratic legacy of the FSLN in Nicaragua, see: James Dunkerly, "Reflections on the Nicaraguan Revolution," in *Political Suicide in Latin America* (London, 1992) and Carlos Vilas, "What Went Wrong?" NACLA *Report on the Americas*, vol. 24, no. 1 (June 1990), pp. 10–18.

There were two outstanding books to appear relatively early on the overall logic of the entire revolutionary process: Carlos Vilas, *Perfiles de la Revolución Sandinista* (Madrid, 1984) and John Booth, *The End and the Beginning: The Nicaraguan Revolution,* 2nd ed. (Boulder, 1985). For a whole series of indispensable overviews of the general process of social transformation in Nicaragua, see the various books and numerous anthologies by Thomas W. Walker, who is "the dean" of Nicaraguan studies in the United States. Two of the books he has written on the topic are: *The Christian Democratic Movement in Nicaragua* (New York, 1970) and *Nicaragua: The Land of Sandino,* 3rd ed. (Boulder, 1991). Of the anthologies he has edited see: *Nicaragua in Revolution* (New York, 1982); *Nicaragua: The First Five Years* (New York, 1985); *Reagan Versus the Sandinistas* (Boulder, 1987); *Revolution and Counterrevolution in Nicaragua* (Boulder, 1991); and, finally, *Nicaragua Without illusions: Regime Transition and Structural Adjustment in the 1990s* (Wilmington, Del., 1997). The latter collection is probably the finest book to appear in the last ten years.

11 See: David Craven, *The New Concept of Art and Popular Culture in Nicaragua*, ch. 2: "A Dialogical Culture," pp. 29–106. The two main sources for the term "dialogical" (which originated the word independently of each other) are the writings of Mikhail Bakhtin (along with his circle in Moscow) beginning in the late 1920s and the texts of Paulo Freire of Brazil starting in the early 1960s (see below).

12 Interview with Terry Atkinson, The University of Leeds, Great Britain (May 1, 1991). See also: *Art and Language* (Eindhoven, 1980), p. 241.

13 Raúl Quintanilla, "A Suspended Dialogue: The Nicaraguan Revolution and the Visual Arts," *Third Text*, no. 24 (autumn 1993), p. 26.

14 Dreifus, "The Sandinistas: An Interview," p. 64. See also the important discussion between Tomás Borge and a leading literary scholar on the U.S. left: Fredric Jameson, "An Interview with Tomás Borge on the Nicaraguan Revolution," *New Left Review*, no. 164 (July–August 1987), pp. 51–64. For a short piece on Borge's impressive intellectual range (and also on the fact that the Reagan Administration refused, for political reasons, to allow Borge to visit the United States), see Stephen Kinzer, "Sandinista Portrait: Poet, Militant, Bible Devotee," *New York Times* (September 3, 1985), p. 2. His most well-known poem was made into the Sandinista national anthem, "Himno de la Unidad Sandinista," which was set to music by Carlos Mejía Godoy. See the album titled *Guitarra Armada* (Managua, 1979). In 1989, Borge won the Casa de las Américas Prize for non-fiction for his autobiography, *La paciente impaciencia* (Patient impatience) (Managua, 1989).

15 Dreifus, "The Sandinistas: An Interview," p. 64.

16 "III. Revolución en cultura y educación," in *El Programa histórico del FSLN*, pp. 16 ff.

17 Ibid.

18 Ibid.

19 See Jeffrey Gould, *To Lead as Equals: Rural Protest and Political Consciousness in Chinandega, Nicaragua, 1912–1979* (Chapel Hill, 1979), where this misguided viewpoint is not so much in evidence, or Les Field, *The Grimace of Macho Ratón: Artisans, Identity, and Nation in Late Twentieth-Century Nicaragua* (Durham, N.C., 1999), where this erroneous view of the FSLN position largely undermines any general claims in his study. This routine error in Field's book invalidates most of his contentions about the Ministry of Culture on the national level, while nevertheless leaving most of his local or provincial points in place. The result in Les Field's case are some vertiginous non-sequiturs, in which Ernesto Cardenal is made to sound like an essentializing thinker in the tradition of Leo Tolstoy or Jean-François Millet. Yet one need only compare Tolstoy's deeply populist text "What Is Art?" to see how complete the contrast really is with Cardenal's "dialogical" and non-essentializing conception of art. As Cardenal made clear, the latter view presupposes a "new synthesis" that goes beyond old-time populism and traditional *indigenismo* or *mestizaje*.

20 Field, *The Grimace of Macho Ratón*, p. 38. The merits of this study reside largely in its status as a microhistory. Whenever Field tries to elevate his material to the level of a macrohistory for Nicaragua or the Sandinistas, however, he stumbles rather glaringly. In part, this is a consequence of his inability (here at least) to engage theoretical issues in a more sustained or complex way. A quick look at his one-dimensional and quite monolithic definition of the state on page 2 makes clear what is in store for the reader, namely, a type of "them-versus-us" populism that is without nuance or subtlety—one that supposedly represents "the people" against "the state." Thus, his valuable fieldwork is saddled by a clumsy binary framework that sometimes does a disservice to his own research—and to the Sandinistas. The position of the Sandinista leadership was in fact far more sophisticated and flexible than Field would have us believe in his rather conservative and innocently populist book on regional culture in Revolutionary Nicaragua.

21 *El Programa histórico del FSLN*, pp. 16–17. This phrase alone, which was embraced by Cardenal and Wheelock Román along with all other FSLN leaders, flatly disallows the claims of Gould and Field.

22 The use of Macondo as a trope for prerevolutionary Nicaragua was first used by another scholar: see Harry E. Vanden, "The Ideology of the Nicaraguan Revolution," *Monthly Review*, vol. 34, no. 2 (June 1982), pp. 25–41.

23 There are several outstanding texts by Sandinista intellectuals that provide a framework for reconfiguring cultural history and reconstructing identity on several levels. Among the best are the following: Sergio Ramírez, *Balcanes y Volcanes* (1973, Managua, 1983); Alejandro Serrano Caldera, *Filosofía y crisis* (Managua, 1984), along with *La Utopía posible* (Managua, 1991) by the same author; and Orlando Núñez Soto, *La insurrección de la consciencia* (Managua, 1984). For a broader discussion of this set of theoretical issues, see Donald C. Hodges, "Ideologies of the Revolution," in *The Intellectual Foundations of the Nicaraguan Revolution* (Austin, Tex., 1986), pp. 256–91.

24 Ernetso Cardenal, *Vida perdida: memorias*, vol. 1 (Managua, 1998), pp. 168–69. On Cardenal's theological position and his poetic practice, see Robert Pring-Mill, introduction to *Zero Hour and Other Documentary Poems* by Ernesto Cardenal (New York, 1980), pp. xii–xiii. The two best overviews of Cardenal's position in poetry and politics are: John Beverley and Marc Zimmerman, *Literature and Politics in the Central American Revolutions* (Austin, Tex., 1990), pp. 66–72, 82–87, and 92–94, and González and Treece, *The Gathering of Voices*, pp. 194–96 and 286–98. For a lively and resourceful look at

Cardenal's poetry and his conception of art more generally, see Greg Dawes, *Aesthetics and Revolution, Nicaraguan Poetry, 1979–1990* (Minneapolis, 1993), ch. 3.

25 In chronological order, the four "classic" texts that triggered the emergence in Latin America of "liberation theology" were: Gustavo Guttiérrez, *Un teología de liberación* (Lima, 1971); Ernesto Cardenal, *El evangelio en Solentiname*, 4 vols. (Salamanca, Spain, 1975); Leonardo and Clovis Boff, *Da libertação: O sentido teológico das libertações sóciohistoricoas* (Petropolis, Brazil, 1979); and José Porfirio Miranda, *Comunismo en la Biblia* (Mexico City, 1981). All four have been published in an English translation by Orbis Books of upstate New York. See also Michael Löwy, ed., *Marxism in Latin America from 1909 to the Present*, tran. Michael Pearlman (Atlantic Highlands, N.J., 1992), pp. lvi–lvii.

26 William K. Tabb, ed., *Churches in Struggle* (New York, 1986), p. xvii. See also Penny Lernoux, *Cry of the People: The Catholic Church in Conflict with U.S. Policy* (New York, 1982).

27 Tabb, *Churches in Struggle*.

28 Friedrich Engels, "On the History of Early Christianity," *Die Zeit*, vol. 2 (1894–95), pp. 1–3. Reprinted in Karl Marx and Friedrich Engels, *On Religion* (Moscow, 1957), pp. 313–15. See also Harry Magdoff and Paul M. Sweezy, "Marxism and Religion," in *Churches in Struggle*, pp. 191–97.

29 Ernesto Cardenal, *La santidad de la revolución* (Salamanca, Spain, 1976), p. 20, translated by John Beverley and Marc Zimmerman, in *Literature and Politics*, p. 85. See also, Ernesto Cardenal, "Lo que fue Solentiname," *Casa de las Américas*, no. 108 (1978), pp. 158–60; Jaime Quezada, *Un viaje por Solentiname* (Santiago, Chile, 1987); and Giulio Girardi, *Fe en la Revolución, revolución en la cultura: Marxistas y Cristianos* (Managua, 1983).

30 Letter from Ernesto Cardenal to Marc Zimmerman (November 19, 1984), cited in Beverley and Zimmerman, *Literature and Politics*, p. 82.

31 Hodges, *Intellectual Foundations of the Nicaraguan Revolution*, pp. 278–82.

32 Cardenal, *El evangelio en Solentiname*, tran. Donald C. Walsh, vol. 4, pp. 50–54.

33 Ibid.

34 Interview with Ernesto Cardenal by David Craven and John Ryder (New York City, November 30, 1983).

35 See Julio Valle-Castillo, "Los primitivistas de Nicaragua o el inventario del paraíso," *Nicaráuac*, vol. 6, no. 12 (April 1986), pp. 161–74. Valle-Castillo discusses these artists in relation to the ideas of Gramsci about "organic intellectuals": "se convertieron en intelectuales fieles al modelo Gramsciano," p. 169. See also: Ernesto Cardenal, *Tocar el cielo* (Managua, 1980); Ernesto Cardenal, *Nostalgia del futuro* (Managua, 1982); Ernesto Cardenal, "Naive Art

in Nicaragua," *World Encyclopedia of Naive Art* (London, 1984), pp. 678–80; Ida Rodríquez-Prampolini, "Ante una exposición de Solentiname," *Casa de las Américas*, vol. 20, no. 118 (January–February 1980), pp. 114–15, and Jorge Eduardo Arellano, *Historia de la pintura nicaragüense* (1977), 5th ed. (Managua, 1994), pp. 127–30 and 135–36.

For more recent reassessments, see: Porfirio García, "Solentiname," *El Nuevo Diario* (October 17, 1998), p. 6; Porfirio García, "El primitivismo en la pintura de la década de los años ochenta," *El Nuevo Diario* (January 17, 1999); and, finally, Neerja Vasishta, "From Promising Reality to Impossible Future: Nicaraguan Primitive Painting, 1970–2000" (unpublished thesis, University of New Mexico, 2000, book in progress).

36 Mayra Jiménez, ed. and intro., *Poesía campesina de Solentiname* (1980, Managua, 1985), pp. 8–9: "la poesía surge en Solentiname como un producto artístico colectivo. . . . Es decir, es una poesía campesina, del pueblo y para el pueblo y en consecuencia ha resultado ser una producción eminentemente social, política, humana. En definitiva, revolucionaria y testimonial." See also: Steven White, "Interview with Mayra Jiménez," in *Culture and Politics in Nicaragua*, pp. 106–13. Jiménez notes, for example, that as of 1982, there were 535 aspiring poets who had already participated in the fifty-three *Talleres* (there were seventy at the high point) and that around two hundred participants had already been published in *Poesía Libre*.

37 Beverley and Zimmerman, *Literature and Politics*, pp. 67–68 and 85–86.

38 Cardenal, "Lo que fue Solentiname," pp. 158–60.

39 Beverley and Zimmerman, *Literature and Politics*, p. 87.

40 Miguel D'Escoto, "Nicaragua: Unfinished Canvas" (1983), in Peter Rosset and John Vandermeer (eds), *Nicaragua: Unfinished Revolution: The New Nicaragua Reader* (New York, 1986) p. 441.

41 *Manifiesto del Grupo Praxis*, no. 2 (December 18, 1964), p. 6. See also *Manifiesto del Grupo Praxis*, no. 1 (August 26, 1963). Cited in Mercedes Aróstegui, "Reseña historia de la pintura contemporánea en Nicaragua," in *Pintura Contemporánea de Nicaragua* (Mexico City, 1981), p. 9. See also: Alejandro Aróstegui, "Orlando Sobalvarro en Praxis," *Praxis*, no. 1 (August 26, 1963), p. 41; Jorge Eduardo Arellano, *Historia de la pintura nicaragüense*, pp. 79–90; and María Dolores G. Torres, *La modernidad de la pintura nicaragüense, 1948–1990* (Managua, 1995). The latter book is quite impressive and the colour plates are terrific. María Dolores G. Torres is one of the three main art experts in Nicaragua. The other two are Raúl Quintanilla and Porfirio García.

42 *Praxis*, no. 2, p. 6.

43 Betty LaDuke, "Six Nicaraguan Painters: Revolutionary Commitment and Individuality," *Art and Artists* (New York, July 1983), pp. 9–12. This article contains segments of interviews with Róger Pérez de la Roche, María Gallo, Efrín Medina, Santos Medina, Bayardo Gámez, and Orlando Sobalvarro. Among North American scholars Betty LaDuke has been outstanding both for her breadth of coverage and her seriousness of purpose. Her other articles include the following: "The National Fine Arts School," *Nicaraguan Perspectives*, no. 4 (summer 1982), pp. 28–30; "Nicaraguan Mural Painters: Hilda Vogel and Julie Aguirre," *Off Our Backs* (October 1983), pp. 11–12; and also her book through City Lights Press, *Compañeras: Women, Art, and Social Change* (San Francisco, 1985).

44 Marta Traba, "Mirar en Nicaragua," *El Pez y la serpiente*, no. 25 (winter 1981), pp. 27–86. See also: Raúl Quintanilla, "Soy tu mar y en mi confía (1981)," introduction to *ArteFacto*, no. 6 (spring–summer 1993), n.p. This keen essay by Quintanilla is particularly important since it shows quite well that parts of Traba's original essay that were pro-Sandinista were covertly edited out of the essay without her knowledge (she died in early 1983) by Pablo Antonio Cuadra. This is ironic, since Cuadra claimed quite vocally that his own texts were "censored" by the Sandinistas to make them politically acceptable. As for Marta Traba, who still remains little known in the mainstream art-world of the U.S.A., see: Florencia Bozzano Nelson, "The Art Criticism of Marta Traba" (unpublished Ph.D dissertation, University of New Mexico, 2000).

45 Luis Morales Alonso, "Reflexiones sobre el muralismo," *Ventana* (November 12, 1985), pp. 2–3, reprinted in an English translation in *Community Murals Magazine* (summer 1986). See also: Alejandro Aróstegui, "Breve historia de muralismo mundial" (unpublished MS, 1983) and Raúl Quintanilla, "Apertura de la nueva Escuela de Arte Mural" (unpublished MS, 1984), both documents are in the personal papers of Raúl Quintanilla, Managua, Nicaragua. See also Myra L. Pérez Díaz and María Dolores G. Torres, "El arte mural en Nicaragua," *Encuentro*, vol. 32 (September/December 1987), pp. 13–33.

46 Letter to the author from Raúl Quintanilla (July 13, 1997). On the justifiable admiration of the Praxis group for the contribution to painting of Rodrigo Peñalba, see: *Peñalba Retrospectiva: El Maestro indiscutible* (Managua, Galería Casa Fernando Gordillo, November 4–22, 1986). There are essays in homage to him by both Leoncio Sáenz and Orlando Sobalvarro, as well as by Ernesto Cardenal, Marta Traba, José Gómez-Sicre, and Jorge Eduardo Arellano.

47 LaDuke, "Six Nicaraguan Painters," *Art and Artists*, p. 12. This position was repeated by

Orlando Sobalvarro in an interview with the author, Managua, January 8, 1990.

48 LaDuke, "Six Nicaraguan Painters," *Art and Artists*, p. 11. This material was corroborated by Santos Medina in an interview with the author, Managua, July 5, 1995.

49 See, for example, the two excellent essays in this regard: Dore Ashton, ". . . y los sueños sueños son," in *Armando Morales: Recent Paintings* (New York: Claude Bernard Gallery, November 19–December 19, 1987), pp. 7–12 and Marta Traba, "Su imagen: Armando Morales," in *Hombre americano a todo color* (Bogota, 1995), pp. 37–46. See also: Donaldo Altamirano, "Armando Morales: Nicaragüanidad y universalismo," *Ventana* (July 15, 1986), p. 2 and Carlos Martínez Rivas, "Morales—Una observación y cuatro preguntas," *Nicarauác*, no. 10 (August 1984), pp. 175–78. There are at least two monographs of note about his artwork: *Armando Morales: Pintura* (Mexico City: Museo Rufino Tamayo, April to September 1990) and Lily Kassner, *Morales* (Rome, 1995).

50 For more on this relationship see David Craven, *Abstract Expressionism as Cultural Critique: Dissent during the McCarthy Period* (Cambridge, 1999), pp. 12–13.

51 Interview of Armando Morales by the author, New York City (November 19, 1987). See also David Craven, "Armando Morales: clásico del realismo mágico," *Nuevo Amanecer Cultural*, vol. 11, no. 259 (September 1990), pp. 1–2. The response by Morales to my essay was quite favorable: see letter to the author by Armando Morales (February 25, 1990) in the personal papers of David Craven, Albuquerque, New Mexico.

52 On Frente Ventana, see White, "An Interview with Sergio Ramírez," in *Culture and Politics in Nicaragua*, pp. 78–80. See also Beverley and Zimmerman, *Literature and Politics*, pp. 27–74.

53 Sergio Ramírez, *Estás en Nicaragua* (Managua, 1986), pp. 20 and 30.

54 On Luis Amanda Espinosa and *Rayuela*, see Sergio Ramírez, *Estás en Nicaragua*, p. 32. See also, Steven White, *Culture and Politics in Nicaragua*, p. 32.

55 For his 1983 acceptance speech, see Julio Cortázar, "Esta Revolución es cultura," *Areito*, vol. 9, no. 34 (1983), pp. 17–20. For a splendid book on the early years of the Nicaraguan Revolution, see Julio Cortázar, *Nicaragua, tan violentemente dulce*, tran. Kathleen Weaver (Barcelona, 1984).

56 Julio Cortázar, *Rayuela* (1963, Mexico City, 1977): Tablero de Dirección, "*A su manera este libro es muchos libros . . . El lector queda invitado a elegir una de las dos posibilidades siguientes.*" On Cortázar's decisive significance to Latin American literature, see: Jean Franco, *Spanish-American Literature*, pp. 336–39 and Carlos Fuentes, "Julio Cortázar, 1914–1984," *New York Times Book Review* (March 4, 1984), p. 3.

57 Roland Barthes, *S/Z* (Paris, 1970), tran. Richard Miller (London, 1975), p. 4.

58 Michele Najlis, *El viento armado* (Guatemala City, 1969). For a discussion of Najilis's place in Nicaraguan literary history, see Beverley and Zimmerman, *Literature and Politics*, p. 89.

59 Margaret Randall, *Risking a Somersault in the Air: Conversations with Nicaraguan Writers* (San Francisco, 1984), p. 148.

60 Beverley and Zimmerman, *Literature and Politics*, p. 90.

61 Randall, *Risking a Somersault*, p. 148.

62 Beverley and Zimmerman, *Literature and Politics*, p. 90.

63 Ibid. See also Margaret Randall, *Sandino's Daughters* (Vancouver, 1981).

64 Margaret Randall, *Sandino's Daughters*, p. 45. See also the following: Maxine Molyneux, "Women," in *Nicaragua: The First Five Years*, pp. 163–82; Elizabeth Maier, *Las Sandinistas* (Mexico City, 1985); Clara Murguialday, *Nicaragua, revolución y feminismo: 1977–1989* (Madrid, 1990); and Sofía Montenegro, "Nuestra madre: La Malinche," *Gente*, vol. 5, no. 138 (October 2, 1992), pp. 11 ff.

65 On Gioconda Belli's career see Margaret Randall, *Sandino's Daughters Revisited* (New Brunswick, N.J., 1994), pp. 168–90.

66 Ernesto Cardenal (and Rosario Murillo), "A New Culture," in Philip Zwerling and Connie Martin, eds, *Nicaragua: A New Kind of Revolution* (Westport, Conn., 1985), p. 43. See also Ernesto Cardenal, "Cultura revolucionaria . . . ," in *Hacia una política cultural*, p. 178.

67 Karl Marx and Friedrich Engels, *The German Ideology* (1846), ed. C. J. Arthur (New York, 1977), p. 108.

68 *El Amanecer del Pueblo*, Ministerio de Educación (Managua, 1980) and *Cruzada Nacional de Alfabetización*, Cuadero de Orientaciones, Ministerio de Cultura (Managua, 1979). For the first great theoretical treatise on the "dialogical method" of pedagogy, see Paulo Freire, *Pedagogy of the Oppressed* (1968), tran. Myra Bergman Ramos (New York, 1981). Two other books by Freire of the late 1960s helped to consolidate this position: *Educação como Practica de Libertade* (Rio de Janeiro, 1967) and *Extensión y Comunicación* (Santiago, Chile, 1969). For an informative interview with Freire about such issues as "generative words," see Rex Davis, "Educating for Awareness: A Talk with Paulo Freire" (1970), in Robert Macke, ed., *Literacy and Revolution* (New York, 1981), pp. 57–69.

For the Nicaraguan literacy campaign and Freire's contribution to it, see Fernando Cardenal, s.j, and Valerie Miller, "Nicaragua 1980: The Battle of the ABCs," *Harvard Educational Review*, vol. 51, no. 1 (1981), pp. 1–26. In this article by the Minister of Education (and Ernesto Cardenal's brother), mention is made of formative conversations between Freire and Fernando Cardenal from October through

November 1979. See also: the special issue entitled "The Literacy Crusade in Nicaragua," *Interracial Books for Children Bulletin*, vol. 12, no. 2 (1981), pp. 12–14, which includes a section "About Freire"; Sheryl Hirshon (with Judith Butler), *And Also Teach Them to Read: The National Literacy Crusade of Nicaragua, 1980* (Westport, Conn., 1983); and, finally, Carlos Vilas, "The Case of Education," in *Perfiles de la Revolución Sandinista*, tran. Judy Butler, Monthly Review Edition (New York, 1986). In his fine analysis, Vilas observed (pp. 215–16): "The opening up of the educational system has not meant distributing 'more of the same,' but putting at the disposal of the people, and through their active participation, 'more of something else'. . . . Education in the Sandinista revolution is not then a mechanism of reproduction."

69 Freire, *Pedagogy of the Oppressed*, p. 13.

70 Ibid.

71 Ibid., pp. 52–54. A crucial point here is how Freire both admired Lenin as an individual leader and also implicitly rejected as a valid model for revolutionary societies the paternalistic ultravanguardism known as "Leninism." In this sense both Freire and the Sandinistas were Marxists without being Leninists. Yet both admired Lenin in a personal sense.

72 Ibid., p. 57.

73 Ernesto Cardenal, "La Cultura: primero seis meses de Revolución" (1980) and "Cultura revolucionaria, popular, nacional, antiimperialista," *Hacia una política cultural*, pp. 175 and 179.

74 Julio Valle-Castillo, editorial, *Poesía Libre*, no. 2 (1981), p. 1. This publication, *Poesía Libre*, appeared from 1981 through 1986 as the main way of disseminating poems by participants in the Talleres. *Poesía Libre* was edited by the instructors from five of the workshops: Carlos Calero, Juan Ramón Falcón, Marvín Rios, Cony Pacheco, and Gerardo Gadea. Interview with Juan Ramón Falcón and Gerardo Gadea by the author and John Ryder, The Ministry of Culture, Managua, July 22, 1986.

75 Kent Johnson, "Nicaraguan Culture: Unleashing Creativity," NACLA *Report on the Americas*, vol. 19, no. 5 (September/October 1985), pp. 8–11. See also: Kent Johnson, ed., *A Nation of Poets: Poems from Sandinista Workshops* (San Rafeal, Calif., 1985); David Gullette, *Nicaraguan Peasant Poetry From Solentiname* (Albuquerque, 1988) and the review of it by Allen Josephs, in the *New York Times Book Review* (January 1, 1989), pp. 5–6; Richard Elman, "Fighting the Darkness: Ernesto Cardenal's *With Walker in Nicaragua*, ed. by Jonathan Cohen," *The Nation* (March 30, 1985), pp. 372–75.

76 Cited by Ernesto Cardenal in "Toward a New Democracy of Culture," in Peter Rosset and John Vandermeer (eds), *The Nicaragua Reader: Documents of a Revolution Under Fire* (New

York, 1983), p. 353. In fact, Cardenal himself had earler declared the socialization of poetic production to be a defining aim of the revolutionary process in: Ernesto Cardenal, "Talleres de Poesía: socialización de los medios de producción poéticos," in *Hacia una política cultural*, pp. 225–32.

77 Dinah Livingstone, dedication to *Poets of the Nicaraguan Revolution: An Anthology*, ed. and tran. Dinah Livingstone (London, 1993), p. i. For two other earlier anthologies that were of significance in the Anglo-American world during the 1980s, see: Bridget Aldaraca, Edward Baker, Illena Rodríguez, and Marc Zimmerman, eds., *Nicaragua in Revolution: The Poets Speak* (Minneapolis, 1980) and Marc Zimmerman, ed., *Nicaragua in Reconstruction and at War: The People Speak* (Minneapolis, 1985).

78 Reprinted in Livingstone, *Poets of the Nicaraguan Revolution*, pp. 5–7.

79 "Los Centos Populares de Cultura," in *Hacia una política cultural*, pp. 283–85. See also interview with Emilia Torres by the author and John Ryder, Centro Popular de Cultura, Managua, July 10, 1986.

80 Emilia Torres, "III asamblea annual de los CPC," *La Chachalaca*, no. 2 (1983–84), pp. 5–6.

81 Alan Riding, "On the Ashes of War, the Arts Flower in Nicaragua," *New York Times* (August 1, 1980), p. 2. Some of the notable albums by Nicaraguan groups in the 1980s were as follows: Grupo Pancasán, *Vamos Haciendo la Historia*, Ministerio de Cultura (Managua, 1980); Guardabarranco (Katia and Salvador Cardenal), *Si Buscabas* (Oakland, 1985), produced by Jackson Browne for Redwood Records; Salvador Bustos, *Tragaluz/Skylight* (Oakland, 1985), Redwood Records; and *Música Folklórica Nicaragüense de Masaya* (Managua, 1985), including a translation of the lyrics into English by Norma Helsper and T. M. Scruggs for Cano Records.

82 Interview with María Gallo by the author, Xavier Kantón Gallery, Managua, July 16, 1986; interview with Emilia Torres by the author and John Ryder, Centro Popular de Cultura, Managua, July 10, 1986; and interview with Olga Montiel by the author and John Ryder, Ministry of Culture, Managua, July 29, 1982. See also "Dirección de Los Centros Populares de Cultura," in *Hacia una política cultural*, pp. 283–84.

83 Interview with Mariá Gallo, July 16, 1986.

84 The CPC at Estelí has always been one of the most successful branches and it remained in operation right up to 2001. See the exemplary catalog about it that was compiled by a team of scholars from Germany led by Professor Dr. Matthias and Ms. Ines Dettmar of Gesamthochschule Kassel: *Arte Popular: Bilder einer Region Nicaraguas* (Kassel, 1986). This catalog contains a broad cross section of interviews and statements from both local

participants and national officials, along with a set of reproductions by the artists who worked there. See also: interview with Manuel Romero, a painting instructor at the CPC of Estelí, by the author and John Ryder, Managua (July 29, 1982) and interview with Milton Timothy Hebbert Watson, painting instructor at the CPC in Bluefields, Managua (July 29, 1982).

85 Field, *The Grimace of Macho Ratón*, pp. 15–18. Field focuses largely on the CPC at San Juan de Oriente. For a more nuanced and detached assessment, see: *Arte Popular: Bilder einer Region Nicaraguas*.

86 "Bringing the Arts to Your Doorstep: The Association for the Promotion of the Arts," *Barricada International*, no. 393 (February 1996), pp. 16–17. This article contains passages from an interview with Emilia Torres.

87 Instituto Nicaragüense de Estadísticas y Censos (INEC), *Encuesto anual de la Industriá Manufacturera* (Managua, 1981), cited in Carlos Vilas, *Perfiles de la Revolución Sandinista*, pp. 72–75. See also: "Nicaragua, Tres Años de Revolución," *Envío*, no. 13 (July 1982), pp. 5–6 and West Coast Trade Union Delegation, *Nicaragua: Labor, Democracy, and the Struggle for Peace* (San Francisco, 1984).

88 Ernesto Cardenal, "Toward a New Democray of Culture," pp. 351–52. See also: Jaime Wheelock Román, *Nicaragua: Imperialismo y Dictadura* (Havana, 1980); Xabier Gorostiaga, "The Private Sector and the Mixed Economy," in *Nicaragua: Unfinished Revolution*, pp. 386–89; Roger Burbach and Patricia Flynn, eds., *The Politics of Intervention: The United States in Central America* (New York, 1984), especially the essay by Carmen Diana Deere and the one by Nora Hamilton with Norma Stoltz Chinchilla, and, finally, Richard R. Fagan, et al., *Transition and Development: Problems of Third World Socialism* (New York, 1986), which contains several outstanding essays about the Nicaraguan economy and underdevelopment.

89 Randy Martin, "Nicaragua: Theater and State Without Walls," *Social Text*, no. 18 (winter 1987/88), p. 88. See also: Judith Weiss, "Teyocoyani and the Nicaraguan Popular Theater," *Latin American Theater Review*, vol. 23, no. 9 (fall 1989), pp. 71–77 and Randy Martin, *Socialist Ensembles: Theater and State in Cuba and Nicaragua* (Minneapolis, 1994), pp. 45–112.

90 David Kaimowitz, "Nicaragua's Agrarian Reform: Six Years Later" (1985), in *Nicaragua: Unfinished Revolution*, pp. 390–92. See also: María Veronica Frenkel, "The Evolution of Food and Agricultural Policies during Crisis and War," in Michael Conroy, ed., *Nicaragua: Profiles of the Revolutionary Public Sector* (Boulder, 1987), pp. 203 ff.

91 Interview of Alan Bolt by Randy Martin, Matagalpa, July 27, 1986, cited in Randy Martin, "Nicaragua: Theater and State," p. 87. See also

Alan Bolt, "Un teatro que vaya más allá de la propaganda," *Ventana* (October 12, 1985), p. 6.

92 Joan Peters, "The Long March of Alan Bolt," *The Nation* (June 18, 1989), p. 856. See also Alan Bolt, "La consciencia no se trasmite de manera mágica," *Pensamiento Proprio*, vol. 4, no. 33 (May/June 1986), pp. 11–16.

93 Peters, "The Long March of Alan Bolt," p. 856.

94 Ibid., p. 858.

95 Martin, *Socialist Ensembles*. The one key area of theater left unaddressed in Martin's study involves the amateur theater troups located within the large mass organizations associated with the ATC (Associación de Trabajadores Campesinos), that was linked to the FSLN. Foremost among them was MECATE (Movimiento de Expresión Campesina Artística y Teatral) ("mecate" also means "lasso" in Spanish), whose director was Nidia Bustos. For a statement of their aims, see MECATE, "1er Foro Nacional de Artistas Aficionados" (unpublished mimeograph pamphlet, 1980). See: interview with Nidia Bustos by the author and John Ryder, "El Tropican," Nicaragua (July 9, 1986) and Nidia Bustos, "MECATE, The Nicaraguan Farm Worker's Theatre Movement," *Adult Education and Development* (Bonn, Germany), no. 23 (September 1984), pp. 129–39 and David Craven, *The New Concept of Art and Culture in Nicaragua Since the Revolution in 1979*, pp. 54–71.

96 See interview with Milton Hebbert Watson of Bluefields by the author and John Ryder, Managua (July 29, 1982).

97 Carmen Diana Deere, "Agrarian Reform as Revolution and Counter-Revolution: Nicaragua and El Salvador," in *The Politics of Intervention*, pp. 167 ff. See also: Eduardo Baumeister and Oscar Neira Cuadra, "The Making of a Mixed Economy," in *Transition and Development*, pp. 184; Carmen Diana Deere, "Agrarian Reform, Peasant and Rural Production, and the Organization of Production in the Transition to Socialism," in *Transition and Development*, pp. 97–142; and José Luis Coraggio, "Economics and Politics in the Transition to Socialism: Reflections on the Nicaraguan Experience," in *Transition and Development*, pp. 143–170. Two books—one for and one against the agrarian economic policies of the 1980s—are worth mentioning because of the way they sum up their respective positions: Forrest D. Colburn, *Post-Revolutionary Nicaragua: State, Class, and the Dilemmas of Agrarian Policy* (Berkeley, 1986) and Alejandro Martínez Cuenca, *Sandinista Economics in Practice* (Boston, 1992), with a prologue by Sergio Ramírez.

98 Deere, "Agrarian."

99 Kaimowitz, "Nicaraguan Agrarian Reform: Six Years Later," p. 392.

100 Ibid.

101 Valle-Castillo, "Los Primitivistas de Nicaragua," pp. 166–70.

102 For more on this issue, see: Craven, *The New Concept of Art and Popular Culture in Nicaragua Since the Revolution in 1979*, pp. 72–96.

103 See: Ministerio de Educación, *Nicaragua triunfa en la Alfabetización* (San José, 1981), Randall, *Sandino's Daughters*, the chapter on Dora María Tellez; as well as Vilas, *Perfiles de la Revolución Sandinista*, pp. 214–19. See also: The FSLN Directorate, *Women and the Sandinista Revolution* (Managua, 1987); CIERA, *Tough Row to Hoe: Women in Nicaragua's Agricultural Cooperatives*, tran. Food First (San Francisco, 1985); Adriana Angel and Fiona Macintosh, *The Tiger's Milk: Women of Nicaragua* (Managua, 1987); and, finally, two pieces on Nora Astorga, the Sandinista Ambassador to The United Nations: Elaine Sciolino, "Nicaragua's UN Voice," *New York Times Magazine* (September 28, 1986), pp. 29 ff and Wolfgang Saxon, "Nora Astorga, a Sandinista Hero and Delegate to the UN, Dies at 39," *New York Times* (February 15, 1988), p. A18.

104 See the pertinent passages in Gonzálo Fernández de Oviedo y Valdés, *Historia natural y general de las Indias* (1529; Madrid, 1855). See also: Doris Stone, "Synthesis of Lower Central American Ethnohistory," in Gordon Elkholm and Gordon Willey, eds., *Archaeological Frontiers and External Connections* (Austin, 1966), pp. 209–14; and the impressive anthology *Women and Colonization*, ed. Mona Etienne and Eleanor Burke Leacock (New York, 1980).

105 Valle-Castillo, "Los Primitivistas de Nicaragua," p. 169: "es cierto que todos se hicieron de una ideología, muy elemental si se quiere, pero funcional y eficaz en su contexto, o sea, se convirtieron en intelectuales fieles al modelo gramsciano."

106 Ernesto Cardenal, *Nostalgia del futuro: Pintura y buena noticia en Solentiname* (Managua, 1982). See also interview with Miriam Guevara by the author, Albuquerque, April 12, 1994.

107 On the paintings of Tshibumba Kanda-Matulu, see Guy Brett, *Through Our Own Eyes* (Philadelphia, 1986), pp. 82–97.

108 Stone, "Synthesis of Lower Central American Ethnohistory," p. 230.

109 Omar Cabezas, *La montaña es algo más que una inmensa estepa verde* (1982) 4th ed. (Managua, 1985), pp. 29: "cuando me fui a la montaña, subí can la idea de que la montaña era un poder. . . . hablemos de la montaña como algo mítico . . . la guarantía del futuro." See also Henry Ruiz, "La montaña era como un cristal donde se forjaban los mejores cuadros," *Nicaráuac*, no. 1 (May/June 1980), p. 18.

110 Carlos Fuentes, foreword to Omar Cabezas, *Fire From the Mountain: The Making of a Sandinista*, tran. Kathleen Weaver (New York, 1985), pp. vii–xiii.

111 Stephen Kinzer, "To Get Electricity, Nicaraguans Go to the Volcano," *New York Times* (August 29, 1983), p. A2. See also: Joshua Karliner, Daniel Faber, and Robert Price, *Nicaragua: An Environmental Perspective*, Green Paper, no. 1 (San Francisco, 1984). Reprinted in *Nicaragua: Unfinished Revolution*, pp. 393–408; Sean L. Swezey, "Nicaragua's Revolution in Pesticides Policy," *Environmental Magazine* (January–February 1985); and Denis Corrales Rodríguez, *Impacto ecológico sobre recursos naturales y renovables de Centroámerica: Caso particular de Nicaragua* (Managua, 1983).

112 Luis Morales Alonso, "Arte nicaragüense," in *La Segunda Bienal de la Habana* (Havana, 1986), pp. 420–21. Also interview with Luis Morales Alonso by the author and John Ryder, ASTC Office Building, Managua (July 11, 1986). For reproductions and biographical sketches of these artists and others in the ASTC, see: UNAP, *Pintura contemporánea de Nicaragua* (Managua, 1985).

113 Morales Alonso, "Arte nicaragüense," p. 420–21. See also the set of four essays by Rosario Murillo in the July 2, 1982 issue of *Ventana*: "Arnoldo Guillén: De una época a otra," pp. 2–3; "Orlando Sobalvarro: Un disciplina constante," pp. 3–4; Santos Medina: "En busca de nuestro propia expresión," pp. 5–6; and Leonel Vanegas, "Veinte años de pintura," pp. 6–7.

114 "Exposición Casa Fernando Gordillo," *Ventana*, no. 79 (July 24, 1982), p. 1. See also in the same issue: Julio Valle-Castillo, "Signos visibles y previsibles," pp. 6–7.

115 On the precolonial and postolonial dialogue in painting of the Americas, see César Paternosto, *Piedra abstracto: La escultura Inca, una visión contemporánea* (1989), tran. Esther Allen (Austin, Tex., 1996).

116 Doris Stone, "Nicaragua," *Encyclopedia of World Art*, vol. 10 (New York, 1965), p. 631. See also: S. K. Lothrop, *Pottery of Costa Rica and Nicaragua*, 2 vols. (New York, 1926); and Lydia Wyckoff, *A Suggested Nicaraguan Pottery Sequence*, Monograph no. 58, Museum of the American Indians (New York, 1971).

117 Ernesto Cardenal, "Las Tortugas," in *Vuelos de Victoria / Flights of Victory*, ed. and tran. Marc Zimmerman (Maryknoll, N. Y., 1975), pp. 72–73. See also Ernesto Cardenal, "Cántico del Sol," *Ventana* (July 19, 1986), pp. 12–13. On this issue, see Craven, *The New Concept of Art and Popular Culture in Nicaragua Since the Revolution*, pp. 140–56.

118 LaDuke, "Six Nicaraguan Painters," p. 12.

119 Interview with Santos Medina by the author, Managua (July 5, 1995).

120 "Obras premiadas en el V. Certamen Nacional de Artes Plásticas," *Ventana* (July 19, 1986), p. 24. See also in the same issue, Donaldo Altamirano, "Rendimientos de la imagen: V. Certamen," p. 3.

121 See, for example, Omar Cabezas, *La montaña es algo más . . .* , pp. 29 ff.

122 Marta Traba, "Mirar en Nicaragua," pp. 29–86. (See note 44 above).

123 Marta Traba, *Dos décadas vulnerables en las artes plásticas latinoamericanos, 1950–1970*. (Mexico City, 1973), p. 6. For more on this, see: David Craven, *Abstract Expressionism as Cultural Critique: Dissent in the McCarthy Period* (Cambridge, 1999), pp. 9–18.

124 Interview with Donaldo Altamirano and Raúl Quintanilla, as well as Mario Martínez and Boanerges Cerrato, by the author, David Kunzle, and John Ryder, ASTC office building, Managua, July 8, 1986. Also, interview with Donaldo Altamirano by the author, *Ventana* editorial office, Managua, July 24, 1986.

125 Interview with Donaldo Altamirano, July 8, 1986.

126 Adolfo Sánchez Vázquez, "La pintura como lenguaje," *Nicaráuac*, no. 10 (August 1984), pp. 25–28. The importance of this series of lectures—which seems to provide a fine conceptual framework for approaching many of the best Nicaraguan paintings seen during this period—was emphasized on several occasions at the Escuela Nacionel de Artes Plásticas, Managua, as, for example, in an interview with Raúl Quintanilla, then Director of ENAP, by the author on July 21, 1986.

127 Interview with María Gallo by the author, Xavier Kantón Gallery, Managua, July 16, 1986. For more on María Gallo, see LaDuke, "Six Nicaraguan Painters," p. 10.

128 Porfirio García, "Las mujeres de Gauguin," *Nuevo Amanecer Cultural* (March 27, 1993), p. 2: "Sus bellas mujeres tercermundistas las que . . . pintó . . . y defendió en vida." See also: Stephen Eisenman, *Gauguin's Skirt* (London, 1998).

129 On the political involvement of Jasper Johns with Latin American art, specifically that of Cuba, see *First Look: Ten Young Artists From Today's Cuba* (New York: The Westbeth Gallery, November 3–22, 1981). The Acknowledgments read: "This exhibition is sponsored by Dore Ashton, Romare Bearden, Christo, Dorothy Dehner, Robert Gwathmey, Jasper Johns . . ."

130 U.S. Congressional Arms Control and Foreign Policy Caucus, "Who Are the Contras?" *U.S. Congressional Records* (April 23, 1985), reprinted in *Nicaragua: Unfinished Revolution*, pp. 247–56. For some sobering statistics on the horrific terror spread by the U.S.-backed Contras, who targeted school teachers in particular for assassination as "subversives," see: Dianna Melrose, *Nicaragua: The Threat of a Good Example?*, Oxfam Report (Oxford, 1985), pp. 31–38. For two public confessions of atrocities by people who worked with the Contras, see: Edgar Chamorro, "Terror is the Most Effective Weapon of the Nicaraguan Contras," *New York Times* (January 9, 1996), editorial page; and "Ex-CIA Specialist [David Macmichael] Testifies in Hague," *New York Times* (September 14, 1985), p. 5 Surely the best U.S. publication to consult from the 1980s on

the "real facts" about the Contras would be *The Nation*. Alexander Cockburn's column, and also that of Christopher Hitchins, were invaluable in this regard, as were essays by non-staff writers. See, for example: Alexander Cockburn, "Bandits, Vicious and Wrong," *The Nation* (June 13, 1987), pp. 790–91 or "The Execution of Ben Linder," *The Nation* (October 17, 1987), pp. 402–03; and also: Perry Anderson, "Contraband," *The Nation* (July 20, 1987), pp. 855–57; Bill Weinberg, "Bad Seeds in Nicaragua," *The Nation* (July 10, 1984), pp. 50–51; and Lucy Lippard, "Art in Central America," *The Nation* (January 20, 1984), pp. 102–03.

As for primary sources to be examined directly, see: The Central Intelligence Agency, *Guía para liberar a Nicaragua* (Washington D.C., 1983) reprint by Grove Press, New York, 1988. For the sordid details of the illegal channeling of money to the Contras by the Reagan–Bush Administration, see *The Tower Report for the U.S. Congress*, intro., R. W. Apple, Jr. (New York, 1987).

131 Bruce Barthol, "In the Face of Fear," *American Theater*, pp. 26–28. See also Fernando Butazzoni, "With Rubén Darío Beneath the Bullets," *Cuestion* (Sweden, June 1983), reprinted in White, *Culture and Politics in Nicaragua*, p. 130.

132 Armando Morales, "Pintar es ver e imaginar," *Ventana* (July 5, 1986), p. 3. See also: Donaldo Altamirano, "Armando Morales: Nicaragüanidad y universalismo," *Nuevo Amanecer Cultural* (July 5, 1986), p. 1, and Teresa del Conde, *La Saga de Sandino: Litografías* (Mexico City, 1994). This debt to Goya was reaffirmed by Armando Morales in an interview with the author, Claude Bernard Gallery, New York City, November 19, 1987.

133 Morales, "Pintar es ver e imaginar," p. 3.

134 Jorge Eduardo Arellano, "Esencia e interpretación" (1975), in *El Güegüense: Comedia–Bailete de la época colonial* (Managua, 1993), p. 14: "todos las pistas conducen a señalar el XVII . . . y posiblemente alrededor de su mitad." For a discussion of Güegüense's dramatic revival in the 1980s as part of the "dialogical culture" of the revolutionary process, see Craven, *The New Concept of Art and Popular Culture in Nicaragua Since the Revolution*, pp. 63–70. Such a dialogical framework features a staging of *Güegüense* as both a parable of cultural history and as a means of reconstructing national identity, in addition to being a trope for postcolonial cultural resistance in the Third World more generally. (The dichotomous belief that Güegüense could only be one of the three is precisely what undermines the untenable position assumed by Les Field in his book, *The Grimace of Macho Ratón*.)

135 "Schultz Meets Ecuador's New President [Borja], Criticizes Anti-U.S. Mural," *Hartford Courant* (August 11, 1988), p. A7. See also: Frank Fitzgerald and Ana Rodríguez,

"Guayasamin: An Interview on 'Artless Power and Powerful Art'," NACLA *Report on the Americas*, vol. 23, no. 2 (July 1989), pp. 4–6; Katherine E. Manthorne, "Oswaldo Guayasamin," *Latin American Art Magazine* (December 1991), pp. 56–58; and José Camón Aznar, *Oswaldo Guayasamin* (Barcelona, 1981).

136 See for example, Johnson, "Nicaraguan Culture," pp. 8–11. The first thesis on this topic in the Anglo-American world, and probably elsewhere too, was written under Dawn Ades and Valerie Fraser at the University of Essex, which is the main center for Latin American studies in the United Kingdom: M. W. A. Axworthy, "Nicaraguan Popular Muralism, 1979–1987" (unpublished masters thesis, University of Essex, 1988).

137 David Kunzle, *The Murals of Revolutionary Nicaragua, 1979–1992*, foreword by Miguel D'Escoto and introduction by Raúl Quintanilla (Berkeley, 1995). This study is the definitive catalogue raisonné of the murals in Nicaragua, many of which have now been destroyed. This book has understandably been well received in Nicaragua, even as it has been largely ignored by the U.S. artworld. For a review in Nicaragua, see Gareth Richards, Review Essay, *Barricada International*, no. 393 (February 1996), pp. 30–31.

138 On the number of Mexican murals done in relation to the Mexican Revolution, see: Orlando S. Suárez, *Inventario del muralismo mexicano* (Mexico City, 1972) and Philip Stein, *Murales de México* (Mexico City, 1991).

139 Interview with Leonel Cerrato by the author and John Ryder, ENAP, Managua (July 21, 1986). For more on Leonel Cerrato's murals, see John P. Weber, "Sandinista Arts," *New Art Examiner* (October 1985), pp. 42–44 and John P. Weber, "Report from Nicaragua," *Community Murals Magazine* (spring 1985), pp. 11–12. Weber, who is one of the most important U.S. muralists of the last three decades, and who works out of Chicago, was invited to Nicaragua to collaborate on a mural with Leonel Cerrato and Boanerges Cerrato at the Mercado San Judas in 1985. See letter from John P. Weber to the author (March 10, 1990).

140 See: *Guía a la obra de Integración Interna, "Historia de Nicaragua" en Santa María de los Angeles* (Managua, 1985), pp. 3–4 and interview with Sergio Michilini by the author and John Ryder, Managua, July 14, 1986. See also: Sergio Michilini, *L'occupazione di tiempo: Le pittore murali della chiesa S. María delgi Angeli, Managua* (Milan, 1988); David Kunzle, "The Murals of Santa María de Los Angeles," *Latin American Perspectives*, vol. 16, no. 2 (spring 1989), pp. 47–60; and David Kunzle, *The Murals of Revolutionary Nicaragua*, pp. 134–35.

141 David Alfaro Siqueiros, *Cómo se pinta un mural*, Ministerio de Cultura (Managua, 1985). See also *Palabras de Siqueiros*, ed. Raquel Tibol (Mexico City, 1996).

142 Interview with Raúl Quintanilla by the author and John Ryder, Managua, July 21, 1986. Francisco Letelier, a Chilean artist living in exile in California, also made this same point about the Central American preference for Diego Rivera and José Clemente Orozco versus the European and Chicano preference for Siqueiros. Interview with Francisco Letelier by the author, Managua, July 20, 1986. Letelier, who designed the excellent album cover for Jackson Browne, *World in Motion* (Elektra/Asylum Records, 1989), was then in Nicaragua working on a mural in the Parque de los Madres, near the Plaza de España in Managua. For more on this mural, see David Kunzle, *The Murals of Revolutionary Nicaragua*, pp. 126–27.

143 See Leoncio Sáenz, "La Revolución en un mural de Canales," *Ventana* (January 22, 1983), p. 15. See also Alejandro Canales, "Temas sobre el Maíz," *Nicaráuac*, no. 6 (December 1981), pp. 160–66; "Alejandro Canales," *Encyclopedia of Latin America and Caribbean Art* (London, 2000), p. 144; Eva Cockcroft, "A Report on Murals in Nicaragua," *Community Murals Magazine* (fall 1981), pp. 8–13; Craven, *The New Concept of Art and Popular Culture in Nicaragua Since the Revolution*, pp. 189–91; and Kunzle, *The Murals of Revolutionary Nicaragua*, p. 95. For more on Diego Rivera's "La maestra rural," see Craven, *Diego Rivera as Epic Modernist*, pp. 78–79.

144 Betty LaDuke, "Alejandro Canales," *Community Murals Magazine* (winter 1985), pp. 10–11. See also Craven, *The New Concept of Art and Popular Culture in Nicaragua Since the Revolution*, pp. 198–207 and David Kunzle, *Murals of Revolutionary Nicaragua*, p. 96.

145 LaDuke, "Alejandro Canales," pp. 10–11. On "synecdoche," see *Oxford Dictionary of Literary Terms* (Oxford, 1990), p. 221.

146 See John Vinocur, "Nicaragua: A Correspondent's Portrait," *New York Times* (August 16, 1983), p. 1. Accompanying the text is a photograph that shows a billboard in the style of Antonio Reyes with a standard depiction of the three martyrs, Sandino, Rigoberto López Pérez, and Carlos Fonseca. The quite erroneous caption, with its neo-Stalinist implications, reads: "Posters of the Sandinista leaders were erected last month in León, Nicaragua . . ." In response to this misleading caption, I sent in a letter asking that the mistake be corrected. My letter was not published and the mistaken view was allowed to go unchecked. A far more serious case of intentional mislabeling, however, happened in *Time Magazine*, and this misinformation caused considerable outrage in Nicaragua. In an early report about the FSLN, *Time* ran an article entitled: "Nicaragua: Challenge From the Contras, as Disillusionment Spreads, the Sandinistas Face a New Threat" with an accompanying photo of the Sandinista leadership in front of a bill-

board mural in Masaya, Nicaragua on July 19, 1982—an event that I attended and photographed. The caption of the photo reads: "Sandinista leaders, including Ortega, left, in cap and glasses celebrate in Moscow." The subcaption below it states: "Strident Marxism, disregard for human rights, and dependence on the Cubans." (*Time Magazine*, August 2, 1982, p. 32). When this crude propagandistic act was pointed out by readers, the editors claimed that the mistake had occurred as the result of an innocent "typo"! In short, they had mispelled "Masaya" and somehow "Moscow" emerged from the misspelling. A comparable act with no possibility of being dismissed as a typo occurred on the cover of *Time Magazine's* March 31, 1986 issue, when the cover featured a painted portrait of Daniel Ortega (by an illustrator named Paul Davis). Ortega is shown wearing eyeglasses that are decorated with a hammer and sickle through which Ortega is purportedly "seeing the world."

 The reportage by the *New York Times* was not nearly so onesided or jaundiced as that of *Time Magazine*. One need only recall the courageous and well-informed articles by Raymond Bonner, a favorite target of the Reagan Administration, and even some of the pieces by Stephen Kinzer, to appreciate the fairly broad range of pespectives available at the *New York Times* during this period. For the media coverage more generally in the United States, see: Wayne S. Smith, "Lies About Nicaragua," *Foreign Policy*, no. 67 (summer 1987), pp. 87–103; Esther Parada, "Covert Ideology: Two Images of Revolution," *Afterimage*, vol. 11, no. 8 (March 1984), pp. 7–15; and Fred Landis, "CIA Media Operations in Chile, Jamaica, and Nicaragua," *Covert Action Information Bulletin* (March 1982), pp. 6–36.

147 See White, "Leonel Rugama (1950–1970): The Earth Is a Satellite of the Moon," in *Culture and Politics in Nicaragua*, pp. 85–86. There is also a moving tribute to Rugama in the book by Omar Cabezas, *La montaña es algo más . . .*, pp. 22–24: "Yo conocía a Leonel Rugama . . . Recuerdo que entonces dijo al grupo de compañeros que estaban allí discutiendo con el, fruncido el ceño: 'Hay que ser como el Che . . . ser como el Che . . . ser como el Che.'"

148 White, "Leonel Rugama," pp. 85–86.

149 Ernesto Cardenal, "Ofensiva Final," *Vuelos de Victoria*, pp. 2–3.

150 See Kunzle, *The Murals of Revolutionary Nicaragua*, catalog numbers 1, 2, 6, 8, 12, 42, 53, 65, 80. Cat. 6 is by Leonel Cerrato and is titled *El Encuentro* in that monograph, while I use the title *La Reunión* in my text for the same work. Both titles were used for the same painting.

151 This point is demonstrated both in Craven, *The New Concept of Art and Popular Culture in Nicaragua Since the Revolution*, pp. 207–23 and Kunzle, *The Murals of Revolutionary Nicaragua*, pp. 235–45.

152 On the Russian and German collectives, see John Willet, *Art and Politics in the Weimar Period: The New Sobriety, 1917–1933* (New York, 1978). On the *Taller de Gráfica Popular*, see Helga Prignitz, *TGP: Ein Grafiker–Kollectiv in Mexico von 1973–1977* (Berlin, 1981), a landmark study in the field, and also David Craven and Kathleen Howe, *A Partisan Press with Revolutionary Intent: The Work and Legacy of the TGP* (Albuquerque, forthcoming 2003). On Chilean graphic production, see David Kunzle, "Art of the New Chile," in *Art and Architecture at the Service of Politics*, ed. Henry Millon and Linda Nochlin (MIT, 1978). On the posters from May 1968 in Paris, see Jean Cassou, ed., *Art and Confrontation* (Paris, 1968).

153 Cockcroft and Kunzle, "Report From Nicaragua," *Art in America*, pp. 51–53 and Craven, *The New Concept of Art and Popular Culture in Nicaragua Since the Revolution*, pp. 235–45.

154 Gioconda Belli, "El debate ideológica," *Barricada* (September 5, 1982), p. 3. Interview with Gioconda Belli by the author and Colleen Kattau, Managua, January 9, 1990.

155 Gioconda Belli was responding specifically to an earlier neo-Stalinist article: Rudolf Wedel, "Arte por quién?," *Barricada* (August 22, 1982), p. 7.

156 For more on this, see Craven, "A New Public," in *The New Concept of Art and Popular Culture in Nicaragua Since the Revolution*, pp. 97–107.

157 *La insurrección de las páredes*, pp. 58–59. Interview with Raúl Quintanilla by the author and John Ryder, ENAP, Managua, July 21, 1986.

158 Ernesto Cardenal, "Somoza Unveils Somoza's Statue of Somoza in the Somoza Stadium," tran. Donald D. Walsh, in Ernesto Cardenal, *Apocalypse and Other Poems*, ed. Robert Pring-Mill and Donald D. Walsh (New York, 1977), p. 14. For an exemplary look at the situation of art and culture under the Somozas, see David Whisnant, *Rascally Signs in Sacred Places* (Chapel Hill, 1995), ch. 3.

159 Mario Flores, "El 'Boom' de las galerías," *Barricada* (July 10, 1982), p. 3 and LaDuke, "Six Nicaraguan Painters," pp. 9–10. See also Elizabeth Dore, "Culture in Nicaragua," in *Nicaragua: the First Five Years*, pp. 412–422; Judith Doyle and Jorge Lozano, ed., "Culture in Nicaragua: A Special Issue," *Impulse*, vol. 11 (summer 1984); and Peter Ross, "Cultural Policy in a Transitional Society, Nicaragua: 1979–1989," *Third World Quarterly*, vol. 12 (April 1990), pp. 110–30.

160 Flores, "El 'Boom' de las galerías," p. 3.

161 Booth, *The End and the Beginning*, pp. 89 ff.

162 Betty LaDuke, "Six Nicaraguan Painters," p. 9.

163 See for example the following catalogs of these various art spaces: *Racquel Villareal: Dibujos desde Managua* (Managua: Sala Ricardo Morales del Ministerio de Cultura, July 29–August 17, 1982); *A 50 años . . . Sandino Vive: Exposición de Artes Plásticas* (Managua: Sala Ricardo Morales del Ministerio de Cultura, February 22–30, 1984); *Escuela Nacional de Artes Plásticas, '86 en saludo al Séptimo Aniversario, Inauguracion de la Galería Xavier Kantón* (Managua: ENAP, July 1986); *Leonel Vanegas: Nuevas Propuestas* (Managua: Galería Casa Fernando Gordillo de la ASTC, June 24–July, 1986); and *Angulos de Managua por La Unión de fotográfos de la ASTC* (Managua: Casa Fernando Gordillo, July 1986).

164 Galería de los Pipitos (Managua, Janurary 1990). A private gallery run by art dealer Lauren Lacayo also opened about this time: Galería Hogar Felíz (Managua, January 1990).

165 Murillo, "A New Culture," in *A New Kind of Revolution*, pp. 39–40 and interview with Rosario Murillo, cited in Lippard, "Hotter than July," p. 14.

166 Murillo, "A New Culture," pp. 39–40 and Lippard, "Hotter than July," p. 14. Interview with Artists in the Unión Nacional de Artístas Plásticas (UNAP) by the author, Managua, January 10, 1990.

167 *Museo de Arte Contemporáneo "Julio Cortázar"* (Managua: Instituto de Cultura, 1989). This eight-page pamphlet lists the names of more than four hundred artists and "más de 1300 piezas de diversos géneros y estilos de importantes artístas." Also included in this publication is an essay by Julio Cortázar, "Aquí la dignidad y la belleza," about this collection. On the FSLN record concerning the establishment of museums, see Whisnant, "Archiving the Past: Libraries and Museums," *Rascally Signs in Sacred Places*, pp. 205–14.

168 Cortázar, *Nicaragua tan violentement dulce*, p. 68.

169 "Nicaragua: Museums VIII," *Encyclopedia of Latin American and Caribbean Art*, p. 489.

170 On the collection in the Casa de los Tres Mundos in Granada, which was established in the 1980s, see Stephen Kinzer, "Brooding Idols Evoke an Ancient Nicaragua," *New York Times* (January 20, 1987), p. 3.

171 Cortázar, *Nicaragua tan violementemente dulce*, pp. 67–69.

172 Oscar Wilde, "The Soul of Man Under Socialism" (1891), in *The Artist as Critic: Critical Essays*, ed. Richard Ellman (Chicago, 1969), p. 271.

173 On the latter, see Pablo González Casanova, the distinguished Mexican political theorist and historian, in his foreword to Roger Burbach and Orlando Núñez Soto, *Fire in the Americas: Forging a Revolutionary Agenda* (London, 1987), pp. ix–xii. See also, the remarks of Uruguayan author Eduardo Galeano, "La Revolución como Revelación," *Nicaráuac*, no. 6 (December 1981), pp. 108–14.

174 Cardenal, "Cultura revolucionaria," in *Hacia una Política Cultural*, p. 181. For a French response to this claim, see Jack Lang, "Anticultura transnacional y el poder de la imaginación," *Nicaráuac*, no. 9 (April 1983), pp.

39–53. It is worth mentioning that in front of the Xavier Kantón Gallery of ENAP during the mid-1980s were two sculpted busts flanking the entrance: one of Carlos Fonseca and the other of Voltaire (after Houdon).

175 "Entre la Libertad y el Miedo," *Ventana* (March 7, 1981), pp. 2–3. For excerpts from this group discussion, see White, *Culture and Politics in Nicaragua*, pp. 101–05.

176 Ibid.

177 Cited in White, *Culture and Politics in Nicaragua*, pp. 100–01.

178 This 1983 statement by Ernesto Cardenal is reprinted in Johnson, *A Nation of Poets*, pp. 10–12.

179 Ibid. Author Greg Dawes, in *Aesthetics and Politics*, pp. 28–29, contends that Rosario Murillo, et al., "felt that there should be greater access to consuming and appreciating art, but not necessarily to creating it."

180 Interview with Mayra Jiménez by Steven White, included in White, *Culture and Politics in Nicaragua*, p. 111. See also Beverley and Zimmerman, *Literature and Politics*, pp. 96–101.

181 Beverley and Zimmerman, *Literature and Politics*, p. 104.

182 Ibid., pp. 106–07.

183 Margaret Randall, *Sandino's Daughters Revisited: Feminism in Nicaragua* (New Brunswick, N. J., 1994). The original and now "classic" first version was: Margaret Randall, *Sandino's Daughters: Testimonies of Women in Struggle* (Vancouver, 1981).

184 Randall, *Sandino's Daughters Revisited*, p. 57.

185 Interview with Mayra Jiménez, in White, *Culture and Politics in Nicaragua*, pp. 106–13. Mayra Jiménez put it this way: "Now art isn't for the people, but from the people."

186 Larry Seigle, "Sandinista Artists' Association," *The Militant* (April 29, 1989), p. 8. Also, interview with Gioconda Belli by David Craven, Managua, January 9, 1990.

187 Beverley and Zimmerman, *Literature and Politics*, p. 109. See also Dawes, *Aesthetics and Politics*, p. viii.

188 Interview with artists in UNAP by the author, Managua, January 10, 1990.

189 Beverley and Zimmerman, *Literature and Politics*, p. 110.

190 Ibid.

191 On the postrevolutionary censorship of art, see Gabriela Selser, "Odio a la cultura," *Barricada International* (November 17, 1990), pp. 33–34; Raúl Quintanilla, "La unidad del sector cultural," *Barricada* (November 11, 1999), p. 11; and Jack Rosenberger, "Nicaragua's Vanishing Murals," *Art in America* (July 1993), p. 27. There was also "An Open Letter / Una Carta Abierta" (April 25, 1992) protesting against the destruction of these murals that was signed by seventeen scholars and artists from the U.S., Europe, and Latin America and sent to President Violeta Chamorro in Nicaragua. This letter was initiated by Dawn Ades, Alicia Azuela,

David Craven, and O. K. Werckmeister. It was published in the Managua-based art journal *ArteFacto* (summer 1992). For more on *Arte-Facto*, see Lindsay Jones, "Artefacto in Contemporary Nicaragua: Haunting the Margins of Acceptance," *Third Text*, no. 48 (autumn 1999), pp. 17–28.

192 "Nicaragua's New President," *New York Times* (October 23, 1996), p. A18: "Mr. Alemán was an energetic manager and salesman as Mayor of Managua from 1990–1995. But his style bore touches of the caudillos who controlled the country for centuries . . . He has further polarized an exhausted country."

193 The primary book at issue here is a shrill and poorly researched study that originated in The Netherlands in the Center for Latin American and Caribbean Studies at the University of Utrecht: Klaas Wellinga, *Entre la poesía y la pared* (Amsterdam and San José, 1990). He begins by dismissing the "unproven assumption that culture enriches the lives of citizens" and then proceeds to claim quite erroneously that the FSLN enforced a "public prohibition against any discussion of cultural policy." Other essays of this ilk by right-wing authors from Nicaragua, as well as elsewhere, have surfaced in *La Prensa Literaria*, as one sees, for example, in the October 28, 1995 issue. For an excellent recent corrective to these ill-informed studies, see Neerja Vasishta, "From Promising Reality to Impossible Future: Nicaraguan Primitivist Painting, 1970–2000." (unpublished honours thesis, University of New Mexico, 2000).

194 Bruce Cockburn, "Nicaragua," from *Stealing Fire*, Columbia Records (New York, 1984). Another striking song on the same album, "Dust and Diesel," is also about Nicaragua. For other moving tributes to the Nicaraguan Revolution, see Lawrence Ferlinghetti, *Seven Days in Nicaragua Libre* (San Francisco, 1984), a collection of poems published by City Lights; Silvio Rodríguez, "Canción urgente para Nicaragua," on the album *Unicorno* (Havana, 1984); and Heinrich Böll, "En los 60 años de Ernesto Cardenal," a poem from 1986.

195 This statement is found on the backcover of David Kunzle's book *The Murals of Revolutionary Nicaragua*. For information on the solidarity movement with Revolutionary Nicaragua in the U.S.A., see *Arts Magazine: Special Issue* (January 1984); Jamey Gambrell, "Art Against Intervention," *Art in America* (May 1984), pp. 9–19; and Van Gosse, "Active Engagement: The Legacy of Central American Solidarity," NACLA *Report on the Americas*, vol. 28 (March/April 1995), pp. 22–29.

See also Noam Chomsky, *On Power and Ideology: The Managua Lectures* (Boston, 1987). These public lectures about the history of U.S. military intervention in Latin America were given in 1986 at the Universidad Centramericana in Managua and had a profound impact on the intellectuals of Nicaragua. This was

emphasized by Claribel Alegría in an interview with the author, Cortland, New York, April 3–5, 1989.

Appendix B

1 See José Veigas: "Estas láminas dicen mucho," *Revolución y Cultura*, Havana, no. 24, August 1974, pp. 30–35.

2 See Roberto Segre, *Diez años de arquitectura en Cuba revolucionaria*, Havana, Ediciones Union, 1970, pp. 172–73 and 210–14.

3 See a photo in Gerardo Mosquera, "El conflicto de estar al día," *Revolución y Cultura*, Havana, no. 10, October 1984, p. 40.

4 See: "Proyecto de educación artesanal," *Revolución y Cultura*, Havana, no. 42, February 1976, pp. 54–55 and Sandú Darie, "Apuntes para un método básico de arte popular," in the same publication, pp. 55–59.

Appendix D

1 Father Cardenal was in the United States to speak at an opening for an art exhibition sponsored by the Organization of American States (OAS). His treatment by U.S. Immigration officials acting under orders from the Reagan Administration was little short of scandalous. Despite the fact that he was traveling with a diplomatic passport, the U.S. customs officials detained him for three hours (in order to interrogate him about such things as "international communism" and the Colombian drug trade), and then violated international protocol when they went through his diplomatic pouch looking "for drugs." On the same day that Father Cardenal was repeatedly insulted by the U.S. Customs officials, the Reagan Administration also denied a travel visa to Tomás Borge, the Minister of the Interior in Nicaragua. This prominent leader of the FSLN had been invited to speak in the United States by several instititutions of higher learning, including Harvard University.

2 The creation of the Ministry of Culture was one of the very first actions of the Revolutionary leadership. The victory occurred on July 19th, 1979 and the Ministry of Culture was established on July 20, 1979, with Father Ernesto Cardenal as Minister and Daisy Zamora as Vice-Minister. See: *Hacia una política cultural de la Revolución Popular Sandinista*, ed. Daisy Zamora and Julio Valle-Castillo (Managua, 1982), p. 277.

3 For examples of poems by members of the armed forces in Nicaragua, see: *Poesía de las fuerzas armadas*, ed. Mayra Jiménez, prologue by Hugo Torres (Managua, 1985), as well as *Fogata en la Oscurana: Los Talleres de Poesía en la Alfabetización*, ed. Mayra Jiménez (Managua, 1985).

4 On performing at the northern front in Nicaragua, see the experiences of a theater troup from the United States: Bruce Barthol, "In the Face of Fear: Mime Troup at Nicaraguan Theater Festival," *American Theater* (June 1987), pp. 27–28.

Appendix F

1 For the author's response to the show with a discussion of his scholarly projects in Nicaragua, see "Entrevista con David Craven" published in *El Nuevo Diario's* cultural supplement, *Nuevo Amanacer Cultural* (November 24, 1990).

2 The situation was grim as of 1988, but it became much more grave after the elections in February 1990. The postrevolutionary UNO government even actively discouraged most artists as "Sandinista supporters" and under Mayor Arnold Alemán in Managua engaged in the mass destruction of public artworks, as well as in public book burnings of radical books. See: Tim Johnson, "Artists Given the Financial Brush-Off in Nicaragua," *Miami Herald* (June 20, 1992), pp. A1–3, and Jack Rosenberger, "Nicaragua's Vanishing Murals," *Art in America* (July 1993), p. 27.

BIBLIOGRAPHIC NOTE

Archival Holdings and Primary Sources

Mexican Art and Culture (1910–1940)

An essential starting point is the Centro Nacional de Información, Documentación e Información de Artes Plásticas, or CENIDIAP, which is a key agency of the Instituto de Bellas Artes (INBA), the main ministry of culture for the visual arts within Mexico. This vast archive, now located in the Biblioteca de Bellas Artes within the Centro Nacional de las Artes in Mexico City, houses both photocopies and/or originals of primary sources about most of the main artists and institutions of the period. These sources cover *los tres grandes* (forty-one volumes of material on Diego Rivera alone) and members of the Taller de Gráfica Popular, such as Leopoldo Méndez or Pablo O'Higgins, and such phenomena as the Escuelas al aire libre started by Ramos Martínez. (Many of the sources about these schools have been published by Laura Matute, who works in CENIDIAP, along with Francisco Reyes Palma).

A few other archives in Mexico City are crucial starting points for almost any research on art and cultural policy from this period. These include the following: the Biblioteca Justino Fernández in the Instituto de Investigaciones Estéticas of UNAM, which contains around fifteen thousand volumes of such rare journals as *Savia Moderna* or *El Machete*, plus a comprehensive collection of the book-length studies by all the main commentators on Mexican art from this country (along with such artifacts as all the black and white photographs made by Guillermo Kahlo of colonial architecture); the libraries of the Escuela Nacional de Artes Plásticas (including almost all of the books, prints, an documents connected to the Academia de San Carlos); the Archivo del Taller de Gráfica Popular in Mexico City (only two institutions in the U.S.A. have complete microfilm sets of this archive: the Library of Congress and the University of New Mexico); the Archivo General de la Nación in Lecumberri, Mexico City (which contains several million images within the audio visual resources department from *La Revolución*, including many of the Morelos insurgency); and the extensive holdings of the national photograph archive, the Fototeca del Instituto Nacional de Antropologia e Historia at Pachuca.

Other archives with primary sources of note can be found in such unlikely places as the José Gómez Sicre Papers in Miami, Florida (which Alejandro Anreus used to telling effect in his exemplary recent book on José Clemente Orozco); or in such expected places in Mexico City as the Biblioteca Nacional, the Colegio de México, the Universidad Iberoamericana, the Biblioteca del Museo Franz Meyer, the Museo de Arte Moderno, and the Museo National de Arte. As for primary sources about individual artists, these are located in such sites in Mexico City as, the Museo Siqueiros in the Zona Polanco, the Museo Frida Kahlo Casa Azul in Coyoacán, the Museo Estudio San Angel, the Museo Mural Diego Rivera de Alemeda, the Museo Anahuacalli, or in such provincial capitals as the Museo Casa Diego Rivera in Guanajuato.

In the United States, there are several institutions with some key primary sources both published and unpublished about Mexican muralism: the Detroit Institute of Arts; the Library of Congress; the National Archives (specifically the General Records from 1940 through 1944 of the U.S. State Department); the Harry Ransom Humanities Research Center at the University of Texas, Austin; the Rockefeller Archival Center in Sleepy Hollow, New York; the Bertram Wolfe Papers in the Hoover Institute at Stanford University; and the Museum of Modern Art in New York City (which contains such unpublished documents as Beaumont Newhall's firsthand account of Diego Rivera's fresco technique in the 1920s in Mexico City). For the two best overviews of repositories for primary sources in this regard, see: E. Barberena, "Un analisis de la información del arte latino-americano contemporáneo" (unpublished Ph.D. diss., UNAM, 1987) and Orlando S. Suárez, *Inventario del Muralismo Mexicano* (UNAM, 1972).

Cuban Art and Culture (1959–1989)

Three collections of government documents concerning modern art and culture in Cuba can be singled out. First, there is the file of press dossiers on Cuban artists in the Centro Wifredo Lam, Havana. Secondly, there are two unsurpassed collections in the archives of the Ministerio de Cultura de la República de Cuba, Havana: *Documentos normativas para las Casas de Cultura*, Havana, Ministry of Culture, 1980 (dealing with the national system of Casas de Cultura); and *Instrucciones metodológicas, objetivos, funciones y funcionamientos y requisitos fisco-ambientales de las galerías de arte*, 2 vols., Havana, Ministry of Culture, 1988 (detailing the national network of gallery spaces).

The most important research libraries in Cuba for both unpublished and published documents (plus an outstanding collection of artworks by major figures like Wifredo Lam) are to be found at the invaluable Casa de las Américas in Havana, which is among the most significant cultural institutions in the Americas; and the large Biblioteca Nacional José Martí in Havana. In addition, there are other archives in Havana with notable primary documents for art history in the Academia San Alejandro, the Museo Nacional de Bellas Artes, and the Instituto Superior de Arte. As for key sources about such things as cultural policy in the provinces, see the archives at each of the Casas de Cultura around the country in various townships.

For a solid overview of institutions in the arts within Cuba, see the various subsections by Gerardo Mosquera and Roberto Segre in their entry for "Cuba" for the *Dictionary of Art* (London, 1996). See also a publication of the United Nations: Jaime Saruski and Gerardo Mosquera, *La política cultural de Cuba* (Paris, UNESCO, 1979). Also of fundamental importance are the following: O. López, *Escuela San Alejandro: cronología* (Havana,

1983); Jorge Rigol, *Museo Nacional de Cuba* (Leningrad, 1978); and *Los museos de Cuba* (Havana, Consejo Nacional de Cultura, 1972).

Much the best guide to collections of primary documents from Cuba to be found within the United States is by the Dean of Cuban specialists in the United States, namely, Professor Louis A. Pérez, Jr., of the Latin American Institute at the University of North Carolina, Chapel Hill: *A Guide to Cuban Collections in the United States* (Westport, Conn., 1991). For a comprehensive catalog of Cuban newspapers, journals, unpublished manuscripts, and rare books located in the U.S., see: Louis A. Pérez, Jr., "Cuba Materials in the Bureau of Insular Affairs Library," *Latin American Research Review*, vol. 13 (1978): pp. 182–88 and J. Fonseca, "Cuba Materials and Primary Source Collections: A Bibliography of Microfilm Negatives," *Cuban Studies*, vol. 22 (1992): pp. 231–46. Overall, the most current and comprehensive bibliography of the literature on the Cuban Revolution, both primary and secondary, is to be found in the annual publication *Cuban Studies/Estudios Cubanos*, which is published by the Center for Latin American Studies at the University of Pittsburgh. For the predominant historiographical trends in Cuba during the first twenty-five years of the Revolution, see the Special Issue of the *Revista de la Biblioteca Nacional José Martí*, vol. 27 (January–April 1985) and also Louis A. Pérez, Jr., *Historiography in the Revolution: A Bibliography of Cuban Scholarship, 1959–1979* (New York, 1979).

Several institutions in the U.S. contain primary sources of considerable importance. They include the following: the Center for Cuban Studies in New York City, the Center for the Study of Political Graphics in Los Angeles, the Library of Congress in Washington D.C., and the Center for Southwest Studies along with the Slick Collection of Latin American Graphic Arts in Zimmerman Library at the University of New Mexico, Albuquerque. The latter institution houses, for example, the Margaret Randall Papers.

Nicaraguan Art and Culture (1979–1990)

The national institutions in Nicaragua for doing primary research on the Nicaraguan Revolution are few in number. On this, see: David Craven, "Art Libraries" in the entry for "Nicaragua" for the *Dictionary of Art* (London, 1996), p. 86. First there is the Biblioteca Nacional in Managua, with its Colección Rubén Darío, and then there are a few other libaries and archives of note. They include the following: the Instituto de Historia de Nicaragua (directed by Lic. Margarita Vannini) at UCA, the Universidad Centro-americana in Managua; the Fondo de Promoción Cultural (directed by Lic.

Luisa Amelia Castillo Ramírez) and the Pinacoteca (directed by Ana Ilce Gómez), both of which are in the Banco Nicaragüense de Industría y Comercio (BANIC); the small library in the Escuela Nacional de Artes Plásticas in Managua; and the archives of the Instituto de Cultura that in the 1990s replaced the Ministerio de Cultura of the 1980s, and which is housed in the old Palacio Nacional. (An important archive that I consulted in the 1980s, but which no longer exists, was the one located on the grounds of the old ASTC Headquarters and Gallery Space in Managua.)

Several private libraries and personal archives (along with art collections) are, however, among the only places at present to locate many of the most fundamental primary sources of the Sandinista years. These private collections include the archives of *ArteFacto* and those of the following people: Father Miguel D'Escoto, Father Ernesto Cardenal, Dr. Sergio Ramírez, Raúl Quintanilla, Jorge Arellano, and Roberto Parrales. Among the most important archives (including books and photographs, as well as more occasional primary sources) from the Sandinista years to be found in the U.S.A. are those in the personal papers of David Craven in Albuquerque, David Kunzle in Los Angeles, Margaret Randall (now in the Center for Southwest Studies at the University of New Mexico), John Ryder in Cortland, New York, and Carol Wells in Los Angeles. Two collections of post-Sandinista period interviews and primary documents are those of Lindsay Jones in Phoenix (which is centered on the artists of *ArteFacto*) and Neerja Vasishta in Washington D.C. (which concentrates on the fate of artists producing *printura primitivista* since 1990).

One of the most comprehensive bibliographic compilations of publications about the Nicaraguan Revolution up through the mid-1980s was published by a group of scholars at UCA: *Libros sobre la Revolución* (Managua: Escuela de Sociología de la Universidad Centroamericana, 1986). This book listed almost three hundred publications from thirty-nine different countries. A more limited but still noteworthy survey is found in *Editorial Nueva Nicaragua, catálogo de publicaciones* (Managua, 1989). Perhaps the single most significant collection of primary sources about the conception of cultural policy during the late 1970s and early 1980s is to be found in Daisy Zamora and Julio Valle-Castillo, eds., *Hacia una política cultural de la Revolución* (Managua: Ministerio de Culture, 1982).

Yet other crucial primary sources for this book were, of course, the scores of unpublished interviews that I conducted in Nicaragua in 1982, 1986, 1990, and 1995. Those of the 1980s were usually done with John Ryder. Some of these interviews are cited above in the endnotes. For a partial listing of these primary sources, see: David Craven, *The New Concept of Art and Popular Culture in Nicaragua Since the Revolution in 1979* (Lewiston, New York, 1989), pp. 383–84 and the Appendices of this book.

Photograph Credits

Unless otherwise noted, the photographs were taken by the author, with many of the prints (silkscreens, etchings, etc.,) from Cuba and Nicaragua being in my personal collection. Their acquisition resulted from research trips to points South in the Americas. Moreover, a number of the artworks reproduced here are in the collections of the University of New Mexico, including the University Art Museum and the Zimmerman Library, with its Center for the Study of Southwest Culture. The photographs of public murals in Mexico have been authorized by the Instituto Nacional de Bellas Artes (INBA).

Photograph by Dirk Bakker: 8, 17, 23, 44

By permission of the British Library: 12, 13

Photograph by Luis Camnitzer: 62, 65, 67, 89, 91, 92, 93, 94, 95, 96, 97

Commissioned by the Trustees of the Dartmouth College, Hanover, New Hampshire: 147

© 1986 The Detroit Institute of Arts: 8, 17, 23, 44

Photograph by Leonad Folgarait: 39

© The J. Paul Getty Museum: 145

James Hart Photography, Santa Fe, N.M.: 28

Photograph by David Kunzle: 5, 179

Photograph © 2001 The Museum of Modern Art, New York: 22

Photograph courtesy Roberto Salas: 70

Photograph by Bob Schalkwijk: 29, 31, 32, 35, 36, 40, 42, 43, 116

Courtesy of Throckmorton Fine Art: 34

© 2002 Andy Warhol Foundation for the Visual Arts/ARS, New York: 84

Index